Carleton Watkins

Making the West American

Tyler Green

UNIVERSITY OF CALIFORNIA PRESS

University of California Press, one of the most distinguished university presses in the United States, enriches lives around the world by advancing scholarship in the humanities, social sciences, and natural sciences. Its activities are supported by the UC Press Foundation and by philanthropic contributions from individuals and institutions. For more information, visit www.ucpress.edu.

University of California Press
Oakland, California

Library of Congress Cataloging-in-Publication Data

Names: Green, Tyler, 1974– author.
Title: Carleton Watkins : making the West American / Tyler Green.
Description: Oakland, California : University of California Press, [2018] |
 Includes bibliographical references and index. |
Identifiers: LCCN 2017058334 (print) | LCCN 2017060907 (ebook) |
 ISBN 9780520963023 (ebook) | ISBN 9780520287983 (cloth : alk. paper)
Subjects: LCSH: Watkins, Carleton E., 1829–1916. | Landscape photographers—West
 (U.S.)—19th century.
Classification: LCC TR140.W376 (ebook) | LCC TR140.W376 G74 2018 (print) |
 DDC 770.92—dc23
LC record available at https://lccn.loc.gov/2017058334

Designer: Lia Tjandra
Compositor: IDS
Prepress: Embassy Graphics
Printer: PrintPlus

Manufactured in China

27 26 25 24 23 22 21 20 19 18
10 9 8 7 6 5 4 3 2 1

For Mom, who, I think, would have liked this

CONTENTS

ILLUSTRATIONS

AS CARLETON WATKINS OFTEN gave different titles to different prints of the same work, titles reflect the most common usage.

Images of additional works may be found at carletonwatkins.com.

ACKNOWLEDGMENTS

WHEN I STARTED WORKING on this book in 2012, I was beginning to transition away from journalistic art criticism and toward history. I expected that one of the pleasures of writing a big book on a major artist would be the solitariness, a pleasant loneliness. Instead it ended up being a richly collaborative project.

A quick story demonstrates how: In early 2016 I traveled to New England to research Carleton Watkins and his circle. Family friends David and Kathy Holdorf kindly put me up in their Concord, Massachusetts, home. One of my research targets was Ralph Waldo Emerson, with whom Watkins enabler Thomas Starr King regularly corresponded. I planned to study Starr King-Watkins-Emerson links at Harvard, which has a rich trove of Emerson papers and Watkins photographs, and at the Concord Free Library, which Emerson helped establish and where he probably left a set of Watkins's glass stereographs of Yosemite. If I had time, I thought I'd try to talk my way into Emerson's house, which is typically open only in the summer. Maybe, *maybe*, a picture that Starr had sent Emerson might be somewhere in the house, maybe in a desk or a closet. If I ran out of time to get there, so be it, but thoroughness dictated that I make an effort.

Then, from my first day in Concord, I encountered a repeating weirdness: Friendly Concordians, such as the baristas at Haute Coffee, two staffers at the Free Library, and my server at dinner one night, would ask me why

I was in town. I told them I was researching a book on the artist Carleton Watkins. Usually the farther away from the West Coast I was, the more I'd have to explain who Watkins was. Not in Concord. Time and time again, Concordians nodded at my mentions of Watkins and asked me if I was going to the Emerson house. I figured that the Concordians were, in their friendly way, thinking of the oldest photographs in town and that I might be interested in them. I responded by politely nodding and saying that yes, I hoped to visit Emerson's house.

After several days, after *everyone* to whom I'd mentioned Watkins asked me if I was going to the Emerson house, I realized that seemingly all of Concord knew something about which I had only dimly theorized: there really *were* Watkinses at the Emerson house. With belated urgency, I asked the Holdorfs to help me network my way through Concord until I found Marie Gordinier, who opened the Emerson house for me. Sure enough, collective Concord was right: there were two big pictures by Watkins on the wall of the most important, most public room of the house. This key discovery of prints previously unknown to scholars guided me toward understanding probable links that previously had been mere fuzzy musings.

While not every trip resulted in that kind of payoff, everywhere I went I found warmth and helpfulness. In Ukiah, California, volunteers at the Mendocino County Historical Society guided me to the best and most reliable sources on local history and even explained the politics of why one Mendocino-area repository of nineteenth-century material would likely turn me away. (I made the drive anyway; the Ukiahans were right.) In Berkeley, Christine Hult-Lewis, one of the most thoughtful and reliable scholars on Watkins, generously tolerated my ideas in progress and pointed me in better directions. In California's Kern County, museum curator Lori Wear dropped everything for a day or two to show me the least-known great collection of Watkinses in America and to share with me her knowledge of the region's history. Would that there were space here for another forty examples of the kindness I found on my research travels.

One of the joys of this project has been experiencing the collegiality of other historians, librarians, archivists, curators, artists, and others. Early on, Mark Stevens sent me an encouraging letter full of guidance and advice. I still read it every week or two. In Los Angeles, Bill Deverell and Jenny Watts welcomed me into their circles of knowledge and friendship. Their rich

knowledge of the nineteenth-century West and, in Jenny's case, of Watkins in particular were valuable resources. I'd have to cut a chapter to name everyone at the J. Paul Getty Trust who helped me out, but Kara Kirk was particularly helpful. Eleanor Harvey took my work seriously at a time almost no one else in the art and history worlds of Washington, DC, did. Sarah Meister was among those who invited me into rooms I hadn't earned my way into.

Walter Holemans's willingness to hear my weekly debriefings on all things Watkins was much needed; his life of informed exploration and research into the unknown has provided a model for how I've chosen to work and to try to have a career. Terry and Tom Zale, whose quiet acceptance of this project as something that made sense to do, were supportive and reassuring at a time I needed it most. Karen Levine acquired this book for University of California Press, larded me up with good advice, went above and beyond in putting me up during some of my research, and became a trusted friend and mentor after leaving the press. Nadine Little, Maeve Cornell-Taylor, and Erica Olsen shepherded the book toward publication. My agent, Erika Storella, was one of the first people to think this could be a meaningful project. Corey Keller, Jeffrey Fraenkel, Douglas Nickel, and the aforementioned Christine Hult-Lewis were among the Watkinsians who helped me as soundboards and guides. Artists such as Julie Mehretu, Robert Adams, John Divola, Edward Burtynsky, David Maisel, Judy Fiskin, Jo Ann Callis, and Mark Ruwedel are among those who have helped me find ways into Watkins's work.

I'm particularly grateful to the over two dozen art museums that have advertised on *The Modern Art Notes Podcast* since its inception in 2011. Their support made it possible for me to make a living while I worked on this book.

This book would not have been possible without a significant recent change in the way many nonprofit institutions make material known as open content available to scholars. Museums such as the J. Paul Getty Museum, the Metropolitan Museum of Art, and the National Gallery of Art and libraries such as Stanford's and Yale's Beinecke allow scholars to publish any artwork in their collection free from rights fees that many of their peers charge. (All images in this book from the collection of the J. Paul Getty Museum, Los Angeles, are courtesy of the Getty's Open Content Program.) Outside of these and some other exceptional institutions, image-rights fees

are so routine that even the University of California's Bancroft Library charged me a substantial amount to publish out-of-copyright Watkinses in a University of California Press book. As luck (and a little bit of advance planning) would have it, Watkins's work is unusually well held by institutions with open-content policies. Two institutions that have major Watkins holdings charge particularly high fees: the Hearst Museum of Anthropology at UC Berkeley and the Hispanic Society of America. Their holdings are important, but Watkins's work from those collections and others that restrict scholarship and knowledge via fees that prioritize revenue generation over mission and scholarship is not reproduced here. The most significant obstacle to historians' understanding and sharing how artists have contributed to history is fees that effectively prevent knowledge of and the dissemination of artists' work.

One of the most special joys this project provided me has been getting to know Peter Palmquist through his work. Like me, Palmquist was not trained to be an academic historian. No matter; he was a ferocious and perceptive researcher who built a preposterously intense knowledge of photography in the nineteenth-century American West. His greatest project was to help restore Carleton Watkins to his proper place in history. Palmquist curated the first Watkins retrospective in 1983 for the Amon Carter Museum and kept working on Watkins until his death. Every historian who has worked on Watkins starts with Palmquist. Even though later discoveries, many made possible by technologies that came online after Palmquist died, superseded parts of Palmquist's 1983 show and catalogue, every Watkins scholar starts there. From it, I went through the exhibition archives at the Amon Carter Museum, the Palmquist archives at Yale's Beinecke Library, and finally a set of uncatalogued papers that Palmquist left at the Huntington Library. To his great credit, Palmquist was not satisfied with the Watkins he presented in 1983. He kept working on Watkins and discovered new material all his life. He was obviously building to a major project that would update his 1983 work, but he died before he could complete his update. His papers at Yale and at the Huntington Library taught me not just about Watkins but about the value of continuing to research, trying to learn more, and challenging previous understandings. Scholars of Watkins, photography, and American art owe Palmquist even more than any of them knew at the time of his death. I'm disappointed that I never met him.

Historians also benefit from the Watkins collection that curator Weston Naef built at the J. Paul Getty Museum. It is the world's greatest and most important Watkins collection, and it is one of the great single-artist holdings at any American art museum. Naef bought wisely and daringly, spending then-huge sums of money, breaking Watkins auction records again and again, because he believed Watkins was that good and that important. Naef bet right.

Finally, thanks to my father, Ed Green, for his confidence in my work and his support of my weird career. From the age of twelve, I grew up in a single-parent home under circumstances that were materially comfortable but otherwise challenging. He turned out to be a pretty terrific single father. There's also the surprise in chapter 21, which I never would have known if my father hadn't remembered a name and pointed me in the right direction. Thanks also to my aunt Diane and her husband, Bob Tokheim, who let me stay in their home on my many research trips to Berkeley's and Stanford's libraries—and then tolerated my prattling on about bits of American history in every formerly quiet moment.

I'm also grateful to two anonymous peer reviewers and to Richard White, Jenny Watts, Bill Deverell, Eleanor Harvey, and Christine Hult-Lewis for reading parts of the book and for encouragement and advice. Each has made this a much stronger book. Any errors are mine alone.

INTRODUCTION

SAN FRANCISCANS HAVE ALWAYS heard earthquakes before they have felt them. Just after dawn on the morning of April 18, 1906, seventy-six-year-old Carleton Watkins, like nearly everyone else in San Francisco, heard a mighty rumble.

It started as a low hum southwest of the city, under the Pacific Ocean. The sound traveled through the seabed until it reached the western edge of the city, Ocean Beach, and continued under the rocky highland that was the mostly unpopulated western half of San Francisco, underneath the Army Presidio and nearby Golden Gate Park, under Twin Peaks, then right down the rail line that linked park to city. As it hit the Western Addition, where the populated core of San Francisco began, it grew into a wall of sound. Until now, the deep roar was made by the earth acting on itself, by rock grinding against rock. Now it was also timbers snapping, iron bending, and brick walls crashing. This was when the invisible disaster in the making would have awakened Watkins, one of the few San Franciscans who had lived through the last great earthquake in 1868, a temblor that left streets with deep, broad cracks and that knocked buildings to the ground. Once you hear a big earthquake, you never forget.

Back in 1868, Watkins, then a sprightly thirty-seven-year-old, had grabbed a couple of cameras and headed out into the streets. Back then, he was at the height of his powers. He was famous not just in San Francisco but in

New York, Boston, Washington, and even in Europe, where he had just won a medal at the Paris Exposition Universelle, a world's fair. In that exciting decade, Watkins's pictures of Yosemite Valley, created in the spirit of strengthening ties between California and the Union, exhibited in New York and passed around Capitol Hill and probably the White House, created a sensation and motivated Congress and President Abraham Lincoln to preserve a landscape for the public, the first expression of the idea that would later come to be known as the national park and that would lead to the designation of public land such as national forests. His reputation made, Watkins spent the next few decades making pictures of the West that defined the region for scientists, businessmen, bankers, policy makers, his fellow artists, and Americans who were thinking of moving west.

Watkins's customers, clients, and friends were the men who pushed America into an age gilded by the gold they extracted from the mountains of California and Nevada. These bankers, miners, and land barons collected Watkins's work and hired him for commissions that both showed off their wealth and would help make them wealthier. Among Watkins's collectors and sometimes commissioners were John C. Frémont, conqueror of Indian tribes, explorer, railroad promoter, son-in-law of one of the Senate's most powerful, West-focused men, and the first Republican presidential candidate; John's wife, Jessie, the brains behind Frémont's books, his 1856 presidential campaign, and his California gold mine; and scientists such as John Muir, Clarence King, and George Davidson. Easterners such as Ralph Waldo Emerson, Frederick Law Olmsted, and Asa Gray, the most important American scientist of the nineteenth century, who would bring Darwin's revolution to the United States, snapped up Watkinses too. The U.S. Senate hung pictures by Watkins in the Capitol, and an outgoing American president may have wanted four Watkinses so badly that he stole them from the White House.

Watkins courted men of learning and influence, but he made surest to become close with men of capital. First through John and Jessie Benton Frémont and later through William C. Ralston, the most powerful investor and banker in the West, then through the executives of San Francisco water, railroad, and mining companies, and then through land baron and mine owner James Ben Ali Haggin and his colleagues who made the desert bloom, Watkins built business connections to California's wealthy elite, to the miners who extracted gold, silver, and copper from western lands, to the ranch-

ers who raised cattle and later engineered the land into suitability for staple crops and orchards, and to the bankers who helped enable it all. Watkins was accepted as one of them: he was an early member of San Francisco's famed Bohemian Club, the private enclave of San Francisco's journalists and its moneyed, progressive elite. But by 1906, Watkins was poor, as he had been for over ten years. The skills that had brought him to prominence were gone. Photography was no longer a specialized skill; it had been a full decade since technology had advanced and passed Watkins by. Now Watkins was an avatar of a West in which allied men of capital and their companies controlled vast wealth and power, and in which the unaffiliated individualist, no matter how great he had been at what he did, withered.

Now, as the sound of the earthquake built into cacophony, Watkins was no longer famous or wealthy. His home was apparently a cheap apartment in a low-rent neighborhood south of the Slot, as San Francisco's Market Street was then known. Except for a handful of photographers and photography aficionados who recognized his work as important to the West and to America, he had been forgotten.

Below the Slot, apartment buildings were stacked close, and the walls were thin. When the roar was followed by shaking, Watkins would have heard the iron stoves commonly used for heating crashing through his and his neighbors' floors. He'd have heard plaster separating from walls and ceilings, bricks crunching and disintegrating as the timbers and giant iron beams that held up all of it snapped. A few blocks away, the dome on top of San Francisco's brand-new City Hall smashed through three floors of offices. In his own rooms, Watkins would have heard the sound of many hundreds of his glass negatives clanging back and forth. Within moments, nature's low rumble was replaced by the sound of man's ruin, as an untold number of apartment buildings, boardinghouses, industrial buildings, meatpacking factories, hotels, office buildings, banks, theaters, and more crashed to the ground.

The earthquake lasted forty-five seconds, but the disaster was only just beginning. Even as buildings continued to fall, Watkins would have smelled smoke. Fires, ignited by all those hot stoves crashing through wooden floors, started throughout the city. To this day, no one knows how many fires started in the minutes after the earthquake. Many grew into infernos that consumed entire blocks, entire neighborhoods, and, within hours, much of the city itself.

By now Watkins's senses would have been overwhelmed: he heard disaster, he felt the vibrations of falling buildings, and every minute the smell of fire intensified. The more smoke Watkins smelled, the more afraid he must have been. For weeks Watkins had been preparing to transfer much of his life's work to the museum at nearby Stanford University. In fact, just a week before the earthquake, a curator from the university had visited Watkins in these very rooms in preparation for the university's apparent acquisition of Watkins's archives, the first time an American university or museum would recognize a photographer's importance in such a way. We don't know if Watkins thought about any of that. There may not have been time. Watkins rose and dressed in a black suit, put on a hat, and grabbed his cane. He left his negatives, prints, and papers behind—what else could he do?—and left the house.

A photograph captures what happened next. Gingerly, Watkins walks along a sidewalk toward Russian Hill or Nob Hill, toward somewhat safer ground. Bricks that had fallen off the front of the building to Watkins's right litter the sidewalk. A few feet behind him, the crumbled front of another building covers the street. There are flames in the windows of the Beaux-Arts building behind Watkins. Thick black smoke streams from its roof.

Watkins pushes much of his weight onto the right side of his body, which is further transferring it to his cane. He is having difficulty walking. A younger man keeps a steadying hand on Watkins's back. Nearly everyone in the pictures is gawking at the fires, at the damage. Everyone, that is, except for Watkins, who stares blankly ahead. Someone standing behind a camera has yelled something like "Look here!," and so Watkins, a man who had once been famous for seeing creatively, looked where he was told. He might as well; while he could smell the ash and smoke, while he could feel dust coming down like snowflakes, while he could feel the sidewalk shake, he could not see. The greatest photographer and most influential American artist of the nineteenth century was now nearly blind.

As someone led Watkins away from the Slot in the hours after the quake, Watkins would have known that everything he had—all the photographs he'd taken since 1876 plus a life's worth of records, correspondence, notes, and more—was in danger. Within hours a fire would destroy all of it. The Carleton Watkins collection would never make it to Stanford University, where an institution's early recognition of a "mere photographer" as a ma-

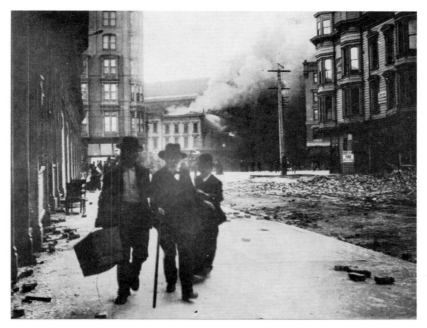

Unknown, *Carleton E. Watkins* [with cane, during aftermath of earthquake], April 18, 1906. Collection of the Bancroft Library, University of California, Berkeley.

jor figure of post–Civil War America may have played a pioneering role in elevating both Watkins as an artist and photography as an important art historical discipline nearly a hundred years earlier than it did.[1]

As a result of the 1906 San Francisco earthquake and fire, which destroyed not only all of Watkins's possessions but also much other material around the city that might have informed our knowledge of the nineteenth-century West, almost no textual documentation of Watkins's life exists. Among the first-person accounts of Watkins's life that have survived are a couple of dozen letters in the artist's own hand, two flawed and routinely factually incorrect oral histories provided by Watkins's daughter, Julia, and a similarly error-strewn minibiography by one of California's first historians, a Watkins friend named Charles Beebe Turrill.

Telling the story of Watkins and his impact on the West and the nation has required building an understanding of his community, the people with whom he interacted and for whom he worked, understanding that constel-

lation, and then intuiting how Watkins and his work fit into it. Fortunately, many of the people with whom Watkins interacted during his life left California for the East, either to return home or to work there. Many of the most important archives related to Watkins and his work are in places such as Massachusetts, Vermont, and Washington, DC, places where earthquakes and fires were less common.

Thank goodness for Watkins's pictures, which are both art and historical documents. Watkins was a preposterously prolific artist. He made over 1,300 mammoth-plate pictures, the huge photographs on which his reputation rests today, and thousands more stereographs and smaller-format pictures. They provide the most important clues to his story, to the men and businesses for whom he worked, to the ideas and artworks that informed his approach to art, and to the nineteenth-century world to which he hoped to contribute.

Writing about Watkins has been like writing about artists such as Goya or Titian, other artists about whom little textual material survives. Like the historians who have written about them, I have done my best to reconstruct and understand Watkins's world. The biographer T.J. Stiles has written that we read (and write) biography to affirm our belief that "the individual matters . . . How does the world shape the individual, and the individual the world? To what extent are convictions, judgment and personality merely typical, embedded in a larger context—and where does the individual wiggle free?"[2] Surviving material does not allow us to know about Watkins's personality, his convictions, his judgment, or much of anything else about him. However, through his work and its impact, we can see how important his individual life was to art, to the West, and to America. That's all any of us will be able to do.

The American West is an artificial construct. The region that is now part of the United States was first home to Native Americans. The West's history of European contact starts with British, Russians, French Canadians, and Spaniards. Much of the region was later northern Mexico and became American only after the United States won a war it instigated in 1848. California's admission as a U.S. state in 1850 settled the matter of national allegiance less than we tend to remember: California, and by extension the rest of the West, was tenuously bound to the Union as late as the spring of 1861. From

roughly then forward, no single American did more to make the West a part of the United States, to join the remote new lands to the East, than Carleton Watkins. How is that possible? First, Watkins had a more than thirty-year career, and his pictures carried on after he stopped making new work. (For example, in California, Kern County land interests continued to use Watkins's pictures to entice farmers west and to sell government on irrigation plans into the twentieth century.) Other influential individuals, such as explorer John C. Frémont, scientist Josiah Whitney, or banker William C. Ralston, had significantly shorter western careers. By the 1870s, companies rather than single actors began to drive the West toward the East. The Big Four railroad barons—Collis Huntington, Leland Stanford, Mark Hopkins, and Charles Crocker—were in the vanguard of this change. The first individual who emerged to challenge Watkins's mantle was his friend John Muir, who became a national leader in conservation at the end of the 1880s, just as Watkins's career was winding up.

For thirty years, between 1860 and 1890, Watkins's pictures joined the often remote, little-known, and less understood West with the dominant East, with its history, its art, its science, its business, and its public policy. During the decades when Americans, including westerners, were interested in western lands for their extractive potential and not much else, Watkins's work repeatedly, insistently urged America to see not just ore and timber but beauty, to discover new species of trees, a new topography, newly discovered glaciers, and agricultural potential. In so doing, Watkins substantially invented an idea that we now take for granted: that the western landscape was awesome enough to care about—and that it was rich enough to encourage and sustain a westering nation. Watkins's story is the story of the West's maturation.

Historian Richard White has rightly complained that Americans tend to think of a mythological West, a place of mountain ranges free of humans, of cowboys and Indians, of tough pioneers and of a destiny so inevitable that it was manifest. Many of those myths—of uninhabited mountainscapes, of water so abundant that deserts may be converted to fruit orchards, and so on—have their visual origins in Watkins's pictures. But the more closely we look, the more we find that Watkins's art reflects the conflicts that have driven the West since the 1850s. "There are cultural visions of the West, constantly changing but always present, that define both for westerners and

others what the western experience means," White writes. "There is not and never has been a single myth, a single imagined West. Myths and meanings are constantly in competition just as various groups within the West were always in competition."[3] So too in Watkins's work. His pictures enabled the preservation of a landscape, Yosemite, for the first time. He also made the greatest pictures of how mining despoiled nearby mountainscapes. The only singularity that runs through Watkins's oeuvre is his consistent ability to compose images.

Today it's striking how much of the nineteenth-century East's knowledge about the West came through Watkins's work. Watkins's pictures influenced artists looking for both subjects and ideas from the newest West. They guided businessmen in their decisions about where to dispatch capital and how to strategically approach investments and partnerships in a land whose vastness was matched only by America's ambition to fill and exploit it. Watkins's pictures helped scientists, especially botanists, geologists, volcanologists, and geodesists, to understand the land, its flora, its past, and its future. They informed both governmental policy and land use in places as different as the mountainous Sierra and pancake-flat Kern County. They convinced America that industrial-scale irrigation had transformed western deserts into the nation's most valuable farmland. They insisted that the West was a full and equal partner in the history of America—and that the West's history went back as far as the rest of the nation's too. For three decades (an unusually long artistic career in nineteenth-century America), Watkins's pictures showed and helped inform the succession of economies that drove the West: mining, transportation, agriculture, and tourism.

Art historians typically focus on narrow silos, on how art or a specific artist impacted other art and other artists. They too rarely examine more horizontal histories, the impact artists have outside art, such as on their world and on events that continue after their careers and lives. Watkins had an extraordinary impact on his America. His career offers a prime example of a history too little studied, of an artist's impact on a nation. I do not mean to suggest that artists and their work have an impact alone, independent of other actors. Art is most impactful within a broader culture when artists ally with or are embraced by outside actors. As in so many other areas of American life, coalitions, formal and ad hoc, matter. Throughout his career, Watkins was active in and useful to networks of the most influential westerners.

It may be that no artist has ever had a greater impact on America. No photographer of the nineteenth century was a greater artist.

Watkins also had a significant impact within the silo. Landscape is the greatest subject of American art. It is to our art what for centuries the church was to Europe's. Until Watkins, the landscapes that made up the nascent American canon were overwhelmingly eastern. In fact, they were overwhelmingly *north*eastern. In the first half of the nineteenth century, the best American artists only rarely ventured south of New York or west of the Appalachian Mountains. Still, by making pictures of northeastern river valleys and mountains, especially the Whites and the Catskills, men such as Thomas Cole, Jasper Cropsey, and Frederic Church established the thing. More than anyone else, Watkins added the West to the American canon both through his own work and through motivating artists such as Albert Bierstadt to travel to the far West and to make art there. It is thanks mostly to Watkins that we cannot think of American art or American visual culture without including the West.

This is the story of how Watkins and his art saw the West and gave it to the nation.

1

SUNRISE IN THE FOOTHILLS OF THE CATSKILL MOUNTAINS

ON NOVEMBER 21, 1829, **CARLETON WATKINS** was born to John Maurice and Julia Anne Watkins in Milfordville, New York, a tiny town in the tight hills west of the Catskill Mountains.[1]

The lesson Carleton would take from his mother's family was to go west, so Carleton's story must start with them. Julia's father, John McDonald, was a classic example of his type, a Scots-Irish Presbyterian whose family had settled the first western frontier in the late 1700s.[2] He seems to have arrived in Milfordville around the turn of the nineteenth century, though exactly how and from where the McDonalds came is somewhat fuzzy. According to one local oral history, the McDonalds were descended from the famed Scottish MacDonald clan that was nearly wiped out by Robert Campbell at the Massacre of Glencoe in 1692. Many of the remaining MacDonalds then emigrated to Nova Scotia. It was said that John McDonald's forefathers were among those MacDonalds, and that they subsequently traveled west, into the Catskills. That may or may not be true. At the turn of the eighteenth century, Milfordville was the frontier, and civic record keeping is rarely a priority of frontier towns.[3]

Eventually several McDonalds worked their way west to an empty, nameless place in central New York State. They built a sawmill and a bridge

that forded the Susquehanna River. As a result, the place became known as Milfordville.[4] Julia's father, John, would inherit this mill and much land. John McDonald expanded the family's holdings to include a hotel and tavern and apparently a second mill, this one a gristmill that was also used for the production of whiskey. Milfordville grew from a name to a town around John McDonald's holdings, which assured both his prosperity and the stability of the town. John McDonald was a manifestation of one of the young republic's early themes: individual opportunity lay in new land, and the new land was always to the west of the settled East. Think of McDonald as the real-life embodiment of Marmaduke Temple, the frontier town builder in *The Pioneers,* James Fenimore Cooper's classic 1823 novel of early American westering that was set in these same foothills of the Catskills. Temple's town is usually considered an analogue for Cooperstown, but it could just as easily be another town a stop or two down the Susquehanna, such as Milfordville.

Milfordville's McDonalds began to intersect with Milfordville's Watkinses around 1800: It is likely that one of John McDonald's brothers was one William Ellis McDonald. William married Lydia Burgett Watkins, a woman who had four children with her first husband and then more with William. One of those children was named John M. Watkins.

It is not clear where John Watkins was born, but he grew into the sort of solid citizen on whom communities depend. He arrived in Milfordville by 1821, when he was fifteen. He had been an orphan since the age of ten. John cut timber in the mountains around Milfordville until, wanting to better himself, he found work in town as a carpenter's apprentice.[5] He built houses for the leading men of the village, men who must have recommended his work to the other leading men of the village, because before long most of them lived in John Watkins houses.[6] John thanked them by building Milfordville's first house of worship, a Presbyterian church. Years later, John would express his continuing commitment to this place by painting the church and then by building it a bell tower.[7] He would become one of the region's most respected hotel- and tavernkeepers. John was well enough regarded by the menfolk of Oneonta, as Milfordville became known after 1832, that they elected him a sergeant in the town's militia.[8] He was well enough regarded by the militia captain, John McDonald, that McDonald gave to John the hand of his eldest daughter, Julia. For John Watkins, marrying Julia was an

excellent career move. McDonald was far and away Milfordville's leading citizen, the town's postmaster, its biggest landowner, and surely its wealthiest man.[9]

There is no record of how John McDonald's daughter Julia met John Watkins. While family records are imprecise, John and Julia were almost certainly either cousins or cousins by marriage. It seems that John McDonald was willing to give Julia's hand to a local orphan of lesser social status because he was, in fact, a McDonald.

John Watkins would have realized that marrying Julia ensured that he would play a role in the town's future. Not long after, the townsfolk confirmed John McDonald's decision: the town's militia voted McDonald's son-in-law into McDonald's old captaincy.[10] As a result of the intertwined history of Milfordville and the McDonald family, when Julia Watkins gave birth to Carleton, the couple's first child, John would not have been just concerned about the troubled economic state of the town and its prospects for the future, he would have been expected to play a role in trying to improve them. He would, but first: Carleton.

A child remembers moments of freedom and wonder. Carleton's earliest memory was the night the sky snowed fire.[11]

It started with a ruckus outside four-year-old Carleton's window, where hundreds of Oneontans were rapidly gathering in the street. In a way, this was no accident: the hotel and tavern that John Watkins ran for or inherited from his father-in-law was located on Oneonta's most commercial block, between the river and the highway that ran through town.[12] Whenever something big was happening, like the Fourth of July, militia drills, or a political rally, Oneontans came here.[13] Oneontans could find this stretch of Chestnut Street in the dark, which was exactly what they had done this night.

Carleton ran out of his father's house and into the street. Everyone was looking at the same place: up the narrow valley of the Susquehanna, toward where Charlotte Creek fed into the river, creating a gentle V that broke up the weathered foothills of the Catskill Mountains. They were staring at the constellation Leo and at the lion's mane, which was where the stars seemed to come from as they streaked across the sky. That was where Carleton

looked too. He saw stars, shooting stars, an almost impossible number of shooting stars.[14]

How many? So many that the great Leonid meteor shower of November 1833 may still be the greatest celestial event in U.S. history. The numbers that quantify the event are so large that they become abstract: Carleton saw ten to twenty falling stars per second. *One one thousand*: twenty shooting stars. *Two one thousand*: forty. *Three one thousand*: sixty. Eventually two hundred thousand shooting stars, and maybe many more, flew through the sky that night.[15] For now, Oneontans had absolutely no idea what was going on. Like other townsfolk across America, they looked to the most prominent, best-educated man among them for guidance. On this occasion and on others, that man was Ira Emmons, who farmed a large piece of land in East Oneonta, a mile or two up the Susquehanna River from the town.[16] As Emmons had a little farther to go to reach John Watkins's hotel, he arrived on his horse-drawn sleigh after a crowd was already assembled. As Emmons probably knew they would, townsfolk crowded his sleigh and asked him to explain why the skies were falling. He did not disappoint. Emmons climbed up onto his chaise and turned to explain to the crowd why the sky was snowing fire.

Emmons's entrance was so grand and the way Oneontans treated him was so deferential that Carleton would remember the moment for the rest of his life. Seventy years after that night, when he was asked about it by an Oneonta historian who had traveled to San Francisco to meet him, Carleton described the scene in detail: Emmons, wearing a long cloak with a cape attached to it, spoke to the assembled from atop his sleigh, a tall, black silhouette as the heavens showered streaks of white, red, blue, and green behind him. Carleton remembered being both awed by something he didn't understand and excited by learning what it was. He remembered the respect accorded the man who built insight from experience and who melded beauty with science. The way a seventysomething Carleton recounted the story leaves the reader suspecting that he was also talking about his own career, that he was establishing the point of genesis for his own interest in the intersection of beauty, science, and philosophy.

Meanwhile, as Carleton's father fretted about the future of a tiny mountain town, Carleton grew up. There was the time four hundred people cele-

brated the Fourth of July in the front yard of Carleton's father's hotel, the day on which a man from nearby Cooperstown marked the occasion by letting loose a huge paper balloon that drifted into the sky.[17] There was the time Carleton and the other boys in town went on a covered-sled ride through the snow to Otego, the next town to the west, a grand journey to a new world,[18] and the time seven-year-old Carleton and a chum scrambled up to the Rocks above town and carved their names in stone, and the many, many times Carleton climbed to the top of the bell tower that his father had built onto the Presbyterian church, lit balls of cotton with turpentine, and threw them out toward town, his own personal fireworks.[19] And then there was the time Carleton was playing by the Susquehanna River behind his grandfather's house and fell in! It was spring and the river was high and it was fast and Carleton was scared and out of nowhere Carleton's dog, a huge bulldog-and-mastiff mixed breed known for both his size and his good nature, jumped in, grabbed his young master's clothes with his mouth, and pulled the boy to the far bank. These are the kinds of thrills a boy remembers.[20]

In Carleton's case, he also remembered a mural on the side of a building. The painting was commissioned by William Angel, friendly business rival of Carleton's father, John, and father of young Carleton's best friend, Myron, who hired an itinerant artist named David Wakelee to paint two signs on the external walls of his hotel. Angel's instructions to Wakelee, to paint a coach-and-four on one wall and a locomotive and train on another, suggest that Angel had a sophisticated understanding of Oneonta's past, present, and future. Angel knew that the coach-and-four, a kind of box-on-wheels pulled by four horses, was Oneonta's past and present. It was how goods and people transited to and from the Hudson River valley and from New York to this little mountain town. The mural also suggested that Angel knew the old-fashioned coach-and-four wouldn't cut it anymore. Like the night on which the sky snowed fire, the mural became a memory Carleton carried with him across the continent and through seven decades: art wasn't just a pretty picture; it could deliver messages about the present and about the future too.

The limited-capacity, slow, unreliable travel provided by the coach-and-four had been rendered obsolete not by the railroad—not yet, anyway—but

by the Erie Canal, the biggest infrastructure project in the nation's history. The canal enabled the cheap transport of wheat, flour, and whiskey from Ohio, Illinois, Michigan, and western New York across the state and down to New York City. By the time Watkins was born, the Erie Canal carried $15 million of goods each year, twice as much as floated down the Mississippi to New Orleans; it had transformed America's economy and built New York City into the commercial powerhouse it still is today.[21] From almost the day the canal opened in 1825, it was cheaper, overwhelmingly cheaper, for wheat to be shipped on a barge from a farm in Ohio up to Lake Erie, across the lake to the Erie Canal, and then floated down the Hudson to New York than it was for Oneontans to send wheat, flour, or whiskey to Philadelphia or Baltimore via the only route available to them, the Susquehanna River.[22] As a result, the number of farms in New York's Mohawk Valley, through which the canal ran between the Hudson and Lake Erie, doubled, and the value of land there quadrupled.[23] Simultaneously, the canal made most of Oneonta's farms obsolete.

William Angel understood that if Oneonta was to compete with the Erie Canal, if it was to grow, if it was to give Myron and Carleton a reason to make their lives there rather than go west, it would have to attract the railroad, the only means by which Oneonta's goods could reach market at a price competitive with goods from the Great Lakes. Angel had just chartered a railroad company that was raising capital in an effort to make that future happen. The signs he had Wakelee paint were a hat tip to Oneonta's past and an advertisement for Angel's hotel, but they were mostly a plea for the town's future. The railroad of which William Angel dreamed was not to be: he retired two years later and soon died. Oneonta wouldn't attract a railroad for another thirty years,[24] by which point both Carleton and Myron had gone west. (In an extraordinary coincidence, they would each become pioneering chroniclers of California's Kern County, the prototype for industrial-scale western irrigated agriculture.)

Near the end of his life, Carleton tied those two Wakelee paintings to another memory, to one of the Fourth of July spectaculars from his youth. Sometime in the late 1830s, Oneonta was midway through its celebration when an extraordinary spectacle belched its way up the Susquehanna River: a steamboat that had come from Unadilla, about twenty miles downriver

from Oneonta. Steamboats were by no means unusual in the United States by this point—the first steamboats ran up the Hudson around 1807.[25] Oneontans knew how important steamboats had become as movers of goods and people. Many Oneontans had offloaded agricultural products onto steamboats at Catskill, the terminus of the rough wagon road that ran east-west from Oneonta to the Hudson. Until now, no steamboat had ever made it up to this sometimes feeble point of the Susquehanna, just a couple of dozen miles from the river's source. As it turned out, none would again: this steamboat got stuck and had to be dislodged from the rocky bottom before it could head back downriver. No railroad (yet) for Oneonta, no steamboats either.[26]

This lack of access to the most important recent technologies was rapidly exacerbating Oneonta's isolation and retarding its potential growth.[27] The prosperity that had carried Oneonta and the Watkinses through Carleton's first decade was ending, fast.

In 1840, as a railroad connection from Oneonta to the outside world turned from plan to dream, a rumor about John Watkins spread quickly through the town and the surrounding area. Farmers poured into Watkins's hotel at River and Main Streets to plunk a quarter onto his bar for a glass of local whiskey and to ask John a question: was the rumor true, was he really giving up on the town he had spent two decades building, often with his own two hands, for a new life on the western frontier?[28]

Yes and no, John would have told them, yes and no. Yes, he was going to Ohio, but he was just going to look, and then he was coming back. He told them that he was taking the two-month trip with just a horse and buggy. You don't leave home with your wife, with four children and a fifth on the way—had the men heard Julia was pregnant again?—to start a frontier life in just a horse and buggy. The men would have offered congratulations and prayers in equal measure. Given the risks of pregnancy, John was plainly going to Ohio alone—and he was coming back.

Still, John would have realized that his own window for going west was closing. He was thirty-four years old, and going west was a young man's move. Carleton was about the age John had been when his parents died, and only a bit younger than John had been when he apprenticed himself to William Angel. If John was ever going to provide Carleton and his brothers

with upward mobility and a future, and if they were going to stick together as a family rather than slowly, steadily move west one by one by one in the coming years, the move would have to be now.

While John Watkins and his wife's family were deeply invested in the town they had helped create, maybe John thought of Oneonta in the way so many Americans in 1840 thought of where they were: as a waypoint, a jumping-off place. America's westward migration was well into its sixth decade. Maybe it was time for the Watkinses to join the rush. In 1825, the year the Erie Canal opened, the U.S. government sold about four million acres of western lands to settlers. In 1840, it would sell about *thirty-eight million acres* of western lands.[29] Maybe John had missed the boom. Then again, maybe the boom meant there were now enough people in Ohio to support a fine hotel.[30]

There is no evidence that, at the time, Carleton thought anything of his father's trip to Ohio. But the same year, his dog, the same dog that had pulled Carleton out of the Susquehanna when he was younger, developed a couple of bad habits. There was the time that the dog chased one of Mr. Van Leuvan's cows into the Susquehanna out behind Carleton's house. When the cow jumped in the river to escape the fearsome bulldog-mastiff mix at its heels, the dog jumped in after the cow, landing square on the terrified animal's back. That was kind of funny, if only because Mr. Van Leuvan's cow crossed the river to the other side, at which point Carleton's dog jumped off and considered the game at an end. From there the dog's behavior degenerated. He began to chase sheep, by now Oneonta's most important agricultural assets. When sheep become scared, they produce less milk or run away. Like most small towns, Oneonta had few laws and fewer ways of enforcing them. One of the rules was that animals who came into the habit of chasing sheep on outlying farms had to either leave town or be shot. John Watkins may have been one of the half-dozen most important men in Oneonta, but his son's dog was not immune from the laws of the town. When a couple of farmers complained to Carleton's father that the boy's dog had become a nuisance, there was only one thing to do: John Watkins waited until one of the men staying at his hotel mentioned that he was headed for Ohio. "Would you like some company on your way to the frontier?" John would have asked. "My son has a fine dog, and he can't stay with us any

longer." The man took Carleton's dog and left for Ohio. Seventy years later, asked for a few memories of his boyhood in Oneonta, Carleton recalled that story. Everyone was going west, Carleton told the man, even my dog.[31]

Unlike most of the men who left Otsego County for Ohio, John Watkins came back to make his life in central New York. Excepting a few years he spent running a hotel in Albany, he would live the rest of his life in Oneonta.[32] There is nothing in the historical record that even hints at why he chose to stay.

Soon after John's return, Julia would give birth to their fifth child, George; the couple had two more children, Jane (born in 1842) and James (born in 1844). One wonders if John Watkins later regretted his decision: In part because he chose to stay put, three of his children fought in the Civil War. One did well and was promoted to lieutenant colonel, but another died in 1865, thirteen months after mustering out. As we shall see, at least two and probably four of John's children left Oneonta. Only one of them remained to survive him.[33]

Having decided to stay, John naturally became interested in the matter that consumed the town's leaders in the fall of 1840: the death of local merchant Jacob Dietz and how it left Oneonta without a general store. Then as now, there are certain businesses that a town must have to enable the workaday routines of the residents, the kind of businesses that attract people to the town. In 1840 a store of general merchandise, where you could buy or trade for sugar and salt and yarn and flour and nails and paint, was one of those things.

John and the men of the town sent word through their families and friends that Oneonta was in need of a new storekeeper. It is likely that then, as now, the men who ran the town sent word that certain civic allowances would be made in order to entice such a businessman to Oneonta. The record suggests that a fine storefront right along the busy Charlotte Turnpike was assured; that the store would be within a stone's throw of all the local hotels and taverns; that a sizable piece of land suitable for a businessman to erect a substantial home might be found; and that it would be close enough to the gentleman's store that in case of fire or other disaster, he would be quite near the store.[34] Before long, such a man was found. His

name was Solon Huntington, and for several years, he had been operating a small store in Connecticut. He was ready to move west—but not *too* far west, not to the frontier—so he came to Oneonta, where he promptly built a three-story stone house complete with a basement for the warehousing of goods, a public indication of his commitment to the town. But Solon Huntington wasn't the only Huntington that Oneonta attracted. In addition to a storekeeper, Oneonta got itself a butter man.

Townsfolk may not have thought much about how the region needed a butter man, but the farmers who lived outside the village surely had. Here's why: When Oneonta-area farmers all but stopped growing wheat in response to the arrival of the Erie Canal, they invested in sheep and cattle. In 1840, no New York county was home to more sheep than Oneonta's Otsego. Butter was the motivating reason. Farmers in Ohio and western New York could not ship butter down to New York City; it was too far for the product to travel without spoiling. For once, geography worked in favor of Oneonta's farmers, who produced butter that they salted heavily and placed in sixty-six-pound barrels called firkins, which they sent down the Charlotte Turnpike to the Hudson, then down the Hudson to New York City.[35] While Solon Huntington would soon become a prosperous local merchant of distinction, the operator of a general store that was the biggest and most successful in at least a three-county area, the main reason we remember him today is that he helped launch the career of a butter man.[36]

Solon's brother was Collis Potter Huntington, and Oneonta had never seen anything like him. Collis was a significant physical specimen: at over six feet tall and a brawny two hundred pounds, his mere presence attracted attention. Collis made good use of his size in his business, in which he handled leaden butter firkins as if they were mere packets of yeast. But it wasn't just Collis's size of which Oneontans took note, it was his business savvy, his drive.

Upon visiting Oneonta in 1840 or 1841, Collis, an experienced traveler, intuited that for every tradesman or merchant in Oneonta, there were fifty-six farmers in the surrounding country. There were five times as many sheep as people in Otsego County, a ratio that was only slightly lessened in bordering Delaware and Chenango Counties.[37] Collis noticed all those sheep and cattle; he noticed the Charlotte Turnpike and the access it provided to

the Hudson and to New York City, which was then the largest commercial hub in the United States. Those farmers were producing an enormous amount of quality butter, butter that could be bought inexpensively (high supply!) and transported to New York, where it could bring strong prices and a healthy profit.

That is exactly what Collis did. "The butter trade was a precarious one, breaking up nearly everybody who tried it," he later said, well aware of how quickly the product could spoil. "I was the only person who followed it for eight years without losing money on my invoices."[38] Collis was so proud of his hugely profitable butter runs that fifty years later, when he dictated a kind of oral history of his life, he devoted a couple of dozen pages to his prowess as a butter man, the most he devoted to any section of his semiautobiography but one.[39] If the dollar figures and profits about which Collis boasted were even sort of accurate—and when it came to the story of his own life, Collis was perfectly capable of selective and embellished memory—by the mid- to late 1840s, he was likely the wealthiest man in Oneonta. He was not yet thirty years old. In the decades to come, he would remember how the Watkinses and other leading Oneontans had welcomed his brother and him, financially and otherwise. He would take care of those families for the rest of his life. One of those families was the Watkinses.

A teenager such as Carleton Watkins, who was fourteen when Collis, twenty-two, began making his butter runs, would have been plenty impressed with Collis's success. Carleton fished with Collis in Silver Brook. They played an early version of baseball in Oneonta's streets.[40] Whether Collis realized it or not, he was teaching Carleton ambition; he was showing him what could happen when a determined young man moved west to a new place, grabbed the sheep by the firkins and made a business of it. Carleton surely knew that when his father was his age, he was already working as a lumberman and was learning carpentry. Carleton grew up in substantially more comfort than had his orphaned father, so there wasn't as much urgency about his future, but still, what next? What did Oneonta hold for him?

Not much. As the 1840s and Carleton's teenage years neared an end, the small economic boom provided by the construction of the road between the Hudson and Oneonta had played out. Between 1840 and 1850, the population of the United States grew 36 percent, but Oneonta's population barely

budged. When four-year-old Carleton had seen the great meteor shower, there were about fifty houses in the village. Sixteen years later, there were only sixteen more. The local economy was contracting. Carleton would have noticed that he was far from the only Otsego County teenager with nothing to do. He was the eldest of his parents' seven offspring. Theirs was a typical family size for that time and place.[41] Sixty-eight percent of the residents of Otsego County were under thirty years old.[42] As Carleton approached his twentieth birthday, he and virtually every other area teenager must have wondered what there could possibly be for him to do in a no-growth town surrounded by filled-up farmland.

The answer arrived like a flash: gold had been discovered in California! The nation-changing news probably arrived via word of mouth, from traders such as Collis who had traveled the New York-to-Oneonta route. Soon it was all anyone in Oneonta was talking about. Within about a year of the discovery, almost 5 percent of the population of Otsego County, two thousand men, would leave for California.[43] Among the first Oneontans to decide to leave was the butter man, Collis Huntington.[44] His plan was to open a branch of the Huntingtons' general store in California, not to pan for gold. If the most prominent trader in central New York, Oneonta's newly elected fire captain and probably the wealthiest man in the area, was giving it all up for California, who would want to stay?[45]

Many Oneontans asked Collis to take them with him. Eventually Collis picked five men. They each paid their own way. One was named Leroy Chamberlin,[46] and nothing else is known about him. Another was Daniel Hammond, about whom we know little, except that once in California, he made a good life for himself in Sacramento. The others have better survived in the historical record: George Murray, a bookkeeper at the Huntingtons' Oneonta store, and Egbert Sabin, son of local businessman Timothy Sabin. Collis did not much like the corpulent and lazy Egbert, and in California he would come to like him so much less that he would ship him back to Oneonta. There seems to have been some quid pro quo or business deal between the Huntingtons and the Sabins: When the Huntingtons moved to Oneonta, they bought the large plots of land for their homes at a good price from Timothy Sabin. After Collis left for California, Timothy Sabin would take over the region's butter trade.

The final man Collis took to California was the son of the town's newly elected supervisor (which told you all you needed to know about how much faith Oneontans had in the future of their town).[47] He was a rangy nineteen-year-old whose father had helped bring Solon and Collis Huntington to Oneonta. The young man's passage to San Francisco was financially backed in part by Dr. Samuel Case, who lived in a house that had been built by that same new Oneonta supervisor. Collis's fifth gold rusher was his fishing buddy, Carleton Watkins.

Over the next half century, Watkins and Huntington would play starring roles in the rise of the American West and in the transformation of the nation from an agrarian coastal state to a continent-filling industrial power. Meanwhile, in the 165 years since Carleton and Collis left Oneonta, the annual growth rate of New York's Otsego County has been about .01 percent.

2

ARRIVING IN CALIFORNIA

THE JOURNEY FROM ONEONTA to San Francisco most likely began in a familiar place: in nineteen-year-old Carleton Watkins's front yard.[1] The party would have traveled along the Charlotte Turnpike, the toll road that joined hilly, agricultural central New York with the Hudson River, where they would have caught a steamboat to New York City.

This was the same route Collis Huntington used to take Oneonta's butter to market.[2] However, none of the other Oneonta gold rushers would have seen anything like the busy Hudson, the most important waterway in New York, if not the nation. People moved up and down the river, as did commercial goods such as lumber, iron ore, and books, such as those Buffalo publisher G. H. Derby was floating toward the New York City market at the same time the Oneontans were on the river. Derby's shipment was trying to beat as many northeastern gold rushers to New York as possible, for his firm's new book, *Oregon and California: The Exploring Expedition to the Rocky Mountains, Oregon and California* was intended for them. It was a fresh edition of famed explorer John C. Frémont's exploits, books that had been best sellers throughout the 1840s and that had helped stoke America's westward push. Derby expected that men sailing to California, America's most distant outpost, would be eager for practical information about gold-rush country

and the voyage to it—and would want a little positive reinforcement about their life-changing decisions.[3]

"The mines, it is estimated, are worth a thousand millions of dollars," Derby claimed in new material he published with Frémont's text in an effort to make the book au courant. "The region which they embrace . . . lies, according to authentic reports, on both sides of the Sierra Nevada, [and] must be 'larger than the state of New York.'"[4] (It did not and it was not.)

As an expression of fever, Derby's mash-up of Frémont and guesspeculation is a revealing thermometer. Derby included chapters titled "Purity of California Gold Dust" (it was "remarkably pure"), "Physical Geography of California" (there were gold deposits "within a few miles of San Francisco," which was off by a hundred miles), "The Gold Region—Miscellaneous Matter" (which reported that the mines were so tempting that "three-fourths of the houses in the town on the Bay of San Francisco are deserted," a claim that would have required the aforementioned town to have houses, which it almost entirely did not), "Letter from [U.S. Army] Capt. Folsom" ("I look upon California as perhaps the richest mineral country on the globe," and "[a]ny person who could come in here now with ready cash would be certain of doubling his money in a few months"), and finally, on the off chance anyone had missed the point, a final chapter titled "GOLD," in all caps, which promised that "the places where it is found are much more numerous than we might at first suppose," a promise that, given how much Derby was supposing, was nigh impossible.[5]

As a light snow fell on the gray morning of March 15, 1849, the Oneontans and 344 other future Californians boarded the steamer *Crescent City,* bound for the mouth of the Chagres River in Panama, where they would catch connections to California. For Carleton, this was a new experience: there were more people on board the *Crescent City* than there were in all of Oneonta, including not a few national celebrities. Among Carleton's fellow passengers was Jessie Benton Frémont, the twenty-four-year-old wife of the explorer whose western adventures had just been republished by G. H. Derby.[6] Accompanied by her six-year-old daughter, Lily, a servant, and her brother-in-law, Jessie was planning to meet her husband, John, in San Francisco, and from there depart for Las Mariposas, the ranch in the Sierra Nevada foothills that John had purchased the previous year.[7] (While Jessie and Lily would make it to San Francisco, the servant would not: just after the *Crescent*

City left New York, she robbed Jessie's luggage. Jessie awoke from a nap in time to catch the maid in the act; she reported it to the *Crescent City's* captain, who arrested her.) At 2:20 in the afternoon, the ship pulled away. Missouri Sen. Thomas Hart Benton, Jessie's father and the man who had done more than any elected official to urge America westward, waved at the *Crescent City* as it left.

If Carleton noticed Jessie Benton Frémont in the saloon or elsewhere on the ship—and as she was one of just two women aboard, she'd have been hard to miss—there is no record that they met. A decade later, when Carleton was a regular visitor at Jessie's San Francisco home, an unlikely participant in the first and most important intellectual salon in the American West, did he and Jessie discuss their shared experience? Maybe. For now, for a teenage rube who had just spent three days throwing up everything he'd eaten in New York City, the western dissolution of the eastern class system was as unimaginable as the idea that Collis would do anything but open a general store selling boots and whiskey to gold rushers.

Nine days after leaving New York, the *Crescent City* terminated in Chagres, less a town than a stretch of sand covered by fifty palm-thatched huts extending from the river's mouth into the Caribbean. Carleton and his mates found hundreds of men crowded onto the spit, waiting for boats or any other passage up the Chagres River and across the isthmus to Gorgona, where eight thousand men were waiting for the increasingly rare boats to San Francisco. Until a couple of weeks before, Carleton had never been beyond the weathered stone hills of Otsego and Delaware Counties; soon after arriving in Panama, he found himself in one of the world's largest refugee camps, where dysentery, cholera, and malaria preyed on men who didn't keep themselves well fed and well rested.

The Oneontans waited and waited. Finally a ship for San Francisco arrived. The Oneontans couldn't gain passage on it (the better-connected Jessie Benton Frémont did), but a few days later, another ship pulled in, a Dutch-flagged coal ship called the *Alexander von Humboldt*. It was not a passenger ship, but seeing that money could be made, the captain nailed up bunks, built some flimsy cabins, and sold passage to San Francisco for $175 to $300 a head. The Oneontans spent $175 each to sleep in steerage with the coal, and soon the ship lumbered out of port. It took five weeks before the *Alexander von Humboldt* found enough Pacific breezes to fill her sails and

push her northward. By then her supplies of food were running low, and the ship's passengers instituted food rationing. Finally, after a stop for provisioning in Acapulco and a stunning 102 days in the Pacific, the *Alexander von Humboldt* entered San Francisco Bay on August 30, 1849.

As San Francisco had no wharves into which a ship might pull—ownership of bayfront property was a contentious issue that wouldn't be settled for many years—the *Alexander von Humboldt* wove between the abandoned ships that littered the bay, what one traveler described as "a forest of masts," until reaching Clarke's Point, a tidal mudflat at the bottom of Telegraph Hill roughly between where Pier 7 and Pier 9 are today.[8] The ship's passengers either swam ashore or were ferried by rowboat. G.H. Derby had said the trip from New York would take about five weeks. For Carleton, it took twenty-four.

The six Oneontans left the ship together. Once they reached shore—the embarcadero, as it was called then, and as the road along the bay is called today—they stepped through piles of muddy goods that ship crews had dumped on the tidal flat: trunks, loads of lumber, barrels of whiskey, butter and grain, piles of brick, reams of canvas, and anything else a San Franciscan might need. Their first view of the city was of a succession of sand dunes, some fifty feet or more high, interrupted by canvas tents and half-built wood-frame buildings with muslin roofs and paper doors. Within this mostly tent city lived twenty thousand people, which placed San Francisco on par with Detroit and Milwaukee as one of America's forty biggest cities. Beyond the recently gridded streets lay adobe sheds, home to Native Americans who were part of the Ohlone cultural group, descendants of the Pomo who lived to the north along the Pacific coast. Beyond the Ohlone encampment was a series of steep, wooded hills. Carleton might have heard the sound of rifle fire coming down from them, hungry men pursuing small game, inexpensive meat.

The Oneontans did not stay in San Francisco for long. They made for Sacramento, where Collis thought the new Huntington Bros. store would be close enough to the diggings to do well. They found a boat up the Sacramento River, realized how far Sacramento was from gold-rush country, and continued into the foothills. Eventually Collis settled on a mining camp called Dry Diggings that was located on one of the three overland trails into

gold country and established a store. It appears as though Carleton worked there, delivering goods from the store to the nearby mining camps. An 1851 tax document indicates that for a time, he lived in Butte County, California, a mining region northeast of Sacramento.[9] Like everyone else in the Sierra foothills, Carleton probably tried his luck in the rivers.

Boom towns rarely maintain records, and the people racing through them to gold fields are too busy racing through them to gold fields to leave much behind. Compound human tendency with the disasters that regularly afflicted California cities in the making in the 1850s—fires, earthquakes, floods, cholera epidemics, and more fires—and little that details the Oneontans' first four years in California survives. Watkins may have stayed in the foothills until late 1853. In the early twentieth century, when Charles Turrill, a fellow photographer and an amateur historian, wrote a version of Watkins's life story for a California State Library journal, he started it in 1854, nearly four years after the Oneontans arrived in California.[10] Collis's own self-aggrandizing oral history, provided to historian and publisher Hubert Howe Bancroft in the late 1880s, only mentions his Oneontan travel mates to disparage them. There is no evidence that Carleton and Collis were in contact between the mid-1850s and the late 1870s, by which point one was a famous, wealthy railroad entrepreneur and the other was a famous, substantially less wealthy artist.

From here Carleton's story frays, and the textual record of his life is thin. Mostly we will have to trace him through his pictures, through ephemera, and through the stories of the people for whom and with whom he worked. He becomes less a person, Carleton, than C.E. Watkins, the name under which he worked and which he signed in black ink just below the lower right-hand corner of his pictures. In the few surviving letters that reference him, he is "Watkins," or sometimes "Mr. Watkins." It was an era during which men were referred to, even by their friends, by their last names. In deference, and because we cannot know Carleton as we would like to, from here on he is just Watkins.

Watkins would spend the 1850s figuring out what he wanted to be. The state of California would too. Would it remain a free state? Would it remain a single state or cleave itself into two states (one free and one slave)? Would it align with the North or with the South, and later with the Union or the

Confederacy? As California's address of the sectional crisis early in the 1860s would launch Watkins's national career, a bit of background on the state's tangled allegiances is in order.

In late 1849, when Watkins and the Oneontans arrived in San Francisco, California was neither territory nor state. Since the conclusion of the Mexican-American War with the signing of the Treaty of Guadalupe Hidalgo eighteen months earlier, California had been ruled by an American military government. The discovery of gold at Johann Sutter's mill nine days before the treaty was signed—almost no one knew about it until afterward—made it clear, necessary even, that California would skip territorial status and instead would apply to Congress for immediate statehood. Accordingly, California's earliest elites met at a constitutional convention in Monterey in September 1849. Convention delegate Henry Halleck, who would later become President Abraham Lincoln's Civil War general in chief, proposed that the constitution establish California as a free state. No delegate contested Halleck's motion, and it was done.[11] Californians ratified the Monterey constitution nearly unanimously.[12]

That meant California could petition Congress for statehood, which it did. That left Congress with a problem: admitting California as a free state would destroy the decades of compromises that had kept slave and free states in balance. The legislative solution was Rep. Henry Clay's Compromise of 1850, which, among other things, strengthened the Fugitive Slave Act and admitted California as a free state. Historians don't generally consider California a border state as they do Maryland or Missouri or Kentucky, but until early 1861, in both Washington and on the Pacific coast, California would behave more like a South-aligned border state than it would a safely northern state.

While the state constitution seemed to settle the slavery question in California, it did not settle it at all. For much of the 1850s, Californians continued to debate slavery. For example, the Monterey convention appointed two U.S. senators: One, the aforementioned explorer John C. Frémont, was Southern-born but strongly antislavery. The other, William M. Gwin, owned two hundred slaves back home in Mississippi and would continue to do so throughout his eleven-year career as a U.S. senator.[13] Gwin also owned a productive California gold mine, much of the profits from which he poured into establishing what became known as the Chivalry wing of the California

Democratic party, which allied California with southern interests in Congress. California's Chivs were unambiguously proslavery and pro-South and would eventually be prosecession. Gwin and his allies would dominate antebellum California politics from the start, even engineering Frémont's ouster just twenty-one days after he became a senator. The Chivs advanced slavery-friendly legislation at every chance and even advocated a new California constitutional convention that would split California into two states, a free north and a slave south.[14]

This combustibility would allow tensions to build.

In the fall of 1853, Watkins returned to San Francisco to work as a retail clerk for his Oneonta chum George W. Murray, who had opened a books-and-stationery store. When Watkins left for Sacramento and gold-rush country, San Francisco had just a handful of roofed wooden buildings. Now it was home to fifty thousand residents. Its downtown area alone had 626 buildings made of brick or stone, a reflection of the city's slag-to-riches wealth. A semipublic library had opened. Built on a subscription model (for a working man, a month's access cost about the same as a pound of pork), within a year the library would have three thousand books, including titles in French, German, and Spanish, plus periodicals from the East Coast. Women, who were almost wholly absent the first time Carleton was here, now made up 15–20 percent of the population. The young city was bursting with enough ambition that it held a series of meetings to demand a transcontinental railroad and to propose routes. San Francisco's first book-length chronicler boasted that its "buildings are becoming palaces, and her merchants, princes," which was a bluff, before doubling down by claiming that San Francisco was "fast approaching that peculiar and regal character which in days of old was borne by the great maritime cities of the Mediterranean, in more recent times by Venice and Genoa, and perhaps at this date by Amsterdam and St. Petersburgh [sic]." At the time of this comparison, Amsterdam was 695 years older than San Francisco, and Russia's greatest city was at least ten times larger. Close enough.

It would have been obvious what enabled all this: according to contemporary estimates, which were based on the carefully counted quantity of gold dust deposited and coined at the U.S. Mint, about $60 million was lifted out of the Sierra in each of the years Watkins was up around

Sacramento. How to understand $60 million in 1853 dollars? Each year gold diggers were taking out of the Sierra an amount *double* the capitalization of the fifth largest corporation in the nation, a company that was the Apple or ExxonMobil of its day.[15]

With the benefit of 160 years of hindsight, it's possible to see something of a civic character forming in the sandy boomtown by the bay. San Francisco's tendency to treat braggadocio as fact, self-representation as truth— given that for some years the town's poker tables outnumbered its roofed buildings, it's not hard to imagine from where the local tendency to over-represent strengths came—was part of the place's charm. Psychologically, almost every person in San Francisco had traveled across the continent one way or another, at great expense and substantial peril, to be here. San Franciscans were quick to pat themselves on the back not just for making it but to tell themselves that they'd made it.

Furthermore, these tens of thousands of still mostly men were here for the same reason Watkins was: to create opportunities for themselves that were not available to them back home, wherever that was. In the four years that Watkins had been in Sacramento and in the Sierra foothills, San Francisco had filled with men who embraced the risk inherent in the newest and most distant America and hoped to reap the rewards of that gamble. By the by, San Francisco was filled with men who liked to play cards.

San Francisco offered more than the next year's crop or the next week's paycheck: it offered a chance to create or re-create yourself. In a city of fifty thousand people, almost none of whom knew each other before gathering on this sandy spit, why not present yourself as what you wanted to be? Who was to say no, you can't? That was what Murray had done. He hadn't just made himself into a small-business owner, he'd moved his business from Sacramento to big-city San Francisco and into a prime, ground-floor location in the city's newest, biggest, most important office building, the Montgomery Block. This was where the city's most important government offices were located, its most important lawyers and businessmen too. As strange as it sounds, with the opening of Murray's store and Watkins's employment there, most of the elements in the alchemical soup that would help turn Watkins from an upstate New York innkeeper's son into the West's most important artist were in place: He had traveled six thousand miles to America's newest, most dynamic city. He was working in the city's most

important building, in the shop next to the building's entrance, which ensured that everyone who walked into Murray's Montgomery Block office or the Ivy Green saloon or the billiard room might get to know the young man from central New York. It seems to have helped: Watkins's future client list would be stuffed with attorneys, bankers, and real-estate investors who worked in or socialized at the Montgomery Block.

The most important element in Watkins's future was the one that was still missing: photography. Nothing in the historical record places Watkins behind a camera until 1856, and that would be in San Jose, fifty miles south of San Francisco. How did Watkins transition from a magazine-store clerk into a photographer? Chances are we'll never know.

It's likely that Watkins benefited from relationships with other San Francisco photographers. Watkins may have known a photographer of cityscapes named George Robinson Fardon. Historian Peter Palmquist thought that Watkins was involved with Fardon's production of an 1856 album of outdoor views. Watkins probably also knew William Shew, especially as Shew later exhibited (and presumably offered for sale) portraits of at least one of Watkins's friends.[16] The major photographer in San Francisco in the mid-1850s was Robert Vance, and Watkins must have known him.[17] Beyond these kinds of subcircumstantial connections, we just don't know.

Maybe one way Watkins became informed about photography was through his access to the books and especially to the magazines he sold in George Murray's shop at the Montgomery Block. Murray's unusually broad offering of European cultural journals was so much a point of San Francisco pride that local newspapers gave them special praise: "Messrs. Geo. W. Murray & Co. have received a bountiful supply of the latest newspapers and magazines," wrote the *Daily Alta California* newspaper. "The March number of the *Art Journal* is one of the finest of the present volume. The *Illustrated London News,* two numbers, have the usual interesting engravings and descriptions."[18]

Art Journal may have caught Watkins's eye. No English-language art magazine published more on photography—on aspects both technical and artistic—than *Art Journal.* Watkins could have seen stories and essays on the new medium such as "Photography Exhibition at the Society of Art," which detailed one of the first British exhibitions of the new "sun-pictures" and surmised that new pictures "might be produced which would exhibit a high

degree of beauty, in addition to that truthfulness which could not be ob-
tained by any other method."[19] *Art Journal* found "truthfulness" to be such
an important attribute of the new medium that it used the word over and
over again, in nearly every issue. While the editors did not directly explain
their use of the word, it is evident that they considered "perfect" a synonym
for technical perfection. Photographs were to faithfully represent a scene. A
viewer should see what's in a photograph as clearly as he might see its sub-
ject before him. A print should be as clear and as perfect as the surface of a
painting, and not marred by dust spots or other visual noise. During the
1860s, even very good photographers would struggle with these kinds of
problems, problems that Watkins would quickly eliminate from his work. By
1861 Watkins's prints would be technically perfect, and soon his peers would
travel to San Francisco to ask him how he did it.

Even better for a young man in one of the English-speaking world's most
remote cities, *Art Journal* regularly published news of even the smallest de-
velopments in the chemistry of photography and substantial reviews of new
books on photographic science and chemistry. As photographic technique
became rather more established, *Art Journal* examined how the new me-
dium might be used. *Art Journal* editors were especially excited by the ways
in which photography might allow more specific views of trees and what it
called "geology" but what might today be called "landscape." In particular,
Art Journal noted that when it came to trees, a photographer had substantial
advantages over a painter. "It was a common remark that with our artists a
tree was a tree and nothing more—that regardless of the wonderful variety
of the vegetable world, all trees were nearly the same in form, and not very
dissimilar in color," wrote an unknown *Art Journal* contributor. "This, pho-
tography has, to a considerable extent, remedied; and we can now discover
some difference between an elm and an oak in the pictures on the walls of
our exhibitions."[20] Watkins seems to have paid heed: throughout his career,
he would take dozens of pictures of individual trees, titled by their scientific
names. There is nothing like these pictures anywhere else in American art.

Many of Watkins's other innovations and preoccupations seem to have
their roots in *Art Journal's* early consideration of photography. A few months
before Watkins began taking pictures, *Art Journal* ran a long review of Roger
Fenton's "Photographs from Sebastopol," the now-famous pictures of the
Crimean War. It included a description of Fenton's "van," the means by

which he took photography out of his studio and into the landscape.[21] Watkins would soon build his own well-stocked photographic wagon, one that would enable his travel across the West. Watkins's wagon was unusual enough that newspapers and other artists regularly commented on it. While it is certainly possible that Watkins came to photography through some other mechanism, as long as he worked at Murray's, the most advanced thinking about the new medium was with him every day, an arm's length away.[22]

It is not clear when Watkins had the opportunity to put into practice what he probably read. It was not unusual for books-and-stationery stores to offer the services of a photographer, so it's possible that Watkins first picked up a camera while working for Murray. However, Murray's newspaper advertisements never mentioned photography. Either way, in early to mid-1856, Murray closed his shop in the Montgomery Block, apparently to put his bookkeeping skills to work as the deputy treasurer for the City and County of San Francisco.[23] Watkins took a position with Ford's San Jose photography studio and remained there, taking ambrotypes of babies, possibly until November 1856.[24]

While Watkins seems to have begun making photographs at Ford's, mostly studio portraits, the next question is: how did an itinerant laborer who briefly took portraits in a small-town studio fifty miles from San Francisco come to emerge two years later as a landscape photographer who would soon, quite soon, create a series of photographs that changed American art and impacted the nation's history?

The likeliest answer may be the most insufficient: his deciding that he would. After all, in 1850s San Francisco, a man could be anything he made himself into. This may well have been how suddenly, sometime at the end of 1856 or early in 1857, Watkins decided that he would be a photographer and that taking pictures of babies in a studio was not the way he wanted to do it, because on August 27, 1858, when an attorney trying the case *United States v. Fossat* at the San Francisco United States District Court asked Watkins for his name, age, place of residence, and occupation, he replied, "Carleton Watkins, [I] am 29 years old, reside in San Francisco, Cal[ifornia], and [I] am a Photographist."[25] Just like that, he was.

United States v. Fossat was the longest, wildest court case in American history. U.S. Attorney General Jeremiah Black would soon call it "the heaviest

case ever heard before a judicial tribunal." At issue was who controlled access to an immense vein of quicksilver ore accessed by the Guadalupe, a mine founded during the period when California was Mexican but that was now owned by Americans. The case was of crucial import to the California economy because quicksilver, or mercury as it is now known, was used to separate gold from the surrounding rock. Guadalupe, along with its neighbor New Almaden, would return more than $70 million, making it by some measures the richest mine in state history.[26]

The details of *Fossat* are so specific and yet indistinct that entire books have been written on the case.[27] For our purposes: it mattered to Henry Laurencel, the San Francisco investor who claimed ownership of the mine and who employed "photographist" Carleton Watkins, which giant oak tree on what nearby hill had been used by Mexican authorities to determine the mine property's boundary. As imprecise and even far-fetched as this sounds, the young Mexican government routinely used nearly abstract features—a large stone in a field or a tree on a topographical feature—to mark property boundaries. When the United States assumed Alta California after the Mexican-American War, the federal Land Commission was set up to settle competing land claims and, in cases such as this one, to try to decipher Mexican administrative determinations and to adjudicate them under U.S. law.

We do not know how Laurencel and Watkins met, or if their relationship extended beyond this case. The receipt books from the Guadalupe mine suggest that by November 1858, several months after Watkins's engagement in *Fossat,* Watkins's mate George W. Murray was involved with the Guadalupe Mining Co., apparently as a bookkeeper.[28] (It is not clear if he was working full-time for Guadalupe, or if he was moonlighting while working for the City and County of San Francisco.) Perhaps Murray suggested to Laurencel that his land-claim case might benefit from the work of a photographer, or maybe Murray introduced his boss to his friend.

Laurencel's attorney was A.P. Crittenden, a onetime state legislator whose legal career would meet a Wild West end when he was shot and killed by his mistress in front of his wife and daughter.[29] For now, it was his job to introduce Watkins and his pictures into evidence. This was significant. Until now, the acceptance of photographs as evidence in court was quite new, and those instances were a different thing altogether: in 1857 and in 1858,

Carleton Watkins, *Sierra del Encino* [*Two-Part Panorama of Guadalupe Quicksilver Mine, Santa Clara County, California*], 1858. Collection of the National Archives and Records Administration, Washington, DC.

respectively, Albert Southworth and Robert Vance had made photographic copies of certain textual documents, pictures that had been admitted into evidence in lieu of the actual documents.[30] Laurencel hired Watkins to do something more ambitious: to photograph the landscape in an effort to help one side prove its claim to a piece of land. This was not only groundbreaking legal procedure but also rare photographic practice. In the late 1850s, California photographers mostly worked indoors.

The photograph that Crittenden entered into evidence for Laurencel's side, or rather the two photographs that were joined into a large panorama (over two feet long), is the first picture that can be securely attributed to Watkins. A clerk wrote on the picture, which passed from the Federal District Court Archives to the National Archives sometime in the twentieth century, that it was "Taken Aug. 27, 1858 / Filed Aug. 27 1858." ("Taken" refers to when the court took possession of the exhibit, not to when Watkins made the picture.) The viewer's eye is first drawn to a large oak tree in the lower left of the picture, and then to the ridge of a hillside that seems to end at the oak tree. As a result, the eye moves up the ridge until it reaches another oak tree that stands distinctly above anything else around it. Laurencel's side believed that *this* oak, on *this* hill, was the Sierra

del Encino—the Mountain of the Live Oak—referred to in Mexican documents.

It is evident from the tentative way in which the attorneys in the case questioned Watkins on the witness stand that they were unsure of this new thing, of *photographic evidence,* or whatever it was. How to use it? How to refer to it? How definitive could it be? Would the land commissioner-cum-judge at some point decide that this expensive newfangled technology was just too much to trust and throw it all out of court? After Watkins was sworn in, Crittenden asked him from where he took the picture. "It was taken immediately in front of Mr. Faxon's house, about twenty yards in front, at the Guadalupe mine, north of the arroyo, at a point about thirty feet in direction above the creek, and about two hundred yards from it," Watkins said. "[It is a] view of the country looking about south. It is accurate."

Then Crittenden asked Watkins what that was poking up from the mountain at the upper right. "It is a large oak," Watkins said. Apparently believing he had delivered a coup de grace, that the Sierra del Encino had been identified beyond any possible doubt despite his having asked Watkins just four questions (one of which inquired as to his name), Crittenden sat down. What happened next would do much to build Watkins's future.

The law firm that represented the other claimant was Halleck, Peachy and Billings. Until the outbreak of the Civil War, HPB would be California's most important and wealthiest law firm and the only California firm to maintain close ties with leading eastern businesses and institutions. HPB reflected California's own divisions: Halleck was the same Henry Halleck whose motion at Monterey in 1849 had made California a free state. Archibald Peachy was a Virginian who would be loyal to his region rather than to his nation. Frederick Billings was the firm's brains and its brass, a hardworking, far-thinking Vermonter who would soon be crucial to Watkins's career; later, he would be a pioneering landscape conservationist, and his work on *Fossat* would be called "the finest research ever done until then by an American lawyer."[31]

Peachy was HPB's trial ace, the smoothest, suavest courtroom operator in San Francisco. It was Peachy who would cross-examine Watkins. While Peachy could be a bit of an imperious Southerner, surely he recognized Watkins: HPB's office was in the Montgomery Block. To access it each day, Peachy would have walked past George Murray's store—and Murray's clerk.

Peachy's brevity suggests that he was either as wowed by or as uncertain of the new photographic technology as Crittenden had been. Peachy asked just two questions. The first: "Who selected the point from which you took that view?"[32] This was the polite way of asking Watkins if someone else, someone such as Laurencel, had selected a spot that might misrepresent the actuality of the place in the favor of his own side.

"I did myself," Watkins said.

Peachy followed up: "What induced you to select that view, or to take it at all?" The answer to this question seems self-evident: Watkins had been hired by the opposing side to represent, in an image, documents that presented a land claim as a confusing abstraction that required 3,500 pages of argument. The reply Peachy wanted from Watkins was something along the lines of *I was paid to take this picture so as to best represent Mr. Laurencel's view in the matter.* Watkins seems to have realized that this would have been the wrong answer.

Instead Watkins said, "The view looked best of the buildings from that point," meaning that he took the picture in part to establish the relationship between the mine and the Sierra del Encino. "I took the sketch at the request of Mr. Laurencel. He desired a view of El Encino from the Guadalupe Mines and requested me to make one from that neighborhood. In compliance with that request I went to the ground and when there selected the spot which would give the best view of El Encino." It was a perfect answer: *Yes, Laurencel hired me. But the selection of the view was mine and mine alone. Trust that the land looks the way I have shown it.*

Historians long ago gave up on trying to determine if there was a turning point or key bit of evidence in *Fossat.* As the case generated an outstanding number of suspiciously generous cash handouts to connected individuals, the case may have been determined outside the record of proceedings rather than within it. For our purposes, *Fossat's* establishment that photographs could be evidence in a legal dispute placed Watkins in the vanguard of what would become a common practice. Over the next thirty-five years, Watkins would continue to make pictures for use in court.

It would be a mistake to try to grasp at something in Watkins's first photograph that would portend greatness many years hence.[33] Still, the picture represents a significant and conscious decision: at a time when nearly every wet-plate photographer in California and across America worked primarily

indoors, Watkins's journey into the landscape reflected an intent to do something different. Whether Watkins knew it in 1858 or not—and he may have known it—in becoming an outdoor photographer of the land, he was aligning himself with his young nation's greatest art subject: the American landscape.

It is not clear what Watkins did for a living after *Fossat*. He fulfilled no known commissions in the two years after testifying in the case. Maybe Watkins went back to making studio portraits. Certainly he was broke. Only a single record of Watkins's life from the period between August 1858 and the autumn of 1860 survives. On July 20, 1859, Watkins wrote Laurencel a letter that suggests Laurencel was in arrears:

> Dear Sir: If you can without inconvenience send me $150, you will confer a great favor. I am at present without and cannot obtain employment and must go into the country. I wish to go to Carson Valley and have no means of getting there, or anywhere else. Except through you. I have a number of setts [*sic*] of each of those views that you can get at any time by calling or sending to Muygridge. I am happy to hear that the new mine is developing so satisfactorily, and sincerely hope that you may be as successful as you can wish.[34]

This letter is the first writing of Watkins's that has survived. It is otherwise unremarkable: the florid language and its indifference to standardized spelling speak more to the era than to Watkins's lack of polish or education. It also establishes that Watkins and the other, later significant artistic innovator of the American West, Eadweard Muybridge, a chameleon who changed the spelling of his name as often as he changed careers, had an unknown relationship in the late 1850s, years before Muybridge himself took up a camera in the mid-1860s.

As for the substance of the letter: in the late 1850s, when San Francisco laborers worked for about $2 a day,[35] $150 was a pile. Given the difficulties in reaching a remote location such as the Guadalupe quicksilver mine and in making photographs outdoors, plus the time Watkins would have spent preparing for the trial and testifying in it, a fee of $150 for the *Fossat* panorama and testimony seems reasonable. The Carson Valley to which Watkins refers is the soon-to-be-famous Comstock Lode in Virginia City, Nevada,

which had just started producing America-changing volumes of silver and gold. (The mines there, almost all owned by San Francisco investors, would provide much of the hard currency that would enable the federal government to back the bonds that funded the Union war effort.)

Regardless, Watkins's apparent struggles were typical for the place, time, and profession: photographers had a tough time making a living as only photographers. I. W. Taber, a future Watkins rival, moonlighted as a dentist until he could make photography work as his sole occupation, and Julia Shannon, one of San Francisco's earliest daguerrean photographers, worked as a midwife. Chances are Watkins did something else too. Maybe no one knew quite what to do with something as new as landscape photography. Certainly California, a free state with pro-South business and political leadership, was fraying and was a bit distracted.

In the nearly two full years between *Fossat* and Watkins's next known work, California began to unravel. We do not know what Watkins thought of any of this, but it all created the conditions that would launch his career and would likely motivate the pictures he would make.

The most significant political event in California in those years was fought between two of California's most prominent Democratic politicians. On the day after the 1859 gubernatorial election that saw Democrats win over 90 percent of the state's vote, David Terry, the Democratic chief justice of the state supreme court, challenged California's junior U.S. senator, David Broderick, to a duel. Terry was proslavery; Broderick was the last prominent antislavery Democrat in the state. Just outside the San Francisco city limits, on a foggy morning, Terry killed Broderick.

At Broderick's funeral, Edward Baker, a Republican, arguably California's leading antislavery politician and originally an Illinoisan so close to Abraham Lincoln that Lincoln would name a son after him, gave a eulogy establishing Broderick's killing not just as politically motivated but as connected to the biggest national debate of the era. "[Broderick's] death was a political necessity, poorly veiled beneath the guise of a private quarrel," Baker said. "What was his public crime? The answer is in his own words: 'I die because I was opposed to a corrupt administration and the extension of slavery.'"

Almost immediately, Baker's speech was considered the greatest ever given in California, the kind of speech that, in a less Southern-oriented

state, might launch a man such as Baker into high elected office. As California's electoral opportunities for Republicans and Free-Soilers remained poor, and as being a Free-Soil man could, obviously, get you killed, Baker left for Oregon. In the late 1850s, and indeed for the rest of the century, other western states were mere satellites of California. Often their elected officials, even their U.S. senators, lived in San Francisco while representing other states. Baker hoped that the Oregon legislature would do something California's proslavery-controlled legislature would never do: select him for a U.S. Senate seat.[36]

As Baker left, a rumor spread through the state: Terry's killing of Broderick was merely the beginning of a proslavery Democratic plot to kill every Free Soil, antislavery politician who opposed partitioning California to create a new western slave state. Many California homes took down the Stars and Stripes and instead flew two flags: the palmetto flag, honoring South Carolina, and the Bear Flag, a reference to California's twenty-five-day stint as an independent state in 1846.[37] California was lit.

While California was across the continent from New England's abolitionists and South Carolina's fire-eaters, its connection to the national question wasn't experienced just via regional proxies such as David Terry and David Broderick. At about this time, the young state also became home to one of America's most famous antislavery families.

In 1856, a new political party, the Republicans, had contested the presidency. Their candidate was John C. Frémont, the Pathfinder, the man whose westering expeditions of the late 1830s and 1840s had opened the West to American settlement. The antislavery Frémont lost the presidency to Democrat James Buchanan, but his campaign, significantly orchestrated by his wife Jessie Benton Frémont, provided the template for how Republicans would run and win in 1860.

After the 1856 defeat, and after nearly twenty years of public service, John and Jessie retired to private life at Las Mariposas, their vast gold-mining ranch southeast of San Francisco in the Sierra Nevada foothills. The Frémonts were the most prominent Americans ever to live in California. They brought to the state antislavery, Republican, and Unionist bona fides, as well as national political and business connections. Soon Watkins would work with the Frémonts at Las Mariposas, but that commission would be

almost incidental to Watkins's ascent. It would be the Frémonts' politics, especially Jessie's, that would propel Watkins to national prominence.

In 1848 the Frémonts had bought Las Mariposas by accident. (Frémont had given an American official $3,000 to purchase land for him along the California coast, but the official bought him land in the Sierra foothills instead.) In 1849, John realized there was gold there.[38] He was busy exploring and then running for president, so developing the estate to its full potential had to wait. By the end of the 1850s, it became clear that Las Mariposas might be one of the greatest gold mines in the world. The question was how to realize its potential. Jessie insisted on reorganizing the estate's business operations, and by 1860 Las Mariposas was delivering as much as $64,000 in gold per month.[39] This was good, great even, but more was possible.

The promise of Las Mariposas lay in a vein of gold that ran through the heart of the property's mountains. The only way to realize the potential of this massive vein was through what was known as quartz mining, a massive, industrial, and expensive process through which rock would be taken from the mountain's core and transported by rail to stamping machines that would crush the rock into paste. The crushed rock would be run through either quicksilver or borax, which would separate the gold from the worthless rock. This all required enormous infrastructural costs: mine shafts would have to be dug deep into the mountains, stamping machines would have to be purchased and transported to Frémont's remote property, railroads that would transfer the mined rock to the stamping plants would have to be built, and so forth. Because of this, quartz mining was a risky bet. Still, Josiah Whitney, the head of the California Geological Survey, examined the mine in 1861 and found that "the quantity of material which can be mined may, without exaggeration, be termed inexhaustible. I can hardly see a limit to the amount of gold which the property is capable of producing, except in the time, space and capital required to erect the necessary mills, build roads to them, and open the mines so as to keep them supplied with ore."[40]

This was all terrific, but the Frémonts lacked the capital to invest in enough quartz-mining technology to fully realize the potential of Las Mariposas. Help arrived in the form of two San Francisco attorneys who invested in real estate on the side: Trenor Park, a self-dealing rapscallion who owned three-sixteenths of the estate and would soon manage it, and Frederick Billings of Halleck, Peachy and Billings fame, who would own one-

eighth of it. Billings decided that the only way Las Mariposas would pay off was if he, a mere minority owner, took the lead in raising the necessary capital to fully industrialize it. The question was how to attract as much as $1 million from investors in New York or Europe to such a remote place.

Billings was as close as decade-old California had to an establishment man. He had grown up in comfortable middle-class circumstances in Woodstock, Vermont, attended the University of Vermont, and was trying to decide what to do with his life when gold was discovered in California. Upon arriving in the same chaotic San Francisco in the making as the Oneontans would, Billings spent $200 to buy one of the hundreds of abandoned ships that littered San Francisco Bay, broke it down, and sold the timber at a steep profit. Despite not having been an attorney in Vermont and not even having gone to law school, Billings used the money to open San Francisco's first law office. Within a few months of declaring himself a lawyer, Billings was the attorney to the military government that ran California between the end of the Mexican War and statehood. Remarkably, by simply moving West and offering himself as a lawyer, Billings made himself into California's de facto attorney general.[41]

Shortly after California passed its constitution, Billings spearheaded the creation of HPB and focused the firm's energy on land-claims issues, such as in *Fossat*, and invested in everything from sugar to mines to one of California's first railroads and real estate. (HPB also built the Montgomery Block, where George Murray's books-and-stationery store had been located.) By the time of *Fossat*, Billings was one of the West's wealthiest men.[42] He thought Las Mariposas could make him one of America's wealthiest men, but to get there, he had to help the Frémonts unlock its potential, and to do that, he would have to find a way to attract New York or European capital to the remote and distant Sierra foothills.

Part of the answer may have arrived as Billings took one of his beloved long walks through San Francisco. Typically Billings broke up these walks with visits to the city's photography galleries.[43] What he saw on his walks in either late 1859 or early 1860—more on that later—seems to have given him an idea: why not hire a photographer to make pictures of Las Mariposas that could be included with an investment prospectus to help convince bankers to lend? Billings, who had probably sat in the courtroom when Carleton Watkins presented his landscape pictures during the *Fossat* case, and who

probably remembered Watkins from when he had worked in the Montgomery Block as a clerk at Murray's, knew just whom to call.[44]

While Watkins had experience working outdoors making two pictures of one hill, a composite that he had made after packing a couple of dozen pounds of material for a carriage ride a few dozen miles from San Francisco to the hills above San Jose, now Billings (and Park) wanted Watkins to pack many hundreds of pounds of material and travel several days from San Francisco via steamboat, stagecoach, and mule, so that he could take dozens of pictures across a forty-four-thousand-acre property. Either Billings and Frémont's team didn't realize the immensity of their request, or for reasons unknown, they had tremendous confidence in a thirty-one-year-old who had fulfilled just one professional commission. Only in the West.

3

CREATING WESTERN CULTURE AT BLACK POINT

LATE IN THE SUMMER OR EARLY in the fall of 1860, as America was turning its attention to a presidential election, Carleton Watkins left San Francisco for Las Mariposas.[1] Of his time in the Sierra foothills we know nothing except what is in the roughly fifty twelve-by-eighteen-inch pictures, a size known as "imperial," and twenty-seven stereographs he made there.[2] The sites Watkins photographed were spread across the mountainous, far-flung, seventy-square-mile estate. Watkins was certainly at Las Mariposas for weeks, and maybe for several months. We don't know the order in which Watkins made these pictures or whether Frederick Billings, Trenor Park, or even John C. Frémont himself gave Watkins any particular instructions beyond making him familiar with Billings's investment prospectus.

Watkins's Las Mariposas pictures show life and work at the ranch. They show the foothills that held the greatest stores of gold, mill buildings, the railroads that the Las Mariposas owners had built to transport ore from the mountains to be crushed in those mill buildings, the towns that were home to the men who worked in those mines and mills (and that showed that labor was at hand), and they even show the landscape itself. Watkins's pictures suggest that $766,000 that Billings and Park had spent on an initial,

pre-investment-prospectus round of improvements—$270,000 in roads, in railroad construction, and in rolling stock, $155,000 in new quartz mills that would pulverize rock so that gold could be separated from it, and more—had Las Mariposas heading in the right direction and that more investment would put it over the top.[3] Within all this industrialized landscape, Watkins also found something unexpected, something that would have long-term consequences for his own career, for the West and for America: beauty.

Among Watkins's Las Mariposas pictures is one of John C. Frémont himself. It shows the Pathfinder sitting in a luxe stagecoach in front of the estate's Oso House hotel, with staff or visitors lined up as if in deference to the great man's presence. It is a commanding picture—as well as the only evidence that Frémont and Watkins actually met.

Did Frémont and Watkins chitchat? Had Watkins stayed with Frémont at his Las Mariposas home or here at the Oso House? Did they get along? We don't know. It is possible that Frémont, accustomed to famous visitors such as newspaper editor Horace Greeley and Richard Henry Dana, the man who had introduced America to Mexican California in his memoir *Two Years before the Mast,* was not interested in the unknown Watkins. After all, Watkins was Billings's and Park's man. (Frémont liked Billings, but he loathed the slippery Park. "I am not willing to have him associated with me," Frémont wrote in a letter to a colleague in 1859. "Mr. Park has brought several actions which produced embarrassment . . . which obliges me to put the property in a state of defence.")[4]

It is more likely that Frémont was intrigued by Watkins and his work. Frémont had been among the first Americans to become interested in the then-new medium of photography. Starting in 1842, just three years after the daguerreotype process was introduced to the public in Europe, Frémont bought daguerreotype equipment for use on his western expeditions. As Frémont often acted first and thought second, he didn't bother to learn how to use the gear before his First Expedition (or before his second, third, or fourth). It wasn't until his Fifth Expedition in 1853–54 that Frémont hired help.[5]

Frémont had been interested in photography because he believed that the best way to interest Americans in the West was to show it to them. He was right, but he was two decades ahead of his time: the small daguerreotypes made during Frémont's Fifth Expedition attracted little attention. It

would be interesting to know if Watkins and Frémont talked about Frémont's belief in photography's utility to the West, because the best pictures Watkins made at Las Mariposas are landscapes first and pictures of a gold mine second.[6]

Take an untitled picture now known as *Railroad Bridge, Looking Down the Mountain*. In it, Watkins focuses on two stout mountains covered in thick brush. The nearer of the two mountains slopes steeply from the upper right of the picture to the lower left, creating a dramatic diagonal that pulls us into the scene. In the far distance, Sierra foothills continue, receding into the background. In the lower right of the frame, Watkins foregrounds his two mountains with a blurry oak tree, thus providing the viewer with scale and a suggestion of depth of field. The roads built into the mountains and the railroad tracks at the bottom of the picture are impossible to miss: Watkins has composed the picture so that the landscape's dominant diagonal ends at the tracks' bend, so that the viewer's eye is coaxed to what his client would have considered the most important thing here. Watkins uses landscape to point us to the industrial infrastructure. It's as if he made the client's needs fit into his ideas rather than the other way around. A picture of Benton Mills, a rock-crushing facility at Las Mariposas that Frémont named after his famously West-obsessed father-in-law, Missouri Sen. Thomas Hart Benton, features a wooden mill building in front of two mountains. Watkins lined up his picture so that the mill's pitched roof would provide a visual echo of the two mountains behind it. It is a picture that uses the landscape to support the mill.

Not all of Watkins's Las Mariposas pictures were this good. Watkins was not yet as skilled a craftsman of the challenging, precise method of making wet-plate photographs in hot, dry, and dusty outdoor conditions as he would become. Some of the pictures are a bit blurry, their tonal range limited, and one even has a thumb-sized black spot in the middle of it. On many of them, it looks like fluid has pooled atop the image, a significant technical imperfection. Many pictures are rote and show little attempt at providing context, let alone building a composition driven by an idea.

Still, there are glimmers of what is soon to come. More importantly to Billings and Frémont, it's easy to see how the pictures would have done exactly what the client needed them to do. In Europe, Billings or Frémont could open an album of these Las Mariposas pictures, open the prospectus next to them, and take a banker through each simultaneously: *Here's the*

Carleton Watkins, *Railroad Bridge, Looking Down the Mountain*, 1860. Collection of the J. Paul Getty Museum, Los Angeles.

Benton Mills facility, which is at the foot of two of our richest mines, the Josephine and Pine Tree Mines. Then he could turn the page and show them the Josephine Mine and then the Pine Tree Mine.

Well, sort of. This is where the startling freshness of Watkins's approach to Las Mariposas reveals itself. Instead of showing the mining shafts from which tons and tons of rock were removed from, say, Mount Josephine via the Josephine Mine, instead of showing the industrial butt end of the operation, Watkins climbed to the top of Mount Josephine to photograph the mountain itself and the view from it. The resulting picture, *View from Mount Josephine, Looking North*, is one of the first major American landscape photographs. Watkins didn't just climb a mountain with a couple of hundred pounds of gear to make a random view from the top, he built a composition that lined up one of the mountainside roads the Las Mariposas management team had built with the distant Merced River, which, at the moment Watkins took the picture, reflected bright sunshine. The result is a ribbon of

beige and then silver that pulls the viewer through the entirety of a vast mountainous terrain, a picture that highlights both the landscape and the investments already made at Las Mariposas. Part of Watkins's cleverness was that there was something here for Billings, who would have pointed prospective investors to the roads that Las Mariposas had built into the steep mountainsides and noted that the estate's workers ran ore along these roads into Benton Mills and that the investment was already paying off, and there was something here for Watkins: an assertion of individual authorship via the presentation of a new idea, namely that the West is beautiful, and that this beauty is a metaphor for its potential. Today this is a straightforward, even obvious idea. In 1860, it was not.

Today we are so accustomed to the idea that California and the West are beautiful that we forget people did not always see the place that way, or we forget, at least, that its beauty wasn't of interest, let alone significance. To understand Watkins's construction of beauty, his dependence on beauty in the Las Mariposas pictures and thereafter, to understand why his making pictures that wielded beauty as metaphor and message was a radical idea, we need to understand the time and place in which he was working.

When Frederick Billings took his walks through San Francisco, stopping into the city's photography galleries along the way, pretty much the only photographs of the California landscape he could have seen were by a photographer named Charles Leander Weed. Weed seems to have been the first photographer to have followed up on Watkins's work for *Fossat* by taking his own wet-plate camera into the land. Weed's first landscape pictures, apparently made in 1858, just after *Fossat*, stand as an introductory primer for how late 1850s California considered its landscape: as something unremarkable that was there to be used, and no more. At the time, Weed was better known than Watkins. It was Weed's presentation of the West that fit the then dominant understanding of the place.

Born in New York State in 1824, five years before Watkins, Weed moved with his family to frontier Wisconsin Territory when he was just a few years old. As an adult, Weed continued west, moving to Sacramento in 1854. There he operated a camera in a photography gallery, the same job Watkins had under James M. Ford in San Jose. Near the end of the 1850s, Vance brought in Weed as a junior partner, apparently with the idea that Weed would ex-

Carleton Watkins, *View from Mount Josephine, Looking North,* 1860. Collection of the J. Paul Getty Museum, Los Angeles.

pand the business from in-studio daguerreotype portraits to wet-plate land-scape photography. Weed's first such pictures date to the fall of 1858, when he made seventeen pictures in two California counties that named them-selves in solidarity with the men who worked there at their founding: Placer County, named for the form of mining that was done there (a man with a pan sifting river water and sand) and El Dorado County, the Golden County.[7]

Weed's 1858 photographs are less landscapes than photographs taken outdoors. They document one of the most common mining processes: the redirection or removal of a river so as to enable access to the gold presumed to be in the riverbed. This was crude and effective. Here's how it worked: The Middle Fork of the American and other rivers drained not only water out of the Sierra but also gold. Each year, for thousands of years, snowmelt swelled the water table in the mountains, lifting gold into suspension. As the rivers drained that snowmelt, they carried gold downstream until the heavy metal fell into riverbeds, leaving the rivers to continue without it. Over the centuries, the riverbeds silted up with both dirt and gold. Miners

wanted access to the gold within that silt, so they cut down Sierra forests, milled trees into boards, and then used that lumber to build channels into which they funneled the former river. Weed's pictures show variations on this theme. The river brought gold out of the mountains; the river must die.

In each of Weed's seventeen pioneering pictures, he looks at the miners' handiwork rather than at the landscape in which they worked. He is uninterested in nature or beauty. Weed's focus is so narrow that he routinely cuts off the tops of the mountains that run down to the river, apparently because the mining, only the mining, was the good stuff. The river itself, the reason all these men were here, makes it into only one of the pictures: Weed shows us a bit of the Middle Fork of the American at Poverty Bar so that he can show us how miners have built a crude stone dam that funnels the river into a timber-built channel, thus drying out most of the riverbed below the dam. The brutishness of the Californians' approach to the land is matched by Weed's coarseness: none of these pictures is composed to direct the eye or to pull it through a scene. Nor are these pictures sophisticated enough to have a critique of man's use of the land embedded within them. Certainly they might have: for several decades eastern painters such as Thomas Cole had included critiques of the way Americans used the land in their paintings. Most famously, Cole winced at the conversion of eastern forests into the lumber that built eastern cities and the firewood that fueled them. Cole objected, Weed bought in.

Weed's pictures were of their time and in keeping with how westerners considered the land. Even after a decade of the gold rush, Californians still valued the land and the landscape for what could be wrought from it. Neither the Sierra nor its foothills had any value to Californians as nature, wilderness, scenery, or source of ecological balance to the activities of man (miners never quite linked the cholera and other diseases that ran through mining camps to their contamination of fresh water supplies); the value was as terrain from which to take and extract, even if to do so meant to obliterate the landscape. English-born illustrator and journalist John David Borthwick, who detailed his gold-rush years in *Three Years in California*, a classic of the genre, noticed this tendency on his first carriage trip into the diggings: "As we traveled . . . the country would seem to have been deserted. That it had once been a busy scene was evident from the uptorn earth in the ravines and hollows, and from the numbers of unoccupied cabins; but the

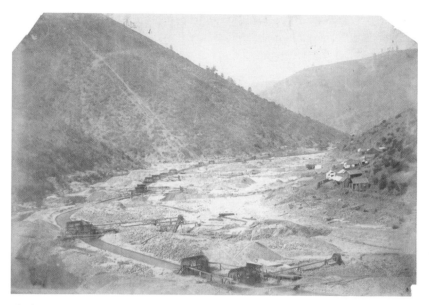

Charles L. Weed, *Poverty Bar, Middle Fork, American River,* 1858. Collection of the Bancroft Library, University of California, Berkeley.

cream of such diggings had already been taken, and they were not now sufficiently rich to suit the ambitious ideas of the miners."[8] A few miles on: "The beds of the numerous ravines which wrinkle the faces of the hills, the bed of the creek, and all the little flats alongside of it, were a confused mass of heaps of dirt and piles of stones lying around the innumerable holes, about six feet square and five or six feet deep, from which they had been thrown out. The original course of the creek was completely obliterated, its waters being distributed into numberless little ditches, and from them conducted into the 'long toms' of the miners through canvass [*sic*] hoses, looking like immensely long slimy sea-serpents."[9] While Borthwick takes note of numerous such mining operations and their aftermaths, never does he find natural landscapes worthy of note or description.

In fact, it's striking how rarely the memoirs, compilations of newspaper columns, or other first-person chronicles of 1850s California include mentions of the natural landscape.[10] The reportage of Alonzo Delano, who was born in the Finger Lakes region of New York and whose parents made the move to the trans-Appalachian West on which John M. Watkins apparently

passed, is typical of the sort. In between spells as a miner, cartoonist, and dry-goods seller, Delano pioneered western humor writing in which reality was exaggerated to the point of hilarity, the same genre that Bret Harte and then Mark Twain would make famous. Before becoming a humorist, Delano wrote a series of letters to newspapers back home, giving his former neighbors a glimpse of California. Delano detailed all manner of mining techniques, such as how "some wise citizens of Chicago are coming out with a mud machine attached to a scow, to scrape up the mud from the bed of the Sacramento and wash it for gold. Before they get a scale, they will have to scrape the mud to the base rock, and then go down in diving bells and dig the dirt out of the crevices with spoons," before finding something natural and beautiful worth describing, a view of a waterfall set against stark, steep granite.[11]

Historian Roderick Frazier Nash tied this failure to appreciate nature to fear. To succeeding generations of frontier settlers, raw, unconquered land was dangerous; to venture into it for an extended period, such as in pursuit of mineral riches, was to gamble one's life. Nash notes that given man's reasonable predisposition to survival, he "appreciated what contributed to his well-being and feared what he did not control or understand. The 'best' trees produced food or shelter while 'good' land was flat, fertile and well-watered."[12] Gold-rush country was none of these things. Grizzly bears and poisonous snakes were a constant threat. Mountain elevations created unpredictable weather, often hot during the day and frigid at night. Disinterest in the aesthetics or pleasures of nature was not just a product of Californians' gold fever. Nash cites the example of Alexis de Tocqueville in noting that as the American frontier moved west in the late eighteenth and nineteenth centuries, newly settled land was always more feared than appreciated. When de Tocqueville visited Michigan Territory in the summer of 1831, he was eager to take a hike in a primitive forest. The frontiersmen thought him either nuts or a timber-claim jumper. Nash notes that the land had to be conquered and tamed before it could be embraced.[13] During the gold rush, westerners were busy conquering and taming.

So Californians, at least, had an excuse. But in the 1850s, even wealthy easterners comfortably moving through the West as tourists failed to find much beauty or aesthetic value there. New York newspaper editor and Republican Party cofounder Horace Greeley traveled to the Sierra the year af-

ter Weed and chronicled the trip both in the *New York Tribune* and in a travel memoir called *An Overland Journey.* (Greeley made the trip to urge Frémont to run for the 1860 Republican presidential nomination. Frémont passed.) Greeley scarcely mentions the Sierra beauty that we now take as self-evident. Instead, he repeatedly advises westerners how to better exhaust the land: "You feel that you are once more in a land where the arm of industry need not be paralyzed by sterility, obstruction, and despair."[14] To Greeley, rivers only have value when they can be "easily arrested and controlled," so that they can be converted to mining or agricultural needs.[15] Greeley thinks that the miners he sees aren't using rivers properly: "If the amount of available water were doubled, with a considerable reduction of price, the gold product of California would thereupon be increased several millions per annum."[16] When Greeley expresses awe at the High Sierra's "giant, glorious pines . . . at least eight feet in diameter and tall in proportion," it is mostly to exult that one "which measured eight feet across at a height of eighty feet from the ground [was a tree] from which two hundred and forty thousand shingles were made." If that didn't make the point, Greeley celebrates the next "giant cedars, balsam-firs and some red-wood [and] some oaks at least four feet through" because he "never saw anything like so much nor so good timber in the course of any seventy-five miles' travel as I saw in crossing the Sierra Nevada."[17] (The West gave Greeley enough auriferous vapors that he apparently forgot that seven years earlier, he had urged Americans "to spare, preserve and cherish some portion of your primitive forests.")[18] Finally, after thirty pages of encouraging California's conversion of nature into wealth, Greeley devotes two paragraphs to the prettiness of the forest and rivers that were consumed because progress.[19]

Even the writers of travel guides prioritized visiting mines over relishing the landscape. In 1857, T. Addison Richards published America's first travel guidebook of national importance. He directed people to the Sierra Nevada not for the sake of mountains' majesty, but so they could see the ways miners tried to pull gold out of the ground. Richards devoted three and a half pages to mining towns, camps, and diggings that a traveler should visit, followed by just two paragraphs that suggested a side trip to the "Valley of the Yosemity," which Richards almost certainly had not seen himself.[20] And what of California in the next decade, after the gold rush? Only Delano

seems to have thought ahead: "As for the future prospects of California, I say nothing."[21]

It was in this context that Watkins chose to present a gold mine and its potential by emphasizing the beauty of the surrounding landscape.

After finishing work at Las Mariposas, Watkins returned to San Francisco. His first task was to make hundreds of prints of his Las Mariposas pictures, both the imperial-sized pictures and the stereographs, because Frederick Billings, John C. Frémont, and their associate Albia A. Selover would need enough to leave suites of pictures with prospective investors. Billings and Park would also each purchase a complete set of the pictures for themselves, and they thought so much of them that they both kept them for life. Later on Watkins would employ a staff that would print his pictures and fulfill orders such as this. In 1860 he did not, so he had some work to do.

Watkins also returned with an introduction to Jessie Benton Frémont. While John gallivanted about the continent, it was mostly Jessie who turned his reports of the search for mountain passes and water sources into best-selling books that were equal parts travel literature and how-to guides that sent Americans into new lands. It was Jessie who ran John's 1856 presidential campaign that created the template Abraham Lincoln would follow to victory in 1860. It was Jessie whose head for business had begun the process of turning Las Mariposas into a source of wealth. John may have experienced more of the West than any other American, but Jessie had thought more about the West's place in America. Billings and perhaps Park gave Watkins access to the Frémonts, but Watkins made the Las Mariposas commission a life-changing opportunity because of the relationship he forged with Jessie.

Of the specifics or closeness of the Carleton Watkins-Jessie Benton Frémont friendship, we know little. No correspondence between them has survived. In letters with her friends, Jessie refers to "the artist Mr. Watkins," the same proper manner in which she referred to even her husband. The most revealing documents of their time together are visual and suggest they hit it off very well indeed: Watkins made at least five stereograph portraits of Jessie, and more of her children at play on the lawn outside Jessie's home on Black Point, on San Francisco's northwestern edge. They were rare for Watkins, who made no similar stereographs of anyone else then or at any other time in his entire career. They were rare for Jessie too, as they were

Carleton Watkins, *Jessie Benton Frémont at Black Point*, ca. 1860–61. Glass stereograph. Collection of the Beinecke Rare Book & Manuscript Library, Yale University.

the only portraits for which she sat during this period of her life, or for many years thereafter. In an era when photographs of people tended to be stiff and studio made, pictures in which aloofness and distance were metaphors for a commercial transaction, Watkins's pictures of Jessie stand out for a casualness that tends toward intimacy. They are pictures of a friend.

At least three of Watkins's portraits of Jessie show her sitting or standing on the porch that wrapped around her Black Point home. In one Jessie holds a teacup—civilization was possible in the unruly West!—and in two others, she writes a letter. A fourth shows Jessie holding freshly cut flowers, posing in front of ivy that crawls up the outside of the house. The fifth is a picture of Jessie on the veranda. Watkins titled this one *Black Point View*. The view may be of San Francisco Bay, the East Bay hills, or of Jessie herself. Among the many pictures Watkins made at Black Point that don't include Jessie is one of her private study, a stereoscope on a table behind Jessie's inkwell, a reminder that the Frémonts loved photography. A few months before making these pictures of the woman who might have been first lady, Watkins had been an unemployed aspiring photographer; now he was an insider, an intimate of the most powerful woman in America. In the West, everyone was in it together. Make yourself into what you wanted to be. Traditional class distinctions meant less here.

Jessie was not the sort of woman whose highest aspiration was to sit for photographs. Ranking high among her abundant achievements and even

higher among the major accomplishments of the early American West was her creation of a cultural and political circle. It was in Jessie's Black Point salon, as it became known, that attendees developed new modes of cultural expression rooted in the West—new ways of writing, new ways of making art, new ways of thinking about the land—and especially new ways of furthering antislavery, Unionist Republicanism in the obliquely proslavery, Democratic West. As Jessie's biographer Pamela Herr put it, "the first fragile blooms of a distinct California culture [emerged] from the fertile soil of Black Point."[22] Herr's metaphors are apt: It was the cross-pollination among easterners who had moved West, where they would create art and literature and participate in California politics that created the new thing. Watkins was one of the most important participants, one of the two key figures who would help the new western culture boomerang back across the country, where it would soon impact the East from which the Black Point salon's participants had come.[23] The seemingly disparate threads of our story—the rise of the Chivalry, the pro-Southern, proslavery California Democrats, Broderick's killing at the hands of a proslavery Democratic lieutenant, and Watkins's discovery of beauty in the California landscape—all began to come together here.

Jessie attracted to Black Point people to whom Watkins would not otherwise have had access. Her attendees included leading figures in journalism, politics, and poetry. There was Herman Melville, who visited Jessie's salon on his 1860 California lecture tour. There was Joe Lawrence, the editor of the *Golden Era*, San Francisco's first literary magazine. There was J. Ross Browne, a satirist and journalist who wrote for *Harper's* magazine about subjects as diverse as Germany and Nevada's Comstock Lode. Along with salon regular Bret Harte, a young writer of short stories and poetry, and later criticism and plays, these men would invent western fiction. Over the next 150 years, the western would become one of America's most popular literary forms, rich enough to allow for both pulp fiction and literary breakthroughs, and would eventually birth America's most popular film genre.

Black Point was also the clubhouse for San Francisco's progressives, regardless of whether they self-identified as Free-Soil Democrats, antislavery Democrats, or Republicans. (Jessie seems to have realized that in 1860–61, parties and party allegiances were in flux, and she probably realized that the Free-Soil and antislavery crowd would end up in the Republican column

regardless of immediate affiliation.) The most important regular at Black Point was a short, skinny, long-haired, frog-faced bundle of energy named Thomas Starr King. Starr, as he styled himself, was the most important Californian of the Civil War era, and he would be the man who did the most to share Watkins's work with the East.

Starr was born to Thomas Farrington King, a Unitarian minister who preached in a series of small New England churches, and his wife, Susan, in 1824. When Starr was fourteen, his father died. With his family in need of a breadwinner, Starr went to work as a teacher, and then as a bookkeeper. Despite working long hours at the Charlestown, Massachusetts, Navy Yard, Starr read widely and sought out tutoring from his late father's fellow clergymen. The precocious, ambitious teenager began to attract attention from leading Unitarians, including pioneering transcendentalists Hosea Ballou II and Theodore Parker, who found churches in which Starr could be a guest preacher. Before long Starr ascended to his father's pulpit in Charlestown and then to the top job at Boston's Hollis Street Church. Hollis Street gave Starr prime access to Boston's progressive intelligentsia.

Starr's energy, speaking ability, and clarity of thought helped him become one of New England's best-known preachers. Many of America's leading intellectuals, men such as poet, critic, and physician Oliver Wendell Holmes, painter Albert Bierstadt, poet Henry Wadsworth Longfellow, and *Atlantic Monthly* editor James T. Fields considered Starr a friend. Starr was also a regular on the New England lyceum circuit, where he spoke regularly on abolitionism, the pleasures of nature, and even Socrates. Despite Starr's abundant popularity and intellectual heft, his lack of a Harvard education made it difficult for him to advance beyond Hollis Street, and by the late 1850s, he wanted a bigger challenge.

Starr asked New York Unitarian majordomo Henry Bellows for guidance. Bellows put out the word, and two Unitarian churches in the West, one in Cincinnati and another in San Francisco, replied. With an eye on America's rising sectional conflict, Bellows steered Starr toward San Francisco, where the Unitarian church had gone through six ministers in eight years and was $20,000 in debt, because he believed Starr's antislavery, Republican, Unionist message was most needed in California. Never one to shy away from a challenge—especially one with mountains nearby—Starr picked San Francisco. On April 5, 1860, *New York Evening Post* editor William Cullen Bryant

presided over a grand New York party organized as a farewell to Starr. Virtually every leading American intellectual was in attendance, including more than two hundred Unitarian clergy. Transcendental Club founder Frederic Henry Hedge read a tribute, after which *New York Tribune* editor Horace Greeley escorted Starr to his steamer, the *Sonora*, and Starr was away.[24]

On Saturday, April 28, Starr arrived in San Francisco with his wife, Julia. After a long, tough voyage, no one expected Starr to preach at First Unitarian the very next day, but Starr tipped off the *Daily Alta California* that indeed he would. The paper squeezed the late-breaking news onto its second page. Such was the excitement over the arrival of the famed preacher from Boston that all of First Unitarian's 170 pews were filled, and scores of curiosity seekers sat in the aisles. Starr's immediate success was such that the news of his arrival was sent east by pony express.

The next week John and Jessie Benton Frémont, neither of whom were Unitarians, attended Starr's second service and invited him over to dinner the next night. Starr accepted. Jessie showed him around Black Point, stopping at a bench that overlooked a beach below the bluff on which the Frémonts' house sat. "You must call your house the Porter's Lodge as it is near the Golden Gate which your husband named," Starr told her. "Thus you have christened it," she replied, and an intense friendship, at least, began.[25] Almost immediately, Starr, whose wife Julia found herself bedridden with one malady after the other in these years, spent every spare minute at Black Point. (John, meanwhile, did not. He worked mostly at Las Mariposas.) Jessie encouraged Starr to write in a small cabin behind the house, and she brought lunch out to him each day. When Starr worried that his wife would mind him being away so much, Jessie waved off his concern. "Mrs. King can decide which day she will be bored for my benefit," Jessie wrote to Starr. "Shut up with myself, I take fancies that become positive wants if they are thwarted."[26] In another letter, Jessie conspiratorially references the small red birthmarks that both she and Starr had.[27] Meanwhile, Starr wrote letter after letter to his closest friend back east, Randolph Ryer, that mentioned Jessie with awe and mentioned Julia mostly to note her invalid status. ("Julia will soon weigh three hundred. I am slim as ever.")[28] Before long, Starr and Jessie would own bookcases with matching keys.[29] In a related story, Starr and Jessie both loved metaphor-laden poetry.

From the moment Jessie Benton Frémont invited Thomas Starr King to Black Point, Starr was the intellectual force of her salon. We don't know when or where Carleton Watkins met Starr, who would do more to bring him to prominence than anyone else, but it was almost certainly here, at Black Point. Watkins, having no other calling card to present, no professional status to argue for his belonging with Starr or anyone else, would have offered what he had: the Las Mariposas pictures. Within them, Starr must have recognized a fellow traveler, the rare westerner who valued landscape and the rarer westerner who found in it the same beauty that Starr did. Watkins's pictures would have been the perfect context in which Starr could share with the other Black Pointers the thing about which he was most passionate, his love of nature. Starr was a second-generation transcendentalist, a devotee of Ralph Waldo Emerson (Starr called himself Starr because Emerson called himself Waldo), and, as such, an ardent lover of the land, wilderness, mountains, and forests. Starr's introduction of Emersonian transcendentalism to the West at Jessie's salon was a major moment in the development of a culture of the American West.[30] Starr's presumed introduction of these same ideas to Watkins would immediately show in his work and would help enable the America-changing work Watkins would soon make.

Transcendentalism is famously difficult to reduce to key tenets—there was never a transcendentalist manifesto or a core set of ideas or principles to which the group agreed—but transcendentalists typically believed that Americans should seek self-improvement from within rather than expect to find it through reading and rereading of Biblical texts, that people should examine their own lives rather than the lives of Abraham or Jesus. Transcendentalism had its origins in Boston's Unitarian preachers and their study of German theological scholarship that questioned the absolute truth of Biblical history. Frederic Henry Hedge, the leader of the Transcendental Club and a particular friend of Starr's, was among the first Americans to translate this German scholarship into English, and he built upon it in his own writings and sermons. Hedge and his followers, Starr among them, believed that long-term self-study was the key to becoming closer to God. Biblical truth having been shattered, transcendentalists argued that traditional forms of revelation—say, the existence of angels—should be replaced with human observation, personal experience.[31]

No one extended this idea more impactfully than Emerson, whose observations of and experiences in nature had a lasting effect on Starr. For Emerson, proximity to nature equaled proximity to God. He believed that nature grew upward toward God, both literally and metaphorically. The transcendentalists' emphasis on the importance of personal observation led Unitarians to be unusually open to the new developments in science, especially in botany, geology, and soon Darwinism. Eager to be included as a peer, Starr checked all the requisite transcendentalist boxes: he learned German, traveled in the nearby White Mountains of New Hampshire, and became a science buff.[32]

By the time Starr was preaching at Hollis Street, transcendentalism's heyday as a dedicated movement, semiorganized around published journals, regular meetings, and the like, was dying down. However, its adherents continued to advance and evolve its core ideas, and its influence remained strong, especially through Emerson's writings and lectures. Out of all the bright young men in New England, few were more dedicated to Emerson than Starr. When Starr was considering a move west, he took comfort in Emerson's example: starting in 1850, the diminutive Emerson became the rare Boston intellectual to make annual trips across the Appalachians.[33] For both Starr and Emerson, nature replaced Jesus Christ as the primary target of their veneration. (As Scottish philosopher Thomas Carlyle, Emerson's friend and intellectual guide, put it to him, "I dare say you are a little bored occasionally with 'Jesus,' &c." Starr too.)[34] Accordingly, it was out of doors, surrounded by forest and rocks and ponds, that Emerson felt closest to God.

For Jessie, a Missouri Episcopalian by way of Washington, DC's southern culture, Emerson's philosophy, rooted in New England Unitarianism, was a tough nut. Jessie understood Starr's love of nature and shared it, but considering it in Emersonian terms was a whole 'nother thing. When Starr loaned her a collection of Emerson's essays, Jessie tried to get through it but, at first, could not. "I return your Emmerson's [sic]," Jessie told Starr via letter in early 1861. "They're not in my style—above or beyond me in some way."[35] In time.

We do not know if or how Starr shared Emerson with Watkins, but as Starr was the evangelizing sort, he probably did. (Conversely, Starr would soon send Watkins's pictures to Emerson.) Starr was the embodiment of one of Emerson's most important contributions to American philosophy,

what Emerson called "self-reliance." It is the root of the now common American belief that regardless of birth, status, station, or anything else, any American can become anything. Starr lived Emerson's idea: he lacked a college education but transformed himself from a bookkeeper into a leading Unitarian and chose to go west for the opportunity to make himself into an even more important, influential minister, intellectual, and political actor. He would soon encourage similarly unschooled San Franciscans, such as Harte, poet Charles Warren Stoddard, and especially the lightly schooled Watkins, to rise above their humble roots to become writers and artists with something to contribute to the West and to the nation. For men such as Watkins and Starr, each of whom had started life as country bumpkins and then moved to the big city, self-reliance offered a path to significance.

That was not the only way in which Starr probably helped make Emerson important to Watkins. As Starr knew, Emerson encouraged the idea that art was not merely the assembly of words into a poem or visuals into a rectangle; it also provided ways an artist could actively make and form the world in which he wished to live.[36] "Nothing less than the creation of man and nature is [art's] end," Emerson wrote in his 1841 essay "Art." For Emerson, an artist, be he poet or painter or whatever, should begin his work with an appreciation of nature and wield the beauty in the landscape to express ideas about his world. "Have mountains, and waves, and skies no significance but what we consciously give them when we employ them as emblems of our thoughts?" Emerson asked in *Nature*, his 1836 book-length essay, which did more than anything else to encourage Americans to find pleasure, meaning, and value in landscape and, well, nature. "The world is emblematic. Parts of speech are metaphors, because the whole of nature is a metaphor of the human mind." This idea was so important to Emerson that he offered rephrasings of it throughout *Nature*. "By a few strokes [the artist or poet] delineates, as on air, the sun, the mountain, the camp, the city, the hero, the maiden, not different from what we know them, but only lifted from the ground and afloat before the eye. He unfixes the land and the sea, makes them revolve around the axis of his primary thought, and disposes them anew. . . . The sensual man conforms thoughts to things; the poet conforms things to his thoughts."[37]

Emerson's instruction may not be the introduction of metaphor into American literature and art, but it was close. Starr spent his career living

Emerson's recommendations, and he would have shared these ideas with Watkins. There are many reasons Starr is one of the major, albeit underknown, figures of the American nineteenth century: There is his leading role in stump-speaking up and down California for both Lincoln and progressive Republicanism and later for Union, an effort widely credited with keeping California and the West in the nation (so well recognized on both coasts in Starr's own time but now mostly forgotten). There is his leading role in helping Americans find beauty and value in both New England and western landscapes. There is his leading role in raising unprecedented sums for the U.S. Sanitary Commission (the Red Cross of the Civil War). There is his leading role in introducing Watkins's work to the East. All of this is matched, at least, by Starr's single-handed introduction of transcendentalism and Emersonianism into the West. It was Starr's introduction of sophisticated eastern ideas into the West that prepared the ground for what was to come: national parks, forests, and monuments, John Muir's influence, the Sierra Club, and the American environmental movement. For many decades, California recognized Starr's contributions by making sculptor Haig Patigian's bronze likeness of him one of the two statues representing the state in the U.S. Capitol's Statuary Hall.[38] Jessie was the first Californian to encourage Starr's talent.

As the Starr-Jessie relationship blossomed in whatever ways it may or may not have blossomed, as they got to know Watkins, the election of 1860 approached. Everyone in the United States, and especially the Black Point set, understood that the election could prompt a national fracture. Starr stumped for Lincoln and Union both from his pulpit in San Francisco and beyond. "I give the slavery sentiment hits with improving success," Starr wrote his New York friend Randolph Ryer.[39] As Jessie knew all too well, Republicans had never done well in California. The party's candidates were such minor afterthoughts that when the *Daily Alta California* ran day-by-day updates of the tally of the 1859 gubernatorial election, it repeatedly referred to the Republican candidate, Leland Stanford, as "Sandford." But that was before Starr's arrival. With Union on the line and Jessie to impress, Starr was doing all he could for the cause. More than he realized, he was making progress, substantial progress. Soon they would all be called to take their ideas out of Jessie's salon and into the contested West.

4

SECESSION OR UNION?

HOWEVER MUCH JESSIE BENTON FRÉMONT, Thomas Starr King, and the rest of the Black Pointers wanted to impact national events, how to do it from the remote and isolated West? There was no telegraph linking the coasts, and travel from California to the Northeast took at least four or five weeks, precluding even vaguely immediate engagement. Then, a few weeks before the 1860 election, Edward Baker, now famed not just as a builder of California Republicanism but as the friend of Abraham Lincoln, the party's nominee for the presidency, returned to San Francisco.

It had been a year since Baker had left California for Oregon in the wake of David Broderick's death. He was returning triumphant. As a result of Baker's pledge to support popular sovereignty in the West and, more importantly, an inter–Democratic Party feud in the Oregon state legislature that reached its apex when a group of legislators hid in a barn in an effort to prevent a quorum, Oregon selected Baker to be just its third U.S. senator.[1] The news was greeted with literal hundred-gun salutes from California Republicans, who considered Baker one of them—and who were stunned that a Pacific Republican actually, finally controlled a position of power. Soon after being selected, Baker had come to San Francisco to catch a ship to Washington, DC.

As he was in town, California Republicans asked Baker to help fire up the faithful by giving a speech in favor of Lincoln and Union. Baker, one of the greatest speakers in antebellum America, agreed. His backers secured the two-thousand-seat American Theater for October 26, just eleven days before the 1860 election. It was an ambitious booking; there was so little Republican feeling statewide that just seven of California's fifty-three newspapers had endorsed Lincoln. In the last statewide election, the 1859 gubernatorial contest, Republican Leland "Sandford" had received barely three thousand San Francisco votes. Were two thousand people really going to come out for a mere speech?[2]

Thanks substantially to Starr's efforts, not only did two thousand people turn out, but many hundreds more did too. "The American Theater has had the reputation of being a little shaky, and whenever any large company has gathered in it there have been whisperings and some fears that the galleries would not stand," reported the *Bulletin*. "But that question is settled forever. If [the American] ever meant to break down under a crowd, last night was the time. The house was never so jammed before. It was packed as tightly as men and women could be packed and yet breathe."[3] The *Alta* noted that it wasn't just working-class, trouble-making toughs who filled the seats either, that "the dress circles, orchestra boxes, and parquette and stage literally blazed with female beauty, while the house was actually crammed in every foot of space from pit to dome."[4] Among the attendees were many of the Black Point set, including Jessie Benton Frémont, Thomas Starr King, and Bret Harte. We don't know if Carleton Watkins joined them.

With hundreds of people denied entry to the theater, a thick throng gathered outside. The Republican majordomos didn't want to let the occasion pass—they'd never had an audience or a moment such as this!—so San Francisco state assemblyman Frank M. Pixley went outside to speechify to the overflow crowd. Pixley stepped up onto a pile of boxes and gave it his Republican, antislavery, Unionist all until someone in the front of the crowd yelled at him, "You're a damned liar!" Pixley responded by kicking the man in the face.[5] That a Republican crowd quickly dispatched the heckler and that Pixley continued his speech with no further interference, either from the crowd or from the police, was a sign that change was imminent.

Back inside, Baker took the stage to applause so insistent that it denied him voice for a full minute. His oratorical strategy wouldn't be just to stump

for Lincoln, Republicanism, and Union; it would be to offer California a path from its status as a satellite, as the gold mine on the little-considered edge of the nation, to full participation in the American project.

Baker ticked through the familiar national Republican themes—freedom, antislavery, a homestead bill to spur western settlement, infrastructural improvements such as a transcontinental railroad, and still more antislavery. It was standard stump-speech stuff delivered with loquacious fire. Then, about halfway through, Baker took a surprising turn. He pivoted away from specific issues to ask his audience: Was it enough to be the distant ally of the Southern slave power? Or had California matured enough to think of itself as more than a bunch of mineral extractors? Excepting the Black Point set, which was thinking about exactly these issues, Californians hadn't much considered this.[6]

Baker moved toward the meat of his speech: Pro-Southern Democrats of the sort that ruled California were holding back the West, he said. Southern-allied politicians, including the northern Democratic presidents, such as Franklin Pierce and James Buchanan, that California had voted for in the past, had claimed they were in favor of a transcontinental railroad but had done nothing to realize it because they, like California's Democrats, were allied with the South. Southerners cared about slavery and only slavery, and they spent no political effort or capital on railroads or anything else. Was California content to defend and reinforce a regional anomaly, *or did it want to contribute to an entire nation and its future?* Baker had spent enough years in California to know his audience. The American Theater was packed with a nation's overflow, its surplus, men who had left home for California in pursuit of a future that had not been available to them back in Oneonta or wherever. They loved hearing that the East's excess was ready to blossom into the nation's present and future.

Now Baker was reaching the crux of his speech. He told his audience that California could not realize its potential through business alone. After all, California could send its gold anywhere. As part of Baker's fundamental question to California and the West—*do you want to be a part of national greatness, or do you want to be an adjunct to a regional interest built around slavery?*—he pointed out that Southerners had contributed little to the humanities. "In much that makes up national greatness and excellence, they are lamentably deficient," Baker said. "In deep philosophy, in inspired

poetry, they are lacking. The books we write, they read, the lectures we deliver, they hear; Bancroft and Prescott write their history for them; Bryant and Longfellow write their poetry."

What an extraordinary passage! In 1860, no westerner had created anything of any broad cultural import whatsoever, and here was Baker urging California, an extraction-oriented state 1,700 miles from another American city of consequence, that it should vote for Lincoln and Union so that it might participate in the North's arts and humanities? It was mad, and it worked. Baker's audience applauded with gusto.

Baker continued. "Even under the shadow of the throne of Russia, on the banks of the Seine where the ashes of the first Napoleon repose, [and in London] where the British Queen in majestic dignity presides over a nation of freemen—everywhere abroad, the great ideas of personal liberty spread, increase, fructify," he said. "Here—ours is the exception!"

This was a doubling down on implausibility. Liberty, Baker argued, enabled greatness, especially the sort of cultural achievement that lasted through the ages. "*Our* interests," Baker said, concluding his point with a reminder to his audience that westerners ought to ally with the North rather than with the region with a single-track interest in slavery, "are diversified."

Sometimes it is men who are farthest from greatness who most believe that they can be great. Baker's audience went nuts. A man rushed onto the stage to drive home Baker's point. "It is true! It is true, gentlemen! We are slaves compared with the rest of the world! The Colonel is right!" The stage rusher was Black Pointer Bret Harte, who punctuated his exclamation by waving a huge American flag (a hint that his rushing the stage may have been preplanned).[7]

Baker had prepared a doozy of a finish: "One year ago, I, your champion, in your fair state, my own state then, was beaten in a fair contest," he said, reminding everyone of the 1859 gubernatorial election in which Chivalry Democrats had boat-raced the Republicans. "With my heart somewhat bruised, my ambition crushed, one week later I stood by the body of my friend Broderick, slaughtered in your cause, and I said, 'How long?'" The crowd stirred. "The tide is turned!" Baker preached. "The warrior, indeed, rests! He knows no waking; nor word, nor wish, nor prayer, can call him from his lone abode. I speak to those who loved him; and in another and

higher arena I shall try to speak for him." The audience clapped, its applause building to a great rumble. "I shall say that the people who loved him so well, and among whom his ashes rest, are not forgetful of the manner of his life, or the method of his death." This was as clear an accusation of political murder as a man could make. The deed was done. Baker had urged California to throw off its decade-long status as a last resort for desperate men, to embrace ambition, to participate in the cultural life of the nation, and to further express that aspiration by voting Lincoln and Republican and by standing with Broderick and Union. He had tied up every neuron in the western psyche into a neat package.

Starr watched the speech from a private box with Jessie Benton Frémont. During one of Baker's pauses for applause, Jessie leaned into Starr, gestured toward the rapt crowd, and told him that it should all be his. If Starr had lived in the state a little longer, Jessie told him, she could have had him elected senator straightaway. Starr was awestruck both at Jessie's declaration and at Baker's speech. "That is the true way to reach men!" he told her. "I can never do that. How I envy him!"[8]

Baker's speech stunned San Francisco to attention. The city's newspapers printed the full text in the next day's editions. Then they published it in pamphlet form, as they had Baker's funeral oration for Broderick, and sold it throughout the state. A few nights after his triumph, Baker visited Jessie's salon at Black Point. Such was the occasion that John C. Frémont made a rare appearance in San Francisco. Perhaps a onetime U.S. senator wanted to share some insider information with a senator-to-be, perhaps Frémont wanted to discuss a possible position for himself in a Lincoln administration, or perhaps Frémont wanted to talk up Las Mariposas to a senator-select who was in a position to be helpful.

Starr was at the dinner too, and it's hard to imagine that Harte or Watkins or Frederick Billings or any other of Jessie's Black Point regulars would have missed it.[9] No one kept a record of the evening's discussions, but surely they all wondered if the enthusiasm for Baker would translate into votes for his friend Abraham Lincoln. What would the West's legislative priorities be under a Republican presidency? (The railroad, of course, but what else?) As Baker's call for the West's cultural engagement with the North seemed so directly pointed at Black Point, did they discuss how Baker's summons might be answered?

This is when the predominant interests of Jessie's salon—a passion for nature, the development of cultural expression rooted in western experience, and progressive Republican politics—coalesced into cultural Unionism, the creation of distinctly western art, prose, and poetry and the sharing of it with the North in an effort to build common bonds. The history of mining regions around the world had been that once their ore was exhausted, their ties to the places to which they sent their riches frayed. The cultural Unionism for which Baker called, born at Black Point, would ensure lasting bonds between America, the North, and the West. Starr would go first, then Watkins, and then Harte.[10]

Starr would lead because he had the best connections in the East and because he had done this kind of thing before, sort of. In late 1859, just before leaving Boston for California, Starr had published a popularizing, practical expression of Ralph Waldo Emerson's ideas about landscape and nature titled *The White Hills: Their Legends, Landscape, and Poetry*.[11] The book, born from a series of essays Starr had written for the *Boston Evening Transcript,* was a mash-up of travel memoir, guidebook, literary criticism, and transcendentalist tome as applied to New Hampshire's White Mountains, the highest peaks in New England. *The White Hills* was so popular that it required ten printings.[12] The success of Starr's *Transcript* essays and book helped motivate American painters such as Sanford Gifford to venture into the Whites to paint the wonders Starr described. (Gifford made his terrific *Early October in the White Mountains,* now at the Kemper Art Museum at Washington University in St. Louis, in the wake of the release of Starr's book.) By the time Starr met Watkins in 1860, he well knew that artists might respond to his work and to his ideas.

Now with Baker nearly calling on westerners to make culture for country, Starr had an idea. He understood the way eastern poets and artists wielded landscape as both cause and metaphor to support broad ideas, and he had a landscape in mind for doing the same in the West. He would introduce the East to the place he'd spent his summer vacation: the Mariposa Big Tree Grove, a stand of towering sequoia trees, the largest on earth, and a nearby mountain valley called Yosemite. Starr took his immediate cue from Baker, but his intellectual core descended from Emerson. "Nature is made to conspire with spirit to emancipate us," Emerson had written, his verb newly poignant.[13] Baker had urged a western cultural Unionism, but it was

Emerson who pointed to how it might be done: by seizing the metaphorical possibilities inherent in nature, in the landscape. By addressing a northeastern philosopher with a project rooted in the western landscape, Starr would establish cultural Unionism's fundamental recursiveness.

Starr probably became interested in Yosemite through Jessie, who loved to tell easterners about the amazing place that was a mere day's ride from Las Mariposas. She had recently hiked up to the top of a mountain on her land, probably the same Mount Josephine from which Watkins had made one of his best Las Mariposas pictures, and had written to friend and future Lincoln adviser Francis Preston Blair of the view: "It is about thirty miles as the crow flies to the snow mountains but in this transparent, rarified air they look not ten. The cliffs and chasms of the Yosemite Valley are perfectly distinct."[14] Upon visiting Yosemite three months earlier, in July, Starr had written to friends in Boston of his trip. Many of them encouraged Starr to write about what he'd seen. "Why not propose a 'California Book' as a rival to the White Mountains Book?" wrote Hosea Ballou II, a minister who had recently served on Harvard's board and who was now the president of Tufts University. Ballou didn't quite grasp the Yosemite marvels Starr described in his letter, but he thought he understood Starr's seemingly far-fetched claims about the trees at Mariposa. "Posh, posh . . . [there is not] vegetable nourishment enough in the whole globe to rear a tree 90 feet in circumference. But I understand the moral of the fable, which is that in California you are as much greater than anybody here as 90 feet is greater than the circumference of any tree here."[15]

In August and September, Starr had been too busy with the election and a lingering bit of flu to do any writing. Did Starr sit down to write about Yosemite and the Mariposa Grove in direct response to Baker's call? Did he think of himself as answering a specific call to cultural Unionism? We don't know. Certainly Starr's friends had encouraged him to write about Yosemite before now, and he had passed. Then there had been other priorities; now Starr would make time. He would begin the process of transforming California's sparkling granite-walled jewel, the view from Jessie's Las Mariposas, into America's next famed landscape—and he would blaze the trail for Carleton Watkins.

Today, when about five million people visit Yosemite each year, it seems inevitable that nature-loving San Franciscans such as Thomas Starr King

and Carleton Watkins would go there and that the place would become popular.[16] But even in 1860, when California was entering its second decade as an American state, Yosemite was substantially unknown and little visited. As late as 1858, no one visited Yosemite, and in 1860, the year in which Starr first went, it appears that no more than a few dozen people did likewise.[17]

William A. Scott, a southern preacher and rival of Starr's, and his ally, Yosemite hotelier James Mason Hutchings, had spent the rest of the 1850s trying to attract visitors to the valley. Hutchings hired artist Thomas Ayres to make some drawings of the valley and published Ayres's sketch of Yosemite Falls as a print.[18] Ayres's work wasn't particularly impressive—like the photographer Charles Leander Weed, Ayres is remembered for his primacy rather than for his talent—but it was something.[19] Notwithstanding Hutchings's efforts, it was mostly the Frémonts' proximity at Las Mariposas that nudged tourists toward the valley. In 1859 Las Mariposas delivered to Yosemite its first famous visitor: *New York Tribune* editor Horace Greeley. His reaction, as presented in his travelogue *An Overland Journey,* was an odd mix of awe and indifference. Greeley spends most of his account of the valley noting the lateness of the hour and his tiredness. Upon seeing Yosemite by daylight, Greeley describes Yosemite Falls as a "humbug" and then spends five pages bellyaching before admitting that "[t]he Yosemite Valley (or Gorge) is the most unique and majestic of nature's marvels, but the Yosemite Fall is of little account." He speed-traverses the length of the valley only to shrug, arguing that "[a]n accumulation of details on such a subject only serve to confuse and blunt the observer's powers of perception and appreciation." Finally, just before leaving the valley after less than a day's visit, Greeley supposes that it might be OK. "I certainly miss here the glaciers of Chamonix; but I know no single wonder of nature on earth which can claim a superiority over the Yosemite." And that was it. Reluctant in its only occasional awe, nothing in the five pages Greeley devoted to Yosemite in his 386-page book intrigued Greeley's northeastern audiences.[20] (So lackadaisical was Greeley's interest that Starr would later poke fun at his friend's visit.)

In 1859 Hutchings had another idea that he hoped would attract visitors to Yosemite: bring Weed, then the most prominent landscape photographer at the most prominent photography gallery in San Francisco, to the valley. As with the pictures of gold mining that were almost immediately surpassed

by Watkins's Las Mariposas pictures, Weed's Yosemite photographs weren't much. They made immense features in a vast landscape, such the three-thousand-foot monolith El Capitan, look like they could be held in a viewer's hand and made the grand Cathedral Rock look like a gumdrop. Furthermore, the prints themselves were muddy and technically ill-accomplished. When Weed's Yosemite pictures went on view at Robert Vance's gallery in August 1859, the response was mixed. One newspaper was effusive. "Every important place about the valley, the giant cliffs, the huge pines, the memorable waterfalls and cataracts, and in fact all but the reality is vividly depicted," wrote the *San Francisco Times*. "Each tree, rock, sprig, and cliff seems to stand out boldly and clearly. The great waterfalls, glistening in the sunlight, are seen leaping out from the crags and hang in mid air as clearly as if witnessed in nature."[21] Another was less impressed. The *Daily Alta California,* the over-the-top boosterism of which typically could be relied upon, didn't even mention Weed's views until his stereographs were awarded at the state fair in Sacramento, at which point it found them merely "admirable."[22] By the *Alta*'s standards, this was practically an insult. Yosemite had not yet found its bard. Then Starr arrived.

Five weeks after Edward Baker's American Theater speech, a little longer than the time it would have taken a letter to reach Boston from San Francisco by boat, and in plenty of time for a letter to reach Boston by overland express, Thomas Starr King debuted the first in a weekly, eight-part, twenty-thousand-word Yosemite travelogue in the *Boston Evening Transcript.*[23] Starr had written of California for the *Transcript* before, light, short, humorous essays of travels around a distant land. This two-month-long series was something different, an altogether more ambitious project. Edward Baker had called for cultural Unionism that would strengthen the bond between the North and the West, and Starr delivered. The timing suggests intent, but it is not conclusive.

Starr's travelogue, published in the *Transcript* between December 1, 1860, and February 9, 1861, was not the first account of Yosemite or the Big Trees to be published in an eastern paper, but it was easily the most important.[24] While Starr's series aroused interest in and around Boston, its impact was stunted by current events. Over the course of the seventy-one days in which

Starr's Yosemite missives appeared in the *Transcript,* six states seceded from the Union, the Texas legislature approved secession, and several other states took steps toward the same result.

Throughout his missives, Starr linked the new western landscape to eastern places and traditions. He related California's "vegetable Titans"—the Mariposa Grove's giant sequoias—to America's dominant Protestant faith and the most famous marker of the nation's founding: "We need to see the 'Mother of the Forest' towering near Trinity Church in New York, and overtopping its spire with a column whose life is older than the doctrine of the Trinity, to appreciate its vastness," he wrote. "We ought to see the 'Fountain Tree' of the Mariposa grove, a hundred and two feet in circuit, rising near the Bunker Hill monument [a 221-foot granite obelisk in Starr's native Charlestown, Massachusetts], and bearing up a crown eighty feet above it, to feel the marvel of its bulk and vitality."[25]

Starr went on to compare the features in the Yosemite Valley to northeastern mountains such as Mounts Adams and Washington and to White Mountain meadows and valleys, or "notches," as they were called in the East. Some of this was Starr simply comparing the Sierra to places his audience knew, a way of getting the new place over. But in so doing, he implied a relationship between the new West and the old East. In case anyone was missing what he was up to, at the end of the sixth of Starr's eight installments, in a description of his first meal in Yosemite Valley, Starr drew Baker's line directly. "What, O *Transcript,* do you think our meal consisted of? Stewed oysters and lobster! I hold up my pen and make oath. Among those wilds of the Sierras we had on the table oysters and lobster from New York, with a bottle of Boston pickles. And the shellfish were cooked for us by a Chinaman! The crustacea finding their way from the Atlantic, and the cook from the Pacific, to that magnificent glen—so lately the undisturbed camp of the grizzlies—is it not a sign of the union which California is destined yet to celebrate between the remotest East and West?"[26]

Using the familiar Whites as a point of entry into the grandeur of Yosemite had its utility (especially for Starr, whose book about the Whites was still new to booksellers), but to truly fulfill Baker's call to cultural Unionism, Starr would have to go beyond Boston's sphere of influence and relate Yosemite to America's most famous landscape, New York's Niagara Falls. He linked Niagara to Yosemite's Nevada Fall, a spectacular 594-foot

waterfall over a granite cliff. "[T]here is ten times the quantity of water, and the power of the fall as from 'the head-long height it cleaves the wave-worn precipice' seems as great as any portion of the American fall at Niagara," Starr wrote, quoting Lord Byron because Americans were still eager to argue that their natural wonders were at least as good and as old as Europe's, and a British poet would help. In his final paragraph, Starr tossed in one other symbol that his readers would have recognized. "My companion killed a rattlesnake that buzzed generously near our legs before making us acquainted with his fangs."[27] The snake was a reference deftly done, both Biblical allusion and a popular contemporary metaphor for disunion and southern treachery.[28] Best of all, Starr's party had killed the snake.

As good a read as Starr's account remains today, it was just the beginning. In the coming months, Starr would reverse the flow of his cultural Unionism by bringing cultural production into the West via a statewide lecture series about northern poetry. Starr also wrote to *Atlantic Monthly* editor James T. Fields to ask him to help solicit new poems for the series from the North's greatest poets, Longfellow, Holmes, Whittier, and Lowell. (Starr knew them all and could have asked them himself (and he would ask Bryant), but he knew that enlisting Fields in the campaign might earn him coverage in the *Atlantic*.) "The state must be Northernized thoroughly by schools, *Atlantic Monthlies*, lectures, N[ew] E[ngland] preachers, Library Associations," Starr wrote.[29]

When Bryant's poem arrived, it was exactly the kind of cultural bonding agent that Starr had wanted. Bryant began:

> O country, marvel of the earth!
> O realm to sudden greatness grown!
> The age that gloried in thy birth,
> Shall it behold thee overthrown?
> Shall traitors lay that greatness low?
> No, land of Hope and Blessing, No![30]

Starr encouraged Californian cultural producers, too, especially poets such as Ina Coolbrith and Bret Harte. Then there was a young man of even less previous achievement. Starr had seen his pictures of Las Mariposas and knew that his ideas about nature, landscape, and beauty aligned with his.

Enter Carleton Watkins. Alas, Watkins's moment in Yosemite would have to wait until the 1861 season because now, in late October or early November, snows had shut off access to the Sierra and especially to the infamously bad road into Yosemite. Watkins's breakthrough was near, but it would have to wait for the summer of 1861. Between now and then, America would cleave.

On November 6, 1860, Lincoln defeated proslavery Democrat John C. Breckinridge and two soft-on-slavery candidates, Democrat Stephen A. Douglas and Constitutional Unionist John Bell, to win the presidency.

In California, the vote was so close that the outcome, which arrived in the West by pony express late on November 14, was known before the state's own results were. Edward Baker's American Theater speech seems to have had an impact, but it also helped that three pro-Southern candidates split California's pro-Southern electorate. Lincoln carried 32 percent of the state, far more than the 10 percent the Republican had earned in the last statewide election and enough to beat Douglas by 734 votes out of 120,000 cast. Lincoln won Baker's borrowed state of Oregon almost as narrowly, with 36 percent of the vote and a margin of 254 votes out of 15,000 cast.

The Black Point set was thrilled but knew that Lincoln's thin margin and low percentage left California and the West's future unpredictable. The West certainly wasn't going to join the emerging Southern confederacy, but it had other options. The threat that Unionists around the country took most seriously was the possibility that isolated California—the state whose processing of the gold and silver coming out of the Sierra would be crucial to paying for any war to save the Union, a state moored to the motherland by neither railroad nor telegraph—would join with Oregon and gold- and silver-rich Nevada Territory to form an independent but South-allied Pacific Republic. The U.S. senator from California with the closest ties to San Francisco, Democrat Milton Latham, encouraged the idea, as did California's more ardently pro-Southern Democratic senator, William Gwin. Both of California's congressmen supported disunion as well.[31] (A third California congressional seat was unfilled.) "If the Union crumbles, come out here & we will squat on a silver mine in Washoe [in Nevada Territory] & snap our fingers at disaster," Starr wrote to a friend with the dark humor that suffuses much of his correspondence from this period.[32] Historians have long had varying takes on how serious the Pacific Republic threat was or was not, but

contemporary California accounts from 1860–61 indicate that the primary actors, men such as Starr and women such as Jessie, believed it to be real and took it seriously.

In January 1861, with the fate of Union and California's role within it uncertain, John C. Frémont, Frederick Billings, and their associate Albia A. Selover packed up Watkins's Las Mariposas pictures and sailed east to try to raise capital for Las Mariposas.[33] Their first stop was New York. While there, Frémont met with President Abraham Lincoln and asked for a field command should a war for the Union happen. In Europe, the Las Mariposas team would split up: Billings and Selover handled London and Germany while Frémont went to France (in part because it seemed as though Lincoln might name Frémont his minister to the country, and in part because Frémont had preexisting contacts in the French aristocracy). Billings and Frémont treated the trip with different levels of focus: Billings believed that turning around Las Mariposas was his best chance at becoming one of America's wealthiest men, and he worked hard. To Billings's enormous frustration, he believed that Frémont mostly viewed the trip as an opportunity to take a woman he thought to be Frémont's mistress, one Margaret Corbett, on a European sojourn and to purchase armaments for the Union army in both England and France.[34] (Jessie seems not to have minded remaining behind. She presided over Black Point, encouraged Unionism, and continued her friendship with Starr.)

By the time Frémont and Billings arrived in Europe, the Civil War was under way. With California's loyalties uncertain, the Las Mariposas group's chances of raising investment were doomed. Still, the trip generated attention for Watkins's work; Billings showed Watkins's pictures to members of Parliament, to the *Times* of London, and to numerous British financiers. In France, Selover showed Watkins's pictures to Emperor Napoleon III. These viewings were the introduction of the western American landscape to Europe, which would become fascinated by the new land. Frémont, named to an army command in Missouri while in Europe, would not return to California for many years. Billings would be away until well into 1862.

Throughout the winter of 1860–61, news of states seceding from the Union trickled into California as slowly as the election results had arrived. By midwinter the trend was plain, and California's Unionist Republicans began to organize to try to keep California in the Union. Just as Starr had traveled

the state speaking in support of Lincoln, now he barnstormed for Union. "I go for Union as a [matter of principle]," Starr wrote to his New York friend Randolph Ryer in February 1861. "As a matter of *taste*, I prefer a divorce. Anyway, we shall try to keep California with the north. This week I shall write my address on Washington['s Birthday] for the 22d & I mean to manufacture a little thunder for our Southern brethren. They are beginning to talk Pacific Republic here, & we mean to squelch the idiots."[35] Days later, Starr renewed his contract at First Unitarian, putting off his return to the East for at least a year.[36] He believed that the Union needed him in San Francisco.

He was probably right. The event that Starr mentioned in his letter to Ryer was planned as a Union rally that would masquerade as a celebration of George Washington's birthday. As the holiday fell two weeks before Lincoln's inauguration, it emerged as a crucial event in the push to keep California in the Union, an opportunity for the West's largest and most important city to declare its allegiance and to urge California and the rest of the Pacific into line. Starr was almost certainly involved in the planning of the grand outdoor event. Ostensibly because his voice was a bit fragile and didn't carry well in outdoor settings, he planned to save himself for an evening speech at Tucker's Music Hall, conveniently located just a block from the outdoor rally. In other words, Starr booked himself a solo gig at which he could be the end-of-the-day headliner.

The day's events were an extraordinary success. The committee set up an immense "orator's stand" complete with podium and room for the press. It was plastered with banners proclaiming

IN UNION THERE IS STRENGTH,
THE UNION, THE WHOLE UNION, AND NOTHING BUT THE UNION.

—Webster

REPUBLICANISM, DEMOCRACY AND EVERY OTHER POLITICAL NAME
OR THING, IS SUBORDINATE TO THE UNION. SO FAR AS I AM
CONCERNED IT SHALL BE SO.

—Seward

The *Daily Alta California* claimed that fourteen thousand people, a quarter of the city's population, marched from San Francisco's City Hall on Ports-

Attributed to Carleton Watkins, *Washington's Birthday Rally*, 1861. Collection of the Stanford University Libraries.

mouth Square to the rally site eight blocks away to hear several hours of pro-Union speeches.[37] The Republican *Alta* also noted that "if the Union-loving sentiment of this people ever admitted of question, the last shadow of doubt is now dispelled . . . so grand and solemn an uprising of the people has never before been witnessed on the Pacific coast."[38] Shortly after Washington's Birthday, the *Alta* published a pamphlet of speeches given at the event and sent it throughout the state.

That night, Starr took to the stage before a capacity crowd of a thousand people at Tucker's Music Hall. Hundreds more waited outside. Such was the demand, both near and far, that Starr would give the speech over and over again, in San Francisco and beyond, for several months. "I pitched into secession, concession, and Calhoun right and left and made Southerners applaud," Starr wrote to Ryer, adding with schoolboyish pleasure that Jessie had come to support him.[39] The unnamed San Francisco correspondent for the *New York Times* took note of Starr's successes, describing him as the

embodiment of "the ghost of old Sam Adams. . . . While he charms his hearers with eloquence, he charges them with the very spirit that filled the air about Bunker Hill in 1774 and '75 . . . He has brought every element of power that his popularity gives him to bear in all our [western] cities in favor of liberty and human rights."[40]

The pro-Union campaign included speeches, pamphlets, Starr's lecture tour, and one other almost unprecedented document: a photograph of a crowd gathering for the Washington's Birthday event speeches. It was almost certainly taken by Carleton Watkins.[41] No information about how or even if Watkins sold and distributed it survives. It's not hard to imagine the likeliest way it came about: at Starr's and Jessie's instigation. Not only were they two of the city's most important Republicans, and not only did they know Watkins and his work well, but Jessie, who was the co-manager of her husband's 1856 presidential run, was campaign savvy enough to recognize the value of such a picture. As something of a photography buff and as a friend of Lincoln pal Edward Baker, Jessie probably knew about an August 1860 picture that the Lincoln campaign had made and distributed of a rally in Springfield, Illinois. Like the Springfield picture, Watkins's view of the crowd was elevated and taken across an open space from the speaking podium, and it plainly shows the banners surrounding the podium and a gathering crowd. An increasing crowd may be moving down Market Street, from the direction of City Hall, toward the three-way intersection. The picture shows nothing like the fourteen thousand people the *Alta* claimed. It was probably taken before the speakers began their orations.

Today, absent any information about it, it's difficult to know how to read the picture. Why would Watkins make it before the speeches started, before the crowd was at full strength? An answer may be in the picture itself: the rally was scheduled for 2:00 P.M., but the unexpectedly enormous crowd may have caused the program to start late. In February, the sun would set behind San Francisco's western hills early, and any afternoon fog may have left it too dark for Watkins to make an effective picture of a bustling crowd. Regardless, the length of the shadows and the glare in the left-hand third of the picture suggest that Watkins took it late in the day. Watkins probably monitored the light levels and took the picture as late as he thought he could.

The February 22 rally fired up the Unionist faithful, but in terms of motivating California solidly into the Union column, it was not decisive. Na-

tional events did not require California's Democratic majority to get serious about siding with Union or disunion until after April 24, the day on which news of the April 12 Confederate attack on South Carolina's Fort Sumter arrived in California. The two halves of California's Democratic party met in San Francisco around May 8. The party split had dated from the mid-1850s, when the proslavery, William Gwin–led Chivs and the Free-Soil, David Broderick–led half of the party had begun to feud. That split continued after Broderick's death both in the 1860 election results (the proslavery Breckinridge and the slavery-tolerant Douglas had received similar vote totals in California) and beyond. At this California Democratic meeting, the pro-Southern Breckinridge men moved to join the two halves of the party. The Douglas men, whose candidate had received a mere four thousand more votes in California than Breckinridge, recognized that this would mean allying California with the South either as a secessionist Pacific Republic or as something else, and they rejected the proposal. In so doing, they followed Douglas himself, in particular a recent speech in which the former candidate pledged himself to supporting the Union and the Lincoln-led government. Thus the Douglas men effectively expelled the pro-Southern Democrats from the party.[42] Six months after the November election, California Democrats finally had a clear choice: support the Union, or go underground with their allegiance to the South. Most Democrats, at least in dominant Northern California, chose Union.[43]

"We have saved California," Starr wrote to his friend William R. Alger, an influential New England Unitarian whose writings helped open the field of comparative religious studies. "From the white Sierra to the white-edged sea, the villains are prostrate. We dance on their heads. Their fangs are smashed. [Southerners] are an awful race, shallow, hard-hearted and vile. We must flog them for their good, and then throw them off. I dread yet some compromise that will enable them to come back with [illegible] step into Congress and a civilization to which they do not belong."[44]

The result of the meeting was an almost immediate realigning of San Francisco business and politics. This was, in many ways, more important to California's future than its having voted for Lincoln. Some San Franciscans (and most Southern Californians) would refuse to go along with the newly prevailing Unionist sentiment and would ally themselves with the Confederacy.

Lincoln never asked for nor drafted Californians to fight in the East. The official reason was that the cost of transportation from California to the theaters of war was too great and that westerners were needed in the West itself to protect the mails and to deal with Native Americans (which they did with murderous efficiency that would serve as a template for how the federal government addressed Native Americans in the trans-Mississippi West after the Civil War). As a result, by virtue of his migration to California, Carleton Watkins, now thirty-one, escaped fighting in the Civil War. His brothers did not. Three Watkins brothers fought for the Union, and one of them probably died for it. All three signed up in 1861, well before the draft. Charles Watkins entered the army as a first lieutenant in New York's Seventy-Sixth Regiment. He raised a company of thirty-two men that would fight under Maj. Abner Doubleday. Charles was initially assigned to detached duty, but he asked to be in a frontline unit and was sent to join Doubleday at the forts surrounding Washington, DC. In the months to come, the Seventy-Sixth would be enormously active, fighting at Antietam, South Mountain (Maryland), Gainesville, Cedar Creek, Warrenton Springs, Fredericksburg, Chancellorsville, Gettysburg (where he was wounded), and Spotsylvania, where Charles Watkins, then a captain, was commended for his service. In the first ten months of his service, 875 of his unit's 1,000 men and 24 of its 30 line officers were killed or wounded and unable to continue. Charles Watkins remained in the army until nearly the end of 1864 and rose to become a lieutenant colonel. George Watkins joined the Third Cavalry early, in July 1861, as an enlisted man and rose to second lieutenant before mustering out in January 1864. The third Watkins brother, Albert, joined the Third Artillery as an enlisted man at the end of 1861. He died less than four weeks after being discharged, likely as the result of wartime injury or infection.[45] Carleton Watkins's contribution to the Unionist fight would be cultural.

5

TO YOSEMITE IN WARTIME

IN LATE JUNE OR EARLY JULY 1861, just before the Union's defeat at the Battle of Bull Run and President Lincoln's realization that the 75,000 troops for which he called in April would not be enough, at about the time Oregon Sen. Edward Baker was recruiting a regiment of soldiers in Pennsylvania and New York to fight in what he would call the California Regiment (a name chosen to honor California's commitment to Union), and as California was in a panic about the possibility that one or two Confederate ships could theoretically blockade the narrow opening to San Francisco Bay and thus devastate the West's economy, Carleton Watkins prepared to leave San Francisco for Yosemite. He would have known that the events at Fort Sumter had forced Americans to pick sides and that a broader war between North and South was imminent, but the final lines of the contest might not have been clear. Watkins probably did not know that his brothers were early enlistees in the Union army.

Planning to go to Yosemite would taken Watkins much of the winter of 1860 and the spring of 1861. In the middle of his preparations, he paused to fulfill two legal commissions for a single boundary dispute. The case was *United States v. D. & V. Peralta* in the East Bay. Remarkably, Watkins worked for both sides of the case. One way or another, his work was at least

partially determinative: the judge in the case cited Watkins's pictures in his decision.[1]

Watkins was no doubt pleased, especially to get paid, but his focus would have been on purchasing, stockpiling, and packing chemicals, glass-plate negatives, food, and other provisions at a scale no American photographer had ever attempted. Watkins's most daring preparation was the design and construction of a new camera.[2] His ambition was such that he didn't want to just go to Yosemite, he wanted to go with the biggest camera ever made, one that could make the biggest glass-plate negatives and, because in 1861 (and for several decades thereafter) prints were made at a one-to-one ratio from a negative, the biggest prints in the world.

Inclusion in the events at Black Point alongside men and women of national repute seems to have driven Watkins's ambition. Jessie Benton Frémont and Thomas Starr King were both encouraging sorts. Starr, in particular, was known to read the work of a poet in a local magazine, think it was great, and track him or her down at home to offer both assistance and encouragement.[3] Maybe the enormity of the national crisis, its blue-and-gray lines between in or out, participating in the Unionist moment or no, pushed Watkins to think big. Maybe Watkins had just needed to be channeled toward meaning, and Baker's call for patriotic, cultural Unionism provided it. Watkins, who had made only one significant photography trip in his entire short career, was feeling pretty good about himself.

Watkins's new camera helped transform his career. It was a technological marvel so advanced that his peers and competitors would need most of the 1860s to catch up. Now Watkins's photographs would be so large that they would compete with paintings to present the depth and breadth of the American landscape. This would have been a nice enough advantage in the Catskills or the Whites, but in the vast West, it was transformative. The unprecedented size of Watkins's prints played a major role in how his work would be seen, considered, and remembered, so Watkins's new camera deserves some attention.

The largest commercially available camera in 1861 allowed photographers to make pictures on 13-by-16-inch glass negatives. This was about the size of the camera Watkins took to Las Mariposas.[4] Prints made from these glass plates maxed out around 208 square inches. Because of the distortions

caused by lenses or light bleed into the camera housing, most photographers cut the edges off their prints, creating a slightly smaller final object.

Many mid-nineteenth-century photographers, perhaps most, did not use the largest camera available to them. Big cameras were cumbersome, especially for photographers who worked outdoors. A camera that allowed a photographer to make a roughly 13-by-16-inch glass-plate negative virtually guaranteed that the photographer would require one and probably two assistants to help carry gear. Adding to the challenge was the way in which chemicals had to be handled to turn that glass plate into a negative. A photographer would have to coat the entire sheet of glass with chemicals and then tilt the glass back and forth, to and fro, so as to spread the chemicals around it as evenly as possible, and he'd have to do it in the dark. This is why, in many large-format pictures of the era, including Watkins's Las Mariposas pictures, it looks like waves of something are moving across the surface of the image; they were. The bigger the plate, the harder it was to avoid the watery waviness.

Watkins went bigger in part to compete with other photographers. Locally, his major competition was Charles Leander Weed. Weed's 1859 Yosemite pictures were substantially smaller than the pictures Watkins would take at Las Mariposas the next year. They measured about 13 ½ by 10 ½, or 142 square inches.[5] This was pretty good; Weed was making bigger prints than some of his peers elsewhere in the country. For example, in 1862, in the eastern theaters of the Civil War, Alexander Gardner and Timothy O'Sullivan used smaller cameras than Weed had used. Their prints are 8 by 10 inches, or 80 square inches.[6] No doubt Gardner and O'Sullivan picked that size for convenience and speed across land that had, only days before, been battlefield. In the years after their Civil War work, both Gardner and O'Sullivan would use bigger cameras. As O'Sullivan traversed the interior West in the late 1860s with the federally funded Survey of the Fortieth Parallel (better known as the King Survey, after leader Clarence King), O'Sullivan would make glass plates of 9 by 12 inches.[7] Gardner's *Scenes in the Indian Country* pictures from 1868 are a smidge bigger, 9 ½ by 12 ¾, and may have been made with the same camera.[8] (O'Sullivan was a much more careful printer than the oft sloppy Gardner and may have cut down his edges a bit more.) Either way, even the 208-square-inch negatives Watkins was making at Las

Mariposas were 72 percent larger than the negatives his peers O'Sullivan and Gardner would use in their biggest work at the end of the 1860s.

No matter. Watkins didn't think that camera was big enough. The only way he could go bigger was to have someone in San Francisco design and build a bigger camera for him, or to do it himself. There were no camera makers in San Francisco in the early 1860s, so Watkins, the son of a skilled cabinetmaker, probably designed and built one himself. This new camera would use 18-by-22-inch glass plates, negatives that, at 396 square inches, were almost twice the size of the plates he had used at Las Mariposas. This size negative would come to be known as a "mammoth plate." The etymology of the term is uncertain, but in the mid-nineteenth-century, the word *mammoth* was commonly applied to things that seemed impossibly large, so enormous that there was no point in providing dimensions, such as a really big American flag. Watkins didn't want a camera that was a little bit bigger than the one he'd been using, he wanted a behemoth. Ambition? He had it.

Watkins's decision to design and perhaps build a bigger camera also points to intent. The reason James Mason Hutchings had commissioned Weed's photographs in 1859 was to have etchings made from them and then reproduced in his *Hutchings' California Magazine*. (It was not yet technologically possible to include photographs in mass-market publications.) By going large, Watkins was declaring first that his pictures weren't for use as etchings, nor were they necessarily to remain in albums (though he certainly would sell the Yosemite pictures in albums); they were to be framed and hung on a wall, to be considered next to and on par with paintings. Watkins was, after all, an *artist*. The British art magazines he almost certainly read while a stationery-store clerk for George Murray had said photographers were artists, and Watkins never forgot it. Photographs of Watkins's own sales and exhibition places show him presenting his pictures mounted and presented in fashionable frames.[9] A Watkins notebook from 1864 even reveals that he often sold his pictures in frames, a strikingly unusual practice. Watkins knew what he wanted to be, figured out what would give him a chance to compete, and did it. The ambition Watkins found in 1860–61 would drive him for the rest of his career.

We can only imagine how Watkins's friends and other photographers around San Francisco reacted to this enormous new camera, but it must have been something along the lines of, *are you nuts?* Watkins had mindfully

styled himself a landscape photographer—unlike most other photographers, he didn't even have a walk-in studio—so he was not building a big camera to compete with the many local tradesmen who shot baby portraits for a buck a pop. This was a camera Watkins intended to use out in nature. This meant additional challenges—and significant additional expenses. Starting with the 1861 trip to Yosemite, and for the rest of his career, Watkins would need to travel with bigger glass plates, more chemicals, bigger and more everything than any other photographer. The new camera's requirements were substantial: the glass plates Weed used in 1859 had weighed a pound and a half; Watkins's weighed four.[10] (Speaking of which, Watkins's new camera meant an additional logistical challenge: he'd have to make sure a glassmaker custom-made his plates at the right size to fit into the housings Watkins had designed for the camera.) As the era's wet-plate photography required artists to completely coat a plate with a chemical solution, Watkins's super-sized negatives would require nearly triple the amount of chemicals that Weed had used. Watkins would have to protect the glass and flasks of chemicals well enough that none of it would break or spill. When he left, Watkins packed two thousand pounds of equipment.[11]

The cost of all this would have been enormous. Watkins seems to have traveled with two assistants: Charley Staples, who would work as Watkins's gear packer for many years, and an unknown man identified only as Dick. Other valley visitors employed security to deal with potential attacks from highwaymen or Native Americans, and Watkins may have too. For a party of five to travel to Yosemite with normal provisions for an eight-day stay cost around $340.[12] Watkins and his team were there for about three months. In addition to the usual costs of a trip to the valley, Watkins spent plenty of gold coin on photographic materials, a cutting-edge Grubb-C lens, provisions, and pay for his assistants. The total bill must have been at least $1,000, perhaps twice that. (For context, in 1861, a day laborer in San Francisco earned $6 a day. At that rate, Staples and Dick alone would have run Watkins about $500.)[13]

We don't know how Watkins paid for the camera, the trip, his new assistants, any of it. Certainly he'd have been well paid for his work at Las Mariposas the previous season. Watkins would soon charge $4 to $6 for a single Yosemite view; at even the low end of that rate, he could have earned upward of $600 from the Las Mariposas job. Maybe his picture of the

Washington's Birthday Union rally sold well—at least three copies survived numerous fires, earthquakes, and whatever else might have happened over 150 years until today. More likely, Watkins's trip was backed by a wealthy San Franciscan. The best candidates would have been Frederick Billings, who had learned to love the western landscape at Las Mariposas and who would eventually become one of America's leading conservationists; financier William C. Ralston (whom we'll meet in chapter 8); businessman, diplomat, rancher, and Black Pointer Edward Beale; Starr; or Jessie. All had been to Yosemite. Ralston, in particular, prided himself on his support of artists and anything that could elevate San Francisco and California as places to live, work, and invest. We'll probably never know.[14]

The voyage, then trek, that Carleton Watkins made to Yosemite in 1861 was the same that illustrator Thomas Ayres had taken six years earlier and that Charles Leander Weed had taken in 1859. It started with an overnight steamship trip from San Francisco up through what is now called Suisun Bay and then along the mosquito-ridden San Joaquin River to Stockton, an inland port in the Central Valley. Watkins's steamer arrived at Stockton around 6 A.M., at which point the passengers and their luggage transferred to stagecoaches for the trip to Coulterville, perhaps with a stop for a meal or a change of stage in the mining-camp towns of Mound Springs or Sonora. Once the road reached the foothills, it became littered with rocks, stumps, and ruts, making the passage, as one stage driver dryly noted, "jolty." If the weather was good, the road was empty, and Watkins's party had done the Stockton-to-Coulterville route in a single day, they'd gone about seventy-five miles in fifteen hours. After spending the night in Coulterville, the party would transfer its goods from the stage to mules for the final forty miles into Yosemite Valley. Their route would follow mountain ridges and the Merced and Tuolumne Rivers past Hazel Green, Crane Flat, Cascade Creek, and plenty of streams too small to have been named before finally passing the rest stop of Wawona on the way into Yosemite Valley. It is a minor miracle that any of Watkins's glass plates survived the passage in and out.[15] Under normal conditions, this was a three-day trip. Given the unusual amount of Watkins's provisions—it's unlikely that anyone had ever traveled into Yosemite with more stuff—the trip probably took longer. Finally, Watkins and his team would have reached Inspiration Point, which provided the first

view of the great Yosemite Valley. Watkins would make pictures from Inspiration Point eight times in the ensuing years, but in 1861 either he passed or the glass plate(s) broke before he returned to San Francisco.

He would not leave Yosemite until the third week of October. The pictures themselves reveal that Watkins made mammoth-plate pictures at about a dozen distinct sites in the valley and in two places in the Mariposa Big Tree Grove, which was about thirty miles from the valley. Because of the logistics involved in traveling with all the necessary equipment, Watkins was unlikely to have been able to work at more than one site in a day. At some spots, such as in the meadow with Cathedral Rocks to the south and El Capitan and Three Brothers to the north, Watkins made seven mammoth plates. At others, such as along Mirror Lake below Half Dome, he made just one.*

* The making of a single Watkins mammoth-plate picture required a time-consuming, careful process. It went something like this: First, Watkins would select his view. If he made his pictures in the day's first light, as Palmquist reasonably suggests, Watkins would have selected his compositions the day before he took a picture. That meant spending each late afternoon or early evening deciding what he wanted to photograph, moving his tripod and camera around until he could capture the precise composition he wanted the next day. As straightforward as this sounds—and as straightforward as it evidently was for most nineteenth-century photographers, men who were typically more concerned with *what* a picture showed than *how* it showed it—Watkins's pictures suggest that he painstakingly composed images to create the right depth of field, the right amount of foreground, the right lines in a picture that would draw the viewer's eye to where he wanted it to go, and so on. Watkins composed images more skillfully than any other nineteenth-century American artist. His compositions were no accident.

Once waking and returning his camera to the place he'd selected the day before, Watkins would set up a small black tent, known as a dark tent, through which light could not penetrate, nearby. Watkins or an assistant probably prepared each glass plate in the dark tent. Each plate was polished and smoothed with a waxy solvent, something like liquefied rottenstone. Next, because any dust particles on the plate would show up in prints as black spots, the glass was cleaned with a brush. (It was difficult enough to ensure that a plate was free of dust particles in the studio; outdoors it was all the more challenging.) Once the plate was clean, Watkins or an assistant would pour collodion—a mix of pyroxylin (a low-level explosive), iodides, bromides, ether, and alcohol that could have been premixed back in San Francisco—onto the center of the plate. Then Watkins would place the newly wet plate in a bath of silver nitrate, the chemical that would make the plate sensitive to light. Three to five minutes later, and while still in the dark tent, Watkins would remove the newly light-sensitive plate and fit it into brackets within a light-safe wooden box. Then Watkins would leave the dark tent to take the light-safe box to his camera, where, before affixing the box to the back of the camera, he would make any final changes to the composition of the view. Once he was sure he had the view he wanted, he would place the light-safe box into the camera and remove the lens cap. This allowed light into the camera; when light hit the glass plate, an image was fixed to the plate. Palmquist estimated that Watkins's Yosemite views required exposures of up to an hour and that Watkins made each of them right around dawn, when temperatures were coolest and when there was no wind. (If there was wind, there would be no picture making that day.)

We do not know how Watkins moved through the valley. There is no reason to believe that he intended his Yosemite pictures to have a prescribed beginning, order, and end, a narrative. However, a reconstruction of Watkins's most likely path through the valley reveals something surprising: the invention of Yosemite as a landscape, as a whole rather than as a parade of individual features. Today we take for granted this idea of Yosemite as total landscape, a union of separate, individual features. But that's not how nineteenth-century visitors described it in either their letters or their travelogues. Watkins's contemporaries typically experienced Yosemite as a succession of separate, distinct stops: one, then another, then another, all the way around the valley. Watkins's Yosemite has become so familiar that we assume it's how we always considered the place.

Starr's account reveals a tourist's usual procession through the place: Enter the valley below Inspiration Point. Arrive at Bridal Veil Fall. Look up at Bridal Veil Fall. Walk to the next place, the three-thousand-foot granite wall called El Capitan. Look up at it. Move on to the next place, Cathedral Spires (which in Starr's time was called the Sisters), and so on.[16]

Watkins seems to have started in this manner himself, though he necessarily followed a slightly different route. When Starr and Watkins were there, the snowmelt-swollen Merced River ran rapidly down the valley. Starr reported that the Merced was one hundred feet wide and ten feet deep.[17] As Watkins required about a dozen mules and a couple of thousand pounds of equipment to do his work (Starr had needed just a single horse and maybe a single mule), he would not have crossed the Merced any more than was necessary; the bulk of his gear would have made that difficult, and crossing would have put the gear at risk. Thus Watkins likely started his visit to Yosemite along the South Rim in the western part of the valley, crossed the

Back in the dark tent, Watkins would remove the glass plate from the light-safe box and pour developer on the plate. By this time, Watkins had better learned how to spread the developer across the plate evenly, so that the waviness characteristic of some of the Las Mariposas pictures would not recur. Then Watkins would pour water over the plate to stop the chemical processes started by the developer. Next, Watkins would put the plate in a bath of another chemical to permanently "fix" the image to the plate. Upon removing the plate from the fixer bath, Watkins would again wash it with water. Then he would heat the plate, possibly over an oil lamp, before varnishing the plate, which would protect the plate and the image. Once the varnish dried, Watkins would store the plate for the trip back to San Francisco. All printing would be done in his studio. (For a demonstration of this process, see the video *The Wet Collodion Process,* by the J. Paul Getty Museum, at https://youtu.be/MiAhPIUno1o.)

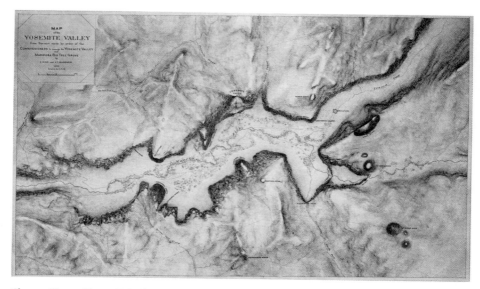

Clarence King and James T. Gardiner, Map of the Yosemite Valley [made from surveys commissioned by the state of California's Yosemite Commission], 1865–66. Photographed by Carleton Watkins, ca. 1865–66. The Miriam and Ira D. Wallach Division of Art, Prints and Photographs: Photography Collection, the New York Public Library.

Merced on a bridge at the far eastern edge of the valley, and then have concluded his picture making while traveling back toward the way in and out of the valley, below the North Rim. (For a contemporary map of the valley and trail access to it, see "Map of Yosemite Valley.")

If so, the first three pictures Watkins took were of Bridal Veil, Cathedral Rock, and Sentinel Rock. As it turns out, these three pictures are different from the other twenty-nine that Watkins made in Yosemite in 1861. Each is an up-close, isolating view of a single Yosemite feature. As such, they might be Watkins's only Yosemite pictures informed by Charles Leander Weed's 1859 Yosemite photographs. Take Weed's Bridal Veil picture: Weed filled as much of his (much smaller) negative as possible with the mountain cleaved by the falls and made no attempt to frame the thing in any particular way. Weed provides only a sliver of situating foreground. It's as good a photograph as Weed made in 1859, but it's still spatially confusing. Now, Watkins was taking pictures three times as big, allowing him to include much more in each picture, but at Bridal Veil, Cathedral Rock, and Sentinel Rock, Wat-

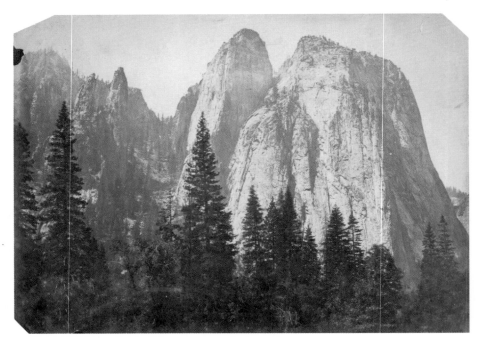

Charles L. Weed, *Cathedral Rock*, 1860. Collection of the Bancroft Library, University of California, Berkeley.

kins still took his picture from within a few dozen yards (maybe even feet) of where Weed took his. The result, for both men, reduced the South Rim of the valley to a flatter monolith and denied the viewer any foreground in which to anchor herself. The unifying weakness of Watkins's first three Yosemite pictures is also the unifying weakness of Weed's pictures: because the photographers eliminated foreground and filled the entire pictorial frame with a single feature, they denied Bridal Veil or Sentinel Rock a place in the landscape.

If Bridal Veil, Cathedral Rock, and Sentinel Rock were indeed Watkins's first three pictures, between the third and fourth pictures he figured something out. In a moment of self-realization, he seems to have understood that by isolating formations rather than constructing landscapes, he was missing the greatness of the place. It is as if Watkins thought to himself,

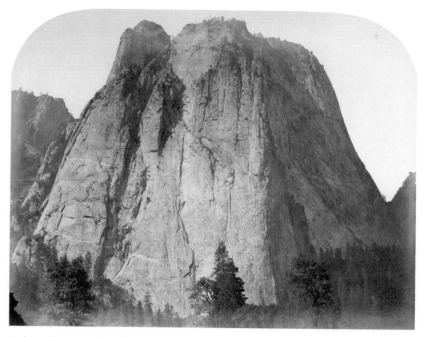

Carleton Watkins, *Cathedral Rock, Yosemite*, 1861. Collection of the J. Paul Getty Museum, Los Angeles.

I designed a camera three times as big as Weed's. Why am I making the same pictures he did?

If Watkins was, in fact, looking for a way out of the Weeds, he might have thought back to what must have been many conversations about Ralph Waldo Emerson at Black Point. Emerson's first important and most influential book-length essay was called *Nature*. As the Black Point salon was significantly organized around considering western land, landscapes, and beauty, it was an essay that everyone in the group would have read. In the mid-nineteenth-century, *Nature* was so important, so central to progressive intellectualism, that Jessie's group, Starr above all, would have discussed it as naturally as they would the weather. It was the most influential book of its era. "There are sentences in 'Nature,' which are as exalted as the language of one who is just coming to himself after having been etherized," critic Oliver Wendell

Holmes wrote. "Some of these expressions sounded to a considerable part of [Emerson's] early readers like the vagaries of delirium. Yet underlying these excited outbursts there was a general tone of serenity which reassured the anxious. The gust passed over, the ripples smoothed themselves, and the stars shone again in quiet reflection . . . There are some touches of description here, vivid, high-colored, not so much pictures as hints and impressions for pictures."[18]

Why would Watkins, a country lad lightly educated in a school his father had built with his own hands, have been able to find his way into cosmopolitan intellectualism such as Emerson's *Nature?* Because he would have recognized himself in it. In several passages, Emerson describes the process of making a picture with a large-format camera of the sort Watkins used. "In a camera obscura, the butcher's cart, and the figure of one of our own family amuse us. So a portrait of a well-known face gratifies us," Emerson writes in *Nature*'s sixth chapter. "Turn the eyes upside down, by looking at the landscape through your legs, and how agreeable is the picture, though you have seen it any time these twenty years!"[19] When Watkins looked into the eyepiece to compose a picture, he would have seen the landscape he would photograph inverted, upside down. If Emerson had not yet earned Watkins's attention, this would have done it.

Another *Nature* passage seems to describe a photographer and the process he would use to coax a composition onto a glass plate. At the beginning of the third chapter, titled "Beauty," Emerson defines what beauty is and how it is conceived. "Such is the constitution of all things, or such the plastic power of the human eye, that the primary forms, as the sky, the mountain, the tree, the animal, give us a delight in and for themselves; a pleasure arising from outline, color, motion, and grouping," Emerson writes. "This seems partly owing to the eye itself. The eye is the best of artists. By the mutual action of its structure and every mass of objects, of what character soever, into a well colored and shaded globe, so that where the particular objects are mean and unaffecting, the landscape which they compose is round and symmetrical. And as the eye is the best composer, so light is the first of painters. There is no object so foul that intense light will not make beautiful."[20]

This was almost exactly how a photographer made a picture. Once Watkins had wetted a glass plate with the necessary chemicals, he would slide it

into the back of his camera. After he had looked through the camera's eye-piece and lined up exactly the view he wanted, he would have removed the lens cap and left it off for a minute or two. As Watkins was working outdoors and was hoping that distant objects, mountains or trees that were many hundreds of yards or more away, would impress themselves upon his glass plate, and thus later on a print, he relied entirely on light landing on the plate for long enough to leave on it an image. What a brush and paint were to a painter, his own eye and light were to a photographer.

In 1836, when he published *Nature,* Emerson did not know about any kind of photography. The first photographic processes were developed by Henry Fox Talbot in England in 1834–35 and by Louis Daguerre in France in 1839. The Talbot process, which resulted in an image that could be fixed to a paper print, was not shared in an open forum until 1839, after Daguerre revealed his differ-ent process (which fixed an image to a silver-coated copper sheet). Emerson could only have known of Talbot's experiments if one of his British corre-spondents had known of it and had mentioned it in a letter to Emerson. There is no evidence of any of this. Watkins may or may not have known about photography's earliest history. It's possible that he thought Emerson knew.

Watkins may have thought of Emerson now, after these first three pic-tures, because *Nature* offered an unusually specific way out of the poor pic-tures Watkins started making in Yosemite. The crux of the thing was the difference between land and landscape. Emerson realized this himself while on a walk around his Concord, Massachusetts, home. "The charming land-scape which I saw this morning is indubitably made up of some twenty or thirty farms," Emerson wrote. "Miller owns this field, Locke that, and Man-ning the woodland beyond. But none of them owns the landscape. There is a property in the horizon which no man has but he whose eye can integrate all the parts, that is the poet."[21] Emerson scholar Lawrence Buell notes that Emerson's chapter "Beauty" defines this "perception of unity within surface variety as the basis of *all* art: sculpture, music, architecture, as well as literature."[22]

A comparison of two 1861 Watkinses of Cathedral Rock reveal how Wat-kins changed his pictorial approach, how he pulled back his gaze to create a different, holistic version of the Yosemite landscape. The picture that was presumably the first Watkins took of Cathedral Rock includes no fore-ground, just the tops of some trees. Cathedral Rock itself fills about 85 per-

cent of the frame. It is vaguely disorienting. Each time I see it, I need a few moments to figure out what I'm seeing and what the scale of the picture is. Is Cathedral Rock huge or tiny?

Watkins seems to have realized this himself, because he made another substantially different picture of the landscape that contains Cathedral Rock. The Merced River forms the entire bottom of the picture. A tree, probably a California black oak, fills the right edge of the picture. Several species of bushy trees rise up across the Merced from us, between the river and Cathedral Rock. Also between the viewer and Cathedral Rock are dozens of ramrod-straight ponderosa pines. Only then, finally, Cathedral Rock. This is not merely a picture of a feature, it's a composition of water, flora, sky, and geological formation, features unified into landscape.

Watkins would also approach Yosemite Falls much differently than he'd handled Bridal Veil. Both of Watkins's 1861 pictures of Yosemite Falls are taken at a significant remove, all the better to emphasize landscape rather than feature. They show the granite cliff over and through which the Merced River plunges, forming Upper and Lower Yosemite Falls in the process, the stands of trees and the meadows through which the Merced runs. These aren't isolations of a waterfall; they're pictures of two falls and the land through which the falls cut and a river runs, uniting features with the land around them, a *landscape*—and a perfect metaphor for an artist engaging in a project meant to further cultural Unionism.

Whether Watkins consciously, intentionally built such metaphors in some of his 1861 Yosemite pictures is unknowable. By 1861 metaphor was among the primary tools in any American artist's kit, and Watkins aspired to full artisthood. He also had as fine a guide and mentor as he could have hoped for: Starr, a student of contemporary painting, friend to painters such as Sanford Gifford and Albert Bierstadt, and a preacher and speaker who had made his career on building Emersonian metaphors from his travels through mountains and forests (to which he often added a pinch of Protestantism and, now, a dash of antislavery Unionism). Take an 1863 sermon in which Starr pointed out that the parts of Virginia west of the Appalachian Mountains remained loyal to the Union, as did the mountainous regions of the southern Appalachians, in Tennessee. "They carry the temptation of that sentiment through their cool air to northern Georgia and Alabama," Starr suggested, embedding metaphor within metaphor before reminding

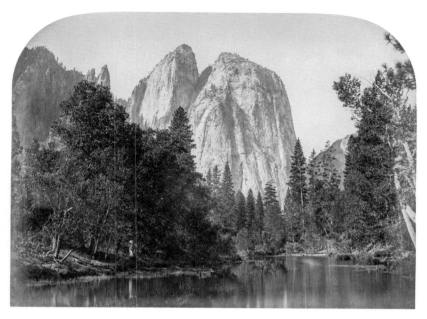

Carleton Watkins, *River View, Cathedral Rock, Yosemite*, 1861. Collection of the J. Paul Getty Museum, Los Angeles.

his flock that disunion (and slavery) were strongest in the flattest, lowest lands of the South. (Emerson himself had used wind as a metaphor for unity in *Nature*.)[23] For Starr, that mountains walled in the slave power was proof of their divine origin, which allowed him to extend his metaphor. He demanded that his parishioners build mountains in their souls to help them resist whatever form of evil may threaten them. The height and beauty inherent in mountain's majesty also represented their faith and their belief. Finally, Starr tied mountains, nature, Unionism, antislavery, and modern religion to the Biblical past by noting that the apostle Paul "lived high up" (presumably Starr was referencing the mountains around Jerusalem), and that Jesus did too, though "the mountain to which he retired was inward more than outward. . . . Large districts of our life and feeling should be above the world, on the Sierra heights from which the world and our toil and our home cares and our surroundings look noble, previous, bathed in light."[24] It all sounds a bit flowery to today's ear, but Starr's baroqueness

would not have been experienced in isolation. Contemporary poetry, routinely printed in even the humblest newspapers, was full of similarly drawn-out metaphors.

Watkins's citing of poetry in the title of at least one Yosemite picture suggests that he both read verse and was mindful of building into his work associations with contemporary literature and philosophy. That picture is a stereograph, *Inverted in the Tide Stand the Gray Rocks*. Watkins took the line from Henry Wadsworth Longfellow's 1825 poem "An April Day."[25] Watkins may have found Longfellow on his own, or through Starr, who was friends with Longfellow and who corresponded with him from California. The passage Watkins quotes is near the end:

Inverted in the tide
Stand the gray rocks, and trembling shadows throw,
And the fair trees look over, side by side,
And see themselves below.

Longfellow wrote "An April Day" just before he turned eighteen. It is a classic of transcendentalist verse, full of love of nature, landscape, and the reflection Watkins references in title and image. The picture, one of Watkins's most engrossing stereographs, shows the Three Brothers, a tripartite formation of triangular peaks, reflected in the Merced River. Watkins made a terrific mammoth-plate picture of the Three Brothers too and may have wanted to make a Three Brothers reflection picture in 1861, but he lacked a lens that could give him a wide enough field to capture both the mountain and its reflection in the Merced. Elsewhere in Yosemite Watkins tried to make reflection pictures. He attempted a reflection picture of a chunky, angled dome of granite reflected in Mirror Lake, but again he lacked an enabling lens. (When Watkins returned to Yosemite in 1865–66, he'd get his Mirror Lake reflection picture. As for the Three Brothers reflection, it wouldn't be until 1878–81 that Watkins would have the lens that would help him get that picture. It is one of his best.)

Excepting the three proto-Weeds, the quality of Watkins's 1861 work in Yosemite is extraordinary, even unprecedented. The wavy technical problems and mistakes that mar some of the Las Mariposas pictures are no more. (Did Watkins just put up a dark tent in his home or outside some-

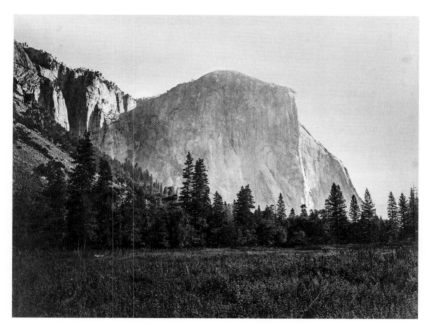

Carleton Watkins, *El Capitan, Yosemite*, 1861. Collection of the Library of Congress.

where and practice and practice until his glass-plate-making technique was flawless?) His compositions are stronger, as if he had benefited from focused pictorial critique. (One suspects, again, Starr's influence.) Watkins's best 1861 Yosemite pictures may have been of El Capitan. One of them seems to encourage our eye to start with the Merced River, which runs from the lower-right foreground to the left. A California black oak that is growing on the sandy edge of the river shoots up into the middle ground of the picture. Behind it, some distance behind it, rises an austere, stiff granite monolith, El Capitan.

Another might have been the last picture Watkins made before leaving the valley for either the Mariposa Big Tree Grove or the town of Mariposa. Watkins took it standing in a meadow looking east up the valley at El Capitan. Watkins made this picture as early in the day as he could, probably at about 6:30 A.M. The sun is rising off to the right, in the east, just out of frame. The tall grasses of El Capitan Meadow fill the lower fifth of the picture. Their texture, soft and fluffy, tempts touch, especially in comparison to the hard talus pile along the picture's left-hand side. To the west of El

Capitan, a talus pile falls to the edge of the meadow. A row of pines and bushy cedar fill a middle ground that runs almost the width of the picture. Beyond them, standing erect, imposing, enormous, is El Capitan. The part of the mountain facing us is in shadow, sort of. Watkins made this picture with an exposure of many minutes, which allows the stone face to take on texture, even to become visage. Watkins knew this was a good one: he sent it to both the Paris and Philadelphia World's Fairs.[26] This ensured *El Capitan* would be well-known. For years hence, painters would jump off from this picture, occasionally masking their crib by adding a tree or two, as Albert Bierstadt did in a circa 1872–74 painting now at the Arkell Museum in Canajoharie, NY, and in an 1875 painting at the Toledo Museum of Art.

Watkins made four pictures of El Capitan in 1861, more than he took of any other part of the valley. No doubt Watkins was fascinated by it, but he also would have known that El Capitan was a particular favorite of Starr's. "This wonderful piece of natural masonry stands at an angle with the valley, presenting a sharp edge and two sides in one view," Starr wrote in the *Transcript,* effectively describing the view Watkins captured in this picture. "[H]ow high, think you? 3,817 feet! Can't we honestly put an exclamation point there? Remember, too, that it stands straight. There is no easy curve line as in the sides of the White Mountain Notch—to a picture of which I lift my eyes as I write in my library."[27]

From Yosemite, Watkins traveled thirty miles to the Mariposa Big Tree Grove, home of the giant sequoias. Watkins made two pictures there in which he struggled—and succeeded—in conveying the preposterous immensity of trees that almost defied belief.

Finally, in late October, he began the trip back to San Francisco. On the way, he stopped at the office of the *Mariposa Gazette* newspaper, a place he had probably visited the year before when he made his pictures of the Frémonts' surrounding Las Mariposas estate. On October 22, the paper previewed Watkins's pictures, promising pictorial triumphs "on a larger scale than has before been taken."[28] Now to go home and print them.

6

SHARING YOSEMITE

AFTER CARLETON WATKINS RETURNED to San Francisco at the end of October 1861, he did not rush to print the pictures he had made in Yosemite and at the Mariposa Grove. Why not?

There were many distractions. The San Francisco to which Watkins returned was different from the city he had left. The Union, with which California was now firmly aligned, was moving to wartime footing. San Francisco and the state of California took measures to address their fear of a Confederate blockade or attack. The city amped up its patriotism at every opportunity, hanging and raising flags everywhere. Patriotic songs were popular; brass bands were in demand. Most importantly to Watkins, President Abraham Lincoln had given John C. Frémont the military command he wanted, in Missouri, and Jessie Benton Frémont had left to join him there. Watkins must have been sorry he did not have a chance to say goodbye, but Jessie's correspondence suggests that she continued to champion his work. Separation from Jessie was no doubt harder on Thomas Starr King.

The other major San Francisco development during Watkins's time away was the completion of the cross-country telegraph, which would finally deliver to the Pacific coast same-day news from the East. Starr was granted the honor of sending one of California's first messages. "All hail! A new bond of

union between Pacific and Atlantic!" he wrote. "The lightning now goeth out of the west and shineth even in the east! Heaven preserve the republic, and bless old Boston from hub to rim!"[1]

A few moments after Starr sent his message, to the offices of the *Boston Evening Transcript*, the third telegraphic message to arrive in San Francisco ended the pleasure of the new thing. It reported that Edward Baker, who had resigned his Senate seat to lead men in the Union army, had been killed in the Battle of Ball's Bluff, near Leesburg, Virginia. "We have no celebration here," Starr wrote of the long-awaited telegraph's arrival. "The first news was of Col. Baker's death and the people say they don't feel like celebrating."[2]

For many Americans, Baker's death on October 21 drove home that America was at war. Lincoln found out about his friend's death while in conference with top Union general George B. McClellan. Lincoln excused himself and stumbled into the street, crying.[3] Funerals for Baker, who was remembered as the Union's finest orator and the builder of Republicanism and defender of Union in the West, were held in Philadelphia and New York before Baker's body was sent to San Francisco for a final funeral and burial.

When Watkins returned from Yosemite, it was to a city that had just learned of Baker's death. Watkins would have almost immediately learned of the intensifying of the war (which was barely beginning when he left). He would have been told that Lincoln had authorized the enlistment of one million troops. Letters from Oneonta would have told him that his brothers had signed up. Watkins may have been preoccupied with matters other than printing Yosemite pictures. At the same time, he surely realized that they could become symbolic of California's support of Union.

San Francisco threw its grand public funeral and burial for Baker on December 11, about six weeks after Watkins's return. An unknown, pointedly Unionist official had placed Baker's tomb just thirty yards to the west of David Broderick's grave. A military team of pallbearers lifted Baker's coffin from the catafalque and placed it over the flower-covered mouth of his cemetery vault. Starr, whose work over the last year had been so deeply informed by Baker's urgings to join the West with the North, gave the last funeral address.[4]

Baker's death spurred California, and especially San Francisco, to mark his grave and memory with a memorial. This was new territory for a young, only

recently unified city. When David Broderick had died in 1859, San Francisco had planned a Broderick tomb monument and commissioned a design, but that year's election and the subsequent civic consideration of Union or disunion had distracted everyone.[5] As Baker and Broderick were now entwined in the western mind, Baker's death reminded the city and the state (which would help pay for the Broderick monument) that the city should finish memorializing Broderick before moving on to Baker. California Gov. Leland Stanford laid the cornerstone of the Broderick monument on February 26, 1863.[6] The *California Farmer and Journal of Useful Sciences* described it as "purely Corinthian: a fluted column broken off, typical of manhood arrested on its great course" and as thirty-four feet tall and twenty-four feet square, featuring the coats of arms of both California and New York, a large eagle, a wreath of oak leaves, and a statue of Broderick.[7] Watkins trekked out to Lone Mountain and made a striking stereograph for which he positioned his camera down the hill from the monument, looking up at it respectfully, even admiringly.[8]

Progress on the Broderick monument cleared the way for unknown parties to commission a design for the Baker monument from Horatio Stone, a prominent American sculptor whose work included a bust of Sen. Thomas Hart Benton owned by John and Jessie Benton Frémont.[9] The Baker monument was never constructed, a casualty of more immediate war-related demands on both the public purse and private philanthropy. Baker's vault at Lone Mountain would remain substantially unadorned.[10]

In addition to the picture of Broderick's tomb, Watkins made five other stereographs at Lone Mountain. One probably shows Baker's tomb, but as the grand Baker monument was never constructed, it's impossible to know which one it might be. Broderick was buried on a hilltop; as contemporary reports indicate that Baker was buried nearby, his tomb may be shown in a Watkins stereo of a small but handsome tomb marker installed on a hillside and behind a short wall. The path to this grave, which Watkins includes in the foreground, is heavily traveled.[11] (Today, Broderick and Baker Streets run parallel, a block apart, through the San Francisco neighborhood that was built over Lone Mountain.) With Baker buried, Watkins would finally take to his darkroom to print some of the seeds Baker had sown.

The month after Edward Baker's funeral and burial, January 1862, delivered the worst weather that San Francisco had seen in its fourteen American

years. It rained, sometimes two and three inches a day. It was cold, so cold that snow turned Mount Diablo, the beefy 3,849-foot peak in the East Bay, bright white.

"There is a great flood in the interior [of the state]," Starr told his New York friend Randolph Ryer. "California is a lake. Rats, squirrels, locusts . . . and other pests are drowned out. I am a home-bird and enjoy it hugely."[12]

Apparently Watkins was also a home-bird, because it was during this Biblical deluge that he finally finished printing a set of his Yosemite pictures. Now, what to do with them? Watkins did not have Starr's connections; he did not have immediate access to the country's most important newspapers and magazines. Even if he did, even if Starr could have arranged that for him, the technology for publishing photographs did not yet exist. The logical thing to do was to exhibit these new mammoth-plate pictures, these pictures Watkins had intended to compete with painting as art, but where? Unlike Charles Leander Weed, Watkins did not have a partnership or business arrangement with any of San Francisco's photography galleries. What to do?

Certainly, in the short term, there were his friends and professional colleagues: Trenor Park and his wife, Laura, would have been eager to see them, especially as Watkins had taken a stereograph of the Park party enjoying a lavish Yosemite lunch under California black oaks. Billy Ralston, whose Yosemite honeymoon was already legendary in San Francisco, would have wanted to show off the place.[13] Most importantly, sometime in late January, Watkins showed them to Starr, who was blown away. Now Starr found himself with the same question as his friend: what to do with the pictures?

One of Starr's first ideas was to show them to a new friend of his, the man who would take Jessie's place as Starr's closest confidant. His name was William H. Brewer, and he would become not just one of the major American scientists of his era but also Starr's partner in sharing with the East the work Watkins was now printing.

Brewer, thirty-three, grew up on a small farm outside Ithaca, New York. He made his unlikely way to Yale, where he studied chemistry, geology, and botany with an eye toward teaching agriculture. After Yale, Brewer studied in Europe, mountaineered, and studied geology in the Alps, chemistry in Paris, botany in the south of France, and more chemistry in the German laboratory of Robert Bunsen, of Bunsen burner fame. In 1858, a year after returning home, Brewer took a teaching position at what is now Washington

& Jefferson College in Pennsylvania. He married, had a son, and seemed on the fast track to a comfortable, influential life in the second generation of American science.

Then disaster struck. Within weeks of giving birth, Brewer's wife, Angelina, died. Soon the child died too. At about this time, a well-regarded Harvard-trained scientist named Josiah Whitney, who had years of experience in running government scientific surveys in the Northeast and Midwest, invited Brewer to join him in California. Whitney had just accepted an appointment to head the California Geological Survey (CGS), and he wanted Brewer to be his field director, his second-in-charge. Brewer said yes and moved west, to a new life, as fast as he could. He was a great hire, both as a scientist and as a complement to the brilliant but often shrill and dogmatic Whitney. Unlike his boss, who could hold onto old ideas after the scientific evidence pointed in new directions, Brewer followed data and observation wherever they led. This made him a good scientist and a better friend—and helped him recognize talent in people who shared his modest background, people like Starr and Watkins. Brewer would spend four years with the CGS, during which he trekked to every corner of the state. By 1864, when Brewer wrote a memoir of his California experiences, only his close friend Starr had seen anywhere near as much of California.[14] Starr and Brewer visited each other a couple of times each week, comparing notes about their shared interest in the natural sciences, and especially about the rich intersection of Starr's transcendentalism and Brewer's secular, Humboldtian science.

It was on Friday, January 31, 1862, on one of those routine visits, when Starr first showed Watkins's pictures of Yosemite to Brewer. Brewer was wowed. Writing in his diary later that night, he described them as "magnificent . . . the finest I have ever seen."[15] This is the earliest record of anyone seeing Watkins's Yosemite pictures.

Remarkably, weirdly, there seems to have been no public exhibition of Watkins's Yosemite pictures in San Francisco in 1862. Maybe there was, early in the year, and records were destroyed by that year's flooding or by the events of 1906.

Ultimately it seems that dissemination of the pictures, at least at first, was substantially handled by Starr and Starr's new friend Brewer. Both men liked Watkins and promoted his work. Brewer and Starr would acquire many Yosemite pictures from Watkins and would send them to many people back

east. Neither man considered these mere souvenirs of their lives at the farthest reaches of American empire. Both men had specific reasons for spreading Watkins's work across the continent, reasons tied to their respective professions and to the impacts they wanted to have on their fields and even on the nation. Their distribution of Watkins's work would tie their precocious friend to two of the most important intellectual currents in America, Emersonian transcendentalism and the maturation of American science. First, Brewer.

Brewer finally visited Yosemite in 1863. He was there in his official capacity, as the head of field studies and botany for the CGS. His job was to build knowledge about California's land, its rocks, its formation, its mineralogy, and its soils, to assess and reveal the state's economic potential. It was a progressive idea, a very big job . . . so, of course, the state government underfunded it from the start and made the lives of the scientists as challenging as possible. As with other scientific surveys in other states, mostly in the East and the Midwest, California legislators wanted the CGS to point investors and emigrants toward ore, timber, and agricultural potential. The scientists signed on to that mission but were just as interested in two ancillary projects: building knowledge for its own sake and discovering and heralding the unique glories of California's wilderness, two emphases related to the state government's idea of their mission but not always in line with it. In short, the scientists believed that their way of doing the job would help the state grow at least as much as the state government's way of doing the job. They turned out to be right. William H. Goetzmann, the greatest historian of America's era of exploration, considered the CGS the most important government scientific project of the time.[16]

Brewer and his CGS colleagues, men like Josiah Whitney and Clarence King, were the best and the brightest of their generation of American scientists. They were students of America's first scientists, men such as Harvard's Asa Gray, Princeton's and Columbia's John Torrey, and Yale's Benjamin Silliman Sr., who had been the first Americans to study and catalogue America's rocks, plants, minerals, and topography. Brewer and his fellow CGS mates maintained their connections to those men when they went west and hoped to ascend into their professorships when they retired. Between their eastern learning and their western spirit of adventure, Whitney and Brewer were well prepared for their task.

The question, as Brewer realized that day while standing above Yosemite Valley, was how best to share this wildly unfamiliar land and what the scientists learned about it with a science-minded audience, and with the general public too. In a way, the problem Brewer and Whitney faced was the same challenge Starr had faced: the West was so different from the America that people knew and understood—say, the gentle mountains of New England or the steeper, more rugged, but still middling Appalachians—that they needed a way to describe this new place and its new flora to scientists.

One of the ways upon which Brewer and Whitney settled was to enlist Carleton Watkins. Starting shortly after meeting Watkins in 1862, Brewer and Whitney bought Watkinses by the armful and shipped them to their eastern family, friends, and colleagues. This wasn't just showing off the new country or networking, it was information sharing. It was also the beginning of a project Watkins would continue for much of his career: informing American science, an overwhelmingly northeastern establishment, about the distant West. Over the next twenty-plus years, scientists in fields such as botany, geology, geodesy, and glaciology would all benefit from Watkins's work.

Take Brewer's primary field, botany. The great work of mid-nineteenth-century botany, in the world, in the United States, and especially in all-but-unknown California, was to learn what flora existed and to document and catalogue species. This required scientists the world over to communicate, to compare notes about similar species, to understand what Alexander von Humboldt called the web of life. The way for a young botanist such as Brewer to get ahead in the field was to find species that had not yet been identified, to name and document them, and to expand science's knowledge of species that had already been identified, thus allowing connections to be made or at least questions about plant life to be raised; for example, if a species existed in the White Mountains of New Hampshire, the Sierra Nevada foothills, and the Scottish Highlands, what might that suggest? And if an only slightly different species exists in the High Sierra and the European Alps, what might explain that minute variation?

In this early scientific world, the two most important things a scientist could possess were botanical samples—leaves, flowers, and so on—and a network of contacts with other scientists, especially at Harvard and Yale, the two most important places in American science, and in Europe, especially in London and Paris, to which Brewer had traveled. California pre-

sented acute challenges to a career-minded botanist: by ship, it was 5,500 slow miles from Harvard, Yale, and the rest of the tiny American scientific establishment. Scientific material could be damaged in transit. (The distance overland was shorter, but the ongoing Civil War doomed mail sent overland through fiercely contested Missouri to an uncertain future.) Still, this was how seeds, the most valuable botanical currency, were exchanged.

In a typical letter between scientists, a man in the field, such as Brewer, might describe a plant to a colleague and include in the letter some carefully wrapped seeds. Upon receiving the seeds, the scientist would plant them and wait for them to grow; only then would he be able to contribute to a discussion about the plant. For small flora this worked tolerably well, except when it didn't. Take the example of *Darlingtonia Californica*, the California pitcher plant, which Brewer sent to William Darlington, a gentleman scientist who lived outside Philadelphia and after whom a colleague had named it. Darlington had never seen his namesake plant, so Brewer sent him some seeds. "I feel myself greatly indebted to you," Darlington, 80, wrote Brewer. "I had a great curiosity in seeing a living specimen of the plant, and scarcely dared hope for the privilege at my advanced age . . . I trust . . . that I may yet live to see the living plants."[17]

Despite the possibility that the time it would take for a plant to mature might be longer than the expected life span of the scientist studying it, scientists would beg each other for seeds. In 1860, upon hearing that Brewer was moving to California, Harvard professor Asa Gray, the father of American botany and the most important American scientist of his era, wrote to him to ask him to send pinecones from California. Brewer did. Then Gray wrote to ask for other seeds. He kept writing, and he kept asking. Brewer, recognizing a prime networking opportunity with one of the world's leading botanists, sent Gray seeds every chance he got. Sometimes the seeds arrived in better shape than the letters: Gray once thanked Brewer for a shipment of seeds even though he didn't know what they were. "We will see when it grows," he wrote.[18]

While the California pitcher plant goes from seed to maturity in a single growing season, many of the most interesting, least seen, and least known California species, especially its trees, did not. Just as many Americans had read about Yosemite but lacked topographical context for understanding the place's grandeur until Watkins's photographs arrived in the East,

scientists were oft flummoxed by what their colleagues told them of the new western lands and the trees that covered them—or didn't. When Brewer climbed California's 14,179-foot Mount Shasta, he wrote Gray to share a new discovery. "The forests ascend to about 8,000 feet, then suddenly cease . . . Above this, a few species of . . . shrubs . . . at about 9,000 feet or 9,500 feet *all vegetation ceases*," Brewer wrote, writing faster and underlining more as he became excited. "Above this I looked diligently, but in vain, for *even a moss or lichen!*" Gray did not believe what Brewer was telling him. After all, trees grew to the summit of nearly every mountain in the East. "I was tempted to print what you wrote of Shasta—but refrained," Gray replied. "The barrenness of the higher part of the peak is very strange."[19] Gray worried that sharing Brewer's obvious "mistake" within the profession would damage Brewer's reputation—and perhaps his own.

This was where Watkins came in. When seeds were too slow and when the disbelief of fellow scientists could only be dislodged by pictorial fact, Watkins came to the rescue. From almost the moment Brewer saw Watkins's pictures of Yosemite and the Mariposa Grove, he recognized how they could be useful. The same day Starr showed Brewer Watkins's pictures of Yosemite and Mariposa, Brewer excitedly wrote to Gray about what he had seen, the first letter he had sent Gray in five months.[20] After reengaging with the most important scientist in America, Brewer tracked down Whitney and told him about Watkins's pictures. Soon Brewer was ordering prints from Watkins and shipping them east as fast as Watkins could print them; and Whitney too.

Among the Watkinses Brewer sent east was a picture of an enormous tree known as the Grizzly Giant. It was one of hundreds of giant sequoias in the Mariposa Grove, south of Yosemite Valley. The giant sequoias, here and in nearby Calaveras County, are among the largest living things on earth, and at thousands of years old, among the oldest. Just as easterners had heard of Yosemite before but had not quite understood it, so too with the Mariposa Grove. Not even Starr, an experienced outdoorsman and nature author, trusted what he'd heard about the Mariposa trees: "I began to doubt, as the time for mounting again approached, as to the existence of the marvels. Was it possible that, before sunset, I was to stand by a living tree more than ninety feet in circuit, and over three hundred feet high? Think what these figures mean, my hasty reader, when transformed into

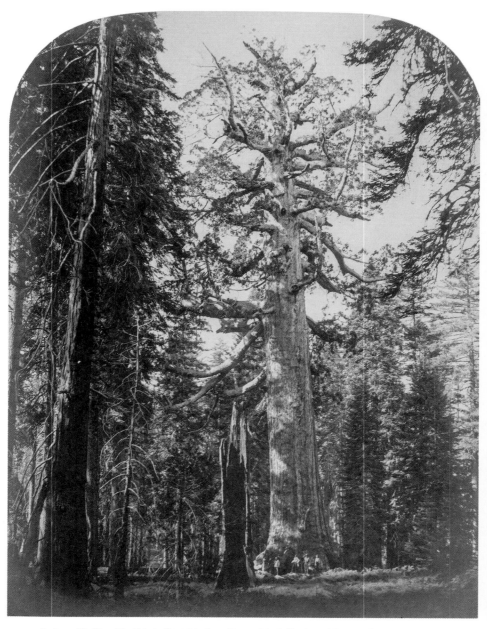

Carleton Watkins, *The Grizzly Giant, Mariposa Grove,* 1861. Collection of the J. Paul Getty Museum, Los Angeles.

solid bark and fibre. Take a ball of cord, measure off a hundred feet from it, cut it and tie the ends, and then by the aid of four or five companions, stretch it into a circle, (if you have a parlor spacious enough to permit the experiment), and imagine that space filled with the column of a vigorous cedar [sic]."[21]

When Watkins visited Yosemite in 1861, he tacked on a side trip to the Mariposa Grove. He made two pictures of the Grizzly Giant, which measures nearly one hundred feet around and over two hundred feet tall. One of them showed the entire tree from the ground to the tree's highest reaches, a nearly implausible picture. Four people stand at the base of the Grizzly Giant as if they were matchsticks leaning against a man's trouser leg. Gray, who knew more about plants than anyone in America, saw Watkins's picture and was floored. "I cry for the photograph of the Grisly Giant [sic]!" he wrote to Brewer.[22] As we shall see, Gray's engagement with Brewer and with Watkins's pictures of the Grizzly Giant—in time Gray would acquire each picture Watkins made of the mammoth tree—began with Watkins's 1861 picture and would continue for a decade, through Gray's contributions to and defense of Charles Darwin's theory of evolution, in which the sequoia would become hotly discussed, and a major lecture Gray gave to the American Association for the Advancement of Science about the tree in 1872.[23]

Brewer also answered Gray's questions about less dramatic trees. In 1862 Gray asked Brewer about *Arbutus,* known in the West as the madrone. Brewer replied with measurements and other details. At almost exactly this time, Watkins made a spectacular picture of a single *Arbutus,* with a younger specimen off in the distance, a kind of mother-and-child image.[24]

Brewer also shared Watkinses with University of Massachusetts botanist W.W. Denslow and Yale professor Benjamin Silliman Jr., the heir to his father as the most important scientist at Yale. Silliman was so wowed by what Brewer showed him that when he visited San Francisco, he knocked on Watkins's door and personally ordered a set of Yosemite pictures and some stereographs. Silliman and his sons even built an extra room onto their house as a photography gallery for the Watkinses and, no doubt, other pictures. Silliman declared the Yosemites "superb" and the Mariposa pictures "beautiful," and he bought a set of 1863 pictures Watkins would make of the famed New Almaden mercury mine for good measure.[25]

While Brewer was the CGS staffer most engaged in a transcontinental dialogue with his scientist peers and thus with Watkins, Brewer's introducing survey chief Josiah Whitney to Watkins turned him into an ardent collector too. Whitney sent Watkinses to family members and colleagues, including his brother William, a Yale professor of languages who was just finishing up writing and editing the soon-to-be-famous *Webster's American Dictionary.* "I can think of nothing more suitable than a set of those Yosemite photographs which seem to me among the most beautiful things I have ever seen," Josiah wrote. "They cost $50 [for 15] and are about as large as Britain."[26]

William Whitney was impressed. "The most important thing which I have to tell you is that the pictures have come at last," he replied, adding that sets for *Boston Evening Transcript* editor Horatio Woodman and *Atlantic* editor James T. Fields, pictures surely sent by Starr, had also arrived by post. "I have taken care that they be seen as extensively as possible among my friends who are interested in such matters, and they have made a considerable commotion. Everyone says that such specimens of photograph were never seen before in these parts, let alone the scenery. I join in the enthusiasm fully: they are the most superb works of art and nature combined, I think, that my eyes ever rested on . . . I did not imagine that photographic views of scenery could be made such perfect works . . . What foregrounds too! As surely as if he must have composed them and with a genius and taste beyond that of most landscape painting. I have never had such a treat."[27]

It was at about this time that Whitney and Brewer hit upon an idea: given how spectacularly useful they were finding Watkins's pictures in networking and in helping other scientists discuss the alien new world of California and especially the Sierra Nevada, what if Watkins made some pictures for the CGS? The survey was entangled in budget problems, and it would take a few years, but Brewer and Whitney would arrange it. Their commissioning of more Watkins Yosemite pictures would go a long way toward cementing all of their legacies.

When Jessie Benton Frémont left San Francisco in the summer of 1861, the last person to leave her shipboard cabin was Thomas Starr King. He had brought her two gifts: long-stemmed English violets from his (and presumably his wife's) garden, and a copy of Ralph Waldo Emerson's *Essays.*[28] The book wasn't just shipboard reading (as well as an indication that Starr had

successfully brought Jessie around to the Sage of Concord), it was Starr's acknowledgment of the role landscape and nature had played in their time together and in their Republican Unionist project. Starr may even have realized that in sending Emerson east with Jessie, albeit in book form, he was completing a circle: Starr had done more than anyone else to bring Emersonian transcendentalism out of New England and into the West, where its impact was still growing, and now he was sending it back east.

Boston had noticed Starr's triumphs; its reaction to Starr's California dispatches in the *Transcript* was swift. "Are there any *views* of Yosemite? Or any other wonders in the [mountains]?" wrote Hosea Ballou II, a Universalist minister and Biblical scholar in Boston. *Views* was the mid-nineteenth-century way of referring to pictures of something other than people, such as landscape. "Indeed, *can* such scenes be pictures? Would it not elevate one's notions of human nature to see a travelling daguerreotypist or photographist drawing his machinery into Yosemite, to take the Falls and the Cliffs? That he might peddle out the prints afterwards to the tune of 'What's the Price?'—eh—ninepence."[29]

Oliver Wendell Holmes, the physician, poet, and perhaps the most important cultural critic of the day, also wrote to Starr. "We read all you write from California with great pleasure," he said. "I wonder if you could for love or money procure me a set of stereoscopic view of the great pines? I have a great collection of stereographs and am curious in trees."[30]

Through Starr, Watkins delivered. Holmes expressed his thanks to Watkins by sending him a poem, now lost, and continued to pay thanks by including him in an article he wrote for the *Atlantic Monthly*.[31] Over the course of several articles in the magazine, Holmes investigated photography, complete with extended passages on everything from the paper photographers used, to how pictures were developed, to how wet-collodion photographs were made, a kind of John McPhee–style treatment a hundred years out. "One of the most interesting accessions to our collection is a series of twelve views, on glass, of scenes and objects in California, sent us with unprovoked liberality by the artist, Mr. Watkins," Holmes wrote. "As specimens of art they are admirable, and some of the subjects are among the most interesting to be found in the whole realm of Nature. Thus, the great tree, the 'Grizzly Giant' of Mariposa, is shown in two admirable views; the mighty precipice of El Capitan, more than three thousand feet in precipitous

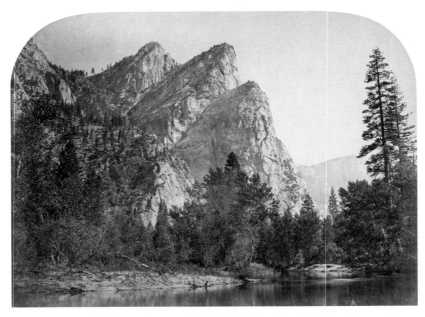

Carleton Watkins, *The Three Brothers, Yosemite*, 1861. Collection of the J. Paul Getty Museum, Los Angeles.

height,—the three conical hill-tops of Yo Semite [The Three Brothers], taken not as they soar into the atmosphere, but as they are reflected into the calm waters below—these and others are shown clear, yet soft, vigorous in the foreground, delicately distinct in the distance, in a perfection of art which compares with the finest European work."[32]

Starr's favorite correspondent was his mentor Ralph Waldo Emerson. The two men had known each other since at least 1852 and often compared notes on natural wonders, such as on Niagara Falls. When Emerson's son Edward visited California in 1862, he stayed with Starr and planned to visit Yosemite, but as the war went badly for the North in the summer of that year, Edward Emerson returned to the East to enlist. (Starr couldn't fathom this. "He needs to go to see the Yo Semite [to find out] if there is something tougher in him than the texture of its pinnacles," he wrote Emerson père.)[33] Only fragments of the Emerson-Starr correspondence survive, but Starr seems to have sent Emerson his first Watkinses in October or November of 1862, when Edward returned to the East. "I send to you two photographs of the

largest tree now standing in our State," Starr wrote, explaining that he was including two pictures of the Grizzly Giant. "The artist, my friend Watkins, wandered in the Sierra wilds last year with a thousand pounds of photographic luggage, crossing steeps seven thousand feet high, to report the Yo Semite cliffs and the neighboring wonders. These are the only photographic likenesses that have yet been taken of the great cedars in our State."[34] The pictures Starr sent Emerson were among his favorites to distribute.

Starr did not know that the giant sequoia, *Sequoiadendron giganteum*, was its own species. Like most laymen, he knew it as a cedar. Starr's reaction to the Mariposa Grove and the sequoias within offers a strikingly clear example of how he adapted New England transcendentalism to California and suggests why he was eager to share Watkins's *The Grizzly Giant* and other Sierra spectacles with his eastern friends. First, Starr linked Mariposa Grove to his faith. "The delicious afternoon light is pouring down the snuff-colored bark of the Titan over my head, who is as old at least as Christianity," Starr wrote to his transcendentalist colleague William R. Alger. "[The Mariposa Grove] is a natural temple in wh[ich] man is a mite."[35] Later that year, when Starr presented the Mariposa Grove to *Transcript* readers, he expanded the metaphor. "How many centuries of summers has such evening splendor burnished thus the summit of the completed shaft? How long since the quickening sunbeam fell upon the first spear of green in which the prophecy of the superb obelisk was enfolded? . . . Are you as old as Noah? Do you span the centuries as far as Moses? Can you remember the time of Solomon? Were you planted before the seed of Rome took root in Italy? At any rate, tell me whether or not your birth belongs to the Christian centuries; whether we must write 'B.C.' or 'A.D.' against your infancy."[36]

Starr probably sent Emerson more pictures, especially of Yosemite Valley, or Emerson ordered more from Watkins. There's a good chance that a set of thirteen Watkins glass stereographs of Yosemite now at the Concord Free Library came from Emerson.[37] They are all valley views. One picture, taken along the Merced River, appears to be Watkins's attempt at taking a picture of wildlife and is titled in Watkins's hand "[Illegible] Taking a Bath." Emerson was soon familiar enough with the valley's features to use Yosemite as a metaphor in his lectures, such as in "The Powers and Laws of Thought," which he first wrote in 1849–50 and which he reused and revised until 1871.[38] "There are times when the cawing of a crow . . . is more suggestive to the

mind than the Yosemite gorge or the Vatican would be in another hour," Emerson said in speaking about the importance of authentic rather than received experience. Heeding his own advice, after the transcontinental railroad was completed, Emerson would go to Yosemite.

When Starr left New England for California in 1860, his reputation as an intellectual, as the most significant eastern man of letters to move to California, rested less on his contributions to Unitarian Biblical interpretation or on his consideration of Greek philosophy, though he lectured on both in New England, and more on his engagement with nature, on his encouragement of Americans into forests and mountains. Starr played a key role in building America's interest in unspoiled places and, in his distribution of Watkins's work, extended that interest to the rugged, new western landscape and to Watkins's medium, photography. Starr's advocacy and influence did much to make Watkins a key link between the nature appreciation of Emerson and the New England transcendentalists and John Muir's generation, which built on nature appreciation by turning it into conservation. Watkins's work was also a demonstration of Starr's impact on the West.

The ad hoc alliance between Watkins, Starr, Brewer, Whitney, and the CGS team and their eastern peers would set an important precedent that continues to have an impact on the environmental movement to this day, the inauguration of a western sociocultural alliance made up of nature lovers, artists, and scientists that remains intact as a national political coalition. No similar partnership emerged in the mid-nineteenth-century East.[39]

More specifically, Watkins's, Starr's, and Emerson's love of nature would lead directly to the emergence of the American conservation movement. Among its early leaders would be Frederick Billings, who would become one of America's most important nineteenth-century conservationist-minded philanthropists; Billings's Woodstock, Vermont, neighbor George Perkins Marsh, whose 1864 book *Man and Nature* is America's first important conservationist text; and Frederick Law Olmsted,[40] who is about to join our story. California's most famous conservationist would eventually be John Muir, a friend of Watkins and an avid reader of Emerson who also made important scientific discoveries up and down the West Coast. At the end of the nineteenth century, Muir would become the first president of the Sierra Club, the world's first large environmental preservation organization. The Sierra Club would maintain Muir's relationship with artists, especially pho-

tographers, through its work with Ansel Adams and Eliot Porter. Today the West still plays an outsize role in the American conservation movement. It all came out of the cultural Unionism that Edward Baker motivated and that Starr and Watkins fulfilled.

For almost all of 1862, Watkins had relied upon the CGS scientists and Starr to spread the word about his pictures. In autumn that would change. Midway through the run of the 1862 World's Fair, the Great London Exposition, person or persons unknown added three groups of pictures to the American section of the exhibition: a series of pictures from Matthew Brady's *Incidents of the War* series (which began in the summer of 1861); a series of Brady portraits including those of British royalty, John C. Frémont, and, weirdly, Confederate president Jefferson Davis; and a group of Watkinses. It is not clear whether the Watkinses on view were 1860 pictures of Las Mariposas, which Frederick Billings had introduced to England in early 1861, or 1861 Yosemite pictures shipped from America to London. The *British Journal of Photography* described them as "exceedingly large" and "much faded," a descriptor that no other contemporary publication applied to the Yosemite suite. Still, the journal was impressed: "Where do photographers not penetrate?" It is possible, but far from certain, that Watkins's 1861 Yosemite pictures received their first public viewing thus in London, at the World's Fair.[41]

Roughly concurrently, the San Francisco gallery Roos & Wunderlich sent Watkins's Yosemite pictures to Goupil's, a New York gallery with which it had a relationship. Goupil's was the American outpost of one of France's most prominent galleries, and maybe the most prominent gallery in New York.[42] (Roos & Wunderlich was the San Francisco agent for Goupil's prints business.) Carleton Watkins was about to become famous, but first the war would intrude.

7

EXHIBITING YOSEMITE IN WARTIME

THE CONTEXT FOR THE INTRODUCTION of Carleton Watkins's Yosemite pictures to New York was provided by Generals Robert E. Lee and Ambrose Burnside. On December 11, 1862, Burnside, the commander of the Union's Army of the Potomac, ordered his troops to cross Virginia's Rappahannock River and to attack the little town of Fredericksburg. Lee could hardly believe his good fortune. His Army of Northern Virginia, 75,000 soldiers strong, had built stout defenses and installed artillery on the bluffs above the town. Lee's position was impregnable. Burnside ordered his 110,000 soldiers to attack it anyway.

Confederates slaughtered the onrushing Union troops, handing the North its worst defeat of the war. Thirteen thousand federals were killed, wounded, or went missing at Fredericksburg, a bloodbath on par with the one seven weeks earlier at Antietam.

The Confederate victory at Fredericksburg was the culmination of the Union's worst seven-week stretch of war. The disaster had begun with a Union victory, at Antietam, when Union commander George B. McClellan repelled Lee's first invasion of the North. Union forces suffered enormous losses, over 12,000 casualties, 15 percent of McClellan's army, but Lee's losses were far greater—over 10,000 of his 38,000 men. A better com-

mander might have finished off Lee and probably the Confederacy by attacking the retreating rebels, but McClellan failed to activate reserve units. (Among the units McClellan failed to summon was one led by Carleton Watkins's brother Charles.) That had allowed Lee to retreat to Fredericksburg, regroup, meet up with other units, and dare a Union army to attack.[1]

Today, Antietam is remembered primarily as the single bloodiest day in American history, and for the photographs made of the aftermath of the battle by Alexander Gardner and Timothy O'Sullivan. They went on view at Brady's photographic gallery in late October 1862, about a month after the battle. Mostly taken by Gardner, they showed rows of headless, dismembered corpses along Bloody Lane, a trench that had been the heart of the Confederate line, bloated corpses with their limbs spread unnaturally akimbo, a row of dozens of corpses ready for a quick, perfunctory burial, and more bloated corpses. The new albumen printing process allowed Gardner and O'Sullivan to print pictures of corpses on battlefields with acute detail and quality.[2] Especially for New Yorkers, whose sons and friends made up much of the army that had fought in northern Virginia and Maryland in 1862, horror, death, speed, and the present were joined. When news of the disaster at Fredericksburg arrived via the newspapers, New Yorkers did not have to imagine mangled or bloated corpses. They could go to Brady's photographic gallery.

"Mr. Brady has done something to bring home to us the terrible reality and earnestness of war. If he has not brought bodies and laid them in our dooryards and along the streets, he has done something very like it," wrote an unidentified *New York Times* correspondent.

At the door of his gallery hangs a little placard, "The Dead of Antietam." Crowds of people are constantly going up the stairs; follow them, and you find them bending over photographic views of that fearful battle-field, taken immediately after the action. Of all objects of horror one would think the battle-field should stand preeminent, that it should bear away the palm of repulsiveness. But, on the contrary, there is a terrible fascination about it that draws one near these pictures, and makes him lo[a]th to leave them. You will see hushed, reverend groups standing around these weird copies of carnage, bending down to look in the pale faces of the dead, chained by the strange spell that dwells in dead men's

eyes. It seems somewhat singular that the same sun that looked down on the faces of the slain, blistering them, blotting out from the bodies all semblance to humanity, and hastening corruption, should have thus caught their features upon canvas, and given them perpetuity for ever. But so it is.[3]

Brady's exhibition of the Antietam pictures continued into December. They were on view when Burnside initiated the slaughter of his own troops at Fredericksburg. The confluence of battle, reportage, and exhibition made a modern moment at which many new media came together: First, the telegraph delivered news of the Fredericksburg battle to newspapers so fast that it was in the next day's editions. Throughout the second week of December, lists of Union casualties filled two-thirds of newspaper front pages. Not only did newspapers such as the *Tribune* publish names of the dead, but also, when a soldier was wounded, they published the soldier's name, unit, and the injured (or removed) body part. Soldiers wrote home that their belief in Union was waning, that maybe Virginia and the heretic South weren't worth the trouble. Units from New York were particularly active at Antietam and Fredericksburg and suffered enormous losses. Historian James M. McPherson wrote that "Fredericksburg brought home the horrors of war to northerners more vividly, perhaps, than any previous battle."[4]

It was at this moment, seven weeks after Antietam and on the same day that the names of the Fredericksburg dead and lists of body parts amputated near the battlefield filled New York newspapers, that New Yorkers could walk out of Brady's gallery of shocking war scenes, turn left down Broadway, walk past a couple of storefronts, take another left into Goupil's, a Parisian-owned gallery that was one of New York's most sophisticated art spaces, and see Carleton Watkins's pictures of Yosemite. In those few dozen steps, New Yorkers could go from seeing slaughter secondhand to seeing something completely different, a landscape that was unbloodied, pristine, and topographically dramatic, a place that some of them may have heard of but that none of them had seen. A more visually disjunctive moment—a more acute clash between eighty-square-inch representations of death and four-hundred-square-inch, tonally complex mountainscapes, between the con-flicted, bloodied East and the glorious new West, between the pessimism that characterized Union in late 1862 and the hopefulness that the West had

represented for generations of Americans now reversed and offered as the West's hopefulness about the East and Union, a profound expression of cultural Unionism—could hardly be imagined.

Given that it took about a month for goods to travel from San Francisco to New York, Watkins could not have intended for his pictures to be viewed within the context of the Battle of Fredericksburg. However, he may well have shipped his Yosemite suite to New York just a week or two after Antietam, so he could have known that they would be exhibited in the wake of unprecedented carnage. While there's no textual suggestion that Watkins wanted his pictures viewed as any kind of specific response to battle deaths, he was plainly eager to have them seen in the context of the war for Union: in late 1862, printing and especially shipping nearly three dozen (or more) Yosemite pictures would have strained Watkins's financial resources or, perhaps, left him indebted to an unknown person who footed the bill. (The best guess is Starr, whose church members had enriched him by steering him to some wildly profitable mining investments, or William Ralston.)[5] The pictures were a sign of the West's commitment to Union, an explicit engagement with the American (read *northern*) tradition of landscape. Their going on view at Goupil's as news of the Battle of Fredericksburg was arriving in the North was an accident, but an accident enabled by the nature of the project.

We do not know how Goupil's exhibited Watkins's pictures. At Brady's, Gardner's Antietam prints lay flat in glass cases.[6] Watkins never installed his work that way. From the outset of his career, he framed his pictures and hung them on walls, the same way paintings were displayed. Watkins's camera, that self-designed, probably self-made behemoth, was made to create huge photographs. Part of the reason was to make giant pictures of the enormous western landscape, pictures that would command a room's attention. Assuming Goupil's hung Watkins's work as he did, it's easy to imagine Watkins being pleased with this dichotomy: little gray rectangles of death in prophylactic cases at Brady's; big pictures of the newest, most beautiful West booming out from the walls of Goupil's.

We do not know precisely which Watkinses Goupil's showed. Given that albums of the full Yosemite set entered eastern collections shortly after the exhibition, it's likely that the whole suite was on view. American art criticism that considered exhibitions in relation to each other was some decades away, so today we can merely look at the Antietam pictures and the

Watkinses and wonder if war-smacked New Yorkers would have seen what we do. Certainly a few points seem too obvious for any audience, now or then, to miss: Watkins's Yosemite is a rich, living place. Gardner's Antietam battlefield has been reduced to a muddy, lifeless ground speckled with corpses and body parts. As a result of a daylong fusillade of artillery and bullets, nearly nothing lives on it. In several of Gardner's pictures, Confederate corpses seem to have become part of Maryland itself, such as in *A Confederate soldier who after being wounded had evidently dragged himself to a little ravine on the hillside where he died*. Because the corpse is in a slight depression in the land, it appears to have been partially swallowed by it.

Meanwhile, life bursts from each Watkins. Trees and plants find ways to live and thrive on rocky cliffs. Several Watkinses are almost portraits of trees: *Cathedral Spires* is mostly a picture of a perfectly centered, majestic ponderosa pine (so much so that Cathedral Spires itself is mostly obscured). Trees, shrubs, and grasses are so omnipresent in Watkins's Yosemites that we rarely see the ground from which they grow.

In the context of cultural Unionism, this richness of life amid the topological challenges of Yosemite was a metaphor for the justness of the cause. Thomas Starr King made this link between Yosemite, its lush verdancy, and the providential blessing of the North in one of his finest sermons, the 1863 "Lessons from the Sierra Nevada." Several passages from it can be read as referring to specific 1861 Watkinses. In the sermon, Starr fused three seemingly disparate threads to argue that the Sierra Nevada was a manifestation of God's presence, that the South was a lesser land because God had not provided it with skyward-reaching ranges such as the Sierra or the White Mountains, and he linked those ideas to science, in particular to the antislavery German scientist Alexander von Humboldt and his pioneering ecological work.

"Each quality of soil has its peculiar element of nutrition and supports peculiar products," Starr said. "Each change of average temperature, though slight, is marked by new kinds of flowers and shrubbery. Every gradation, every cranny and chink is veined, often bristling with life or bloom. We go up from the gray, hot sweeps or billows of the plain into coolness, into green, into magnificent forests of fir, into a glorious belt of the sugar pine, lovelier than the cedars of Lebanon, into the region of pure water and cold, foamy cascades that sometimes show a stream of winding whiteness for half

a mile on a desolate cliff and lastly into the healthful, blazing clarity of the eternal snow! What is the condensation into speech of all this good but the language of the psalm: 'Thou openest thine hand and satisfiest the desire of every living thing.'"[7]

The *New York Times*, which published more thorough art coverage than any other New York newspaper, was impressed. An unnamed writer called Watkins's pictures "a valuable contribution to art . . . The views of lofty mountains, of gigantic trees, of falls of water which seem to descend from heights in the heavens and break into mists before they reach the ground, are indescribably unique and beautiful. Nothing in the way of landscape can be more impressive or picturesque."[8]

The *Times'* address of Watkins's Yosemite series reveals the triumph of cultural Unionism. First, the *Times* considered Watkins's pictures exactly as he wanted: not as pictorial reportage, like what was on view at Brady's, but as landscape art. For an artist who had designed and built a huge camera with the apparent goal of having his work presented and considered within the context of the most important tradition in American art, landscape painting, this was validating.

Next, by specifically defining the Watkinses as landscapes, the *Times* was acknowledging that Watkins had extended the American landscape tradition into the farthest West. This is not a merely geographic distinction. Until now, American art had been an overwhelmingly northeastern phenomenon. The great landscapes of pre–Civil War American art were the Hudson River Valley, the White Mountains, and Niagara Falls.

To put it another way, the greatest subjects of American landscape art, the ones that drew painter after painter to them, were all in free states. Watkins was bidding, in part, to use a new medium, a new technology, in a new place, California, and to bring a new landscape, Yosemite, into this tradition.[9] While California had entered the United States as free, the tenuousness of California's commitment to Union was well-known, as was the intensity with which an overwhelming majority of California's politicians had long worked to split the state in two, to carve out a place for the expansion of slavery into the West. California was not the rock-ribbed Unionist Northeast, where abolitionism was born and whose artists and patrons had dominated American art. Starr's writings and Watkins's Yosemite pictures were an attempt to move California past its pro-Southern, occasionally

secessionist past by engaging the North's most significant visual cultural tradition. Starr and Watkins had succeeded in doing what Edward Baker had called on them to do: they had used the means at their disposal to offer California as a full participant in American culture and in the Union.

If the Antietam-Yosemite contrast was not enough, there was an even more explicit connection between Watkins, America's new landscape, and the American painting tradition. At the same time Goupil's debuted Watkins's *Yosemite*, it also premiered Frederic Edwin Church's newest canvas. The new painting wasn't just any old Church, it was a major work titled *Under Niagara*, the artist's first revisiting of the subject of his five-year-old masterpiece and the most famous painting in America, *Niagara*.[10] In that earlier painting, Church had put the viewer nearly on the edge of the falls, a dramatic, precipitous placing that emphasized Niagara's steepness and power. *Under Niagara* was a strikingly different approach to a different part of Niagara Falls: this time, in a painting that the *New York Post* reported Church had sold for $5,000, Church put the viewer in the middle of the Niagara River, looking up at foamy American Falls.[11] "The spectator comes up to the picture with a sense of down-rushing force and volume that fairly take one's breath," reported the *New York Times.* "High up, giddily high, to the left, the white foaming waters lift themselves to the tremendous plunge and form a surging crest of yeasty columns, leap down with an impulse so absolute and full of force that one listens involuntarily for the thunder of the crash into their abyss . . . It is Niagara in motion, Niagara felt and heard as well as seen, and it will take its place at once in the permanent company of landscapes really great, as the reflection of a grand effect in nature from the mirror of a seeing eye and understanding heart."[12] The *New York Post,* the paper edited by friend-of-Starr-and-Olmsted William Cullen Bryant, went even further: "[T]here is none of that elaborateness of detail which has heretofore distinguished [Church's] efforts," the paper said. "It is, in our view, his greatest production, much freer and more animated than his first view of Niagara, and altogether more spontaneous and emotional than his *Heart of the Andes.*"[13] (The painting is now lost and known through chromolithographs.)[14]

As the historian Eleanor Jones Harvey has noted, it was common for American landscape painters to use landscape to build metaphors that referred to specific events, especially during the Civil War.[15] Savvy New York-

ers would have understood that *Under Niagara* was painted in the summer of 1862 just as George McClellan's Army of the Potomac stuttered across Virginia and Maryland and as the Confederacy rolled back Union gains in the western theater. In what may have been an effort to emphasize the painting's relationship to current events, Church or his agents told the *New York Post* that he'd painted it in just five hours. Church, a staunch Unionist who had made a number of paintings that he had expected to be read in the context of the conflict, probably revisited *Niagara* because it gave him an opportunity to tie the war to his greatest subject.[16]

The 1857 *Niagara* had placed the viewer on the cusp of new lands, a rainbow confidently pointing the way west. Now, looking up at American Falls, viewers would have understood both the water's turbulence, tumbling down upon the viewer "below," and the choppy whitecaps of the Niagara River in the foreground as metaphors for the Union's struggles. The colorful 1857 rainbow was replaced here by the beginnings of a paler rainbow that rose from the Niagara River up toward the falls only to peter out, lost in the mist. Even the size and orientation of the 1862 painting vis-à-vis its predecessor underscored difference. The 1857 *Niagara* was 90 inches wide and 40 inches tall, an unusual 2.25-to-1 ratio that sent Niagara Falls flowing from right to left, itself a metaphor for an eastern nation rushing west. *Under Niagara* was a 48-by-72-inch canvas hung in a north-south orientation that emphasized the power of the falls—and the dissolution of the river as it moved down the canvas, top to bottom, metaphorically north to south. Church understood it was an uncertain time.

Never had Americans been able to see so varied an exposition on American landscape, on our land's relationship to our nationhood, as on Broadway between Ninth and Tenth Streets during the winter of 1862–63. Nothing in the media coverage of the Yosemite–Niagara Falls double at Goupil's or its overlap with Antietam at Brady's suggests that New Yorkers realized that the exhibition represented a moment of transition (the city was understandably focused on other things), but in hindsight the moment is clear: with Watkins's Yosemite, the West had arrived, aligned itself with the North, and, at the darkest moment of the war, pledged itself to Union's future.

As the exhibition of *Under Niagara* together with Watkins's Yosemite demonstrated, mid-nineteenth-century art galleries had no compunction about

exhibiting photography with painting. Newspapers routinely wrote about landscape photography such as Watkins's as "art" and described practitioners as "artists." The firm divisions that would, for a time, segregate painting, a.k.a. *art,* from photography, a.k.a. *not art,* were years away. (The division would persist in American scholarship until the last decade or so of the twentieth century, at which point curators and historians returned to the previous realization that painters and photographers were informing each other and that to separate their work was to impose an artificial barrier between pursuits that artists themselves understood were related.) Therefore, it's tempting to wonder whether New Yorkers looked at Church and mused on a relationship between Church's 1857 *Niagara* and a nearby Watkins.

That picture is *Cascade [between Vernal Fall and Nevada Fall]*, one of the best and most dramatic pictures Watkins made on his first trip to Yosemite. It is one of just four photographs, all featuring the narrow spot where the Merced River runs through the southeastern corner of Yosemite Valley, that Watkins made above the valley in 1861. To make this picture and two of the others, Watkins and his assistants hiked a thousand feet up from the valley floor with hundreds of pounds of equipment to a steep granite ridge between Nevada Fall, which drops the Merced River on its first big jump from granite highlands down to Yosemite Valley, and Vernal Fall, over which the river completes the journey. In the roughly half mile between the two falls, the Merced races across a nine-hundred-foot drop. Watkins's idea was to capture the briskness with which the Merced skipped across the stretch of granite between the two falls.

The spot Watkins selected for his picture was extremely steep, easily the steepest terrain on which he took a picture in 1861. The trickiness of the location is revealed by the janky angles at which trees grow out of the surrounding granite: each of a dozen or so pines grows at a slightly different skew, giving the group a kind of drunken appearance. Compare their collective disorientation with the movement of the Merced, which rushes down a minifall at the center right of the picture and then races right to left across three-quarters of the picture. Where the water falls down the minifall, it prints as bright white; as it accelerates across the picture, it transforms into a streak of silvery gray. No photographer had ever made a picture anything like it.

But a painter had: Church's 1857 *Niagara* offered a similarly bravura treatment of rushing water, a presentation so dramatic and actual that it

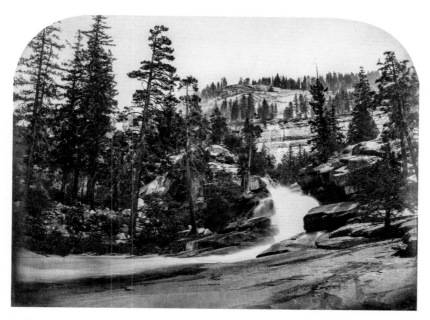

Carleton Watkins, *Cascade, Yosemite*, 1861. Collection of the J. Paul Getty Museum, Los Angeles.

earned Church unprecedented acclaim not just in New York but also in London, where American paintings typically went to be derided. In *Niagara*, the falls seem to fill almost the entire painting. One end of Horseshoe Falls nearly touches the left edge of the painting, the "bottom" of the horseshoe nearly touches the right edge of the painting, and the near edge of the falls is somewhere off canvas on the left. Water rushes toward the falls, becomes foamy as it traverses the rocks just before the falls, foamier yet as it plunges down the falls, and misty as wisps of water vapor rise up from the depths.

An unnamed *New York Times* writer compared the seeming impossibility of painting Niagara Falls to other historical improbabilities, such as Egypt's building of the pyramids or Hannibal's crossing of the Alps.[17] Public reception of the painting focused on two elements. One was Church's dramatic point of view, which emphasized the speed of the water rushing toward the falls, the steepness of the falls, and the danger of all of it. "Mr. Church has shown himself the great artist in the selection of his point of view," said the *New York Times*.[18] Also important to contemporary viewers was the awe-

some quality of Church's handling of water. "[T]he vast quantity of water, a characteristic which distinguishes this fall above all others in the world; we have never before seen it so perfectly represented," wrote an unnamed writer in *The Crayon* magazine.[19] When the painting traveled to London, the *New York Tribune's* Bayard Taylor reported that the great British critic John Ruskin swooned before it and that "he had found effects in it which he had been waiting years to find."[20]

Taylor's art-aware readers would have understood that Ruskin's reference to "effects" was certainly to Church's handling of water. For some years Ruskin had been quite concerned with what he believed was the poor way in which painters portrayed water. He addressed the subject in a nearly book-length 1843 essay called "Of Truth of Water." "Another discouraging point is, that I cannot catch a wave, nor daguerreotype it, and so there is no coming to pure demonstration," Ruskin said. "[T]he forms and hues of water must always be in some measure a matter of dispute and feeling, and the more so because there is no perfect or even tolerably perfect sea-painting to refer to. The sea never has been, and I fancy never will be nor can be painted; it is only suggested by means of more or less spiritual and intelligent conventionalism."[21] As Ruskin's interest demonstrated, the way in which painters handled water was one of the more significant critical topics of the day, first in London, and then in the United States, where the ambition of painters was nothing less than to be fully accepted by the British and European art world. For example, before *Niagara,* Church had been criticized by *The Knickerbocker* newspaper for his handling of water in *Tequendama Falls, near Bogota, New Granada* (1855): "He should not paint falling water—for he cannot."[22]

Watkins would have known *Niagara* through prints. As he seems to have read the London *Art Journal,* he may have read its review of *Niagara's* debut in London, which found that "it seems to us that no work of its class has ever been more eminently successful; it is truth, obviously and certainly. Considered as a painting, it is a production of rare merit; while admirable as a whole, its parts have been all carefully considered and studied; broadly and effectively wrought, yet elaborately finished. We have seldom examined a picture that so nobly illustrates the power of Art."[23] Almost immediately after its inaugural exhibition in New York in March 1857, the New York gallery Williams, Stevens, Williams & Co. offered prints for as much as thirty

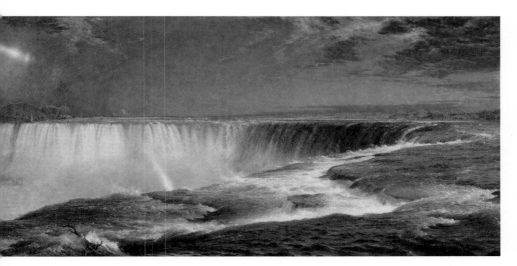

Frederic Edwin Church, *Niagara*, 1857. Collection of the National Gallery of Art, Corcoran Collection.

dollars, and the London firm of Risdon & Day produced a chromolitho-graph.[24] The painting never traveled to the young American West, but its fame certainly did—and the prints did too. The *Sacramento Union* reported that *Niagara* was "the only good view ever taken of the mighty cataract."[25] Neither the painting (nor the about-to-be-produced prints) had been seen in San Francisco in July 1857, but *Niagara* was so famous that the *Daily Alta California* published a poem "suggested by B.F. Church's [*sic*] picture" that included these lines:

> Let me gaze across the Fall,
> For I would not paint it all;
> Only where the waters leap,
> Crashing o'er the rocky steep,
> Mark their course a little way,
> Till engulfed in wreathing spray;
> Give me ocean's varied hue,
> Emerald green to deepest blue,
> And the rainbow tints enlist
> Lambent on the rolling mist;

Eddying to my very feet
Let the rapid current beat;
Launching thence with ponderous fall,
See it stoop, and feel it all.[26]

By 1860, when the *Alta* reported that leading citizens were proposing to open a picture gallery somewhere on Montgomery Street, a print of *Niagara* was one of the promised pictures.[27]

If there was a painting that Watkins would have considered addressing or measuring himself and the western landscape up against in 1861, a painting so famous that it practically begged for cultural Unionist engagement, it would have been Church's *Niagara*. In *Cascade,* with its broad, sweeping rush of river from nearly the far right of the picture through the left—the Merced River continues beyond the edge of Watkins's picture, just as the Niagara River does in Church's—Watkins may have considered himself to be adapting *Niagara* for a new medium and a new landscape. At Goupil's, viewers would have had the opportunity to make the connection between the greatest eastern landscape and subject and what Watkins was establishing as its western peer.

There's one other reason to believe Watkins was engaging with a specific moment and a specific painting: in 1865 and 1866, Watkins would acquire a new, up-to-date lens and would return to Yosemite to remake nearly all of his 1861 pictures. In fact, throughout his career, for one reason or another, Watkins would return to Yosemite to take new versions of almost all of the 1861 pictures. One of just three pictures he never remade was *Cascade.* Maybe Watkins felt that he had succeeded in his western *Niagara* and that the moment, the reason for the picture's making, had passed.

8

EXPANDING THE WESTERN LANDSCAPE

W**HILE CARLETON WATKINS'S BROTHERS** fought for the Union in the Civil War's most contested theater, Watkins remained in California. While historians have not typically considered Watkins a Civil War photographer like eastern photographers of battlefields and troop movements, men such as Alexander Gardner, Timothy O'Sullivan, and George Barnard, Watkins was still plenty engaged with the war, especially through the Yosemite project.

Watkins also made Civil War–related work in San Francisco. If there was an individual patron for this work, it was probably William C. Ralston, one of the wealthy Democratic elite who ran San Francisco in the late 1850s and 1860s. It was men such as Ralston whom Republican Unionists targeted with their public demonstrations and activism. When Ralston and his ilk made their last-minute break for Union in the spring of 1861, their support effectively created the environment that allowed Republican policies, such as the promotion of a transcontinental railroad that enabled the West's post–gold rush growth, to succeed. From whenever Watkins and Ralston met, probably in early 1861, Ralston would be Watkins's most important patron and enabler.

Born on the Ohio frontier in 1826, Ralston started his working life on Ohio River boats (where he came to be known as Billy), graduated to steam-

boats on the Mississippi, and finally advanced to manage steamships on the hypercompetitive route from New York to Central America to California. With each advancement, Ralston expanded his network of young, westward-minded businessmen. His associates would include Mississippi steamboats boss C. K. Garrison, a future mayor of San Francisco; John C. Ainsworth, who would dominate transportation and shipping in Portland, Oregon; Jacob Kamm, a San Francisco–based financier whose specialty seems to have been investing in Oregon businesses; and Darius Ogden Mills, a gold-trading businessman. Thanks substantially to their relationships with Ralston, all of these men and their business interests would play key roles in Watkins's career.

By the end of 1860, Ralston was the most important banker in San Francisco and thus west of St. Louis, an investor in real estate, shipbuilding, banking, textiles, and more. At around the time of the 1860 election, Ralston opened a new bank. Lincoln's victory and California's uncertain allegiance put the bank at risk. Ralston himself was plenty soft on Union in this period; he and his business colleagues were almost entirely men who had voted for Douglas or for the more explicitly proslavery Breckinridge. We don't know when Ralston chose Union, but there is no indication that he made his choice until after Lincoln's election, maybe as late as early 1861. Given how long Ralston had wavered—and given that significant federal contracts were on the line after California had delivered for Lincoln in the 1860 election—once Ralston picked Union, he had every incentive to make his Unionism as clear and evident as possible. That's when he seems to have brought in Carleton Watkins.

Evidence of a close Ralston-Watkins relationship is circumstantial but overwhelming. Throughout the Civil War, Watkins made pictures related to Ralston's investments. After the war, Watkins continued taking pictures in line with Ralston's interests, including pictures of his country estate, foreign dignitaries who visited him, and so forth, until Ralston's death. The two men likely bonded over their shared heritage: each was Scots-Irish. Throughout Watkins's life, his closest friends, men such as the naturalist John Muir and the painter William Keith, were Scots-Irish.

Once Ralston went for Union, he went in big. He oh-so-publicly introduced each speaker at the 1861 Washington's Birthday event that Watkins photographed, and he was the chairman of a home-guard-style security

force that patrolled San Francisco streets looking for secessionist activity.[1] Only a portion of the so-called muster rolls for this provisional force survives, but the rolls are full of men who were or soon would be close to Watkins, including *Daily Alta California* editor Frederick MacCrellish, painter Frederick A. Butman, and future California governor Frederick Low.[2] Ralston also became one of the thirteen "executive committee" members of Starr's efforts to raise money for the U.S. Sanitary Commission.[3]

Once Ralston forsook his previous Democratic allegiance, his overt Unionism helped put businesses in which he invested in line for federal war contracts. Prime among these was a dry dock at San Francisco's Hunters Point, the West's premier shipbuilding facility. It quickly secured a war contract for an immense ironclad ship variously called the *Comanche* or *Camanche* that was intended to protect the crucial port of San Francisco from Confederate sneak attack.[4] Sometime in either 1863 or 1864, Watkins made a picture of the ironclad with well-dressed men in suits and top hats, some with their children or wives, aboard the boat or on the gangplank. A few workers milled around underneath.

Watkins made plenty of other Civil War–related pictures in San Francisco, including ten stereographs of the ironclad, pictures of the *Aquila*, which delivered ironclad parts to the San Francisco dry dock, and pictures of the USS *Lancaster*, the ship the navy sent to defend San Francisco.[5] Several other pictures from this period may have been related to the war. Sometime between 1862 and 1864, Watkins took a picture of Alcatraz Island from Black Point.[6] Maybe he made it for the Frémonts, who believed that when they purchased Black Point, Alcatraz was part of the purchase.[7] Alternatively, Watkins may have photographed Alcatraz because once the federal government appropriated it from the Frémonts or from the previous owner, the island became part of San Francisco's Civil War defenses: it was during the war that Alcatraz first became a prison, for secessionists found to be operating within the state.[8]

While Watkins's Yosemite pictures were winning over easterners at the end of 1862 and in 1863, a commercial and critical success for which he may have hoped but on which he could not have counted, he had to make a living. That meant building on his Yosemite success by making new pictures, building both a local client base and an inventory of pictures he could offer for

sale. For much of 1863, Watkins traveled to fulfill commissions and to make new landscape views. In between trips, he printed Yosemite pictures as fast as he could.

But how to follow Yosemite! Thanks especially to Thomas Starr King and William Brewer, who between them had made California's natural magnificence their passion, Watkins would have been well informed about where he might take his cameras. At a time when artists valued finding new vistas both to make their own and to offer their publics, Watkins had the advantage of California's being almost entirely unexplored by other artists.

So where to go? To the famed mercury mine known as New Almaden, for one. The mine was among California's major tourist attractions, written about even in a magazine edited by Charles Dickens in England and reproduced in *Harper's New Monthly Magazine*.[9] But where beyond the Bay Area? No doubt Starr, Brewer, or both had told Watkins about Mount Shasta, the fourteen-thousand-foot volcano that dominates the northern reaches of the state. After Yosemite, Shasta is California's most spectacular feature. Both Brewer and Starr visited Shasta in the summer of 1862.[10] Maybe Starr told Watkins that the roads to Shasta were worse, far worse, than even the marginal road to Yosemite and that his material might not make it to the mountain and back, or maybe Watkins just didn't have the financial resources for yet another expensive undertaking, for while Watkins may have been the first artist to go to Shasta, he passed. Instead he chose Mendocino, 130 miles north of San Francisco on the Northern California coast, the sparsely settled hub of a vast forested region.

Watkins's Mendocino views are the pictorial equal of his Yosemite suite. Many demonstrate his increasing ability to build complex compositions. They are important because they established beyond any question that Watkins was not merely a beneficiary of Yosemite's topographical grandeur, that he was becoming a great artist, and that he stood unrivaled as America's finest photographer. Furthermore, by going to the Mendocino coast, Watkins extended what was fast becoming an investigation into the full diversity of the western landscape. He had already made significant works of San Francisco, the Sierra Nevada foothills (the Las Mariposas work), Yosemite, and the Mariposa Big Tree Grove; in Mendocino he extended his views to the Coast Range and to the California coast itself.

Just three years into his career, Watkins was already defining the western landscape. The Mendocino pictures established the Northern California

coast as one of the major landscapes in American art and photography. Among the photographers who traveled here after Watkins did are Eadweard Muybridge, who photographed the coast as part of an 1871 commission from the federal Lighthouse Board, Edward Weston, Ansel Adams, Wynn Bullock, Minor White, Imogen Cunningham, and Dorothea Lange.[11] With the exception of Lange's pictures, at least two of which updated Watkins's 1863 *Entrance to Big River Harbor from above the Mill*, other artists seem to have been careful not to revisit any of the sites Watkins photographed. Today the reefs, islets, and rock outcroppings off the Mendocino coast are protected as part of the California Coastal National Monument. At Yosemite, Watkins had partners in encouraging Americans to find value in a landscape. At Mendocino, he did it alone.

The town of Mendocino, a remote outpost of imperial San Francisco, sat upon a peninsular bluff just north of where the Big River drains the Coast Range into the Pacific Ocean.[12] Up the Big River and along other rivers that came out of the tightly folded, steep coastal mountains stood dense stands of redwood, vast stores of equally vast potential wealth. While the Noyo, Albion, and Big Rivers made it relatively easy to cut down those redwoods and move them to mills where they would be cut into board and shipped to San Francisco, moving all that product to market proved a problem: Mendocino didn't have a natural harbor, and rocks such as the ones Watkins would photograph were ship killers. (Between 1850 and 1900, there were over 150 shipwrecks off the Mendocino coast.)[13]

As San Francisco timber prices were outrageously outrageous, the incentive to solve this problem was considerable. In pre–gold rush San Francisco, a thousand board feet of timber—a board foot is the volume of a one-foot length of board that is one foot wide and one inch thick—cost $40. Eighteen months later, as gold seekers piled into San Francisco, the price exploded to $400–$450. By mid-1850, the price was up to $750, seventy times the price of lumber in eastern markets.[14] The mines and San Francisco had such a voracious need for timber that traders from New York and Boston shipped board to San Francisco as fast as they could—and so did dealers from as far away as Norway, Australia, Panama, and Chile.[15] As Mendocino was somewhat closer to San Francisco than Norway, San Francisco capital bought up all the land in Mendocino County it could and

figured it would solve the shipping problem later. That proved unexpectedly difficult.

Finally, by 1863, investors came up with a method that would seem a little bit preposterous if it hadn't worked. Mill owners built cable car–style systems that lifted the cut board from the riverside mills up the steep inclines to the ocean bluffs. From the top of the bluffs, workers literally dropped the cut timber to an ocean barge via a narrow chute suspended above the water by a long cable. Then that barge delivered its cargo to packet ships anchored offshore, which sailed the timber to San Francisco. This was all complicated, expensive, and time-consuming, but given the price of timber in San Francisco, it was worthwhile. By the end of the 1850s, prices had fallen from their peak, but Congress's passage of the Pacific Railroad Act in 1862 brought a massive new industry online. When the Central Pacific Railroad began buying Mendocino redwood for use as railroad ties, prices took off again. Mendocino timber baron Jerome B. Ford, who seems to have been the client who motivated Watkins's trip to Mendocino, reported profits of $52 on prices of around $100 per thousand board feet in 1863, still a premium of up to 1,500 percent over prices in the East. A new Mendocino timber rush was on.[16] "What the discovery of gold did for the developing of California, redwood did for the Mendocino Coast," wrote historian David Warren Ryder.[17]

Watkins's trip to Mendocino appears to have inaugurated a strategy he would use for the rest of his career: travel somewhere at the behest of a client, but use the trip to make landscape pictures unrelated to the client's business to offer for sale. (Watkins typically offered his business-commissioned work for broader sale too.) For a photographer who did not yet have his own commercial gallery and who did not want to be entirely reliant upon unpredictable commissions, this was a crucial strategy. As there were only so many trips Watkins could make per year due to the vagaries of weather, especially now that orders from his Yosemite work were beginning to come in, this allowed him to maximize his limited time in the field.

Sometime in late 1862 or early 1863, Ford seems to have decided that he wanted some pictures of his fast-growing operation. We don't know why. Most likely he was looking to raise investment dollars to expand or improve his operation in response to the railroad boom. Ford was well positioned to serve new customers: He was among the first half dozen Anglo-Americans

to settle Mendocino, and he had carefully guided the county's timber business through its early shipwreck-related challenges. He owned mills that cranked out twice as much board as his nearest competitor's mills and ten times as much as most other local mills. Ford seems to have wanted Watkins to make pictures that showed off his local-industry-leading operation.[18]

Watkins's pictures for Ford range from the routine (pictures of the houses of various lumber-company executives) to the explanatory (pictures of the rails that delivered logs up an incline from the Big River to one of Ford's mills, a picture of the cable contraption that delivered the milled timber to a barge in the ocean below) to the infrastructural (several pictures of mill buildings and operations). Few of these would become the major pictures of the trip, but even when going down the checklist of things Ford needed, Watkins's ability to compose an image of the mundane into quality is repeatedly evident. Take *The Big River Mill, Back End,* a picture of the butt end of a workaday building of no distinction. Watkins puts the squat mill in the far right two-thirds of the picture, a strange gambit that should have thrown the whole picture cattywampus. Watkins saves it by running the mill's timber chute from somewhere beyond the lower left edge of the frame into the dead center of the picture, thus anchoring the building so effectively that it seems to be centered. Then Watkins plays with scale. The mill building appears to be of a routine size—until the viewer notices that there is a log at the top of the timber chute, about to enter the mill to be cut into board. The viewer's eye follows the log to a surprise: it turns out that a little white speck in front of the log is a man wearing a white shirt, dwarfed by what's left of an enormous redwood. It is a disjunctive moment in which scale is made clear—and almost unbelievable. It is the kind of question that makes us wonder how Watkins learned to make a picture such as this and leaves us frustrated that we'll never know.

While in Mendocino, Watkins lugged his big mammoth-plate camera, half a dozen glass plates, chemicals, and his dark tent out to a grass-topped bluff eighty feet above the Pacific Ocean. The town was at Watkins's back, a couple of hundred yards inland, back toward where the Big River rushed out of the coastal mountain range and into the Pacific. Watkins set up his camera to look out at the ocean, due west, where a smattering of craggy rocks lent the oceanscape a danger both romantic and real. Over the course of a day or

Carleton Watkins, *A Coast View, Rocks (No. 1), Mendocino County, California*, 1863. Collection of the J. Paul Getty Museum, Los Angeles.

three, Watkins made five pictures of the sharp rocks among which the Pacific Ocean met Mendocino. As with all of his best pictures, these look effortless and preordained, like pictures that anyone could have made had they thought to go there. They were not. Watkins would have had to maneuver his equipment partway down the steep bluff, anchor himself and his tripod in the sandy soil, and brace himself and his camera against the wind that always seems to blow here in order to make his pictures. For a couple of them, Watkins must have tipped his bulky camera out and over the bluff, down toward the ocean below, and somehow maintain it in that position while making his picture.

The five views Watkins made here introduced the California coast into art and even into America's consciousness. Prior to these pictures, there is little consideration of the dramatic places where the ocean met the land in California literature, and none in art of the West. Actually, there's not much like them in East Coast art either. When eastern painters looked toward the

Atlantic, they painted placid beach scenes: In Gloucester, Massachusetts, Fitz Henry Lane painted gentle oceanscapes such as *Western Shore with Norman's Woe* (1862), which shows a calm cove and the placid water before a quiet beach. Martin Johnson Heade's still coastlines occasionally featured the remnants of a passing storm—a broken branch or two here, some becalmed boulders there, but nothing too dangerous. In his *The Stranded Boat* (1863), the boat looks just fine. The Mendocino coast, where land met sea atop hundred-foot rocky bluffs, was not that kind of place.

Watkins's Mendocino County landscapes rank with his best work. First among them are those pictures of the offshore rock outcroppings he took as he stood on the bluffs between the town of Mendocino and the Pacific Ocean. Watkins titled each of them *A Coast View,* which understates the combination of the pictures' prettiness and the danger created for mariners or swimmers by the rough rocks. Each of them is unlike the others, a variation that underscores the visual variety of the Pacific coast. The picture known as *Coast View No. 1* features a dramatic, seemingly pyramid-shaped rock framed by two lines of outcroppings running out to sea. The grassy bluff on which Watkins placed his camera fills the lower left-hand corner of the picture, providing the viewer with a sense of distance and scale. It is as if the central rock is bracketed between parentheses and held in place by virtue of its relationship to the coast. Other pictures in the group feature two outcroppings in which the ocean has eroded a giant hole, giving Watkins an opportunity to create a picture that offers a small, secluded bay, dramatic cliffs, and a portal to the ocean beyond.

Not all of the Mendocino pictures are great. A suite of pictures Watkins took at the Rancherie, a U.S. Army–designated Indian reservation above the Big River, are the most shameful pictures he ever made.[19]

Mendocino County was home to an unknown number of California Indians, including Pomo and Yuki, who increasingly encountered Euro-American settlers as the timber industry began to advance throughout the county in the 1850s and early 1860s. The U.S. Army and state militia conducted a series of campaigns against the natives, alternately slaughtering them and steering them onto reservations, including the Rancherie. Of all the militia operations against California Indians, these late 1850s and early 1860s campaigns along the North Coast resulted in the largest number of killings.[20] Watkins's Black Point mate Bret Harte exposed the apparently

routine military slaughter of Indians in a newspaper article in the late 1850s. Such was the reaction of North Coast whites to Harte's story that he was forced to move to San Francisco.

When Watkins was in Mendocino County, the Army ran its operations out of Fort Bragg, which was ten miles up the coast from the town of Mendocino. (*Garrison at Fort Bragg*, a mammoth-plate picture, shows seven of the U.S. soldiers based at the fort.) Watkins made two mammoths at the Mendocino-adjacent Rancherie, one of a mud, timber, and log conical structure that Watkins called a "Sweat House" and another of a cluster of tent-sized homes that a group of Pomo or Yuki had built from tree branches and discarded timber, a sad picture of the squalid living conditions to which the Native Americans were subjected and restricted. Historian Benjamin Madley notes that by today's standards, the treatment of Mendocino County's Native Americans, including at the Rancherie, was genocidal.[21]

To today's eyes, Watkins's most shockingly voyeuristic pictures of the Rancherie are stereographs, pictures meant to be sold back in San Francisco as inexpensive entertainment. In one picture, two Indians making baskets appear to assent to having their picture taken. In others, Pomo turn away from the camera to which they are being subjected. Watkins's pictures at the Rancherie revel and attempt to profit from the whites' subjugation of Indians. They were not out of character for the time and place. Watkins's California was racist and bigoted. Chinese, Irish, native Californians, and other peoples were routinely treated harshly. Later in his career, at least, Watkins seems to have at least pictorially objected to California's routine bigotry. He would make sensitive, thoughtful pictures of Native Americans and Californios, persons of Spanish or Mexican heritage who were born in or lived in California, in Kern County, and especially of San Francisco's widely hated Chinese. The only baldly exploitative photographs in his oeuvre are these Mendocino County pictures. Given the later work, and what Watkins must have heard about the slaughters Harte described and condemned, the Mendocino reservation pictures are inexplicable.

Watkins made one of his finest Mendocino pictures looking out from the Rancherie: *Big River*, which shows the Big flowing past steep mountains thickly forested with redwood and fir. It's hard to know how far Watkins had to schlep his gear from the nearest road, but today this view requires a tough, steep trek through dense undergrowth and thick bunches of trees to

reach the approximate spot where Watkins made it. Watkins probably took advantage of a natural clearing—there are some rocky escarpments that run down toward the river here—to look upriver. The Big is framed by awesomely tall redwoods on either side of the picture and is pierced by a couple more redwoods (or pine trees) that rise from farther down the slope. Watkins put a couple of other trees, possibly oaks, in the left foreground of the picture and made his negative just as the sun hit them, which provided contrast with the seemingly ubiquitous dark redwood and gave the picture depth. Just to the right of the main body of the river, the Big has cut a ribbon of S-curves through what almost looks like a tidal marshland, turning the river from a streak of silver into a living, self-determinative thing. (The Pacific is less than a mile away.) The effect is of a picture of a seeming wilderness taken from within that same wilderness . . . an effect which persists until the viewer discovers a large bunch of floating logs in the center foreground. Only then does the viewer realize the impact man is having on this place. Suddenly we realize that this is a picture of where nature meets extraction. In the nineteenth century, this intersection was a sign of progress and triumph. Today the picture's magnificence is bittersweet.

A number of Watkins's Mendocino pictures, including *Big River,* suggest Watkins was familiar with eastern painting. Watkins was well-connected to lovers of American painting: Thomas Starr King discussed the work of painters such as Frederic Church, Asher Durand, John Frederick Kensett, and more in *The White Hills* and may have traveled through the Whites with Sanford Gifford (who would soon become or who was already a Watkins collector).[22] Watkins's friend Clarence King, a colleague of Josiah Whitney's and William Brewer's at the California Geological Survey, was up on contemporary art too, so much so that he would soon become a collector of both American and European painting. San Francisco was home to numerous printsellers. Watkins probably knew that for the previous thirty-plus years, the two major concerns of America's cultural approach to landscape had been to wince at America's destruction of nature and wilderness—witness the way clear-cut sections of forest and tree stumps are prominently featured in, say, Thomas Cole's *View from Mount Holyoke, Northampton, Massachusetts, after a Thunderstorm—The Oxbow* (1836) and George Inness's *The Lackawanna Valley* (c. 1856), respectively—and to celebrate America as a virgin land, a God-kissed, even God-preferred land, a place unsullied by the

Carleton Watkins, *Mendocino River [Big River] from the Rancherie, Mendocino, California*, 1863. Collection of the Stanford University Libraries.

problems of Europe, such as the famine that had sent nearly a million Irish across the Atlantic to American shores or the wars that routinely swept across the continent. To historian Barbara Novak, that these two seemingly conflicting ideas would coexist in American art is almost inevitable: "Such intense reverence for nature came only with the realization that nature could be lost."[23]

Watkins's *Big River,* a tremendous landscape picture of redwood forests that stands out amid a series of pictures made to show off the capabilities of an increasingly efficient local timber industry, seems to reference that same idea. Consider it as a westernization of Cole's *Oxbow:* a large landscape viewed from above, unified by a river that first draws the viewer's attention to nature's majesty and that reveals, only upon close inspection, the impact of logging.

Could *Big River* indicate that Watkins, like Cole, was becoming interested in conservation? There is no textual evidence from this period—or any period of Watkins's career—that reveals he was. Still, as Watkins's San

Francisco was about to become a hub of the new thinking about landscape preservation, he was surely aware of the conversations his art was helping prompt (especially because nearly everyone involved in the new ideas about conservation would be friends and collectors of Watkins's work). While Watkins was in Mendocino, one of them, Frederick Billings, would return to San Francisco from his travels to New York and Europe a new man. Another soon to arrive, a parks designer who had recently helped run the U.S. Sanitary Commission, the private wartime relief agency that raised and spent money on field hospitals and related facilities for Union soldiers, was Frederick Law Olmsted.

Before leaving California for Europe, New York, and Las Mariposas business, Frederick Billings had been interested in nearly nothing but business. The trip changed him. In Europe he discovered (and purchased) art, including prints by Murillo and Raphael.[24] In New York he discovered and would soon marry Julia Parmly, the daughter of a New York real estate investor and abolitionist philanthropist. Julia would push Billings to commit himself to philanthropic pursuits.[25] Almost immediately, Billings's causes became the U.S. Sanitary Commission and landscape conservation. These interests would seem to have been unrelated, and perhaps initially they were, but the networks of Billings's friends that were interested in each overlapped and reinforced each other. Perhaps Billings was motivated by Edward Baker's 1860 call for cultural Unionism just as Starr had been, but as a wealthy businessman, he had other ways of participating.

Given the ongoing Civil War, Billings's most immediate focus was the Sanitary Commission. Prime among the New Yorkers that Billings met while courting Julia was Rev. Henry Whitney Bellows, the Unitarian majordomo who had steered Thomas Starr King to San Francisco and who was now the Sanitary Commission's president. Billings, who had previously bonded with Starr over Union, Yosemite, and their shared fondness for Jessie Benton Frémont, became a significant donor to Starr's Sanitary Commission efforts in California. (In 1860–61, when the threat of a Pacific Republic had loomed, Billings had joined Starr on his speaking tours throughout the state's rural districts. Starr would speak on national unity; Billings would follow up with a talk on why California or Pacific independence would be a mistake.)[26] Billings had met Bellows through an introduc-

tion from Starr, who wrote Bellows a whiz-bang letter in which he described Billings as the "strongest pillar" of San Francisco's Calvary Presbyterian, as a particularly "eloquent interpreter" of Unionist patriotism, and as "the man I love more than any other in California."[27] (Starr did not mention, because he wouldn't have needed to, that Billings was a key figure behind his California fund-raising success. Despite a population a tenth the size of New York and an eighth the size of Pennsylvania, Californians gave more to the Sanitary Commission than any other state—and four times as much as New Yorkers.[28] Californian expressions of solidarity with Union were not limited to Emersonian transcendentalist preachers or to artists.)

It wasn't just European art that interested Billings in these years but also art of America, especially of California and Yosemite. Among his art purchases were scores of Watkinses, pictures he eagerly shared with his social circle. For example, Billings loaned a set of his Watkins Yosemite pictures to Harvard professor Louis Agassiz, the man who had determined that the Alps were formed by glaciers and now the most famous scientist in America. "Allow me to return my best thanks for my share in the great enjoyment which your photographs of the Yo Semite Valley have given to our family circle," Agassiz wrote to Billings. "I have never seen photographs equal to these. Aside from the interest of the subject. . . . They were most instructive to me, indeed so much so that I shall make every possible effort to secure a set for our Museum in Cambridge, as the best illustration I know of the physical character of any country."[29]

In the meantime, there was still Las Mariposas to deal with. In the spring of 1863, Billings traveled to Las Mariposas and discovered that his onetime law partner and colleague Trenor Park had run the estate into the ground—and that Park had greatly enhanced his own wealth in the process. Billings concluded that Park had either been guilty of gross mismanagement of the estate, or he had been running it as a personal slush fund. Eventually Billings decided the only option was a sale. He not only had much of his own wealth at risk but also was still close to the Frémonts, especially to Jessie, and wanted the best thing for them. A sale would be difficult, especially when it became caught up in Republican politics: Park, an active Republican donor and state committeeman who stood for the U.S. Senate in 1863 (and lost), tried to engineer a sale that would enrich his political allies and that would result in Salmon Chase selecting Park as his vice president if he ran

for the presidency in 1864. With help from San Francisco banker (and future Watkins client) John Parrott and a group of New York bankers, Billings forced Park to agree to his sale terms and mostly cashed out of Las Mariposas in 1863. Remarkably, Billings escaped with his fortune intact and still maintained a small interest in the new company that would run Las Mariposas. It is unknown whether Watkins's photographs were used in the extraordinary range of conversations that resulted in the sale, but as they were the clearest way for Billings to show off the size and potential of Las Mariposas to New Yorkers, and as Watkins's triumph at Goupil's was ongoing or had just concluded, it's likely that many New York bankers saw and were perhaps even gifted Las Mariposas albums or pictures.

The new Las Mariposas mining company needed a supervisor, a CEO, to run the mine's day-to-day business. At the behest of the New York bankers and surely the Sanitary Commission–connected Billings himself, the company hired Frederick Law Olmsted, then the commission's secretary (or executive director in today's parlance). Olmsted had become weary of the commission's complicated internal politics, he was in debt, and the Las Mariposas job came with a fat salary. Olmsted fretted to his wife that "I hate the wilderness & wild," but took the job anyway.[30] Las Mariposas—and the friendships he would form with Billings, Starr, and Watkins—would teach him to love both and to become active in their conservation.

Olmsted was among the most remarkable men of his century. He had worked as a gentleman farmer, as a journalist (he traveled the South on foot, writing a diary about the slave-ridden society he saw for the *New York Times*), and most recently as the co-designer of Central Park, a major New York City project that was languishing for reasons related to both politics and the war. Olmsted biographer Witold Rybczynski notes that Olmsted's life was defined by a certain skilled prescience: His dispatches from the South were published in the *Times* just after Harriet Beecher Stowe's novel *Uncle Tom's Cabin* roused the North to antislavery. His designs for parks in cities such as New York, Brooklyn, Buffalo, Milwaukee, suburban Chicago, Louisville, and Boston helped create the stage on which the post–Civil War industrial boom in American cities would take place. He also planned campuses for several dozen colleges and universities, including Stanford University, Washington University in St. Louis, and the University of California, Berkeley; designed the grounds for the 1893 World's Fair in Chicago; and led

efforts to conserve the area around Niagara Falls and the Adirondack region in upstate New York. He would become crucial to the future of Yosemite and the Mariposa Grove too.

As for so many men of his generation, Olmsted's foundational ideas came from Ralph Waldo Emerson, particularly from *Nature*. Olmsted didn't just read Emerson, he spent time with him when Olmsted was the editor of a literary magazine in the 1850s. Olmsted's publishing company, Dix, Edwards & Co., even published one of Emerson's books.[31] Olmsted seems to have taken note of one of the most progressive themes in *Nature*: as Emerson celebrated forests, mountains, and streams, he bemoaned America's insistence on economic growth by any means necessary, the nation's relentless pursuit of more wealth, more commercial luxury goods. Emerson noted that rapaciousness itself had a cost, and that cost was nature, wilderness. In order to grow, Americans had moved off the Atlantic seaboard, up the river valleys, and over mountain ranges into the near West, replacing wild lands with towns and farms and industry. Emerson urged his readers to pause, to reject "matter" (the transcendentalists' word for the material world), to reject consumerism for its own sake, and to instead find pleasure in nature. This was a radical idea. To argue for finding value and worth in nature in the nineteenth century was to advocate for an examination of the American social and economic model, which was to move west at all speed and at all costs, finding monetary value in the new land because of its agricultural or industrial potential but not in landscape.

With Billings's return and Olmsted's move, California was suddenly home to the Americans who were thinking most progressively about landscape. Starr's lectures in San Francisco and around the state, and increasingly his sermons at First Unitarian, urged Californians to find Emersonian value in nature. For Starr, that value was in a supernatural; he argued that God's presence was best and most reflected in nature. However, for Billings, Olmsted, Watkins, and others, men who may have attended church on occasion but who didn't tie everything back to a deity, the question of how to assign nonmonetary value to nature or how to recognize a landscape's worth in a way that wasn't related to immediate economic ends was becoming increasingly important.

Olmsted would help their thinking along. The principles for which we remember Olmsted today—his espousal of the restorative properties and

beneficial psychological effects of nature, and the idea that experiencing it can have a civilizing, social-reform-like effect on society—were prompted by Emerson but coalesced during his years in California, which would also be the place he learned how to migrate philosophy and ideas into tangible outcomes. Indeed, as Olmsted himself seems to have realized, it was no coincidence that his ideas about land, landscape, and their purpose and potential role in American life became clearest when he was at vast, remote Las Mariposas, isolated from the rest of America, during the Civil War, when previously unimaginable wartime horrors seemed to require a new form of metaphysical restoration.[32]

No single one of them—not Starr, not Billings, not Jessie, not Watkins, not Olmsted, not their friends, men such as Brewer and Whitney—had figured out yet what it meant to value a landscape and how to fully establish or enshrine the value of nature. But as they came together in correspondence, over dinners and sermons and in other ways at Las Mariposas, in San Francisco, and at Yosemite in 1863 and 1864, they were, perhaps unbeknownst even to themselves, beginning to figure it out.

During the Civil War years, the commercial popularity of Carleton Watkins's work both demonstrated America's increasing embrace of nature and allowed Watkins to upgrade his living and working quarters. When Watkins had returned from Yosemite to San Francisco in 1861, it was to a room in the Metropolitan Hotel.[33] It was a comfortable neighborhood, well north of the industrial area and slaughterhouses amid which the city's working class lived south of Market Street, but it was not a distinguished address. Watkins next moved into San Francisco's business district and power center, first to an address half a block from the Montgomery Block, where he'd worked as a magazine clerk for George W. Murray, and where friends and customers such as William Brewer and Frederick Billings now lived.[34] A year or two later, in about 1864, Watkins would move around the corner to 425 Montgomery, between Sacramento and California, presumably to establish a retail presence on the best block of San Francisco's main street. He would remain here until 1872. Watkins's success did not go unnoticed by his photographer peers. In 1863 there were about ten photography galleries in San Francisco.[35] Just two years later, there would be more than twice as many. Watkins had arrived as an artist in 1860, and now he had arrived as a businessman too.

Watkins had plenty of orders to fill. Demand came from all over the United States. An 1864 business notebook, one of just a handful of surviving 1860s documents in Watkins's own scribbly hand (and from which many pages have been torn or gone missing), chronicles orders from many parts of California as well as from New York; Hartford and New Haven, Connecticut; Surry, Maine; Chester County, Pennsylvania; Baja California, Mexico; and even distant Paris and Londoner Charles Marsham, the Earl of Romney. Conservative estimates of Watkins's 1864 sales, based on what remains of this notebook alone, suggest Watkins filled $3,000 worth of orders that year.[36] He was doing well, very well.

The notebook lists sales and not necessarily prices, but Watkins seems to have sold mammoth-plate pictures for $4.50 to $5.00 each in the early 1860s, a sum equal to three times what a carpenter in New England might earn in a day or ten times what a textile factory worker might make.[37] (The price per print seems to have depended on if a customer was buying an entire album of thirty or so Yosemite and Big Tree Grove views, or if the customer was buying just a few stand-alone pictures.) In the coming years, Watkins's price for mammoth-plate pictures would increase. Watkins also sold stereographs: $1.65 for stereos on glass, $1.00 for stereos printed on paper and mounted on cardboard. These prices would drop, sharply, over the course of Watkins's career because the market for stereographs, which were maybe four or six square inches per picture, as opposed to nearly four hundred square inches for the mammoths, was less reliant on quality than price. This brought piles of low-end stereos into the market in the 1870s and 1880s.[38]

How many pictures did Watkins make and sell? We don't know. Today many of the 1861 pictures exist in substantial numbers. For example, there are twenty known Watkins prints of *The Grizzly Giant* and twenty-five of *El Capitan, Yosemite*.[39] Far fewer of the Mendocino prints have survived. None of the *Coast View* pictures is known today by more than six prints. A single entry notes the sale of groups of Mendocino views to four different clients, a good reminder that a low percentage of the pictures Watkins printed survive today.[40] The 1864 diary of some of Watkins's sales from that year suggests that the Mendocino pictures were tremendously popular on both coasts. Buyers included manufacturer and art collector C.W. Denslow of Hartford, Connecticut; Civil War veteran and western Pennsylvania businessman William Chalfant, who would move to Mendocino; Yale chemistry

Carleton Watkins, *The Big River Mill, Back End, Mendocino, California,* 1863. Collection of the Bancroft Library, University of California, Berkeley.

professor Benjamin Silliman Jr., who bought many Mendocino pictures as part of a twenty-four-print order; and Starr's friend William H. Brewer, the California Geological Survey field leader, whose interest in Watkins's work intensified throughout 1863.

Another indication of Watkins's popularity was that his competitors often followed him in an effort to make their own attempts at Watkinses. Take the Mendocino pictures: After Watkins made his trip in 1863, Lawrence & Houseworth, San Francisco's biggest commercial photography operation and from this point onward Watkins's biggest rival, followed. It made lesser versions of many Watkins pictures, such as *The Big River Mill, Back End.* Certainly Lawrence & Houseworth wouldn't have bothered sending an unknown photographer on an expensive trip to attempt to remake Watkins views—from as close to the places Watkins made his pictures as could be determined—if Watkins's success hadn't given them cause. In this case, as usual, the Lawrence & Houseworth picture is inferior to the Watkins. It isn't as cleverly built. It's difficult to ascertain scale, and the composition fails to

Lawrence & Houseworth, *Big River Lumber Mills, Mendocino County, California*, ca. 1860–70. Collection of the Society of California Pioneers, San Francisco.

move the eye through the picture. There are no rewarding visual nuggets—such as the redwood log and the lumberman—for the viewer to find and be wowed by.[41]

Today many Watkinses, most especially the work that was obviously done for a client, exist in only one version. Much of Watkins's Mendocino work, for example, exists in only one print. Given that Jerome B. Ford spent hundreds of dollars to commission these pictures, no doubt he had in mind an audience beyond his own family. But only Ford's own copies, given by his descendants to the Bancroft Library at the University of California, Berkeley, in 1957, exist today.

Given all this, what percentage of the pictures Watkins printed and sold exist today? The books and albums of Watkins's pictures that were likeliest to enter institutional collections such as libraries, universities, and athenaeums upon purchase or close to that time are overwhelmingly likeliest to have survived. Watkins made and sold Yosemite albums; he may not have offered Mendocino albums. Given the scale of Watkins's operation and the expense of running it, especially in the 1870s when Watkins would expand his business, the percentage of works Watkins must have printed that survive is extremely small. What happened to them? People throw out old things of uncertain value. Fires and, especially in the West, earthquakes

must have destroyed vast numbers of Watkinses. In working on this book, I accidentally found many copies of many pictures that were previously unlisted by scholars, even in as prominent and well-used a collection as the Huntington Library's. To take the Mendocino pictures as an example, the surviving 1864 notebook listing a fraction of Watkins's sales from that single year lists at least six sales of groups of Mendocino pictures. Watkins continued to exhibit the Mendocino suite until the mid-1870s and surely sold many dozens more over the next dozen years. I'd guess that somewhere between 1 and 3 percent of Watkins's total printed output is known today. It's likely that more prints, especially of popular pictures such as the Mendocino *Coast Views,* will be found in the coming decades.

While Watkins displayed and sold his pictures framed and behind glass, ready for hanging, he also sold his mammoth-plate pictures in necessarily enormous albums. The vast majority of Watkins's albums have been lost or destroyed over the decades. More recently, original albums have been destroyed and the individual pictures sold, a practice that historians, curators, and art lovers find deeply objectionable. However, many original albums still exist, mostly in libraries and art museums. Many are mammoth-plate albums; others, particularly of Watkins's work from the late 1880s, are substantially smaller.[42]

A number of public institutions hold Watkins albums that are open to public viewing. A particularly fine example is the album of 1861 Yosemite views at New York's Buffalo and Erie County Public Library. The album was purchased in 1864 or early 1865 by the Buffalo Young Men's Association, a private subscription library. (Forerunners of what became public libraries, private libraries were common in major American cities in the mid-nineteenth-century.) The album passed into the collection of the city-and-county library when the Young Men's Association dissolved itself in 1887 and turned its collections over to the city of Buffalo, thus creating the free-to-all Buffalo Public Library.

The Young Men's Association no doubt wanted a look at the landscape that had supplanted nearby Niagara as America's most famed. At about $150, roughly equivalent to what a Buffalo carpenter would have been paid for two months of work (plus the not inconsiderable costs of shipping the album from San Francisco to western New York), it may have been the single most expensive book the library acquired. Bound in black with red trim,

complete with a red-leather plate on the front cover promising, in gold lettering, "VIEWS OF YOSEMITE VALLEY," it is a handsome but not opulent volume. Each page of the album features a mounted mammoth-plate picture from Yosemite or the Mariposa Grove. There is no frontispiece nor any kind of text, just pictures, thirty in all. Watkins signed each page *C.E. Watkins* to the lower right of each picture. The album is enormous and heavy; when opened for viewing, it's over five feet wide and both too heavy and too unwieldy for a person to place on his lap. Contemporary photographs suggest that albums such as this were typically placed on wooden stands. A viewer could stand or pull up a chair to page through the album.

Among the Buffalo Young Men's Association members who likely viewed the album was Samuel Clemens. Between 1869 and 1871, Clemens was the coeditor of the *Buffalo Express*. While living in Buffalo, he began his novel *Roughing It* and published his travelogue *The Innocents Abroad* as Mark Twain. Clemens almost certainly would have known Watkins's work from his time out west. In 1861, Clemens had left his native Missouri for newspapering in Virginia City, Nevada, America's newest mining boomtown. By 1864 Clemens was in San Francisco, where he wrote for a short-lived but prominent literary newspaper called *The Californian*.[43]

Did Watkins and Clemens know each other? Maybe. Watkins was particularly skilled at meeting and networking with writers and journalists. When he traveled to make pictures, he routinely stopped into the local newspaper to promote his work. He seems to have made a point of socializing with journalists, such as at the Bohemian Club when it was founded (by journalists) later in the 1860s. Watkins certainly had ties to Twain's San Francisco circle: Twain rolled with a group of writers that included Black Point salon regular Bret Harte, whom Watkins certainly knew. (It is unclear if Watkins maintained any relationship with Harte after Jessie Benton Frémont sailed away.) In the same year Twain arrived in San Francisco, Watkins sold a substantial trove of pictures, over one hundred in all, to Captain Ogden, the man who hired Twain onto the staff of *The Californian* and who would first publish one of Twain's most famous short stories, "The Celebrated Jumping Frog of Calaveras County."[44]

Furthermore, on several occasions in 1864, Watkins and Clemens were very likely in the same place at the same time. For example, Twain covered the 1864 Mechanics' Institute Fair, a single-city commercial, industrial, and

cultural exhibition on the model of the World's Fair, for three different San Francisco newspapers. Each year, for three decades, the four-week-long fair was the biggest thing in San Francisco. Residents would buy "season tickets," enabling them to go every evening if they so chose. Some nights the fair would draw 10,000, even 20,000 people.[45] The central gathering place was the art gallery, where as many as 1,500 people would gather at a single time, seated along the fair's promenade, seeing and being seen.[46] Watkins was often the most prominent exhibitor in this art gallery, where in 1864 he installed fifty-six pictures on an enormous wall, along with framed sets of stereographs. (Several dozen of those Yosemite pictures would end up in the Buffalo Young Men's Association album.) In an effort to encourage contemplation of his work (and sales!), Watkins set out chairs on a custom-built wood-panel floor, facing his custom-built, wood-panel picture wall, the all-encompassing environment of the installation and seating arrangement an imitation of how painting galleries often set up their displays.[47] Watkins was also active throughout the fair as a photographer, making stereographs of many of the exhibits. He may even have made a mammoth-plate panorama of the exhibition hall (now lost).[48] Still, for all Watkins's prominence at the fair, Twain seems not to have met Watkins there. "It is a nice place to hunt for people in," Twain wrote of the fair in *The Californian*. "I have hunted for a friend there for as much as two hours of an evening, and at the end of that time found the hunting just as good as it was when I commenced."[49]

9

THE BIRTH OF THE NATURE PARK IDEA

AT THE END OF 1863 OR VERY EARLY in 1864, a group of San Franciscans began to wonder if something could be done to prevent Yosemite and the Mariposa Big Tree Grove from devolving into any other place in the West that had potential timber and mineral wealth, which was to say: what could keep Yosemite and the Mariposa Grove from being cut down, developed, and otherwise despoiled?

There was immediate cause for concern: the combination of recent road construction to Yosemite and the national popularity of Carleton Watkins's pictures was beginning to have an impact on the place. When Watkins visited Yosemite in 1861, only a few dozen people traveled to the valley each year. Now hundreds did. Especially with the passage of the Pacific Railroad Act in 1862, it was easy for Californians to imagine easterners coming to Yosemite in enormously higher numbers, with corresponding pressure for development and worse.[1] At the Calaveras Grove of big trees, some promotion-minded yahoos had even cut an immense piece of bark from the entire circumference of a sequoia and shipped it to England for exhibit.[2] The San Franciscans who loved Yosemite worried about it becoming overrun by this kind of scheme—and may even have heard of some. The question was, what could be done?

Today the answer would be clear: set aside the land, perhaps by protecting it like one of our 59 national parks, 129 national monuments, 154 national forests, or 765 wilderness areas. However, in the early 1860s, a "landscape preserve," or whatever it would be called, was a faintly and narrowly expressed theoretical construct. Such an idea had never been seriously considered by government—or by almost anyone. True, a few men of national prominence had nibbled around the perimeter of the idea for a couple of decades. In 1832, ethnographer and illustrator George Catlin suggested that land lightly touched by Anglo-Europeans was worthy of "preservation and protection [because] the further we become separate from that pristine wildness and beauty, the more pleasure does the mind of enlightened man feel in recurring to those scenes." Catlin's idea was to create one or more vast preserves in the Great Plains, where Native Americans, buffalo, and prairie grasses would live, grow, and be left alone. A few years later, painter Thomas Cole proposed but ultimately failed to write a book that would address, in part, the need to save and perpetuate landscapes fast being lost to American expansionism. Emerson proposed something similar in an 1844 lecture-cum-essay about America's maturation titled *The Young American*. He called for "the interminable forests [to] become graceful parks, for use and for delight."[3] There was also *New York Tribune* editor Horace Greeley, who, as we have already seen, vacillated between arguing for rapacious consumption and mild conservationism, including the suggestion that America "spare, preserve, and cherish some portion of your primitive forests."[4] Their ideas did not advance. There is no reason to believe that anyone in California knew what Cole or Catlin had written, and Greeley's positions were so contradictory and tossed off that they made almost no impression (recall how Thomas Starr King ribbed his friend via the *Transcript* by referring to his "very hurried September visit to the valley").[5] The only proposition that the Californians may have known was Emerson's—and his advocacy was just one phrase from one sentence within a twenty-one-page essay.

In the winter of 1863–64, a group of San Franciscans began thinking about whether Yosemite could be spared from development, deforestation, and related ills. It is unclear when or how this concern transformed into the idea to set aside the landscape, to preserve it as a special place, to invent something like a nature park.

The conditions that led to the idea were almost uniquely San Franciscan. First, the city had ready access to Watkins's pictures, which presented a specific, unprecedented place to San Francisco and the nation at an acute moment of national calamity. The specifics of the pictures surely mattered: they showed a seemingly pristine and thriving landscape at a time when Civil War battles resulted in horrors—including the destruction of whole forests in the East. (The Battle of the Wilderness in Virginia famously resulted in the evisceration of a landscape dense with underbrush and trees.)

A second important factor was the extraordinary geographic diversity of San Francisco's population, its amalgamation of Americans from many corners of the Union, and the proximity in which they lived. The Yosemite idea seems to have been born in a single neighborhood, in the several blocks around the intersection of California and Montgomery Streets. This was the heart of San Francisco's business district, the area whose growth had been fueled by the construction of Frederick Billings's Montgomery Block, and now the intersection at which Watkins lived and worked. Among the other men who also lived and worked in this neighborhood and who contributed to the Yosemite idea were Billings, Starr, and Israel W. Raymond, about whom little is known except that he was a businessman whose interests included representing New York's Central American Transit Co. Also there were Frederick Law Olmsted, who lived at Las Mariposas but who spent much of his time in San Francisco and in a hotel in this neighborhood, and California U.S. senator John Conness, who would have spent time here because so many government offices were in the Montgomery Block. These men were all connected by the usual covalent bonds of business and politics, and connected personally too. For example, when Frederick Billings and his wife left California for Vermont (a sometimes on, sometimes off move that took them several years to conclude), their friends the Raymonds moved into the Billingses' former flat in the Occidental Hotel. And, of course, Billings, Olmsted, and Starr all knew each other from the U.S. Sanitary Commission. All of these men were connected to Watkins directly and also via concentric circles that reached the eastern intelligentsia. For example, during Olmsted's single semester at Yale, he took a class from Benjamin Silliman Jr., who would buy many Watkinses of Yosemite and Mendocino. In 1864 Olmsted would invite Silliman to visit and assess Las Mariposas.[6] Olmsted was also close friends with Watkins collectors Asa Gray and Albert

Bierstadt, and he may have been an investor in San Francisco's Spring Valley water company, for which Watkins made pictures in the 1860s.[7]

Just beyond this circle were the California Geological Survey scientists, Josiah Whitney, William Brewer, Clarence King, and the rest, men who both mapped the state and discovered and chronicled its natural resources. For men of capital such as Billings and Raymond, the discovery of potential sources of wealth would have been of great interest. Most of these same men were also involved with early efforts to build a significant college in California. These men were where the Venn diagram of California's interest in business, science, politics, cultural Unionism, and education overlapped.[8]

While the mechanics of how these men joined to come up with the new idea to preserve an entire landscape is lost, we can see how America's approach to nature evolved in a way that would have led them to see the preservation of a large, remote park as something reasonable, even possible. The story is not as simple as historians, especially Watkins historians, have suggested: that Congress and President Abraham Lincoln liked Watkins's Yosemite pictures so much that they were moved to set aside the landscape that is now Yosemite National Park. In this telling, the nature-park idea alchemically emerged from Watkins's albumen prints. This is simultaneously implausible and not entirely wrong. Considering the Yosemite idea within a broader historical context elevates the importance of Watkins's pictures by including in the story contemporary influences that informed both the pictures and the nature-park idea itself, bringing them closer together.

The history of the idea of the national park, the Yosemite idea, begins with America finding pleasure in nature. As we saw in chapter 3, this was no sure thing. Among those who urged America to value wilderness were many men and women who have skipped through our story, including William Cullen Bryant, a friend and mentor to Thomas Starr King and the host of Starr's New York going-away luncheon. Bryant was one of the most widely read poets and writers of his day. His 1817 nature-celebrating poem "Thanatopsis" may have been the most-read poem of pre–Civil War America. The influence of men such as Bryant, Starr, and Henry David Thoreau was crucial: before America could set aside a remote landscape as a park for the nation, Americans had to find value in nature.

While Bryant and Thoreau were important, it was Emerson who had more influence on the parks idea than any other easterner. In *Nature* and in other writings and lectures over many decades, Emerson made the radical argument that land's value wasn't only in the ore or timber or agricultural crops that could be harvested from it; mere nature had value because trees and flowers and fauna were beautiful and provided benefits related to both faith and spirit. ("Cities give not the human senses room enough," Emerson writes in the essay "Nature," in his second series of essays. "We go out daily and nightly to feed the eyes on the horizon, and require so much scope, just as we need water for our bath.")[9] As we'll soon see, Emerson's importance to the Yosemite idea was well understood in the 1860s but has somehow become lost in the decades since.

Next, Americans who loved wilderness had to embrace a specific landscape so intensely that others would join in their discovery and embrace it as their own. Thanks substantially to Starr's writing and especially to Watkins's pictures (and secondarily to Albert Bierstadt's paintings), this happened with amazing speed in relation to Yosemite. So how did an intensity of feeling for Yosemite lead to the idea that an immense, rural, mountainous landscape could and should be preserved? After all, Americans had admired other remote landscapes, most notably Niagara Falls, but those landscapes had been commercially developed rather than preserved. Here is where San Francisco's unusually polyglot population—nowhere in America had more people come from more different places to create a city—brought together men with a range of ideas and experiences. The San Franciscans who began to formulate the Yosemite idea were unusually well informed about how a range of American communities had treated landscapes, and especially about the decades-long progression of the American parks idea.

As Starr and Olmsted would have known better than the rest, American parks of all kinds had their origins in the establishment of nonsectarian cemeteries, in the separation of burial grounds from church land. The first of these was Mount Auburn, which opened in 1831 on the edge of Cambridge, Massachusetts, a short walk from Starr's Hollis Street Church. It was immediately a popular destination for day-trippers and would soon become such a hit that, along with George Washington's Mount Vernon plantation-cum-gulag and Niagara Falls, it was early America's most popular tourist attraction.[10] Starr would have recognized that rural cemeteries were born

from a tentative fusing of nature with city, of spirituality with landscape, each a manifestation of transcendentalist thought.[11] For Olmsted, the rural cemetery movement provided both inspiration and professional opportunity. Olmsted knew and admired Brooklyn's Green-Wood Cemetery, and as the codesigner of New York's Central Park, he recognized that rural cemeteries pointed to the American version of the municipal park idea.[12] When brought together in California, might Boston's Starr and New York's Olmsted, who knew each other from their transnational work for the U.S. Sanitary Commission, have discussed the confluence of nature, cemeteries, and parks? No doubt, as it was the non–Sanitary Commission thing California's two leading intellectuals had most in common. Their other major points of connection were Billings, who was becoming interested in conservation, and their mutual New York friend Bryant. Starr and Bryant had remained so close after Starr had left the Northeast for California that Bryant helped Starr raise money for a new organ at San Francisco's First Unitarian.[13] Bryant was also crucial to Olmsted's career: in 1844, Bryant had written an editorial in his *New York Post* that did much to advance what would become Central Park.[14]

Mount Auburn was the manifestation of another idea that was important to Starr and that would become important to Olmsted and the rest of the San Franciscans: the notion that ideas and ideals could be assigned to a landscape. Emerson trumpets this possibility throughout *Nature*: "Have mountains, and waves, and skies, no significance but what we consciously give them, when we employ them as emblems of our thoughts? The world is emblematic. Parts of speech are metaphors, because the whole of nature is a metaphor of the human mind."[15] Mount Auburn pushed Emerson's suggestion past metaphor and into actuality. Its radical ideals were represented by and even literally embedded in its landscape: Mount Auburn was established with no restrictions on who could be buried there or on who could visit. African Americans were buried next to white Unitarians who were buried next to Jews.[16] It may have been the only such egalitarian burial place in America. In late 1860, when Starr responded to Edward Baker's plea to engage northern culture from California, he would have known Mount Auburn as a place where landscape held an idea within itself.

Seventeen years after Mount Auburn opened, painter Frederic Edwin Church nudged forward its founding idea in a painting called *To the Memory*

of Cole (1848). It is a tribute to Church's late mentor Thomas Cole, who died that year. Church offers a Hudson River landscape with a cross, Church's imagined marker of Cole's gravesite, in the middle of the landscape. If Mount Auburn was a spiritual landscape of burial, Church's picture is a landscape *made* spiritual by a burial. Another key difference between the Mount Auburn idea and *To the Memory of Cole:* Mount Auburn wasn't activated by the dead but by the living, by its design as a place for people to visit. Conversely, there are no people in *To the Memory of Cole;* Church is suggesting that the landscape can hold an idea, and even a memory, without human presence.

The next advance in the American park idea came in late 1863 with the establishment of a new national cemetery at Gettysburg, where a state and the nation would establish a secular landscape of burial, a place where people were welcome to visit but at which the idea that motivated the place, respect and thanks for valiant death, did not require it. The Battle of Gettysburg, fought July 1–3, had been the apex of Confederate penetration of the North and, as it turned out, the beginning of the end for the South. It was an extraordinary bloodbath: over the course of three days, twenty-three thousand Northern soldiers, 20 percent of the Army of the Potomac, were killed or wounded or went missing. Confederate losses totaled about twenty-five thousand, more than a third of Robert E. Lee's Army of Northern Virginia. It was the latest, most costly battle in U.S. history, nearly doubling the slaughter at Antietam.[17]

Gettysburg, a rural town of 2,500 residents, was ill-prepared to cope with the thousands of corpses and body parts. Three weeks after the armies moved on, David Wills, the town's leading attorney, wrote to Pennsylvania Gov. Andrew Gregg Curtin to report that "in many instances arms and legs and sometimes head protrude [from the ground], and my attention has been directed to several places where the hogs were actually rooting out the bodies and devouring them."[18] The usual practice, by which states sent commissioners to a battlefield to physically reclaim their units' fallen for burial back home, simply would not do here. If the corpses and body parts were not swiftly dealt with, they could, at minimum, contaminate local streams. Curtin assigned Wills management of the situation. Wills stopped land speculators from buying up possible burial grounds around Gettysburg, formed an interstate commission that would collect funds from the

states for the establishment of a cemetery on the battle site, and hired William Saunders, a "rural architect," to design the new cemetery's layout.

As was the custom, Wills planned a ceremony at which the burial ground would be dedicated with commissioned oratory. He invited Edward Everett, esteemed former diplomat, elected official, Harvard president and an orator whose speeches at Bunker Hill, Lexington, and Concord had popularized those revolutionary sites, to speak in Gettysburg in October, and planned to begin burials shortly thereafter. Everett, whose speeches were known for being deeply rooted in the history of a given place, insisted on more research time, which pushed the dedication event into the fall. Wills also invited President Lincoln and members of his cabinet to attend. Lincoln accepted. On November 19, 1863, the ceremony took place. Everett delivered a two-hour speech, which was well received by both the assembled tens of thousands and by Lincoln's own staff. Lincoln's three-minute address followed.[19] (Starr, the West's greatest orator, was surely paying attention from afar: Everett's nephew Edward Everett Hale was among Starr's closest friends and most frequent correspondents. After Starr's death, Hale would be one of the three speakers at Starr's memorial service at Boston's Hollis Street Church. Olmsted was plenty familiar with Hale too—Hale had wooed away and married Olmsted's first fiancée, Emily Perkins.)[20]

For whatever reason, California's newspapers initially paid little attention to the dedication of the new ground at Gettysburg. The ceremony had taken place on November 19, the news was sent west over the telegraph on November 20, and the *Daily Alta California* published but a single paragraph on it in the next day's edition. Oddly, the paragraph concluded: "The weather being fine, the programme has been carried out successfully."[21]

Soon California newspapers realized they had underplayed a big story and began to publish firsthand accounts of the ceremony. It was not until the third week of December, a month after the event, that Lincoln's dedication of the Gettysburg ground and Everett's grand oration were published in full in the West. As a result, it wouldn't be until nearly the end of 1863 that Californians, no doubt Starr and Olmsted most of all, could have understood Gettysburg's significance as a new kind of landscape park. Given their experience with land and landscape, surely several of the San Franciscans, Starr especially, realized that never in American history had the relationship between a landscape and a nation's imagination of itself been made as

explicit as Wills, Curtin, Saunders, Everett, and ultimately Lincoln had made it at Gettysburg. A Pennsylvania landscape had been effectively handed over to the nation, a wholly novel concept, by virtue of its use as a cemetery for young men from many states who stood and died together while "dedicated to a proposition." At Gettysburg, landscape was explicitly made into both a memorial and the hilly embodiment of an idea.[22] By comparison, Mount Auburn had been muted in its underground progressivism.

Carleton Watkins understood Gettysburg's importance, especially what it meant to westerners. No later than mid-1864 and by means unknown, he procured pictures of twenty-four-year-old Edward B. Williston, a Californian who had volunteered for the army in the summer of 1861, was commissioned as a second lieutenant, and evidently paid his own way to the eastern theater. Williston would serve with distinction and was twice brevetted, including to major on Gettysburg's final day. (The next summer Williston would earn the Medal of Honor for gallant service in destroying Confederate railroad tracks at Trevillian Station, Virginia.) Watkins pointedly exhibited a photograph of Williston, the local war hero in a locality with few of them, at the 1864 Mechanics' Institute Fair.[23]

Olmsted also understood Gettysburg well, for he had been there in July, in the wake of the battle. As the secretary of the U.S. Sanitary Commission, Olmsted had spent weeks personally coordinating the commission's relief efforts from Baltimore, Frederick, and Williamsport, Maryland, and in Gettysburg itself.[24] As a professional designer of a city park intertwined with New York politics, and now as an administrator of a sprawling nongovernmental agency, Olmsted was singularly positioned to understand the importance of what to most people was a mundane detail: the seventeen acres on which the cemetery sits were purchased by the State of Pennsylvania but would be offered to the United States as an explicitly national site.

Historian Gary Wills explains the importance and originality of this idea in a way that suggests how Gettysburg may have become a precedent for the Californians. He points to Lincoln's speech and the way in which it established not the Constitution but the Declaration of Independence as the nation's founding document. Lincoln's Declaration-centric approach to U.S. history answered radicals who believed that the South had strayed from the founding idea (Starr among them) and that the South should be excised from the nation, allowed to go its own way. Lincoln offered the Declaration

as what Wills calls "the sovereign act of a single people"; as such, a group of those people could not choose to except themselves from it.[25] This was Lincoln's rationale for fighting the war, and it would be the rationale that converted those seventeen acres in rural Pennsylvania into hallowed ground, a memorial and a symbol, that from that moment would be the nation's, and not just Pennsylvania's. With input from the progressive recent past of the Union states, especially the New England states, American ideas about landscape and how the country could and would consider it were changing to meet the extraordinary time. Wills wrote that Lincoln's Gettysburg Address "remade America." Certainly it helped remake the way in which America considered how and to what ends it might use specific landscapes.

It was with knowledge of this recent American landscape history that the San Franciscans considered what to do about Yosemite. The development of their approach is lost, but our first surviving document of what historians call the "Yosemite idea" or the "national park idea," dated February 20, 1864, represents an idea well formulated and obviously well advanced.[26] It is likely the product of conversations that began in San Francisco sometime earlier, probably in late 1863, at about the time the news of Gettysburg's dedication arrived in the West. In this letter, sent to Conness above Raymond's signature, the author or authors suggest a need for speed lest commercial "occupation" advance and cost the valley some of its trees. The author or authors, and perhaps only Raymond himself, presents all this in language intended to be dropped into legislation.[27]

The letter opens with a Watkins picture: "I send by Express some views of the Yosemity [sic] Valley to give you some idea of its character," Raymond writes. "No. 1 is taken from a point on the Mariposa trail and gives a view of about seven miles of the Valley, and the principal part of it. You can see that its sides are abrupt precipices ranging from 2500 feet to 5000 feet high. Indeed there is no access to it but by trails over the debris deposited by the crumbling of the walls." It goes on to roughly define the area to be preserved as Yosemite Valley and the Mariposa Big Tree Grove, which Watkins had photographed, but not the Calaveras Big Tree Grove, fifty-five miles to the northwest, which he had not. The letter asks that the land be set aside for "public use, resort and recreation" and be "inalienable forever."

While Raymond's letter is the oldest surviving document of the Yosemite idea, it is not an introduction of the idea but a continuation of a now-lost

conversation or correspondence. It is not clear how the letter was delivered to Conness, though its dating suggests that either Raymond sent it from New York or that he handed it to Conness in Washington or New York. As for the "views of the Yosemity Valley," Raymond mentions one specific picture taken from the Mariposa trail, likely Watkins's stereograph *From the Foot of the Mariposa Trail*, a view that shows, as Raymond writes, the valley's drama."[28] (Aside from mostly forgotten Charles Leander Weed, Watkins was the only photographer who had been there.) Raymond also suggested to Conness that preserving the landscape in some form would not negatively affect the state's economy. "The summits are mostly bare Granite Rocks," Raymond writes to Conness. "In some parts the surface is covered only by pine trees and can never be of much value." This was not true, but it served its purpose. The letter closes by suggesting some commissioners who might oversee the new park, including George Coulter, the Mariposa County businessman who had constructed the stage road from Coulterville into Yosemite, and John F. Morse, a Sacramento-based medical doctor, editor of the *Sacramento Union,* and an influential man close to many California elected officials.[29] It's not clear if or how either Coulter or Morse participated in the formation of the Yosemite idea, or whether they were just useful allies. Neither of them is known to have had the long-term ties to nature appreciation or preservation that the others had.

With that, the Yosemite idea had been presented to an influential senator. It did not immediately advance. It may have needed a nudge. It seems to have received one in the form of the greatest tragedy in California's young American history.

In February 1864 Frederick Billings traveled to Washington, DC, to meet with Lincoln administration officials and legislators about matters important to his investments in the West and, no doubt, about his own political future. For several years Billings had considered putting himself forward for one of California's Senate seats. There was also talk that Billings might be appointed to a cabinet post in a possible Lincoln second term.[30] Lest there be any doubt about the purpose of Billings's visit (or his wealth), he stayed at Willard's, the hotel a block from the White House in whose lobby businessmen and politicians met—the place and practice that gave us the word "lobbying."

Upon waking on March 5, Billings walked to the door of his hotel room to pick up the morning paper. He probably didn't expect to find much in it. Both the Union and the Confederate armies were still in semihibernation, and it would be several days yet before Lincoln would make the first big news of the year: the elevation of Ulysses S. Grant over Billings's former San Francisco law partner Henry Halleck as general in chief of the Union armies.

Billings looked first to the section of the paper that featured the latest news from the telegraph, what we'd now call the national news section. It delivered a shock: Thomas Starr King was dead. He was just thirty-nine.

Overcome, Billings reached for pen and paper and wrote his wife, Julia. "The only thought in my mind is, Starr King is dead!" he wrote. "It came so suddenly it stunned me. After a while tears came to my relief—but I am yet greatly disturbed that he should die in the point of his manhood with all his wealth of intellect while laboring so earnestly and so effectively and to [so?] generously [illegible word] good work.—I cannot understand it! A great darkness seems to have come down upon California. A great light has gone out there. . . . Now that he is dead, are you not glad that you knew him? Have you ever seen a man of such courage, philanthropy, such an unselfish worker? I never did."[31]

For Billings it was the loss of one of his closest friends, for California it was the loss of its greatest man, for the nation it was the loss of its first transnational intellectual and the Union's most important charity fundraiser. Edward Baker's death in 1861 introduced the West to the pain of civil war; Starr's death "shocks it like the loss of a great battle or tidings of a sudden and undreamed of public calamity," as the *San Francisco Bulletin* put it.[32] In hindsight, it was clear that Starr's premature death was several years in the making. As Starr raised money to pay off First Unitarian's $20,000 debt and then to build a new, 1,500-seat church, as he built the antislavery Republican Party in South-aligned California from near nothing and then campaigned for its early candidates and eventually for Lincoln and then for Union, as his western fund-raising for the U.S. Sanitary Commission provided a quarter of its funds even though the western states and Nevada Territory made up 1.4 percent of the nation's population, as he brought a love of nature out of the Unitarian churches of New England and into the West thus infusing America's mining state with a respect and even love of the landscape it was hell-bent on eradicating, and even as he nurtured and launched

the careers of Bret Harte and Carleton Watkins, he complained of exhaustion and of shortness of breath even as he refused to slow. It had caught up with him, first as diphtheria and then pneumonia. "California enjoys an excellent reputation to-day for loyalty, liberality and devotion to the Union," the *San Francisco Bulletin* said. "We owe to no man so much for this reputation as to Mr. King."[33]

Watkins's immediate response to the death of his friend has been lost. Before long, he would mark it with his camera. Just as Watkins had photographed David Broderick's tomb and apparently Edward Baker's too, he would make a picture commemorating Starr's resting place. In late 1863 or early in 1864, Watkins had made a mammoth-plate picture of the English Gothic facade of Starr's new, William Patton–designed First Unitarian Church. ("The church is a perfect type of Mr. King's character," Rev. Henry Whitney Bellows wrote in his diary after traveling to see it. "The . . . walls are a delicate blue and light yellow color, and are especially beautiful when the church is lit up at night.")[34] Watkins's picture, taken at a slight angle from the front, which he had made from the top of one of the buildings across the street, emphasized First Unitarian's solidity, the permanence of the thing that his friend had built. After Starr's death, Watkins returned to take a picture of Starr's memorial-cum-tomb out in front of First Unitarian. Today this picture, surely made in a mammoth-plate version that is no longer known, exists as a medium-format picture.

San Francisco, understanding that Starr had worked himself to death for the Union, filled First Unitarian with Egyptian lilies, a traditional symbol of martyrdom. As many as twenty thousand mourners paraded through the church. "His star kept rising in strength and power, whilst his physical system was not vigorous enough to withstand the heavy tasks he crowded upon it, and breaking down under the heavy pressure, the whole fabric gave way," said the *Daily Alta California*, which, like other newspapers in California, lined its typeset columns with black in Starr's honor.[35] The news stunned Jessie Benton Frémont, who was now living in New York. Remembering the gift of violets Starr had given her when she departed San Francisco at the outbreak of war, Jessie telegraphed, "Put violets for me on our dear friend who rests."[36] The *Alta* published her telegram, but instead of identifying Jessie as its author, coyly (but clearly) described the sender as "the wife of a Major General not unknown on the Pacific Coast." Starr's antislavery

position and the rare welcoming warmth he regularly showed members of California's small black community was well remembered too: at Starr's funeral, two sobbing black women kissed the American flag that served as his burial shroud.[37]

The state of California recognized Starr's death as a war casualty. Guns from San Francisco's forts were fired during the funeral, and flags at all military posts flew at half-mast. A military guard stood over Starr's remains until he was buried. Across the bay in Oakland, at the College of California, the institution that would become the University of California, Berkeley, a senior named D.L. Emerson read a eulogy at the school's chapel. Emerson pointedly aligned Starr's death and oratorical skills with Edward Baker's.[38]

The feeling was no less in the East, to which the still-new transcontinental telegraph had delivered the news. "It is universally conceded that no man had ever done so much as he toward making California loyal," reported a telegraphic dispatch published by many eastern papers. In Boston, where Starr's prodigious letter writing had kept him engaged with the city's intellectual community, his death was the lead story in the *Evening Transcript,* and coverage spilled onto two pages. "Throughout the East and the West crowds welcomed the brilliant writer and the eloquent speaker—the boy in appearance that was so manly in his graceful and attractive power," the paper reported. "The whole loyal country knows and honors his brave and efficient patriotism. His entire soul, all that was in him of intellectual force and fire, of persuasive, convincing or rebuking speech, was dedicated to the cause of the republic, to the saving of its freedom and its nationality."[39] Cyrus Augustus Bartol, the sort of man who had all the advantages that had been unavailable to Starr because of the early death of his father, spoke at a memorial service in Boston's West Church: "He has stood there [in California] like that Mount Shasta," Bartol said, no doubt prompting a snicker from an audience familiar with Starr's diminutiveness. "More than any man, he has bound California to the United States."[40]

As a sign of respect for both Starr and California's outsize philanthropy, Bellows, whose idea that Starr should go to San Francisco had turned out so spectacularly for church and country, sailed for San Francisco to temporarily fill his pulpit at First Unitarian.[41] Bellows would stay for several months, preaching in San Francisco, fundraising for the U.S. Sanitary Commission, and visiting many of Starr's favorite places in the state. In a nod to

Starr's other major legacy, his advocacy for nature in a region that had never much considered it before he and Watkins trumpeted its wonders, Bellows preached a sermon from atop a tree stump in the Calaveras Grove.[42]

Starr's death marked the end of California's founding period. Many of the key figures in California's first American generation had already died or left to fight in the Civil War: First the Frémonts had moved east, and now the Billingses were spending more and more of their time there too. Broderick had died before the Civil War, Edward Baker had been killed in one of its first battles, and now Starr.

For Watkins, Starr's death would have been the deepest blow imaginable. More than anyone else, it was Starr who had shared Watkins's work and advocated for him with the East's greatest men, Ralph Waldo Emerson, Oliver Wendell Holmes, and the sort of intellectuals Watkins never could have reached on his own. With Starr's death, all of Watkins's earliest enablers, sponsors, and motivators were either gone east or dead. He would have to adjust.

On the day after news of Thomas Starr King's death arrived in Washington, Sen. John Conness acted on the Yosemite idea. Conness forwarded Israel Raymond's letter to the General Land Office with instructions to draft the bill described therein, the bill that would ultimately preserve Yosemite and the Mariposa Grove. The confluence of Billings's presence in Washington, news of Starr's death arriving there, and Conness's moving forward with the Yosemite proposal the day after learning of the passing of the most distinguished, best-known resident of his state raises two related questions: Did Starr's death specifically motivate Conness's decision to advance the Yosemite bill? Did Yosemite advance in part as a memorial to Starr?

Both the context provided by the moment and a series of seemingly related facts and events suggest yes, and yes. Everyone likely involved in the Yosemite story understood the immediate precedent for the linkage of landscape and memorial: Gettysburg. Everyone would have read and remembered Lincoln's address there, notably the part about how soldiers "gave their lives that [a] nation might live." In California and beyond, Starr's death was immediately seen as a martyrdom, as his having given his life for antislavery Unionism, as his having given his life to elect Lincoln and save California for Union, and most recently, as his having given his life to the U.S. Sanitary Commission. So clear was the tie between Starr's death, the

Union cause, and nature that even Bellows, a mainline New York Unitarian a continent removed from the West's devotion to Starr and himself neither Emersonian nor friend of transcendentalism, made the connection in a widely published memorial message, which he telegraphed to California the day after learning of Starr's death. "The mountains he loved and praised are henceforth his monument and his mourners," Bellows wrote. "The White Hills and the Sierra Nevada are to-day wrapped in his shroud. His dirge will be perpetually heard in their forests."[43] Whether Bellows knew it or not—and as he was well-connected to nearly all of the leading actors both in Washington and San Francisco, he may have—the process of creating such a monument seemed to be well under way.

Might Conness have moved at this precise moment on his own initiative? Sure, but it's more likely he was prompted by Billings, who was shaken into increasing conservationism first by Starr's example and then by Starr's death. When Conness introduced the bill drafted by the General Land Office on the Senate floor on March 28, he cited its origin in "California gentlemen of fortune, of taste, and of refinement."[44] Billings was a regular visitor to Yosemite and the Big Trees, and aside from Jessie, the only one of the people apparently involved in the Yosemite idea who could be said to possess a fortune.[45] (Conness would not have referred to a "woman of refinement," even if she had telegraphed encouragement from her home in New York City, because to do so would have pointed too directly to Jessie Benton Frémont and the Frémonts' influence, which, given John's various faux pas and then failures as a Union general and his interest in challenging Lincoln for the presidency that year, would not have been politically advantageous.) Upon introduction in the Senate, Conness's bill was assigned to the Committee on Public Lands.

The bill was reported out of committee onto the Senate floor on May 17. It was not delivered through the logical body, the Committee on Public Lands and its chairman, James Harlan of Illinois, but through Solomon Foot, a mere member of the Committee on Public Lands and, until a few weeks earlier, the Senate president pro tempore.[46] This too hints at Billings's influence: Foot was a Vermonter. In the late 1840s, when Billings had worked as a secretary to Vermont's governor, Foot had been the speaker of the state House of Representatives. The two men were from neighboring counties and were friendly correspondents.[47] Once introduced on the Senate floor, the bill quickly passed. It was swiftly approved by the House of

Representatives as well.[48] Then it went to the White House for President Abraham Lincoln's consideration.

The next step was to ensure that President Lincoln signed the bill. Did Conness show, or give, Watkins pictures to President Lincoln in an effort to inform his decision on the bill? There is no surviving Conness archive, and White House documents offer no clues. However, shortly after Lincoln assumed office in 1861, he and Conness became close. When Lincoln was assassinated, Conness would be one of the pallbearers at his funeral.[49] Lincoln was indebted to California for staying in the Union, for supplying the gold and silver that backed the bonds that paid for the Union war effort, and for contributing so much to the U.S. Sanitary Commission, and he was accordingly attendant to its interests. His friendship with Conness was part of that. If Conness had wanted Lincoln to consider Yosemite with favor, Lincoln would have.

President Lincoln signed the Yosemite bill on June 30.[50] The new law granted Yosemite Valley and the Mariposa Grove to the State of California to be "held for public use, resort, and recreation" and said that the use of the land in this manner "shall be inalienable for all time." The act did not define the boundaries of the grant and instead required that California survey the potential park and affirm its boundaries with the federal government's General Land Office. It also called for the state to appoint a commission to determine, in essence, what this new thing, this park, should be. (The word *park*, in such common usage now, was not in the 1864 legislation.) California Gov. Frederick Low named Frederick Law Olmsted to lead the commission and named Josiah Whitney and William Ashburner of the California Geological Survey, several Mariposa County businessmen, and Galen Clark, the protector of the Mariposa Grove, to round it out.[51] Olmsted asked three artists to advise him and the commission: Watkins and two painters whom Watkins counted as friends, Thomas Hill and Virgil Williams. It seems to have been the first time in American history that artists were included in a public-policy process.[52]

Today the Yosemite bill's establishment of public land, a concept that the United States would copy in establishing the Forest Service and other federal agencies and that dozens of countries around the world would copy in establishing their own national parks and other preserves, stands with the early twentieth-century changes to American child-labor laws motivated by

photographer Lewis Hine as the most significant American public policy motivated by an artist.

Fast forward, for a moment, to four years after Lincoln's assassination, to the spring of 1869. The president now, for a few more days, is Andrew Johnson, the Unionist Tennessee Democrat who had been vice president when Lincoln was assassinated. In 1868 Johnson had sought the Democratic nomination for the presidency, election in his own right. Unpopular almost everywhere, especially in Washington, where the House had voted to impeach him and where the Senate came within a single vote of going along, Johnson lost handily. On the Democratic convention's final ballot, Johnson won only four delegates, all from his home state. In the national election that followed, Ulysses S. Grant was elected Johnson's successor. As the inauguration approached, Grant made it clear that he would not adhere to the custom of sharing a carriage ride to the inauguration with the sitting president. Johnson reciprocated by refusing to attend Grant's inauguration.

On his way out of Washington, a spiteful Johnson took a certain revenge on the political establishment that had repaid his loyalty to the Union with impeachment: he essentially plundered the White House, absconding with furniture and more, all of which he took home to Greeneville, Tennessee. Some of what he took he kept; some of it, such as a sofa now at Greeneville's Dickson-Williams Mansion, he gave away.

Among the items that have passed from the Johnson family to the National Park Service, which now administers Johnson's postpresidential home as the Andrew Johnson National Historic Site, are four 1861 Carleton Watkins photographs of Yosemite: *Cathedral Spires, Outline View of Half Dome, The Lake,* and *Cascade,* the picture that may have been a response to Frederic Edwin Church's *Niagara.* Each is glued to thin card stock, not the heavier stuff Watkins usually used. Each is signed *C. E. Watkins,* in Watkins's hand.

As with much of the material descended from Johnson and now at the national historic site, there's no contemporary documentation of the provenance of the Watkinses.[53] How did Johnson come to have them?

It is unlikely that Johnson acquired the Watkins pictures before he was president. In 1862, when Watkins started printing, distributing, and ultimately selling his 1861 Yosemite pictures, Johnson was the military governor of the parts of Tennessee controlled by Union troops. There's no

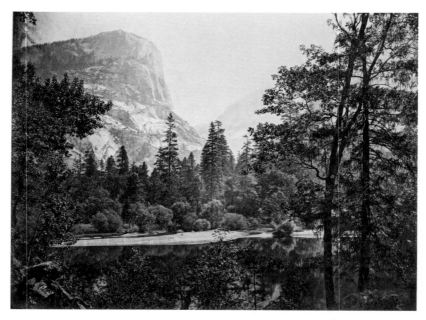

Carleton Watkins, *The Lake, Yosemite*, 1861. Collection of the Stanford University Libraries.

reason to believe Johnson, cut off from Northern newspapers and mail, knew about Watkins's pictures, had heard of Yosemite, or could have received Watkinses from California. The chronology of Johnson's ascent to the 1864 Republican ticket and then to the vice presidency does not seem to allow him to have acquired them in Washington before becoming president. On March 4, 1865, Johnson was sworn into his new office. Because Johnson had as much faith in liquid courage as he did in the Lord, he met the moment by downing a substantial amount of whiskey. As all Johnson had to do at the swearing-in was repeat words that were read to him, he did fine. But after the swearing-in, Johnson and the whiskey gave an acceptance speech that Johnson probably should have given alone. President Lincoln quickly ensured that Johnson would not speak at the formal inauguration later that day.[54] Disgraced, Johnson retreated to the edge of the city, to the home of Lincoln ally Francis Preston Blair. He stayed there, out of sight and mercifully out of mind, until Lincoln was assassinated. As Johnson had become an embarrassment almost immediately upon his return to Washington from Tennessee, there was little to no opportunity for him to have even been

given an 1861 Watkins Yosemite picture, even as a gift intended to mark his ascension to the vice presidency.

By the time Johnson became president in the spring of 1865, Watkins was about to make a trip to Yosemite, where he would congregate with Frederick Law Olmsted and update his 1861 pictures. Had President Johnson been gifted Watkins pictures of Yosemite, surely they'd have been the new 1865–66 pictures, not the 1861 pictures. And yet Johnson came to have four 1861 Watkinses. He hung each of them in his Greeneville home; visitors calling on the former president would have understood that Johnson displayed these pictures as a symbol of Union and of the Union's triumph.

The likeliest source of these four Watkinses is the White House itself, which means that these may have been the Watkinses that Lincoln saw before signing the Yosemite bill. While no documentation proves that they were among the objects Johnson took with him when he left Washington in a huff—there is no documentation recording the sofas, drapes, or anything else he took with him either—there seems to be little other place from which Johnson could have procured 1861 Watkinses.

Today the Andrew Johnson National Historic Site, which has kept Johnson's house as true as possible to how Johnson kept it, has wisely replaced the four historic, faded pictures with copy prints. It does not know where Johnson hung the pictures, but it still has what appear to be period frames in which Johnson displayed them.

In early August 1865, Frederick Law Olmsted gathered his fellow Yosemite commissioners at a campsite along the Merced River for an impromptu meeting of the Yosemite Commission. For several months he had been working on a draft of his report to the State of California, and he was ready to share his work. There was a second reason for this little gathering: the largest and most distinguished eastern delegation ever to visit Yosemite—or, for that matter, the state of California—just happened to be in the valley, and in this very camp. It seemed a good time for Olmsted to begin to win others over to his idea of what Yosemite should be.

Olmsted knew that his audience included four of America's most prominent journalists and newspaper publishers: the *New York Tribune's* Albert D. Richardson, whose wartime exploits had made him the most famous journalist in America, *Daily Alta California* publisher and Watkins collector

Frederick MacCrellish, *Springfield (Mass.) Republican* editor Samuel Bowles, and *Chicago Tribune* deputy editor William Bross (who was also the lieutenant governor of Illinois). Both Richardson and Bowles would later write books about this trip. Also present was Indiana Rep. Schuyler Colfax, the speaker of the House of Representatives, and Boston attorney Charles Allen. The entire party had been organized to join Colfax on what was ostensibly an inspection tour of the overland mail route. That was a pretense. The complications of cross-country travel and the realities of impending sectional conflict and finally the Civil War itself had prevented government officials and other eastern men of distinction from seeing America's Pacific lands until now. This trip, begun just a few weeks after the Civil War ended, was essentially a victory lap for seventeen Republican Unionists.[55]

Understanding that the reading of a report can tend toward dry, Olmsted seems to have arranged a visit from a local celebrity, one of the few Californians of whom everyone in the party would have heard, the man who had most stirred America's interest in this place: Carleton Watkins. We don't know when Watkins and Olmsted met. Olmsted arrived in San Francisco from the East on October 1, 1863, so they probably had known each other for several years before this evening in Yosemite.[56] Olmsted was an early photo bug, and he had a particular appreciation for how photography could present landscape: while touring England in 1859, he had hired a photographer to make pictures of the parks and gardens that he visited.[57] As for the origin of the Olmsted-Watkins friendship, Olmsted was likely pointed toward Watkins by Billings, Starr, or Harvard botanist Asa Gray, who bought and probably commissioned Watkinses. Gray was a close friend of Olmsted's and had formally recommended Olmsted for the Central Park job.[58] (Another recommender: Olmsted's pal Albert Bierstadt.) Watkins and Olmsted seem to have gotten on well; Olmsted was not only about to establish Watkins's most important legacy but also would be a customer and collector for decades hence. That they hit it off is no surprise. Watkins marked the occasion by making pictures, a stereograph and a mammoth plate, of the Colfax party in camp.

Olmsted may have realized that an exciting visitor was a good idea because the title of the text he planned to present to the Colfax party, *Preliminary Report upon the Yosemite and Big Tree Grove*, suggested none of the radicalism within.[59] Olmsted used his title as a bit of bureaucratic blandness

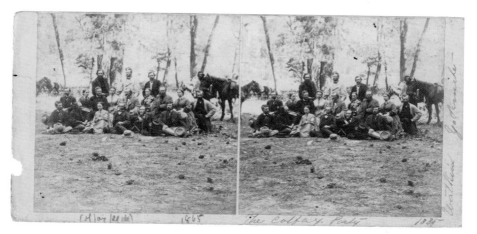

Carleton Watkins, *The [Schuyler] Colfax Party*, 1865. Collection of the Society of California Pioneers, San Francisco.

designed to mask the truth: the ensuing pages were full of new ideas that had never before been suggested, let alone implemented. Today Olmsted's report stands as one of the most important essays written in nineteenth-century America. Along with George Perkins Marsh's 1864 *Man and Nature* and Thomas Starr King's various writings, to which it is indebted, and Watkins's Yosemite pictures, which it repeatedly references, Olmsted's report is a landmark document that links New England's transcendentalism, and specifically Ralph Waldo Emerson's love of nature, to John Muir's later western-motivated conservationism. The report would be influential—Olmsted biographer Witold Rybczynski notes that the way visitors move through Yosemite today comes from it—but after Olmsted returned to New York in 1866, his fellow Yosemite commissioners formally tabled it because they thought its recommendations too expensive. (Josiah Whitney was particularly concerned that funds the state might spend on Yosemite would take away from the California Geological Survey's appropriation.) Olmsted resigned in frustration.[60] He lost on the immediate, short-term specifics, but he won in every other respect.

The unusualness of Olmsted's report is evident in his opening paragraph. He begins this, a public-policy recommendation about land use, by detailing how the Civil War had been good for art in America (by which he meant the Union states). As evidence, Olmsted offered architect Thomas U. Walter's

Capitol dome, which was constructed even as two armies fought a hundred miles to its west, Thomas Crawford's *Statue of Freedom* atop the Capitol dome, Emanuel Leutze's fresco of the settlement of the Pacific West, the completion of architect Isaiah Rogers's West Wing of the Treasury Department's building, the main hall of New York's Academy of Arts, and even his own Central Park as proof that the arts had flourished during the war years. (It's easy to imagine Olmsted reading this last bit and looking right at Bross, who, in his dual position as lieutenant governor of Illinois and deputy editor of the *Chicago Tribune,* was in a position to further Olmsted's interest in building a major Chicago park.)

Why would Olmsted begin a report on preserving a landscape with a summary of four years' worth of Northern achievement in the arts? By now Olmsted had been in California for almost two full years. He understood the state, its politics and its history. He especially understood how intensely the West had felt the deaths of Edward Baker and Thomas Starr King. The opening paragraph—indeed, the entire beginning of Olmsted's report—is a nod at Baker's 1860 American Theater speech. Specifically, the opening paragraph's recitation of Northern cultural achievements picks up on Baker's charge to link the West with the Unionist North through the arts and humanities. (The ubiquitous Olmsted had firsthand knowledge of the special tragedy of Baker's death: as secretary of the U.S. Sanitary Commission, he had visited the hospital at Ball's Bluff just days after Baker died.)[61]

Next, Olmsted presented the manifestation of Baker's speech and Starr's development of it into cultural Unionism: "It was during one of the darkest hours, before Sherman had begun the march upon Atlanta or Grant his terrible movement through the Wilderness, when the paintings of Bierstadt and the photographs of Watkins, both productions of the War time, had given to the people on the Atlantic some idea of the sublimity of the Yosemite, and of the stateliness of the neighboring Sequoia grove." Olmsted could not have linked North with West via culture any more plainly. The subtext was plain: Baker and Starr, California's two martyrs, will not have died in vain.

Olmsted knew, and was OK with, treading on more explicitly sectional terrain. He would have realized that the exhibition of Watkins's pictures in New York just as the Union was suffering its worst battlefield catastrophes of the war at Fredericksburg imbued them with added meaning. Olmsted knew that Bierstadt had exhibited his first Yosemite-inspired painting, *Val-*

ley of the Yosemite, at the 1864 Sanitary Commission fair in New York, where it raised $1,600 for the commission.[62] (As Olmsted was the executive secretary of the Sanitary Commission until late 1863, he may have personally solicited his longtime friend Bierstadt's donation.) *Valley of the Yosemite,* now at the Museum of Fine Arts, Boston, is a fictionalized valley-floor view. It essentially inverts, expands, and exaggerates the view in Watkins's 1861 stereograph *From the Foot of the Mariposa Trail,* one of the stereographs that Israel W. Raymond sent to Sen. John Conness as part of his lobbying Congress to preserve Yosemite.

In a second extension of cultural Unionism across the continent, Bierstadt also exhibited an 1863 painting now known as *The Rocky Mountains, Lander's Peak,* at the fair. While Bierstadt had been to the Rockies in 1859, he did not paint *Lander's Peak* until 1863, by which point a contested landscape—in this case, Nebraska Territory—where the question of whether the land within it would be slave or free had played a leading role in antebellum sectional conflict. By 1863 the idea of presenting a once-contested western landscape to eastern audiences as an act of cultural Unionism had been established by Starr's writings and Watkins's 1861 Yosemite pictures.

Bierstadt's cribbing from Watkins was no accident. When Bierstadt traveled to California in 1863, he had taken along journalist Fitz Hugh Ludlow, who wanted to write a book about the experience. Ludlow wrote that Watkins's Yosemite pictures had inspired his and the painter's westward journey. "We were going into the vale whose giant domes and battlements had months before thrown their photographic shadow through Watkins's camera across the mysterious wide Continent, causing exclamations of awe at Goupil's window," Ludlow wrote in his book *The Heart of the Continent.* "At Goupil's counter and in Starr King's drawing room we had gazed on them by the hour already,—I, let me confess it, half a Thomas-a-Didymus to Nature [a doubter], unwilling to believe the utmost true of her till I could put my finger in her very prints."[63] (Whether Bierstadt knew that *From the Foot of the Mariposa Trail* was one of the pictures that Yosemite backers used to lobby Congress is unknown, but Bierstadt was in California at about the time the Yosemite idea was born, so maybe he knew what pictures San Franciscans had sent to Washington.) Bierstadt's painting's subject, venue, and buyer all further linked Yosemite to Unionism.

By opening his report with where Baker had left off just a few months be-

fore his death in battle, by linking Yosemite's emergence as a national treasure to Starr, Watkins, Bierstadt, and the war, Olmsted was coming as close as he could to defining Yosemite as an explicitly Republican and Unionist landscape. Olmsted had plenty of experience with politicians—his Central Park in New York City had run into delays and problems because it was seen as too much the project of a single political regime—so he knew that he should not, could not, present Yosemite as *too* aligned with Republican and antislavery Unionist heroes.[64] Instead, he walked as close to these lines as he dared and then retreated into an eleven-paragraph description of the new place, a bit of rope-a-dope until he could return to his most significant theme.

In his description of Yosemite, Olmsted aligned it with Europe's greatest landscapes. He described the Merced River that runs through the valley as "such a [stream] as Shakespeare delighted in, and brings pleasing reminiscences to the traveller of the Avon or the Upper Thames." Those rivers had produced the language's greatest playwright; the Merced had already aided Bierstadt and Watkins (and after them, who knows?).

A few paragraphs later, Olmsted again nodded toward Watkins, this time to mention how his photographs had made the Mariposa Grove's Grizzly Giant famous, before returning to Europe and to Yosemite Valley: "These [mountain rivers] have worn deep and picturesque channels in the granite rocks, and in the moist shadows of their recesses grow tender plants of rare and peculiar loveliness. The broad parachute-like leaves of the *peltate saxifrage*, delicate ferns, soft mosses, and the most brilliant lichens abound, and in following up the ravines, cabinet pictures open at every turn, which, while composed of materials mainly new to the artist, constantly recall the most valued sketches of [Alexandre] Calame in the Alps and Apennines."

The materials "new to the artist" were wet collodion and wet-plate photography. Astute readers would have known that Calame had also produced paintings of mountain waterfalls and of magnificent, character-filled individual trees, paintings that celebrated individual specimens just as did Watkins's pictures of the Mariposa Grove, and a few of his Yosemite pictures too. Across that campfire, Watkins, who knew that his work had been seen and purchased by the British aristocracy and by the emperor of France, must have felt a strange and new sense of both belonging and *holy cow, that's me he's talking about.*

At the end of the descriptive passage, Olmsted returned to Union. For the next five paragraphs, he used the landscape of the Yosemite Valley as a metaphor for the condition of the former and future United States of America in the wake of the war. "By no statement of the elements of the scenery can any idea of that scenery be given, any more than a true impression can be conveyed of a human face by a measured account of its features," Olmsted started.

In the previous paragraphs, he had offered Yosemite as an American equal to the great landscapes and famed idylls of Europe. Now, as he made the case that America had an equal to the old world, Olmsted needed America to be whole again so that it could compete. Substitute *nation* for *scenery* in Olmsted's transition, and the directness of the metaphor reveals itself.

Olmsted took his metaphor from Ralph Waldo Emerson's *Nature,* from that passage in which Emerson writes about how a landscape's beauty comes from its entirety rather than from its disparate parts. Watkins' 1861 Yosemite pictures may have been informed by this same passage, and Lincoln used it to defend Union by aligning his rationale for Unionism with the Declaration of Independence. Olmsted seems to have been carefully stitching together Baker's cultural Unionism, Lincoln's understanding of U.S. history, Emerson's love of nature, and especially Watkins's Yosemite in a way that suggests he understood—or knew—their overlapping motivations and sources.

Next, Olmsted expanded upon the metaphor to draw a line between Yosemite's landscape and current events: "It is conceivable that any one or all of the cliffs of the Yosemite might be changed in form and color, without lessening the enjoyment which is now obtained from the scenery. Nor is this enjoyment any more essentially derived from its meadows, its trees, streams, least of all can it be attributed to the cascades [the waterfalls] . . . They are mere incidents, of far less consequence any day of the summer than the imperceptible humidity of the atmosphere and the soil. The chasm remains when they are dry, and the scenery may be, and often is, more effective, by reason of some temporary condition of the air, of clouds, of moonlight, or of sunlight through mist or smoke, in the season when the cascades attract the least attention, than when their volume of water is largest and their roar like constant thunder."

Olmsted's metaphor for the secession of the Southern states was the seasonality of Yosemite's waterfalls. The great valley of the Yosemite was stu-

pendous even when the waterfalls withered in the drier seasons, such as now, late summer, when Olmsted was speaking and writing. Similarly, the United States had remained great even after the Southern states had left the Union.

Now Olmsted was really rolling: "There are falls of water elsewhere finer, there are more stupendous rocks, more beetling cliffs, there are deeper and more awful chasms, there may be as beautiful streams, as lovely meadows, there are larger trees. [Actually, there weren't.] It is in no scene or scenes the charm consists, but in the miles of scenery where cliffs of awful height and rocks of vast magnitude and of varied and exquisite coloring, are banked and fringed and draped and shadowed by the tender foliage of noble and lovely trees and bushes, reflected from the most placid pools, and associated with the most tranquil meadows, the most playful streams, and every variety of soft and peaceful pastoral beauty."

There may be greater nations, so went Olmsted's metaphor, and even "more awful chasms"—so direct a reference to the Civil War that it is hardly a metaphor at all!—but the beauty and greatness of Yosemite lay in its unity as one thing, one place where cliffs and waterfalls and trees and all of it came together. Yosemite's diversity, its "varied and exquisite coloring"— again, hardly a metaphor at all!—was what gave the place its greatness.

Twice in that paragraph, Olmsted had veiled his reference to Emerson and metaphor so thinly that I suspect he was eager to have readers see through it, especially because his next sentence made the metaphor's translucence plain by delivering the most explicit word in the American vocabulary: "The union of the deepest sublimity with the deepest beauty of nature, not in one feature or another, not in one part or one scene or another, not any landscape that can be framed by itself, but all around and wherever the visitor goes, constitutes the Yo Semite the greatest glory of nature." Had this been the American Theater in San Francisco or the Cooper Union in New York, the place would have gone nuts.

(Embedded within that passage may be yet another Olmsted reference to Watkins. In referring to the impossibility of a landscape being framed, Olmsted could be referring to Watkins's then unusual method of displaying his pictures in frames, like paintings. Olmsted was evidently aware of Watkins's preference for such: upon returning to New York, Olmsted would hang his home's parlor with Watkins's Yosemite pictures. This room was the heart of the Olmsted family home, the place where he and his wife, Mary, installed

their piano, where Mary would sing as she played, where they spent their favorite time together.)[65]

Next, Olmsted again paraphrased Emerson's assertion that the beauty of a landscape is in the totality of its component parts, and, along the way, used Watkins's pictures as a metaphor for the secessionist moment: "No photograph or series of photographs, no paintings ever prepare a visitor so that he is not taken by surprise, for could the scenes be faithfully represented the visitor is affected not only by that upon which his eye is at any moment fixed, but by all that with which on every side it is associated, and of which it is seen only as an inherent part. For the same reason no description, no measurements, no comparisons are of much value. Indeed the attention called by these to points in some definite way remarkable, by fixing the mind on mere matters of wonder or curiosity prevent the true, and far more extraordinary character of the scenery from being appreciated."

Here Olmsted refers to states that believed that their individual interests trumped the greatness of the whole of the nation. (It is almost as if Olmsted had those three failed 1861 Watkins pictures in mind, the ones that zoomed in too closely on specific valley features, fixing on mere matters of wonder or curiosity.) Olmsted did not cite the vanguard treachery of South Carolina or Georgia, but in 1865 he would hardly have had to for the reference to be understood. With that episode now in the past, let's focus on the "far more extraordinary character of the scenery," Olmsted said. Or let's focus on the unified nation. Whichever.

Olmsted finished with an acknowledgment of Congress's mandate that the new park be "inalienable for all time," but instead of using the straightforward language in the legislation, he invented his own and in so doing ignored the nation's bifurcation at the time of the law's passage: "It is the will of the Nation as embodied in the act of Congress that this scenery shall ever be private property, but that like certain defensive points upon our coast it shall be held solely for public purposes."

This was a neat bit of triage. When it came to Yosemite, obviously there were no Southerners, no secessionists in Congress when the nation exerted its "will." Olmsted had already made his victory lap. He had already made clear that Yosemite was born from antislavery Republican Unionism. Without making a big deal out of it, he quietly offered Yosemite to the whole nation, as it was again now, after the war's conclusion. Still, within it was a

dig at the South: Olmsted's readers would have known that the Union controlled most of the nation's "defensive points upon the coast," such as Virginia's Fortress Monroe, from early on in the war, and that they had stayed in Union hands for the duration.[66] California (and Olmsted) would offer Yosemite to the nation, but with a nodding smirk.

Olmsted continued for several more pages, outlining the remunerative benefits that Yosemite and the Mariposa Grove would have for future generations, and how the park might be administered. But the important part, the establishment of context and conceptual intent, the placing of the park in the context of art, Union, West, and nation, was done. In his conclusion, Olmsted emphasized the precedent Pennsylvania had established at Gettysburg, describing Yosemite as "a trust from the whole nation."

How must Watkins, 35, sitting around a campfire on a summer night, have reacted to all this![67] Here Frederick Law Olmsted, one of America's most famous and admired men, had singled him out by name as a key protagonist of a big, new idea, had made several other references to his work and influence, and then had defined the new American thing. Across the campfire, Watkins would have seen one of the most powerful men in Washington, the speaker of the House, and the nation's top journalists. Watkins, born in a tiny hamlet a continent away and the mostly unschooled son of a tavern-keeper, who had arrived in California to shuttle shovels between a general store and mining camps before reinventing himself as one of America's best-known artists, had made it. Nowhere in the world but in the woolly American West could a nobody have self-reliantly built himself into someone like Watkins had, nowhere but in America could that someone have contributed to ideas that his country's most distinguished men would adopt and that their government would pass into law, and nowhere else could that someone hear a great and famous man laud his contribution around a campfire to some of the most powerful men in America. On that night in 1865, Watkins lived an impossible dream. I wonder if he thought of Starr.

Remarkably, that would not be all, not for Olmsted's insistent linking of Yosemite to Union, nor for his admiration of Watkins's role in establishing it. Olmsted had in mind an appreciation that went beyond a government report.

As Olmsted knew, Yosemite was already home to a mountain named for David Broderick. It was a bulbous, nearly sheer granite monolith that towered 1,000 feet above Nevada Fall. (Before Mount Broderick stuck, some

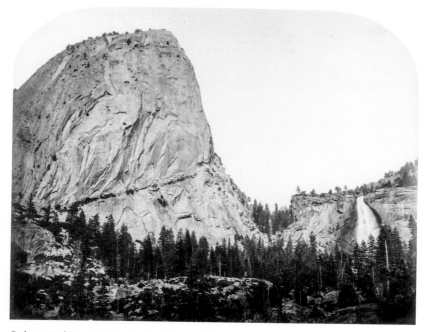

Carleton Watkins, *Mount Broderick and Nevada Fall, Yosemite*, 1861. Collection of the Metropolitan Museum of Art.

Southern-minded Californians tried to name it Gwin's Peak, after William Gwin, David Terry's 1859 duel sponsor and California's longtime proslavery, Mississippi-based U.S. senator.[68] Sectional politics played out on the Yosemite landscape from just about the moment the Mariposa Battalion had tried to kill all the Native Americans in the valley in 1851.) Naturally Watkins had made a picture of Mount Broderick. It is among the greatest and most stylish of his career. Watkins built an innovative composition that uses Mount Broderick to fill nearly the entire left half of the frame and pushes the seemingly tiny Nevada Fall to the right-hand edge of the picture. The tension between the thickly flowing Merced River as it plunges down 594 feet and the stolid mountain to the left is riveting. If the number of prints of this picture that survive today, thirty, is any judge, it was one of Watkins's most popular 1861 images.[69]

The next man to have a Yosemite peak named after him was Starr. On

either Watkins's 1865 or his 1866 trip to the valley, he made a mammoth plate of Mount Starr King, a kind of pendant to his pictures of Starr's church. Even though Mount Starr King is south of Nevada and Vernal Falls, on a plateau several thousand feet above the valley, Watkins tried to make the picture from the valley floor, from alongside the Merced River. As Watkins made no pictures from that plateau in 1865–66 (even though he had in 1861), it's possible that it was inaccessible. Most of the surviving prints of Watkins's Mount Starr King pictures are faded from display, rendering Mount Starr King difficult to see. Far more successful were the stereographs Watkins made of the mountain, in which he uses two tall, skinny ponderosa pines to lead the viewer's eye right to Starr's peak.

Israel Raymond would not be forgotten either. One or more of his fellow Yosemite commissioners who was affiliated with the California Geological Survey saw to it that the peak above the Mariposa Grove would be known as Mount Raymond.[70] Watkins did not photograph it, perhaps because the giant sequoias effectively blocked the view.

California was not done naming Yosemite peaks after antislavery Unionist stalwarts. Having camped at the base of Mount Broderick and having sat alongside Mount Starr King, Olmsted knew how antislavery Unionist politics had been triumphantly imposed upon the landscape. Several weeks after reading his text to Colfax's party by the campfire, Olmsted wrote a letter to Calvert Vaux, his business partner and the man with whom he had designed and built Central Park. "I enclose a copy of a note to artists in Yosemite chiefly intended as a recognition of their function in society," Olmsted wrote. "I have a little scheme afoot for a more tangible recognition of them by the state, to which the Governor has promised me his aid, and several members of the state legislature are committed."[71] Today Mount Watkins, a gently angled granite dome to the northeast of Half Dome and above Tenaya Canyon and Mirror Lake, is evidence of Olmsted's success and California's gratitude.

Back in 1861 Watkins had photographed the mountain that would later bear his name. He had called the picture *The Lake[,] Yo Semite* (p. 170). The future Mount Watkins was at the extreme top left of the picture. The rest of the horizontal picture features the trees and shrubs along the shore of Mirror Lake and their reflection in it. Watkins had tried to show the reflection of the mountain in the water as well, but his lens had not allowed it.

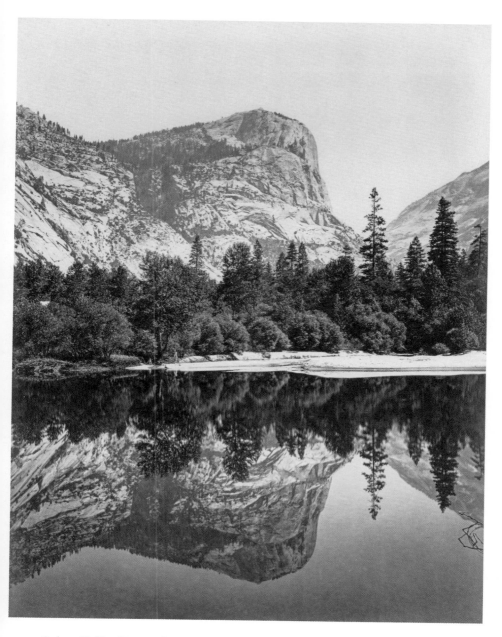

Carleton Watkins, *Mount Watkins, Fully Reflected in Mirror Lake, Yosemite*, 1865–66. Collection of the Library of Congress.

Now, in 1865–66, enabled by a new lens, Watkins returned to this place to retake the picture of what was now (or was soon to be) Mount Watkins, as a vertical composition. The top half of the new picture shows Mount Watkins and a stand of pine, oaks, and shrubs along Mirror Lake. The bottom half shows Mount Watkins and the trees, perfectly reflected in the famously still lake. It is a masterpiece born from Emersonian transcendental ideas. Watkins used reflection to unify the landscape and, perhaps, as a metaphor for Union: with the reflection of Mount Watkins in Mirror Lake, the mountain and the lake, the top and the bottom, the north and the south of the picture become one. "The standard of beauty is the entire circuit of natural forms, the totality of nature," wrote Emerson.[72] "Nothing is quite beautiful alone: nothing but is beautiful in the whole."[73] Here it is.

10

ASSISTING AMERICAN SCIENCE

NEAR THE END OF *PRELIMINARY REPORT upon the Yosemite and Big Tree Grove,* after pivoting from art and Unionism to the practicalities of ensuring that Yosemite is accessible to visitors, Frederick Law Olmsted turned to science. Today this seems logical—after all, much science is performed on America's public lands. However, when Olmsted wrote his report, the parks of the day, cemeteries and Olmsted's own Central Park, were not specifically science-inclusive places. It's not that they were hostile to the work of scientists, it's just that there didn't seem to really be a reason for a cemetery or an urban park to have much to do with a still tiny, mostly northeastern academic discipline.

Olmsted wrote of "[t]he value of the [Yosemite] district in its present condition as a museum of natural science and the danger—indeed the certainty—that without care many of the species of plants now flourishing upon it will be lost and many interesting objects be defaced or obscured if not destroyed," bringing science and emergent conservation together in a way common among Carleton Watkins's San Francisco circle but not so much elsewhere. Olmsted went on to argue that science, like art, should receive place of privilege in Yosemite because man tended to use nature far too rapaciously. Olmsted didn't explain how this should happen—the

California Geological Survey was doing the only real science happening anywhere within a thousand miles of Yosemite, and it was absurdly under-funded by the state—but he wasn't shy about advocating for a progressive idea.

"The Yosemite yet remains to be considered as a field of study for science and art," he wrote in the concluding paragraphs of his report, driving home what he thought were his most important points. "Already students of science and artists have been attracted to it from the Atlantic States and a number of artists have, at heavy expense, [spent] the Summer in sketching the scenery. That legislation should, when practicable within certain limits, give encouragement to the pursuit of science and art [as] has been fully recognized as a duty by this State."

As Olmsted surely knew, science was much of the reason Watkins had returned to Yosemite in 1865, and would again in 1866. He was here to make new pictures for the CGS and for his own gallery sale. The pictures Watkins made on these trips were not transformative like the pictures he'd made at Las Mariposas in 1860, in Yosemite in 1861, or in Mendocino in 1863, nor were they as precedent setting as Watkins's pioneering use of photography in court cases. On the 1865–66 trips, Watkins simply made terrific pictures that demonstrated his willingness to stretch and try new things—an eagerness to show off the strides he'd made as an artist since 1861. The 1865–66 pictures—historians have never been able to tell which pictures Watkins made on which trip and have simply lumped them together under those dates—seem to have been informed by Watkins's continuing study of American and possibly European painting and by his engagement with scientists, especially with CGS staffers Josiah Whitney and William Brewer, but also with Asa Gray, the great Darwinian botanist at Harvard. In just five or six years, Watkins had grown from a novice photographer into an artist whose work engaged the elites of American art and science. He'd come a long way.

The CGS instigated both trips. For several years Whitney and Brewer had used Watkins's 1861 Yosemite pictures in their personal correspondence with their colleagues in the East, an experience that helped them realize how Watkins's work could help explicate the survey's science. Now the CGS's idea was to use Watkins's pictures more officially, to explain and further the survey's scientific work in Yosemite and, in the wake of the federal set-aside of Yosemite as a nature park, to inform tourists. The federal grant

of Yosemite to the state only sort of gave Whitney and Brewer the idea—Whitney had stuck $2,000 in his 1862–63 state budget request with the plan of hiring a photographer, no doubt Watkins, but problems wringing appropriations for the survey out of the state legislature had foiled those plans.[1] Finally, in 1865, after the state accepted the federal grant of Yosemite and the Mariposa Grove, Whitney found a way to work with Watkins: a book project.

Whitney may have taken his cue from Olmsted's report. Olmsted had argued that scientists and artists should receive place of privilege in both the park and its management. Olmsted recommended that the legislation informed by his commission "should, when practicable within certain limits, give encouragement to the pursuit of science and art [as] has been fully recognized as a duty by this State." He went on to recommend that four of the eight Yosemite commissioners appointed by future California governors be "students of Natural Science or Landscape Artists."[2]

Between his own experience sending Watkinses east and Olmsted's prompting, Whitney realized that he had an opportunity to create a guide to Yosemite that would encourage and inform visitors and, in so doing, promote and secure the future of the CGS's own science (and appropriations). The result was *The Yosemite Book*, a CGS publication that would be an innovative mix of guidebook and scientific treatise.[3] Whitney and the CGS would write the scientific portions and include some practical tourism information, and Watkins would make and print pictures that would be included in the book. This was not as straightforward as it would be today: the technology necessary to reproduce photographs in magazines or books did not yet exist. Illustrated publications typically based quick, cheap, low-quality engravings on paintings or drawings or photographs, and published those. Thomas Starr King's *The White Hills* was a good example: it was illustrated with dozens of small, sketchy engravings that vaguely suggested what a place might look like but looked more cartoonish than representative. The CGS's idea went far, far beyond that. It planned to have Watkins make a new suite of pictures for the book, to print each picture and glue it in place on its own page. The idea was to produce a hybrid of the albums of thirty or so mammoth-plate Yosemite views Watkins was offering for around $150 and a more traditionally sized, more moderately priced volume. The CGS planned to print 250 books with twenty-eight eight-by-six-

inch pictures glued into each. This meant that after visiting Yosemite, Watkins's studio would have to print a stunning, probably unprecedented seven thousand pictures for the book. It would be published in 1868. Whitney proposed paying Watkins $6 per book, but it is unclear if that payment schedule materialized.[4] The price for which the CGS sold the book is unknown, but it seems to have been more than $10.[5]

Originally Whitney had planned for thirty Watkinses to accompany and support his text; the final number would be twenty-four pictures, plus four by an otherwise obscure figure known only as W. Harris. (The inclusion of the four non-Watkinses did not prevent Whitney from emphasizing that the book's pictures came from "Mr. C. E. Watkins, the well-known and skillful photographer whose views of Pacific coast scenery have been highly praised by good judges in this country and in Europe.") The initial edition of 250 sold out quickly. It was followed by a concurrent edition that did not include tipped-in photographs. Additional editions would be published in future years for one dollar a copy. Historian Jim Snyder described *The Yosemite Book* as "an early effort to domesticate the Sierra, to make the range accessible and familiar through scientific knowledge and reliable travel information."[6]

The Yosemite Book, even in its limited-edition form, was intended to be read. As Thomas Starr King's friend William Brewer must have realized, *The Yosemite Book* was an updating of *The White Hills* in that it melded material from many previously distinct disciplines into a single volume, all wrapped around practical travel information. Like Starr's book, Whitney's told visitors what to see and where to go and offered some ideas on why those were the things to do. The biggest difference was the philosophical jumping-off point: Starr built *The White Hills* around an Emersonian passion for nature; Whitney planned *The Yosemite Book* around Humboldtian science.

From this point on, Watkins wouldn't just know many of the nation's top scientists, he'd work for them and with them. Scientists would use Watkinses to build scientific knowledge, to teach, and to explain new ideas. The unlikely Watkins-and-science ad hoc partnership was enabled by both moment and geography: American science was still young, so new that it was often little respected even by academic institutions that offered scientific majors or that had established schools (such as Yale), and this isolating nascence left scientific practitioners open to accepting other newcomers in other new areas, such as photography. As historian William Goetzmann

noted, American science was so young that it hadn't completely decided what would motivate and inform its investigations. "As late as 1860, what was called science was still an attempt, pre-Darwinian in nature, to comprehend in Louis Agassiz's terms a vast system that was the mind of God," he wrote.[7] While Agassiz loved Watkins's photographs—Frederick Billings had been just the first of several people in Watkins's circle to share them with Agassiz—the scientists who sided with Alexander von Humboldt's dictate to allow observation and data to inform science rather than aligning science with a supernatural were the ones who found Watkins most useful. Watkins could provide visual evidence to support their discoveries and ideas. Thus a shotgun marriage was born between Watkins's newish medium and the newish Humboldtian American science. Watkins and his pictures would become one of the major conduits through which the overwhelmingly eastern American scientific establishment—almost all of the scientists who worked for the CGS in the 1860s would return to the East—engaged with the West.

This melding of art with science points to another key way in which Watkins's work (and Olmsted's) was immediately informed by Emerson's *Nature*. Near the end of his extended essay, Emerson urges the fusing of art and science, of art's focus in landscape with science's study of the land, for the benefit of both disciplines. "It is not so pertinent to man to know all the individuals of the animal kingdom . . . When I behold a rich landscape, it is less to my purpose to recite correctly the order and superposition of the strata, than to know why all thought of multitude is lost in a tranquil sense of unity," Emerson writes. "I cannot greatly honor minuteness in details, so long as there is no hint to explain the relation between things and thoughts; no ray upon the *metaphysics* of conchology, of botany, of the arts, to show the relation of the forms of flowers, shells, animals, architecture, to the mind, and build science upon ideas."[8] As Whitney's eager use of them to support his scientific arguments underscores, Watkins's 1865–66 pictures are full of this kind of joining of botanical and geological interests with the artist's own constructs.

On the 1865 and 1866 trips to Yosemite, Carleton Watkins started taking a new kind of picture, the tree portrait. Unlike his landscapes, the tree portraits exist almost entirely as mammoth-plate pictures with few, if any, stereograph equivalents. These were not pictures Watkins intended for a mass

audience, though as it turned out, a number of them would be popular with his customers. The 1865–66 tree portraits went well enough that Watkins would make dozens more of them over the next twenty-plus years. Sometimes he labeled them with the Latin name of the tree in the picture, such as *Cereus giganteus, Yucca draconis, Pinus flexilis, Amibilis, Arcaria imprecata, Librocedrus decurrens, Pinus ponderosa, Sequoia gigantea,* and *Arbutus,* which his titles sometimes referred to by their common name, such as in the case of sugar pine, California live oak, buckeye, cypress, palo verde, cork, palm, date palm, pepper, mountain hemlock, and lemon. Most were pictures of trees that didn't grow in the East. Think of them as a nature lover's version of a painter fulfilling a commission and showing off a member of the aristocracy to best advantage, or as the pictorial version of the way American writers, such as Henry David Thoreau in *The Maine Woods,* proudly described and used the scientific names of flower after shrub after tree that they saw when trekking through wilderness. There is nothing like the tree portraits in nineteenth-century American art. Where did they come from, and why did Watkins begin to make them?

Strong circumstantial evidence suggests that they had their origin in Asa Gray, the Harvard professor, the father of American botany, the man who brought Darwinism to America, arguably America's greatest nineteenth-century scientist, and close friend of CGS scientists Josiah Whitney and William Brewer. Gray and his mentor, Princeton and later Columbia botanist John Torrey, had long had close ties to the West: the early American government surveys that explored and mapped the region, such as Frémont's, typically employed botanists. Torrey and Gray would be the prime beneficiaries of their accumulation of material.[9] Gray maintained his interest in the region after Torrey moved on. Gray and Brewer were frequent correspondents, and when Gray left Cambridge to visit England in 1868, Whitney rented his house. (When Gray returned, Whitney moved into the home of another Watkins collector, astronomer Benjamin Apthorp Gould.) Almost all of Watkins's tree portraits were acquired by botanists, occasionally for themselves but most often for their universities. Gray was the most prolific acquirer—or, just as likely, his collections have survived better than others. Gray acquired at least thirty-seven of Watkins's tree portraits, mostly for the Harvard Herbaria.[10] Many of Gray's botanist colleagues, including Torrey, W. W. Denslow of the University of Massachusetts, and

Carleton Watkins, *Douglas Fir* (Librocedrus decurrens), *Yosemite*, 1865–66. Collection of the Stanford University Libraries.

McGill University botanist and geologist John William Dawson, did too.[11] As botany was the king of American sciences at the time, the field in which scientists often started before moving on to other disciplines (witness Brewer, who also wrote on geology and later taught agriculture), that was a significant chunk of the mid-nineteenth-century North American academic science establishment.

Why were Watkins's pictures of western trees popular with botanists? Watkins's pictures allowed the easterners to compare western trees to their own, to begin to consider difference, similarity, and possibly common origin. Some of the botanical "samples" in Watkins's pictures couldn't even live in eastern sample drawers, meaning that the only way for Gray and his colleagues to share them with students was Watkins's pictures. A 1915 picture of the Harvard Herbaria's sample room suggests that Gray and perhaps even his successors used Watkins pictures in just this way: above the sample cabinets hang Watkinses of a cypress and a saguaro, flora unique to the West. A roughly 1900 picture of a similar space shows an 1877 Watkins of a yucca tree, another only-in-the-West species. Similarly, in the nineteenth century, Gray and his colleagues often taught in front of glass cabinets in which samples, seeds, and the like were arrayed. Given that the Watkinses at the Harvard Herbaria are almost all much light impacted, they were probably on long-term display in this manner rather than stored flat, in the dark, for only occasional reference.[12] (Gray also liked nonbotanical Watkinses. His home was stuffed with them, especially Yosemite views. Gray's British colleague, Kew Gardens director Joseph Hooker, also had at least one Watkins in his London home, either an 1861 or an 1865–66 *Grizzly Giant*.)[13]

There is no clear first Watkins tree portrait. From the start of his photographic career, Watkins had an interest in solitary trees in the landscape: the 1858 *Fossat* case for which Watkins made the first photograph that can be confidently attributed to him required his attention to the Sierra del Encino, the Mountain of the Live Oak. Then, on his 1861 trip to Yosemite, Watkins made two pictures of the Grizzly Giant, the immense sequoia in the Mariposa Grove. Gray was impressed and seems to have asked for more pictures of trees. (Sadly, only a fraction of the Gray-Brewer correspondence survives. Brewer's journal of letters he wrote and received reveals that only about half of the letters they exchanged when Brewer was with the CGS survive.)[14] In 1863, after Brewer and Gray had begun to trade letters about Watkins's Grizzly Giant pictures, Watkins made a tree portrait in Mendocino. He called the tree a Durant pine, which is either a dated term or a mistake. At least one of the prints identifies the tree as a *Pinus contorta*, better known as a lodgepole pine. The portrait exists today in several collections, including at Harvard's Olmsted-designed Arnold Arboretum, where Gray was influential, and as part of an extensive collection of Watkins tree portraits at the University of

Vermont. The Mendocino tree portrait is not a great picture, but it hints that Brewer communicated to Watkins Gray's interest in his work no later than before Watkins left for the North Coast in 1863. It is unknown if Watkins himself corresponded with members of the eastern scientific establishment, but correspondence between Whitney and Brewer suggests that he did, and certainly he filled their orders for tree pictures from both Yosemite and Mendocino. However, no letters between Watkins and any of the group are known to have survived. Gray's archives and those of his colleagues mostly include correspondence with other scientists.

Gray seems to have made a special request to Brewer or Watkins for tree portraits from Watkins's 1865–66 trips to Yosemite. Ten such pictures from that trip exist, and all are still in Gray-related collections. Watkins focused his attention on five species: *Pinus lambertiana, Pinus ponderosa, Abies amabilis, Libocedrus decurrens,* and, of course, *Sequoia gigantea.* Pictorially, a picture of an incense cedar standing at what appears to be the junction of footpath and, perhaps, an animal path is the most successful. At the place the two trails cross, the cedar rises as a nearly perfect isosceles triangle. The composition, Watkins's use of the paths and the trees and hills in the background, conspires to push the solitary incense cedar toward the viewer. Another, a picture of a silver fir, uses an immense, dark incense cedar to form the left-hand edge of the frame, backstops it with cliffs, and places the silver fir as seeming to emerge from shade into a grassy foreground.

Why did Gray apparently want to see these five trees in the Sierra? It's not clear. Certainly something about these five related species intrigued him enough that he tracked them and their relatives around the globe as early as a landmark 1859 paper that compares the flora of eastern Asia, eastern North America, and Europe, a paper that is the major supporting document of early Darwinism. Gray kept at these species until 1872, when, as president of the American Association for the Advancement of Science, he devoted his farewell lecture to those species' geographical distribution.[15] (Another puzzling Watkins-Gray-evolution link that remains fuzzy: in the early 1870s, Watkins friend John Muir became interested in Darwinism. Gray would become his "personal tutor" in evolution.)[16] The 1859 paper, written ten years before the transcontinental railroad would be completed, is notably light on information and understanding about flora in western North America. Could Gray, in 1865–66, when it was not evident that the

transcontinental railroad would be successfully completed, have asked Watkins to make pictures of those five key species in an effort to compare them with samples in his herbaria from Asia and Europe? Probably. Did pictures of these five trees play a role in Gray's Darwinism-supporting research or in his years-long efforts to introduce Darwinism to America? The relationship between Watkins's tree pictures, especially the 1865–66 pictures, and Gray's research lies just out of focus.

One reason it is likely to remain so is that one or more entities at Harvard University, nineteenth-century America's most important scientific center, seems to have thrown out hundreds of Watkinses in the 1960s. According to Tony Morse, a Californian who attended high school in Cambridge, Massachusetts, Harvard threw out two to three hundred Watkinses in 1966. Morse was not sure if the institution discarding the Watkinses was the Peabody Museum, the Widener Library, or another Harvard-affiliated institution, but the librarian at Morse's high school managed to save an unknown number of them. (Morse himself donated some geology books to his school's library in exchange for about three dozen Watkinses and believed that others from the trove made it into the market and to the Oregon Historical Society.) Our best bet at a fuller understanding of Watkins's import to 1860s and 1870s American science was damaged, probably irreparably.[17]

Regardless, Watkins's relationship to mid-nineteenth-century science, both to the eastern establishment and its western offshoots, was well established by 1866 and would expand in the coming decades. Watkins himself realized that scientists were an important constituency and customer base: in 1873, he offered the California Academy of Sciences portraits of each of its members so that the academy could have a pictorial record of its roster.[18]

Among American artists of the period, only New York painter Frederic Church was as interested in America's nascent engagement with Humboldtian science. Art historian Barbara Novak wrote that Church's "interests were broader, his involvement in natural science more intense than those of any artist of his era." In 1980, when Novak published her landmark *Nature and Culture: American Landscape and Painting, 1825–75*, Watkins's oeuvre was narrowly known and little published. Accordingly, Novak presented Watkins as a western survey photographer and as a resuscitator of the Claudean sublime. Neither was accurate: as we'll see in chapter 15, Watkins was attached to only a single subsurvey and only for a few weeks. Few, if any, nine-

teenth-century American photographers rejected Claudean compositions—
middle-ground human action framed by trees with something grandly
sublime beyond it all—more thoroughly than Watkins. Novak also missed
Watkins and science. Church was an enthusiast; no American artist of his
era was of greater use to scientists than Watkins.[19]

Another benefit Watkins gained from working with the CGS was access to a
new lens, which, combined with what seems to have been an improved cam-
era design, allowed him to make sharper, more detailed pictures than had
been possible in 1861.[20] The advancement in lens technology seems to have
enabled new, audacious compositions too. Even Josiah Whitney, far less in-
formed about art and photography than his surveymates William Brewer or
Clarence King, noticed. "Watkins is on the pot, with a most wonderful
camp, & has taken many fine pictures," Whitney wrote to William Brewer,
who had moved back east, to teach at Yale and to process and publish his
California material, after encountering Watkins in the valley. "Some of these
I think will surpass anything we have ever had. Especially the great views
from the Mariposa trail & one in particular from a spot two-thirds of the
way down, which we all think gives the best general view of the Valley itself.
This Watkins thinks is his best picture. He took views from five points—
from Inspiration P[oint] on down. [Charles Leander] Weed's point of view
he does not like as well as any of the others."[21]

Watkins was surely pleased to work for the survey, but no doubt he con-
sidered his major project of 1865–66 the making of new mammoth-plate
views that he could offer for sale through his gallery. Over the course of two
seasons, Watkins remade almost all of the 1861 pictures and made many
new ones too. For example, in 1861 Watkins had made just two pictures in
the Mariposa Grove; now he made thirteen.

Whitney was right to focus on the extraordinary new pictures Watkins
was making at Inspiration Point, a famous spot on the Mariposa Trail
that delivered visitors into Yosemite. (Most places in America, or in the
world, where visitors approached mountainous destinations, they approached
from below and saw a landscape rise up around them. At Yosemite, visitors
approached *from above,* via the South Rim, and then descended into the val-
ley. Inspiration Point was the spot at which the valley was fully revealed to
them.) Watkins's Inspiration Point pictures may have been enabled by trail

improvements in the years since his first visit. Two of them appear to be the pictures Whitney mentioned in his letter to Brewer.

Yosemite Valley from the Best General View would seem to have been one of Watkins's biggest commercial hits. Today twenty-six prints of it survive. Watkins made it from about as close to the trail's edge as he dared. Then he built the composition out of a triangle: The right edge of the triangle is a pine tree that grows like a ramrod from where the cliff begins its thousands-foot drop to the valley below. The pine grows out of the picture; we can't see its top. Its trunk is almost impossibly narrow, and Watkins "supports" it with a sheer granite cliff to its right. The result is a solid, almost heavy right quarter of the picture that is lightened and given depth by the skinny trunk of the pine. The next line of the triangle runs along the ground out of which the pine grows at the bottom right of the picture toward the upper left. The line is the rim of the valley, which is covered in dense, dark brush. Just above the point where this diagonal reaches the pine tree, Bridalveil Fall plummets 617 feet from the top of Cathedral Rocks to the valley floor. Pictorially, its straight white streak of water echoes the verticality, the erectness of the pine up on Inspiration Point. The third line of the triangle is formed by the surprisingly straight line of mountains that runs across the entire top of the picture, the granite-made horizon line. One of the few points of difference in that line is Half Dome, which peeks out from the rectangular butte that enables Sentinel Dome. A painter could not have imagined this view into greater visual complexity or drama, and none have.

As Whitney noted in his letter to Brewer, Watkins was not the only photographer to make a picture from this point. Charles Leander Weed had been here first, and many, many others would follow. Weed made his picture from Inspiration Point in 1864. Just as Watkins returned to the valley after an initial visit, so too had Weed, who was making what would be a brief stop in California after having spent several years in Asia. Weed's 1864 pictures were an enormous improvement over his 1861 set, but they still weren't as well composed, as large, as sharp, or as awe-motivating as Watkins's pictures. As Whitney noticed, Weed had made the first pictures from Inspiration Point but had made them farther from the valley rim, had built no particular composition, and had inserted a man leaning against the pine tree gazing at the valley below. Whereas Watkins's building of his picture leads the eye to Bridalveil, Half Dome, and more, in Weed's picture there was no

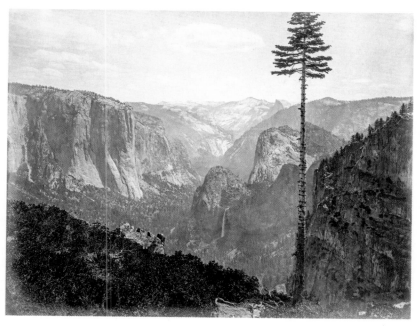

Carleton Watkins, *Yosemite Valley from the Best General View*, 1865–66. Collection of the J. Paul Getty Museum, Los Angeles.

compositional organization. To the extent the viewer is guided anywhere, it's to the man admiring the view, not to the landscape itself. In Watkins, the landscape is always the thing.

As great as *Yosemite Valley from the Best General View* is, apparently it wasn't Watkins's favorite Inspiration Point picture. Watkins made several pictures from Inspiration Point that fit the description he gave Whitney of his "best picture." One he titled *The Yosemite Valley from Inspiration Point,* the other *Yosemite Valley from Mariposa Trail.*[22] The latter is the keeper. It is as close as Watkins comes to making a composition derived from European landscape painting: it features a tree on each edge of the frame and a fore-ground that runs across the picture like a stage. The valley below runs off into the middle distance. The juxtaposition of rocky foreground and distant, distant granite creates a vibrational tension—is this place huge or is Brid-alveil close enough to touch? Consciously or not—while we have some con-text that suggests what art Watkins may have known, we have no such infor-mation about Weed—Weed aligned himself with a hundreds-of-years-old

European tradition: he put a person in his picture, a stand-in for the person looking at the photograph. Watkins realized he needed no such reflexivity. Watkins decided here, as he would throughout his career, that he was not showing a viewer a replacement for Yosemite, he was creating an artwork that was itself a discrete object, an accomplishment.

The best picture Watkins made in Yosemite in 1865–66 is one of the weirdest, most unlikely why-did-he-do-*that* works of nineteenth-century American art. Titled *First View of Yosemite Valley from the Mariposa Trail*, it offers a seemingly impossible view—a scene that seems to have required that Watkins's camera hover in midair. As with the 1861 *Cascade*, in which Watkins likely riffed on Frederic Church's *Niagara*, *First View* seems to be Watkins taking a visual idea from American painting and applying it to his own work. The painting is one of Thomas Cole's most famous pictures, *View of Schroon Mountain, Essex County, New York, after a Storm* (1838). Watkins almost certainly had not seen the actual painting but may have known of it through reproduction. The Cole also seems to suspend the viewer above a forest. Two trees in the near ground zag off from the bottom center of the painting toward its upper-left and upper-right corners, framing a dramatic view of pyramidal Schroon Mountain. (Today the 3,704-foot peak is known as Hoffman Mountain.) Watkins adapted Cole's composition to the Yosemite landscape, a pointed inclusion of the West in the American art historical tradition. The left-hand side of Watkins's picture features a tall ponderosa pine running at an angle from the bottom left all the way up out of the top of the picture. Another ponderosa runs from the lower left center up toward the right-hand edge of the picture. Watkins's pines frame a view of El Capitan on the other side of Yosemite Valley.

As usual, the events of 1906 ensured that we don't know if Watkins owned a print or magazine reproduction of *View of Schroon Mountain* or if he might have simply seen it somewhere in San Francisco. *First View* strongly suggests that Watkins's pictorial curiosity, his interest in looking at work made by painters, continued after Starr's death. While it's impossible to know if Starr had introduced Watkins to eastern American painting, no one Watkins knew was as well versed in American art as Starr. Watkins's continuing development as an artist could have been stunted by Starr's death; it was not.

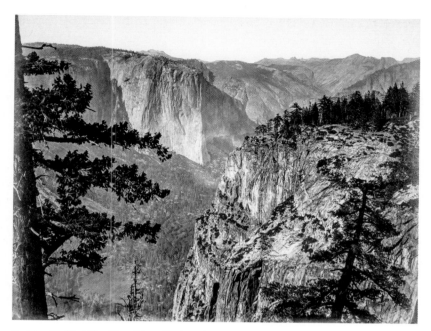

Carleton Watkins, *First View of the Valley from the Mariposa Trail, Yosemite*, 1865–66. Collection of the J. Paul Getty Museum, Los Angeles.

Watkins's picture was probably immediately influential. A year or two later, Watkins's old friend Eadweard Muybridge would begin his own San Francisco–based photography practice and would nickname it the Flying Studio to emphasize the way he took views in which his camera, and thus the viewer, seemed to be hovering above the distant valley floor. This Watkins was surely one of the pictures that motivated and informed Muybridge's own outstanding work.

With new, significant mammoth-plate pictures of Yosemite made, with orders coming in, and with his printer working on fulfilling those orders and providing the prints for *The Yosemite Book*, Watkins was ready to continue to expand his portfolio of views. Like any other American landscape artist, he was eager to go somewhere his peers had not been, eager to find yet another place to make his own.

In February 1867, Watkins told Josiah Whitney that he wanted to spend the summer picture-making season in Oregon. Whitney was skeptical. "I do not see how he can, unless he gets more patronage," Whitney wrote to William Brewer. Several months later, Watkins still wanted to go to Oregon but still didn't have the financial backing for such a trip. "Watkins goes to Oregon if I can lend him the money," Whitney wrote Brewer in June.[23]

How Watkins, who had brought in over $3,000 in 1864 alone and $1,500 from the CGS in 1865–66 (though it's not clear the perpetually government-retarded and thus cash-strapped CGS paid Watkins on time), could be so short of funds in early 1867 is a puzzlement. This would not be the last time that Watkins's finances would confound historians. Because so few snippets of letters and such have survived San Francisco's occasional earthquakes and infernos, historians have often overinterpreted surviving material. For example, historians have tended to accept the Brewer-Whitney correspondence prima facie, as the authoritative word on Watkins's finances in the post–Civil War years. As a result, they have presented Watkins as being routinely, even perpetually, penurious. Maybe he was. But maybe Watkins was just politely leaning on the CGS to pay him the money it owed him by suggesting the CGS's long-standing financial problems were negatively affecting his professional plans.

Historians have also tended to read a letter from Harriet Errington, the English nanny to Frederick Law Olmsted's children, to her relations back home to ask if they might help facilitate the sale of Watkins's Yosemite albums in England as a sign of desperation. Errington notes that Watkins was "lukewarm about pushing their sale," which could as easily be read as an appropriate nod to Victorian reserve as it could be to poor business acumen. In fact, the whole letter might be read as Watkins taking advantage of the networks available to him, of his building upon personal connections (Watkins's client roster suggests that he was an excellent networker), rather than being read as desperation.[24]

Ultimately, there's so much missing from the historical record that we don't know if Watkins's finances really were in as bad shape as Whitney thought they were in early to mid-1867. One way or another, around the Fourth of July, Watkins and his usual couple of thousand pounds of equipment were on a ship sailing north for Oregon. He had already helped make

Yosemite and the Mariposa Grove famous and had popularized the California coast, sparking conservation, tourism, and science. He was about to elevate another western landscape. This time he would help call attention to the West's history and present the Northwest as a business opportunity for eastern investors. With every project, Watkins was bringing the West closer to the East, making the West and its potential a greater part of the national future.

11

TO OREGON (FOR INDUSTRY)

———

UPON ARRIVING IN PORTLAND IN MID-JULY 1867, Carleton Watkins almost immediately hiked up the Scappoose, the steep hills that rise a thousand feet behind Portland. Watkins was up here as a kind of research trip, knowing that the landscape would provide a guide to the picture making he had come here to do. He saw the city, built tight against the west bank of the Willamette River. About 6,800 people lived down there. That wasn't much—San Francisco was now home to almost 150,000 people—but Portland was growing 20 percent a year, and it was a prime outlet for San Francisco capital needing somewhere and something in which to invest. Portland was becoming the West's second city, and Watkins was here to help it along.

Watkins would spend the rest of the summer and the early fall in the Columbia River region. He was here to make pictures for the Oregon Steam Navigation Co. (OSNC), the most important private concern in the economically promising Pacific Northwest, and to make scenic views. Just as Watkins's pictures of Yosemite would define it, so too would his pictures of the steep basalt cliffs and plunging waterfalls of the Columbia River Gorge. By the end of this trip, Watkins would have made pictures of every western landscape of interest to both the nation and to westerners themselves. He

was creating America's visual understanding of the farthest and most promising regions of its new continental empire. The pictures were informing eastern businessmen who were making decisions about how and where to deploy capital and whether to build alliances and Americans who were considering which of the new lands to visit or even move to, and they would hang on the walls of lovers of western landscape.

The work here would have to wait a bit. Watkins still had to figure out how to address the northwestern landscape in which he would be working, which was why he was up here on the Scappoose waiting for fog or low clouds to lift. Watkins could see two rivers, the Willamette and the Columbia. They were why Portland was here, and why OSNC was attracting interest from eastern capital and businesses: To Portland's south, the Willamette Valley offered some of the richest farmland in the West. Six miles to the north of Portland, Watkins could see the Willamette flow into the Columbia, the waterway that offered access to the Pacific and to trade with Asia, as well as a 1,200-mile path inland, where it drained a watershed equivalent to the combined area of New England, New York, New Jersey, Pennsylvania, Delaware, Maryland, West Virginia, and Virginia. Towering over the entire region were the Cascade mountains, which rose in waves, finally ascending to the magnificent, massive, volcanic Mount Hood. This immense region included America's richest timberlands and vast mining districts. Its economic potential was huge. Portland was geographically positioned to benefit. So was the OSNC.

Having learned the lay of the land, Watkins descended the Scappoose and made straight for the offices of the local newspaper, the *Oregonian*. Watkins announced that he'd seen the vista from the Scappoose, had looked out at the mighty Columbia and down the Willamette, that he'd seen thick forests, high plains, and the blue-tinged Cascades. He said it was all as "variedly picturesque" as any view he'd seen. (Everyone knew that Watkins was practically synonymous with Yosemite, which meant that however great Yosemite was, apparently it wasn't "variedly picturesque.") Watkins said he would be taking a steamer up the Columbia that afternoon to plan his Columbia River Gorge picture making and that he would return that night. And oh, by the way, his mammoth-plate California pictures, including views of Yosemite and the Mariposa Grove, were on sale at Shanahan's, at the corner of Front and Morrison Streets.[1]

It would take Watkins over three months to make at least 58 mammoth-plate pictures and no fewer than 139 stereographs in Oregon and across the river in Washington Territory.[2] The perpetual rain, low clouds, and fog would try his patience and leave him frustrated, but it would be worth it: these pictures make up one of the finest bodies of work of Watkins's career. If Watkins existed in the historical record as a photographer of only the Columbia River region, his place as one of America's greatest artists would have been assured.

After scouting the Columbia, Watkins hiked back up the Scappoose to make a three-part panorama of the young city. Panoramas, first painted and then photographic, were a nineteenth-century phenomenon. The painted versions, hundreds of feet long and unrolled over the course of an hour-long stage show, were the central attraction of a traveling, ticketed spectacle often complete with a narrator or a band and special effects such as smoke, steam, or even fireworks. Starting in the 1840s, three themes dominated American panorama painting: Mississippi River travel, overland exploration and migration, and finally the unprecedented, almost unimaginably rapid growth of San Francisco. The organizers of these shows argued that their panoramas represented reality and were thus a kind of substitute for expensive, time-consuming travel. As photography ascended in the 1850s, daguerrean operators took the stage show out of the formula and began to make and market their own framed, handheld panoramas of cities. By the end of the decade, photographic panoramas printed on paper had supplanted daguerreotypes. San Francisco was the national capital of this new thing. In 1851, dentist, daguerrean, and eventual mining executive Sterling C. McIntyre made and showed the first San Francisco panorama and then sent it to London, where it may have been exhibited at London's 1851 Crystal Palace Exhibition. Over the next couple of years, photographers offered seven more San Francisco panoramas, and by 1877 at least fifty more multipart panoramas had been produced and marketed in San Francisco alone. The most famous of them all came the next year, when Carleton Watkins's old friend Eadweard Muybridge produced a 360-degree panorama made from thirteen glass negatives. When exhibited in a single line, it covers seventeen feet. It is one of the major photographic achievements of the nineteenth century.[3]

Naturally Watkins made panoramas too. Though one art historian thinks an 1850s panorama of San Francisco may be a Watkins,[4] it's more likely that

his first San Francisco panorama was an 1864 five-part view that includes Russian Hill, North Beach, Alcatraz Island, Telegraph Hill, Goat Island (today's Treasure Island), Rincon Point, and Mission Bay and that looks toward modern-day Hunters Point. Both it and another Watkins San Francisco panorama, made a few years later, are stiff and formulaic; the city views lack the compositional ingenuity of his landscapes. For the most part, the panorama was a proscribed type, a primarily technical achievement, while a landscape picture allowed an artist, painter, or photographer to bring ideas to bear. San Francisco panoramas seem to have bored Watkins.

Conversely, his three-part Portland panorama crackles with cleverness. Watkins certainly had time to consider from where to make it as he found himself stuck in a reluctant morning routine: each day he hiked up to the top of Marquand's Hill, discovered that rain and low clouds obscured his view, waited in vain, and eventually hiked back down, having failed to make any pictures. With nothing better to do while the city was socked in, Watkins wandered back to the *Oregonian* to complain. "Ever since his arrival here we have had almost continuous bad weather for the taking of such pictures," the *Oregonian* admitted.[5] When the *Oregonian* tired of listening, Watkins turned to Josiah Whitney, who was in town on California Geological Survey work. "The last I heard from him, he was watching his toes to see if the webs had started between them," Whitney wrote to Brewer, referencing the Californian nickname for Oregonians: the webfeet.[6] For the next few months, this hurry-up-and-wait routine determined Watkins's productivity. He learned to live with it.

When Watkins got his picture, it would all be worth it. He made it from just south of Robinson's Hill, probably Marquand's Hill. He brackets the growing city with forest on the northern edge, at the far left of the first picture, and on the southern edge, at the far right of the third picture. In between, across all three panels, are hundreds of wood-frame buildings, built up more densely along the river and thinning as the city extended toward the Scappoose, some dirt roads, and nary a surviving tree. Farms and fenced-in livestock and chicken pens fill the ground between the Scappoose and the city. This was the stuff of nineteenth-century western suburbs; Watkins would have recognized both the sights and the smells of agriculture on the near perimeter of urbanity from his years in early San Francisco. The third panel shows most clearly Portland's rapid expansion: fat tree stumps litter

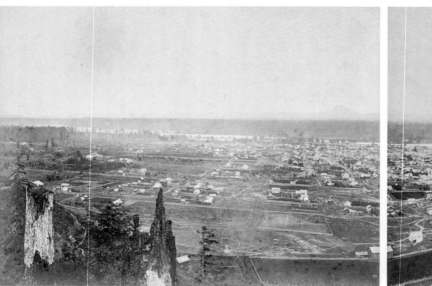
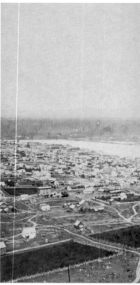

Carleton Watkins, *City of Portland and the Willamette River*, 1867. Collection of the Beinecke Rare Book & Manuscript Library, Yale University.

the terrain as if they were Cascadian confetti that had fallen from Watkins's perch to the rich soil below, a sign the city was growing so fast that it couldn't be bothered to finish the work of clearing them. (A baseball field in the left-hand panel is a rare smoothed ground.) These hundreds of stumps, whitewashed so that they'd be visible to nighttime travelers (and, less intentionally, to Watkins's camera), earned Portland the nickname Stumptown. Watkins seems to have known this: he included the stumpy remains of trees in the foregrounds of all three panorama panels.[7]

Finished with the panorama, Watkins began his Oregon travels by steaming south down the Willamette River.[8] His first, northernmost Willamette Valley pictures were evidently commissioned by the just-opened Oswego-based Oregon Iron Co., whose investors believed greater Portland could become the Pittsburgh of the West.[9] From Oswego, Watkins traveled to Oregon City, where he made a fine three-part panorama of the city and the steep but small waterfall below which the city was perched, as well as one of his best architectural photographs. It is a picture of Imperial Mills, which ground grain into five hundred barrels of flour each day, and a woolen mill

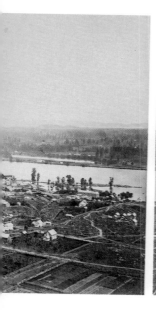
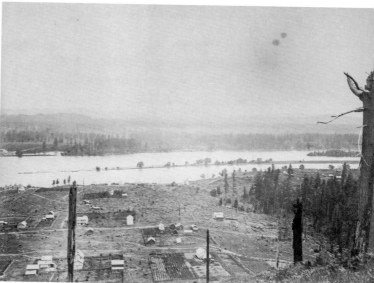

behind it. The foreground of Watkins's picture shows Imperial Mills' shipping barge, which transported those barrels to Portland.[10]

After taking thirteen mammoth-plate pictures along the Willamette, Watkins returned to Portland. The side trip was over; it was time for Watkins to start the work that had brought him to Oregon.

There were two reasons Carleton Watkins was in Oregon, one related to his art and another related to the business relationships that enabled it. With Watkins's rivals in San Francisco increasingly sending less talented photographers to places Watkins had been to try to remake his pictures, *his* compositions (witness Lawrence & Houseworth's attempt to copy his Mendocino pictures), there was a certain business imperative to traveling to artistically little-discovered places. While the Oregon landscape was less known in San Francisco than still little-visited Yosemite, Watkins would have heard about the majestic Columbia River landscape from Thomas Starr King, who had traveled here in 1862 to give speeches and raise money for the U.S. Sanitary Commission. Starr had been so awed by the Columbia

River Gorge and the nearby volcanoes that until the Civil War and Sanitary Commission fund-raising intervened, he had planned to make the region the subject of his next opus for the *Boston Evening Transcript*.[11]

Next, Josiah Whitney or William H. Brewer, most likely both, seems to have wanted Watkins to photograph Mount Hood for the California Geological Survey. Why the chief of the *California* Geological Survey wanted documentation of a volcano in Oregon is less clear, but it's possible that Whitney divined a relationship between Mount Shasta, in Northern California, and Mount Hood.[12] As Asa Gray's 1866 letter to Brewer expressing skepticism at Brewer's observation of the lack of trees atop Mount Shasta revealed, American scientific understanding of the ecology on and around America's highest peaks—and especially of volcanology—was near nil. Almost any information was new data. Even in 1885, eighteen years after Watkins first photographed Mount Hood and sixteen years after the transcontinental railroad was completed, Watkins's pictures of Mount Hood and later Mount Shasta would be so valuable to scientists that they were still using them to study volcanoes (in this case, the formation of volcanic cones).[13] For Whitney and Brewer, having first access to such pictures represented a professional advantage. Having read Gray's astonished response to his correspondence about Shasta, Brewer, who was now occupying a chair at Yale's Sheffield Scientific School, knew this as well as anyone; he personally commissioned at least $217.50 worth of Watkins's Oregon work.[14]

However, as trips such as this were expensive, Watkins no doubt needed a more remunerative reason for the trip, a business that would bring him to the place just as a business had brought him to Mendocino or Las Mariposas. An overwhelming amount of circumstantial evidence indicates that business was the Oregon Steam Navigation Co., the Pacific Northwest's transportation monopoly. To a significant degree, the OSNC and Portland made each other: the OSNC was the largest business concern in the vast region west of Chicago and north of San Francisco. From the OSNC's founding until the rise of Los Angeles at the end of the nineteenth century, Portland would be the second city of the West. Certainly Portland's advantageous geography helped it rise over early competitors such as Oregon City, Milwaukie, and Milton City for dominance in the Pacific Northwest, but the OSNC's ability to move goods through the region to market and to access San Francisco capital to help it grow were every bit as important.

It was through that capital-providing connection that Watkins, a networker par excellence, had multiple ties to the OSNC. For one, his old Montgomery Block newsstand boss George Murray was now working for the OSNC as a bookkeeper.[15] That was nice, Watkins had someone to look up when he was in Portland, but middle-management didn't hire famous and no doubt expensive photographers. In all likelihood, Watkins was introduced to the OSNC by Billy Ralston. As we saw in chapter 8, Watkins made a string of pictures of Ralston's business interests during the war years and would continue to make pictures for Ralston well into the 1870s. Ralston, who was beloved by San Francisco artists and performers because he kept an eye and wallet out for them, was well positioned to know that Watkins was considering an 1867 Oregon trip. Ralston would have quickly realized how Watkins could be useful to his interests there.[16]

Upon beginning his San Francisco banking career, one of Ralston's earliest investments was in what would eventually become the OSNC. The man who consolidated the myriad steamboat operators on the Columbia River into a single monopolistic powerhouse was John C. Ainsworth, an old friend of Ralston's from their days in the Midwest.[17] Both men were typical of the industrious, risk-it-all men who made their fortunes in the early West. Like Ralston, Ainsworth grew up on the Ohio frontier. He began working as a retail stockist at age eleven, moved on to working Ohio River boats in his teens, and quickly advanced, becoming a steamboat captain in the Mississippi River basin, where he ran goods between Saint Louis and Iowa. Ainsworth bought his first boat at twenty-two and soon thereafter met Ralston. When Ralston decided to go west to seek his fortune, he talked Ainsworth into following him. Ainsworth had tried gold mining for a while, failed, and moved up to Oregon to pilot steamboats. Ainsworth did well. Back in 1860 he had wanted to expand, and so he turned to his old friend. Ainsworth's business plan was straightforward: whoever controlled transportation along the Columbia controlled trade within the Pacific Northwest, to San Francisco, and to Asia.[18] At the time, Ainsworth owned three boats, including the massively profitable *Carrie Ladd*, which Ainsworth named after the wife of Portland's mayor (who, in a story that may or may not be related, would become Ralston's business partner). Five other boats on the river were owned by three other men. Ainsworth intended to consolidate these eight boats into a single company. Ralston's financial backing of the scheme ena-

bled the formation of the OSNC. Two years later, in 1862, the OSNC merged with a rival company based across the river in Washington Territory, completing the OSNC's dominance of the Pacific Northwest's waterways. Ralston's involvement gave the OSNC the ability to invest in new steamships, including the impressive *Oneonta*, which Ainsworth had named after a certain New York town in which his family had roots. When the Schuyler Colfax party that had met Watkins in Yosemite back in 1865 continued on up to Oregon, it had traveled the Columbia River Gorge in this very boat, no doubt with Ainsworth himself as the party's guide.[19] (Not long thereafter, Ainsworth would write Colfax one of those letters so regularly received by Gilded Age politicians, thanking him for certain unnamed services rendered.)[20] The party's trip along the Columbia helped awaken the East to the economic potential of this new part of the American West. In his book about the trip, Samuel Bowles proclaimed that "the Columbia, with its chief division, the Snake, may be anywhere from twelve hundred to two thousand miles in length; but that it ranks among the three or four great rivers of the world, and that it is the key to vast political and commercial questions and interests—giving to its line the elements of a powerful rivalry to the great central commercial route of our Continent, of which San Francisco is the Pacific terminus, no one who examines its position and extent, and witnesses the various capacity of the territory it waters [such as timber and mining] can for a moment doubt."[21] (It is not clear if Bowles intended his meandering run-on sentence as a metaphor for the Columbia's path through the Northwest.) In another book, Albert H. Richardson wrote similarly boosterish passages about the Pacific Northwest.[22] The OSNC itself could not have written two prospectuses more likely to attract the attention of eastern business and capital.

At about this time, in late 1866 and early 1867, Ainsworth became interested in two related possibilities. The OSNC had made Ainsworth comfortably wealthy, but the Colfax party helped introduce Oregon to new eastern finance mechanisms, such as the railroads-driven boom in stock-market activity, that allowed for the post–Civil War accumulation of preposterous individual wealth. Ainsworth liked that idea. The second possibility was substantially more complicated and involved the transcontinental railroad, for twenty years a western dream that had remained ephemeral. Even after Lincoln signed the Pacific Railroad Acts, there was reason for skepticism

because the Central Pacific was having trouble building through the Sierra Nevada's granite. In April 1867, when the Central Pacific found a solution to its construction problems in the form of nitroglycerin, suddenly it became clear that the transcontinental would be built. A transcontinental railroad was great for San Francisco and Sacramento, but it created problems for the OSNC. Ainsworth and much of Portland feared that the impact of the transcontinental, with its terminus in California, would doom Portland to be a mere branch line that would be built through the Sacramento and Willamette Valleys. Who would run trade through Portland or its port over a remote branch line up the rugged Siskiyou Mountains, assuming a branch line would ever be built, when a direct route to San Francisco was available? A second transcontinental, voted into possibility by Congress in 1864, presented similar problems. It was planned as a northern road and seemed likely to terminate in Washington Territory's Puget Sound. Either way—and maybe in both ways—Portland would be left out, and the growth of both the city and the OSNC would be stunted.[23]

Ainsworth responded to the transcontinental threat by trying to make it into an opportunity—and he saw a way to become fabulously wealthy in the process. First, the OSNC cemented its regional monopoly by expanding the company's business east into timber-and-mining-rich eastern Idaho, Montana, and Utah. This allowed the OSNC to raise shipping rates and thus maximize the profits it earned on moving timber, fruit, cattle, grain, iron, and whatever else out of the Columbia and Willamette River valleys to markets in San Francisco, South America, and Asia. Ainsworth and three other major OSNC investors, Simeon Reed, William Ladd, and R.R. Thompson, saw that many of the OSNC's twenty-five shareholders were happy cashing fat dividend checks and were unwilling to make further potentially risky decisions that would ensure the company's continued growth. They consolidated ownership into an Oregon Big Four.[24]

Ainsworth was an old riverboat gambler, and his plan was accordingly audacious: he wanted to make Portland, a town one-twentieth the size of San Francisco, a western co-terminus of the strongest transcontinental railroad line the city and the OSNC could attract. While this was preposterously hubristic, the OSNC's monopoly encouraged big thinking. Imagine that the OSNC could continue to make sure that all of the raw and produced material generated by a region the size of France continued to run along its

lines as the region's natural resources were brought to market. Suddenly the idea doesn't seem so crazy.

From a distance, to someone ignorant of the Pacific Northwest's unique geography, Ainsworth's idea seemed to ignore the most damning problem of all: the OSNC was an old-fashioned rivers-and-steamships transportation company at a time when railroads had long ago sidelined eastern versions of such companies. Surely someone would build a railroad network throughout Oregon, which, when combined with the transcontinental, would deal a deathblow to OSNC's business, no?

No. The OSNC understood its geography and topography. While back east, iron rails were increasingly replacing rivers as the primary carriers of people and goods, the Columbia River Gorge's topography made railroad construction difficult or impossible. In much of the Pacific Northwest, the only cost-effective way to get through much of the terrain was along the routes cut by rivers. This was especially true of the OSNC's region, as the Columbia ran between volcanoes Hood and Adams and cut steep passage through the massive basalt flows that stretched between them. In theory, a railroad could build along the Columbia and almost immediately put the OSNC out of business. In reality, perhaps without quite realizing he was doing it, Ainsworth had already moved to prevent this: when he used Ralston's capital infusion to consolidate Columbia River transportation companies into the OSNC back in 1860, he had bought out two portage railroads that skirted two areas of rapids or waterfalls along the Columbia, areas known as the Cascades and The Dalles.[25] These portage roads were the most critical parts of the Columbia River transportation infrastructure. Upon reaching the rapids, ships would unload their cargoes onto portage railroads; the trains would run the cargo past the watery impasse and then load cargo onto another steamer on the other side. Because of the steep topography, these two portage roads were the *only* cost-effective way to get freight through the region. As a result, control of those portage roads was imperative to any transcontinental that wanted to run roads through the Columbia River Gorge. To control them was to control right-of-way along the entire Columbia River system, 268,000 square miles of future wealth. The OSNC controlled them.

Even if the OSNC could not attract a transcontinental to Portland and had to make do with a branch line of some sort, it was clear that whichever railroad built that branch line would have to buy OSNC's twenty miles of

well-maintained portage roads. Congress tended to require newly chartered railroad companies to build fifty miles of track in two years to maintain their charter. OSNC was sitting on anyone's first twenty. Its position was strong.

As the OSNC worked through all this in early to mid-1867, as the Central Pacific and Union Pacific raced toward Promontory Point, it first decided that the Central Pacific wasn't the right partner. The best the OSNC could hope for from the Central Pacific was a branch line built north from Sacramento. That might be good enough for some Portlanders, but it wasn't good for the OSNC because it failed to take advantage of the OSNC's monopoly along the Columbia. While the OSNC would engage with the Central Pacific in an effort to build a stronger negotiating position with others, it would focus on two other possibilities: Encourage the Union Pacific, which was building the transcontinental west from Omaha, to extend a branch from Salt Lake City northwest to the Columbia along an already existing, graded OSNC stage route. Alternately, encourage the Northern Pacific to plan its transcontinental to bypass Puget Sound and instead establish its terminus in Portland. The OSNC's idea was that the Northern Pacific could build on the OSNC's stage road from Lake Pend Oreille in northern Idaho, through the flat deserts of eastern Washington Territory and Oregon (it was far less expensive to build road through flat terrain than through the mountains of central and western Washington Territory), and then along the Columbia into Portland.[26]

With all of this in mind, Simeon Reed traveled east to visit railroad officials and congressional offices. He succeeded in coaxing Oregon Sen. George Henry Williams to introduce a bill that would charter a new railroad from Salt Lake City to Portland, a westward continuation of the Union Pacific line, an indication that Union Pacific officials were intrigued by the idea. (The Central Pacific countered the next year: it backed a competing line that would instead join Portland with the Central Pacific line well west of Salt Lake, through Nevada's Humboldt Valley. This didn't make much sense for anyone—railroads were fueled by the value of land grants, and land grants through the Nevada and eastern Oregon desert were worthless—and the proposal soon withered.)[27]

The game was on. But—and for the OSNC, this was the key to its whole future—would easterners, whose railroads, capital, and political support the OSNC needed to attract, understand how different eastern geography

and topography were from western topography? Would investors, bankers, railroad executives, and politicians understand the OSNC's geographic and topographic hammerlock on the region? No, they would not—not by a long shot. For example, in response to Sen. Williams's Salt Lake and Columbia Railroad bill, Michigan Sen. Jacob Howard said he attached "a great deal of importance" to the bill, then admitted he didn't know how far Salt Lake was from Portland, guessed a thousand miles (he was off by half), and killed it.[28] Geography gave OSNC its biggest business advantage, but for now, easterners failed to understand the geography.

This, I think, is why John C. Ainsworth needed Carleton Watkins. If Watkins could make America believe in Yosemite, maybe he could make the right Americans believe that the only way to Portland, the Columbia, and the vast region's immense wealth was via the Oregon Steamship Navigation Co.

Ainsworth's idea, or maybe Ralston's (or maybe both), seems to have been that Watkins's pictures would prove that the OSNC controlled the Columbia. Of the fifty-eight mammoth-plate pictures Watkins made in Oregon in 1867, thirty are directly related to OSNC business interests. None of them show the OSNC's day-to-day business, its cargoes of timber and fruit and whatnot along the Columbia, its Portland terminal, the luxuriousness of its $400,000 steamer *Oregonian*, the clubroom in which the OSNC's owners supped with the speaker of the House of Representatives, none of it. Instead Watkins photographed portage roads and transfer facilities, trestle bridges and riverside train tracks, the OSNC's land and infrastructure, the source of its control of the Columbia. By 1867 eastern bankers and investors had seen lots of railroad prospectuses and business plans and investment pitches and knew to be skeptical of the words within them. The OSNC was going to show them proof of its dominance.

When Carleton Watkins returned to Portland from his trip down the Willamette, John W. Stevenson was there waiting for him. Stevenson was the man the OSNC had appointed to serve as Watkins's guide and assistant for his trip up the Columbia, the man whose job it was to provide everything Watkins needed—transport on OSNC vessels and trains, access to smaller boats for side trips, food, and cooperation from company staff all along the line. If Watkins needed a train stopped on a portage railroad for a picture, it

would be done. If Watkins needed staff to pose outside a maintenance facility, it would be done.

Stevenson was carefully chosen by OSNC management. He wasn't just a longtime employee, he was the head carpenter for the Oregon Portage Railroad, the OSNC subsidiary that operated and maintained those twenty crucial miles of portage road around the Columbia River rapids and waterfalls. Along with his brother-in-law, Stevenson also supervised a staff of about a dozen men at the OSNC's Eagle Creek Lumber Mill, which cut the board the OSNC used to maintain the trestles on which the portage roads ran. No one in the OSNC knew more about the terrain the company most needed Watkins to photograph.[29]

Stevenson didn't just know the OSNC's infrastructure, he knew the river and the landscape. His family had been among the first settlers in the Cape Horn region of the Columbia River, twenty-five miles east of Portland and fourteen miles west of the Eagle Creek Lumber Mill, and had planted the area with apple trees. Perhaps as a nod to his guide and assistant, Watkins included a couple of crates of apples in one of the pictures he would make at Cape Horn, a picture that may have been taken on the Stevensons' land. The two men seem to have gotten on well, perhaps because Stevenson, six years Watkins's junior, was, like Watkins, of Scottish heritage. Watkins would take one of his best stereograph portraits of Stevenson. It shows a narrow-shouldered man with a weathered face, thick, dark hair that was losing ground to a widow's peak even though he was just thirty-one, and a flowing goatee so long that it hides the top of his necktie.

As Watkins and Stevenson moved upriver, their first half dozen or so stops were for scenic views Watkins wanted for himself. (We'll look at those in chapter 12.) The first stop they would have made for an OSNC-related picture was at Stevenson's Eagle Creek Lumber Mill, at the bottom of the Cascades, the rocky rapids closest to Portland and the first portage railroad that Watkins and Stevenson encountered. His composition led the viewer's eye to everything in the picture that mattered to the OSNC. This was no easy thing. To make the picture, Watkins lugged his camera, dark tent, and related materials up a steep hillside on the upriver side of Eagle Creek, waited for the fog and low clouds to clear, and then made the picture. At the right edge, Watkins uses a short bridge over Eagle Creek to guide the eye into the mid-

Carleton Watkins, *Eagle Creek Lumber Mill and Tooth Bridge, Columbia River, Oregon,* 1867. Collection of the Stanford University Libraries.

dle, where two trees frame a whitewashed two-story building. Stevenson, his sister, and his brother-in-law probably lived and worked here. It is the only white thing in the picture. It holds the eye. After a moment, the viewer notices a bright line extending from the right side of the roofline of the house. This was Watkins's visual intelligence at work, the reason OSNC hired him: he had chosen his viewpoint on the hill so that the portage railroad that skirts the Cascades rapids and runs to the right edge of the frame, the most important thing in the picture for the client but also the most distant, smallest, hardest-to-see thing in it, would visually extend from behind the easiest-to-see thing in the picture, the whitewashed house. On the far left of the picture, and nearer to us than anything else here, is the sawmill that cut the board that built and maintained the portage road. If the Columbia flooded and took out part of the road, the OSNC had smartly put repair facilities right along—and above—the road. Everything that mattered to the OSNC was here, and Watkins had organized it all so that anyone familiar with railroads or river-borne transportation would understand.

Next, Watkins floated a hundred yards or so downriver from Eagle Creek, climbed up the steep basalt through which the Columbia had once cut, and took another picture of the trestle road, this one looking back toward Eagle Creek. It's a beautifully languid picture in which the road appears to be a parenthesis on the edge of the placid river. The photograph suggests that the trestle road was well made, that it was stable, that it presided over the river rather than the other way around. (None of this was true—the OSNC often had to rebuild parts of the trestle after the annual spring floods, but whatever.)

After working along the Columbia for most of the summer and early fall, Watkins and Stevenson finally reached their ultimate destinations—The Dalles rapids, the town named after them, and, via an OSNC portage railroad, the town's upstream neighbor, the village of Celilo. The town of The Dalles, eighty-five miles east of Portland at almost the exact place the forests of Oregon's western third give way to the immense desert of its eastern two-thirds, is sited at one of the most dramatic points on the Columbia. Mount Hood is just thirty miles to the southwest and is visible from anywhere in town. For the OSNC, this was a crucial site: a few years before Watkins arrived, it spent a staggering $1 million to build a thirteen-mile portage railroad around the Columbia's Celilo Falls and The Dalles rapids, a rough stretch of river that was at one point only seventy-five feet wide. The rapids ended just a bit downriver from the town, and so the portage railroad did too. This new road would enable the OSNC to move ore and timber, as well as local salmon.[30] The Dalles was also a key operational site: because beyond The Dalles lay hundreds of miles of desert, The Dalles was a key lumber-storage point; trees provided OSNC portage trains and steamships with fuel.

Shortly after reaching The Dalles, Watkins set up his camera on the Washington Territory side of the Columbia, put up his dark tent, and lined up a picture in which Mount Hood stood sentry behind the town, with hills tumbling down to the gentle plain on which The Dalles had been built. The local newspaper, *The Weekly Mountaineer*, noticed the triangular black tent against the yonder pale brown rocks and sent a man across the river to see what was going on. In its last issue of September 1867, the paper reported that the tent belonged to one Mr. Watkins, "a celebrated photographic artist from San Francisco." The paper noticed that Watkins was taking a picture of the town—

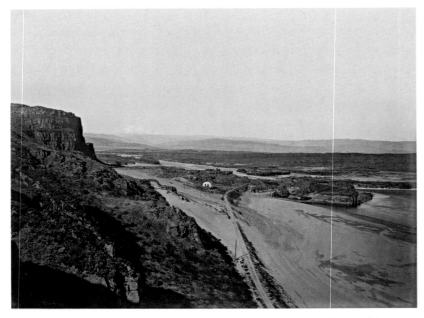

Carleton Watkins, *Mount Hood and The Dalles, Columbia River, Oregon*, 1867. Collection of the Stanford University Libraries.

how exciting! "This, Mr. Watkins thinks, will make one of the finest pictures of any he has taken."[31] Watkins called it *Dalles City from Rock Land [Washington Territory], Columbia River, Oregon*. Is it really one of Watkins's finest pictures? No, but with Mount Hood, thirty miles distant, looming above the little river town, it is a good one, full of topographical and geological drama, science, the history of the nation's westward movement, and more.

Compared to the other work Watkins would make here, it's a minor picture. Over the course of several weeks, Watkins made thirteen pictures and several dozen stereographs in and around The Dalles. At least three of the mammoth plates rank as masterpieces and are among his most popular pictures. While other photographers flocked to Yosemite and Mendocino after Watkins made those landscapes famous, The Dalles' remoteness meant that Watkins would have the place to himself. Detractors who, in recent decades, have argued that Watkins was a mere photographer in an era of painters, or that he merely made the pictures that were in front of him and thus gets credit for being there but not for doing anything special, must reckon with

The Dalles pictures. They are conceptual masterworks that required a knowledge of landscape, geology, and history, as well as a physical nimbleness more typically found in mountain goats.

Watkins's Dalles pictures start sometime between 6.5 and 8 million years ago, when, in one of Mount Hood's periodic eruptions, the mountain ejected cascades of lava to the northeast, pushing toward and then through the Columbia River and well into modern-day southern Washington. Where the lava met water, it created pillow basalt, a rapidly cooled area of rock that is quickly taken over by more hot lava flow, which is quickly cooled by the water, and so on. The resulting rock is craggy and crumbly, which, when combined with millions of years of Columbia River erosion, made it possible for Watkins to scramble partway up a 1,200-foot bluff of pillow basalt that towers above the Columbia River between The Dalles and Celilo Falls.

Today, it's almost unimaginable that in 1867 a thirty-seven-year-old photographer and one assistant—one assistant?—could scramble a hundred or more feet above the river, carrying, certainly in multiple trips, a mammoth-plate camera, glass plates, a tripod, a stereographic camera, dark tent, and chemicals to make a picture here. But Watkins did exactly that to make the extraordinary *Mount Hood and The Dalles*. Today nineteen prints of the picture still exist, a hint of the picture's popularity.

Watkins must have known that there were two reasons to hop up what geologists now call the Dalles Formation. By this point of his career as a professional picture maker, almost ten years in, Watkins had developed the ability to think about a landscape in three dimensions, to realize what changing his vantage point or elevation would earn him. He would have understood that by hiking up above the landscape through which he'd just moved via train, he would get a picture that showed the Columbia River cutting through basalt flows and over The Dalles rapids, and that showed The Dalles' and Celilo's portage road around the falls. Any nineteenth-century railroad man who saw this picture would have read it this way: He would have seen the Columbia enter the picture at the middle right, flowing downriver toward the center left. Familiar with seasonal flooding—that happened in the East too—he'd have noticed the high-water marks along the basalt flows through which the Columbia had cut over many millions of years. That railroad man would have seen an enormous sand dune between the river and the OSNC's slightly elevated track, and the way that the sand in

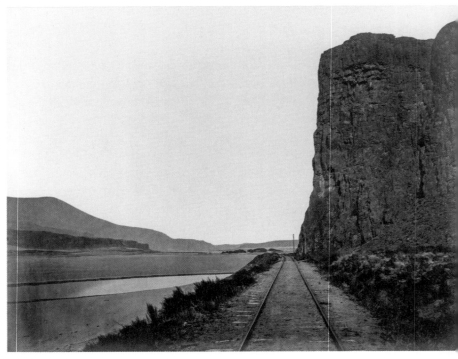

Carleton Watkins, *Cape Horn, near Celilo, Columbia River, Oregon,* 1867. Collection of the Stanford University Libraries.

the center of the picture, right in front of the white OSNC building at the middle of the frame, flowed from left to right; he would have understood that water came into the river through that spot during the spring. He'd have noticed that the OSNC's portage road had been built as close to the basalt butte as a surveyor dared and that it hadn't mattered; the tracks were covered with sand from recent flooding. Watkins's picture would have communicated exactly what OSNC wanted it to communicate: if any railroad wanted access to national and international trade via Portland, access to the entire Pacific Northwest, that railroad would have to deal with the OSNC because the OSNC owned the only places a railroad could transit the Columbia Gorge.

The other two pictures Watkins took along this section of railroad deliver the same message. For *Cape Horn, near Celilo,* Watkins stood directly on the OSNC tracks. We cannot see the railroad ties on which the iron rails

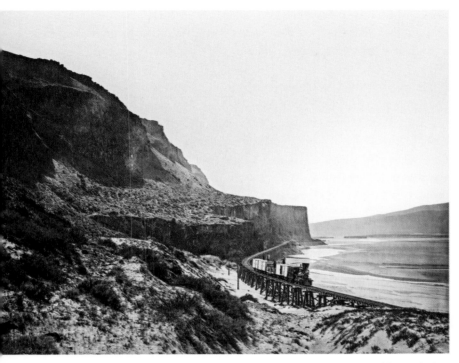

Carleton Watkins, *Cape Horn, near Celilo, Columbia River, Oregon*, 1867. Collection of the Stanford University Libraries.

run because they are covered with sand, the same sand that we see to the left of the tracks. A small pond also lies to the left of the tracks, a reminder of the river that isn't visible. The tracks run into the distance, curving gently toward the river just before they vanish in infinity. The entire right third of the picture is a massive basalt butte, an immovable behemoth. Again the message is plain: the OSNC owns access to the Columbia. Don't believe it? Look across the sand dunes on the left to the other side of the river. There are more steep basalt flows and the steep Columbia Hills in Washington Territory. Any OSNC executive showing these pictures to another railroad executive would have told him that the hills on the left side of this picture form a 2,500-foot wall on the opposite side of the Columbia.

The third picture proves that despite all that sandy evidence of flooding, the seeming temporality of the railroad track in the other two pictures, the OSNC routinely ran trains here. It shows a locomotive on the OSNC's

tracks, with a huge basalt bluff rising about a thousand feet behind it on the left, and the Columbia River alongside it on the right. The locomotive is on a trestle road that links two sand dunes. The train looks like a toy.

While many Watkins pictures remain in the archives of the OSNC's Big Four, such as in the papers of Simeon Reed at the Portland college that bears his and his wife Amanda's name, the details of how the OSNC used Watkins's pictures are lost. The company's surviving archives, almost entirely at the Oregon Historical Society, are long on routine paperwork and short on specifics of the company's strategy, as are the archives of key directors who collected Watkins's work, men such as Ainsworth and Daniel F. Bradford.[32] Almost certainly, the OSNC used Watkins's pictures to show bankers such as Jay Cooke how solid the OSNC's position on the Columbia was as Cooke helped it recapitalize in 1868, thus massively increasing the wealth of Ainsworth and his ring.

What of the battle related to the transcontinental railroad? As the Central Pacific was pushing for a side branch off the transcontinental from Nevada's Humboldt Valley toward the Willamette, the OSNC was almost certainly wholly aligned with the Union Pacific, which wanted to build a line from Salt Lake City toward Portland. As it turned out, both the Union Pacific and the Central Pacific exhausted themselves, financially and otherwise, in completing the transcontinental in 1869. That forced the OSNC to align with the next transcontinental that was being built, the Northern Pacific. Coincidentally—or not?—Frederick Billings, associate of Watkins, Ralston, and Ainsworth, was a director of the Northern Pacific and would later become its chief executive. (The other key player in the Northern Pacific was Cooke, whose money and capital network backed the railroad, another suggestion that Watkins's pictures had been important to the OSNC's future.) The Northern Pacific–OSNC alliance worked well until 1872–73, when the Northern Pacific ran out of money before it could complete its line. In an effort to raise cash, the railroad spun off the OSNC, and Ainsworth reacquired his old company. It was at this time, probably as a thank-you, that Ainsworth gifted Cooke a lavishly bound volume of Watkins's pictures of the Columbia River Gorge, the clearest surviving suggestion of why the pictures were made.[33]

12

VOLCANIC LANDSCAPES

THROUGHOUT HIS CAREER, WHENEVER WATKINS traveled for a client, he made pictures that went beyond the necessities of the commission. In Oregon, Watkins made pictures of the Oregon Steamship Navigation Co.'s facilities and portage railroads and of the land it controlled, but he also made pictures of the spectacular scenery, especially along the Columbia River Gorge. Today we consider there to be a difference between commercial photography and photography intended as art, but when it came to pictures of the landscape in 1867, there was not. Today we think of landscape art as being as free of man as possible. In Watkins's time, the presence of humans or their business activity did not render a picture a nonlandscape. The land was there to be filled and used, so it was only natural that an artist would celebrate America's fulfillment of its destiny in the West within pictures of the landscape. Specialization of an artist's practice and the separation of natural from productive use of the land would all come later. In his galleries, Watkins would sell the OSNC-specific pictures alongside Columbia River Gorge pictures that were not explicitly about the OSNC's narrative. Great pictures were great pictures. (Watkins also knew that a client such as the OSNC would be happy to have contextualizing pictures, photographs that showed the majesty, and perhaps the challenges, of

the landscape it inhabited. As at Las Mariposas, beauty was a terrific metaphor for potential.)

One of the last pictures I introduced in chapter 11 demonstrates how Watkins made pictures that fit multiple uses and narratives, the landmark *Mount Hood and The Dalles.* While this picture served the OSNC's purposes in that it showed some of its most important infrastructure and its dominance of the Columbia, it was also a picture of one of the most dramatic places in the history of the nation, and especially of the West: the end of the Oregon Trail.

First marked by fur traders in the 1810s, from the 1840s until the completion of the transcontinental railroad in 1869, the Oregon Trail was the primary overland route from the Midwest, usually Independence or Westport, Missouri, to points west. Some travelers stopped in Salt Lake City and stayed. Others, upon reaching the Humboldt River in Nevada Territory, split off for Northern California, while others took the trail to its end point—this point around The Dalles, Oregon—and made arrangements from there. At least, that's what they would do if they didn't die en route to the West. Roughly four hundred thousand Americans went west along the trail; as many as twenty thousand of them died on the way.[1]

The end of the Oregon Trail came after a particularly tough stretch of grueling travel. Over the previous fifteen miles, between where the Deschutes River meets the Columbia and The Dalles, travelers passed through a desolate canyon of sheer basalt cliffs so high that the wind howls and this stretch of the Columbia River was kept in deep, dark shadow. Except for a few tufts of grass, travelers would have seen almost nothing living. Then, after enduring a full day of travel through a kind of moonscape unlike anything they'd ever seen before, travelers would reach a seemingly indistinct bend in the river. This bend takes about fifteen minutes to traverse on foot. At the end of the bend, on the way out of its broad curve, suddenly a traveler would see shrubs and small trees on hills that had been naked only a few moments earlier. Within just a couple of minutes, off in the distance, that traveler would see firs and cedars by the thousands—huge, thick, rich, lush green forests. Then, with a rapidity that usually happens only in smartly edited movies, they would have seen Mount Hood rising before them, massive, white, and shining. With a suddenness that still seems astonishing today, desolation gave way to robust flora. It is this exact moment, at this place in the landscape, that Watkins made *Mount Hood and The Dalles.*

Within the picture was the trail's end, promise, the beginning of a new life in a new place.[2]

As Oregon Trail alumni showed this picture to their friends, they could tell them that at this exact moment, they could look back over their shoulders and see the deserts they had survived. Then they could look forward, toward the forests, rich with timber (warmth!), water, and game to the west. They could see the wood fires and maybe the roofs of buildings in The Dalles, which meant that finally, after two thousand miles of travel across the plains and desert, they would reach a place that offered food, warmth, and shelter, salvations of almost unimaginable import to a twenty-first-century reader. It's easy to imagine how a salesperson in Watkins's San Francisco gallery would set up this picture to a prospective buyer: this is the moment of your family's triumph, its survival, the moment when the desperate dreams of a two-thousand-mile journey began to come true.

While no records that make explicit the intent that motivated the Columbia River Gorge pictures have survived, it's possible that *Mount Hood and The Dalles* was not the only picture in which Watkins would appear to reference the Oregon Trail and the history of the Americanizing West. It's possible to read Watkins' non-OSNC-motivated Columbia River landscapes as a conscious sequence of the landscape features that an Oregon Trail traveler would see on the way down the Columbia and into Portland. While the damming of the Columbia River and other changes man has made to the riverscape makes it difficult to tell from where Watkins made many of his gorge pictures, most non-OSNC-related Columbia River views Watkins took face *downriver*, mimicking the way Oregon Trail travelers would have rafted from The Dalles down to Portland. While a salesperson in Watkins's gallery may have described the views to a potential customer as flowing toward Portland, that was not the order in which Watkins made them. If we take Watkins's own numbering system as a cue to the artist's chronology, he made these pictures on the way out to The Dalles and Celilo. On some days Watkins took OSNC pictures; on other days he took scenic views for himself. For the sake of making the Watkins-in-Oregon story easier to follow, we'll separate the scenic views from the OSNC work and discuss them here.

After leaving Portland, Carleton Watkins and his OSNC-provided assistant John Stevenson first stopped on Government Island, just a few miles up the

Columbia from its confluence with the Willamette. As Josiah Whitney and William Brewer had expressed an interest in views of Mount Hood, and as Watkins surely wanted pictures of the famous mountain to sell as well, Watkins made the first of several attempts at capturing a view of the volcanic peak.[3] The combination of the technology available to Watkins, the distance (over forty miles from where he took this first picture, on or near Government Island in the Columbia), and the difficult Oregon weather conditions meant that in each picture Watkins took of Hood on this trip, it would appear only faintly, slightly better than ghostlike in the finished print. Watkins was about ten miles closer to the mountain when he made *Mount Hood and The Dalles*, and it shows. However the prints look today, the mountain was probably clearer when the prints were made in 1867, as the picture sold well enough that ten prints have survived.

A dozen miles later, Watkins and Stevenson stopped to make a mammoth-plate picture at Rooster Rock, a phallic two-hundred-foot basalt monolith that rises from the south shore of the Columbia. From Rooster Rock, Watkins and Stevens boated four miles up the Columbia, past Cape Horn, a five-mile-long sheer basalt cliff that rises from four hundred to eight hundred feet above the river. (Early settlers named many formations across the West Cape Horn, as a nod to how challenging it was to navigate certain areas. The reference was to Cape Horn at the southern tip of South America, a famously difficult area for ships to pass. Watkins photographed at least four different Cape Horns in at least two states.) Stevenson knew this area particularly well: it was where his family lived and tended an apple orchard. Watkins and Stevenson probably spent several days here. Watkins took stereographs of Stevenson's large two-story house with the impossibly steep Cape Horn butte behind it, the orchard (where the trees were nearly overwhelmed by the enormous apples hanging off their branches), and of the basalt formation itself.

Two of Watkins's Cape Horn mammoths rank among his best pictures. One is a vertical composition that, no matter how impossible it may have been to have done this, looks like it was taken from the middle of the Columbia River. (The movement of a rowboat or a barge on the water would have doomed any picture Watkins could have attempted. Maybe he set up his tripod on a protruding rock that has long since been submerged by Columbia River dams?) The left-hand third of the picture is filled by a seeming

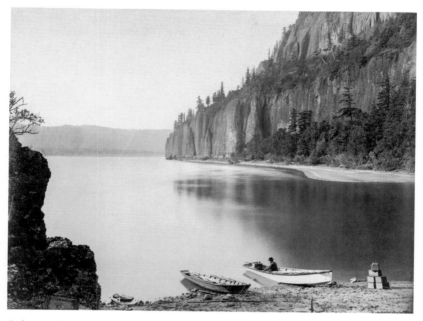

Carleton Watkins, *Cape Horn, Columbia River, Washington Territory*, 1867. Collection of the J. Paul Getty Museum, Los Angeles.

wall of sheer basalt. Watkins plays the pockmarked, gritty surface of the cliff against the placid river surface below it, one of the best moments of visual tactility in any of his pictures. The viewer's eye moves from the top of the cliff, at the top middle of the photograph, down to two trees that stand on top of Cape Horn, then down, steeply, to the point at which the formation juts out into the river. Just to its right, barely visible, is Stevenson's house.

The picture raises a question about Watkins's awareness of recent developments in art. Did he know that a continent and an ocean away, a pioneering French painter had recently earned fame for pictures he had painted from the middle of a river? The painter was Charles-François Daubigny, who, along with Gustave Courbet, Camille Corot, Jean-François Millet, and Theodore Rousseau, was a pioneer of French realism, the painting movement that turned French art away from classicized scenes mimicking Italian vistas and instead spotlighted France's own landscape. A decade earlier, in 1857, Daubigny had outfitted a rowboat with all the accoutrements of his usual painting studio, such as paints, stretched canvases, brushes, and more basic

supplies such as food and wine. One end of Daubigny's studio boat had a big rectangular aperture that he would use to literally frame the river and landscape he wished to paint. Claude Monet was so impressed with this idea that he built his own studio boat, prompting Edouard Manet to teasingly call him "the Raphael of water."[4] Daubigny made an etching of his studio boat setup, *The Boat Studio,* in 1861, and published it as part of the series *Voyage en Bateau* the next year. Watkins would not have seen French painting yet, but French prints were almost certainly available in San Francisco.

Watkins also made a horizontal Cape Horn picture from the rocky beach below Stevenson's house. While Watkins regularly featured people in mammoth-plate pictures made for businesses, here he includes a man, no doubt Stevenson, in a landscape photograph. Stevenson sits in a boat with his head slightly turned so that Watkins's camera catches him in profile. A crate of apples sits on the bench at his feet. Six more crates, at least one of apples, are piled up into a ziggurat on the beach, just to the right of Stevenson's skiff. Having loaded up with photographic chemicals (and apples), Watkins and Stevenson pointed their skiffs back upriver.

Their next stop was four miles upriver at Multnomah Falls, one of the Columbia River Gorge features longest known to Americans. It would result in not only another of Watkins's best pictures but also a whole series of pictures that provide a rare glimpse into how Watkins worked in—and on—a landscape he wanted to photograph.

Multnomah Falls was a particularly famous waterfall. Sixty-two years earlier, as part of the landmark expedition President Thomas Jefferson sent to explore America's acquisition of a sizable acreage purchased from France, Meriwether Lewis stopped to admire this exact waterfall. That he stopped was itself notable—in their diaries, both Lewis and William Clark mention seeing so many hundred-foot falls as they sailed down the Columbia that the mentions become routine. "We passed several beautiful cascades which fell from a great height over the stupendous rocks which cloles [*sic*] the river on both sides nearly, except a small bottom on the South side in which our hunters were encamped," Lewis wrote in his diary in April 1806. "The most remarkable of these cascades falls about 300 feet perpendicularly over a solid rock into a narrow bottom of the river on the south side. It is a large creek, situated about 5 miles above our encampment of the last evening. Several small streams fall from a much greater height, and in their descent

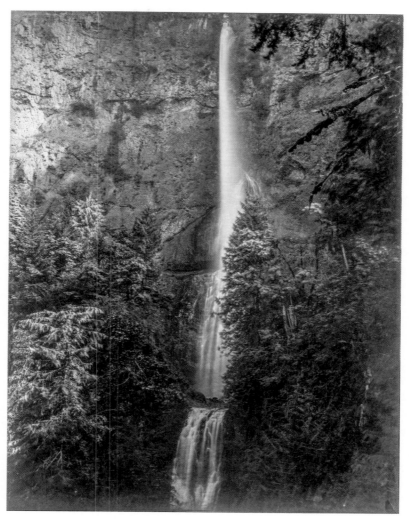

Carleton Watkins, *Multnomah Falls, Front View, Oregon*, 1867. Collection of the Metropolitan Museum of Art.

become a perfect mist which collecting on the rocks below again become visible and descend a second time in the same manner before they reach the base of the rocks."[5]

Watkins tried to rename this two-stage waterfall Bridal Veil, after the falls in Yosemite, but the name didn't stick.[6] The height of Multnomah Falls

has been measured at 620 feet, making it the second-highest year-round waterfall in America. It's impossible to know how far back Multnomah Falls was set from the river, which was undammed in 1867, but it was certainly far enough back that Watkins and Stevenson would have had to do some work to transport Watkins's equipment through a mature forest and thick underbrush, and along slick moss and lichen, to get to where Watkins would make his pictures.

The forest made a direct, head-on picture of the entire falls all but impossible. Watkins tried anyway, and made both a stereograph and a mammoth plate of that view. In the resulting mammoth plate, Watkins used a cedar branch in the upper right of the picture to provide some depth and took the picture at a moment when sunlight touched the huge firs on either side of the falls. Those clevernesses rescue an otherwise blah picture, as neither the top of the falls nor the bottom is visible, and the spectacular two-stage three-dimensionality of the falls is flattened into sameness, an effect that eliminates Multnomah's stupendous uniqueness. Evidently Watkins realized that the site was forcing him to be more creative in building his picture. This is when he was at his best.

Watkins's next attempt was downriver from the falls, at a tight angle to the basalt cliff that Multnomah cleaved. (Today the Multnomah Falls visitor center is on the spot where Watkins set up his camera.) This viewpoint allowed him to make a picture that showed how the falls had worn through the top of the basalt cliff from which it plunged, and to show off the booming power of the upper and lower falls. Pictorially, it allowed the two stages of the falls to create their own depth of field, thus faithfully representing the experience of seeing the falls in person. Having selected a second viewpoint, Watkins put his stereographic camera on its tripod and snapped a picture. It was then that he realized there was a problem: a tree was blocking the best possible view.

True, the view of the upper falls, which filled the left-hand side of the frame, was perfect. The falls started as a narrow stream at the top of the basalt cliff and widened as the spray dispersed on the way down. That contrasted nicely with a tree Watkins had "placed" at the left-hand side of the frame, a tree that was wider at its base than at the top. The problem was with how Watkins wanted to frame the lower falls: his plan was to make a picture with thick cedars on either side of the view, thus framing the falls,

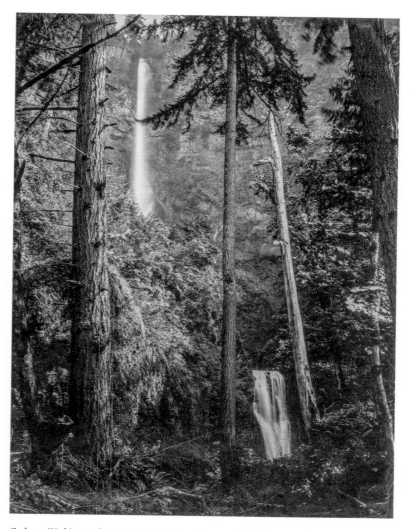

Carleton Watkins, *Multnomah Falls, Side View, Oregon,* 1867. Collection of the Metropolitan Museum of Art.

with a skinny, sunlit pine in the middle filling and joining the space between the upper and lower falls. An angled dead tree just to the right of the lower falls, also in sunlight, framed the whole scene perfectly. That was all in place. But so was an intruder: a pine tree that had either grown at an angle or had recently partially fallen and was leaning against Watkins's cedar at

the right-hand edge of his picture was almost cutting off the top of the lower falls. This pine tree was also in shadow, thus wrecking not just the composition but the way Watkins had built a foreground of sun-dappled tree trunks. There was only one solution: cut down the offending tree. Watkins did so, covered the remaining stump with some fallen tree branches and underbrush, and tried the picture again. In the finished mammoth-plate picture, the ferns and the detritus that Watkins had used to cover the stump he'd created serve to soften the foreground, highlighting the rough basalt cliffs, the plunging falls, and the massive trees at the two edges of the frame. At least thirteen prints of this picture survive. Today the combination of the mammoths and the stereographs provides rare, perhaps unique, evidence of how Watkins labored to build a composition.

From Multnomah Falls, Watkins and Stevenson continued just past what was then known as Castle Rock, a fat basalt plug on an island in the middle of the Columbia River. (Today it is known as Beacon Rock, and the island on which it sits is on the Washington side of the Columbia.) Watkins would make two equally terrific pictures of Castle Rock: one from a rocky riverside beach and another from atop a basalt bluff a little farther to the east. As at Multnomah Falls, Watkins had to cut down a tree to get this picture. Unlike at Multnomah Falls, Watkins hiked up a bluff on the Washington side of the Columbia and made a picture from the eastern side of the rock.

As at Yosemite and at Mendocino, Watkins's pictures of the Columbia River Gorge still define our visual idea of the place. They are so complete that other artists avoided competing with Watkins's presentations. Painters, notably Albert Bierstadt and William Keith, would surpass how Watkins could capture Mount Hood—oils allowed them to seem closer to the mountain than they were, a difficulty Watkins, with his chemicals and glass plates, struggled to overcome—but otherwise the Columbia River Gorge is still Watkins's.

Nearly all San Franciscans returned home from Portland via steamship, the fastest, most comfortable, and least expensive way. No doubt the dozens of glass plates Watkins made in Oregon did too. They traveled more comfortably than their maker, who took a long, slow, dusty, bumpy, rocky, and dangerous stagecoach ride through the Cascade and Siskiyou Mountains instead. Watkins took the overland route because he wanted to make pictures

Carleton Watkins, *Castle Rock, Washington Territory,* 1867. Collection of the J. Paul Getty Museum, Los Angeles.

of Mount Shasta, then believed to be either the highest or second-highest mountain in America. The only way to get to Shasta from Portland was by stage.[7]

However enormous, Shasta was difficult to reach and rarely visited. In 1851 a few gold miners had ventured into the Shasta region, but there wasn't enough gold here to prompt a rush. In 1853–55, Lt. Henry L. Abbot's federal Pacific Railroad Survey studied the area. Team member John J. Young's sketch of Shasta and Lassen's Butte, now known as Black Butte, was included in the survey's 1857 report, but Young's drawing so downplays Shasta's true immensity that no one took much notice. While San Francisco newspapers routinely featured news from up and down the state, the Shasta region merited mention only at election time and on the occasion of stabbings, which were sometimes related. As Shasta was farther away from San Francisco than the Sierra, and bad roads made it more difficult to reach, it existed mostly outside both experience and imagination.

Watkins was well-connected to San Franciscans who were interested in nature and landscape, so it's no surprise that he was connected to many of

the handful of San Franciscans who had visited Shasta. John C. Frémont had been to the base of the mountain in 1846, and a California Geological Survey team had climbed to the summit in 1862—and then descended by sliding down the mountain.[8]

The man who spread the Shasta gospel to Watkins and to the rest of San Francisco was, naturally, Thomas Starr King, who visited in August 1862, six weeks before CGSers Brewer and Whitney.[9] "Our state has one [mountain] wh[ich] may claim to be classed with the select aristocracy of mountain heights on the globe," Starr wrote for a sermon delivered at First Unitarian late in 1862.[10] As he had with Yosemite, Starr used cultural Unionism to link Shasta's magnificence to the North and its landscape tradition. Here he did it in a way that suggests he may have been familiar with prints of Frederic Edwin Church's hyperpatriotic 1861 painting *Our Banner in the Sky,* which used a tree trunk as a flagpole and then invented clouds, sunset, blue sky, and a few stars or clouds into an American flag.[11] "I longed to have the peak crowned with a staff stouter and taller than one of the mammoth evergreens of [the] Calaveras [Grove], supporting the country's banner, large enough to be seen as far as the mountain blazes on the horizon," Starr wrote. "Red, white and blue are the colors of the mighty pile itself, the rose of sunset, the dazzling white of the snow at high noon, and the azure shadows in its gorges in the earth and the dying light."[12]

While Watkins had quickly followed Starr's metaphors into Yosemite, the combination of the short summer photography season and other professional obligations had prevented him from immediately going to Shasta. He had to print his 1861 Yosemite pictures, prepare them for display at Goupil's in New York, and maintain cash flow via the 1863 Mendocino commission and the filling of thousands of dollars of orders in 1864. He had to return to Yosemite in 1865 and 1866 to make pictures for both himself and the CGS. This 1867 trip was probably Watkins's first opportunity to go to Shasta since he'd heard about it.

It's possible that Watkins went at the behest of his CGS chums. Not only were Brewer and Whitney on Shasta in 1862 but CGS staffer Clarence King had followed them in 1863. There's no surviving evidence that Brewer or Josiah Whitney had any particular interest in Watkins going to Shasta on their account, but if Whitney had wanted Watkins to make pictures of Hood, why wouldn't he have wanted pictures of Shasta too?[13]

Maybe Watkins recognized that few artists had captured Shasta and saw a business opportunity. He may have known that a few illustrators had made attempts: Edward Kern, Frémont's expedition artist, made a sketch of Shasta in 1843. Thomas Ayres, the illustrator who made the earliest lithograph of Yosemite, made either the first or the second print of Shasta, reproduced in *Frank Leslie's Illustrated Newspaper* in January 1858; Ayres drew Shasta's monumental peak as resembling the pointy end of a sweet potato. Eugene Camerer, a German painter who had moved to San Francisco in the 1850s, made a fairly representative print of Shasta, possibly as early as 1858.

By 1867 only one painter had been to Shasta: Albert Bierstadt, who visited with Fitz Hugh Ludlow in 1863, upon Starr's recommendation. Bierstadt's Shastas, produced in his New York studio after sketches he made in California, are far from his best work. Like the illustrators who preceded him, Bierstadt seems to have been unsure how to portray the mountain's bulk (Shasta covers an area roughly equivalent to the square mileage of modern-day San Francisco), its prominence (topographers generally record Shasta as rising around 9,800 feet from the surrounding plain, but from the lava-poured flats to the northwest and southeast, it rises even more, around 11,000 feet), or its steepness, which, when offered in two dimensions, often looked delicate, even farcical. This was a special problem for Bierstadt, whose modus operandi was to fictionalize mountainscapes into greater glory. In Shasta he found a topographical drama already at maximum crescendo—and was defeated. By some margin, the most successful paintings of Shasta would not be made for another decade or two, by Thomas Hill and by William Keith, both friends of Watkins's.[14] Watkins would be the first photographer to make pictures at Shasta—and apparently the only photographer to make work there for over twenty years. To this day, the work he made at Shasta stands alone.

Upon arriving in the Shasta region on the stage from Portland, Watkins surely did what everyone else had done for years before and would do for decades thereafter: ask for a room at John and Lydia Sisson's ranch and guesthouse, the only lodgings within ninety miles in any direction. Sisson's, as it was widely known, sat at the head of Strawberry Valley, where the Klamath Mountains met the Shasta Valley on Shasta's southwestern slope, closer to Sacramento than to Portland. Virtually every traveling artist of the era made a view of Shasta from near Sisson's, and Watkins seems to have

Carleton Watkins, *Mount Shasta, Siskiyou County, California,* 1867(?). Collection of the J. Paul Getty Museum, Los Angeles.

been no exception. An apparently cut-down mammoth-plate picture of the mountain taken from Sisson's meadow, in the collections of the de Young Museum and the Bancroft Library, is typically attributed to him.[15]

We do not know how Watkins approached the mountain, either physically or pictorially.[16] The Shasta mammoths that seem to date to 1867 suggest that Watkins, like the illustrators and painters before and after him, struggled to find the most effective way to show both Shasta's enormous size and its chameleonlike shape. Three of the either five or six mammoth plates Watkins took at Shasta in 1867 are from more or less the same place; apparently Watkins initially thought he'd found the view that suggested the way in which Shasta's bulk loomed over a landscape as large as entire eastern states. He was wrong: none of these three are pictures of any particular distinction. Perhaps Watkins ultimately realized it too, because he made two other completely different views of the mountain. The other two views, each made from a separate place, were made almost 180 degrees around the

mountain from Sisson's, fifteen to twenty miles away as the crow flies, and at least twenty to thirty miles by horse and wagon.

It paid off, and big: one of Watkins's 1867 Shasta pictures, a view that offers Shasta as a volcanic pyramid, is iconic. Even today, with the benefit of four-wheel drive, it's hard to figure out how Watkins reached the place from which he took the picture. A look at a topographic map suggests the challenge: while Shasta is the rare American mountain that can be circumnavigated on foot, the terrain is difficult.[17] For an artist intent on getting a view of the mountain that a competitor could not easily duplicate—and by now Watkins was absolutely fed up with his Yosemite pictures having been stolen by New York publishers and with San Francisco photography houses traveling in his wake for the purpose of mimicking his most successful pictures—difficult was best.

Given that Watkins shows Shasta as acutely conical, might his view have been informed by eighteenth- or nineteenth-century Japanese prints? At first glance, this Shasta picture seems indebted to Hokusai's and Hiroshige's prints of Mount Fuji, Japan's most famous stratovolcano. Hokusai's and Hiroshige's work balances bulk with steepness with solidity in a way that Watkins's American predecessors never approached. While it's certainly possible—San Francisco was a global emporium—it seems unlikely that Watkins had access to nineteenth-century Japanese material. The first Japanese to emigrate to San Francisco arrived in 1869, two years after Watkins made his first group of Shasta pictures.[18]

So where did Watkins get the idea to turn Shasta into geometric perfection? He may have just traveled around the mountain, hundreds of pounds of gear in tow, until he found the view he wanted. He did that kind of thing. Still, the scale of the Shasta landscape and the difficult terrain makes it unlikely. Sure, for the first few miles, he could follow the stage road back toward Oregon, but that road offered little comfort. "In some places, an attempt had been made to mend the road with lava," reported Bierstadt's traveling companion and personal bard Fitz Hugh Ludlow. "As it crunched under our horse's hoofs we could almost imagine ourselves making the circuit of Vesuvius, so evident was it from the look and feel of things that Pluto has at no very remote period boiled his dinner-pot on the hob of Shasta Peak."[19] At a certain point, Watkins would have had to turn right off the stage road and simply head across the grass-tufted lava bed to get to where he wanted to go. Once he found his spot,

he would have had to hike up a steep, sharp escarpment to get his picture. It must have taken Watkins days to find the right picture and to make it.

Might one of the many Watkins friends who had been to Shasta have tipped him off to a particularly good viewpoint? Yes. When Clarence King visited Shasta in 1863, he kept a detailed notebook that included scientific observations and sketches of the mountain. Within its pages is a pencil drawing of Shasta in which the volcano rises like a massive triangle from the plain formed by its own lava flows. King's sketch almost exactly matches up with Watkins's picture. King may have shown Watkins this sketch and told him where it was made and how to get there.[20]

For Watkins the journey was worth it because circumnavigation of Shasta reveals dozens of different faces. From the west, Shastina, the volcanic cone on Shasta's western shoulder, is omnipresent. From the east, where Watkins took this picture, it is completely hidden by Shasta's summit (which is how Watkins was able to offer a compound mountain as a sleek, seemingly pyramidal cone). In his picture the mountain's rocky tip is partially exposed; the next many thousands of feet down the stratovolcanic triangle are mostly covered in snow. Below the snow line, it's easy to see rock lightly covered by trees, a strip of landscape that makes lava flow clear. The place where the triangular bulk of the mountain transitions into the Shasta Valley is a melding point with which artists have struggled in the decades since Watkins's pioneering picture: Watkins merely suggests that transition area by hiding it between a thick band of trees. The foreground half of the picture is an ancient lava bed only occasionally broken up with scrub and perhaps a tiny pond. The scale of Shasta—and the height of the hill up which Watkins climbed to make this picture—is revealed only when the viewer finds what appears to be a pine tree in the lower right of the picture. It is preposterously small and skinny; we're far above it.

Before returning to San Francisco, Watkins stopped at the Geysers, a geothermal field and tourist attraction in Sonoma County, where he made four mammoths and stereos. This 1867 trip was the longest and probably the most challenging of his career to date. He had made work that would show America both the Columbia River Gorge and Mount Shasta, that would help eastern capital, business, and government decide how to invest and move through the newest West, and that would inform eastern science about vol-

canology. And he may have introduced an investigation of American and western history into his work.

As if that wasn't enough, when Watkins returned to San Francisco, he would learn that the thirty 1865–66 pictures of Yosemite and the Mariposa Grove that he had sent to the 1867 Exposition Universelle in Paris were a hit. A report on the fair for the U.S. Senate reported that Watkins's pictures were "the most notable display from the United States" and that they were "not only interesting as pictures but as splendid specimens of the art."[21] The commissioners of the U.S. section reported that Watkins had offered the pictures in his usual unusual custom: framed behind glass for hanging on a wall. Watkins had even placed the Mariposa pictures in carved sequoia wood. "These photographs attracted much attention," the commissioners reported, noting that Watkins won a bronze medal for them.[22]

Watkins's triumph was partial: somewhere between Paris and San Francisco, the communication was garbled, and the California press initially reported that Watkins's rival Lawrence & Houseworth had won the medal with pictures made by Charles Leander Weed. (Watkins addressed the error through his advertisements in the city directory and an imagined medal that William Keith designed and Watkins printed on the backs of his stereographs. The error seems to have done him little harm.) Between his European triumph and the Oregon trip, Watkins had enough inventory and critical notoriety that it was time to enjoy success a bit and to focus on selling, on building the retail end of the business. The man who would help Watkins do it—and help him enjoy it—would be the same man who helped send him to Oregon: Billy Ralston.

13

BASKING IN ACHIEVEMENT, BUILDING A BUSINESS

LATE ONE NIGHT, NEAR the end of June 1867, when Carleton Watkins was packing the couple thousand pounds of equipment he'd use in Oregon, a team of men quietly emptied Billy Ralston's Bank of California of gold coin, securities files, and bank ledgers. Over the course of several trips, they loaded their haul into wheelbarrows and wagons and slipped into the night.

The next morning, San Francisco awoke to a surprise. Everything the men had taken, every last gold coin, was in a new place: it was all now two blocks away, in the Bank of California's opulent new building at Sansome and California Streets. Who knows why Ralston chose to move the bank's headquarters with such subterfuge—maybe he feared theft had the move been preannounced, or maybe he just thought a no-warning opening would be good publicity—but the new Bank of California was immediately the talk of the city.[1]

"Here I saw more gold and silver coin and bullion than I ever before held at one time," wrote one visitor from the East who understood that the new bank building was part corporate headquarters and part theater.[2] Rival banker John Parrott was both awed and envious. "Ralston is a man of wonderful resources," he wrote to friend Joseph Donohoe. "People look upon

him as on a King. He has a ring formed of very strong people . . . such as the Barrons, Bell, Butterworth, Hayward, Sunderland, Tevis and their stripe . . . They stop at nothing these days."[3] Most of those men, Parrott included, owned Watkinses and would commission work from him. Their futures were all tied together, and the man around whom their fortunes swirled was Ralston. By the time Watkins left for Oregon, no one was more important to his career than Ralston. Everyone who had been important to the first decade of Watkins's career—Jessie Benton Frémont, Thomas Starr King, Frederick Billings, Frederick Law Olmsted, Trenor Park, Josiah Whitney, and William Brewer (who accepted appointments at Harvard and Yale)— had left California or died. Watkins had evidently made work for Ralston since Ralston had sided with Union in 1861, but with Ralston's probable arrangement of the Oregon Steam Navigation Co. commission, he became the most important force in Watkins's career and would remain so for a decade. Ralston was the West's biggest booster and the biggest supporter of its nascent visual and performing arts, Watkins its best and most famous artist. It was a natural fit.

By the mid-1860s, Ralston's bank was the biggest, most important, best-connected financial concern west of at least Chicago. As the decade advanced, the Bank of California increasingly dominated western finance, providing enabling loans and a bank-built business network, known as Ralston's Ring, to most of San Francisco and to much of Oregon too. With the move to an ornate, $250,000 new building—complete with solid Italianish architecture ("It resembles in some respects the Library of St. Marks in Venice," reported the hyperventilating *Daily Alta California*), stone quarried from Angel Island in San Francisco Bay, nineteen-foot ceilings painted in the latest European style, massive iron-walled vaults, twenty-seven mahogany desks, shimmering bird's-eye maple wainscoting, green morocco-covered chairs, and art featuring the Yosemite Valley (symbol of the West's commitment to the nation) in the private rooms upstairs—the Bank of California was sending a message about its patriotism, its wealth, and its future, and about San Francisco's. It was all designed by David Farquharson, the best architect working in the West, a Ralston favorite, and a friend and customer of Carleton Watkins.[4] Ralston's Ring stuck together.

Much, even most, of Watkins's San Francisco work in the 1860s and 1870s can be linked to Ralston's interests. Ralston owned the Mission

Woolen Mills, which made uniforms for Union troops and then converted to making blankets so fine that they won first prize at the Paris World's Fair. Watkins made pictures of the factory. Ralston was the key investor behind the North Bloomfield Gravel Mining Co., which used new hydraulic mining techniques to harvest gold. Watkins made pictures of it. Ralston built and owned a dry dock, a ship-maintenance facility, at Hunters Point in southern San Francisco. Watkins made pictures of it. Ralston and his bank partner and president Darius Ogden Mills controlled the Virginia & Truckee Railroad, which carried gold and silver from the Comstock Lode to the Central Pacific trunk line, a short haul that made it the most profitable railroad in the United States. Watkins would make pictures of it. Ralston would build two of the most lavish, luxurious hotels in the United States, the Grand and then the Palace, both in San Francisco. Watkins would make pictures of them. Ralston backed a railroad-car-building company. Watkins would make pictures of it. Ralston was a partner in a Lake Tahoe resort called Glenbrook. Watkins would make pictures of it. Watkins was even engaged in Ralston's hobbies and philanthropic efforts. Along with Billings, Ralston was an early trustee and treasurer of the College of California, which became the University of California, Berkeley. Watkins photographed it. (On at least one occasion, when state government failed to fulfill its financial obligations to the college, Ralston made the school's payroll out of his own pocket.) Ralston loved theater, so he owned one. When theatrical stars arrived in San Francisco to perform at Ralston's California Theater, they went to Watkins to have their pictures taken. When Frank Mayo, San Francisco's favorite homegrown actor, played Davy Crockett at the California Theater, he posed for Watkins's only known mammoth-plate portrait.[5] When prominent travel writer Charles Nordhoff wanted to write a book about California, Oregon, and the Sandwich Islands (today's Hawaii), Ralston backed him. Watkins's pictures were used to produce many of the book's illustrations.[6] When Ralston's daughter Bertha wanted her picture taken with a new doll, Watkins made the portrait. Ralston seems to have routinely introduced his business contacts to Watkins, who fulfilled commissions for almost everyone in Ralston's Ring. Ralston was so profligate in his "sharing" of Watkins that he referred Watkins to H.D. Bacon, a Missouri banker who had moved to San Francisco and who helped Ralston out of a scrape when one of Ralston's insurance companies lacked enough capital to service

claims. Watkins would make stereographs of Bacon's well-appointed Oakland house, which Bacon doubtless sent back to Saint Louis to show his friends he'd made it out west.

Naturally Watkins made pictures of Ralston's new Bank of California building, in both stereograph and mammoth plate. The first thing a viewer notices about the mammoth is its eerie emptiness: there are no people here. The street looks like horses and carriages had never trod upon it. That's remarkable. The picture was made in the middle of one of America's most crowded business districts, a stretch of Sansome known as the western Wall Street. Still, emptiness. Watkins's *Bank of California* is a picture of power. The client evidently had enough clout with the city to shut down the streets around the bank for a few hours.

The bank was deeply involved in the two projects that would drive much of California's economy over the next decade or so: the construction of the transcontinental railroad, and the Comstock gold and silver mines just east of Lake Tahoe in Virginia City, Nevada. The cycle of Comstock investments, stock ownership, dividend taking, stock selling, stock rebuying (on the cheap!), reinvestments, and all manner of stock manipulation in which Ralston's Ring participated is too involved to bother with here, but suffice it to say that Ralston and his colleagues made millions from Comstock mines, and those millions drove much of the West's economy.[7]

While Watkins's California backers prospered, Watkins's work in Oregon, Mendocino, and especially Yosemite had made him into one of the few nationally famous Californians. This was a particularly good time for Watkins to become better known outside California: in 1865 Congress extended copyright law to cover photography, which, in theory, gave Watkins recourse when eastern publishers pirated his work. He needed it. Among the examples of Watkins's pictures being effectively stolen by eastern concerns was publishing powerhouse D. Appleton & Co.'s appropriation of Watkins's great 1867 Shasta picture and its wholesale copying of Watkins's pictures from *The Yosemite Book*. It hadn't been hard to do. Sometime in the early to mid-1860s, Appleton had bought a complete set of Watkins's 1861 Yosemite pictures and then hired a photographer to make photographs of Watkins's pictures. Appleton then printed these photographs of pictures at 6½ by 8½ inches, bound them, and sold them in album form as *Album of the*

Yosemite Valley, California. There was neither mention of nor payment to Watkins, who only learned of the scheme from Brewer and Whitney.[8]

Appleton's possibly inadvertent manipulation of Watkins's 1867 Shasta picture points to another way such things could happen. In 1871, New York artist James D. Smillie, a fine watercolorist and engraver but a middling painter, visited San Francisco and Yosemite via the transcontinental on an art-making expedition. He stayed at Ralston's Grand Hotel and visited Watkins's gallery. The two artists hit it off and quickly agreed to trade works. Over the course of three visits, Smillie selected several pictures, which Watkins shipped to him, in exchange for a painting of White Mountains destination Mount Lafayette. When Watkins's pictures arrived, Smillie stayed up two to three hours past his usual bedtime to gawk at them, continued to express his awe about them in his diary for weeks, invited his friends over to see them, and was so struck by their enormousness that many of his diary entries are punctuated by noting how large they were. Meanwhile, Smillie labored for months over the painting he had promised Watkins before shipping it west. Then, in early 1873, Appleton asked Smillie for a drawing of Mount Shasta for its upcoming blockbuster two-volume travel book set, *Picturesque America.* Smillie had never been to Shasta ... but he had Watkins's picture of it. Apparently without telling Appleton, Smillie copied Watkins's Shasta, added a couple of Native Americans in the foreground and some clouds in the sky, and pronounced the picture his. Appleton paid him forty-five dollars and sent the image off to be engraved.[9] Historians have made much of how poor a businessman they think Watkins was, but when it comes to the theft and appropriation of his work, both before and after the change in copyright law, none of his options were good.[10]

Ultimately, Watkins's best defense against the kind of thing Appleton had done and that Appleton would keep doing was to become so famous that people would want a *real* Watkins, that they would value the substantial difference in quality between his work and a cheap knockoff. Three stories— one set on a precarious cliffside six hundred feet above the floor of Yosemite Valley, and two from the cultural worlds of New York and Philadelphia— testify to Watkins's success in attaining the fame he needed, the fame that would do more to protect his work than any lawyer could.

In the summer of 1867, as Watkins was sailing up and down the Columbia River, a tourist named De Witt Alexander visited Yosemite Valley. While

Yosemite had emerged as a cultural Unionist project and had become a venue for the production of art and science, by the late 1860s it had finally become a significant tourism destination. As travelers do, Alexander wrote letters home detailing what he saw.

"About one half mile from Hutchings [Hotel] we climbed up a pile of fallen rocks for several hundred feet, and then followed a trail on a ledge in the face of the precipice some six hundred feet high. We had some ticklish spots to cross, where a stumble or slide might have been fatal," Alexander wrote, detailing the arduous passage along a granite shelf that led a mile or so from Hutchings to the two halves of Yosemite Falls, a long stretch where the river tumbled down the rocks without quite waterfalling. Alexander was not exaggerating. The ledge he traveled was narrow, covered with fist-sized loose rocks, had little vegetation, and was rarely traversed. (Years later, the National Park Service constructed a trail on the other side of the falls in an effort to prevent people from using this dodgier route.) Alexander took this long ledge to a smaller one that overlooked the Lower Fall. Instead of turning left and climbing down some perilous rocks toward the Lower Fall, he turned up through a steeply slanting crevice and climbed up to where the Upper Fall poured into an enormous granite shell.

"This so-called basin is an immense amphitheater, but the river has split it across by a huge chasm, into which it disappears, so that the fall wants the beauty of a placid basin of water at its foot," Alexander wrote. "Above us, falling from the very sky, sixteen hundred feet at one sheer plunge was the great fall . . . Mr. Watkins had his photographic apparatus carried up here and took pictures at the foot of the fall."[11]

Such was Watkins's fame that when a man boasted to his wife of the risks he took to reach the base of a waterfall, the three key elements of his retelling were his courage in the face of danger, the waterfall's magnificence, and that Carleton Watkins had been there.

Sometime in the chilly winter of 1865–66, the postal service delivered a tube to the desk of twenty-seven-year-old Edward L. Wilson, the editor of the *Philadelphia Photographer* magazine. Despite Wilson's youth, his journal was already the best-known and most important American periodical on photography. (Then, as now, new media created opportunity.) Like European art journals, the *Philadelphia Photographer* mixed reportage and commentary

on recent pictures, new techniques in photography, new lenses, and so forth. It was available all over America, even in many of the photography galleries in distant, pretranscontinental San Francisco.

At first, Wilson thought this tube contained yet another roll of yet another albumen paper sample that some manufacturer hoped that Wilson would try out and then praise in his magazine. Nope. Instead, it contained a note identifying it as having been sent by one A. T. Ruthrauff of San Francisco, a partner in a firm that sold photographic equipment and materials.[12] Enclosed with Ruthrauff's note were six rolled-up Carleton Watkins pictures of Yosemite. Wilson looked from one picture to the next, astonished. Watkins and Ruthrauff had sent him *El Capitan, Bridal Veil, Lower Cathedral Rock, The Three Brothers, King's Mountain* (known today as *Mount Starr King and Glacier Point*), and one of Watkins's views that included the Merced River. Like the albumen paper manufacturers, Watkins was plainly hoping for the endorsement of an influential figure. He got it.

"At no time has our table been graced and favored with such a gorgeous contribution," Wilson wrote of Watkins's pictures in his April 1866 issue. "They now lie before us, and as we unroll them again, we will endeavor to give a faint idea of what they are like; and *faint* it must be, for no pen can describe such wonders of art faithfully. It has been said that 'the pen is mightier than the sword,' but who shall not say that in *this* instance, at least, *the camera is mightier than the pen*?"[13] Wilson's audience probably would have read "the pen" as a reference to the Yosemite travelogues recently published by Samuel Bowles and Albert H. Richardson, two members of the Schuyler Colfax party Watkins had met in Yosemite. Bowles's book was already out, and Richardson's writings about the same trip had been published in the *New York Tribune*. The book that compiled them was forthcoming.

In addition to its effusiveness, Wilson's review paid Watkins several compliments that acknowledge Watkins's success in addressing some of the artistic issues of the day. Back when Watkins was a retail clerk for his Oneonta mate George W. Murray, he had access to the leading art magazines of the day, most especially London-published *Art Journal*. In 1855 the magazine took a cue from Alexander von Humboldt, the German naturalist who was intrigued by photography, and declared that among photography's potentials was to allow viewers to see trees as individual species. "A few years since it was a common remark that with our artists a tree was a tree and

nothing more,—that regardless of the wonderful variety of the vegetable world, all trees were nearly the same in form, and not very dissimilar in color," wrote an unnamed *Art Journal* critic. "This, photography has, to a considerable extent, remedied; and we can now discover some difference between an elm and an oak in the pictures on the walls of our exhibitions."[14] Wilson, who was conversant in the inside-photography discourses of his day, noted that Watkins's *The Lower Cathedral* went far beyond merely allowing a viewer to "discover some difference" between species. "We never saw trees that were more successfully photographed," Wilson wrote. "There seems to have been no wind, and the very best kind of light. Not a sign of motion is apparent, and the leaves can almost be counted. Along the rocky sides of the Cathedral, we see great pines hanging almost horizontally, as if to peep into the valley below."[15]

While American painters and photographers of Watkins's time could build careers working in and around the United States, sculptors who aspired to significance had only one option: move to Italy, preferably Rome. After all, how was one to become a sculptor in the United States when the highest form of the art, Greek and Roman sculpture, was in Rome? Among those who made the move was Vermont-born Joseph Mozier. Over the course of several decades in Rome, Mozier achieved considerable success both artistically and in building a base of American collectors.

"Mr. Mozier's statues are all strongly characterized by the peculiar grace of attitude, ease of posture, which his figures assume, while the symmetry of each form, the beauty of features, and the strikingly lifelike expression of the countenance have been remarked on favorably by art connoisseurs," reported *Potter's American Monthly* magazine. "But the point in which Mr. Mozier appears most to excel is in the arrangement of the drapery; this is a very important matter, as carelessness or lack of skill in this particular has often marred otherwise meritorious sculptures." In other words, Mozier had succeeded in becoming the classicist he wanted to be. His *Undine* won a prize at the 1874 World's Fair in Rome, and America's first public galleries, such as the Yale College Gallery and the Boston Athenæum, acquired his work. Mozier was even exhibited in the U.S. Capitol.[16]

In 1866 Mozier packed many of his sculptures and joined them on a steamship bound for New York and an exhibition at a gallery on New York's

Tenth Avenue. Just as Watkins made the rounds of local journalists when traveling to Yosemite or Portland, Mozier called upon Albert Richardson. Their conversation turned toward the arts of Europe and how they compared to the arts in the United States. This is when Richardson showed Mozier his collection of Watkins Yosemites.

Mozier was floored. "They think they can take photographs in Rome," he told Richardson. "Hitherto they have taken the best in the world, but they never achieved such triumphs as these. I must carry a set back with me to show them what we can do in America."[17]

Between increasing national fame and increased relationships with wealth and San Francisco, Watkins had quickly gone from struggling to build a career to being famous, successful, and in demand. As we shall see, Watkins would continue to travel to make work, but whereas in the early 1860s he was so focused on making pictures that he sometimes neglected to devote his energies to selling them, now he found a better balance.

Maybe that was how it had to be. While all of Watkins's travel between 1860 and 1867 may have meant occasional relative penury, it had allowed Watkins to build the foundations upon which his commercial sales and then his commercial gallery was built: a significant catalogue of Yosemite, Mendocino, Willamette Valley, and Columbia River Gorge views in both mammoth plate and stereograph. In the early 1860s, he had sold his pictures himself and through various agents in San Francisco, but starting around 1865, he'd begun to operate a gallery that people could visit, where they could see pictures framed on walls and not lying flat in a glass valise, as many photographers sold pictures.[18] Watkins opened his Yo-Semite Gallery, as he called it, at Montgomery and California Streets, the main intersection of the city's business district. (Later he would pointedly rename it the Yo-Semite Art Gallery.) His gallery would remain on this block for seven years, until Watkins's need for more space and a shifting of the city's business center motivated a move a few blocks south. (Among the men who visited Watkins's gallery was Albert Richardson, who wrote that a traveler should visit even if he "has but one day for San Francisco.")[19]

Watkins sold his work farther afield too. Starting in the spring of 1868, he offered his just-printed Oregon pictures in Portland and even in remote The Dalles. "We cannot help but think that these views, exhibited in the older

States, would convey instantly a better idea of the grand and the beautifully picturesque scenery of Oregon than volumes of detailed description," boasted the *Portland Oregonian*. "Mr. Watkins, in procuring and distributing these pictures over the world, has done a good thing for Oregon, while he has, also, we hope, hit upon the foundation of a fortune for himself."[20] Indeed, the financial problems about which Watkins's friends corresponded just before he left for Oregon seem to have vanished. Watkins no doubt received a substantial fee from the Oregon Steam Navigation Co., and as Ainsworth's gift to Cooke demonstrated, company executives went back to Watkins to buy prints for many years. This is also when the *Yosemite Book* project in which Whitney and the California Geological Survey had enlisted Watkins was finally printed in a limited edition of 250. It immediately sold out, which earned Watkins the $1,500, and perhaps more, that the CGS had long owed him.

Watkins also continued to show at San Francisco's annual Mechanics' Institute Fairs, those mini–world's fairs to which San Franciscans flocked in enormous numbers and which drew visitors from all over California. In 1865 Watkins had shown twenty-one pictures, mostly of Yosemite and Mendocino. After returning from Oregon, he showed three times as many pictures and samples of the albums he would make for customers. Watkins even showed at the California State Agricultural Society's annual fine arts exhibition at the California State Fair, first Yosemite pictures, and then Columbia River views too.[21]

Watkins's focus on business was partly prelude for the new American era that would impact San Francisco, California, and eventually Oregon more than anywhere else: the day on which the West would no longer be separated from the East, from "home," as it had been called in the newspapers for almost twenty years now. The transcontinental railroad, discussed and dreamed of for almost all of those twenty years, was near. San Francisco braced for an influx of visitors.

Watkins's time at home seems to have served his business well. For the next decade, he would live comfortably and would circulate in San Francisco society. If he had a love interest in these years, her name has never surfaced. As a single man, he'd have cut quite a path as one of the most nationally famous San Franciscans. As it did for many men from the eastern hinterlands who had gone west to make their way, it took a while for Watkins

to figure out how to make his new thing into prosperity. The carpenter's son from rural New York State had finally, truly made it.

In 1869, the same year that Collis P. Huntington, his Big Four mates, and the Union Pacific completed the transcontinental railroad, Oneonta's other success story wanted to remind the folks back home how he'd done in California. To celebrate, and no doubt to show that he was a big success, Watkins sent his father, John, a special Christmas gift: a custom-made rosewood walking stick with a cap of yellow gold surmounted by a faceted gold quartz cap. An inscription read

J.M. Watkins
From
His Son Carleton
Christmas 1869[22]

14

CELEBRATING GILDED AGE WEALTH

AMONG THE BENEFITS OF CARLETON WATKINS'S sticking close to San Francisco in the late 1860s was the opportunity to meet visiting photographers. Such a destination was Watkins's parlor that one of these visits was even written up in the *Philadelphia Photographer*. The photographer who wrote of visiting Watkins was Charles R. Savage, an accomplished British-born Mormon who worked first on the East Coast, then in and around Salt Lake City, including as a company photographer for the Union Pacific Railroad.[1] Savage had journeyed from Utah to California to kneel at the dark tent of the man who "has produced, with his camera, results second to none in either the eastern or western hemispheres." These pictures, Savage noted with undisguised awe, were even sold in Europe. Savage was hoping that Watkins, whose prints were famed for their crispness, clarity, and technical perfection, would help him improve his own technique. (Like almost all other photographers working in the open, arid West, Savage struggled with dust, light, and other factors that caused imperfections on his glass plates, imperfections that Watkins had eliminated.) Watkins could have considered this information a trade secret, a significant advantage he had over his competition, but he did not. Instead he shared technical specifics with Savage, who then shared them

with the *Philadelphia Photographer's* readership. "I spent many pleasant hours with him and found him ever ready to communicate information to the ardent photographer," Savage wrote.[2] Savage was not the first photographer to visit Watkins: in 1862 John Gulick, a Christian missionary and a biologist, stopped to visit Watkins en route to Asia. Watkins taught Gulick how to make pictures, and soon Gulick would help expand photographic practice in Japan.[3]

Watkins may also have met Alexander Gardner, the great Civil War photographer. In 1867–68 Gardner made photographs for a railroad survey of lands along the 35th parallel, through which the Union Pacific and Kansas Pacific Railroads would run. Gardner's series began in Kansas City, Missouri, and finished, 201 pictures later, in San Francisco. (Gardner was not Watkins's equal as a composer, a pictorial problem-solver, or a technician, and his struggles with all three are in evidence.) Upon reaching San Francisco, Gardner made two pictures of Seal Rocks on San Francisco's western edge, coastal rock islands that Watkins also photographed at about this time. Gardner's pictures are rote. To the second one, the last picture of his trip, Gardner attached the title, "Last scene of all in this strange, eventful history," a line from Shakespeare's *As You Like It*. Did Gardner know that back in 1862, Watkins's 1861 Yosemite pictures had been exhibited a few doors down from his pictures of the aftermath of the Battle of Antietam? Probably. Did he seek out Watkins the way Savage had? We don't know.[4]

Whatever financial pressures Watkins felt before traveling to Oregon in 1867 were long gone. Now he had enough money not just to gift his father a gold-tipped, custom-made walking stick but to join San Francisco's social elite. Watkins was an early member of the Bohemian Club, which had been formed to provide the city's business elite a place to rub elbows with artists, writers, and journalists, and he may have joined the San Francisco Art Association, a similar club that also showed exhibitions of major American artists such as New York–based painter Albert Bierstadt, San Francisco photographer Eadweard Muybridge, and Rome-based sculptor Edmonia Lewis. (Watkins never exhibited at the San Francisco Art Association.)[5] Watkins built on these connections to wealth to bring in commissions and sales. One other factor could not have hurt: his apparent closeness to the man around whom San Francisco revolved, Billy Ralston.

In the late 1860s, California was twenty years old. The mining boom had enabled a small number of men to build extraordinary wealth, to become some of the richest men in America. Their peers in New York had built great estates up the Hudson River Valley; the Californians would build estates on the Peninsula, the thirty-mile stretch of redwood- and oak-covered hills south of San Francisco, between the bay and the Coast Range. As in the East, these were country homes to which the Gilded Agers would welcome their business colleagues, friends, and especially their eastern peers, who began to visit California in unprecedented numbers once the transcontinental railroad was completed in 1869. No one did estate building or guest hosting like Billy Ralston.

Ralston had bought his Belmont estate in 1864 from an Italian count and hired New York architect John P. Gaynor to expand it until it had eighty bedrooms. The main building was substantially built with Peninsula redwood and furnished and decorated with rare, old Chinese porcelain vases, Indian and Persian rugs, Parisian drapery, chairs and tables from London, silverware and cutlery from the finest European manufacturers, a grand piano made from Hawaiian koa wood, carved busts on stands of Carrara marble, and landscape paintings by Albert Bierstadt, Gilbert Munger, and Thomas Hill. Ralston put in parquet floors made of walnut and silver-plated door fixtures; he built a ballroom lined with mirrors à la Versailles and installed a balcony where guests could look down upon the mirrored guests below. Beyond the mansion there was even more. Belmont's outbuildings housed a huge Turkish bath, a bowling alley, and a gymnasium.

Ralston realized that having the famed Carleton Watkins make pictures of Belmont and the landscape Ralston had made there wouldn't just show it off, it would put him and his country estate in good company. He could show Watkins's album of Belmont views to bank visitors or send it to bankers and other men he did business with in New York, Central America, Japan, China, and London and suggest, by pointed association, that Ralston and the Bank of California were as much a part of the West as Yosemite or the Columbia River. Surely Ralston also included a note inviting them to his estate. Only two mammoth-plate pictures from the commission survive; no doubt there were many more.[6] At least thirty stereographs Watkins made of Belmont survive, and his numbering system suggests he made plenty of others. While comparatively tiny stereos are a poor substitute for mammoths,

Watkins's Belmont pictures are one of the most stunning records of American Gilded Age wealth and extravagance.

While mass-market stereographs may seem an odd choice for pictures of a grand estate, Ralston thought of Belmont as something of a private and public (when he wanted it to be) hybrid, an attraction that helped spread word of the promise of the West. He opened Belmont to children and church groups, sweetening their visits with candy and ice cream. When Muybridge came to prominence as a photographer, Ralston invited him to shoot Belmont too. *Bancroft's Tourist Guide* even endorsed a visit, noting that Belmont "happily combines the elegance of a palace with the simplicity and comfort of a home."[7] (Simplicity?)

Watkins's Belmont pictures seem to have become immediately well-known among the rest of the first generation of Peninsula estate builders. Shipping magnate Faxon Atherton, iron manufacturer and future San Francisco mayor Thomas Selby (two of whose daughters married Faxon Atherton's son and Billy Ralston's brother), banker and developer John Parrott, banker Antoine Borel, mine owner William Eustace Barron, and railroad owner and U.S. senator Milton S. Latham were among those who commissioned Watkins to photograph their estates. The Peninsula estate pictures by Watkins that have survived—around 120 mammoth plates, almost 10 percent of his surviving mammoth-plate oeuvre, with more being rediscovered from time to time—show vast landscapes, some ordered into California versions of formal gardens, others offering golden grass and great oaks continuing in both perfection and seeming perpetuity, Victorian gingerbread houses of preposterous size, interiors stuffed with paintings, sculpture, dark, rich woods, and extravagant textiles. They make it hard to believe that just twenty years earlier, no one had been here—which was part of the point.[8]

The man who most accelerated the conversion of the Peninsula into San Francisco's Hudson Valley was probably New York–born Darius Ogden Mills. Mills made his first fortune as a banker in early Sacramento, his second by partnering with Ralston in building the Bank of California into prominence, his third in the Comstock Lode mines, and a fourth as the owner of the most profitable railroad line in America, the Virginia & Truckee Railroad that connected the Comstock mines to the main Central Pacific road. In the early 1860s, Mills had sought Frederick Law Olmsted's advice on land for a country retreat, which led him to purchase part of a

Carleton Watkins, *Residence of D. O. Mills, Millbrae, San Mateo County,* ca. 1872. Collection of the California Historical Society, San Francisco.

Mexican-era rancho known as Buri Buri. It lay only a dozen miles south of San Francisco, between the Spring Valley Water Works' holdings in the Coast Range of minimountains that cleaved the Peninsula (which Watkins visited and photographed in the 1860s) and San Francisco Bay. In the mid-1860s, Mills built a mansion he would call Millbrae (a meld of his name and an old Scottish word for hillside), a glass conservatory, and various other structures.[9]

Watkins's pictures of the exterior of Millbrae (the architect of which is unknown) and of the grounds around it are among his best surviving Peninsula estate pictures.[10] One was taken up the hills that led toward the Coast Range and Spring Valley's land, and looks down at the estate and Millbrae. It shows steep, dramatic hillsides, the flat plain where Mills built his mansion, the conservatory, and outbuildings, all of which were surrounded by thick, stately oaks. Watkins's picture hints at the magnificent view of the bay that Mills must have had from almost anywhere on his land. (The picture exists in just one print, at the California Historical Society, and is in

poor condition, a reminder of just how tenuous the survival of Watkins's pictures was and is.) Another, taken just outside the circular drive that delivered carriages to Millbrae's modest porte cochere, is an angled view of the sparkling-new house, with the conservatory just to its right, one of the best architectural photographs in Watkins's oeuvre. Watkins's pictures of Millbrae were somehow made available to the *California Horticulturalist,* which glued them into the magazine to illustrate an article by Jeanne Carr, the closest friend and confidant of friend-of-Watkins John Muir. A nexus of interests and relationships coalesces just out of sight.

Two mammoth-plate Mills interiors are no doubt Watkinses.[11] One shows off Mills's art collection. Mills was a follow-the-herd art collector who acquired paintings from fashionable artists such as Theodore Rousseau, William-Adolphe Bouguerereau, Eastman Johnson, George Inness, and even a spectacularly porny Jean-Léon Gérôme painting of Cleopatra appearing topless before Julius Caesar. Watkins's picture gives Albert Bierstadt's 1868 *Yosemite Valley* place of privilege in Mills's gallery. Watkins must have found it an entertaining, perhaps vexing moment of circularity: Bierstadt's travel to California was motivated by having seen Watkins's own work, which he collected but failed to pay for; he eventually made amends for that failure by securing Watkins's space at the 1867 Paris Exposition Universelle. As a painter's prerogative is to crib passages from other artists, Bierstadt often used elements from Watkins pictures for his paintings. *Yosemite Valley,* which Bierstadt actually painted while in Europe, is Bierstadt at his borrowingest. Now at the Oakland Museum of California, the painting mashes up four or five Watkins pictures into an imagined Yosemite with an impossible sunset (or sunrise?) thrown in for good measure—and now Watkins was photographing it. (The pictures are hung in different places in the mammoth than in the stereograph, no surprise given that Watkins seems to have worked for Mills over a ten-year period.)

Mills's fellow Peninsula estate holders didn't confine their collecting habits to land, estates, paintings, sculpture, and Watkinses; they were also fanatical plant collectors. Mills probably started the trend by buying a glass conservatory from New York designers Burnham & Lord, whose later projects would include what is now the San Francisco Conservatory of Flowers, the New York Botanical Garden, and the conservatory Jay Gould built at his Hudson estate, Lyndhurst. Mills stuffed his conservatory with

unusual plants such as an Australian fern, which Watkins photographed just after Mills had begun to plant the conservatory. Mills bought up trees such as orange, magnolia, maple, Norfolk Island pine, Irish yew, redwood, ginkgo, Japanese plum, Chinese privet, bay, palm, pepper, Australian flame, cherry, and even the largest rubber tree in California. Atherton, who had made his money as an importer-exporter based in Chile, took Mills's idea and gave it a Chilean twist, installing coquito palms, caracalla vine, and monkey puzzle trees. Borel, a Swiss who found the Peninsula's golden-grass-covered hills that surrounded his estate ugly, planted redwood, larch, birch, pepper, and cypress thicker than those trees would naturally grow, an effort to remind himself of the density of Swiss forests. Ralston and Latham, whose exoticism was limited to hailing from the Midwest, opted for planned gardens and avenues of trees. German landscape architect Rudolph Ulrich, whom Mills hired on Olmsted's recommendation, advised many Peninsula estate holders, including Latham.[12] Watkins's estate pictures are nearly the only surviving documents of the great Peninsula plant race.

Watkins's pictures of Latham's Thurlow Lodge make up the most complete set of surviving Peninsula estate pictures, over five dozen in all. Latham had bought his estate in 1871, only to see the mansion quickly fall to fire.[13] He hired David Farquharson, one of California's best-known architects, to build him a new house. When it was done, Farquharson purchased several Watkins albums of Latham's new mansion, apparently to distribute to potential clients. Farquharson, who also sat for a Watkins portrait, seems to have gifted a Watkins album of Thurlow Lodge to the Bohemian Club.

The highlight of Watkins's Thurlow Lodge commission are the nearly two dozen pictures made inside the mansion, the single most complete archive of a Gilded Age Peninsula interior. By the time Watkins made pictures at Thurlow Lodge, he had learned how to position his camera in such a way as to allow sunlight to bounce off mirrors and polished wood, thus fully illuminating interior spaces even on lower floors. The pictures show the overstuffed Victorian luxury you'd expect—leather chairs, busy carpets, busier wallpaper, earthquake-zone-defying chandeliers, dark woods, ornamental arches, gold-framed pictures, a grand staircase, saccharine academic sculpture and painting, each room so stuffed with stuff that it's hard to know how people moved about. (The interior was substantially outfitted by the same firm Mills had used, Herter Bros. Today the nearly

two-story mantelpiece Herter Bros. made for Latham is in the collection of San Francisco's de Young Museum.)[14]

Latham, once a Democrat who had favored California secession, now embraced Watkins's work. He acquired three Watkins albums that survive today: one of Pacific Coast views, including pictures of San Francisco, Mendocino, the Geysers, Shasta, and Latham's own Peninsula estate; another of Oregon; and, finally, a spectacular album of Yosemite and Mariposa Grove pictures that ranks among the most striking documents of nineteenth-century American art. Now at the Stanford University Libraries, the album has leather covers, is gold-tooled, and weighs thirty pounds. It was bound by Bartling & Kimball, the most exclusive firm on the West Coast. For wealthy San Franciscans who had something remarkable to bind, be it an Aldine Press volume of Catullus from 1502 or Watkinses, Bartling & Kimball was it.[15] (It is unknown whether Watkins had the album bound to his specifications or if his client bought the pictures and later had them bound.) What makes this Watkins album so extraordinary is the cover, which includes a rare and possibly unprecedented inset redwood burl. It is a detail with a near-precedent in European binding practice: a xylotheque, a library of wood samples, in Franeker, the Netherlands, includes a series of books about individual species of trees. In this particular xylotheque, someone thought to bind books in the same wood addressed by the volume inside. Historian Simon Schama cites the example of a bound volume on *Fagus*, the common European beech, which is bound in beech bark and which includes pages that are literally leaves. "By paying homage to the vegetable matter from which it, and all literature, was constituted, the wooden library made a dazzling statement about the necessary union of culture and nature," Schama writes. Xylotheques were better known in the nineteenth century than now, so Bartling & Kimball—or Watkins—were more likely to be aware of such a European practice than we might be now. Even if they had not been aware of it, this Watkins album makes a similar statement about the joining of landscape and culture as the Franeker volumes, and it spotlights in the clearest imaginable way the importance of that bond to the western culture Watkins had helped create.[16]

Fittingly, one of Watkins's best Thurlow Lodge pictures is a tree portrait of an immense oak on the road into the estate, a tall, squarish tree behemoth known, for reasons now lost, as the "charter oak." The road to the

estate leads our eye to the edge of the oak, which is framed by tufts of two Monterey cypresses.[17] At least ten of the surviving Peninsula estate pictures are tree portraits. Surely one of the reasons is that most of Watkins's clients loved and valued the magnificent old oaks that dotted the miles and miles of rolling hills and golden grass that made up estate country, perhaps seeing in the healthy old oaks an allegory for prosperity, lasting success, and the way in which they themselves had overcome a challenging landscape and separation from eastern America to thrive. (Others had other interests in the Peninsula flora: Harvard's Asa Gray acquired many of Watkins's Peninsula tree portraits.)

On the afternoon of Saturday, March 7, 1868, the British ship *Viscata* left San Francisco's harbor bound for Liverpool. Her captain tacked in and out of the wind, standard operating procedure for ship captains aiming to pull out of the bay through the Golden Gate and into the Pacific Ocean. Perhaps because the *Viscata* was weighed down with 1,630 tons of California wheat, $91,000 worth, something went wrong. Instead of pushing through the Golden Gate and out into the open Pacific Ocean, either the wind or an imbalance in the loading of the *Viscata's* 32,731 sacks of wheat pushed the ship hard, real hard, toward the southeast. Almost immediately after passing through the Golden Gate, the *Viscata* wrecked. Minutes later, it washed up on San Francisco's northwestern Pacific coast, just below Fort Point.

This was not good; it would get worse. After the *Viscata* wrecked, a northwest wind kicked up, pushing her farther and farther up the beach. By low tide on Sunday, the *Viscata* was stuck. A tugboat named *Rescue* steamed out to try to right the *Viscata*, but the weight of the wheat counted against her, and the *Rescue* failed. "It is an ominous fact that not a single vessel has ever gone ashore . . . where the *Viscata* is now lying, and then gotten off since the country was occupied by Americans," noted the *Daily Alta California*, which counted a steamer and half a dozen ships that had wrecked here, on what is now known as Baker Beach.[18] Over the next couple of days, rescue attempts would continue. Workers even offloaded the *Viscata's* cargo in the hopes that a lighter barque would be rescued more easily. It had the opposite effect: the lightened *Viscata* pushed even farther up the beach. Within days, a combination of wind and tide pushed sand into the ship's hold. "From the shore, she looks as if she was permanently fixed on the fatal beach," reported the *Alta*.[19]

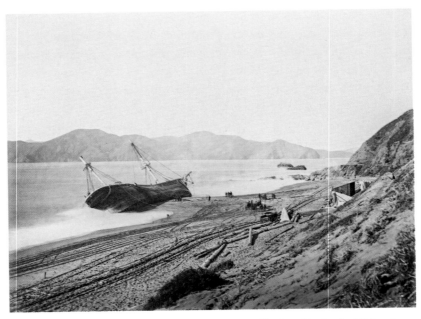

Carleton Watkins, *Wreck of the* Viscata, *San Francisco*, 1868. Collection of the Stanford University Libraries.

This was disaster for the ship's owners but high entertainment for the people of San Francisco. Each day curiosity-seekers traveled out from the city and walked down the bluff to the beach and even onto the *Viscata* itself. Among the gawkers was Carleton Watkins.

Watkins hadn't just come to look, he came to record. He had loaded his mammoth-plate camera, stereographic camera, a couple of tripods, and all the necessary glass plates and chemical fixings onto the bed of a carriage and had driven out to San Francisco's western edge. Watkins would make an extraordinary mammoth-plate picture, maybe the best he made in San Francisco, and around ten stereographs. It shows the 204-foot *Viscata* wrecked on her side, as if she were a great black whale. Watkins climbed about halfway up the sandy bluff that rose behind Baker Beach so as to play the *Viscata*'s gentle black curves against the steep, angular gray mountains of the Marin Headlands across the Pacific, the water softened into gossamer by the exposure time required to make the picture. It is one of those pictures in which the eye is constantly finding something new, somewhere else to go.

Watkins surely knew that *Wreck of the* Viscata was a picture unlike the ones he'd made in the previous decade. It would not define the western landscape for easterners, inform scientists or businessmen, argue for the inclusion of the West in the nation's historical arc, or anything of the sort. The *Wreck of the* Viscata, with its inclusion of Watkins's own horse-drawn cart, his dark tent, and even his stereographic camera aimed at a wave crashing against the *Viscata*'s stern (the resulting picture was available for purchase as a stereograph!), was simply opportunistic, a bit of entertaining spectacle. Watkins, in the midst of printing up his Oregon pictures, was on a lark. Unless . . .

Among the histories that the 1906 earthquake and fire have denied future generations is a complete understanding of the visual culture that informed early western art. Here, again, we wonder how much access Watkins and other California-based artists, such as photographer Eadweard Muybridge and painters Thomas Hill, Virgil Williams, and William Keith, had to paintings, photographs, and prints, made in other places and even at other times?

San Francisco was on the western edge of North America, in many ways geographically remote from the American East, Asia, and Europe, but it was also a fast-growing port city flush with gold and silver. As a result, European businesses of all sorts, from the industrialists who produced agricultural implements to craftsmen who made violins and guitars, sent their products to California. The art business was not immune from this rush to the golden West. By 1862 German Joseph Roos and Albert Wunderlich had opened an art supply store and print gallery on Montgomery Street. Among the goods they offered were prints from the famed Parisian gallery and printmaker Goupil and Co. This was the same Roos & Wunderlich that played a key role in sending Watkins's 1861 Yosemite pictures to New York, where they were exhibited at Goupil's. Watkins certainly would have had access to whatever prints, portfolio, and book-sized compilations of prints Roos & Wunderlich carried.[20] A number of pictures suggest Watkins had familiarity with not only American prints but also European prints. By the late 1860s, the art trade was thoroughly globalized. Watkins himself was participating in it: he had just won a medal at the Exposition Universelle in Paris, in 1873 he'd win another at the Vienna World's Fair, for "progress," for "furnish[ing] evidence of considerable progress over similar products shown at former Universal Exhibitions," and he would send framed pictures to the International Exposition at Santiago, Chile, in 1875–76.[21] Watkins's mammoth-plate

picture of the *Viscata* is one of the pictures that suggests European influence: it recalls sixteenth- and seventeenth-century Dutch paintings and prints of beached whales, a popular art-historical standard.

Whales that washed up on the coast, alive but soon to die, were a Dutch cultural phenomenon. Between 1531 and the end of the seventeenth century, at least forty whales beached themselves along the Netherlandish coast. The best-known surviving image of such is *Whale Stranded at Berckhey* (1598), made by Jacob Matham after a Hendrick Goltzius drawing. The inexplicable presence of the massive beasts was the subject of great speculation—was it a sign from God that portended *something,* be it encouraging or disastrous? Dutchmen argued for both possibilities. Historian Simon Schama reports that the most sensational of these incidents, the one captured in Matham's print of a Goltzius, was so famous that it was included in all of the major published histories of the time, a disaster-cum-national-event on par with battles and sieges that created and maintained the Dutch Republic. If Watkins didn't have access to Matham's print, he may have had access to a reproduction of it in a book.

Watkins's *Wreck of the* Viscata shares a striking pictorial similarity to those Dutch prints of beached whales, especially *Whale Stranded at Berckhey.* The Matham shows a beached whale lying on its side. Two landscape elements provide space and context: in the near distance, hills rise behind the whale; a sliver of ocean explains from where the whale came. Horse-drawn carts are parked on the beach, and people scurry around the scene. *Wreck of the* Viscata includes all of these elements, most of them updated for Watkins's century. While plenty of Watkins mammoth plates include humans, usually posed, no other Watkins mammoths contain this kind of human commotion. And what of Watkins's inclusion of his own gear—his dark tent and stereographic camera, inclusions that by 1868 had become routine for him—in this picture? That probably came from something a little closer to home: American painters, whose work he surely knew through prints by western artists, routinely included signifiers of their presence in the landscape, especially by including their easels or their plein air painting kits. (Among the American painters who did this most was Sanford Gifford, whose work Watkins probably knew through Gifford's close friend Thomas Starr King.)[22] Watkins, never shy about measuring himself up to painters, surely picked up their trick.[23]

15

TAKING SHASTA, DISCOVERING GLACIERS

W HEN GEOLOGIST CLARENCE KING was a volunteer on the California Geological Survey in the early 1860s, he heard that a Native American had shot a man named Watkins. King wrote William H. Brewer to ask if it was their friend Carleton. Brewer assured him it was not. King replied with relief. "Providence will take care of him, I am sure, 'till he has 'taken' Mt. Shasta," King wrote.[1] In 1870 King himself would arrange for Watkins to take it.

King's remarkable career began when he graduated from Yale with a chemistry degree in 1862, moved to New York, and quickly found himself bored. One evening a former Yale professor of King's read to him a letter from Brewer describing his 1862 ascent of Mount Shasta, which prompted King to become interested in the still-new science of geology. King read up on rocks, and the next year he headed west on a lark, hoping to find work with the CGS. The survey was happy to welcome an Eli into the Wild West but told him that there was no budget for him. That's fine, King replied, I'll work for free. He quickly earned a reputation as the CGS's premier peak bagger, becoming the first man to ascend eastern Sierra peaks such as Mount Tyndall and the peak now known as Mount Whitney, the highest summit in the contiguous United States. Like seemingly every ambitious

young man who went west, King also spent time at Las Mariposas. The Frémonts had already sold the property, which left Frederick Law Olmsted to hire King to conduct a geological survey. King discovered rocks that conclusively dated California's gold-bearing slate to the Jurassic period, a discovery that aided future mining engineers and informed future geologists. Later Olmsted would hire King again, to survey the geology and what would become the boundaries of the new Yosemite park. King had done well for himself since leaving California. He had become an urbane raconteur, the kind of easterner at home scrambling over western mountains, in the midst of which he would establish field camps where he would dress for dinner in formal attire. He built stories of his actual experiences into the sort of tall tales about grizzly bears that confirmed everything easterners believed about the West (but that impressed upon his audiences little about the pioneering scientific work he had actually done there). Among King's achievements was his mapping of much of the West, including the timber-rich coast ranges between Mendocino and Mount Shasta, and the explanation of the geological history of an immense swath of the American West. He even cleverly debunked a diamond-mining hoax, which, if it had stood, would have destroyed the entire western economy. Later on King would live a double life as Clarence King—former founding director of the U.S. Geological Survey, famous explorer-scientist, and well-known bachelor about New York— and as James Todd, a Brooklyn man who told his African American wife, the mother of his five biracial children, that he was a Pullman car porter.

In 1870 King, about to return to California as head of the U.S. Army's Fortieth Parallel Survey, was about to take Shasta. He needed a photographer.

The Fortieth Parallel Survey, better known as the King Survey, was an in-depth examination of a slice of the West that ran eight hundred miles east to west and one hundred miles north to south. This would be the part of the West through which the transcontinental railroad would run. King's survey team included geologists, botanists, topographers, and even an ornithologist, all focused on the goal of chronicling what scientific past and economic potential this vast chunk of America held for a still westward-rushing nation.

Congress had just delivered King some unexpected funding, and King planned to use it to study Mount Shasta. In previous seasons, he had employed Timothy O'Sullivan, a photographer based in Washington, DC, who came to

prominence during the Civil War working for Matthew Brady and Alexander Gardner. With O'Sullivan in Panama working for a U.S. government survey that was looking for a Panama Canal route, King needed someone else. As King knew Watkins well from having worked with him in the early 1860s, and as he believed Watkins to be "the most skillful operator in America," he knew whom he wanted.[2] No record of Watkins's fee for the job survives, but when King tried to hire Watkins in 1872, Watkins quoted him a $3,000 fee, expenses inclusive, an extraordinarily large figure. King didn't blink, suggesting that whatever he paid Watkins in 1870, it was no doubt a pile.[3]

Late in the summer of 1870, King, Watkins, and the rest of a nine-man team left San Francisco by steamer for Sacramento and for Shasta. Once they arrived, they'd have to wait a few days to get onto the mountain; Justin Sisson, the inn owner who had previously agreed to serve as the team's guide to the trails onto the mountain, was away.[4]

Three hundred miles to the south, at almost this exact moment, Joseph LeConte was making his first visit to Yosemite. While LeConte, the University of California's new professor of geology, natural history, and botany, had trained at Harvard under Watkins collector Louis Agassiz—the man who first proposed that there had been an ice age and whose studies of European ice sheets had helped create the field of glaciology—he was a southerner through and through. His family had owned enslaved people on a 3,500-acre plantation just south of Savannah, Georgia, and LeConte had worked for the Confederacy during the Civil War. While the thoroughly racist LeConte would have been loath to admit it, he embodied Edward Baker's 1860 observation that the North had led America's knowledge industries. To have the success he wanted to have as a scientist, LeConte had to leave the South for California. As a result, he would eventually become the president of both the American Association for the Advancement of Science and the Geological Society of America, as well as a cofounder and director of the Sierra Club.[5]

Before leaving Berkeley for Yosemite, LeConte had told his friend and University of Wisconsin professor Ezra Carr how much he was looking forward to the trip. Carr responded that LeConte should seek out a former student of his as a hiking mate.[6] The young man Carr had in mind had dropped out of Wisconsin, Carr said, but no matter, he was brilliant. His

name was John Muir. Classroom learning hadn't worked out for Muir, mostly because he was more curious than he was patient. In time, Muir washed up in California. After spending less than a day in San Francisco, he made a beeline for the mountains and, soon, for Yosemite. Muir figured that the way to stay in the Sierra was to work as a sheepherder and tourist guide, so that's what he did. To the knowledge of botany and geology he had gained in his brief time in Madison, Muir added earned knowledge of the Sierra's plants, mountains, and geology. Just as Thomas Starr King, Frederick Billings, and Carleton Watkins had made themselves into what they wanted to be by doing it rather than through academic qualifications, Muir made himself into one of America's best glaciologists.

Once at Yosemite, LeConte bumped into Muir by accident, quickly recognized him as the man Carr had recommended, and asked Muir to guide his party around Yosemite. It took until the fourth day of LeConte's trip into the High Sierra for Muir to screw up the courage to let LeConte in on something Muir had previously revealed only in a series of letters to the Carrs: he believed that Yosemite Valley had been made by glaciers. It was a revolutionary theory—no one had ever found a glacier in North America. Muir's idea would soon transform American geology, especially the story of how the West was made.

LeConte, who attended college at what would become the University of Georgia, earned his medical degree at the New York College of Physicians and Surgeons (now a part of Columbia University), and went on to study natural history at Harvard, until that moment reasonably believed that he knew more about glaciers than anyone in America not named Louis Agassiz. He could have dismissed this sheepherder's theory out of hand, but he did not. As the two men continued their hike, LeConte found himself thinking that while he believed Muir had overstated the glaciers' impact on Yosemite, he was substantially correct. LeConte's reaction gave Muir confidence that he was on to something. LeConte encouraged Muir to do something that would have been unthinkable back east: to lean on the power of his ideas, to take on the scientific establishment.

Whether Muir fully realized it or not, LeConte was urging him toward possible intellectual suicide—to take on the most powerful man in western science and one of the most respected figures in all of American science, Josiah Whitney, the outgoing head of the CGS and soon-to-be Harvard

professor. Whitney's theory of Yosemite's formation, which was in line with then-prevailing ideas about how the West's unfamiliar landscape was formed, dominated 1860s scientific discourse. Whitney had argued that Yosemite was formed by a single, sudden cataclysmic and catastrophic event, such as an earthquake, during which rock above dropped and the valley floor rose up. "The domes, and such masses as Mount Broderick, we conceive to have been formed by the process of upheaval itself," Whitney wrote in the 1865 CGS report. "The Half Dome seems, beyond a doubt, to have been split asunder in the middle, the lost half having gone down in what may truly be said to have been 'the wreck of matter and the crush of worlds.'"[7]

Whitney first illustrated his theory, which was presented as the CGS's official conclusion, with engravings made from Carleton Watkins's Yosemite photographs, pictures that Whitney described as "pronounced by all artists to be as near perfection as possible,"[8] a neat trick by which he suggested that his ideas were correct because the artist with whom he was affiliated was widely acknowledged as approaching infallibility. ("By turning to Plate 3, which is accurately copied from a photograph, it will be seen that there is no exaggeration in this outline [of a cross section of Yosemite geology].")[9] Whitney effectively put Watkins in the middle of the debate about how the most dramatic parts of the West were formed.

Before moving on, Whitney stopped to acknowledge that two members of his team, Clarence King and James Gardiner, believed that there had been an event in Yosemite's geological past for which Whitney was not allowing. "In the course of the explorations of Messrs. King and Gardner [sic], they obtained ample evidence of the former existence of a glacier in the Yosemite Valley," Whitney wrote. "[T]he cañons of all the streams entering [the valley] are also beautifully polished and grooved by glacial action."[10] Whitney was allowing for the possibility that a sheet of ice had, in fact, once been in the region, but he argued that it was a minor, limited event. At this point no one, not even King or Gardiner and most certainly not Whitney, was suggesting that an ice sheet had *created* Yosemite or any other part of the Sierra. It would not be until King was working for Olmsted that he would come to doubt that Yosemite had been formed by catastrophism.[11] (Whitney did not allow King or Gardiner to support their points with references to Watkins's photographs.)

Three years later, in his famed *Yosemite Book*, Whitney doubled down on

cataclysm. "We conceive that, during the process of upheaval of the Sierra, or possibly, at some time after that had taken place, there was at the Yosemite a subsidence of a limited area, marked by lines of 'fault' or fissures crossing each other somewhat nearly at right angles. In other and more simple language, the bottom of the Valley sank down to an unknown depth, owing to its support having been withdrawn from underneath during some of those convulsive movements which must have attended the upheaval of so extensive and elevated a chain."[12] Again, throughout his account of the valley, Whitney cited specific Watkins photographs to support his theory. (This time they were present as tipped-in pictures rather than as mere engravings.)

Whitney wasn't done. With King having left the CGS for the Fortieth Parallel Survey, Whitney was free to be as dismissive of King's ideas about supposed Yosemite glaciers as he wanted. "Much less can it be supposed that the peculiar form of the Yosemite is due to the erosive action of ice," Whitney wrote. "A more absurd theory was never advanced than that by which it was sought to ascribe to glaciers the sawing out of these vertical walls and the rounding of the domes. Nothing more unlike the real work of ice, as exhibited in the Alps, could be found. [This was a reference to Louis Agassiz's research.] Besides, there is no reason to suppose, or at least no proof, that glaciers have ever occupied the Valley or any portion of it . . . so that this theory, based on entire ignorance of the whole subject, may be dropped without wasting any more time upon it."[13] Meow.

Pique is poor scientific proof, so Whitney would be challenged again. In 1867 his work was dismissed by William Phipps Blake, who would use the same aids as Whitney to make his argument: Watkins's photographs of Yosemite. Blake was an Eli, a Benjamin Silliman Sr.–trained geologist and chemist. After a stint investigating the mineral resources of North Carolina, he became Whitney's chief rival to become the founding director of the CGS. Whitney got the job, so Phipps toured Japan and mines in Arizona before accepting a professorship of mineralogy at the College of California (which would soon become the University of California). When the 1867 Paris Exposition Universelle came around, Blake found himself appointed one of California's representatives to the fair. It was in this capacity that Blake arranged to address the French Academy of Sciences regarding the action of glaciers in the Sierra Nevada.

Carleton Watkins, *At Lassen's Butte, Siskiyou County, California*, 1870. National Archives and Records Administration, Washington, DC.

In Paris, Blake reported that there were no longer any glaciers around Yosemite, but that once there had been. Then he took dead aim at Whitney's idea that Yosemite had been formed by a great catastrophe: Yosemite Valley, argued Blake, was formed by subglacial erosion, "the flow of waters arising from the melting of ice above." Like Whitney, Blake used Watkins's Yosemite pictures, borrowed from the Exposition Universelle (where they would win a medal), to make his points.[14] If Whitney knew about Blake's machinations, he was no doubt mad enough to chew granite.

The grand men of American science, trained at Harvard (Whitney) and Yale (King and Blake), waving Watkinses as they made their arguments, had laid out their positions. Fortified by LeConte's encouragement, Muir, who had dropped out of a midwestern land-grant university, persisted. Meanwhile, Watkins and King waited to ascend Shasta, where they would soon have a chance to reengage the debate about North American glaciers.

As Clarence King's Shasta team waited for Justin Sisson to arrive, everyone was surprised—and dismayed—to learn how much gear Carleton Watkins's

picture making would require. "Watkins' traps were about four times the amount [Timothy] O'Sullivan used to carry," griped Samuel Franklin Emmons, one of the team's geologists.[15] (Of course, Watkins planned to make much bigger pictures in much, much more difficult conditions than had O'Sullivan.) As they waited, King's team explored the landscape around Sisson's and mused on its geology. "I was delighted to ride . . . alone, and expose myself, as one uncovers a sensitized photographic plate, to be influenced," King wrote.[16] Possibly while waiting, Watkins traveled to nearby Lassen Peak, which he knew as Lassen's Butte and which is commonly called Mount Lassen today, the southernmost active volcano in the Cascade Range.[17] Watkins made at least three medium-format pictures here, including *At Lassen's Butte,* an otherworldly image of a huge, fractured hunk of igneous rock that resembles a stegosaurus, its bony plates stretching toward the sky.

Eventually Sisson, whom Emmons described as an "old Rip Van Winkle-like hunter," arrived, and the team made its way up Shasta. Instead of taking the usual route direct to the summit along the mountain's gentler southern side, King and his team meandered up so as to better explore Shasta's geology. The first few thousand feet of climb were easy—"There is no reason why any one of sound wind and limb should not, after a little mountaineering practice, be able to make the Shasta climb . . . the fact that two young girls have made the ascent proves it a comparatively easy one," King wrote— but above the eight-thousand-foot tree line, the temperatures were low, the footing was slippery, and the men labored to take measurements and gather specimens.[18] The season contributed to the cold: it was mid-September, about as late in the year as it was possible to summit the peak. Temperatures in the upper regions were frigid, which could be why Watkins made no mammoth plates there. The challenging conditions on the mountain seem to have forced him to make work only in medium format, a little more than twelve by eight inches, and also in stereograph. Perhaps as a result, no Watkins trip of the 1860s or 1870s has received less attention from scholars and historians. That's too bad—the pictures Watkins made on Shasta and on Lassen are pioneering and often great pictures. Never before had an American photographer made work in such difficult conditions—and no one would again for several decades. Several of Watkins's 1870 Shasta pictures rank among his best, and all would be so valuable as scientific documents that

scientists would continue to pore over them for most of the nineteenth century.[19]

The next morning, the men made their first summit of the expedition. They scaled the west side of Shastina, a massive satellite cone on Shasta's western side. Shastina ascends to 12,335 feet in its own right, making it the third-highest volcanic summit in the Cascades. Here both progress and work became tricky. As the men climbed Shastina, volcanic debris underfoot frequently gave way, sometimes causing the men to slide down the mountain as much as they were climbing up it. Once atop Shastina, Watkins stopped to make pictures. He placed his camera a few feet down the steep slope on the outside of Shastina's cone and pointed it out toward the Shasta Valley thousands of feet below. His picture shows the path that lava flowed in making the mountain and the surrounding landscape, a static image of the land-forming lava flow that built this part of the West. Watkins took another picture, probably from here on Shastina, that shows Shasta's summit peeking up across the other side of Shastina, with sharp, angular basalt tubes pushing up out of the foreground. It shows the top of the mountain that volcanic processes made, with an illustration of those processes in the foreground, a striking visual summary of volcanology. Having already contributed to American science's knowledge of botany and geology, Watkins was now helping to inform the still-nascent field of volcanology.

While Watkins was meeting the challenge of taking pictures from higher on a mountain than any American ever had, King had found a surprise so important that he wrote it down even though he couldn't feel his fingers: in careful, slow cursive, he noted that he saw signs of glacial activity just below Shastina's summit.[20] In particular, as he looked down at Red Butte, one of the so-called "colored butte" summits on Shasta's fifteen-mile-wide southern slope, he saw what looked like moraines, the dirt-and-rock debris piles that retreating glaciers leave behind.[21] That was interesting.

King and his team continued to the edge of Shastina's crater and stopped to look in. King estimated the crater's width at a mile (it's actually two-thirds of a mile) and its depth at a thousand feet (it's actually closer to six hundred feet); he described it as "steep, shelving sides of shattered lava mantled in places to the very bottom by fields of snow."[22] That was neat, but there was only so much the team could do in that location. From here King could have followed the north rim of Shastina's summit toward Shasta's

main summit, or he could follow the south side of Shastina's summit and dip into a steep valley that would require reascending a couple of thousand feet to reach the top of Shasta. King could see that this route was treacherous, even dangerous. "We ... came to a place where for a thousand feet [their path] was a mere blade of ice, sharpened by the snow into a thin, frail edge, upon which we walked in cautious balance, a misstep likely to hurl us down into the chaos of lava blocks within the crater," King wrote. He decided to stick to the northern route.[23]

Finally, after making his way around enough of Shastina's cone that Shastina's summit no longer blocked his view of Shasta, at the moment at which he could finally see around the 12,335-foot mountain in his way to see the 14,179-foot main act, the moment at which King might enjoy the view for a brief moment before taking a deep breath to prepare for the toughest part of the journey, he was suddenly distracted. A thousand yards in the distance, King saw, and thus discovered, something no one had ever seen in North America.

"We ... looked down into a gorge between us and the main Shasta," he wrote. "There, winding its huge body along, lay a glacier, riven with sharp, deep crevasses yawning fifty or sixty feet wide, the blue hollows of their shadowed depth contrasting with the brilliant surfaces of ice."[24]

What a moment! Just two years after Whitney had publicly mocked King's ideas about a glacial past, King had found a glacial present! Who needed to argue about disputed historical evidence of ice now that King had found an actual moving, grinding, heaving glacier, an unexpected triumph? And on top of it all, King had Watkins, whose work Whitney had twice used to undermine, even mock, King's ideas, on Shasta with him! King whipped out his notebook and a pencil, drew a sketch of the scene before him, and wrote "Whitney Glacier" under his drawing. The name stuck. King got the last laugh.[25]

King knew that the glacier he discovered needed to be as securely documented as possible, so he asked Watkins to make pictures. This was no easy task: the broad ice sheet was extremely cold, large, bright, and slippery. Watkins struggled. For a photographer to make a picture in the wet-plate era, he had to remove the negative from his camera and develop it in his dark tent, so named because it made conditions dark enough to allow for the development of an image on the glass plate. When Watkins put his tent on Whitney Glacier, light traveled through the glacier and into his tent from

Carleton Watkins, *Man on Whitney Glacier, Siskiyou County, California*, 1870. National Archives and Records Administration, Washington, DC.

underneath, destroying the pictures on his plates.[26] Eventually Watkins figured it out. His four medium-format pictures of Whitney Glacier and five stereographs suggest its movement, its flux, and the powerful natural processes that were changing the landscape just as much as volcanism itself. In one of his pictures, he placed a single black-clad figure in the frame. It takes the eye several moments to find the tiny speck and then to identify it as a person. At that moment, the entire scale of the picture changes.

In another Watkins glacier picture, the curves of the blindingly white ice sheet seem to fight against the dark hills of lava, which was, in fact, exactly what they were doing. In several of the pictures, Watkins—who, at this point in his career, understood a range of science well enough to know how to make pictures that communicated it—uses shadow to suggest movement. These aren't just pictures that informed science, they are contributions to it.

Historians have long argued that King directed his survey artists, first O'Sullivan and now Watkins, to make pictures such as these. No evidence, either in King's own accounts of his expeditions or in those of his coworkers, supports this speculation. In fact, both Emmons's and King's accounts

of the Shasta expedition detail the party splitting up across the enormous mountain at different times in order to accomplish their different tasks. King's own story of taking Shasta, first published in the *Atlantic* in December 1871 and later in his famed memoir *Mountaineering in the Sierra Nevada,* indicates that he and Watkins were rarely on the same part of the mountain at the same time. (King, confident that the *Atlantic's* audience would know of whom he spoke, gave his expedition artist the one-name treatment, simply calling him "Watkins."[27] King treated James Russell Lowell, then America's best-known poet, the same way.) Furthermore, the compositions Watkins built around prominent features on and around Shasta are consistent with his usual approach to making work: build a linearly muscular image that focuses the viewer on the relationships between foreground and the middle view, and use that composition to emphasize links between objects of scientific interest and the broader ecology of the site. It's what he did in the pictures Asa Gray valued, and it's what he did here for King, whose scientific focus was geology rather than botany.

Historian William Goetzmann has argued that starting in the 1870s, survey artists were vanity hires, public-relations accoutrements intended to win congressional favor and to help build the profiles of ego-driven survey leaders such as King.[28] Not here. Never mind the East's continuing lack of knowledge of what America's new lands looked like—in 1870 only a few thousand easterners had any context for California or the Cascades, let alone for Shasta, an immense volcano, a glacier, a moraine, and a forest that covered almost as much area as all of Massachusetts's Cape Cod Bay—until King and Watkins stood on Whitney Glacier, the existence of any North American glacier, past or present, was theoretical. Even leading scientists who were familiar with California, men such as Whitney, who'd been on Shasta himself in 1862, spat at the notion that there was a living glacier in the West. What was to say that King's peers would believe he'd found one, especially considering it was in King's self-interest to find one in order to validate his own theories (and federal appropriations)? The best way to prove to scientific colleagues and the general public that what many people considered a faint or unlikely possibility existed was to show it to them. The best visual data that could be produced in 1870 was a photograph. Better yet was a Watkins photograph because more than any other photographer in

America, Watkins had the skill and talent to make a picture that suggested how that glacier had moved and made the mountain.

By the time Watkins came off Shasta in 1870, he was already the artist who had contributed the most to American scientists' understanding of the West. He was probably also the artist who had contributed the most to American science, period.

In October 1871, a year after sharing with Joseph LeConte his theory about the role glaciers played in forming Yosemite Valley and a year after Clarence King's team discovered the first active glacier in North America, John Muir left the room in which he lived at Yosemite's Hutchings Hotel for a few days in the wilderness. The summer season was over, and the thousand or so visitors that Muir felt overcrowded the valley were gone. Ever since he had hiked the Yosemite with LeConte the previous year, Muir had been thinking about glaciers. He had become certain that his radical theory about how Yosemite had been formed was correct.

Muir's plan was to explore the west-facing lakes and basins created as the Merced Range's ridgeline gently zigged and zagged between the north and south forks of the Merced River. He hiked two thousand feet up out of Yosemite Valley, past Mount Starr King, and up another three thousand feet in altitude along the sloped granite plain beyond it. Muir was looking for streams coming out of the amphitheaters formed by the curving ridges that joined the eleven- to twelve-thousand-foot peaks of the Merced Range. The first one he reached was Gray Creek, which emptied the alpine lake that sat at the base of the J-shaped arêtes that joined Mount Clark, named for Galen Clark, the Mariposa Grove steward and friend of Muir (and of Watkins), and Mount Gray, which was named for Muir correspondent Asa Gray. Perhaps one reason Muir felt at home in Yosemite was because the landscape was named after his friends.

Over the course of several days, Muir followed rivulets that came out of the alpine lakes at the foot of Merced Range peaks up toward their sources. When he reached the Merced Range's third westward-facing amphitheater—one formed by a backward-C-shaped arête, Red Peak, and Black Mountain (now known as Merced Peak)—he became even more excited. "When I be-held its magnificent moraines ascending in majestic curves to the dark, mys-

terious solitudes at its head, I was exhilarated with the work that lay before me, as if on the verge of some great discovery," Muir later wrote.[29] He had found the expected evidence of a glacial past.

Muir pushed up the granite slope. Over a three-mile climb up from around eight to ten thousand feet, he passed several lakes and saw the surrounding flora change from ramrod-straight pines to wildflowers. Before long, Muir was approaching the tree line, where pines grew as dwarves, just a fiftieth of the height they reached only a few hundred feet below, and where hardy wildflowers such as bryanthus, cassiope, and arctic willows clung low to the earth and only scrappy, stringy carex surrounded the lakes. When Muir wrote up this trip for *Harper's*, he listed all these plants, as if reminding us that he had the scientific bona fides to have his own ideas.

The next day, Muir continued to follow the evidence of glaciers past. As the sun and Muir climbed together, the temperature rose. Muir heard pebbles and small rocks, bound in place on the surrounding cliffs by ice, rattle down the steep slopes around him. He moved above the tree line. All around, in what he guessed must have once been the main channel of a huge, powerful glacier, were granite boulders that weighed tens of thousands of pounds. Muir climbed until he reached the last, highest lakelet. He waded in and picked up stones on the lake bottom. "I noticed a fine gray mud covering the stones on the bottom," Muir wrote. "On examination it proved to be wholly mineral in composition, and resembled the mud worn from a fine-grit grindstone. I at once suspected its glacial origin, for the stream which carried it came gurgling out of the base of a raw, fresh-looking moraine, which seemed to be in formation at that very moment."[30]

It was a clue. Muir looked up at the moraine. It was tall and steep enough, around a hundred feet high with a 38 degree slope, that it was all he could see before him. Slowly, carefully, he climbed it. Muir reached the top, looked farther up the mountain, and saw a surprise. "I . . . beheld a small but well-characterized glacier swooping down from the sombre precipices of Black Mountain to the terminal moraine in a finely graduated curve," he wrote. "The solid ice appeared on all the lower portions of the glacier, though it was gray with dirt and stones imbedded [*sic*] in its surface. Farther up, the ice disappeared beneath coarsely granulated snow."[31] For years, Josiah Whitney, a product of the learned East, Harvard's newest geology professor and long California's foremost professional scientist, had argued that the

Sierra was formed by uplift. Yale-trained professor William Phipps Blake had traveled to Paris to argue that water from a melted glacier had been the primary actor in this region. Muir, an amateur, had just taken the first step in proving them wrong.

Muir walked up the glacier to the point where the moving, living ice sheet separated from a static shelf of ice tucked into the mountain, a fourteen-foot chasm. He hopped down into this gap to examine the glacier more closely. He saw decades' and probably hundreds of years' worth of ice. Near the top of the sheet, he saw bands of dirt. Farther down, arcs of deep blue ran into the glacier as if they were veins. Muir used his hands to help him farther down into the chasm. His fingers went numb. He stopped. "Water dripped and tinkled overhead," he wrote. "From far below there came strange solemn murmurs from currents that were feeling their way among veins and fissures on the bottom."[32]

As Muir climbed up through the ice, he saw huge boulders suspended in the glacier, boulders that would someday be added to the debris field up which he had just hiked. In the other direction, he saw that the sun had birthed tiny streams that ran down the glacier. Muir realized that the little glacier on which he stood was one of many small glaciers now in this amphitheater, and that once upon a time, the entire space had been filled with a mammoth glacier, the grinding and growing and contraction of which had built the place in which he stood. After a few more hours, he began to work his way back toward Yosemite Valley.

Now Muir was more confident than ever that his theory that glaciers were solely responsible for the formation of Yosemite Valley was correct. He wrote an article detailing his theory and published it in Horace Greeley's *New York Tribune* in December 1871. "The great valley itself, together with all of its various domes and walls, was brought forth and fashioned by a grand combination of glaciers acting in certain directions against granite of peculiar physical structure," Muir declared. "All of the rocks and mountains land lakes and meadows of the whole upper Merced basin received their specific forms and carvings almost entirely from the same agency of ice."[33]

Muir's was not the kind of proclamation that amateurs typically made—and he made it in a popular newspaper rather than in a scientific journal—so the blowback was intense. Clarence King took particular aim at Muir's theory in his 1878 *Systematic Geology*, the first volume of his *Report of the*

Fortieth Parallel Survey. "It is to be hoped that Mr. Muir's vagaries will not deceive geologists who are personally acquainted with California, and that the ambitious amateur himself may divert his evident enthusiastic love of nature into a channel, if there is one, in which his attainments would save him from hopeless floundering."[34] The only one floundering was King, who either forgot or reacted against his own personal history: he had once worked for the CGS as a volunteer, an amateur.

Muir's theorizing and his discovery of a living glacier above Yosemite Valley embarrassed the CGS, which had missed it. Four years after publishing in the *Tribune,* Muir took to *Harper's* magazine to report that he had found sixty-five glaciers still extant in the Sierra. He did not add, because he did not have to, that the CGS had neither found nor identified any of them. King took dead aim at these discoveries too. "Mr. Muir, in his studies of the high Sierra Nevada, has been frequently announcing the discovery of glaciers, based on simple evidence of motion," King sniffed. "Years before he entered the Sierra Nevada, his identical snow-fields were studied by several members of the Geological Survey of California, and their motion was well known to them as to him. It is a nice matter to draw the line between a well compacted moving *neve* and an actual glacier; but the distinction is a true one."[35] Yes, it is, and King was wrong. If King and his mates had been where Muir was in the early 1860s, they had whiffed. (Among the scientists who took Muir's side of the debate was the greatest glaciologist of them all. "Agassiz said the year before he died, 'Muir knows all about it,'" Muir proudly wrote to his sister Sarah in an 1874 letter.)[36]

Surprisingly, at this point in late 1871, perhaps the only two Californians who had walked on a glacier—Muir and Carleton Watkins—still hadn't met. In the early 1870s, Muir was ensconced in Yosemite year-round. Famously obsessed with glaciers, he droned on and on about them to darn near anyone who would listen. Surely a valley visitor or two must have told Muir about Clarence King's discovery on Mount Shasta and about the pictures of the glacier—pictures! of an actual glacier!—all of which were on view at Watkins's Yosemite Art Gallery.

Watkins and Muir seem to have first met in the winter of 1873–74, when Muir gave up year-round High Sierra living to spend winters in and near San Francisco. While it's certainly possible that Muir just walked into the Yosemite Art Gallery one day and introduced himself to Watkins, it's most

likely that they met through William Keith, the Scots-Irish painter and close friend of the Scots-Irish Watkins; Keith was also an acute nature lover and a close friend of the Scots-Irish Muir. In 1874 Muir wrote an appreciation of Keith's paintings for the *San Francisco Evening Bulletin.* Muir called Keith a "poet-painter" and was particularly appreciative of Keith's fealty to what he considered scientific truth. A friendship was born.[37] Muir and Keith became regular traveling companions. When Watkins wasn't himself traveling, he made the group a trio. Later on, Muir was well enough known to Watkins's children that fifty years later, they would remember the scratchiness of his beard. Surely Muir would have wanted to see Watkins's photographs of Shasta's Whitney Glacier so that he could compare them to what he'd seen in the Sierra. Perhaps Watkins gave Muir some tips: in November 1874, Muir himself climbed Shasta, studied its glacial past, briefly walked its glacial present—and was then socked in by a ferocious weeklong blizzard that prompted Justin Sisson to send a rescue party up after him.[38]

Despite all these discoveries, scientists continued to hotly discuss glaciers and possible glacial history. At the end of the decade, Watkins would rejoin the fray.

The transcontinental railroad had been completed in late 1869, but it wasn't until 1871 that traffic began to pick up, that trains began to deliver significant numbers of tourists to the West. Among the early travelers was a sixty-eight-year-old who had contributed mightily to art and ideas in the early West, Ralph Waldo Emerson. Like most easterners, Emerson had first seen the Yosemite region in the pictures of Carleton Watkins, photographs that had been sent to him by his protégé Thomas Starr King. Now Emerson had come west to see the Sierra. Understanding that he was slowed by age, the Sage of Concord allowed his friend William Forbes to guide him through California and to run interference between Emerson and an adoring public.

Emerson's first destination was Yosemite, where he sought out John Muir. Emerson loved the place and allowed Muir to show him around the valley floor and the surrounding forests. "This valley is the only place that comes up to the brag about it, and exceeds it," Emerson later said.[39] Muir showed Emerson his rooms, in which he kept his botanical sketches and plant collections. Emerson was impressed. Just before leaving for Cal-

ifornia, he had given a lecture at Harvard in which he expanded his ideas about self-reliance by predicting that future advances in the biggest questions facing Americans would come not from the halls of academe but from native, noninstitutionalized genius. In Muir, he found his archetype.[40]

Next the men toured the Mariposa Grove. Surely Emerson told Muir that he had seen these very trees a decade earlier in pictures sent by his friend Starr, a man of whom Muir, new to California and tucked into a secluded rural district, may have known mostly through his namesake mountain. Muir urged Emerson to camp with him on the soft ground beneath the sequoia, but Emerson, feeling his years, declined. Muir asked Emerson and his party to stay in the grove and valley a little longer, emphasizing that they had not seen all there was to see. "It is as if the photographer should remove his plate before the impression was fully made," Muir told Emerson.[41] The next day, Muir stood at the edge of the sequoia grove as Emerson rode away. Just before Emerson vanished from sight, he turned his horse toward Muir and waved his hat goodbye.

Historians have typically presented the Muir-Emerson meeting as a symbolic, generational handoff, the transcendentalist easterner passing the bough of passion for nature to the next generation, to a conservationist westerner. Sort of. When Emerson met Muir in 1871, Muir was still an unknown sheepherder, mill operator, tourist guide, and amateur glaciologist who was years away from publishing his first conservationist tract—"God's First Temples: How Shall We Preserve Our Forests?"[42]—and it would be another half decade beyond that before he became an activist. Muir would not help found the Sierra Club until 1892.

The links between Emerson's foundational transcendentalism and Muir's environmentalism need not be metaphorical. Emerson's ideas about nature, landscape, and how they should be considered, seen, and valued were crucial to Thomas Starr King's work, evidently informed Carleton Watkins, and were mined and paraphrased by Frederick Law Olmsted in his report-cum-essay on what Yosemite should become. Did Emerson realize he was visiting a park that his ideas and his writings, by way of Watkins and Starr, had motivated and informed? I think so, yes.

Back in San Francisco, Emerson visited Watkins's gallery. We don't know if he met Watkins, but as few men in San Francisco had been closer to Starr than Watkins, it would have been natural for the two men to have shared

memories of their late friend. Emerson selected two framed pictures, a view of Cathedral Spires, and a picture of Mount Shasta, which Mrs. George R. Russell—one of Emerson's California companions, a longtime friend, an abolitionist and a transcendentalist ally who had held the mortgage for Brook Farm—purchased for him as a gift.[43]

Emerson took the pictures back to Concord. What to do with them? The most public room in his house was the sitting and dining room just off the front door. While his home was stuffed with prints of paintings by Raphael, Michelangelo, Reni, Correggio, Leonardo, and Lorenzo di Credi, Emerson seems to have reserved for this room his most revealing possessions. This is where Emerson installed a small, two-shelf bookcase as a display of his intellectual source material. In it Emerson offered both his own books and the philosophical writings that informed him throughout his life, such as Frederic May Holland's *The Reign of the Stoics* and translations of Goethe and Sophocles; history, such as several accounts of the American Revolution; poetry; and the books of friends such as Louis Agassiz and Henry David Thoreau. Hanging above them and to the right of the fireplace was a Julia Margaret Cameron portrait of Thomas Carlyle, the Scottish philosopher who may have meant more to Emerson's own thinking than anyone, a man Emerson so admired that he acted as Carlyle's American literary agent.[44]

Across from this fireplace, the two bookshelves, the Cameron portrait of Carlyle, and a suite of European prints and drawings, in the place of honor, Emerson hung the two huge Watkinses of Mount Shasta and Yosemite. Emerson, who, in his own writing, had repeatedly urged artists toward metaphor, seems to have known that Watkins's pictures said something about him: Emerson's favorite metaphor for the human mind and its capacity to examine and create was the volcano.[45] It's surely no accident that he hung a Watkins volcano here in a room he had designed to be self-revealing. Next to the Shasta picture, Emerson hung *Cathedral Spires*, a picture that presents a mountain feature named for the architectural embodiment of the church, and in which the church has been replaced by nature and landscape. It's tempting to think that by including a Yosemite picture in this room—in this display of intellectual heft, of work that had informed Emerson and that his writing had motivated—Emerson realized his ideas had played a foundational role in the creation of the national-park idea.

The Watkinses are still there today.

16

THE BOOM YEARS

BACK AT THE BEGINNING OF THE GOLD RUSH, in the years after gold was first discovered at Johann Sutter's mill near present-day Coloma, California, mining had been a gentle, passive activity. The first generation of California miners relied on simple metal and wood tools to help them pull gold dust and small nuggets from riverbeds. Carleton Watkins made a still life of these simple tools, one of his rare forays into the genre, and called it *Weapons of the Argonauts*. The title used the gold rushers' own nickname for themselves, a reference to the treasure-seeking adventurers of classical mythology. Watkins's picture offered the tools the '49ers used, including a stamped-iron pan—basically a deep-bottomed metal plate that a miner would fill with water and gravel, which he (always he) would gently sift out, leaving the heavier stuff, gold dust or a nugget, in the pan. Sometimes a miner used a slightly more sophisticated tool called a rocker, which Watkins made into the central object of his composition. A rocker was a rectangular, sloping, split-level wooden gizmo; miners shoveled river dirt into it, poured water over it, and allowed the water and gravity to separate gold from the dirt and rocks. For the first few years of the gold rush, this (plus some luck) was enough to help a man find his fortune.

Watkins also made pictures of one of the second-generation mining techniques, the process known as quartz mining, by which tons and tons of rock were extracted from a mountain and crushed into paste so that gold might be separated from quartz deposits. This was what was practiced at Las Mariposas. Watkins did not photograph the other major second-generation gold-mining technique, by which teams of miners dammed and moved rivers so that they could get at the gold-filled beds underneath.

In 1871, Watkins would return to making mining pictures near North Bloomfield, California, a mere dot on the map in Nevada County, sixty miles northeast of San Francisco. The twenty mammoth-plate pictures and at least thirty-three stereographs he would make here portray a third-generation Sierra mining technique known as hydraulic mining.[1] Watkins's pictures of the North Bloomfield hydraulic operation are stunning dystopias. To nineteenth-century America, they were pictures of progress, demonstrations of man's engineering brilliance. Today they are documents of environmental horror, our clearest look at the damage wreaked by the most rapacious mining process of the nineteenth century.

Watkins may have thought that he had better things to do than go to North Bloomfield. He was in the throes of planning a big expansion of his retail gallery, and he had just received the best possible news: word from London that the *Art Journal,* the august British publication that Watkins probably read as a young man, had devoted a fawning article to his 1865–66 Yosemite pictures. This was a big deal, as European art publications were rarely impressed with American art. The magazine gushed over Yosemite, of which its only experience was Watkins's pictures, before turning to Watkins's performance: "[I]n all that has depended on human Art, he has been most successful—especially in the selection of pictorial points of view, as well as in all the delicate manipulation which is necessary to give free scope to the magic chemistry of light," the magazine said, using Victorian word count to praise Watkins's technical capability. "Between the wonders of nature and the skill of man, we have certainly before us in these views of the Yosemite Valley, the finest photographs that have been seen in Europe. It is no small satisfaction to us to be able to bear this testimony to the work of an American artist. To the lover of nature, in her most sublime aspects, as well as to the collectors of what is most rare and perfect in

photography, we can recommend no higher treat than will be procured by the purchase of Mr. Watkins' photographs."[2]

No doubt Watkins shared the rave review with the wealthy barons whose Peninsula lands he was busy photographing in these years, and no doubt the write-up furthered his business in England.[3] Despite this most recent celebrity, Watkins could not decline to go to North Bloomfield because the man who no doubt had asked him to go was his most important patron, Billy Ralston.

The way hydraulic mining worked was simple enough: use nine-inch-diameter nozzles to direct immense quantities of water onto mountainsides with such force that the water would dissolve the mountain into a kind of muddy paste. In a single year, North Bloomfield propelled fifteen billion gallons of water into a single mountainside. Had the North Bloomfield mine operated every day and around the clock, its owners would have fired thirty thousand gallons of water per minute onto the mountain at 125 pounds of pressure per square inch, all with the aim of turning the mountain into slurry.[4] Miners would then chemically separate gold from this slushy debris. The technique required enormous natural resources and the commissioning of unprecedented environmental damage—the redirection of rivers, the building of immense timber dams, the literal destruction of mountainsides, and, finally, the question of what to do with all the debris generated by mountainside removal—all of which was of no concern to Ralston or to the miners who wanted work. There was gold in the mountain; the mountain must die.

The North Bloomfield Gravel Mining Co. had been created in 1866, when Ralston and a team of investors purchased several hundred acres near the hamlet of North Bloomfield for an unknown price. Then they spent $350,000 to buy up rights to water in the region and for easements through or over which they could run canals to the giant hoses and nozzles at the foot of the mountain in North Bloomfield. Over the next couple of years, they hired 1,100 workers and spent another $750,000 building ditches from a reservoir high in the Sierra. The tunnel that would remove the goldless waste, the industry term for the parts of the mountain that had been destroyed by the hydraulics, cost another $500,000.[5] Even after investing over $1.6 million in North Bloomfield, half again as much as it had cost to erect the U.S. Capitol dome, the mine was not yet producing at what Ralston's

team believed was its potential.[6] Confident that it would yield a major strike, Ralston's team spent another $64,000 on exploratory production. This worked, sort of: while that $64,000 yielded just $36,000 in gold, the work suggested to North Bloomfield's investors that they were close to a bonanza. Needing more capital to unlock it, they decided to seek additional investment in England. As European financial capitals were once again awash in sometimes questionable mining-related financial prospectuses from the western United States, a team of British investors commissioned a report on North Bloomfield, complete with pictures. The ideal man for such a job, and a man on whom Ralston could rely, was, obviously, Carleton Watkins. It certainly wouldn't have hurt that Europe was familiar with Watkins, who had won a medal at the recent Parisian World's Fair and who was about to win another at the Vienna World Exposition.[7]

Nothing is known about the specifics of Watkins's 1871 trip to North Bloomfield except that nearly every picture shows water being corralled, transported, or deployed at a scale that was probably unprecedented, all to enable the equally unprecedented mining-related destruction of a vast landscape. Watkins presents it all in his familiar way, in tightly composed scenes that direct the eye to the most spectacular part of the process and thus of the picture, in compositions that find and emphasize beauty even though the landscape had been, to today's eyes, horrifically altered. Looking at these pictures today, it can be hard to remember that virtually no 1870s Californian believed that a precious national resource such as gold should simply be left where it was because to extract it required environmental devastation. In mid- to late nineteenth-century America, today's idea that we at least consider the trade-offs before extracting wealth from the planet would have seemed flat-out nuts. Watkins was not siding with the capitalists or doing his patron's bidding or making a deal with the Sierra-destroying devil in order to make a living. He was just making pictures. Just seven years earlier, Vermont author and American diplomat George Perkins Marsh had published his landmark *Man and Nature,* the most important book-length conservationist tract of the mid-nineteenth century. Even the pioneering Marsh excused the impact of the industrialization of the landscape, especially for the purpose of extracting mineral wealth.

We don't know the order in which Watkins's North Bloomfield pictures were taken, but Watkins's own numbering system suggests how they may

have been ordered in a Ralston & Co. prospectus. The first picture shows what Watkins described as "Rudyard (English) Reservoir, on Headwaters of Middle Yuba River, looking East. Capacity, 600 million cubic feet." This landscape is obviously not a natural lake: trees, some dead and denuded, some alive, poke up above the surface of the water. Felled trees fill the foreground. Investors were meant to understand that Ralston's team had the might to dominate this landscape.

The pictures continue: Watkins climbed one of the pine-covered granite mountains to shoot an "aerial" view of Rudyard (English) Reservoir. It's huge. Next is one of Watkins's greatest compositions, a picture of the timber dam, two walls of hundreds of whole-tree logs containing hundreds of tons of rock that held back 600 million cubic feet of water. To take it, Watkins perched himself on the side of a mountain, about three-quarters of the way up from the canyon floor. He placed his camera on the steep slope, making it appear as if it were hovering above the ground. The dam extends to nearly the edges of the picture. A thin sliver of water is visible beyond it. At the left center of the picture, two towering ponderosa pines shoot up between us and the dam, an inclusion that emphasizes the enormous size of the dam, the reservoir, and the landscape itself.

After this view of the dam, Watkins shows us other dams and a second reservoir that held an additional 400 million cubic feet of water, placing a billion cubic feet at North Bloomfield's disposal. Other pictures testify to the Ralston group's progress by offering evidence of its mining infrastructure, especially the miles and miles of pipe and fluming it had built. (Fluming was the contemporary term for the constructed wooden aqueducts along which the water was delivered from the dams to the mountainside that would be dissolved.) *Magenta Flume* shows a long timber flume crossing a shallow valley along a series of A-frame stilts, a construction feat that must have entailed great risk. Several pictures show a landscape that recalls Martian badlands, with hoodoos of rock that had been more resistant to the water blasting than the surrounding softer soil standing dozens of feet above the surrounding landscape. One picture, of a pipe that runs horizontally across the entire frame, reveals the scale of the operation: the pipe seems small in the midst of a good-sized landscape; then the eye lands on the plumes of water in the far middle distance, and I realize how enormous the landscape, the pipe—and the opportunities for profit!—really are.

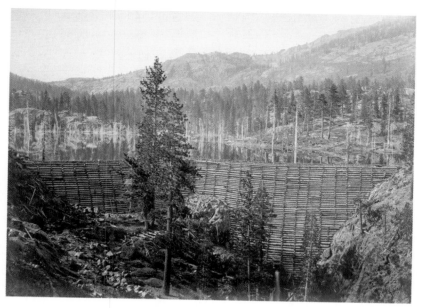

Carleton Watkins, *Rudyard (English) Reservoir, Central Dam, Nevada County, California*, ca. 1871. Collection of the J. Paul Getty Museum, Los Angeles.

Another picture is effectively a zooming in on the scene in the middle distance to show arcing fans of water landing on the base of the former mountain, further breaking down rock into slurry. A few men are standing around. Each is dwarfed by the water jets.

The pictures may have been intended for a British audience, but they were seen in San Francisco too. They are "really masterpieces of the photographic art, and present the most perfect and lifelike representation of hydraulic mining which we have ever seen depicted on paper," reported the *Mining & Scientific Press*.[8] No matter, Ralston & Co. were unsuccessful at raising European capital for North Bloomfield. Ralston, and perhaps the other investors, responded to the disappointment by pouring in more of their own money, essentially by taking the profits they made manipulating Comstock Lode mining stock on San Francisco's stock exchange and pouring them into North Bloomfield. It would take years, but it worked; by the end of the 1870s, the North Bloomfield Gravel Mining Co. was the largest and would eventually become the most profitable hydraulic mining operation in California, and perhaps beyond.

What the pictures don't suggest—or even hint at—is that North Bloomfield was an early turning point in how Californians considered no-holds-barred use of the land. For many years, mining-related waste had been choking California's rivers, turning the Delta into a sediment-clogged miasma and exacerbating seasonal flooding in the Central Valley. The debris had even caused the silting up of San Francisco's vital port and pushed a plume of coffee-colored mud out of the Golden Gate and into the Pacific Ocean. By 1874 the Yuba River, which drained North Bloomfield (or tried to), ran sixty feet higher than it had at the dawn of the gold rush, and debris from hydraulic mines had led to the loss of tens of thousands of acres (and soon hundreds of thousands) of Central Valley farmland. In the late 1870s, downstream farmers and townsfolk sued to stop the dumping of mining material into rivers, but California's corrupt courts shrugged. Watkins did too: his oeuvre celebrates the land and landscape aplenty, but there's nary a hint of a wincing glance at the ravages inflicted upon the land by California's imperial classes. Either he was reflective of the vast majority of San Franciscans, who saw no problem with the way westerners used the land, or he hewed to what his customers, commissioners, friends, and allies wanted shown.

It wasn't until 1884 that a court finally put a stop to North Bloomfield's activities and began to wind down the hydraulic mining era. Without intending it, the court's ending of one use of the land enabled another to come: industrial agriculture. As we'll see in chapter 24, Watkins would be every bit as involved in the new manipulation of land as he had been in the old ways.[9]

Since the mid-1860s, Carleton Watkins had operated a commercial gallery at Montgomery and California Streets, in the heart of downtown San Francisco. This was his first gallery of his own, the business that the 1861 Yosemite pictures had enabled. But by the early 1870s, the city was changing. Its downtown was expanding outward, and tourists were increasingly being delivered into it by the new transcontinental railroad. In early 1872, a few months after finishing the North Bloomfield pictures, Watkins moved his gallery to the city's newest hot spot: the intersection of Montgomery, New Montgomery and Market Streets. As usual, there are no surviving documents that detail why or how Watkins did it, but there can be only one

answer, the usual San Francisco answer: Billy Ralston wanted it, and so it was done. Watkins's new outpost, his new Yosemite Art Gallery, was effectively an adjunct of Ralston's redevelopment of land on the southern end of San Francisco's business district. In some ways it was the pivot point of the whole project.

Why was it relevant to Ralston, even important, that Watkins move his gallery to this particular intersection? The story goes back to the late 1860s, when Ralston and business partner Asbury Harpending, who was also part of the North Bloomfield team and a regular in Ralston's Ring, had bought up land south of Market Street with the idea of extending Montgomery Street, San Francisco's main commercial thoroughfare, a mile or so to the south. They called this street New Montgomery. They hoped that their planned expansion of downtown to the south, with New Montgomery as its main axis, would drive San Francisco real estate for a generation.

Their opening salvo was the construction of a new hotel, which they called the Grand Hotel. (Thanks to the new transcontinental railroad, so the thinking went, San Francisco would need more hotel rooms.) With San Francisco's other luxury hotels, the Occidental, the Lick House, the Cosmopolitan, and the Russ House along Montgomery in the four blocks north of Market and now the Grand just across Market, San Francisco's luxury hotel district was both delineated and freshly expanded. Ralston being Ralston, he went all-in: the Grand was built by John P. Gaynor, the same architect who designed Belmont, in a style Ralston considered to be "French Renaissance." It spread over two full city blocks, its two separate buildings joined by a walkway over a city street; it had four hundred rooms, cost $500,000 to build, and was tricked out with all the newest luxuries, including telegraphic communications in each room, guest carriages trimmed in gold and silver from Ralston's mines, a glassed-in porte cochere, a carved-wood registration desk, a bar with the largest, grandest frescoed decoration in all the city, and a dining room menu that offered meals of salmon and lobster (which were included in the room price). Ralston must have winced when the leading guidebook of the day, *Bancroft's Tourist Guide*, described the hotel's period style as less "French Renaissance" than "modern combination." Watkins's inevitable picture supports *Bancroft's* take.[10] More importantly to Ralston, Watkins's picture of the Grand presents it as bustling with activity. His picture of the Bank of California had offered it as a trophy, its surround-

ing emptiness a demonstration of Ralston's power. Here it was important to the presumed client that the "wrong" side of Market Street look like a busy part of the city.

It seems that Ralston's biggest concern was how to bridge San Francisco's old downtown with Ralston's planned new downtown south of Market Street. He was right to be worried. Market, which ran diagonally from the bay up toward the hills in the city's not-yet-developed western districts, had long been the city's dividing line. North of Market lay the city's banks, its best businesses, its wealth, and its most exclusive residential districts. South of Market lay its stinky stockyards and its pollution-belching factories. San Franciscans of means, class, and station simply did not cross Market Street. Ralston aimed to give them cause.

Before the Grand Hotel opened, Ralston seems to have worried that the Grand was not enough, that he needed something that would link the old Montgomery Street and San Francisco's established downtown to the Grand and the new development. The evidence suggests that Ralston summoned Watkins and made him a suggestion that the businessman-artist couldn't refuse: move your gallery to the corner of Montgomery and Market, on the "old downtown" side, but right across the street from the Grand. This would provide Watkins with ready access to the Grand's visitors and would also position the gallery as the hinge between traditional downtown San Francisco and Ralston's hoped-for expansion, a storefront that would encourage people from the hotel into the main part of the city and, more importantly, from the main part of the city into the hotel, its restaurant, and its bar. There was something in it for everyone.

In all probability, Ralston either offered Watkins a private loan to make it happen, and in style, or he backed the move through his Bank of California. Most importantly to Ralston, no San Franciscan, Ralston included, was better known outside the city than Watkins. Besides, by Ralston's or the Bank of California's standards, a loan to Watkins, probably in the low five figures, was practically nothing.

Now Watkins was in the middle of San Francisco's luxury hotel district and across the street from the newest, biggest entrant. "Around [the hotels] are clustered some of the best shops in San Francisco," wrote British author J.G. Player-Frowd. "Here are the silversmiths, some of the principal haberdashers, tailors . . . this part of the street is most agreeable to stroll in, espe-

cially as the entree to the common hall of the hotels is open to all, and they are always full of people and newspapers from many parts of the world."[11]

Watkins took advantage of the move to make his Yo-Semite Art Gallery a first-rate, high-end operation that covered the ground floor of nearly half a city block, all with windows facing Montgomery. To enter the gallery from, say, the Grand Hotel side, a prospective customer would walk past seventy-six feet of street-facing windows that displayed samples of the pictures that were offered within. Upon entering, a visitor would immediately find himself in a cavernous reception parlor twenty feet wide and forty-five feet long.[12] Watkins had lined its walls with pictures of San Francisco itself, views from its hills, and pictures of its finest residences and buildings, as well as his brand-new (and newsworthy!) pictures of Mount Shasta's Whitney Glacier. A staffer would greet the visitor and encourage her to linger as long as she would like.

From the reception room, a visitor could turn to the left and enter what Watkins called "the operating room," a huge studio in which the gallery would make a visitor's portrait and would offer portraits of western luminaries or of notable visitors to these parts. Beyond the operating room was a series of smaller rooms where men and women sitting for their portrait could change clothes or touch up their appearance. On the opposite side of the reception parlor was Watkins's Gallery of Yo-Semite Views. This was the largest room of all. "The walls of the room . . . are adorned with one hundred and twenty-five of those superb views of Pacific Coast scenery (in size 18 by 22 inches) which have given Watkins a reputation world wide," reported *The Buyers' Manual and Business Guide*, a literary-minded guidebook aimed at wealthy and well-read travelers. "To obtain them, he has spent several of the best years of his life camping beside mountain streams, or laboriously toiling to the summit of lofty peaks, from which he has beheld, and transfixed on his faithful negatives, some of the most awe-inspiring scenery that the eye of man has yet gazed upon."[13] This was one of the most famous rooms in the city. "This, to the stranger, is the point of special attraction," gushed the *Daily Alta California* after attending Watkins's press opening. "Stereoscopes are placed at intervals 'round the room, and views to be obtained range from the smallest card to the largest mounted picture . . . Mr. Watkins has gone to great expense in fitting up the establishment."[14]

San Francisco's most notable men soon arrived to have their portraits

made, both for themselves and, in the custom of the day, so that Watkins could offer their likenesses to his customers. Sitters included an eclectic mix of notable Californians, a reflection of Watkins's professional network. Watkins made portraits of Ralston's business colleagues, friends, and family, including D.O. Mills, opera singers Minnie and Carrie Wyatt, and doll-clutching Bertha Ralston, the banker's daughter. The studio made pictures of local dignitaries and celebrities such as Central Pacific Railroad president and former California governor Leland Stanford; Margaret Crocker, the wife of railroad baron E.B. Crocker; University of California botanist and herbarium keeper J.R. Scupham, who would soon organize the exhibition of California forestry and agriculture for the 1876 World's Fair in Philadelphia; scientist George Davidson, who would soon begin a two-decade-long affiliation with Watkins as a client; cable-car inventor Andrew Smith Hallidie; San Francisco Art Association members Albert Bierstadt, Hiram Bloomer, W.B. Clifford, and Samuel Brookes (aka the Painter of Fish, as Watkins noted on the back of his picture); Rev. Horatio Stebbins, who succeeded Thomas Starr King at First Unitarian; Central Pacific land agent Benjamin Bernard Redding; Comstock Lode mining baron William S. O'Brien; and Spring Valley Water Works superintendent William H. Lawrence.

It was a good time to be Carleton Watkins.

In November 1873, about a year after opening the gallery in the new location, Carleton Watkins made what seems like an odd decision: he decided that late autumn—effectively winter in the mountains—was a good time for his first trip along the transcontinental railroad. He traveled to Utah Territory with friend and fellow Scotsman William Keith, who was in the beginning of what would prove to be a forty-year career as one of the West's finest painters.

Keith was born in Aberdeenshire, Scotland, in 1838 and emigrated to New York with his family in 1850. Somehow he avoided service in the Civil War and worked as an engraver before studying painting with the same Samuel Brookes, Painter of Fish, whose portrait Watkins would make at the gallery. After Keith moved to California, he cofounded an engraving firm called Van Vleck and Keith. Among the photographs for which Keith made engravings were Watkins's Yosemite views. Keith started painting western watercolors in 1866 and then, in 1868, traveled to the Pacific Northwest to make paint-

ings for the Oregon Steam Navigation Co. (Watkins may have helped Keith make the transition from engraver to painter by buying him his first paints.)[15] After leaving Oregon, Keith traveled to Europe for a few years to study art, returning first to Boston and then to San Francisco. He and Watkins would be close friends from the time Keith returned to California in 1872 until shortly after Keith's first wife, Elizabeth Emerson, died. (Keith's second wife, Mary McHenry, seems not to have been a fan of her husband's friends, and after their marriage, Watkins and Keith seem to have had substantially less contact.)

Keith would become a standout of California's first generation of painters, a group that included Watkins friends Gilbert Munger, Virgil Williams, Thomas Hill, and, occasionally, Albert Bierstadt. Today Keith's work is well collected, with fine examples in most of America's major museums, but still little known. Too bad: while Keith made fewer large-scale paintings than many of his East Coast–based peers (San Francisco's collector base was smaller than New York's, and California painters lacked the same access to the European market), his best work compares favorably with theirs. Keith was in almost all of the major California collections of his time, and onetime Californians who moved back east acquired him too. Keith and Watkins shared numerous collectors; Frederick Billings, for one, bought Keith's ca. 1870–80 *Mount Hood from Sandy River,* which still hangs in his Woodstock, Vermont, home. While many easterners who traveled west competed with photography by inventing fanciful luminous effects or by amplifying already dramatic scenery into impossibility (Bierstadt especially), Keith instead relied on his vibrant, expressive brushwork and muscular compositions. (Perhaps not coincidentally, Keith owned scores of Watkinses, and the men compared notes.) While Keith seems to have cribbed less directly from Watkins pictures than Bierstadt did, he certainly learned from the Watkinses he owned. Keith's 1878–79 *Donner Lake* (St. Mary's College Museum of Art, Moraga, California) is plainly indebted to Watkins's mammoth plate of the same subject, as is his later *Sentinel Peak and Merced River* (also at St. Mary's) and many of his paintings of California missions. However, Keith seems to have gone out of the way to make his biggest (and best) paintings of subjects that Watkins's camera could not reach, such as the booming 1876 *Headwaters of the Merced,* now at Stanford University's Cantor Arts Center. It is one of the finest nineteenth-century American paintings of the West.

The timing of Keith and Watkins's trip to Utah, after the snows had begun in the higher elevations, suggests that the trip was spontaneous. The men hired two railroad cars and loaded one with Watkins's photographic wagon and enough creature comforts for Keith to consider that they were traveling "with all the appointments requisite for domestic life." For two and a half days they followed the Central Pacific line as far as Echo Canyon, roughly where modern-day Interstates 80 and 84 meet in northwestern Utah. From San Francisco, they traveled past stations and towns named for men Watkins had known, men who had collected his work, and men who had influenced it, including Frémont, Schuyler, Colfax, and Halleck.[16] Keith's trip output is unknown. (There is no systematic publication chronicling his works.)

Watkins made at least twenty-six mammoth-plate pictures in Utah, at least two dozen stereographs, and an unknown number of medium-format pictures. (Alas, he was able to make prints of only eighteen of the mammoths because his printer broke eight of the glass negatives.)[17] The stereograph subjects suggest that Watkins was thinking about the overland-traveler market as they're heavy on checklist tourism spots such as Brigham Young's house and Salt Lake City's Tabernacle. The surviving mammoths are mostly of features in the rugged Utah desertscape. Many of Watkins's Utah pictures are spatially disorienting, as if the artist intentionally built scenes that would leave the viewer unaware of the size of features in the landscape or the landscape itself. How big is Sentinel Rock (better known now as Monument Rock) in Echo Canyon? Hard to tell. In another picture, the combination of the vastness of the landscape below Profile Rock, also in Echo Canyon, and the rock itself, which fills the entire left-hand side of the picture, vibrates. So does a horizontal view of Echo City from Witch Rocks.

Watkins's best Utah picture is of Devil's Slide, a limestone formation in Weber Canyon near modern-day Croydon. "Devil's Slide [is a] wonder in itself, consisting of two walls of rock about six feet wide and from twenty to fifty feet high, running parallel for six hundred feet up the mountainside, with a space of only fourteen feet between the ledges," wrote Carrie Adell Strahorn in *Fifteen Thousand Miles by Stage*, her 1911 memoir. "A ride down that slide in a toboggan would afford thrills and chills to satisfy the most ambitious lover of wild sensations."[18]

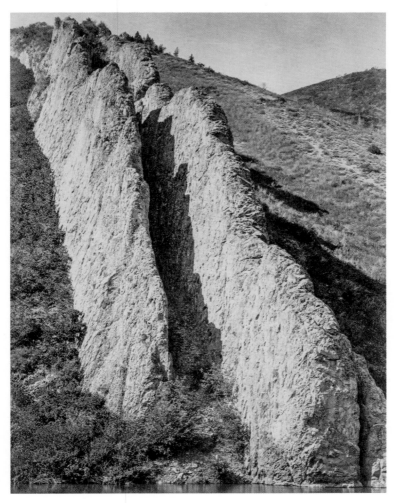

Timothy O'Sullivan, *Devil's Slide, Utah Territory*, 1869. Collection of the Library of Congress.

Because the formation lurks just a few yards above the Union Pacific line, virtually every photographer who passed by captured it. As such, it provides a rare opportunity to compare Watkins's work to those of his peers among the West's first generation or two of photographers.

The earliest picture of Devil's Slide seems to have been taken by Andrew J. Russell, a Matthew Brady–affiliated Civil War photographer who moved

west to become the official photographer for the eastern half of the Union Pacific railroad. Russell made two pictures of Devil's Slide in 1868, just before the Union Pacific completed its road in Utah. Russell's pictures have a certain flair. In one of them, Devil's Slide seems to be cascading from the upper right of the picture to the lower left. It suggests active geologic process.

Next came Timothy O'Sullivan, in 1869. In one of three pictures, O'Sullivan emphasizes the weight of the limestone and the way it thrusts up out of the mountain from which it protrudes. It's a terrific, almost three-dimensional picture. In 1870, Charles R. Savage, a British-born, Utah-based photographer who worked for Clarence King and later for the Union Pacific, and whose work was published in the form of engravings in *Harper's* magazine, photographed the formation, a muddy, dull, head-on view of little interest. (Savage seems to have known he missed it—he returned later to try again.)

Then there was Eadweard Muybridge, who visited in the spring of 1873 (and whose trip may have motivated Watkins's). The Weber River, which ran below the Union Pacific road, was above flood stage, and perhaps as a result, Muybridge didn't quite know what to do (or didn't have many options for a location from where he could make his picture). In his picture, Devil's Slide looks weirdly tiny.

Another prominent nineteenth-century American photographer to visit the place was William Henry Jackson, who went in 1869 and again in 1880. The early picture is routine; the later picture, at the Amon Carter Museum, emphasizes the broader landscape and the weirdness of the formation within it.

Then there is Watkins's picture, which today survives in at least six prints. Unlike his contemporaries, Watkins included a bit of sky and played up the contrast that sunlight created between the limestone formation and the rocky ground around it. Watkins also cleverly arranged for a Union Pacific train to stop just below the formation, allowing his picture to show Devil's Slide, a sliver of Weber River, and a locomotive and car in the foreground. The resulting picture moves the eye around, from Devil's Slide to the train and back up Devil's Slide. (The best surviving print of the picture, at the J. Paul Getty Museum, includes clouds, which were either printed in by someone other than Watkins, who plainly felt that his work needed no such artificial enhancement, or were captured by the otherwise cloud-

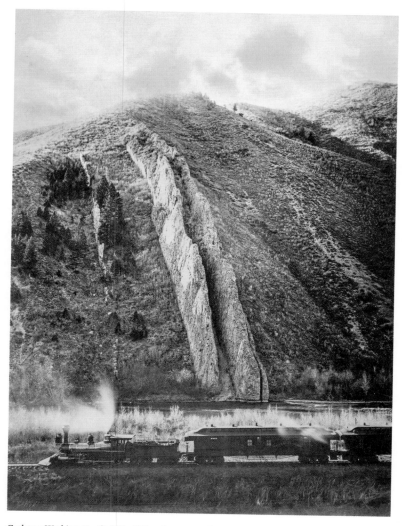

Carleton Watkins, *Devil's Slide, Weber Canyon, Utah Territory*, 1873. Collection of the J. Paul Getty Museum, Los Angeles.

obscuring collodion process because Weber Canyon was high enough in elevation to allow them to fix to the negative.)

The Utah trip notwithstanding, Watkins mostly stayed at home during the early years of the new gallery. His extended stay in San Francisco encour-

aged him to make pictures of home, including of downtown San Francisco, the Farallon Islands, off the city's Pacific coast, the U.S. Army's construction of fortifications on the Golden Gate, and, of course, the Peninsula estate pictures. It was all good work, and no doubt it all paid marvelously well, but for Watkins, accustomed to making significant series of work while on months-long journeys, it was very much the kind of work you do when you're in town and need something to do.

Still, some of it was very good, including the mammoths and stereos Watkins made of the Farallones, a group of rocks sticking up out of the Pacific Ocean thirty miles to the west of the Golden Gate, in 1872.[19] These rocks, some immense enough to be called islands, were similar in formation to the coastal rocks Watkins had photographed in Mendocino in 1863. Curator Weston Naef has speculated that this was work commissioned by George Davidson and the U.S. Coast and Geodetic Survey. However, nowhere in the detailed annual reports that the U.S. Coast Survey (as it was called until 1878) filed with Congress in these years is there any suggestion that the 1869 Coast Survey at the Farallones, undertaken not by Davidson but by Edward Cordell, was interested in the plainly visible rocks that Watkins photographed. The Coast Survey's work was focused on the search for rocks just *under* the ocean surface, rocks that mariners had reported and that could be a hazard to ship traffic.[20] The *San Francisco Bulletin* reported that Watkins made the pictures for gallery stock, perhaps with an eye toward the expected rush of transcontinental railroad–supplied tourist traffic.

While the Farallones were inaccessible to tourists, the rocks could be seen through binoculars from the Cliff House, the attraction perched above the Pacific Ocean at which travelers could have a meal, sun themselves, or gawk at seals frolicking on the Seal Rocks a few dozen yards offshore. Guidebooks promised a great view. Watkins offered twelve even better ones, including the spectacular *Sugar Loaf Island and Seal Rocks,* which shows an immense crag protruding out of the ocean. Its lower reaches, where the ocean has lapped at it, are a dark brown. The top of the rock is nearly white. At first the viewer struggles to understand the scale of the rock, which fills almost the entire frame. Context seems absent. Then, after a moment, you notice the sun shining off some shiny, curved, sausage-like shapes lying where the ocean crashes into the bottom of the rock. After another moment, you realize that these tiny tubes are actually seals. "Some of these sea-lions are monsters of their kind,

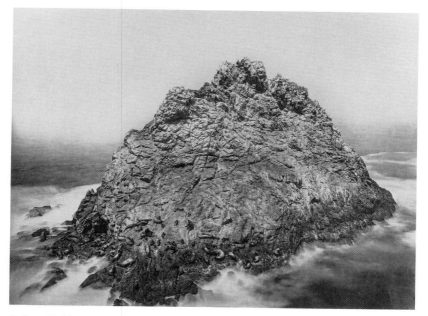

Carleton Watkins, *Sugar Loaf Island and Seal Rocks, Farallon Islands*, ca. 1872. Collection of the National Gallery of Art.

weighing a thousand or twelve hundred pounds," wrote one visitor from Chicago. They look like "men, perhaps, who have warred and wasted, and lived free and high and fast, going through an uncomfortable metempsychosis, prisoned and pinioned in these flabby, slippery and clumsy forms."[21]

Among Carleton Watkins's triumphs of the Yosemite Art Gallery years was the presentation of the western landscape to yet another part of the world. Watkins's pictures had introduced the West to Great Britain and to the European continent in the early 1860s and throughout that decade, and now, in the spring of 1875, Watkins would send dozens of pictures of Yosemite, Utah's Wasatch Mountains, the Farallon Islands, San Francisco, and the North Bloomfield hydraulic mine in Nevada County, California, to the Intercolonial Exhibition, presented by the Agricultural Society of New South Wales in Sydney, Australia. It was the first time the United States was represented in an Australian fair.

Watkins's medal-winning pictures were hung at the entrance to the American Court, next to a large central fountain and just to the left of the entrance to the fair. The American display was fronted by an enormous wood-frame, crimson-painted arch, upon which Watkins's pictures hung in custom-built, thirty-three-inch-wide frames. "Nearly all these pictures are splendid specimens of photographic art," gushed the *Sydney Morning Herald*. "They delineate naturally some of the grandest views obtainable of rugged California scenery—of mining districts, their monster flumes and machinery; of lakes far-famed, and city views, all of which tend to impress the visitor with ideas of the magnitude of the country the annexe represents."[22]

It was all very large, very big, very grand. Maybe it was a little too grand.

17

SAN FRANCISCO'S BORASCA

SHORTLY AFTER CARLETON WATKINS and William Keith returned to San Francisco from Utah, Billy Ralston's California Theater hosted a twenty-night spectacle that everyone considered the greatest event in the short history of California drama: a series of plays all starring a one-time British factory worker and nurserymaid who called herself Adelaide Neilson. In the 1860s she became England's greatest stage attraction, and in the 1870s she traveled to America to conquer the other continent and to become fabulously wealthy in so doing. Over the course of Neilson's three weeks on the San Francisco stage, she set new box-office records night after night by performing as Shakespeare's Juliet, Rosalind, and more. Ralston and his wife, Lizzie, attended all twenty performances. At the end of the run, Ralston presented Neilson with a $10,000 diamond necklace and hosted the actress and her husband at Belmont.[1] Just before Neilson returned to London, Ralston threw her a grand banquet. The guest list was a who's who of San Francisco society, including western iron king Thomas Selby, land baron and mining investor James Ben Ali Haggin, and railroad magnates Edward Crocker and David D. Colton. As usual, Ralston's circle overlapped with Watkins's: all of these men either had or would commission Watkinses.

The lavishness of Ralston's party motivated the *San Francisco Call* to a satirical account of the evening. The party had started with "brandies older than America's history, [and] sherry richer than the Bank of California." The table featured "grand salmon stuffed with brook trout and baked in rose leaves [and] baked macaroni each stock of which had been stuffed with anchovies and Madagascar peas." If that wasn't enough, there was the main course, which featured "a humming-bird filled with baked almonds, surrounded by a Spring linnet, which, in turn, was enveloped by an English snipe. These the carcass of a stuffed goose surrounded, covering which were two canvas-back ducks raised in a celery garden, the whole placed within the bosom of a Chicago goose. Soaked in raisin wine for six days, then larded, and smoked three weeks over burning sandalwood, it was at last placed on the spit and roasted with pig-pork drippings."[2]

Intentionally or not, the *Call*'s unnamed satirist had identified the moment at which luxury pivoted into decadence.

For some years Billy Ralston had relied on the next bonanza to rescue whatever overly gregarious investments or mindlessly lavish expenditures he had made.[3] There were so many mines of so many metals—mercury, gold, silver—that rescue had always been one shaft away. Then, as the 1870s moved on, Ralston began to find himself outmaneuvered in the Comstock. First, his frenemies, men such as Alvinza Hayward and William Sharon, began to have better sources of information. Perhaps all the time Ralston was spending entertaining actresses and delegations of foreign dignitaries was catching up with him. Next, a younger group of businessmen, Irish Americans John W. Mackay, James G. Fair, James C. Flood, and William S. O'Brien, collectively known as the Bonanza Kings, also started to outmaneuver Ralston.[4] Over the course of 1873 and 1874, the Bonanza Kings cleverly bought up and merged key mining properties and were thus able to discover new sources of ore. This was the beginning of the end for Ralston.

The Bonanza Kings celebrated their success by consolidating their gains. In an effort to control every ounce of their own ore, they incorporated their own San Francisco bank, called it the Nevada Bank, and began building it at Montgomery and Pine Streets in January 1875. Observant locals would have noticed that the Bonanza Kings were building in the "old downtown," north of the New Montgomery Street development that Ralston had spearheaded

with the Grand Hotel. If anyone doubted that the Bonanza Kings were taking aim at Ralston, they capitalized their new bank with the exact same outrageous sum, $5 million, with which Ralston had backed the Bank of California.[5] "The quantity of bullion will monthly swell the operations of the mines, which may be regarded as the coin reservoirs of the Bank," the Bonanza Kings boasted to the *Daily Alta California*. "The world never before saw so gigantic a combination of mines and Mints with a bank which will pay out every year, in new coin, a sum equal to the whole capital of the Bank of England, and more than double that of the Bank of France."[6] The Nevada Bank's $5 million in reserves would become a gauntlet less metaphorical than actual.

It wasn't just Ralston's Comstock investments that had flipped from bonanza to borasca. While the Grand Hotel was riding the wave of transcontinental-supplied traffic to success, the rest of Ralston's project to extend Montgomery Street's business district south of Market Street languished. Ralston took this combination of boom and blah as an opportunity to increase his investment in the lodging sector: he would build yet another opulent hotel. Ralston talked William Sharon into taking a half interest, and the Palace Hotel was born.

Ralston began the project in 1874, just as the panic of 1873 promised to slow transcontinental railroad traffic. Believing the West was immune to a national depression, Ralston planned a seven-story, 96,000-square-foot hotel with 755 rooms.[7] How over-the-top was this latest Ralston scheme? The best and largest American hotels of the day were a fraction of this size. The Stuyvesant House in New York had 36,000 square feet of space. In the Midwest, where things were bigger because there was room for it, Chicago's Grand Pacific and Palmer House hotels each clocked in at just under 60,000 square feet. San Francisco was half Chicago's size and had one-fifth of New York's hotels.[8] For Ralston this was all beside the point. The Palace wasn't just a hotel, it was a 27-million-bricks expression of confidence in the California economy and a 3,000-tons-of-strap-iron testament to the Bank of California's strength. Such was the immensity and solidity of the building that some San Franciscans speculated it was being built as a fortress that could, if necessary during an earthquake or a proletarian revolt, house San Francisco's ruling aristocracy. These were far-fetched, apocalyptic notions, but they revealed a certain civic nervousness about the moment.[9]

Ralston expected the Palace to cost $2.5 million, but costs soared to $6 million. There was a statewide shortage of building materials. Then there were Ralston's beloved luxury touches, such as the five elevators and three interior courts, one of which was surrounded by seven floors of iron balustrades, which added to costs. Ralston-owned companies such as the Adams Lock Co. and the West Coast Furniture Co. supplied the property, as did Ralston-affiliated companies. (For example, the Millbrae dairy of Bank of California president Darius Ogden Mills and his ranching partner Alfred F. Green received the milk contract.)[10] The costs all added up.

In 1875 Ralston hit upon a plan that he hoped would save his fast-faltering finances: he would buy up a controlling interest in Spring Valley Water Works, the company that controlled much of the water on the San Francisco Peninsula and that sent it north into the city, thus supplying San Francisco.

Ralston's plan, likely informed by the same kind of industrial intelligence system that for years had enabled his insider trading of Comstock Lode stock, was twofold and three-stepped: First, he would buy up all the shares of Spring Valley stock he could. Concurrently, he would buy up land in watersheds likely to supply San Francisco. Next, he would sell these newly acquired water rights to Spring Valley at a huge markup; one such deal netted Ralston and a partner a 900 percent profit. After Spring Valley bought up all those water rights from Ralston, Ralston would use his, er, influence with the city's board of supervisors to sell Spring Valley to the city for an outrageous price. The city would then run the water company as a public utility, and Ralston would make millions.

Carleton Watkins may have been among Ralston's conduits for intelligence on Spring Valley as Watkins had firsthand knowledge of the company's resources. Back in 1868, he had made pictures of the construction of Pilarcitos Dam, one of the three dams in the Coast Range mountains along the Peninsula in which Spring Valley stored San Francisco's water. The man who had shepherded Watkins around the site was William H. Lawrence, then a construction foreman and now a Spring Valley executive. Forthcoming events would suggest they had stayed in touch.

Inevitably, word of Ralston's scheme leaked into the newspapers. The public was outraged, which forced the board of supervisors to block the plan. Still, Ralston wasn't worried. In the September 1875 election, he

"invested" in a slate of candidates he believed would be favorable to the Spring Valley sale.

Over the months it took the Spring Valley scheme to play out, Ralston was running out of money. He sold prime, undeveloped agricultural land in Kern County, at the southern tip of the Central Valley, to his father-in-law, and other Kern land to a consortium led by James Ben Ali Haggin.[11] He sold his share in the Virginia & Truckee Railroad to Mills. He sold his half of the Palace Hotel to Sharon (and at a significant loss). He "borrowed" on nonexistent Bank of California stock. He borrowed on Southern Pacific bonds that he held in trust for someone else. He ordered that gold bullion belonging to depositors and stored at his San Francisco Assaying and Refining Co. be struck into coin and then made available for his and the bank's use. With this last one, Ralston, the old riverboat captain, was now wheelin' and dealin' with what amounted to stolen money. Worst of all for a bank, Ralston and the Bank of California were short of coin. (While the rest of America trafficked in dollars, greenbacks, federally issued specie, mining-oriented San Francisco clung to gold coin as its currency.)

The lack of available coin must have burned the civic-minded Ralston. Currency was short throughout the state because of a stunt organized by the Bonanza Kings, Ralston's ascendant rivals. The quartet arranged that their brand-new Nevada Bank would exhibit $5 million in coin inside the bank on opening day, a gimmick meant to show off its safety and standing. As a result, one-third of the circulating coin in all California was temporarily unavailable as it was being used in a window display.[12] The Bank of California asked the Nevada Bank for a loan to tide itself over. The Bonanza Kings said no.

Ralston was flat out of money. On August 26, 1875, thirty minutes before closing time, the Bank of California failed.

The next day, the Bank of California's directors did something they should have done much earlier: they examined the books. They discovered that Ralston was $9.6 million in debt. He owed the bank $4.7 million. He owed Sharon almost $2 million. Somewhere between $3.5 million and $5.6 million of Ralston's debt was unsecured. The bank's liabilities exceeded its assets by almost exactly the amount Ralston owed it. The Bank of California was insolvent.

Ralston pleaded for time. He pointed to the Spring Valley scheme as the potential savior. The board refused. It forced Ralston to sign over most of

his assets to William Sharon, believing that this would invest Sharon in saving both his own finances and the bank's. The board asked Ralston to resign. He did.

Ralston was defeated, humiliated, exhausted. As was his regular custom, he decided to go up to North Beach for a restorative swim in San Francisco Bay. Ralston jumped in the water and swam toward Alcatraz. After a time, it became obvious to the men in the *Bullion,* a steamship belonging to Thomas Selby's iron company, that Ralston was struggling with the currents, that he was in trouble. The *Bullion* sped toward Ralston. Its crew launched a rescue dinghy. The rowers reached Ralston. They pulled him aboard. The *Bullion* sped to shore. Ralston was not breathing. Men tried to revive him. They could not. Billy Ralston, forty-nine—the man who had done more than anyone else to build San Francisco into a major global urban center, the man who had made the gold mines into financial instruments enriching himself and others, the banker of imperial California who had bankrolled the California-dependent industries in Oregon and Nevada, the banker who had begun California's pivot from mining toward agriculture, and the man who had almost certainly been the primary enabler of California's greatest artist, the photographer who had done the most to show California to the United States and the world over the last fifteen years—was dead.[13]

After failing, and after Ralston's death, the bank remained closed for five long weeks. Ralston's financial failure, his possible suicide, and the collapse of the Bank of California shattered California's economy. A steep recession had hit the eastern states in 1873 but had little affected the West. Now, throughout the region, investors halted projects. Unemployment in San Francisco spiked to 20 percent and was much higher if you included the Chinese (which no one did).

Now and in the years to come, this had little effect on the wealth of the city's leading men. Mills and Sharon quickly reorganized the Bank of California.[14] Before long it would resume its place as one of America's most important banks. It reopened to the public on October 2, the same day on which the Palace Hotel first opened its doors. The city's newspapers led with the bank's comeback. California's ruling class turned out in a public display of confidence in both the bank and the West's future. Among those in attendance were past and future Watkins collectors Milton Latham,

Lucky Baldwin, Charles Crocker, James Ben Ali Haggin, Lloyd Tevis, John Parrott, and Darius Ogden Mills, each a reminder of how close Watkins had been to Ralston's Ring, and how important those relationships were about to be to his future.[15]

When the Bank of California closed for the day, the well-heeled crowd walked down California Street to the Palace Hotel, where Sharon had arranged for a second gala opening, a public-relations move that aimed to show off the city's financial strength—and Sharon's.[16] Watkins was surely among those in attendance. Probably in the days before the hotel opened, he had made a suite of medium-format pictures of the hotel, pictures of empty, pristine courtyard space, what we might call an atrium today. "There is no hotel in the world equal to this," Andrew Carnegie wrote after visiting in 1878. "The court of the Grand at Paris is poor compared to that of the Palace."[17] Watkins's pictures of the Palace Hotel atrium are beautifully composed and make the white-painted iron supports and flourishes look like piped icing on a gingerbread cake. Watkins has posed a couple of people relaxing in rocking chairs in the courtyard, hanging out, enjoying the sunlight. The chair nearest us is empty, an invitation. In the next century, the German artist Andreas Gursky would make his own series of pictures of the largest twentieth-century hotel atriums, of the Hyatt Regency Atlanta, the San Francisco Hyatt Regency, the Taipei Sheraton, and the Shanghai Grand Hyatt. Like Watkins's originals, the Gurskys suggest wealth, global business, and stability.

The Palace was a marvel. Each floor had its own servants, African Americans rather than the usual Chinese. Pneumatic tubes connected each room with the main hotel office, so all guests had to do to ask for something was to write it down and drop it into a small hole in the wall of their room. Within minutes their wish would be fulfilled. Palace guests could even stay at Belmont, which had passed into Sharon's control, for an extra dollar a day.[18]

Ralston's affairs were not as tidily resuscitated. As the bank's directors had arranged just before Ralston's final swim, Ralston's estate fell not to his wife but to Sharon. Ralston biographer David Lavender concluded that it was impossible to know how much of Ralston's $9.6 million debt was eventually settled. Sharon paid $1.5 million to the bank in exchange for Ralston's $4.7 million in liabilities. Sharon then settled with Ralston's creditors on whatever terms he could as quickly as he could, a decision that resulted in a storm of lawsuits claiming Sharon gave some creditors preferential treat-

ment. This flurry of debt settlements and lawsuits left Ralston's former assets spread across an array of westerners. One of the likely Ralston assets that Sharon almost certainly sold off was the loan Ralston or the Bank of California likely gave Watkins to move and expand his Yosemite Art Gallery. This is probably how Watkins's loan ended up in the possession of one John Jay Cook, a Mariposa County businessman of otherwise little note.

What happened next is even less clear: sometime between Ralston's death in August and the end of 1875, Cook called in Watkins's loan.[19] Charles B. Turrill, one of the first chroniclers of nineteenth-century California and an often unreliable narrator, wrote that Cook foreclosed on Watkins's loan while Watkins was traveling, thus ensuring that Watkins could not fulfill Cook's terms in time to avoid foreclosure. While no surviving Watkins body of work can be firmly dated to the last couple of months of 1875, Turrill's account fits what happened and Watkins's response to it. Maybe Watkins was just away on vacation.

Regardless, for Watkins the combined effect of Ralston's death, the bank's collapse, and the calling in of a loan that Watkins probably hadn't had much reason to think about was catastrophic. By Christmas 1875, Cook owned every mammoth-plate glass negative Watkins had ever made, every stereographic negative Watkins had ever made, either Watkins's lease or his title for his gallery across from the Grand Hotel, and possibly all of Watkins's cameras, traveling gear, and even his photographic wagon. Pretty much everything Watkins had done or made over the previous two decades was lost.

As if that wasn't bad enough, Cook immediately partnered with a lower-tier competitor of Watkins's named Isaiah W. Taber. This must have driven Watkins nuts. Taber's was the kind of photographic studio that had made its bones in part by trying to make pictures identical to Watkins's. Now Taber no longer had to do that. Taber's deal with Cook gave him co-ownership of the genuine article, Watkins's negatives. Taber would henceforth make prints from them and offer them for sale. It got worse: Taber instructed his staff to print clouds into Watkins's skies. Watkins must have felt this as a particularly acute insult. For several decades, photographers had compensated for the inability of mid-nineteenth-century photographic chemicals to capture variations in the sky by printing clouds into seemingly empty space. Watkins had long resisted this practice and was almost alone among his

peers in so doing. He surely felt that Taber was not only benefiting from circumstance but also defiling his work.

Taber was not shy about boasting of the new reality. On December 25, 1875, the *Daily Alta California* reprinted a now-lost item that had been in the *San Francisco Chronicle*: "I. W. Taber & Co. have taken the Yosemite Art Gallery, No. 26 Montgomery [S]t . . . This is the very best location in the city—central to all the leading hotels and horse-car routes. All cars from the Oakland ferry [on which transcontinental railroad traffic arrived in San Francisco] pass near this gallery. This establishment is the most spacious and elegantly furnished in the city." Watkins couldn't have put it better himself. "Its connection with Watkins' celebrated Yosemite View Department makes it the most interesting gallery to visit on the Pacific coast. Mr. Watkins can always be found at this studio." (There is no evidence that Watkins ever actually worked for Taber.)

That was that. Watkins, now forty-six years old, still single, and long single-minded about making art while traveling around the West, had lost everything through no evident fault of his own. Like any businessman looking to expand, he had taken out a loan. In all likelihood, he took it from a friend who valued his pictures and with whom he'd worked closely for many years. As Watkins's new location was useful to Ralston, Watkins probably got pretty good terms. He seems to have prospered: he had a sizable staff, as many as twenty people, and made enough money to join the most exclusive professional clubs in the city. And then, in a matter of days, it was all gone.

A week after Ralston's death, fifteen thousand people turned out for a memorial service. "Schools claim him as their patron," eulogized Tom Fitch, a leading San Francisco attorney. "Art has found in him a supporter. Science has leaned on him while its vision swept the infinite."[20] Watkins, who had made pictures of the university of which Ralston was a treasurer, of Ralston's stage stars, of Ralston's family, of Ralston's estate, of Ralston's business and political interests, knew it all too well.

18

THE COMEBACK

ARLY, VERY EARLY ON THE MORNING of the Fourth of July, 1876, Carleton Watkins lugged a new mammoth-plate camera and a stereographic camera up onto the roof of the building at the southeastern corner of Montgomery and Pine Streets. Watkins had made pictures in the six months since he had lost everything at the end of 1875, but the commission that led to his standing on this rooftop as the sun rose signified a transitional moment for both Watkins and, in some ways, for San Francisco. Watkins was up here to take a picture of the building diagonally across the intersection, the patriotic-bunting-clad Nevada Bank building.[1]

For the owners of the Nevada Bank, the four men known as the Bonanza Kings, surely the whole point of this picture was San Francisco's transition. They had made their fortunes outmaneuvering Billy Ralston in the Comstock Lode. They had planned the Nevada Bank in 1874–75 as their answer to the Bank of California—even the name was a smirk at Ralston's outfit. (That it was a California-based bank named after another state was no big deal. Just as Oregon was a satellite of California, so too was Nevada.) Ralston had built a two-story headquarters; the Bonanza Kings built a building more than twice as tall. While an army of contractors had outfitted the new building, the Bonanza Kings publicized the name of only one of them, the

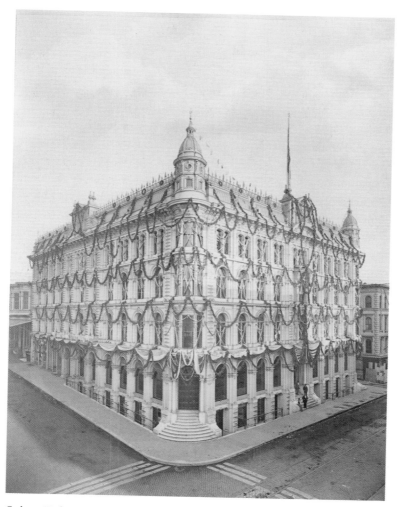

Carleton Watkins, *The Nevada Bank Building, San Francisco,* 1876. Collection of the California State Library, Sacramento.

Hall Safe and Lock Co.,[2] which was essentially the same as publicizing that they were *not* using the Ralston-owned Adams Lock Co. The Bonanza Kings hired the same architect who had built the Bank of California, David Farquharson. Now Watkins was on top of the building catercorner to make a version of the picture he had made of the Bank of California building nearly ten years earlier. These Bonanza Kings didn't miss a trick.

Watkins took three pictures of the Nevada Bank building: a mammoth plate that today exists in a single print (at the California State Library in Sacramento) and two stereographs. One of the stereographs shows the building without its bunting, a suggestion that a corresponding mammoth-plate picture has been lost. The composition is nearly identical to Watkins's picture of the Bank of California: Watkins's position is elevated and diagonal. The bank building pushes toward the viewer, giving it even greater bulk and permanence than it would otherwise have. It looks so easy . . . but if it was, why didn't more photographers, in San Francisco or New York or wherever, make pictures like it? Today Watkins is best remembered as a landscape photographer, but this Nevada Bank picture is a reminder that he was the best American architectural photographer before Alfred Stieglitz.

The Nevada Bank Building also suggests how Watkins worked his way back from disaster: by mining relationships he had spent years building as an artist, as a member of the Bohemian Club, and as the Ralston Ring's favorite photographer. One of those relationships was with Farquharson, the West's top architect. Watkins made pictures of Farquharson buildings throughout his career, a group of work in both mammoth plate and stereograph that may make up the most significant pictures of buildings by a single nineteenth-century American architect.[3]

It has become de rigueur for historians to bemoan Watkins's business acumen. As proof, they point to Watkins's suffering as he waited for the California Geological Survey to pay him for thousands of prints in the mid-1860s, which was not his fault; to his loss of the Yosemite Art Gallery at the end of 1875, which was not his fault; to passages of letters from 1880 that could be read as being about the difficulty of securing paper currency in remote parts of California and Arizona Territory. (Watkins's lacking paper currency in the most remote parts of the United States may indicate more about San Francisco's anomalous financial system and Watkins's distance from even minor cities than anything else.) Later in life Watkins would be flat broke, a status that was shared by many, even most, major nineteenth-century American artists.

For a lousy businessman, the client list Watkins seems to have lined up for his comeback year of 1876 is mighty impressive. Virtually every major interest in the West would be represented: the Bonanza Kings, an unknown commissioner of thirty-six Comstock Lode mines, mills, and related sites,

the Central Pacific Railroad, the Carson & Tahoe Lumber and Fluming Co., the Virginia & Truckee Railroad, and the formerly Ralston-controlled resort at Glenbrook on Lake Tahoe, a property that was likely controlled by Sharon and/or Mills when Watkins photographed it. Each of the West's biggest, wealthiest, and most important concerns wanted Watkins pictures and wanted them right away. Maybe he wasn't too bad a businessman after all.

While Watkins may have lost his gallery and inventory to Billy Ralston's rapid decline and fall, he still knew how to make great pictures and how to put together a trip to far-flung western locales. Besides, what else was there that Watkins, in his midforties, could do that would pay him as well as making and selling pictures? He may have lost everything, but he was still C. E. Watkins, the most famous artist and photographer in the West, soon to be the medalist for photography at the 1876 Centennial Exposition in Philadelphia, a World's Fair attended by 20 percent of all Americans.[4] He was not without credits.

Watkins lined up a remarkable and powerhouse client list for his 1876 trip, resulting in over one hundred mammoth-plate pictures and scores of stereographs. The trip's challenging logistics required him to make work for the aforementioned clients across landscapes and climates as varied as the cool High Sierra and the Nevada desert (and it all had to be done before the first snows!). The expedition was made possible by Watkins's continued use of a custom-made railcar, a setup similar to the one he and William Keith had taken to Utah in 1873–74. If one of Watkins's goals was to demonstrate to San Francisco society and business that even though he had lost his business, he was still Carleton Watkins—and surely it was—the trip was an enormous success. He added new clients to his customer base, none more important than the Central Pacific, and reminded anyone who needed reminding that after nearly a decade of living well, mostly servicing wealth and making pictures of the upper crust's country estates, he could still order industrial landscapes into beauty and present the West as a land of opportunity.

How did Watkins, a few months removed from losing his business, have the wherewithal, both financially and logistically, to make such a complicated trip? Historians have long speculated that Collis Huntington— Watkins's boyhood chum and the man with whom Watkins had traveled

west a quarter century earlier, and now the major power behind the success-fully completed transcontinental and especially the Central Pacific—enabled Watkins's work in this period, perhaps with the special railway car, a railway pass that entitled Watkins and his car to free travel, and a series of commissions from the Central Pacific.

However, even though thousands of Huntington letters, both written and received, financial records, business records, account books, and vari-ous other financial documents are known to historians, there is no evidence that Watkins and Huntington were in contact between the early 1850s, when both were in California's mining region, and 1884.[5] There is every reason to believe that if they had been in contact, Huntington would have saved the correspondence. He diligently saved even the most routine, mundane let-ters to and from not just other Oneontans with whom he traveled to Cali-fornia in the 1850s but also his periodic correspondence with their families. For example, Huntington retained correspondence between his office and Watkins's father, John, at least twice: in 1870, when John asked for a railroad pass, and in 1876, when Huntington appeared to purchase the mortgage to John's conveniently located Oneonta house at about the time when John left Oneonta to open a hotel in Albany.[6]

There is no indication in the voluminous Huntington papers that Hunt-ington recommended or directed Central Pacific officials, in California or anywhere else, to hire Watkins to make pictures on the railroad's behalf. Nor is there any suggestion that Watkins contacted his old mate to ask for the work.[7] To the contrary: in an 1880 letter Watkins wrote to Policarpo Bagnasco, who printed his work, he references an order for pictures related to railroad business, specifically the transfer boat *Solano* that allowed train cars to cross the bay; Watkins's letter makes it clear that the commissioning client wasn't Huntington but San Francisco–based Southern Pacific super-intendent Alban N. Towne.[8] Did Huntington know about Watkins's career and successes in these years? He must have. Huntington was in contact with plenty of men who knew Watkins personally, from George W. Murray to Albert Bierstadt to Clarence King, who sent Huntington a box of pictures from his Fortieth Parallel Survey in early 1871, a box that likely included Watkins's 1870 Shasta pictures.[9] Albums of Watkins's work were owned by New York social clubs, and Huntington was a clubman. Still, Huntington didn't so much as write or telegraph Watkins a simple congratulations in

these years, and there's no record of Watkins reaching out to Huntington in any way. Huntington had nothing to do with Watkins's mid-1870s comeback or with anything else until much later.

If we take Watkins's numbering system as a rough guide to the path he followed in 1876, he first took the Central Pacific road into the Sierra, where he made about twenty pictures around Lake Tahoe.[10] While many of Watkins's friends had been to Tahoe, including Thomas Starr King (who visited in 1863), this was Watkins's first trip.[11]

Watkins traveled around the lake, taking pictures of its hotels, logging facilities, nearby Fallen Leaf Lake, and Tahoe itself. Among the Tahoe sites Watkins photographed was a huge timber mill on the lake's eastern shore. Years earlier, Ralston and the Bank Ring had purchased fifty thousand acres of forest—seventy-eight square miles, an area more than one and a half times the size of San Francisco—near the southern and western sides of Tahoe, built the mill, and incorporated the business as the Carson and Tahoe Lumber and Fluming Co. (CTLFC). It isn't clear who owned the company in the months after Ralston's death: maybe Sharon, maybe Mills, maybe a combination thereof, and maybe one reason Watkins was here was that one or both of them were considering a sale. The CTLFC is the only client that can be tied to Watkins's 1876 trip with documentation. It paid Watkins at least $970 for his work, about forty times what, say, an agricultural laborer made in a month.[12] The company fed the Comstock mines' vast need for timber as building material—the many dozens of mines were built with "square-set timbering," which required thousands of milled wooden supports eighteen inches square and six- to seven-foot-tall diagonal wooden braces and plank-wood floors—and fuel. Rarely does Watkins show what even nineteenth-century industrialists such as Ralston and his ring would have considered environmental degradation, but in these pictures around Lake Tahoe and for the rest of the trip, the elimination of vast Sierra Nevada forests in support of the Comstock Lode mines would feature in Watkins's pictures. By now, a quarter century into California's mining boom, the damage was impossible to hide.[13]

Like so many other artists who traveled to Tahoe, Watkins struggled to make his best work there.[14] After the five Great Lakes, Tahoe is the biggest lake in the United States. Its immense, inland-sea-like horizontality puzzled artists. Painters, at least, had the option of tweaking the landscape in an ef-

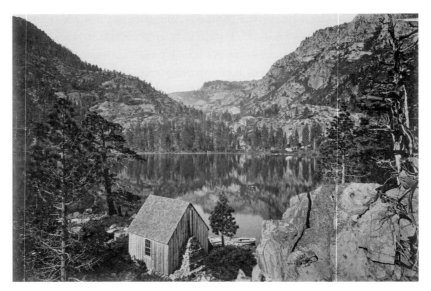

Carleton Watkins, *Emerald Bay from the Island, Lake Tahoe, El Dorado County, California*, 1876.
Collection of the Huntington Library, Art Collections and Gardens, San Marino, CA.

fort to make it work. In *Emerald Bay, Lake Tahoe* (1864), friend-of-Watkins Thomas Hill had shrunk the vast lake to puddle size, a strategy adopted by most every ensuing painter. The best nineteenth-century painting of Tahoe may be a watercolor not much bigger than a sheet of paper: Albert Bierstadt's *Emerald Bay, Lake Tahoe* (ca. 1871) forgoes grandeur to show off the lake's legendary clarity.[15] Watkins's best Tahoe picture is *Emerald Bay from the Island*, which may be the best-known picture of Tahoe in any medium. To make it, Watkins took a boat out to Emerald Isle, the only island in all Tahoe (today known as Fannette Island), and climbed up a granite rock to the island's highest point. His mammoth-plate picture looks back toward the tree-covered granite amphitheater that encircles the bay and captures its reflection in the water. In the left foreground is a tiny handmade cabin that was home to a local character-cum-drunkard named Richard Barter, a man who was fond of showing off his self-amputated toes. Barter also built a stone chapel on the island—Watkins took a stereograph of it—in which Barter famously told every bar patron around the lake that he wanted to be buried in. (Alas, three years before Watkins arrived, Barter drowned in a windy storm. His body was never recovered.)[16] The only Watkins that may

have been informed by luminism, the nineteenth-century American painting style that exaggerated the effects of light on the landscape, is a Tahoe picture: in *A Storm on Lake Tahoe*, Watkins lets sunlight bounce across the lake surface and some distant mountains, resulting in a kind of hazy sublime.

From Lake Tahoe, Watkins took the same route out of the Tahoe basin that Glenbrook timber did: up the CTLFC's private "Z railroad," an 8.5-mile narrow-gauge line to Spooner Summit, just east of Tahoe in Nevada.[17] Watkins made two pictures here, one of a CTLFC train loaded down with timber milled for use as square-set timbering and timber used as locomotive fuel (a practice that continued across the West into the 1890s), and another of the CTLFC track system, before continuing to the CTLFC's lumberyard and flume just south of Carson City, Nevada. Watkins made two views of the lumberyard, unusually direct pictures of what was left of the Tahoe basin's forests. In each picture, piles of milled board are stacked like bodies in a mass grave. The CTLFC's flume, which ran for twelve miles along Clear Creek Canyon down to Virginia City, is on the left-hand side of each picture. The company almost certainly rerouted Clear Creek's water into the flume, which allowed it to float all this board downhill into the mining district. Watkins never took a picture of a denuded Tahoe hillside, but any nineteenth-century viewer would have immediately known what all the other pictures added up to. Today we wince, but the Californians who would later complain about industry's rapaciousness and launch the West's environmental movement had yet to object. Watkins surely told his friend John Muir about what he'd seen here. Muir himself would come to Glenbrook two years later, in 1878. In his journal, he makes no note of the area's massive deforestation.[18] It was routine and understood.

From Carson City, Watkins followed the lumber down to the mining district known first as the Carson Valley and later, and more famously, as the Comstock Lode. The region consisted of Nevada's adjacent Storey and Lyon Counties, about fifteen miles due east of Lake Tahoe. In Storey, rock was mined from the earth; in Lyon, mills separated valuable ore from worthless rock in giant stamp mills. This region is where, in 1859, huge deposits of silver were first discovered in the United States, prompting a rush that created the boomtowns of Virginia City and Gold Hill, paid for the bonds that enabled the Union to fight the Civil War, and ensured that San Francisco, to

which all of the ore was shipped for processing, would be the de facto capital of the West for decades hence.

A giant fire had raced through Virginia City in 1875, so perhaps an unknown client hired Watkins to show that the city had recovered.[19] Watkins visited the Comstock at its peak, and what a peak it was! Virginia City, home to twenty-two thousand people and easily Nevada's largest urbanization, was the region's hub. It was a foul, foul place. The writer J. Ross Browne, one of the first writers to visit, described its climate as alternating between hurricanes and snow, its water as consisting mostly of arsenic, plumbago, and copper, and its landscape as completely devoid of plant life save for tumbling sagebrush.[20] Buildings were routinely fixed to 40 percent grades, hills that made runaway wagons a routine and dangerous occurrence. It was a ridiculously loud place: stamp mills pounded rock into paste, creating a perpetual din.[21] Anyone connected to the mines and who had the money to live in San Francisco did. Anyone connected to the mines who had *real* money, as Big Bill Stewart and William Sharon did, used it to buy a Nevada U.S. Senate seat, which Stewart and Sharon did.

The region's importance to the western and American economies seemed to demand such hubristic excesses. In the first bonanza, in the mid-1860s, the Comstock had peaked at about $16 million per year in gross yield. The mid-1870s bonanza was something else entirely: between 1873 and 1878, the entire Comstock would produce $166 million, more than twice as much per year as the previous record years.[22] In 1876 alone, the Comstock yielded about $40 million in gold and silver, around $1 billion in today's dollars, over half of the gold and silver produced in the entire United States.[23]

When journalist and traveler Grace Greenwood visited Virginia City, a restaurant waiter asked her if she was planning to stay long. "No," Greenwood said. "I shall start tomorrow for a civilized country, shaking the dust of Nevada from my feet, if that be possible." Her waiter looked hurt, then defended his town. "Why, *we are* civilized, madam; we've got a good vigilance committee here now. The time was when you couldn't go out of a morning without stumbling over a dead man or two."[24]

Despite the surrounding chaos, Watkins made remarkable work in the Comstock. Watkins took pictures of mines controlled by the two biggest groups—the Bonanza Kings and the remains of the Ralston Ring, now headed by Sharon and Mills—and also of mine and mill facilities seemingly unre-

lated to them. (Individual Comstock properties were traded—and manipulated—on San Francisco's stock exchange, and ownership at the precise point Watkins photographed them is difficult to impossible to untangle.) It is also unclear why Watkins photographed some mines and not others. For example, pictures of many Bonanza Kings mines survive, but not any of the Kentuck, one of the syndicate's more successful projects. Of all the pictures from Watkins's 1876 trip, it's the Comstock pictures, specifically the pictures of individual mines and the panoramas, that are hardest to identify with a particular client or interest. Were both the Bonanza Kings and the Sharon-Mills team that was leading what was left of Ralston's Ring in need of pictures for possible sales prospectuses? Unlikely. Watkins did not own a gallery in 1876, so he wasn't exactly shooting for inventory (though presumably the Comstock pictures were available once he reopened a couple of years later). Barring the discovery of new documents, there are no evident explanations.

It would have been easy for Watkins to rely upon a formula here, to take the same picture, from roughly the same point of view, of mine building after mill building after mine building. He did not do this. Sometimes he took pictures of buildings surrounded by a river valley, sometimes he took pictures of mines looking down the infamous 40 percent grade, and sometimes he took pictures looking up and head-on. The variation among pictures Watkins made in this landscape, mostly famed for its relentless brown emptiness, is notable. Virtually every Comstock picture is distinct, an individual reckoning with the specifics of each building, landscape, or desert urbanization.

Sometimes Watkins's pictures seem like landscapes that just happen to have mines in them. In pictures of the Merrimac and Brunswick Mills or the Vivian Mine in Lyon County, the Carson River and rocky desert mountain ridges draw the eye, which only reluctantly moves on to the mill complexes. Sometimes Watkins places a mill in the landscape as if the only way it is useful to him is in completing a composition. For a picture ostensibly of the Woodworth Mill, Watkins climbed partway up a mountain to take a picture of the broad valley cut by the Carson, with successively higher mountains climbing beyond the valley. A picture of a vast expanse is anchored by two immense, man-made, timber-built elements: a flume that seems to come out of the mountain below Watkins and that runs toward the far right of the picture, and a plank-board structure, possibly a bridge or a flume, that runs from the

Carleton Watkins, *Woodworth Mill, Lyon County, Nevada,* 1876. Collection of the Bancroft Library, University of California, Berkeley.

mountains on the other side of the valley toward the flume and the picture's right edge. Watkins even posed half a dozen men on the edge of the bridge.

Sometimes the landscape seems to be the thing. In *View up the Carson River,* the Virginia & Truckee Railroad's trestle slides between steep, rugged mountains of rock and a rushing silver curve of river. Maybe this view is a picture for the railroad that emphasizes the company's triumph in an inhospitable desert mountainscape; maybe it's just a picture that Watkins thought would come out well. One of the reasons historians have never convincingly assigned these pictures to a client is that the desert mountainscape is so often primary.[25]

The photographs of the mine buildings, a mix of unlikelihood with seeming permanence, are particularly good. These are among Watkins's most muscular pictures; muscularity reproduces well, and these are among the most reproduced Watkins works. *Bullion Mine* is an unlikely candidate for one of Watkins's stoutest pictures. From 1863 onward, an array of investors plowed $1 million into exploratory shafts at Bullion, finding little ore. Still, future Bonanza King John Mackay, who had once earned $4 a day as a Comstock mine

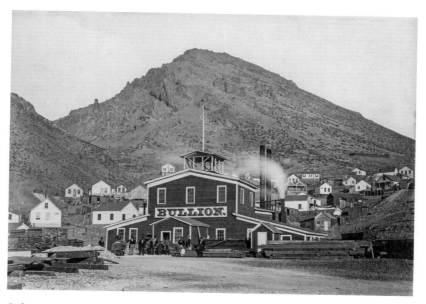

Carleton Watkins, *Bullion Mine, Storey County, Nevada,* 1876. Collection of the J. Paul Getty Museum, Los Angeles.

laborer, had owned a chunk of the Bullion in the early 1860s, flipping it during a hopeful period and making what may have been his first fortune. (Maybe Mackay wanted a picture of the Bullion not because it worked out as a mine but because it proved his acumen as an investor.[26]) Watkins took his picture from slightly below the mine, an unusual angle that emphasized its squatness. The left-hand side of the building extends farther than the right, which makes the mine look like it is flexing a bicep. Watkins also gave the Savage Mine a similar anthropomorphic feel: photographed from above, the wooden building covering the shaft and hoisting works seems to be sitting on its haunches.

Watkins's greatest Comstock mine pictures are, appropriately enough, of the Consolidated Virginia and California Mining Co., whose mines kicked off the bonanza period that had drawn Watkins here. The Con Virginia was not a new mine. In the late 1860s and early 1870s, a series of owners had sunk over $160,000 into exploring it, with few results. By the beginning of 1872, when Fair, Flood, Mackay, and O'Brien purchased the Con Virginia, the entire mine had a market value of a mere $18,850.[27] Following a lead from a nearby mine, the four Irishmen spent months excavating, to no avail. Long after they might

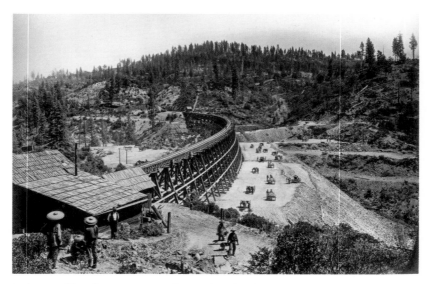

Carleton Watkins, *The Secret Town Trestle, Central Pacific Railroad, Placer County, California,* ca. 1876. Collection of the Huntington Library, Art Collections and Gardens, San Marino, CA.

have given up, they found a section of rock that yielded $60 of ore per ton, enough to convince them to continue. Within weeks, the yields exploded to as much as $632 per ton—and suddenly Fair, Flood, Mackay, and O'Brien were the Bonanza Kings. Over the course of their lives, the Con Virginia and California produced $127 million. Watkins made seven pictures of the Con Virginia and California complex, more than he made of any other Comstock mine. One of them captures the steepness of the mountainside into which the Con Virginia had been built, with six smokestacks from two buildings anchoring the composition, pinning down the building. A fourth great Watkins picture shows a rare mill interior. Everything inside is perfectly still, as it had to be for Watkins to make the picture. Photographer had some clout.

From the Comstock, Watkins returned home the only way extant: over the Sierra Nevada by way of the Central Pacific Railroad. En route, Watkins made twenty-one mammoth-plate pictures and many stereos of the transcontinental as it passed over the Sierra and of property controlled by the Central Pacific's Big Four. While no records detailing a commission

Carleton Watkins, *Rounding Cape Horn, Central Pacific Railroad, Placer County, California*, ca. 1876. Collection of the Huntington Library, Art Collections and Gardens, San Marino, CA.

survive—the Central Pacific's records, like Watkins's, were destroyed by the 1906 earthquake and fire—the pictures themselves suggest a corporate commission. Many of these 1876 pictures of the railroad and adjacent landscapes are the uncredited source material used for illustrations in *The Pacific Tourist*, the CPRR's official guidebook.[28]

Watkins made those twenty-one mammoth-plate pictures at five Central Pacific sites: a passenger station in Reno, Nevada, where the Central Pacific met the Virginia & Truckee; Soda Springs, a Sierra camp-like resort built by Central Pacific associates Leland Stanford and Mark Hopkins (including Hopkins's strikingly tiny A-frame cabin); the landscape around Donner Summit, especially of Donner Lake; and two construction feats of which the railroad was justly proud, the outrageously steep curve around a Sierra mountain at (yet another) Cape Horn and a bridge over the American River known as the Secret Town trestle.

It's a strong suite of pictures. At Soda Springs, Watkins showed his sense of humor in a picture of a croquet game being played on dirt with all manner of trees and granite boulders in the way, and in a picture of three people

posing eccentrically under a gazebo that marks the site of the allegedly ther-apeutic mineral waters. At Cape Horn, the site of a famous view that writers routinely compared to the finest views in the Rockies, Watkins made pic-tures of a Central Pacific train stopped on the tracks as it came around a sharp bend, several thousand seemingly sheer feet above the American River. A few daredevils stood on the cars behind the locomotives, no doubt at Watkins's request. The picture of the trestle structure at Secret Town, complete with dozens of Chinese railroad workers filling the trestle in with crushed stone so as to stabilize it, is one of Watkins's most reproduced pic-tures. As we shall see in 1877, the Central Pacific appears to have been pleased with Watkins's work.

19

CREATING SEMI-TROPICAL CALIFORNIA

AS COLLIS HUNTINGTON SAT BEFORE THE U.S. Senate's Pacific Railroad Committee on January 31, 1878, he looked up at his investments. About half of the committee members were what Gilded Age business barons slyly called "friends," elected officials whose collegiality had been ensured with passes to ride the railroad for free, insider stock tips, and cash, thousands upon thousands of dollars of cash. In fact, just as Huntington was sitting before the committee, he and his chief lobbyist were in the process of making a new friend: committee member William Windom of Minnesota. Windom had long been allied with Huntington's major rivals, but, upon receiving a $1,500 payment from the Southern Pacific, Windom broke up with them and became a new friend of Huntington's company.[1]

Huntington was in Washington because the ten-year battle over a proposed new transcontinental railroad was approaching conclusion. Having firsthand knowledge of the difficulties of building half of the first transcontinental over the Sierra Nevada and later operating it, as early as 1868 Huntington and his partners realized that the difficulties caused by winter weather would someday give rise to a transcontinental route across the milder southern tier of the United States. That road would create competition that would put pricing pressure on the Central Pacific–Union Pacific

transcontinental—and might even become dominant.[2] Huntington was sitting before a Senate committee to argue that a Central Pacific–Union Pacific business rival, the Texas & Pacific, should not receive inducements to build the southern transcontinental. In the process, he would hint that he and his business partners, known as the Associates, should.

The story, which ultimately involves Carleton Watkins and his first trip into the Central Valley and Southern California, requires a decade's worth of brisk backstory. In preparation for battle with the inevitable proposal for a post–Civil War southern transcontinental, the Associates had defended their California turf. First, in the late 1860s, they established a geographic firewall by buying up nearly every railroad in California, a transportation monopoly that they hoped would prevent any other railroad company from building tracks to a port on the Pacific Ocean.[3] Among the companies the Associates bought was a paper road—a railroad that owned a state or federal charter but that hadn't actually built much or any of the road it was chartered to build—called the Southern Pacific. The Southern Pacific was chartered to build between San Jose, California, and the Colorado River, to a point on the map called Fort Yuma, a town of 331 people on the California-Arizona border.[4] The Associates' idea was to effectively force any southern transcontinental to terminate in Fort Yuma, and thus to fail to reach both California and the Pacific Ocean. That would turn any southern transcontinental into a feeder line that provided traffic and revenue for the Central Pacific–Southern Pacific system. With that plan and the Southern Pacific and its charter effectively in hand, the Associates adopted the name of the paper road for their entire company and began building the Southern Pacific's previously chartered road between Fort Yuma and San Jose. Instead of starting construction in San Jose, which would have meant building over the Diablo Range, the Associates started building the Southern Pacific in Lathrop, near Stockton, connecting the Southern Pacific with the Central Pacific; they built to Tres Pinos, near Hollister, and then stopped. Then, to claim its valuable land grants, the Southern Pacific promised it would build from Goshen, in the Central Valley, northwest to Tres Pinos and that this would be the main route (with a spur that would connect to the Central Pacific line at Lathrop). It never did this (and got the land anyway). From Goshen southward, the Southern Pacific would lay road through the lower portion of California's immense Central Valley, toward modern-day Bakers-

field, and eventually to Fort Yuma. Things went well until 1874, when the Associates reached a place southeast of Bakersfield that the Southern Pacific named Caliente. Here they ran into a problem: the Tehachapi Mountains, the desert range that forms the southern wall of the Central Valley.[5] Railroad engineers had been looking for a pass gentle enough to allow railroad traffic over and through the Tehachapis since 1866 and hadn't found a route with little-enough grade over which to run trains. For the time being, the Southern Pacific was stuck.[6] Locals were so sure that the road would have to leave its terminus there, in remote, mountainous Caliente, that a land rush sent the price of lots skyrocketing.[7]

Meanwhile, as the Southern Pacific was building toward Caliente, the long-feared proposal for a southern transcontinental finally advanced. The schemer was one of the most able and corrupt railroad executives of the Gilded Age: Tom Scott, long the first vice president and then the president of the powerhouse Pennsylvania Railroad, as well as the president of the Union Pacific, the Central Pacific's transcontinental partner. Scott's new company was the Texas & Pacific, an initially innocuous regional line chartered to build just forty miles of road, from Shreveport, Louisiana, to Marshall, Texas. From there Scott's plan was to make a beeline for El Paso, then build across the Southwest to Fort Yuma, where the Texas & Pacific would enter California on its way to the Pacific at San Diego. Scott also wanted to build a branch line that would run from Fort Yuma through Los Angeles and up to a Texas & Pacific co-terminus in San Francisco. This access to the Pacific was a big part of Scott's pitch to Congress: he promised that the Texas & Pacific would be a southern ocean-to-ocean road, a real rival to the Central Pacific–Union Pacific transcontinental, and that the competition would result in better prices for travelers and shippers. Scott's two-prong plan was everything the Associates had feared.

The Associates knew that the way to stop Scott was to develop railroad lines within California as well as arguments that would disincentivize Congress from giving the Texas & Pacific construction-enabling land grants and federally backed construction bonds, and then to make sure they had friends lined up against the Texas & Pacific. Thus began one of the greatest and most corrupt lobbying battles in American legislative history. Victory for Scott's Texas & Pacific would have meant land grants and construction bonds that would get the railroad across Texas, New Mexico, and Arizona,

into California, and across the state to the Pacific Ocean at both San Diego and San Francisco. For the Associates, victory initially would mean keeping the Texas & Pacific from crossing the Colorado River and entering California. Later on, the Southern Pacific's definition of victory would expand to keeping the Texas & Pacific as close to its northeast Texas origins as possible. Later still, victory would mean that the Associates themselves would build the southern transcontinental.

Over the course of the 1870s, the two sides battled. Scott, who knew the Washington game from his years with the Union Pacific and the Pennsylvania, began buying the Texas & Pacific its own set of friends. To push something as enormous and as expensive as a transcontinental railroad through Congress, Scott needed to do more than simply hand out cash; he had to create facts on the ground that supported his transcontinental dream. He would need to successfully build road westward across Texas, and he'd need ancillary material—newspaper support, letters to politicians from all manner of prominent figures, petitions, and whatnot—that would build and demonstrate support for the position he wanted his friends to take. Scott would also need a fundamental organizing message, a reason Congress could agree that the southern transcontinental was in the national interest. The message that Scott and his chief lobbyist, former Union general Grenville Dodge, developed was both logical and brilliant: the South deserved its own transcontinental, its own lifeline to the Pacific Ocean, and a railroad would be a post–Civil War economic balm for a struggling region. Furthermore, Scott's road would go not just through the South but through the part of California that had been substantially settled by Southerners and had been aligned with the South since the 1850s, Los Angeles. This was an argument designed to appeal to the Democratic Party, the party of Southern whites. Democrats controlled the House of Representatives. It seemed like a perfect plan.

"Scott is developing more strength for this Texas & Pacific than I thought it possible for him to do," a concerned Huntington wrote to one of his Southern Pacific executives midway through the fight. "He has men all over the country bringing influence to bear on the [members of Congress]. They have considerable money, as they have combined several parties that I thought we were sure of ourselves. I am doing all I can, but it is the liveliest fight I was ever in."[8]

Huntington and the Associates developed a two-prong strategy of their own. First, and most importantly, they would try to block Scott from building across the Colorado at Fort Yuma, thus preventing him from getting to San Diego, Los Angeles, or San Francisco. Next, the Associates would try to defang Scott's plans for a Pacific terminus by buying two small railroads in Los Angeles, roads that gave the Southern Pacific access to Santa Monica and San Pedro, the two best ports in Southern California outside San Diego.[9] This gave the Associates a key argument: why should Congress subsidize Scott's way to the Pacific when Scott could link the Texas & Pacific to the road the Southern Pacific was building to Fort Yuma, which would run from there to Pacific ports at San Pedro, Santa Monica, and San Francisco?

At the core of each Southern Pacific argument and strategy was keeping the Texas & Pacific out of California, restricting Scott to Fort Yuma. The Southern Pacific might not have a great argument for why Scott shouldn't build across Texas, New Mexico, and Arizona, but it could and would make a case that there was no reason for the nation to subsidize his way to the Pacific.

However, there was a problem with each of Huntington's arguments: his promised Southern Pacific line to Fort Yuma remained incomplete. The problem was the Tehachapis. Engineers had been looking for a way over them for almost a decade and hadn't found one. The Associates knew how important getting across the Tehachapis was, so they threw resources at finding an answer.

Finally, in 1875, at almost the last moment, a Southern Pacific engineer named William Hood devised a spectacular two-part solution that might get the SP over and through the Tehachapis and thus out of the Central Valley and into the San Fernando Valley, north of Los Angeles. First, Hood proposed to build track in an enormous loop at a spot in the Tehachapis southeast of Keene. This loop, which from above would look like a lasso, would rise at a steady 2 percent rate, thus making a key section of grade manageable. This loop would include a system of tunnels that would require a train to double over itself as it moved through the loop, essentially meaning that a train's locomotive would cross over its own tail as it ascended. Then, because it was still not possible to find a pass *over* the summit of the Tehachapis, Hood designed a further series of tunnels through the Tehachapis that would exit into the San Fernando Valley. Hood's plan required both corpo-

rate faith in a wild new idea, the loop, and the corporate resources necessary to blast seventeen tunnels of a combined three miles in length through a mountain range. One of Hood's tunnels would be seven thousand feet long, the second-longest tunnel ever built in America. The entire Hood plan would require six hundred kegs of dynamite powder, three thousand workers, and well over $4.7 million.[10] The Southern Pacific was thrilled. Despite the evident challenges, the Associates told Hood to get started immediately. The project was so important that Associate Charles Crocker, a man accustomed to Nob Hill luxury, moved to the construction site in the Tehachapis to supervise it.[11] If Hood could construct his loop and tunnels without a hitch, it would be one of the greatest engineering accomplishments of the era. Hood pulled it off.

Throughout the end of 1875 and early 1876, Huntington, eager to find out how much longer it would take to finish the Tehachapi Loop and the seven-thousand-foot San Fernando Tunnel, peppered his colleagues with letters. The heat was on: Scott had pushed a favorable bill through a House committee, and it had cost Huntington $5,000 to delay the vote on the bill just enough for the full House not to vote on it before a recess.[12] In July 1876, Huntington received news that the Loop was done. Two months later, the San Fernando Tunnel was too. Huntington began to spread the word around Washington.

We don't know how news of the completion of the Tehachapi Loop and the San Fernando Tunnel was received in Congress, but members must have been skeptical. Railroads had a well-earned reputation for shoddy construction and for claiming that said construction was more complete and of higher quality than it actually was. This was a by-product of the system by which railroads received land grants. The railroads didn't receive their grants, which they would sell off for needed cash, until roads were constructed. The law did not require—not exactly—that the roads be constructed well. Sometimes a newly constructed road was built so badly that trains couldn't run on it. Given the ongoing lobbying battle, Congress also knew the Southern Pacific was certainly incentivized to, er, oversell its engineering and construction accomplishments. After all, the Associates who now ran the Southern Pacific had done this exact thing in building the transcontinental and had been forced to rebuild sections of that road.[13] Furthermore, while the Southern Pacific filled friendly newspapers with accounts of

Carleton Watkins, *The [Tehachapi] Loop, Southern Pacific Railroad, Kern County, California,* 1877. Collection of the J. Paul Getty Museum, Los Angeles.

their Tehachapi and San Fernando successes, word no doubt reached the East that the new line into Southern California was almost entirely unused: the daily "express train" between the Southland and San Francisco required thirty-three hours of travel and usually consisted of no more than a baggage or mail car and a half-empty passenger car. The Southern Pacific also ran an even slower regular train between Northern and Southern California. The only passengers on it typically rode not in a passenger car but in the caboose.[14] News of the Southern Pacific's engineering accomplishment had the whiff of fiction.

The best way to demonstrate that a thing had been done was to show it. Enter Carleton Watkins. Shortly after Watkins returned from his late 1876 trip, the Southern Pacific appears to have hired him and sent him south, toward what it dubbed "semi-tropical California." The pictures Watkins made along the Southern Pacific line in early 1877 suggest his presumed brief: show the accomplishments at Tehachapi and San Fernando, photograph the infrastructure the Southern Pacific had purchased in the Los Angeles area, and provide visual evidence that the Southern Pacific was, in fact,

building across the vast Mojave Desert toward Fort Yuma.[15] As usual, no surviving written evidence documents this instruction, but Watkins's pictures align with the arguments the Southern Pacific was making in an effort to counter and end the Texas & Pacific threat.

For Watkins the 1876 trip was importantly resuscitative, but it was the 1877 trip that instigated a reorientation of his career from San Francisco, Yosemite, and points north to the southern half of the state. From now until the end of his career in the early 1890s, most of his work would involve Southern Pacific interests and agricultural developments that had a symbiotic relationship with the railroad.[16] The new region would expose Watkins to new pictorial challenges, new landscapes, new subjects, and new ways of working. His work in Kern County, in the southern tip of the Central Valley, and in Southern California is far less well-known than his work in Yosemite, at Mount Shasta, or in Oregon, but it's every bit as good and at least as important to the development of the West and its relationship with the rest of the United States. For now, the Texas & Pacific vs. Southern Pacific lobbying skirmish would become one of the most important events in California and western history; it would lead to and ultimately enable the West's transition from a mining region whose economy was built around the extraction of natural resources to a region focused on agribusiness. Watkins played a key role in all this.

Watkins started his work at the Tehachapi Loop, where he made at least ten mammoth-plate pictures: seven of the Loop and its tunnels, and three related pictures of a Southern Pacific work camp, a small railroad bridge, and the townlet of Keene.[17] The pictures suggest that it took Watkins a while to figure out how to show the Tehachapi Loop, and that he wasn't sure whether the thin ribbon of rails would stand out on a print in the midst of scratchy desert scrubscape. (Watkins also tried making a few stereographs of the Loop before giving up on that idea.) He took a two-part panorama of the entire Loop, a side view, a few tunnel views, and a distant view from a hillside about five hundred yards away—a single mammoth that captures the entire Loop. The best picture is this last one; it is also the picture Watkins had to work the hardest to make. To get it, he lugged his equipment up about three hundred feet of extremely steep, soft, shifty-soiled hillside, a process that would have required multiple trips. Once atop the hill, Watkins selected a site at which a fringe of stone jutted five to ten feet out

of the ground at an angle he used to make it look like the stone was pointing at the tiny, hard-to-see Loop off in the distance, a trick that had worked for him before when he used a Washington Territory tree stump to point at distant, faint Mount Hood. Watkins also used an oak tree in the center foreground to point at the Loop. Later, in the studio, he became concerned that the Loop was still hard to see on a mammoth print, so he drew or etched a dotted line to make it clear. The result is a picture that perfectly demonstrates the full measure of the achievement, what the *Daily Alta California* described as an engineering feat that "looks like a coil thrown carelessly in a rope,"[18] while still making the road's run look flat enough to be attractive to investors and Congress. (In 1876 everyone knew that flat track was much less expensive to operate than track with a steep grade.) Here, at the beginning of what would be a nearly fifteen-year engagement with the southern half of California, Watkins was learning that new landscapes, especially vast open areas that were sometimes mountains and sometimes not, would require new compositional solutions, that he'd have to use old tricks and devise new ones.

Before leaving, Watkins also made two pictures of the soon-to-be famous spot on the Loop where it is still possible to stand and see a train cross over itself.[19] "I know of nothing like it, unless it be the road over the Styrian Alps from Vienna to Trieste," scientist George Davidson told *The Pacific Tourist*, the official guidebook to Southern Pacific roads. "Even there, if I remember rightly the track does not literally cross itself."[20] (The railroad did not require that Watkins make his pictures available only to its guidebooks. His pictures from this trip were made into engravings by many guidebook publishers.)[21]

From the Loop, Watkins followed the Southern Pacific road into the westernmost arm of the Mojave Desert, making pictures of a yucca tree (which he promptly sent to Asa Gray at Harvard); of a mill that turned yucca into paper pulp that the mill hoped would be used in making paper money; and of oil wells and facilities owned by the Star Oil Co., the first oil concern in the state. Ironically, in dispatches to the press and in their own guidebook, the Southern Pacific talked up the potential of the yucca mill and left out the oil wells, which would later drive much of Southern California's economic growth.[22]

Watkins left the Mojave via the Southern Pacific's San Fernando Tunnel,

the seven-thousand-foot behemoth of which Huntington was rightly proud. He made mammoths of the entrance and exit of the tunnel, each of which shows track vanishing, seemingly impossibly, into the middle of a mountain. His stereographs of the tunnel made plain just how rough was the rock through which the railroad had blasted.

The Southern Pacific didn't seem to think much of the San Fernando Valley, except as a place through which it must travel, at least not yet. The next Southland site of interest to the Southern Pacific, both in terms of its future growth and in terms of the congressional fight with the Texas & Pacific, was Los Angeles, then a minor outpost about the same size as Stockton. As part of its creation of a California-wide firewall against the Texas & Pacific threat, the Southern Pacific had bought those two Los Angeles railroads: the Los Angeles & San Pedro, which ran from downtown to a harbor at Wilmington, near modern-day Long Beach, and the Los Angeles & Independence, which ran to the ocean at Santa Monica and which had been owned by Nevada Sen. John P. Jones. Watkins made a picture related to each purchase. He passed on photographing the Los Angeles & San Pedro's unimpressive, shedlike depot, instead making a picture of the lighthouse on Point Fermin, above Wilmington's harbor. There's no sign of a port here, just beauty as metaphor for potential. Back downtown, Watkins made a terrific architectural picture of the Los Angeles & Independence depot, itself a small, single-story shed that had been tarted up into significance by two gingerbread-style three-story towers. Watkins posed a locomotive out front and used the shadow of a building across the street to give the whitewashed depot even more pop.[23]

The final mammoth-plate picture Watkins took that was important to Huntington's arguments regarding the Texas & Pacific was well to the east, out in the southeastern Mojave Desert. It showed the extreme eastern end of the Southern Pacific line as it existed on the day Watkins was there. Men sat on ties at the left of the section of road they'd just finished, their tents to the right. In the distance, a viewer can see stacks of ties waiting for the road to be continued. It's easy to imagine Huntington or his lobbyists showing this picture around Washington as proof that the thing was being done by the Southern Pacific even as the Southern Pacific charged that Scott and the Texas & Pacific weren't doing much at all.

Watkins's pictures demonstrated the industriousness, intent, and engineering successes that Huntington had told Congress about, and he'd made

track built through what was once considered impossibly steep terrain look so well engineered that it didn't seem to require a steep grade. Were Watkins's pictures decisive? Gilded Age lobbying battles were not linear. No single factor seems to have been decisive in any of them, including in the Southern Pacific–Texas & Pacific battle. Did Watkins's pictures at least prevent a Southern Pacific defeat? Maybe. In the months after Watkins's 1877 Tehachapi and San Fernando pictures were used, the Southern Pacific got what it wanted: Congress did not approve the combination of bonds and land grants the Texas & Pacific needed. Then, in late 1878, Scott fell ill. The Southern Pacific treated his illness as an opportunity. It pursued railroad charters from the territorial governments of New Mexico and Arizona. It bought up small railroad lines across Louisiana and Texas and began to build the southern transcontinental itself. As the Southern Pacific advanced, Scott's legislative friends, men who wanted a southern transcontinental more than they cared who built it, began to abandon him. In March 1879, Congress held one last vote on the Texas & Pacific. The Southern Pacific paid $125 to each member who voted its way, and won. The Texas & Pacific withered.[24] Watkins's friends at the Southern Pacific would own California for decades hence.

The Southern Pacific's enormous victory over its rival significantly affected, almost enabled, Watkins's post-Ralston career. More than any other single factor, the railroad's push into and across Southern California led it to open up the intermediate Central Valley, from Stockton to the Tehachapis, for agricultural investment and development, and fueled and enabled the rapid growth of agriculture in the central and southern parts of the state. For the rest of Watkins's career, those two regions would transform California's economy, shifting it from mining and timber extraction toward agriculture. California's new industries would be more important to Watkins's career than mining ever had been. In time, so too would be another industry that Watkins had helped create back in the 1860s: tourism. What, besides the landscape, would Californians want to visit?

20

SHOWING CALIFORNIA ITS HISTORY

O N A PLEASANT AUTUMN DAY IN 1879, a twenty-nine-year-old British writer visiting the eighteenth-century Spanish colonial capital of Monterey took a day trip to nearby Carmel. The onetime Spanish mission church there was hosting the annual feast day of San Carlos Borromeo, an Italian Counter-Reformation cardinal who founded seminaries and colleges for the education of priests, fed Milan when plague decimated the city and its economy, and was a supporter of the arts.

The writer tolerated the merrymaking—the indiscriminate shooting off of rifles startled him, and a determined drummer traveling around the feast site in a wagon drove him to distraction—but he loved the *carne asada en las brasas*, the coal-roasted meats that the church's priest insisted he try, and the local wine too. "Here was an old mediaeval civilization, and your old primeval barbarian, hand-in-hand, the one devoutly following the other," he wrote in the *Monterey Californian*, the local paper. "And I could not help thinking that if there had been more priests and fewer land sharks and Indian agents, there would have been happier days for a considerable number of human bipeds in your American continent."

The traveling writer especially loved the "fine old church" that barely

contained the day's festivities. Sadly, he noted, the hundred-year-old mission was in an advanced state of decay: the main building was roofless, and the supporting structures were crumbling. He tried to rouse the Californians to act before it was too late. "In England, some great noble or cotton spinner would purchase it, repair it and charge so much entry money to curious visitors," he wrote in the *Californian*. "In France, still better, the government would take it in hand and make it one of the 'Historical Monuments' of the nation."[1]

The writer was Robert Louis Stevenson. His trip to Monterey and Carmel was part of a California tour he took the year before he returned to England, where he would invent Dr. Jekyll, Mr. Hyde, and Long John Silver and become one of the greatest British writers of the century. Historians have often begun stories of California's rediscovery of its Spanish and Mexican past with three publishing events: Stevenson's 1879 letter to the *Monterey Californian*, in which he beseeches Golden Staters to care for and restore the century-old missions, Stevenson's similar urgings in *Across the Plains*, his 1892 travelogue of his American travels, which extends the argument, and Helen Hunt Jackson's 1884 novel *Ramona*, the story of a mixed-race, Scots and Native American orphan girl growing up in romanticized Mexican California, complete with a dewy portrayal of the missions and the imperialist Franciscans who ran them.[2]

Actually, California's embrace of the Spanish colonial past as its own began before all that, with Carleton Watkins. In 1877, while on his way home from the Southern Pacific–backed trip to the Tehachapi Loop, Los Angeles, and the San Gabriel Valley, Watkins began a multiyear series of pictures of the California missions. He would make at least forty-one mammoth-plate pictures and over five dozen stereographs of thirteen of California's twenty-one missions, as well as of Mission San Xavier del Bac near Tucson in Arizona Territory. These pictures were mostly made over the course of two trips, in 1877 and 1880. (Watkins made a picture of Mission Santa Clara de Asís much earlier in his career and, inexplicably, made mammoth-plate pictures of daguerreotypes of San Francisco's Mission Dolores and Fremont's Mission San Jose rather than making new mammoth plates of them.) Watkins's mission pictures instigated the West's interest in its pre-American past and artists' reengagement with the actual missions and mission lands

themselves (as opposed to the idealized fantasy of mission life that a couple of illustrators had tentatively published in the preceding years), a key development in the emergence of western culture.

Historians Edna E. Kimbro and Julia G. Costello have called California's Spanish colonial–era missions the state's "oldest and richest historical legacy."[3] While European contact with California's native populations dates back to the fifteenth century, the Spanish mission project did not begin until 1769. Spanish authorities, concerned about Russian and English presence along the North American Pacific coast, sent land and sea expeditions into California in an effort to solidify their claim to the region. These parties met up in San Diego in July 1769. A Franciscan priest named Junipero Serra marked Spanish preeminence by raising a crude Christian cross on a hillside and founded Mission San Diego de Alcalá, the first Spanish mission in California.[4]

The Spanish plan was Colonialism 101: control native populations (an imperative eased by decades of disease that had reduced and weakened them), settle the land, develop self-sustaining communities that could hold the territory for the crown, and convert California's indigenous people to Catholicism. The Spanish built three state institutions across California: presidios, or forts, the descendants of which survive today in San Francisco and Monterey; pueblos, or towns, made up of nonmilitary, nonclerical civilians; and churches. Each unit supported the others: for example, each presidio was backed by five to eight missions that provided spiritual instruction and support as well as crops and livestock from mission agricultural lands.

From San Diego, the Spanish established a presidio at Monterey, which would also become the colonial capital of California. Serra initially followed but soon decided to separate his churchmen from the soldiers. He traveled five miles south to modern-day Carmel, where he found more fertile farmland and better access to fresh water than in Monterey, and established what is today considered the second mission, San Carlos Borromeo. Serra made Carmel his administrative headquarters, the mission from which he guided the building of other missions.

Over several decades, the first mud- and tule-built mission buildings up and down Alta California were replaced with buildings of timber, adobe, and stone. The Spanish and the natives, who were semiforcibly converted in

increasing numbers, often jointly expanded outbuildings, built farms that grew crops such as grapes and grain, and developed ranchos that raised sheep, goats, pigs, cattle, and horses. These increasingly complex operations soon required additional infrastructure, such as the waterworks built at San Diego de Alcalá and Mission Santa Barbara. (These two waterworks were so well-built that they outlived the missions.) Some of the missions were huge and thriving: Mission San Luis Rey de Francia had been one of the last missions to be founded (in 1798), but thirty years later, it was the largest, complete with three thousand indigenous people employed as farmers, ranchers, carpenters, masons, shoemakers, and weavers. While for the Spanish the missions were not without their material successes, native peoples experienced extraordinary upheaval. The padres relocated native families without their consent, imposed their faith, sexual, and agricultural systems upon them, and effectively eliminated their knowledge of the land, their own crops, and other cultural practices. Native peoples responded to colonial pressure by blending Spanish practices with their own whenever possible. Still, what the Spaniards wanted was what the Spaniards got. Natives who resisted too strenuously or pointedly were punished with lashings, being placed in stocks, or being forced to drag weights in the fields.

After San Diego, the Spanish built twenty more missions in California. In some ways, because of their survival and ultimately their preservation, they are the most significant monuments of European contact with any Native American populations. They are among the few places in the United States where it is possible to see the buildings and landscapes in which Europeans and natives mixed, worked, and prayed, and to visualize how the natives and the Europeans informed each other's architecture and landscape and in so doing developed a distinct culture that was neither Spanish nor native. (Among the earliest to recognize this were Jessie Benton Frémont and her husband, John, whose house at Las Mariposas was modeled after mission-era architecture.)[5] Watkins embedded these ideas within his mission series.

At the conclusion of the Mexican-American War in 1848, the United States took possession of California. The newest Californians divvied up the state's land, but as most of the state's economic activity was in and around the mines and as most of its cultural activity was in one city, San Francisco, the missions continued to erode. In 1863 Bret Harte—who, like Watkins,

had been a regular at Jessie Benton Frémont's Black Point salon—was hardly alone in finding San Francisco's mission run down, a place where "ragged senility contrasted with the smart spring sunshine."[6] It was in this condition that Watkins found the missions.

For the missions project, Watkins would have to give up the luxury and convenience of his custom railcar for hundreds of miles of the worst dusty, rough, remote wagon roads in the state. Robert Louis Stevenson would have sympathized. He wrote that the wagon roads that joined San Francisco with the coast ranges and the Southland "would be an extravagant farce in the country from which I came."[7] As a result, this would have been an exhausting work trip for a man in his twenties; Watkins was now forty-eight. This was something he wanted to do, and badly.

Watkins evidently started where Junipero Serra had, with Mission San Diego de Alcalá.[8] We don't know if Watkins anticipated the condition in which he would find it, but it would have been clear from quite a distance that the hilltop mission, abandoned at some point during Mexico's secularization process in the 1830s, was a ruin. It posed a pictorial challenge: Focus on the decay? The landscape? Show the decay up close or within a landscape context? Watkins seems to have been unsure. As was often the case when he approached a new subject in a new place, he started by circumnavigating the surviving structure, making pictures all the way. His first four mammoth-plate mission pictures feel like tentative explorations. In one picture, he's close enough to the ruins that we can see the buttresses the Spanish built in 1811 to address roof-cracking issues. (By now, these buttresses and the adobe church building were all that had survived.) His best picture at Mission San Diego was of the mission's olive and date orchard, which, despite having been abandoned decades earlier, was still doing well. (This was probably due to infrastructure that still brought water from the San Diego River to the property.)[9] Could this picture have helped him begin to figure out the missions series? Watkins would have known that palm trees, especially date palms, were ancient symbols of immortality, a symbol common to many faith traditions. Perhaps the surviving, thriving palms at San Diego de Alcalá helped Watkins think of the missions as survivors in a hostile land (especially as one other mission picture, a view of Mission San Gabriel Arcangel, in Los Angeles, also includes a dramatic palm).

Carleton Watkins, *Olive and Palm Orchard, Mission San Diego de Alcalá, San Diego County, California,* ca. 1877. Collection of the Huntington Library, Art Collections and Gardens, San Marino, CA.

When Watkins left San Diego for Mission San Luis Rey de Francia, he may have known that he was still figuring out this new subject but that maybe he had a lead. He had a forty-mile ride over a dusty wagon road to think about it. On the way, he stopped at a place he knew as La Joli and what we call La Jolla, a small town on the coast. He made fourteen stereographs of the same sort of coastal rock formations he'd photographed in Mendocino and San Francisco but apparently made no mammoth plates. (Or he made some and they broke on the rough coastal roads.)

Mission San Luis Rey was the perfect place for Watkins to finish solving the pictorial issues with which he'd struggled at San Diego de Alcalá. Instead of getting close-up to the surviving buildings, as he had at San Diego de Alcalá, Watkins would make pictures from a pronounced distance and would set any surviving structures against the emptiness of the surrounding place, a folding of history into landscape. Sometimes he would include people, sometimes he wouldn't. By emphasizing landscape, Watkins granted the missions a certain unlikely monumentality that would be the key to the series. Remarkably, while a parade of photographers would follow Watkins

to the missions, including contemporary luminaries such as William Henry Jackson, not a single one of them seems to have caught on to Watkins's distinguishing concept (or perhaps they were unanimously differentiating their work from his).

The second new idea Watkins explored at San Luis Rey was posing people between his camera and the mission. For years, Watkins had posed people within pictures he made for clients, pictures of mills, banks, or other places of business. For just as many years, Watkins had refused to allow people to intrude on his landscapes. No doubt he knew that this absence made his pictures distinctive: American painters and even most photographers had long adapted the Claudean formula of landscape as stage set for human interaction, typically by placing people in the foreground of an artwork. In a Watkins picture, as in the West, the land had always been enough. At San Luis Rey, Watkins broke with nearly twenty years of practice and included people. In each picture the foreground, fully half the frame, is empty, dusty desert, while the top half is sky. Watkins placed the mission itself in the middle distance, almost exactly halfway between earth and heaven. (You could say that the mission church bridged earth and heaven, but that might be pushing it a bit: Watkins was not religious, and in many mission pictures, he fails to extend the metaphor.) In each of two pictures at San Luis Rey, Watkins positioned two children and two adults, putting them with their backs to the camera, a few dozen yards from the mission church, looking up at it. The only difference between the two pictures was that in one of them, Watkins set up a little closer to the mission church. This is no Claudean composition, no landscape as stage; this is a family interacting with the land and with a monument, a distinctly different thing with little precedent in the American response to the European tradition.

At San Luis Rey, Watkins had also found a way to make the missions simultaneously present and historical. Before Watkins, two artists had made illustrations more *about* the missions than *of* them. In the late 1850s, an obscure illustrator named Henry Miller visited nineteen of the twenty-one missions, making pencil sketches as he went along.[10] Miller offered a nearly cartoonish golden-era ideal of mission life, as would the next artist to become interested in the missions, Bavarian Californian Edward Vischer, who made a series of fantastical watercolors that expanded upon Miller's imaginations.[11] For both Miller and Vischer, the missions were less actual places

than stage-set-like backgrounds for preposterous colonialist tableaus, expressing a nostalgia for conditions that never existed. Their work didn't catch on.

Watkins rejected their approach. Instead he celebrated the way the missions were now. He emphasized the stark beauty of what remained. By so doing, Watkins's mission pictures, no doubt planned during the national centennial celebrations of 1876, were a kind of throat clearing: *look here, California has a historical past just as much as any other part of America.* The nation's founding document, the Declaration of Independence, was written in 1776. The founding of San Diego de Alcalá predated that by seven years!

Speaking of 1776, the Spanish built two missions that year: Mission Dolores in San Francisco and Mission San Juan Capistrano. After a thirty-mile wagon ride up the coast road, San Juan Capistrano would be Watkins's next stop. Like San Luis Rey, San Juan Capistrano was one of the most successful missions. In 1811, for example, the San Juan Capistrano fields grew over fifteen thousand bushels of wheat, corn, barley, and beans.[12] Its church, designed in Mexico and built by master mason Isidro Aguilar, was 180 feet long and 40 feet wide, a stunning monument that took nine years to build. Alas, just six years after it was completed, a massive earthquake hit the Southland coast, destroying the stone-built church and killing forty people. The community left the remaining church walls standing and reoccupied the first church that had been on the site, a temporary adobe structure. When the mission was abandoned under Mexican rule, new local communities plundered the site for building material. By the time Watkins arrived, forty-five years after secularization, the ruins of the stone church were just about all that was left. Watkins made three and possibly four mammoths here, including pedestrian pictures of the entire site and a magnificent picture of what remained of a cross section of the church.[13] The San Juan Capistrano pictures are among the few Watkinses that leave us wondering if photography's short history may have informed his ideas—in this case, the pictures of abandoned churches made by Roger Fenton in England in the mid-1850s. Could he have known them?

Santa Barbara is the only mission that the Franciscans never left. When Watkins went there in 1877, a boys' school was still on the site, monks still walked the grounds and welcomed visitors, and the entrance to the mission

church was still flanked with two paintings-as-warnings: one of purgatory, another of the inferno, in which squirming victims were tortured for not doing more with their ill-spent lives. Watkins would have known that the surrounding town, also called Santa Barbara, was developing a tourism industry that attracted well-off San Franciscans and Sacramentoans who had sailed down the coast for a long weekend.[14] More than the Carmel mission that Robert Louis Stevenson would later help make famous, Mission Santa Barbara was unusually well poised to be in the vanguard of the nineteenth-century mission revival.

While at previous mission sites Watkins had found empty landscapes and abandoned buildings, Santa Barbara was something else entirely. Here the mission was surrounded by tilled fields, lush olive trees, gardens, and an advanced water system (which remains in use today as part of the city's municipal water system), all of it making the mission a small town within a small town. The four mammoth plates Watkins made at Santa Barbara are among his best pictures and have determined how Santa Barbara, the Queen of the Missions, has been seen ever since. Take the picture Watkins made from east of the mission. He climbed a steep hill up to the mission's waterworks and made a kind of three-quarters aerial view looking down on the white mission church, its cemetery, and a dozen or so surrounding farm buildings. Grassy, rolling, oak-strewn hills behind the mission seem to push it up toward Watkins's hillside, which is defined by a scrubby, rocky foreground. It's easy to see why the Spanish fathers chose this site: the mission is on a rare flat spot of earth between the Santa Ynez Mountains and rolling hillside. Doubtless they hoped that the surrounding fields would be agriculturally productive (they weren't) and realized that it would be relatively straightforward to deliver water to the mission from what is now called Mission Creek, in the hills behind where Watkins stood.

Another of Watkins's Mission Santa Barbara pictures features a seemingly mundane feature that was, in its time, notably unusual. The Santa Barbara mission fathers had been so proud of their water system that they even put a fountain, from which drinking water was freely available, right in front of the mission. Even though the transport of water was important to almost every mission, apparently this was the only public fountain in the entire mission system. Today it is considered among the most beautiful examples of mission stonework. (The mission's water features, both the fountain and the

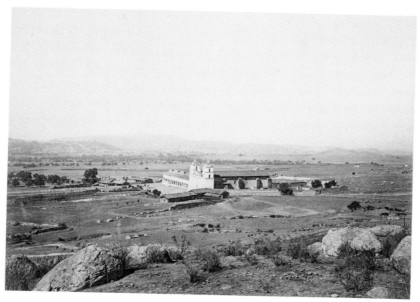

Carleton Watkins, *Mission Santa Barbara, Santa Barbara County, California,* ca. 1877. Collection of the Huntington Library, Art Collections and Gardens, San Marino, CA.

infrastructure that fed it, were so unusual that they were themselves a nine-teenth-century tourist attraction.)[15] Watkins made a striking picture from in front of the mission that is bisected diagonally: the white front of the mission church and arched accompanying building fill the upper triangle, while the stone fountain sits in the lower half. When fashionable New York–based American impressionist Edward Potthast painted the mission early in the twentieth century, he substantially remade this picture. When William Keith went to Santa Barbara on his honeymoon, he made a beeline for the exact spot on the hill, adjacent to the waterworks, from which Watkins had looked down on the mission and painted it. When the Detroit Publishing Co., a lead-ing early-twentieth-century commercial photography publisher, needed a picture of Santa Barbara, it duplicated Watkins's view too.

From Santa Barbara, Watkins continued up the coast to Mission Santa Inés in modern-day Solvang, where he took two mammoths, and then stayed east of the coast mountains as he traveled up to Mission San Luis Obispo and Mission San Miguel Arcangel. At both San Miguel Arcangel and San Luis Obispo, Watkins took significant pictures of the surrounding central Cali-

fornia landscape. They are rarities within both the mission series, whose pictures almost always include mission buildings, but also in Watkins's wider oeuvre, which is thin on central California pictures. *View from Mission San Miguel* is anchored by a spectacularly damaged oak tree on the right and a field of golden grass running down toward the wagon road in the distance. At Mission San Luis Obispo, Watkins took a picture of the landscape behind and west of the mission. The twin attractions are known today as Bishop's Peak and Cerro San Luis Obispo, two of nine nearby volcanic plugs in a chain now known as the Nine Sisters. We don't know if Watkins, by now well versed in geology, recognized this.

While it's hard to know when Watkins's 1877 mission pictures give way to his continuation of the series in 1880, this would seem to be about the point at which Watkins headed home. We don't know why he waited three years to pick it back up. Perhaps post-Ralston, Watkins was busy getting his business affairs in order. Perhaps the business imperative of stocking a new gallery with Yosemite pictures—as we'll soon see, Watkins would go back to the valley several times starting in 1878—took precedence. Maybe both.

In 1880, on the tail end of a trip to the San Gabriel Valley and Arizona Territory, Watkins would resume the series. His two so-so pictures of Mission San Antonio de Padua most likely date to 1880, as do his pictures of the mission Stevenson had visited the year before: Mission San Carlos Borromeo de Carmelo, outside Carmel. Watkins made two pictures at Carmel. One was much copied: a close-in view that emphasized the grandeur of the mission-church entrance and bell tower and the decrepitude of its roof, the same roof that prompted Stevenson to urge preservation. The other—a distant view of the mission with sparse grassland in the foreground and rolling hills and Monterey Bay plainly visible in the background through a foggy or misty gloaming, and with crumbling outbuildings everywhere else—is one of his best. Among the picture's clevernesses is the way Watkins has composed it with a decaying wooden fence undulating across nearly the entire picture. Against the wavy line offered by the fence and the landscape itself, Watkins has perched the mission. The composition gives the mission, a precarious but not quite crumbling structure, both weight and solidity, a hint of a future. Here Watkins seems to have mined the technique he discovered at Mission San Luis Rey: place the mission in the context of the landscape and allow the viewer to see the fragility of the mission enterprise,

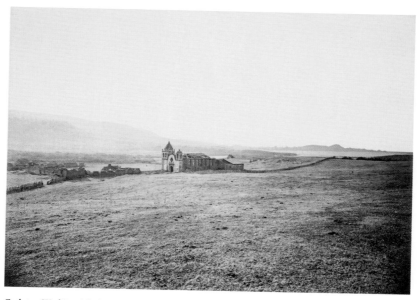

Carleton Watkins, *Mission San Carlos Borroméo de Carmelo, Monterey County, California*, ca. 1880.
Collection of the Huntington Library, Art Collections and Gardens, San Marino, CA.

the harshness of the land in which the Spanish had tried to build an alternative to native civilizations.

The picture seems the pictorial realization of Stevenson's 1879 description: "The valley drained by the river so named is a true Californian valley, bare, dotted with chaparral, overlooked by quaint, unfinished hills. The Carmel [River] runs by many pleasant farms, a clear and shallow river . . . and at last, as it is falling towards a quicksand and the great Pacific, passes a ruined mission on a hill. From the mission church the eye embraces a great field of ocean, and the ear is filled with a continuous sound of distant breakers on the shore . . . The church is roofless and ruinous, sea-breezes and sea-fogs and the alternation of the rain and sunshine, daily widening the breaches and casting the crockets from the wall."[16]

After photographing in Monterey County, Watkins would dip back into the missions from time to time but never photographed all of them. By now he was fifty-one. The wagon roads over which Watkins had to travel to reach the missions were degenerating, their quality in particular contrast to the railroads that he could take almost everywhere else in the West. The mis-

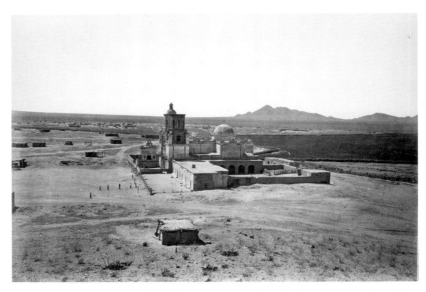

Carleton Watkins, *Mission San Xavier del Bac, near Tucson, Arizona Territory,* 1880. Collection of the
Huntington Library, Art Collections and Gardens, San Marino, CA.

sions he would never photograph were Mission San Rafael, Mission Santa
Cruz, Mission Nuestra Señora de la Soledad, and Mission La Purisima
Concepcion.

Also in 1880, while on a trip through Arizona Territory, Watkins made
four pictures of a Spanish colonial mission, San Xavier del Bac, nine miles
south of the territorial capital of Tucson. We don't know why Watkins was
in Arizona—historian Christine Hult-Lewis thinks that the pictures Watkins
made there of mining facilities, trees, cacti, and views related to the recently
built railroad were commissioned by the Southern Pacific,[17] but Watkins
may also have been recruited to Arizona by his old friend John C. Frémont,
who was then the territorial governor. Watkins may have considered San
Xavier del Bac within the context of the Spanish project in California, as
many guidebooks in the ensuing years would lump San Xavier together with
the California missions as a tourist destination.

Today San Xavier del Bac is considered the finest work of Spanish colo-
nial architecture in the United States. The mission was established by
Franciscan father Eusebio Kino in 1692 on a site convenient to both natural
springs and the Santa Cruz River (which no longer flows year-round). Kino

guided the construction of a mission church that opened in 1700; it was destroyed in an Apache raid in 1770 and replaced between 1783 and 1792 by the building Watkins photographed in 1880. Designed by Ignacio Gaona, it was built by Tohono O'odham workers. (The Tohono O'odham are Native Americans who were seasonal farmers; their presence made San Xavier del Bac's siting convenient, at least.) Thanks to, and sometimes in spite of, extensive restorations, the building still stands.

When Watkins was there, the mission had been abandoned, and a booklet published by the territorial government referred to it as a "crumbling ruin."[18] Watkins's pictures treat it with considerably more dignity. Watkins made at least four mammoth plates of San Xavier del Bac and as many stereos.[19] The pictures present the mission complex, complete with several adobe walls and outbuildings, as somewhat more intact than contemporary accounts suggest. He even took a picture of the mission's interior, the only picture of its kind in the series. For one of the pictures, Watkins climbed a hill to get a picture of the mission and five people, probably Tohono O'odhams, in the foreground. A field, which appears to have been recently plowed, fills a large section of the picture behind the mission. Arizona Territory may have considered the site abandoned, but Watkins's pictures testify otherwise. Watkins seems to have come a long way from Mendocino in 1863, when he participated in dehumanizing Native Americans.

Few Watkins series of works are as difficult to assess as successes or failures than the missions project. Using surviving prints as a barometer of market appeal is chancy, but they seem not to have sold well—only a small number of works survive today, and there are only three known complete sets.[20] Maybe Watkins didn't sell complete sets because he never finished the series, maybe there wasn't enough demand to finish it—we just don't know.

Certainly the mission pictures influenced other artists in the West. William Keith wasn't the only artist who followed in Watkins's wagon ruts. Nationally known illustrator Henry Chapman Ford, who studied in Paris and Florence before the Civil War, made the best-known nineteenth-century mission artworks, a portfolio of etchings published by New York's Studio Press in 1883. Ford had good timing—his etchings came available just as Helen Hunt Jackson's novel *Ramona* was published—and good source material: Watkins's pictures. While Ford surely traveled to some missions, ten of

his twenty-four images are either sourced in or copies of Watkins's pictures. Ford credited Watkins as a source, and he singled out Watkins images of two missions that Watkins is not known to have included in the series, Dolores and Santa Clara.[21] Today Ford's etchings don't look like much, but they were popular in mid-1880s California.

Other photographers rushed in to make mission pictures in the 1880s: S. L. Walkley, W. B. Tyler, and photographers affiliated with the Jarvis firm in Pasadena all made albums of mission pictures a decade after Watkins did.[22] Watkins's mission pictures may have sold well enough to motivate other artists and photographers.

Pictorially, the missions project marks the point in Watkins's career in which he pivots away from mostly making pictures of scenic, often vertically dramatic landscapes. Watkins built his galleries on the West's magnificence, on Yosemite and the Columbia River Gorge, on glaciers, San Francisco, and the California coast. While photographing California's missions, Watkins learned how to make pictures in visually challenging, often flat landscapes, places that didn't well serve available picture-making technology. He seems to have realized the new challenge right away—the San Diego de Alcalá pictures are a rare opportunity to watch Watkins try to solve a visual conundrum—and experimented until he found a solution. His newfound comfort in working in California's flatter and most vast spaces would be important in the coming years, especially in Kern County, where Watkins would make his last great work.

21

ENTER WILLIAM H. LAWRENCE

A DIGRESSION: I spent late 2014 and most of 2015 living in Pasadena, California, while researching this book. In early 2015 I arranged to drive up to the Bay Area for a week of study at the Bancroft Library at the University of California, Berkeley. Whenever I traveled to the Bay Area I called my father, Edwin Green, to invite him down from his home in Ashland, Oregon.

"Haven't you already been to the Bancroft a bunch of times?" he asked. "Surely you've read all their Watkins material by now."

I had. Dad knew that as a result of the events of 1906, there wasn't much Watkins textual material at the Bancroft, or anywhere else. I had, indeed, long since read it all. I told Dad that my research strategy was to learn about people Watkins knew, with whom or for whom he worked, their businesses, and so forth. I knew that my best chance for detailing Watkins's import was to learn the world he inhabited and impacted and to place him and his work in it.

"But didn't you look up all those people last time you were at the Bancroft? So why go again?" asked a loving father, obviously looking forward to seeing his son.

I *had* looked them all up, sort of, but there was plenty more to do. When I started this book, I had scores of Watkins-affiliated names to research.

Many of them had led to dead ends. There were still fifteen to twenty names on the list. I picked one of them by way of explaining to my father what I'd do at the Bancroft.

"Take a couple of pictures I looked at today at the Huntington Library," I said. "Watkins made them in 1880, when he was in Arizona Territory, visiting railroad facilities, mines, and a Spanish-built mission church. The pictures show his wagon, the two-horse-drawn carriage in which he and his photographic material, cameras, lenses, glass-plate negatives, chemicals, and whatnot traveled from place to place. The side of the wagon featured an advertisement for his business painted on the side—C. E. WATKINS: YOSEMITE ART GALLERY. PROPRIETOR W. H. LAWRENCE—that is partially visible in a number of pictures. Watkins historians have long believed that Lawrence was the investor who enabled Watkins to reopen his art gallery after he lost everything in the aftermath of the collapse of the Bank of California, probably in 1877 or so. The inscription on the wagon suggests that Lawrence also took on a managerial role in the new gallery, which makes sense given the frequent travel Watkins did in the years after opening the gallery of which Lawrence was the 'proprietor.' Basically, Lawrence seems to have been the investor who helped Watkins restart his gallery business, and thus his full career, after the bank busted and after Billy Ralston's death. So I'm going to go learn what I can about this W. H. Lawrence fellow."

My father didn't immediately respond. Finally, "Was his name *William* H. Lawrence?" he asked.

I blinked in surprise, and said yes.

Dad: "Did Lawrence work for the Spring Valley water company?"

That was weird. Yes, he did, but how did Dad know that?

Fogged, I replied, "Yes," and mechanically recited to my father everything I knew about Lawrence and Spring Valley: that Lawrence was the superintendent and then the general superintendent of the company, what was then called Spring Valley Water Works, that he was essentially what we'd now call the chief executive.[1] While I had not researched Lawrence, I had previously looked into the Spring Valley Water Works, one of the most important and eventually one of the largest companies in nineteenth-century California. In the mid-1860s, Watkins had made pictures of at least one of the company's projects, the construction of a reservoir called Pilarcitos Lake. In these years, Spring Valley was buying up land around creeks and

small rivers in San Mateo County, creeks that typically ran from the Peninsula's Coast Range into the Pacific or in the other direction, into San Francisco Bay. Then Spring Valley built flumes that moved all that water into a system of upper-Peninsula reservoirs, such as Pilarcitos Lake, from which it delivered the water to San Francisco. By 1868 Spring Valley provided almost 90 percent of San Francisco's water.[2]

While all that was pretty clear to me, I still couldn't figure out how Dad recognized the name of the superintendent of a nineteenth-century water company. After I finished my miniseminar in the history of renewable-resource-oriented California corporatism, it dawned on me to ask Dad how he knew Lawrence and how he knew that Lawrence had worked for Spring Valley.

Again, Dad paused before answering. He paused so long that I thought my cell phone had lost coverage.

"Well, William H. Lawrence is your great-great-grandfather."

What?

Wait, *what?*

Had I spent several years working on Watkins without knowing that someone in my family substantially enabled the last third of Watkins's career? There must have been another William H. Lawrence in 1870s San Francisco, right? Then I remembered those pictures Watkins had made for Spring Valley. *Whoa.* Such was my astonishment that it took me several days to remember that my middle name is Lawrence, that I'm named after Watkins's enabler.

Obviously, belatedly, it was time to research William H. Lawrence.

My great-great-grandfather was born in Vernon, New York, in 1840.[3] Vernon is fifty miles northwest of Oneonta. As a teenager, Lawrence went to school at the Fairfield Academy in nearby Fairfield, New York, the same school as Asa Gray.[4] Already, Lawrence and Watkins would have had something to talk about.

Upon finishing school, Lawrence left New York for California, arriving in the winter of 1859–60. The first employment he found was with brothers George and Charles Laird, probably at a dairy ranch at Point Reyes in Marin County.[5] Lawrence didn't stay long. By the end of 1860, he was working for the then two-year-old Spring Valley Water Works as an assistant to the company's surveyor.[6] He would work for Spring Valley for the rest of his life.

In 1864, Lawrence, twenty-four, married Sarah Carrick, eighteen, about whom nothing is known, though later facts would suggest that she was a rung or two higher on the Bay Area social ladder than her husband.[7] Regardless, Lawrence was doing well for himself: as San Francisco grew in both population and manufacturing might, it needed water, and lots of it. Lawrence had smartly signed on with a company on the cusp of exponential growth.

The first Spring Valley project on which Lawrence worked was probably the construction of (or one of several expansions of) the company's first dam, along Pilarcitos Creek, about seventeen miles south of San Francisco.[8] (As part of the Pilarcitos project, Spring Valley also constructed a 1,500-foot tunnel through a mountain ridge to get the water to the city, no small feat.)[9] The water from Pilarcitos first arrived in San Francisco in time for the big wartime Fourth of July celebrations of 1862, of which Watkins made a series of stereographs. We don't know that Lawrence worked on the Pilarcitos project from the start, but its instigation matches the date of his hiring. He was involved in the project until, it seems, its completion.[10]

Watkins and Lawrence almost certainly met at Pilarcitos Lake sometime between 1861 and 1868.[11] Today Watkins's mammoth-plate pictures of Pilarcitos are lost; only stereographs from the project survive.[12] None of the surviving Spring Valley stereographs are dated, and only a few list specific geographies. (The terrain around Pilarcitos is indistinguishable from the terrain around nearby San Andreas Lake, so it's hard to be sure.) Watkins made pictures of the dam itself, the construction process, waste removal, the Pilarcitos Lake–adjacent cabin in which Lawrence lived, and a particularly charming narrow road through hills densely forested in scrub oak.[13] When the dam was complete and the lake had filled, he returned to photograph it. In fact, if Watkins had made this work after the summer of 1867, we have seen this pipe before: it likely would have been manufactured by the Oregon Iron Co., the opening of which Watkins photographed in the Willamette Valley.

Lawrence finished his work at Pilarcitos on April 27, 1868, at which point Spring Valley transferred him to the San Andreas Dam and Lake project, two mountain ridges away.[14] From time to time, he left the Coast Range to have dinner in San Francisco with William Babcock, Spring Valley's general superintendent (and the man after whom Lawrence would name his first son). By 1881 or 1882, Lawrence had ascended to Babcock's job, which meant that he was the company's top employee and one of the top executives in San Francisco.

These two dams would not provide enough water for San Francisco, so in 1868, Spring Valley purchased Lake Merced and later acquired the rights to the lake's watershed, which prompted the company to expand the lake. As a result, the site of the notorious 1859 Broderick-Terry duel was now underwater. Lawrence and Watkins would have more things to talk about.[15]

At this point, the overlapping circles of associates and clients between Watkins and Lawrence seem to begin to point to something, but what that something might be is unclear.

Sometimes I think that writing about Carleton Watkins is like being the sixth-century B.C.E. Babylonian who looked up at the night sky, saw bright dots, and connected them into animal-like shapes such as Taurus, the bull. The stars and the men Watkins knew, worked for, and befriended are clear. Connecting those stars into shapes that suggest animals—or what happened in nineteenth-century California—often requires a lot of squinting. The Watkins-Lawrence story from around 1868 forward is like that. The connections between the few things we know about their relationship are fuzzy enough that I would not include them in any chapter except this one. This is as much my attempt to figure out my family's history as it is the history of how one of the people a relative of mine worked with, Carleton Watkins, impacted California, the West, and the nation.

The next solid data point on the Watkins-Lawrence relationship came from my father: a day after Dad told me that Lawrence was my great-great-grandfather, he called to tell me he had dug through some old boxes in his yurt and had found a picture of Lawrence. Neat. I figured it had to be a Watkins. Given that Watkins made studio portraits only at his no doubt Ralston-backed Yosemite Art Gallery, that would have meant that it was a picture of a roughly thirty-five-year-old Lawrence.

"It doesn't say 'Carleton Watkins' anywhere on it," my father said. "It's oval shaped. By the way, Lawrence was a really, *really* good-lookin' guy."

Later, when I saw the picture, I noticed that Lawrence and my father look a lot alike.

I suggested that Dad turn the picture over to see if it said "Yo-Semite Art Gallery" or some such thing on the back. He did, and said it did not. I remembered that Watkins's gallery made portraits in a range of formats and sizes, and that the oval portraits typically had Watkins's name embossed in

Carleton Watkins, *Portrait of William H. Lawrence,* ca. 1872–75. Author's collection.

the lower right-hand corner of the cardboard on which the picture was mounted. If the Watkins mark was on this Lawrence portrait, I guessed that my father was holding the picture in such a way as to obscure it.

"Move your thumb and look there," I said.

Pause.

"Son of a gun," Dad said. "Watkins." A few days later, he brought the picture down to the Bay Area and shared it with me, his sister, Diane, and her husband, Bob Tokheim. Lawrence is wearing a suit, a bright-white shirt, and a conservative tie; he looks off to the left; and he has a goatee that extends two or three inches below his chin, just the right length for a professional man of the time and place. He is in his midthirties, a young executive on the come.[16] Today the portrait is in a frame on my desk.

This picture, made in Watkins's Yosemite Art Gallery between 1872 and 1875, is the only evidence that Watkins had contact with Lawrence between the 1860s Pilarcitos commission and 1877–78, when, for the first time since Billy Ralston's collapse, Watkins opened his own commercial art gallery at 427–29 Montgomery Street, at the powerhouse intersection of Montgomery and California Streets.[17]

If Spring Valley sounds familiar, it's because it was the company that precipitated Ralston and the Bank of California's collapse. As we saw in chapter 17, Ralston tried to buy up the outstanding stock of the company and then sell it to the City and County of San Francisco in 1875, a final, ultimately failed bid to fend off his creditors.[18] One reason Ralston targeted Spring Valley was that it was cash rich: in 1875 it earned $500,000 in revenue against expenses of just $60,000, likely making it one of the West's most profitable companies. Ralston's takeover attempt and the ensuing failure of his Bank of California had no discernible impact on Spring Valley. If anything, it emerged more powerful, its centrality to Bay Area life solidified. Among the men responsible for Spring Valley's strength was William H. Lawrence.

Lawrence's career had taken off between when he worked at San Andreas in 1868 and now, a decade later. He had risen to the role of superintendent, the company's No. 2 man, and would soon be its general superintendent, a man of substance and wealth, the man who provided America's tenth-largest city with virtually all of its water. Lawrence lived in a big two-story house in San Mateo, where one of the Coast Range creeks that Spring Valley hadn't yet bought up flowed into San Francisco Bay. Such was Lawrence's neighborhood that Alvinza Hayward, who had made millions in the Comstock Lode, lived next door. Such was Lawrence's status both within the company and in the California business community that when the king of the Sandwich Islands (today's Hawaii) visited San Francisco, Lawrence was selected to show him around.[19]

By the late 1870s, Lawrence was building out his investment portfolio. By now he was earning a sizable salary; he may even have been given some shares in Spring Valley as an inducement to continue with the company. In March 1875, a couple of years before investing in Watkins, Lawrence co-founded and invested in two mining companies: Mountain Queen and Last Chance. The *Daily Alta California* listed each as being in Nevada, which could have meant either the state or the California county. Among Law-

rence's fellow investors in both ventures were prominent San Mateo County Republican politicians and one J.R. Carrick, a relative of Lawrence's wife, Sarah. Each company was capitalized at $3 million and split into thirty thousand shares.[20] From there, the details of Lawrence's investments and their success are foggy: Last Chance and Mountain Queen were wildly common names for both mining companies and veins of ore. There were companies or veins known as Mountain Queen in Oregon, Arizona, California, mountainless Illinois, and Nevada. All this makes it hard to track the success or failure of Lawrence's investment.[21] However, starting in 1881, his Mountain Queen investment may have begun to pay off, as a Nevada County, California, Mountain Queen mine began producing silver.[22] One way or another, by the end of the 1870s, Lawrence was wealthy enough to own at least 2,200 acres of land in San Mateo County.[23] Such huge acreages in the estates district were owned only by the Bay Area's wealthiest men. (In 1860, before the Peninsula was overrun by Gilded Agers and their estates, John Parrott had paid $30,000 for his 260-acre estate. Lawrence's acreage would have cost far, far more.)[24] Among Lawrence's investments was apparently a stake in Carleton Watkins's Yosemite Art Gallery, an investment substantial enough to have earned Lawrence the title "proprietor." This brings us to the biggest question about the second half of Watkins's career: why did William H. Lawrence, one of California's most important executives, invest in something as relatively minor as an artist's gallery?

There is no clear answer, but there are Venn diagrams in which Watkins and Lawrence occupy the overlapping space. In about 1882 Lawrence bought at least two paintings from Watkins's friend William Keith.[25] Maybe Lawrence was friends with San Francisco artists. Watkins and Lawrence both knew Charles A. Felton, a member of Ralston's Ring and the owner and developer of land in nearby Santa Cruz County. Watkins made pictures of redwood trees in Felton, California, including a magnificent picture of an impossibly tall, skinny tree past which a white-staked road ran. Felton was active in Republican politics, a state assemblyman who ran on Republican tickets with Lawrence. Lawrence liked to vacation at the Hotel Del Monte on the Monterey Peninsula, a grand resort built by a company controlled by the Southern Pacific.[26] Watkins would visit Del Monte himself and would make a masterful suite of pictures there in the 1880s. Lawrence kept fine horses; so did Watkins clients Billy Ralston and Milton Latham, and later in

his career, many of his San Gabriel Valley–based clients would too. California's horsemen kept in touch and may have discussed Watkins. Lawrence's across-the-street neighbor Hayward made his fortune in the Comstock; Watkins spent time in the Comstock and had ties to both the Ralston crowd and the Bonanza Kings. These networks, when they overlapped, may have sparked Lawrence's interest in Watkins's business. Still, these all seem more like overlapping coincidences, not like motivating reasons to invest in a business such as Watkins's.

Still, they suggest a possibility. Here's my best guess as to why Lawrence teamed up with Watkins: One of Watkins's assets was the network of wealthy, influential men for whom he worked and, via memberships in exclusive fraternities such as the Bohemian Club, apparently socialized. (The greatest paradox of Watkins's career is that he failed to transform this network into wealth.) Lawrence may have seen what Watkins did not. More to the point, when Lawrence invested in Watkins's gallery, virtually all of Watkins's wealthy clients were influential Republicans. Lawrence was himself a progressive Republican, and he had political ambitions. Maybe Lawrence invested in Watkins as a way of improving or easing his access to Watkins's Republican network.

Watkins probably had specific opportunity and even cause to introduce Lawrence to influential Republican businessmen almost as soon as they had met. For example, in around 1868, Watkins began his decadelong series of pictures of the Peninsula Gilded Age country estates. Among the estates he photographed was that of Darius O. Mills, Billy Ralston's Bank of California president. Mills's estate was on land that had once been part of a Mexican land grant called Rancho Buri Buri. Spring Valley's San Andreas Lake, the construction of which Lawrence oversaw, was also on land that had once been part of Buri Buri. Mills's three-thousand-acre estate ran from flat land near the bay all the way up toward the Coast Range. The western border of Mills's land was the eastern border of Spring Valley land. Watkins seems to have been making pictures at Mills's estate at the same time Lawrence was building San Andreas Dam nearly adjacent to Mills's property line. There is no reason Mills would have known a midlevel executive at Spring Valley, even if that executive was supervising the construction of a huge lake on the edge of his property. However, Mills and Watkins surely knew each other, and Watkins and Lawrence knew each other. If Mills had wanted to know

what was going on with the lake, how it might affect his watershed or his land, Watkins was the guy who could help him with that. (Mills's land factors into my family history too, on my mother, Janet's, side. The subdivision where she grew up, in the Ray Park neighborhood of Burlingame, was built on land that had been part of Mills's estate.)

At the time, Mills had just built a country house called Millbrae on his Peninsula land. He also operated a producing dairy ranch on it. This was unusual. Most other Peninsula estate owners were happy to own vast pastoral lands, but Mills, who traveled between New York City and San Francisco more than any other businessman of the era, had some eastern-informed ideas. He surely knew that for the wealthy New Yorkers who had estates up the Hudson River, running an orchard or a similar agribusiness was a mark of gentility. There was no chance an orchard would produce fruit on the rain-parched Peninsula, so Mills opened his dairy instead. He may have gotten the idea from a pair of butchers who ran a meat market around the corner from his Bank of California offices. Their names were Charles Lux and George Miller, and they would come into Watkins's life later on. For now, it's enough to know that Miller & Lux kept its cattle on land that it too had purchased from the original Buri Buri grant.

Obviously, Mills, busy with the Bank of California as well as with his mining, railroad, and timber interests in the Sierra and other business in New York, wasn't going to personally run the ranch. He looked for a guy, someone who would partner with him on a large dairy operation. As it turned out, along with Miller & Lux, one other man ran a dairy ranch on former Buri Buri lands. He was an attorney and a onetime Republican state assemblyman (1863–64) who had given up practicing law to become a rancher. With his gentlemanly résumé, this rancher made an attractive partner to a business titan such as Mills.[27] Best of all, in the years since this man had left the assembly, he had maintained his ties to the political elite: in 1870, when the state of California gave a handful of wealthy California landowners huge breaks on property tax assessments, this rancher was on the list, along with far wealthier men such as Mills, Miller, Lux, and other Watkins clients such as the Howard brothers, John Parrott, Faxon Atherton, William E. Barron, and Ralston.[28] Mills asked this man if he was interested in building a dairy ranch on Mills's land, perhaps by expanding his existing dairy ranch into a new operation on the property. The man said yes. His name was Alfred F.

Green. Like Lawrence, he is also my great-great-grandfather, also on my father's side of the family. Therefore, in the late 1860s or early 1870s, Watkins was uniquely positioned to introduce Spring Valley's William H. Lawrence to the man who ranched cattle just on the other side of Spring Valley's San Andreas Lake property line, Alfred F. Green. (The dairy is in the margins of at least one surviving Watkins Millbrae picture.[29] Watkins may well have made pictures of the dairy operation that are now lost, as many Watkins pictures of Mills's land seem to be.)

Green ran Buri Buri's dairy operation until the late 1880s. Thanks in part to Mills's San Francisco business ties, it boomed. For example, when Billy Ralston's eight-hundred-room Palace Hotel was preparing to open in 1875, no doubt Bank of California president Darius O. Mills tapped Ralston on the shoulder to suggest that the Mills-Green dairy ranch get the milk contract. It did.[30]

Of course, Watkins may not have introduced Green and Lawrence to each other in the 1860s. Regardless, the men knew each other no later than 1871, when each was elected as a delegate to the San Mateo County Republican convention.[31] At this point, Green had not held political office in seven years. Lawrence, thirty-one, had never run for anything. For now, each was happy to be a wealthy businessman who participated in politics behind the scenes. By 1873 that would change: Green was elected to the county board of supervisors.[32] When another supervisor died, Lawrence was appointed to replace him; soon thereafter he won election in his own right and ascended to the chairmanship.[33] Lawrence held San Mateo County's highest elected office concurrently while working as the general superintendent of Spring Valley, which had become prominent and successful through buying up San Mateo County water and transporting it to San Francisco. The local paper, the *San Mateo Gazette*, seems to have never noticed the potential conflict between these two positions. After all, this was the Gilded Age, a time when men such as Lawrence knew how to encourage newspapers to look the other way, and when newspapers knew how to insist upon encouragement to do so.

Lawrence's political career went smoothly. His investments in mining companies bound some of his financial positions with the area's leading businessmen and leading Republicans. Then, at about the time Lawrence held the top elected office in booming, wealthy San Mateo County, the state

Republican Party appointed him to its executive committee.[34] It would seem that upon turning forty years old, Lawrence was thinking of something bigger, maybe a run for governor. Lawrence's closest ally in county business and politics seems to have been Alfred F. Green. While they sometimes voted on different sides of county matters, they agreed on the main issues. Most importantly, when Lawrence needed a construction supervisor for the building of Spring Valley's next Peninsula dam and lake, he hired Green to build what is now known as Upper Crystal Springs Lake. Green didn't need the work—his cattle and dairy business had made him wealthy—but it's easy to imagine why Lawrence would want a close ally and a fellow county supervisor to be involved in a Spring Valley project that would result in more San Mateo water going up to San Francisco.[35]

The building of this early concrete dam at Crystal Springs would be one of the West's major nineteenth-century engineering feats. Despite sitting smack on top of the San Andreas Fault, Crystal Springs Dam and Crystal Springs Lake survived both the 1906 and 1989 earthquakes. Today, the causeway of the Crystal Springs Dam, which was rebuilt only in the 2000s, is where Highway 92 bisects the two Crystal Springs Lakes.

Lawrence died in 1888 at age forty-eight, shortly after hiring Green to supervise the Crystal Springs project. At the time of his death, Lawrence was the chairman of the San Mateo County Board of Supervisors. Alfred Green, who was already a supervisor himself and would be for nearly twenty years, until 1892, assumed Lawrence's place as chair. Soon their two families would formally join: in 1895, Green's son Edwin Alfred, 30, would marry Lawrence's daughter, Carrie Sarah, 28. This marriage would create my family.

22

REBUILDING A BUSINESS

WITH A NEW GALLERY ESTABLISHED and an investor and "proprietor" to run the business side of his operation, Watkins was free to continue rebuilding his inventory of available views. In 1878 a California artist—painter or photographer—had to offer pictures of one subject above all others: Yosemite. Watkins had not been to the valley since 1866, and since losing his glass negatives to Cook and Taber at the end of 1875, they'd been selling prints made from Watkins's negatives under their imprint, with Watkins receiving authorial credit but no financial compensation. It was time for Watkins to compete with Cook and Taber and, weirdly, with himself. In May 1878, he returned to Yosemite.[1]

It had changed. When Watkins had first gone to Yosemite, seventeen years earlier, he'd had it nearly to himself. Back then, a foreign visitor, in this case from England, was such a spectacle that Watkins made and offered for sale a stereograph of her party. Now two thousand visitors poured into Yosemite each year. Sacramento newspapers named the people who were on their way into Yosemite, their hometowns in places as various as Iowa and Germany. California newspapers routinely ran stories saying that Yosemite tourists brought $1 million per year and more into the state and called for roads to be improved so more visitors could be brought to what one guide-

book called "the grandest scenery on the American Continent, if not in the world."[2] Yosemite Valley was becoming less natural: four children were born there in 1878, and the telegraph now joined the valley floor with the rest of the country.[3] Nor was nature even necessarily prioritized. On the Fourth of July, a local committee set off flares from the tops of the surrounding mountains, a kind of early fireworks show, and cannons were shot off on the valley floor, their booms bouncing off the granite walls.

Watkins had helped make Yosemite this popular. When he was in the valley in 1878, visitors made sure he knew it. "This glorious scenery attracts sundry photographers," wrote Constance Frederica Gordon-Cumming, a Scottish travel writer and artist who spent three months making drawings in Yosemite in 1878. "The great Mr. Watkins, whose beautiful work first proved to the world that no word-painting could approach the reality of [Yosemite's] loveliness, is here with a large photographic waggon."[4] Gordon-Cumming went on to urge her readers to thank Watkins for his role in creating Yosemite by being sure to purchase his 1870s pictures, rather than the old ones sold by Cook and Taber. "The new photographs . . . are superior to the original set."[5]

Watkins's concession to Yosemite's popularity—and perhaps to the attention he was generating—was to split his 1878 visit into two trips: he traveled to the valley as soon as the roads opened, in early May, left during the peak summer months to make a side (return) trip to the Comstock Lode, and then returned late in the season. He would also return to Yosemite in 1879, and maybe in ensuing years too. As the pictures Watkins made in Yosemite in 1878, 1879, and perhaps later are indistinguishable, historians typically date them to 1878–81 and consider them as a single entity.[6]

Watkins had changed too. In 1879 he was in his fiftieth year, an advanced age by the standards of the nineteenth-century West. Fortunately, his days of traveling with thousands of pounds carried by mules were over. The same road improvements to and around Yosemite that had enabled the tourist boom allowed Watkins to take his photographic wagon right into the valley.[7] He took full advantage. For one, he remade many of his 1861 and 1865–66 pictures. Quite often he positioned his camera in the exact spot he had years earlier, which suggests that he had kept careful notes on each picture he took (a reminder of what a devastating loss both Watkins and history suffered in 1906). That saved time.

Watkins also made a suite of circular pictures and twenty-seven all-new mammoth-plate views, plus four more pictures that were much informed by earlier pictures but tweaked—a horizontal picture remade as a vertical, for example. Not only would Watkins have enjoyed new creative challenges, but this also made business sense. Taber didn't have these new pictures, only Watkins did. Eadweard Muybridge had also been in Yosemite in 1867 and 1872, providing both business and artistic competition. While Watkins would offer remakes of earlier pictures to patrons who wanted a real Watkins, these new Yosemite pictures would be the ones on which his new gallery would bank. At about this time, Watkins made his first trip to California's other sequoia grove, the Calaveras Big Tree Grove in Calaveras County, about sixty miles east-northeast of Stockton.[8] He would make fourteen mammoth-plate pictures there, as well as stereographs and medium-format pictures, including of the tree named for Thomas Starr King.

Watkins's greatest series of pictures on these late-1870s trips was the series of ten mammoth-plate pictures he took of Yosemite Falls. For visitors, Yosemite Falls was often the highlight of their trip. "It is a splendid bouquet of glistening rockets, which, instead of rushing heavenward, shoot down as if from the blue canopy, which seems to touch the brink nearly 2700 feet above us," wrote Gordon-Cumming, who made watercolors of the falls as Watkins was photographing it.[9] One reason Yosemite Falls was so popular is that visitors could compare it to other falls. "If you can realize that the height of Niagara is 162 feet, you will perceive that if some potent magician could bring it into this valley, it would merely appear to be a low line of falling water, and would be effectually concealed by trees of fully its own height," wrote Gordon-Cumming, who continued the falls-by-falls breakdown in an extensive footnote.[10] "Niagara is the type of force and irresistible might. Yosemite is the emblem of purity and elegance."

Watkins made pictures of Yosemite Falls from the south side of the Merced River (a bit of a dud) and from the dirt road leading to the falls (an excellent picture in which the pale brown dirt road leads the eye right to and up the falls). In another picture, he mirrors the Upper Falls in Yosemite Creek. With each of these pictures, Watkins is moving closer to the falls. It's possible he intended them to be seen in sequence, as a traveler might experience the falls themselves. His most dramatic Yosemite Falls composition was a picture taken from the bottom of the falls. He somehow tilted his

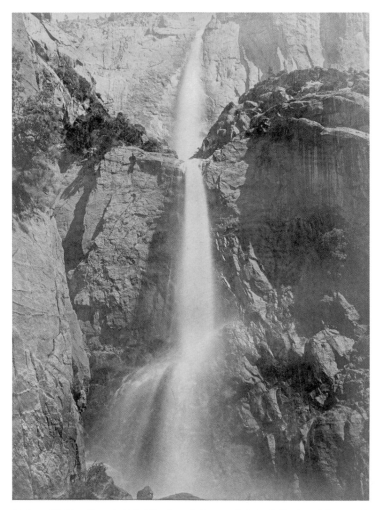

Carleton Watkins, *Yosemite Falls, View from the Bottom*, 1878–81. Collection of the J. Paul Getty Museum, Los Angeles.

mammoth-plate camera backward, fixed it in place, and made a picture in which the entire falls, upper and lower, appears to be a sinuous line cleaving shaded granite. Ansel Adams, as usual, seems to have taken pains not to duplicate it, but his friend Georgia O'Keeffe, to whom Adams introduced Yosemite and maybe Watkins too, may have riffed on it in her 1952 *Waterfall*.[11]

Many of Watkins's new pictures were enabled by new trail construction on both the North and South Rims of the valley. The trails had originally been built as toll roads by private interests, probably Yosemite hotel owners, and were later purchased and maintained by the State of California's Yosemite Commission.[12] These new trails were much more important to Watkins and other photographers, who had bulky gear to schlep around, than they were to painters, who could scramble to places with a backpack-sized kit of paints and a sketch pad. Two of the best pictures Watkins made in Yosemite in the late 1870s were specifically enabled by the new trails. The new Eagle Point Trail along the North Rim allowed him to continue a long-standing conversation with Albert Bierstadt's work and with Muybridge's too; the new Four-Mile Trail on the South Rim seems to have allowed Watkins to side with his friend John Muir in the long-running scientific argument about how the valley was created. Let's start on the North Rim.

By 1878 Yosemite had given rise to an art history that already was beginning to rival the art informed by the two great landscapes of American art: the Hudson River Valley and Niagara Falls. As Yosemite's art history all but started with Carleton Watkins and his landmark 1861 pictures, many of those artists had pointedly addressed Watkins in their work, and many more would, right up into the present day. Watkins's late 1870s trips to Yosemite allowed him not only to make new views for sale in his new gallery but also to visually respond to artists who had engaged his work with their own. Watkins's 1870s trips turned a series of artistic monologues into conversations. I'll focus on two: Watkins's artistic interplay with Albert Bierstadt and with Eadweard Muybridge.

No American artist owed more to Watkins than Bierstadt, the New York painter who had seen Watkins's 1861 pictures at Goupil's in 1862 and who had rushed west the following year, when he saw—and bought—more. Even after returning to New York in 1863, Bierstadt continued to make paintings of Yosemite, at least sort of. Initially his pictures were fairly true to the Yosemite landscape he'd seen, but as the 1860s advanced—and as Watkins's pictures became famous across America and in Europe—Bierstadt's approach became more fanciful. Unable to improve upon Watkins's points of view or compositions, Bierstadt increasingly exaggerated Yosemite's features, injected his canvases with a fantastical, even preposterous luminism,

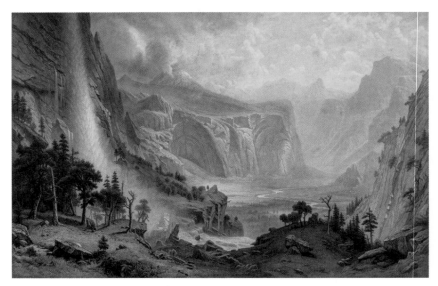

J.J. Dillman (lithographer), Deldruck v. Breidenbach & Co., Dusseldorf, Germany (publisher), After *The Domes of the Yosemite,* by Albert Bierstadt, ca. early 1870s. Collection of the Bancroft Library, University of California, Berkeley.

and sometimes both. Take Bierstadt's 1868 *Sunset in the Yosemite Valley* at the Haggin Museum in Stockton, California. *Sunset* includes a Yosemite-ish landscape in which a Boschian fireball lurks behind a rock formation. Other Yosemite-esque rock features in the painting are so exaggerated as to be unidentifiable. It's gripping, but like so many late 1860s Bierstadts, it is based on Yosemite rather than of it.

Watkins would have known some of these 1860s Yosemite-ish Bierstadts through prints. Bierstadt's circa 1868 *Sunset, California Scenery,* a picture made into a popular chromolithograph, is a kind of collaged landscape painting. It offers a tripartite composition in which the left-hand side of the painting hints at a Yosemite waterfall without actually being one, the right-hand side hints at the Mariposa sequoias without actually representing their enormous size or majesty, and the foreground, appropriated from Bierstadt's sketches of Lake Tahoe, seems unrelated to either. It's all held together by little more than a title.[13] It's easy to imagine Watkins, whose landscapes of Yosemite and everywhere else were rooted in composition and actuality, shaking his head at this kind of syrupy fantasy. Watkins surely also

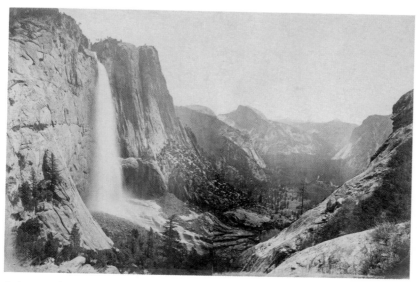

Carleton Watkins, *Upper Yosemite Valley, View from the Eagle Point Trail*, 1878–81. Collection of the J. Paul Getty Museum, Los Angeles.

knew what is so clear to us now, that his pictures had played a role in driving Bierstadt to excesses: with Watkins making faithful views of remarkable places, Bierstadt fictionalized a scene to better compete pictorially with both Watkins and geologic history. Perhaps one reason Bierstadt decided to return to California for two more years of study and painting in 1872–73 was that he realized that he'd gone a little too far over-the-top, that it was time to return to the actual thing.

Watkins hadn't just seen prints, he'd seen (and photographed) Bierstadt paintings in the homes of his wealthiest collectors and commissioners, especially Peninsula estate owners such as Darius Ogden Mills. Chromolithographs were popular among the merely well-off, so no doubt Watkins saw popular Bierstadt chromolithographs all over San Francisco. Sometime in the early 1870s, Watkins saw one based on Bierstadt's *The Domes of the Yosemite*, one of Bierstadt's best—and more faithful—paintings of Yosemite. At an awesome ten by fifteen feet, *The Domes* was also one of Bierstadt's largest paintings. It is not an exact transcription from nature: Bierstadt moved a few mountains around so that he could fit more of Yosemite's most

famous features, including Half Dome, into the frame; he denuded the valley floor of trees so as to better show rocky drama; and he invented a new way for Yosemite Falls to feed into the valley. Still, it's closer to factuality than Bierstadt usually got, and the painting is better for it. Almost immediately after Bierstadt made *The Domes,* it entered a private collection. (Today it's at the St. Johnsbury Athenaeum in Vermont.) Bierstadt was so proud of *The Domes* that he didn't just have it made into a chromolithograph, he had it made into an unusually large chromolithograph. The litho of *Sunset,* for example, was twelve by eighteen inches. Bierstadt had the print of *The Domes* made three times that size, twenty-two by thirty-three inches.[14] It was mighty popular.

Watkins, who knew how much Bierstadt had cribbed from him, saw an opportunity to engage, to show what the valley really looked like, and perhaps to argue that nature and reality bested Bierstadt. Anyone who had spent as much time in Yosemite as Watkins had, even if it had been some years, would have been able to readily intuit the spot in Yosemite from which Bierstadt had planned this painting, and Watkins did. It was more or less along the new Eagle Point Trail, which meant that Watkins and his equipment could get there.

Upon reaching Bierstadt's point of view—the pictures Watkins would make align so closely to the Bierstadt that Watkins must have traveled with either a good sketch or the print itself—Watkins planned two vertical mammoth-plate pictures from almost the exact spot Bierstadt had semifictionalized. This meant measuring off the scene so that he could reassemble it later in print form as a panorama. This was something photographers, especially in the West, had done for years, and it would have come easily to Watkins. Here he needed to be extramindful and to measure extracarefully. His idea, as we shall see, went beyond merely making the usual panorama. Watkins made both negatives, had one of his crew pack them up, and, maybe, smirked in satisfaction before going on to the next site to photograph.

Later, in his darkroom, Watkins took out those two mammoth plates. He printed each at roughly twenty-one by fifteen inches, to be sold as a panorama of two separate prints, the practice western panorama photograph makers, Watkins included, had followed for twenty or so years.

He was not done. While still in his darkroom, Watkins did something he had never done before and would never do again: he stitched the two glass

plates together to create a panorama that he printed and then mounted as if the picture were a single photograph. Its measurements were twenty-two by thirty-three inches, the exact same size as Bierstadt's chromolithograph. For fifteen years, Bierstadt had considered Yosemite as much through Watkins's pictures as through his own experiences there. Now, when Bierstadt had made a painting that was entirely a product of his own Yosemite experience, Watkins realized it, went there, and found a way to tweak Bierstadt not just by making the same view but by revealing how Bierstadt had tried to improve upon nature. Did Watkins intend it as a playful jab to Bierstadt's ribs, or did he deliver it with a squint, a hint of menace? We'll probably never know.

Of the photographers who traveled to the valley between Carleton Watkins in 1861 and Ansel Adams in the 1920s, Eadweard Muybridge is the only one who came close to matching Watkins's inventiveness and technical skill. The two men had known each other in the 1850s—we don't know how or how closely—and they seem to have kept in touch over the years. Muybridge's gallery seems to have offered Watkins stereographs and maybe medium-format pictures as well, a suggestion that the two had some kind of business relationship. Today Muybridge is best known as the chameleonlike drifter who invented the processes that led to the development of motion pictures and who shot and killed his wife's lover in spite. (He was acquitted.)[15]

Muybridge was also a terrific photographer. For the most part, perhaps in recognition of Watkins's primacy in the San Francisco market, he mostly avoided subjects that Watkins shot. Muybridge traveled the Pacific coast shooting lighthouses; he went to Alaska, to Central America, and to the Northern California lands over which the U.S. government fought the Modoc.[16] Watkins may also have steered clear of Muybridge's best subjects. For example, Muybridge was San Francisco's greatest urban panorama photographer, while Watkins mostly just dabbled in the thing. The one place where they couldn't avoid each other was Yosemite. Any photographer working in the West, especially in California, simply had to have Yosemite images on offer.

Muybridge made two significant trips to Yosemite: one in 1867, when Watkins was in the Columbia River Gorge, and another in 1872. Like Wat-

Eadweard Muybridge, *Wild Cat Fall*, 1872. Collection of the California State Library, Sacramento.

kins, in 1872 Muybridge traveled with a mammoth-plate camera. He understood that to compete with Watkins's enormous pictures, he would have to make enormous pictures too.

Writing before the full extent of the Watkins mammoth-plate oeuvre was known and published, essayist Rebecca Solnit wrote that Muybridge's 1872 pictures "stand apart from everything he and his peers had accomplished."[17] Today we know that's only partially true. Indeed, some of Muybridge's 1872 views *are* unique. But quite often Muybridge was riffing on Watkinses, and at other times he was remaking Watkinses and thinly masking it. Among the best of the pictures that are fully Muybridges is an 1867 picture from up Yosemite Falls that Muybridge made by shooting downward, toward the valley. It's a clever picture that shows the steepness of the valley's walls and how water had smoothed the rock over the many centuries.

As interesting are the pictures Muybridge made that were informed by famous Watkinses, pictures in which Muybridge responds to a fellow pho-

tographer in the kind of way painters had responded to each other for centuries. (In the United States, photography was still only a couple of decades old!) In 1867 Muybridge answered Watkins's famed 1861 *Cascade between Vernal Fall and Nevada Fall* by going to Wildcat Creek, a Merced River tributary that was three or four miles to the west of Yosemite Valley, to make *Kahchoomah, Wild Cat Fall*, a picture that aped the onrushing swing of the Merced in Watkins's *Cascade*. (Muybridge would return to the spot in 1872 to make a horizontal composition.) The spot would have taken some finding; the remaking of Watkins's composition may be Muybridge's earliest engagement with his onetime friend's work. Muybridge also seems to have taken note of Watkins's transcendentalism-informed use of bodies of water as mirrors, such as in Watkins's 1861 pictures of Mirror Lake (in which the then-future Mount Watkins is reflected) and his 1865–66 pictures of El Capitan, North Dome, Washington Column, Mount Watkins, and the Three Brothers.

Like virtually every other San Francisco photographer, Muybridge sometimes simply and directly remade Watkinses. Muybridge's 1872 *Valley of the Yosemite, from Mariposa Trail*, was made maybe fifty feet from where Watkins had made his 1865–66 *Yosemite Valley from Mariposa Trail*. Muybridge's 1872 *Cathedral Spires*, a vertical composition, is an even more direct remake of a Watkins, in this case Watkins's 1865–66 vertical picture of the same title, taken a couple of feet from where Watkins had made his.

More often, Muybridge masked his remakes by turning horizontal Watkins pictures into verticals and vice versa. Muybridge's 1872 *Tutokanula. Valley of the Yosemite. The Great Chief "El Capitan"* is a horizontal remake of Watkins's 1861 and 1865–66 vertical pictures of El Capitan, complete with the same use of the same trees as a compositional aid. Muybridge did the same thing at Vernal Fall, remaking Watkins's view from within a foot or two of where Watkins had made his *Vernal Fall* in 1865–66. Watkins's picture is vertical, Muybridge's horizontal.

Did Muybridge's appropriation of Watkins's compositions bother Watkins? We don't know. There is a suggestion, maybe only a hint, that by 1872 Watkins and Muybridge weren't friendly. Only one of Muybridge's pictures of Mount Watkins might include the name of the peak named for Watkins in the title.[18] The closest Muybridge comes is referring to Mount Watkins as Mount Waiya, apparently a phonetic spelling of the Native American name

for the peak. (Josiah Whitney called Mirror Lake, which figures in both Watkins's and Muybridge's pictures of Mount Watkins, Waiya, but I couldn't find anyone but Muybridge calling the mountain by that name.)[19]

Watkins may have responded to Muybridge pictorially as he did to other artists, but I couldn't find such a response. Perhaps other historians or a curator will—there's virtually no comparative history or criticism about Watkins's and Muybridge's work, and the publication of Muybridges lag the publication of Watkins's work. However, if there's a case to be made that Watkins responded to Muybridge's 1872 pictures on his visits later in the decade—that Watkins took note of what Muybridge was doing and engaged—it's conceptual, it involves Watkins's friend John Muir, and it prompted what may have been Watkins's single greatest picture.

Ever since the early 1860s, Carleton Watkins had been interested in science and had made pictures informed by the needs and interests of scientists. As we've seen, one of Watkins's particular interests was glaciers. Watkins had been with Clarence King on the team that discovered the first living glacier in North America, had made pictures of it, and had hung those pictures in place of privilege at his Yosemite Art Gallery. In the years following that discovery, Watkins's friend John Muir become a significant glaciologist, first publishing news of his findings and theories about California glaciers in December 1871. Watkins would have been fascinated by Muir's ideas. Muybridge's 1872 Yosemite pictures suggest that he was too. In the late 1870s, Watkins would make *Agassiz Column and Yosemite Falls from Union Point,* a picture that suggests he was well aware of Muir's ideas about glaciers in Yosemite and that raises the question of whether Muybridge's own surely Muir-informed, glacier-related pictures also motivated Watkins. It is one of Watkins's two or three best pictures.

As Watkins was busy running his new Yosemite Art Gallery and making pictures in and around San Francisco, especially for Ralston's Ring, in the early 1870s, the story started with Muybridge's trip to Yosemite in the season after Muir's *Tribune* article was published. As prime evidence for his theory that glaciers had formed Yosemite Valley and the side canyons that ran off it, Muir cited an observation he had made when following the Mono Trail out of the valley to the northwest, up toward Lake Tenaya. "On the west bank of the Yosemite glacier, about two miles north of the Mono trail

Eadweard Muybridge, *Ancient Glacier Channel, Lake Tenaya*, 1872. Collection of the California State Library, Sacramento.

and throughout its entire length, there is abundance of polished tablets with moraines, rock sculpture, etc., giving glacier testimony as clear and indisputable as can be found in the most recent glacier pathways of the Alps," Muir wrote.[20]

Muybridge took his camera to that exact spot. The result is one of Muybridge's finest pictures, variously titled *Ancient Glacier Channel* or *Ancient Glacier Channel, Lake Tenaya*. The picture shows huge boulders strewn across a broad, open landscape that is occasionally broken up by tall, straight pines and firs. How did those boulders get there? Muybridge's picture and title point toward Muir's theory. *Ancient Glacier Channel* is almost an exact visual match with glacial effects Muir described elsewhere in his essay. "I found a great quantity of loose separate boulders upon a polished hilltop, which had formed a part of the bottom of the main ice stream," Muir wrote. "They were a[n] extraordinary size, some large as houses."[21]

Muybridge made a second 1872 picture that seems to reference Muir's theory, *Glacier Channels. Valley of the Yosemite. From Panorama Rock.* (Pano-

rama Rock is not a name currently in use. The feature is east of the main Yosemite Valley, above Little Yosemite Valley and near Mount Starr King.) Huge pine trees are growing out of patchy dirt that occasionally covers a steep granite slope. Muybridge was little enough interested in the pines themselves that he cut off the top of the two trees that anchor his composition. The subject is less the trees than the dirt left on the slopes, which Muir wrote had been left behind by the glaciers, allowing trees to be "planted in abrupt contact with the bare gray rocks."[22] It is more interesting for its apparent engagement with Muir than as a picture.

It would be six years before Watkins would return to Yosemite, but when he did, there was reason beyond Muybridge's pictures-as-gauntlet for Muir's theories to be on his mind. It was in 1878 that Clarence King published his pointed, rude, and ultimately incorrect rejoinders to Muir's theory that glaciers had formed Yosemite. Watkins, who had been a friend of King's, who had worked for him on Shasta, and who was now a pal of Muir's, would have known of King's sniping.

If Watkins made a picture about glaciation during the 1878–81 Yosemite trips, it is *Agassiz Column and Yosemite Falls from Union Point*. As usual with all things Watkins, we have no textual documentation to suggest or reveal what he was up to. So much Watkins history relies on circumstantial evidence and context, and this is no different. However, this is what it looks like.

Agassiz Column and Yosemite Falls from Union Point shows a once well-known column of granite that rises from Yosemite's South Rim. Nineteenth-century Yosemite hotelier and promoter James Hutchings described the rock, then known as the Magic Column, as "standing on end, like a huge ten-pin, some thirty feet in height, and ten in thickness. It looks as though a good strong breeze would blow it over, but which has thus far successfully withstood all storms and earthquakes."[23] Difficult to find and almost unknown today, in the nineteenth century Agassiz Rock was a popular destination. Its location, northwest of Glacier Point and almost exactly north of and a thousand feet downhill from Sentinel Dome, was well-known. By 1878 or 1879, the Magic Column had been renamed Agassiz Column or Agassiz Rock, probably in appreciation of Agassiz's 1872 visit to San Francisco and of his pioneering glacial theory, which had informed Muir's ideas about Yosemite. (Agassiz had hoped to visit Yosemite and the big trees in 1872, but he was too exhausted by his trip and died shortly thereafter.) It is not clear

who renamed the rock, but it may have been Muir. The name was still fresh enough in 1878 that Watkins put "Agassiz" in quotation marks when titling pictures that included the rock.

Watkins had never photographed Agassiz Rock before, presumably because it was difficult for a photographer to reach, but he'd been close to it in 1865–66 when he took a picture looking down Yosemite Valley from the west side of Sentinel Dome. The challenge was the steepness of the terrain: as Watkins's 1865–66 picture shows, the land below his camera falls off steeply. It was probably about 1,000 vertical feet and maybe as many as 1,400 vertical feet from where Watkins took his 1865–66 picture to Agassiz Rock.

Then, in the early 1870s, a Yosemite Valley hotelier built a road called Four Mile Trail from the base of Sentinel Rock to Glacier Point, thus providing access to Agassiz Rock. The painter Gilbert Munger (who had visited Mount Shasta with Watkins and King in 1870) had found the new Four Mile Trail of fine quality and declared its grade was smooth and easy.[24] Watkins thus would have been able to take his wagon right up Four Mile Trail to Agassiz Rock.

So too could others. In the mid-1870s, Agassiz Rock quickly became a favorite landmark for visiting photographers. During the late nineteenth century and even into the early twentieth century, a great many dealers in western landscape pictures offered pictures of Agassiz Rock. It was not an easy thing to photograph. In pretty much all of these pictures, the rock appears to be one with the background, and there's little sense of drop-off or of the valley's magnificence. This was as much a technical problem as it was an artistic failing. The problem can be explained by looking back to pictures from nearly two decades earlier, such as Watkins's own 1861 pictures of Yosemite. Back then, depth was built into photographs: things closer to the lens printed as darker, things farther away printed as lighter. Watkins, like any photographer, knew this, and he took full advantage: an 1861 picture offers El Capitan as a ghostly silver shadow that rose beyond a field of dark grass. The sense of perspective that painters had to figure out how to represent on canvas, in two dimensions, was effectively built into early photography. But now, in the late 1870s, materials had improved so much that a photographer could produce a photograph of a distant something—say, the granite wall of Yosemite's North Rim—and print it as dark and detailed, clear and rich, as something in the foreground. As a result, objects in the

foreground and objects in the background of late 1870s photographs often seemed to be on top of each other, even melded. This is what happened with second-rate views of Agassiz Rock. If we look at one half of a 1904 stereographic view of Agassiz Rock sold by W. C. White Co., a marketer of scenic views, we see the problem: the rock blends into the background so perfectly that it's nearly invisible. For a snapshot made for a commercial market, this was good enough. Those pictures were not driven by the pictorial expression of an idea.

However, depth was a real problem for Watkins. When he decided to make not just a picture of Agassiz Rock but one that would reveal the processes that he believed formed both the valley below and the rock's unusual shape and cracking, he knew he would have to differentiate the rock, in the foreground, from the distant valley wall opposite his position. It did not come easily. Watkins's presumed first mammoth plate of Agassiz Rock looks at the column from the southeast, with the western half of Yosemite Valley behind it.[25] It is not much of a picture; instead of the delicately perched column of Hutchings's description, this picture offers a leaden lump of clay. That wasn't the only problem. Almost all of the face of the rock is in the shade. Who, in the 1870s—or even today—takes a picture wherein the subject of the photo, the thing at which the photographer wants the viewer to look, is darkly shaded? Watkins seemed to know that this first picture didn't work.

Watkins's next attempt was probably the five-inch, circular print now at the J. Paul Getty Museum. Watkins junked everything from the first attempt. This time he shot Agassiz Rock from an angle that emphasized its fragility. He put the column in bright sunlight and then framed it: A tree enters the picture on the right, and a chunk of granite pushes in from the left, with Agassiz Column between them. Yosemite Falls is not visible. That framing points the viewer at the column, providing the foreground with enough oomph so that the other side of the valley seems distant. It's a strong picture, but not quite a great one.

The great mammoth plate was probably Watkins's final Agassiz Rock picture. Here Watkins is more ambitious. This is the picture that seems to tell the story of Yosemite's glacial origins, the picture that gives image to what Muir believed was the full drama of glaciation in Yosemite, the way thick sheets of ice bulldozed massive, deep valleys. To show the story, Watkins had to emphasize the near-sheer, 2,335-foot drop from Agassiz Rock to

Carleton Watkins, *Agassiz Column and Yosemite Falls from Union Point,* 1878–81. Collection of the J. Paul Getty Museum, Los Angeles.

the valley floor below. That would allow him to show the viewer the steepness of the glacier-carved valley walls. Next he needed a way to show the valley itself, so that drop below Agassiz Column would have to be matched by the steepness of the cliffs opposite—and in a way that left viewers able to understand that there was a broad valley betwixt. Then there was Agassiz Rock itself, the fractured, foregrounded rock that would hold the picture together. In the likely second picture of Agassiz Rock, the circular print, Watkins had hit upon a good idea: for that photograph, he had raised his camera about 15 feet above the ground. (Maybe he placed it on top of his wagon, or maybe he put it up on wooden crates.) This put his camera lens about halfway up the height of the rock. Now Watkins tinkered with the elevation of the camera so that he could be sure to accomplish two goals: First, to have just a smidge of the column poking up above the distant North Rim of the valley opposite. That effectively pushed the rock toward the picture plane, toward the viewer, helped the rock stand out, and helped make plain the distance between Agassiz Rock and the North Rim. Not only did Watkins want the column to push up above the opposite rim, but he wanted to take advantage of a little protrusion on the right side of Agassiz Rock, a gentle bit of granite that he would use to point at Yosemite Falls. While that seems like an obvious bit of pictorial cleverness that just about every other photographer would have created, none did. Something about Watkins pictures makes their details seem obvious, but when there is an opportunity to compare a Watkins to similar views by other photographers, it becomes clear how many little things Watkins saw, realized, and included that the others did not.

That's a lot of precision for one picture, but there's more. Watkins refined another idea from the circle-cut print and made sure that his camera was just far enough away from Agassiz Rock so that some shrubbery along Union Point, probably junipers or manzanitas, was between him and the rock. Watkins put them in the shade. They were to be noticed but not dwelt upon. They provided something for Agassiz to float above. Then Watkins took out something that was in the way: a large ponderosa pine that grew out of the cliff below Agassiz Rock. When Watkins decided where to put his camera, he "hid" the tree behind Agassiz, thus ensuring it was not a distraction from his composition.

Watkins brought back one more idea from those first couple of attempts.

It was the idea that seemed like the biggest mistake. Watkins had learned that putting Agassiz Rock in *total* shade didn't work. It denied the rock texture and personality. This time he put the column not in full shadow, but in mottled shade, effectively dabbing the already speckled granite with light. This emphasized the texture, roughness, and fissures of the granite monolith, almost transforming it into visage. It was brilliant, an example of how breaking a rule could create harmony. Just as importantly: Watkins took the picture when the distant valley floor and the more distant valley wall, split by Yosemite Falls, were all in blinding light. This enabled the trees that grew along the valley floor and up the gentler slopes of the far wall to provide pictorial depth. On his third try, after visiting Yosemite for twenty years, after taking scores of mammoth plates, half plates, and cartes de visites and hundreds of stereographs, Watkins found a way to put all of Yosemite's majesty and the science that explained it into one picture.

When we compare Watkins's picture to Muir's 1871 article, we see how thoroughly the Watkins picture animates what Muir wrote. Muir first explained that the reason Yosemite Falls existed was glacial activity. "To the concentrated currents of the central glaciers, and to the levelness and width of mouth of this one, we in a great measure owe the present height of the Yosemite Falls," he wrote.[26] Yosemite Falls is the co-centerpiece of Watkins's picture.

Next, Muir explained how Yosemite Valley came to have forests both on the valley floor and along the steep granite walls that form the valley. "When a bird's-eye view of Yosemite Basin is obtained from any of its upper domes, it is seen to possess a great number of dense patches of black forest, planted in abrupt contact with bare gray rocks," Muir wrote. "Those forest plots mark the number and the size of all the entire and fragmentary moraines of the basin, as the latter eroding agents have not yet had sufficient time to form a soil fit for the vigorous life of large trees."[27] While both Native Americans and Yosemite's tourism industry had significantly altered the valley floor, Watkins made sure to include that flora in his picture.

Finally, there is the way Watkins uses Agassiz Rock to point to Yosemite Falls. Yosemite Falls reaches the valley floor just below Eagle Cliff, on its western side, and Indian Canyon, which fills the right-hand quarter of Watkins's picture and is just east of Yosemite Falls. This area, the place at which Watkins

uses Agassiz Rock to "point," is of special interest to Muir. It is the part of the valley he describes in his clearest, most dramatic paragraph. "Already it is clear that all of the upper basins [below the mountain peaks that ringed Yosemite Valley] were filled with ice so deep and universal that but few of the highest crests and ridges were sufficiently great to separate it into individual glaciers, many of the highest mountains having been flowed over and rounded like the boulders in a river," Muir wrote.[28] One such example might be North Dome, which San Franciscans would have known from pictures made by Watkins and others. "Glaciers poured into Yosemite by every one of its cañons, and at a comparatively recent period of its history its northern wall, with perhaps the single exception of the crest of Eagle Cliff, was covered by one unbroken flow of ice, the several glaciers having united before they reached the wall."[29] In Watkins's picture, you can see how Muir believes it happened. In the picture, Agassiz Rock points to the spot Muir describes, the spot where the crest of Eagle Cliff and Indian Canyon met the glacier.

Back in the mid-1860s, Frederick Law Olmsted had called for artists and scientists to receive place of privilege in Yosemite because of their respective contributions to the creation and establishment of the nature-park idea. Now, nearly two decades on, artists and scientists were again in intellectual cooperation, this time helping Americans see what the scientists thought. The theory of Yosemite's formation put forth by John Muir, an untrained geologist, is one of the greatest achievements of nineteenth-century American science. *Agassiz Column and Yosemite Falls from Union Point,* made by Carleton Watkins, is one of the greatest achievements of nineteenth-century American art.

23

MAPPING FROM THE MOUNTAINTOPS

SCIENTISTS THEMSELVES SEEM TO HAVE recognized—and valued—
Watkins's engagement with their work. From the early 1860s on,
when the West's top scientists needed pictures, Watkins was their
first choice. So in 1879, when George Davidson, the chief West Coast scien-
tist for the U.S. Coast Survey (and its successor agency, the U.S. Coast and
Geodetic Survey), needed a photographer for an unprecedented survey that
would map the West, he called Watkins. While Watkins was making pictures
at Yosemite, he was enough intrigued by Davidson's offer that he made him-
self available. The work Watkins and Davidson would do together on the
two most prominent peaks in the northern Sierra in 1879 wouldn't just re-
sult in spectacular pictures; it still has practical implications today.

It is difficult to tease out when Watkins and Davidson met or whether
they were close, but their lives, experiences, and social circles overlapped
from the Civil War years, when Davidson bought a full, unmounted set of
the 1861 Yosemite pictures, into the 1880s.[1] (Davidson would buy at least
four dozen more Watkinses.)[2] Both men were Scottish, and each was friends
with John Muir, who occasionally worked as a guide on USCS expeditions.

While Davidson made meaningful contributions to American astronomy
and geography, including selecting the sites for many Pacific coast light-

houses, his most significant scientific achievements were in geodesy, a scientific discipline that uses applied mathematics and earth sciences to measure and ultimately represent, in three-dimensional-map form, the earth. Over the course of Davidson's career, he conducted geodetic surveys of more of the West Coast than anyone else, surveys that established precisely where California and Oregon met the Pacific Ocean (so that ships and sailors would know where to avoid and where they could travel, thus enabling commerce and trade), as well as the West's mountains, deserts, and valleys. On the East Coast, where Davidson started his career, gentle terrain made geodesy a relatively straightforward science. In mountainous California, it was a whole different thing. Between 1876 and 1886, Davidson's geodetic ingenuity would set new international standards both for overcoming difficulty and for quality. Because of the challenges inherent in California's terrain, to geodetically map California, Davidson would have to conduct his work from higher than geodesists had ever worked in America, Europe, or even India.[3]

In the late 1870s, Davidson's major project was contributing to the initial measurement and then mapping of the United States between the Atlantic and the Pacific Oceans. The project would require a series of geodetic triangles to be laid over the continent along the line of 39 degrees north latitude. Today that sounds obscure, but it was crucial to the future of America's still new, still sparsely populated western lands. To explain why, it might help to go back a generation or two. Thirty years earlier, in the 1840s, explorers such as friend-of-Watkins John C. Frémont directed a westering nation toward the Pacific by traveling through the western two-thirds of the continent (some of which was U.S. territory and some of which was not), by describing their journeys in government reports, and by making the first maps of the middle and marking the overland trails on which traders, merchants, and settlers might travel. They told Americans what to expect in the lands west of the Mississippi—where to find water and game, where there would be mountains and passes through them. They offered this information without any particular geographical specificity, let alone precision. For example, there is this passage from Frémont's *Geographical Memoir upon Upper California:* "The fork on which we encamped appeared to have followed an easterly direction up to this place; but here it makes a very sudden bend to the north, passing between two ranges of precipitous hills, called, as I was

informed, Goshen's hole. There is somewhere in or near this locality a place so called, but I am not certain that it was the place of our encampment."[4]

Frémont's geographical unspecificity was apparently good enough for inspiration and as a rough guide through a mostly unclaimed middle, but it was nowhere near good enough for an inhabited place. Watkins knew this from firsthand experience because geographical vagaries had given him his photography career: his first professional assignments came from attorneys litigating Mexican-era land claims, who were trying to give meaning to land titles that established property borders at unspecific, individual rocks or trees. After the Civil War, it would fall to the USCS to overlay the West with a geodetic grid and then to make maps based on that grid. In the West, this meant Davidson, who would measure and invisibly line all California, from the gold- and timber-rich mountains to the flat Central Valley (which everyone realized was the nation's next agricultural heartland) to the booming cities. Instead of Frémont's "somewhere in or near" estimations of place, Davidson would map the nation to a specificity of one part in 5,500,000, to an error of less than one inch per ninety miles. It was this kind of specificity, achieved within two generations of early American exploration's descriptive guesswork, that led to surveyors coining the slyly ironic phrase "good enough for government work." The USCGS's geodetic grid would take decades to complete, but it would be worth it: once finished, it would be possible to determine property lines, state boundaries, and the heights of mountains, to build railroads and eventually civil works such as dams and, eventually, technologies such as the global positioning system.[5] In nineteenth-century America, this was not small stuff. In Kentucky, for example, many farmers had given up on the state and moved away because the property boundaries on the state's land titles were so unreliable. (Among those who left: Abraham Lincoln's family.)[6]

No place in America was more difficult to geodetically survey than California. Other than intensely variable topography, California was tough country for a geodesist because atmospheric conditions could be wildly different across relatively minor distances. This was substantially due to another of California's challenges: succeeding waves of mountain chains block views of still more mountains, a problem because it was imperative to be able to see high points across long distances to do geodesy. In other words,

the greatest obstacle to mapping the landscape in a way that enabled it to have definable economic value was the land itself.

Davidson's solution was front-page news in the contemporary scientific press.[7] As it would turn out 140 years later, his measurements, enabled by fieldwork conducted between 1879 and 1881, were within ten millimeters of measurements made with today's instrumentation. Davidson's work is considered one of the greatest feats of nineteenth-century geography.

Here's how he did it. First, Davidson proposed to superimpose an enormous virtual quadrilateral across the middle of California, with each of the corners of the quadrilateral being high peaks from which the other three mountaintops were visible. Then, using surveying equipment such as heliotropes and theodolites—more on them later—Davidson's teams would take measurements over distances more vast than any human had made measurements before.

This meant that Davidson would have to identify the four high peaks that would form the tent poles of what would come to be known as the Davidson Quadrilateral. Two of the peaks would need to be west of the Central Valley, and two would need to be east of it, in the Sierra. Choosing the western tent poles was relatively straightforward, even obvious. The first was Mount Diablo, a 3,849-foot mountain east of San Francisco Bay well-known to San Francisco day-trippers and especially to artists such as William Keith, who painted Diablo often. Writers flocked to it, including Richard Henry Dana, Bret Harte, and Thomas Starr King, who summited it with William H. Brewer and a California Geological Survey team in 1862. Starr's description suggests its value to Davidson: "[W]e are thirty miles from the Golden Gate by air line," Starr wrote from the summit. "The tops of streets of San Francisco, here and there, are visible. Turning now to the north we see above the glorious Napa valley, and forty miles away, the pyramid of Mt. St. Helena." That very Mount Saint Helena, a 4,342-foot pile of uplifted volcanic rock at the intersection of modern-day Napa, Sonoma, and Lake Counties (where Robert Louis Stevenson would honeymoon a few months after visiting the mission at Carmel), would become the second of Davidson's four points. The western tent poles were set.

Starr's description of the view to the east, a view that no longer exists due to pollution, suggests Davidson's thought process: "Directly beneath us

are the two great rivers of Central California, the Sacramento and the San Joaquin," he wrote. "Far up to the north, for scores of miles, we follow the receding amber of the Sacramento's tide, branching off into its tributaries. Far to the south we trace the same line of the San Joaquin through plains as bountiful as this earth upholds on her liberal bosom . . . But what guards them on the east? Look at the magnificent barrier; what majesty, what splendor! There you see the wonderful wall of the Sierra, its foothills that roll in huge surges, all reduced by distance to regular slopes of unbroken bulwark. For two hundred and fifty miles the mighty breastwork is in view, and along the whole line crowned with blazing snow!"[8]

Starr couldn't have known it, but he was describing the exact landscape that would fall within the Davidson Quadrilateral. No doubt Davidson or someone on his USCGS team re-created Starr's experience, peered across the valley and into the Sierra, and proposed two Sierra peaks as the corners of the eastern half of the quadrilateral. Round Top, a bulbous peak southwest of Lake Tahoe, seems to have been a straightforward choice for the southernmost Sierra tent pole. At 10,381 feet, Round Top certainly wasn't the tallest mountain in the Sierra, but it was an unusually isolated peak that could be seen from both Diablo and Mount Saint Helena, which was exactly what Davidson needed.

Davidson was less sure of what mountain would work as the northeastern corner, but he thought that Mount Lola, a 9,148-foot peak that is the highest point in the Sierras north of Donner Pass and that provides the northernmost view of Lake Tahoe, might work. Then again, it might not. Davidson lived in San Francisco, knew lots of people who had summited both Saint Helena and Diablo, and may have even been up both mountains himself. But could either be seen from Lola? Could Lola be seen from Round Top? What mountains in between Lola and Round Top would be visible from each peak and thus potentially useful for later triangulation? Davidson appears to have been unsure. His idea seems to have been to ask Watkins to make pictures from Lola and Round Top. Given that Davidson was aiming to do something no one had ever done before, he wanted visual documentation, probably both for planning purposes and to allow him to explain what he was doing to his peers and to Congress, which was paying for all this. Furthermore, Davidson was well familiar with eastern skepticism about the

challenges of western topography. His eastern superiors had discounted the degree of difficulty of the work Davidson and his teams had done before. Watkins's pictures could be variously useful.

Watkins arrived at Independence Lake on July 25.[9] The next morning he lined up Davidson's team in front of their hotel for a group picture, made two quick pictures of Lola from the lake, and began hauling his gear up to the summit.[10] He would make fourteen pictures there.

The best of them is *Lake Independence, from Sphinx Head,* a dramatic vertical composition taken alongside Sphinx Head, a rock formation a few hundred feet below Lola's summit. The tentacular, brushlike shards of igneous rock that make up Sphinx Head fill nearly the entire left half of the picture, with Independence Lake and the gentle, tree-strewn granite valley that holds it seemingly hanging suspended in air in the middle distance. Somehow Watkins imagined a composition that made a lake and a valley over two thousand feet below where he placed his camera look like they were aloft, hovering. The picture is likely to have been better known during Watkins's lifetime than it is now: in 1891 it would be among the first photographs reproduced in a magazine, in *Overland Monthly,* the West's most important literary magazine.[11] (As we've seen, before then the only way magazines could reproduce a photograph was to base an etching on it and then publish the etching.)

There's a certain narrative to Watkins's Lola series, but the strongest pictures are those that Watkins took from the summit or a smidge below it. (Given that Davidson complained mightily about the wind atop Lola, it wouldn't be surprising if Watkins, who needed absolute, perfect calm to make a crisp, in-focus picture, made some of his pictures just below the summit and out of the wind.) Each is a mighty mountainscape, rare American photographs made above a mountain range. Watkins's pictures look toward the three other mountains that made up the Davidson Quadrilateral. One, which features Lake Edna (modern-day White Rock Lake), recreates the direction across the Central Valley over which Davidson's heliotropers focused as they sent and received beams of light from Mount Saint Helena, 133 miles to the west-southwest, and Mount Diablo, 136 miles to the southwest. Two other pictures look 57 miles south toward Round Top.

From Lola, Watkins drove his wagon to Round Top via Carson Pass, elevation 8,652 feet. Instead of continuing over the pass toward the Sierra's

Carleton Watkins, *Lake Independence from Sphinx Head, Mount Lola, Nevada County, California,*
1879. Collection of the Huntington Library, Art Collections and Gardens, San Marino, CA.

eastern slope and Nevada beyond, Watkins turned south into the mountains
and toward Round Top and the lake at its base, Winnemucca. Today a popu-
lar hiking trail runs from Carson Pass to Winnemucca and Round Top; Wat-
kins likely followed the same route. He parked his wagon at Winnemucca,
where he took two pictures of the lake and of Round Top standing like a
squat stump at its far end. Along with the pictures he made at Lower Twin

Lake, they are as close to a mountain pastoral, à la Bierstadt or Keith, as Watkins ever made. From Round Top's watery haunches, Watkins took on the next arduous task: hauling hundreds of pounds of gear up 1,500 feet of steep, often slippery trails to Round Top's summit ridges, where he would make sixteen mammoth-plate pictures and at least six stereographs.

The first person Watkins would have met at Round Top was Louis Sengteller, a USCGS staffer who had been stationed on Round Top for the season, apparently alone, essentially to ensure that signals sent from Mounts Lola, Diablo, and Saint Helena could be received on Round Top.[12] Among the ways Sengteller spent the time was by making a spectacular panoramic pencil sketch of the terrain visible from Round Top.[13] His job had been among the most dangerous of anyone on the team: Round Top is an unusually exposed peak, a quality that made it valuable to the USCGS. From Round Top's summit to Summit City Creek below is a three-thousand-foot, almost sheer drop. The summit ridgeline is only a few feet wide, craggy, steep, and composed of loose rock and sediment. Between the poor footing and the wind that howls across it nonstop, it is a dangerous place to stand, let alone work with surveying gear or a mammoth-plate camera.

There are no first-person accounts of the 1879 Round Top field season. Aside from Sengteller, who was on the mountain in July, survey work at Round Top seems not to have begun until early August.[14] Snows would arrive before the end of September, so the USCGS staffers on the mountain had just six weeks or so to build and fortify the three huts in Watkins's pictures, to set up and use geodetic surveying equipment, and to make and record observations between the four quadrilateral peaks before packing up and getting below Carson Pass before the snows created potentially deadly transportation problems.[15] Each hut had to be placed in such a way that it had its own clear view over the surrounding terrain. Each had to be anchored to a stone foundation that had been laid by hand, no doubt as evenly as possible, to prevent the huts from blowing away. One of the huts, probably the one built on the very top of the mountain, was surely dedicated to the geodetic survey. The others may have been related to other USCGS work. That's a lot to do in six weeks, especially when most of your food and all of your water is 1,500 vertical feet below your work camp.[16]

The fifteen or sixteen mammoth-plate pictures Watkins made on Round Top are stunning achievements.[17] As pictures taken at or near the top of high

peaks, their small peer group includes William Henry Jackson's 1873 pictures of the Mount of the Holy Cross in Colorado, Frenchman Auguste-Rosalie Bisson's 1861 pictures on Mont Blanc, and Watkins's own 1870 pictures from Mount Shasta. First, consider the logistics: How did Watkins get many hundreds of pounds of delicate photographic equipment up to a summit ridge no wider than a couple of dozen feet? (The geographers' heliotropes and theodolites were of a size to be handheld but would have had to be fixed, even in concrete, to be useful on windy Round Top. Watkins's camera was twenty times as large, and he also required a dark tent, chemicals, and heavy glass plates.) Several of the no more than forty-two days Watkins could have been at Round Top must have been devoted to simply packing and moving equipment. One of his Round Top stereographs shows several small wooden boxes, likely some of his gear, stashed in a crevasse in the mountain.

Watkins's pictures show both USCGS operations on Round Top and the surrounding landscape. Even by Watkins's standards, they are perfectly composed. They guide the eye along the steep, precipitous ridgelines leading off Round Top, reveal the dangers inherent in the USCGS having to work on the edge of the treacherous south wall of the peak, and, as at Lola, reveal the dicey footing that must have made USCGS work on Round Top (including Watkins's) slow going. Two of Watkins's pictures show USCGS huts perched on the tippy-top of Round Top, sensitive equipment no doubt inside. One of the huts is likely the main heliotroping structure. Another flanks it, and a third is twenty feet down from the summit, supported by a jerry-built stone structure. Six people, including Davidson, pose along the side of the mountain, many of them holding their instruments. Watkins then walked a hundred or so yards east along the narrow ridge with his camera, plates, and dark tent in tow and made another picture of the summit. From this point of view, Round Top looks like a steeply tapered pyramid that falls to nothingness three thousand feet below, which the mountain, in fact, does. The USCGS hut perched at the top of the mountain is visible, as are the silhouettes of three men, posed standing on the thin ridge beyond the summit, literally on the edge of the Sierra. Eadweard Muybridge is said to have repeatedly made pictures at Yosemite that made it seem as if the viewer is perched above the void, pictures that emphasize topographical terror. These are much scarier.

Many of Watkins's pictures of the landscape around Round Top are con-

Carleton Watkins, *View from Round Top, Alpine County, California*, 1879. Collection of the Beinecke Rare Book & Manuscript Library, Yale University.

ceptual remakes of Lola pictures. They look west, toward Diablo and Saint Helena, and north, toward Lola. The Lola picture, by far the least topographically interesting view Watkins could have taken from Round Top, is the kind of picture that makes you wonder why he bothered—unless there was a USCGS motivation for it.[18] Several other pictures, taken from different parts of Round Top's ridge, look north toward Mount Lola too. Watkins's greatest Round Top view looks west[19] and features a person-as-silhouette walking a mountain-ridge tightrope along the crest of the Sierra Nevada. The picture, of which five prints are known to survive, the most of any Round Top picture, includes a rarity within the Watkins oeuvre: clouds. This is no darkroom trickery. The light-sensitive silver used in the wet collodion process printed blue-violet light well, and at this altitude, blue-violet light dominated, allowing clouds.[20]

As occasionally vertigo-inducing as these Lola and Round Top Watkinses are, did they have scientific value, or did they primarily show off the dedication and eventual triumph of Davidson and his team? No surviving documentation details how they were used. Watkins's pictures may have func-

Carleton Watkins, *View from Round Top Mountain, Cloud Scene, Alpine County, California,* 1879. Collection of the Beinecke Rare Book & Manuscript Library, Yale University.

tioned as a visual resource for the surrounding landscape, a guide that would help Davidson decide where to send surveyors to make measurements in 1880, in 1881, and so on. At minimum, they show the terrifically challenging conditions under which his team—which had to take some of the most precise scientific measurements ever recorded in the United States—was working, and as such, they demonstrated that however expensive Davidson's work was, the expense was a product of those conditions. They also may have been insurance in case the grand experiment that was the Davidson Quadrilateral didn't quite work as Davidson hoped; if his approach to geodetically mapping this challenging part of the West failed, the USCGS would have to climb up a lot of the most outstanding peaks in Watkins's pictures to take measurements and would have to understand where all those mountains were in relation to each other. Accordingly, on prints of pictures taken from the summits, Watkins has identified geologic features such as mountains and lakes; on a picture from Lola, he has noted where Round Top is, even though his camera couldn't pick up an object fifty-seven miles away. If this all sounds pretty basic now, remember: almost all of the

terrain in all of these Watkins pictures was unmapped by anyone, in any form. Even a full decade later, *Overland Monthly* would note that vast stretches of land in this part of the Sierra were still unexplored or unknown except to hunters, let alone mapped.[21]

24

BECOMING AGRICULTURAL

BY THE END OF THE 1870S, only a handful of California mines were still producing at a significant level. That was just as well as environmental degradation was so widespread that the land could scarcely have supported another three decades of all-out mining. The Sierra's once rich forests were now substantially gone, as were forests in the coast ranges. The West's environmental condition was so poor that in the early 1880s, when the California State Legislature asked its Nevada counterpart to preserve some Lake Tahoe–area forests to help boost their shared tourist industry, Nevada replied that the forests on the Nevada side of the lake had already been cut down.[1] The decades of forest elimination had led to massive soil runoff, which in turn clogged the state's rivers with sediment and eventually silted up much of the 1,100-square-mile Sacramento–San Joaquin Delta. Worse, so much hydraulic mining had blasted Sierra foothills into slurry that San Francisco Bay was silting up too. The volume of sediment that oozed into the West's most important and delicate hydrological systems was so enormous that it would take 140 years for it all to clear.[2] California's forests had been consumed so quickly and so thoroughly that some San Francisco investors even looked into planting tree farms in the Central Valley.

Tree farming never happened, but that anyone considered it reveals the condition of California's economy in the late 1870s: Northern California natural resources had been devastated, even exhausted, leaving San Franciscans wealthy. Where was capital to go? Where were the big men of the city to invest? With so much money available, interest rates plummeted. That made large-scale investment in agriculture, a business in which certain plantings would take years to mature, possible. Accordingly, starting in the late 1870s and 1880s, San Francisco investors poured millions of dollars into land and irrigation projects in the Central Valley and in Los Angeles County, the vast area south of the Tehachapi Mountains through which the Southern Pacific had looped and blasted. Before long, California would be the world's most productive agricultural region.[3]

San Francisco capital was not interested in enabling small farmers, at least not now. Jeffersonian agrarianism would live on elsewhere in the United States, but in the West, industrial-scale agriculture would spread as quickly and as deeply as mining had.[4] Naturally, big ag would seek out California's most important image maker in an attempt to include the new agricultural landscapes it was building within the western narrative Carleton Watkins had started establishing decades earlier: beauty meant potential.

Watkins wouldn't entirely give up the odd mining-related work—he would accept three mining-related commissions between 1880 and 1890, jobs that would require him to travel as far as Arizona and Montana—but as the West's economy pivoted toward agriculture, he did too. In the final decade of his career, Watkins would demonstrate that he would be nearly as impactful a photographer of California's new agricultural landscape as he had been of the West's topographical landscape. Having helped make Yosemite and public lands happen, having helped eastern bankers and railroad executives and policymakers understand the West, having helped mine owners attract capital in the East, having helped eastern scientists learn about and explain the new land, Watkins would help California through the last great transformation of his lifetime, its emergence as a national cornucopia. As California's new agricultural regions were almost entirely empty, Watkins's pictures would be the demonstration of promise used to lure easterners to them.

Investors focused agricultural investment in two primary regions: the southern part of California's Central Valley, especially vast Kern County,

and the San Gabriel Valley in Los Angeles County.[5] Kern County's biggest landowners would bring Watkins to Kern in 1880 and 1881 and for several visits between 1886 and 1889. (See the next chapter for the beginning of the Kern story.) Watkins's 1877 and 1880 San Gabriel Valley commissioners would be landowners, a resort operator, and the Southern Pacific Railroad, whose success in building the Tehachapi Loop and the related tunnel system had enabled an explosion of Southern California agriculture. His job in each place would be straightforward: show America that new, unheard-of lands—deserts in Kern and open country in the milder, Mediterranean climate of the San Gabriel Valley—offered productive, valuable farmland.

Starting in the 1840s, Anglo-American settlers had acquired whole Mexican-era land grants in Southern California for use as cattle and sheep ranches, so much so that in San Francisco the region was known as the Cow Counties.[6] By the 1860s, some San Gabriel Valley planters diversified into grapes that they made into wine of the sort a traveler might find at a bad hotel, and by the 1870s many had planted fruit trees and were producing fruit brandies. Beyond assigning the region a derisive nickname, few Californians north of the Tehachapis gave Los Angeles much thought until the mid-1870s, when the Southern Pacific had realized that a Southern California road was necessary to keep a rival transcontinental, the Texas & Pacific, out of California. Once completed, the Southern Pacific enabled the realization of the Southland's agricultural potential: suddenly, whatever planters might grow in the San Gabriel Valley could be loaded on Southern Pacific trains and be at market in San Francisco in twenty-three hours or, alternately, in the many markets east of the Mississippi River just a few days after that. The railroad transformed Los Angeles County, and later Kern, from remote ranchland into an agricultural boom region. For example, in 1875, the year before the railroad arrived, the San Gabriel Valley produced 1,300,000 gallons of bad wine. By the end of 1889, when the Southern Pacific network was in place, it was producing eleven times as much, including high-end brandy and liqueurs that were coveted from coast to coast. Even better, San Gabriel growers could ship high-margin fresh fruit all over America and to Europe.[7] Then, about the time the railroad arrived, San Gabriel Valley landowners discovered that they were sitting atop an enormous reservoir of underground water. Incentivized by the railroad's arrival, they invested in hundreds of artesian wells. Some landowners even invested in a

brand-new technology: iron piping that could efficiently irrigate their fields. All that water meant a dramatic improvement in the quality of what Southland planters could grow, in the range of flora that could be grown, and in the value of their land. In the 1860s, Southern California land could be had for the government rate of $2.50 an acre.[8] After the railroad arrived, the most inexpensive land spiked to $25–$50 an acre, and high-quality, well-watered farmland ran as high as $300–$500.

We don't know who first brought Watkins to the San Gabriel Valley in an effort to further the boom, but the leading candidates are a landowner and politician named Benjamin Davis Wilson and John Muir's friends Ezra and Jeanne Carr. The Carr's acreage may have been the first thing Watkins photographed upon arriving in the San Gabriel Valley. The Carrs were new Californians: they'd come here with the Indiana Colony, a group of midwesterners who were establishing an agricultural cooperative in the valley. Watkins took dozens of stereographs of Indiana Colony land in Pasadena, the town the colony founded, including pictures taken from the Carrs' front yard. (Jeanne Carr herself seems to be in the lower-right corner of one stereograph.) Jeanne promoted Watkins's work in an article in the *Pacific Rural Press*,[9] the most important agricultural publication in the West.

While Watkins may have visited the Carrs first, it's more likely that Wilson was the 1877 Southland trip's primary client.[10] Like most of the Southland's first Anglos, Wilson was a southerner, a Tennessean. He had come to California as a fur trapper in 1841 but soon fell in love with both the land and with Ramona Yorba, the daughter of a wealthy Mexican landowner. After they married, Don Benito, as he would now be called, started buying up San Gabriel Valley land as far east as modern-day downtown Riverside and as far west as today's Beverly Hills and Culver City, and along the Pacific Ocean in San Pedro and Wilmington, where he was the power behind what would become Los Angeles's port.

It was Don Benito who established the agricultural prestige and wealth template that the rest of the first couple of generations of Southlanders followed: Wilson started ranching cattle and sheep in the 1840s, moved on to growing wheat, graduated to orchards and vineyards, and finally diversified and cashed in by selling farm plots. The problem was that there weren't enough wealthy-enough people nearby to sell land to. In 1870 only fifteen thousand people lived in all Los Angeles County, an area only a smidge

smaller than Connecticut (which was home to thirty-five times as many people). In response, the planters improvised the system in which Watkins would participate. First, they farmed as much of their own vast acreage as they could manage. They planted it with fruit trees, grapevines, and nuts, and they supported it all with infrastructure that would box and ship fresh fruit to market via the newly arrived Southern Pacific Railroad, and with wineries and distilleries, which would produce nonperishables that could be shipped longer distances. Needing to host the upper-middle-class people who could be encouraged to ride the Southern Pacific to see the land they might buy, the planter class built Sierra Madre Villa, the Southland's premier resort; Watkins was brought in to take pictures of the planted land, the empty land, the resort, the wineries, the distilleries, and so on.

We can trace the planters' narrative in Watkins's pictures. The few mammoths Watkins made in the Southland, such as a picture of a freshly planted orchard at Don Benito's Lake Vineyard estate, make clear the importance of showing the promise of the place and its enormous size. In this picture the trees-to-be were planted in rows that obviously extend far to the left and right of the captured view. Watkins leads the eye right up to the looming mountains, which makes for a spectacular picture and also hints at the source of the water for all those trees. (Oh, by the way, one of Don Benito's businesses was the Lake Vineyard Land and Water Co., which sold not just land to new settlers but water too.) Needing to provide context for these tiny trees, in one picture Watkins sent a man, possibly Don Benito himself, to walk through the future orchard. As Lake Vineyard was also the Southland's biggest tourist attraction, no doubt Don Benito kept a range of Watkins stereographs on hand—some of towering fruit trees, some of empty land, some of both—ready to hand out to remind land shoppers of their visit. (Wilson died in 1878, but his son-in-law and heir, J. de Barth Shorb, took over Lake Vineyard. In 1880 Watkins would make work for Shorb too, including an excellent stereo of thick grapevines with an orange grove beyond and a grand two-story house on a hill in the background.[11])

The eastern visitors-cum-land-investors the landowners were trying to attract needed somewhere to stay, so William F. Cogswell built the magnificent Sierra Madre Villa. It was immediately acclaimed as the grandest hotel in the region, its only rival being the Arlington in Santa Barbara (which Watkins had photographed in 1876). Only the wealthiest easterners could afford

to visit: at a time when a six-room house back east rented for $8 a month and when a schoolteacher earned $200 a year, a round-trip to California via the railroad cost $300 and a fortnight at the Sierra Madre cost $30. By 1880, as both the railroad and the resort owners in the San Gabriel Valley realized that it was in their interest for middle-class tourists to come to the region, to be enchanted, and to purchase land and plant orchards, the Sierra Madre expanded, its prices dropped, and additional hotels opened.[12] Watkins's 1877 and 1880 mammoth-plate pictures of Sierra Madre Villa show it tucked into the foothills at the base of the mountains that formed the northern edge of the San Gabriel Valley. It sat at 1,800 feet above sea level, ensuring pleasant year-round temperatures, and offered visitors music and billiard rooms, a spa, cactus and rose gardens, and access to mountain trails in the San Gabriels. One of the trails followed newfangled iron pipe back into the mountains until it reached the spring whose water fed Cogswell's orchards, and another went to an apiary, a demonstration that the growers had brought in bees to pollinate a previously empty land. Visitors were taken on tours of the homes and estates of the region's wealthy growers and land-owners; they would walk through sweet-smelling orchards; they would be fed local oranges or candied lemon peel and be offered almonds, entertained over local wine and brandy, and served steak that had once been local cattle. When guests returned to Sierra Madre Villa, at which point they must surely have known they were returning to a combination tourist resort and land agency, they could take in a magnificent view down the sloping valley toward Los Angeles. Fifteen hundred orange trees filled the foreground with a verdant green before giving way to hundreds of thousands of acres of undeveloped land. (Hint, hint.) If that wasn't enough, Sierra Madre and the landowners doubtless made available to visitors the dozens of stereographs Watkins had made of the landscape through which they had just toured. Here is why Watkins was making a lot more of the smaller, cheaper work here than he was mammoth-plate work: the landowners wanted visitors to be able to tuck Watkins's views of their available land into their luggage. Stereographs were easy to pack, mammoth-plate pictures weren't.

The self-referencing loop of fruit growing, tourism, and land sales was led by the biggest, oldest San Gabriel growers and by the Southern Pacific. Watkins worked for nearly all of them. For example, Shorb was on the editorial committee of the Southern California Horticultural Society, a consortium of

Carleton Watkins, *At the Residence of Leonard J. Rose, Sunny Slope, Los Angeles County, California,* 1877. Collection of the Huntington Library, Art Collections and Gardens, San Marino, CA.

San Gabriel Valley landowners and planters that served as a local landowners' association, a clearinghouse of agricultural information, and a chamber of commerce and that published the magazine *Semi-Tropic California.* The landowners regularly wrote articles for *Semi-Tropic California* that extolled their plantings, their orchards, the prices their fruit brought at market, and the quality of their fruit, wine, and brandy. Their stories were illustrated with engravings based on Watkins's pictures. Next to the articles were advertisements offering land for sale. Nearly every ad offered land at "favorable terms": a down payment of one-fifth of the total, the rest on "easy terms and low rate of interest" of 10 percent.[13] The advertisements featured engravings from Watkins pictures too. One of them was an ad for the Sierra Madre Villa. Rooms at the Sierra Madre Villa were stocked with issues of the magazine. In the San Gabriel Valley, everything folded over everything else, and quite often the paper being folded was a Watkins picture.

The Southern Pacific Railroad was key to all of this, through its land office, its affiliated boards of trade, and its own land agents. The Southern Pacific seems to have handed out Watkins stereos at fairs and expositions in

Carleton Watkins, *Sunny Slope from the Wine Buildings, Los Angeles County, California,* ca. 1877–80. Collection of the Huntington Library, Art Collections and Gardens, San Marino, CA.

the Midwest, South, and East, places where the railroad built huge displays promoting valley land sales. These displays typically included Watkins's mammoth-plate pictures of the Southland, piles of fresh fruit, cuttings from trees, and more piles of fruit. The displays would have been staffed by salesmen who would explain that while San Gabriel Valley land was more finite than midwestern land, a five-acre citrus farm in California could return the same profit as a two-hundred-acre wheat farm in Illinois. Orange trees might take seven years to mature, but the recent post-mining-era decline in interest rates allowed for patience. Three orange harvests would be enough to pay back the entire principal borrowed.[14] It all worked so well that it prompted what journalist Carey McWilliams called "the great Anglo invasion of Southern California."[15]

Watkins saved his best San Gabriel Valley pictures for a grower, vintner, distiller, and horseman named Leonard J. Rose. He was the proprietor of

Carleton Watkins, *Sunny Slope Wine Buildings [and Distillery]*, ca. 1877–80. Collection of the Huntington Library, Art Collections and Gardens, San Marino, CA.

Sunny Slope, an estate that grew oranges, almonds, walnuts, and especially grapes for a range of wines. In the late 1870s, Rose already had 530 acres of vineyards under cultivation, but a European blight and the expectation of opportunity to fill that market encouraged Rose to double his acreage and to expand his wine-making business by buying grapes from nearby estates, such as from Shorb, former Comstock miner turned land baron "Lucky" Baldwin, and George Stoneman (all of whose estates Watkins made pictures of). Don Benito may have been the valley's wine-making pioneer, but by the mid-1870s, Rose was the area's biggest and best-known vintner. "I presume that there are no places in the State of California better or more widely known than Sunny Slope," reported Benjamin Truman in an 1874 guide-book, conveniently forgetting Yosemite and all of San Francisco. For Truman, Rose's estate was the valley's most impressive: it required thirteen miles of fencing to enclose 135,000 mission grapevines and 45,000 more

vines of European varieties, plus 100 lemon trees, 350 walnut trees, 6,000 orange trees (some of which ran for more than a mile bordering an avenue south of the main house), and soon more.[16]

Watkins made more work for Rose than for any other San Gabriel grower. The finest pictures Watkins made in the San Gabriel Valley are in an album he titled *Sunny Slope, San Gabriel, Cal.*[17] Each of the twenty-seven circular pictures is a prime example of Watkins's sensitivity to landscape and his ability to build compositions from it. They show freshly planted orchards-to-be, mature orchards, irrigation systems, Sunny Slope's world-famous distillery operation, and even several of Rose's favorite horses. It may be the single best surviving document of life on the great San Gabriel estates. The album even includes a prime example of the kind of visual wordplay Watkins loved. It's a picture of one of Rose's horses, Sir Guy, facing away from the camera, his hindquarters shining in the bright midday sun. It's the last picture in the album, the end.

By the early 1890s, the midwesterners and easterners that Watkins's pictures helped attract had built some of the most productive farms in America. It was the beginning of decades of broad prosperity. By the early twentieth century, the eastern edge of the region's brand-new county of Riverside had the highest per capita income in the United States.[18] Watkins's manufacture of beauty in an effort to indicate the potential of a vast, often empty landscape had worked.

In these same years, California's photography business was changing. Prices a gallery such as Watkins's could charge for stereographs, the mass-market, low end of the market, had plummeted.[19] This meant that Watkins's highest-margin consumer product was nowhere near as lucrative as it had been in the 1860s and 1870s. Furthermore, while Watkins had always tried to compete with painters in terms of his subjects, his compositions, the size of his prints, and the way he exhibited his pictures, his customer base had become wealthy enough to acquire and hang the most expensive oil paintings. James Ben Ali Haggin, one of the leaders of the pivot toward industrial agriculture, was a case in point: he almost certainly commissioned hundreds of Watkins pictures in the 1880s, but as an art collector, he was most interested in French academic painting and big Albert Bierstadts.

Historians have generally assumed that Watkins's gallery sold far less in

the 1880s than in the 1870s, but in truth, we don't really know. Yes, fewer prints of the late 1870s and 1880s pictures exist than of the 1860s pictures, but that doesn't *necessarily* mean that Watkins sold less now than then. For one, the earlier work seems to have been more likely to survive because it was often sold in albums, a durable form that seems to have entered institutional collections early, thus ensuring its preservation. That could be as much a reflection of how photography, once a hot new thing, was valued in the 1860s vis-à-vis in, say, the 1890s, early in the Kodak era. Little scholarship has been done regarding exhibitions and potential international sales from any part of Watkins's career, but especially not during this period. Certainly Watkins returned to being internationally active in these years: with his gallery back on solid footing thanks to William H. Lawrence, Watkins again sent work abroad, such as to the Melbourne International Exhibition, the first world's fair held in the Southern Hemisphere.[20]

Even with all the usual travel, Watkins was still spending plenty of time on and in his gallery. We know this because around 1880 or 1881, he seems to have begun an affair with one of his employees, a woman in her early twenties named Frances Snead.[21] Watkins called her Frankie. Born in New York and raised in Nevada, she was the daughter of Frank H. Sneade, a Carson City–based watchman on the Virginia & Truckee Railroad.[22] The other details of her life and her involvement with her boss are cloudier: according to Julia Watkins, her father and mother married on Watkins's fiftieth birthday, November 11, 1879, in San Francisco's First Presbyterian Church.[23] While no marriage license has survived, that information appears to be false: the 1880 federal census lists Frankie as living as a boarder in the home of Alexander Hoy, the proprietor of a hardware store, and as working "in [a] photography gallery," surely Watkins's.[24] Watkins and his wife appear to have lied to their daughter to mask the truth: Watkins was sleeping with the help, got her pregnant, and married her on an unknown date. When Julia was born in 1881, Watkins was about to turn fifty-two, and Frankie was twenty-three. A boy, Collis—perhaps named after Collis Huntington— would follow in 1883.

Most of Watkins's surviving letters are correspondence with Frankie. Many are undated. None of her letters to him survive. Watkins historians have often taken these tiny snippets of what would turn out to be a thirty-seven-year marriage and have inferred an understanding of their relation-

ship. In truth, we just don't know what their relationship was like, how it worked, or if it worked. Sometimes Watkins issues crisp business-oriented commands to Frankie in his letters, sometimes he's tender and encouraging. He appears to have been a devoted, loving father. He knew his work required significant travel, he knew it was hard on his wife and children, and he felt somewhat guilty about it. He tried to update his wife on his daily goings-on while he traveled. Beyond that, we just don't know.

Kern County receives less rainfall each year than the Gobi Desert.[25] Such was the hubris of San Francisco's nineteenth-century men of means that they believed that Kern could become fertile farmland. Such was their determination, persistence, and depth of capital that it did. One hundred and forty years after San Francisco investors began what might have been the most audacious agricultural experiment in American history, Kern ranks only behind nearby Fresno County as the most productive agricultural district in the United States.

California's transformation from a mining state into an agricultural power, into the state whose agricultural production doesn't just lead the nation but whose crops are worth 70 percent more than the no. 2 state, began with the construction of an extensive canal-and-ditch system throughout Kern's desert and continued with the wholesale reengineering of the Central Valley on the Kern model.[26]

Watkins was deeply involved in Kern's transformation. He would make over seven hundred pictures here in both mammoth-plate and dry-plate medium formats.[27] (The new dry-plate technology is discussed in chapter 26.) He participated in the landmark court case that determined who would control the water in the rivers that flowed into Kern County, and he was involved in showing Americans that such was the might of determined westerners that they could make the desert bloom and that any American could benefit from it. Only the San Francisco investors behind the transformation of Kern and maybe their hydrologic engineers were as fundamental to the Kern story as Watkins. However, thirty years into his career, neither he nor other photographers knew or understood how to establish their worth to an enterprise such as that in Kern; not only did Watkins not make the fortune his co-conspirators did, by the end of the Kern project he would be sixty years old, exhausted, and at the beginning of a decade of acute phys-

ical decline. His final project in Kern, completed in 1889, would be the last great work of his life. Watkins helped make Kern, and Kern broke him.

Kern's transformation into a global agricultural powerhouse started by accident. On Christmas Day 1863, a Kern County farmer named R.M. Gilbert realized that the Kern River was approaching flood stage, that it was running so fast and so high that it would soon swamp his home. Gilbert and his family fled, and the house flooded. The Kern Christmas flood of 1863 was the product of an unusually strong autumn snow in the southern Sierra Nevada that was followed by an early winter snowmelt. The timing of the thing was weird, but the Kern's flooding was not: the river descended a stunning 13,000 feet from its headwaters around Mount Whitney, down 165 miles of mountain and southern Central Valley terrain, before ending at Buena Vista Lake in western Kern County. What was unusual was what the Kern River did once it reached Gilbert's homestead.

Shortly before Christmas, Gilbert had allowed a neighbor to dig a ditch around Gilbert's home to the neighbor's farm, about a mile away. Kern farmers routinely extended this kind of courtesy to their neighbors; without the ditch, Gilbert's neighbor would have had no water and no farm. (There were only about 4,500 people in the southern third of the Central Valley, so neighborliness mattered.) When the Kern flooded on Christmas night, it rushed into the ditch that Gilbert's neighbor had built. The force of the water scored the ditch deeper and carved it out wider. It all happened so fast that no one thought much of it until a few days later, when everyone around Gilbert's home realized that the Kern River had found a new and permanent pathway to Buena Vista Lake. Only a small volume of water was left in the previous riverbed.

While Gilbert and his neighbor thought this was weird, a man named Thomas Baker realized that it was a once-in-a-lifetime opportunity. Baker knew that in 1857 the California legislature had passed a law that would grant tens of thousands of acres of swampy Kern River bottom to anyone who "reclaimed" it, that is, to anyone who drained it to make it fit for farming. Baker realized that the land the legislature had specified was downriver from Gilbert's farm, and that as the Kern River had just made an abrupt turn via Gilbert's neighbor's ditch, it was no longer feeding that swampland. Baker hired thirty Native Americans as fast as he could and sent them to build a headgate just below Gilbert's property, across the old bed of the Kern River, thus ensuring that the river couldn't change its mind and return

to its old route. Then Baker wrote a letter to California's governor and surveyor general declaring that he had reclaimed land as offered by the 1857 bill and was entitled to a land grant of about ninety thousand acres. When a year of drought followed the unexpected 1863 Christmas flood, Gov. Frederick Low had little choice but to grant Baker the title to the land.[28]

Meanwhile, up in San Francisco, big-city capital took note. At least a dozen San Francisco investors all realized the same thing at about the same time: if southern Central Valley land, probably the cheapest acreage in America, could be reclaimed for agriculture, imagine the profits that could be made in cattle, sheep, pork, wheat, and everything else needed to feed the arid West's growing population. As usual, the San Franciscan smack-dab in the middle of it all was Bank of California majordomo Billy Ralston. He and Darius O. Mills would invest in irrigation companies in the Central Valley but would run out of money before they could see them through. Over the course of nearly two decades, two investment groups would come to own almost all of Kern County's potential farmland. Each would employ Watkins, first in an effort to make their claims to Kern River water, and then to help market their land.

One group consisted of Charles Lux and Henry Miller, ranchers and meatpackers whose early butcher shop had been around the corner from Watkins's first gallery and whose Peninsula cattle ranch bordered Mills's Buri Buri. Miller & Lux, as their partnership was known, would eventually own 1.25 million acres of land in three western states and, through their control of corresponding water rights, would control land many, many times that size. Theirs was the only agricultural corporation that ranked among America's top two hundred nineteenth-century industrial enterprises.[29]

The other syndicate was dominated by James Ben Ali Haggin, who had made his first fortunes in mining. When he wanted to diversify into land and irrigated agriculture, Kern was the obvious place, especially because Haggin's business partner was a slickster named Billy Carr, a Republican political hand with close ties to the Southern Pacific. Haggin and Carr used inside knowledge of railroad land grants and the 1877 Desert Land Act to buy up hundreds of thousands of acres of Kern. Among the lands Haggin bought up was the plot that started it all, the ninety-thousand-acre grant that Thomas Baker claimed after the Christmas flood of 1863.[30]

This all meant that Kern, a desert county of climatic extremes inhabited by just a few thousand hearty souls, was dominated by two absentee landowners with vastly different business models. Miller & Lux planned to irrigate their land so as to grow alfalfa and raise cattle. Haggin also wanted to irrigate Kern, but he planned to subdivide it, sell off farmland to settlers, and then sell water to those same settlers. Because the two groups shared a landscape but had starkly different business plans, conflict was inevitable. In 1877, by which point Haggin controlled almost every irrigation ditch leading from the Kern River, he cut off water to the Miller & Lux land. As a result, the alfalfa fields Miller & Lux had planted withered, and the ten thousand cattle that were relying on that alfalfa died of starvation. Miller & Lux and other Kern farmers and investors sued Haggin over who controlled Kern River water. Whoever won the case would become the biggest, most powerful land baron in the United States.[31]

The resulting court case, *Lux v. Haggin,* consolidated nine plaintiffs, eighty-six canal corporations and ditch owners, and seventy-six different lawsuits and would rage for almost a decade.[32] It would become a case that still determines water rights in much of the United States and thus probably the most important court case in western history. When the California Supreme Court ruled on it in 1886, the decision was two hundred pages, its longest ever.

Lux v. Haggin is far too complicated to address in detail here, but it hinged on whether Kern River water was controlled on a first-come, first-served basis, or whether it was controlled by those through whose property it ran.[33] The cause of the conflict was the California Constitution and a subsequent state statute, which enshrined both rights into law. Over the course of the case and many appeals, both sides seem to have made both arguments, but the simplest way of boiling down their cases is this: Miller & Lux claimed Kern River water by riparian right, English common law that said that landowners on a river—that is, whose land touched the river—were entitled to the water in that river. Haggin argued that he had the right to Kern River water through prior appropriation, that it was his because he got there first. The case was argued over the course of forty-nine days in the spring and summer of 1881, in two counties. (When the Kern summer became too hot for the attorneys, they moved the trial to San Francisco.) Attorneys for both sides passed the long days by whittling shingles of red-

Carleton Watkins, *Mouth of the Kern Canyon, Kern County, California*, 1881. Collection of the Huntington Library, Art Collections and Gardens, San Marino, CA.

wood, and one kept a potato in his pocket for good luck. When he became agitated, he would wave the potato at the witness he was questioning. One of the witnesses at whom he may have waved it was Carleton Watkins.

Watkins's client here was Miller & Lux, which commissioned a series of mammoth-plate pictures Watkins most likely started making in 1880, on the trip that also saw him visit Arizona Territory and the San Gabriel Valley, and probably finished on a separate trip, on January 9–11, 1881.[34]

Watkins made fifty-one mammoth plates of and related to Kern County agriculture in the 1880s. As the original court records, including those detailing which Watkinses were introduced in *Lux v. Haggin,* are long since destroyed, apparently by an 1889 fire that destroyed much early Kern County material, it's impossible to know which pictures were commissioned by Miller & Lux and which were later work.[35] Adding to the complication, during the trial, lawyers asked Watkins about at least nine Watkins-produced exhibits. As one of them may have been a three-picture panorama and others two-part panoramas; and other pictures may have been made and submitted as evidence but not discussed; and still others may have been part of the appeals process; and as other Watkinses seem highly likely to

have been introduced as exhibits with persons other than Watkins on the stand, it's impossible to know which of Watkins's pictures of the Kern River and early Kern canals and ditches were taken for Miller & Lux.

However, the case offers testimony and clues which, to today's ear, suggest both specific pictures and their utility. One of the issues in the case was who was using the "real" waterway, the Kern River as it "naturally" flowed. Haggin's attorneys argued that Haggin was—after all, hadn't the Kern River followed R.M. Gilbert's neighbor's ditch of its own volition back in 1863 and thus flowed onto Haggin land? Miller & Lux attorneys countered that they wanted to use the river as nature intended it, a tidy bit of locution that suggested that diversionary ditches were more hand of man than hand of God. As finite, even preposterous, as this all sounds now, at least it gave us Watkins's six magnificent views of the Kern River exiting the Sierra via the Kern River Canyon, the point where the Sierra gives way to the Kern desert. Even today, after many generations of hydrologic engineering, road construction, and whatever else, it's a thrilling place—tall, narrow, steep, dark, full of rushing danger. Watkins's pictures seem to have been made to establish a narrative of how the river naturally flowed, at least from Miller & Lux's point of view. The first one shows the Kern entering the Central Valley at the western edge of the Kern River Canyon, a spectacular rock formation that rises two thousand feet above a narrow opening out of which the river transitions from the mountains into the Central Valley. Watkins took the picture from a hill just west of the Kern's exit from the canyon, at an angle that suggested how narrow the river's escape from the mountains is. Trees dot the riverside, but desert is plainly evident. Even today, this picture of a rich river pushing through desert is striking. The rest of the presumed series follows the river away from the canyon and out into Kern County, demonstrating what Miller & Lux argued was the nature-cut flow of the river.

Watkins's testimony focused on his pictures of two features: Buena Vista Slough, also known as Buena Vista Lake, and the Calloway Canal, a major canal off the Kern, which was begun by a private company Haggin bought out in 1876 and which he completed. The heart of Miller & Lux's argument was that Haggin had used canals, most especially the Calloway and a vast network of smaller canals and ditches linked to it, to prevent water from reaching the Miller & Lux lands, especially around Buena Vista. Accordingly, Watkins made low-angle pictures of the Calloway Canal, pictures in which

an abundance of water fills most of the picture, lots of water, all of it being directed, redirected, or cut off by Haggin's system of gates and weirs. They're not Watkins's best pictures, but they showed what Miller & Lux needed shown. (Watkins would return years later to make better pictures of the same canal.) Watkins also made a three-part panorama of Buena Vista Lake/Slough that would have been intended as a rejoinder to the Calloway Canal pictures: the panorama shows a dried-up waste area in which the edges of onetime lake or marshland are clearly evident. Along where the Kern River had flowed into Buena Vista, a viewer, especially Judge Benjamin Brundage, could readily see trees that remained, expectantly, hoping for the Kern to return. Brundage was no doubt meant to think, *Oh, I've seen trees like that before, in the series of pictures by which the bounteous Kern River exited Kern River Canyon. This, of course, is the river's natural flow.*

However, that is not what Brundage thought. Near the end of 1881, he ruled for Haggin. (An 1888 map shows that Brundage owned about 1,600 acres of land split between two plots south of Bakersfield. Haggin's Kern Island Canal flowed through part of Brundage's land.)[36] Miller & Lux appealed. In 1884, the California Supreme Court overturned Brundage's ruling and sided with Miller & Lux. (For reasons that are not clear, the ruling was not posted in Kern County until the spring of 1886.) It is unclear whether Watkins's pictures played a role in the decision (or if Gilded Age graft played a role).[37] Haggin wasn't done: he pursued changes to state law in Sacramento and could have appealed to the U.S. Supreme Court. But at this point, after seven years of fighting, of valuable land investments being held in limbo, it was in everyone's interest to settle. Miller offered Haggin a deal, a partnership by which the two of them would build an upstream reservoir on the Kern that would provide enough water for both of them. And so they did.

For Watkins and for Miller & Lux, that was it: Watkins had made the work they needed, work that may have helped them win. They went back to raising cattle and selling meat. Haggin still planned to subdivide his hundreds of thousands of acres into small farms and then sell both land and water. Once the case was settled, apparently in late 1886, Haggin sought out the artist who, for twenty-five years, had been showing America what could be done in the West to help him offer Kern County to a still westering nation. In the meantime, Watkins took a few years off from making photos related to agriculture to continue restocking his gallery.

25

TRAVELING THE WEST (AGAIN)

WHILE LUX V. HAGGIN ground through appeals and while William H. Lawrence was running Carleton Watkins's business at the corner of Montgomery and California Streets in San Francisco, Watkins was free to do what he did best: travel the West making pictures. In the five years between testifying in *Lux v. Haggin* and returning to Kern County, Watkins went to Oregon, Washington Territory, and British Columbia, to Monterey, to nearby Santa Cruz County, and to what is now Yellowstone National Park and possibly to Montana. There's no single reason for nor any real organization to Watkins's work in this period. He simply went where clients wanted him to go. As we've seen elsewhere in Watkins's career, work he made for a single client rather than primarily for gallery sale tends to be the work about which we know least. Accordingly, this is the most mysterious period of Watkins's career.

Some of the work is readily explained. The photographic record and a couple of slips of paper strongly suggest that Watkins went to Portland and the Columbia River Gorge in late 1882 to replenish his stock of gorge pictures, to remake views that were now being sold by his rival Isaiah Taber. Perhaps thanks to Lawrence's able stewardship of his gallery, Watkins seems to have been riding high: he stayed in Portland's grandest hotel, the Es-

Carleton Watkins, *Summit of Mount Hood*, 1882–83. Collection of the Oregon Historical Society, Portland.

mond, the same hotel at which President Rutherford B. Hayes had stayed when he visited Portland a couple of years earlier.[1]

While Watkins traveled in style, it didn't always help the work. The first pictures he took of Columbia River Gorge features, in 1867, are better pictures than the 1882–83 remakes. Among the few triumphs of the 1882–83 Pacific Northwest trip was a picture Watkins made of Oneonta Gorge, an extremely narrow, high-walled canyon through which Oneonta Creek flows into the Columbia River, just to the east of Multnomah Falls.[2] Watkins's picture is soaked in historical time, the twenty-five-million-year-old basalt flow from Mount Hood that created the land, the millennia of running water that eroded the basalt and made the gorge, the cedars that found enough soil atop the basalt to take root and grow, and the enormous trees that fell and piled up at the base of the gorge. The picture suggests that Watkins had paid close attention to his scientist friends over the years and had learned from them. Perhaps because it exists in only two untrimmed prints, at the Hearst Museum of Anthropology at the University of California, Berkeley, and at the Oregon Historical Society, it is Watkins's least-known great Oregon picture.

The other best new pictures Watkins made in Oregon in 1882–83 also spotlight geological process. The most remarkable picture is *Summit of Mount Hood from the Hood River Ascent,* which reveals that the fifty-four-year-old Watkins climbed much of the way up the mountain to get a picture that it had not been possible to get with a mammoth-plate camera in 1867. The picture seems to capture geological processes suspended in time, mountain-making lava and mud and snow and ice stopped for Watkins's camera.

Back down at river level, Watkins made more natural-processes-revealing pictures of the head of The Dalles, the series of waterfalls and rapids that rendered the Columbia River impassable around the town of Celilo. In the 1950s, the Army Corps of Engineers built The Dalles Dam, which submerged Celilo Falls and the rest of the water-carved basalt features along the Columbia. Watkins's 1882–83 pictures of The Dalles and the Indian village at Celilo are the greatest surviving images of a remarkable waterscape and the clearest pictorial suggestion of how the entire Columbia River Gorge was formed. Watkins also made a seemingly impossible medium-format picture of how man was beginning to remake the Columbia River to suit his own purposes, a picture of Columbia River rocks being blown up so as to clear the channel for easier transport. Watkins captured the moment just after detonation; a watery firework runs from the river to the top of the picture.

Watkins continued on to Washington Territory, to where the Northern Pacific, the northernmost and final transcontinental railroad to be built, met Puget Sound; there he made twenty-four mammoth-plate pictures. He went on to Victoria, British Columbia, where he made six more. Further sign of his relative affluence in these years is in the sole surviving record of how he worked in Seattle:

Mr. Watkins of the Watkins' Photographic Gallery of San Francisco, took some very fine views of the city from Denny's Hill in the northern end of town and from the Coal Wharf in the south end. By erecting a platform twenty feet high on Denny's hill he got a very good view of Lake Union on one side, and Puget Sound with the Coast range in the background on the other. We were shown some of Mr. Watkins' work, which we consider very good. He goes to Olympia tomorrow to take views in and about the Capital city.[3]

They're competent pictures of port facilities, mills, freshly built towns, railroad bridges, and so forth. None of them ranks among Watkins's best work. Few pictures or trips in Watkins's entire career remain as puzzling as these. Why did he go to Puget Sound and British Columbia? Was there a client? Or was Watkins simply traveling to population and commercial centers, hoping that business owners would want pictures of their operations? Unlikely. In Washington and British Columbia in 1882, the client remains a mystery.

Most likely Watkins went to Washington Territory for reasons related to the Northern Pacific Railroad, which would run west from Duluth, Minnesota, and which was completed in 1883. Northern Pacific tracks and facilities figure in many of Watkins's 1882 Washington pictures. Perhaps the pictures were commissioned by Frederick Billings, who had been a steady Watkins patron and customer in the early to mid-1860s and who continued to advocate for his work even after he returned to Vermont and the East, in fits and starts, in the mid- to late 1860s. Billings was a longtime Northern Pacific director and worked as the company's president from 1879 to 1881, when he lost control of the company to Henry Villard. None of Billings's surviving correspondence ties him to Watkins's 1882 pictures, but Billings seems to have saved only correspondence with men he considered to have been his business peers. (A thorough snob, Billings thought of craftsmen or artists or tradesmen as being many stations below his own rank.) Even though Billings lost control of the Northern Pacific in 1881, he seems to have retained enormous landholdings and other property interests along the railroad line, especially in Tacoma and around the Northern Pacific–affiliated Puget Sound ports that Watkins photographed. It's possible that Billings commissioned Watkins to make pictures related to real estate and not the railroad. Another possible commissioner was John C. Ainsworth, the former Billy Ralston confidant who founded the Oregon Steam Navigation Co. and who was now a Northern Pacific director; he remained involved in transportation and land throughout the Pacific Northwest. We just don't know.

Since nearly the start of Carleton Watkins's career, his work had motivated Americans to visit California. His first major subject was John C. and Jessie Benton Frémont's Las Mariposas gold-mining estate, California's first major

tourist draw. When his 1861 pictures of Yosemite were exhibited in New York, easterners began to make the arduous journey across the oceans to see the place for themselves. California's third significant attraction was the Sonoma County geysers, steam vents near Mount Saint Helena, an attraction Watkins helped further by photographing the area in the late 1860s. And once the transcontinental railroad was completed in 1869, tourists made up a crucial part of the market for Watkins's work—the reason Billy Ralston seems to have wanted to help move Watkins's gallery across the street from his new south-of-the-Slot hotel, where it was a bridge from San Francisco's downtown. So, in the 1880s, when the Southern Pacific built the most spectacular resort in the West in Monterey, California, the "Queen of American Watering Places," naturally it wanted Carleton Watkins to do for the new Hotel Del Monte what he had done for so much of the rest of California.[4] Once again Watkins would play the key role in presenting the latest West to America.

The Del Monte, four hours from San Francisco by a special "lightning express" train, was a spectacular, opulent resort. Hubert Howe Bancroft's 1882 guidebook called it "one of the most complete buildings on the continent for the accommodation of pleasure-seekers." The main hotel was three stories tall, had rooms for four hundred guests, and was built in the "modern Gothic" style (which seems to have meant that it had wooden highlights and large windows with occasional pointy parts).[5] It had its own private gasworks for light and heat, its own well, a bar, separate billiard rooms for men and for women, a smoking room, a stable with room for over sixty horses, shuffleboard, swings, croquet plats, archery, lawn tennis, and a grand dining room (plus a separate dining space for "children and servants"). The Del Monte was mighty proud of its indoor bathing pavilion, which housed four heated saltwater swimming pools holding a combined 275,000 gallons of water. All of that was nice enough, but who came to California to sit around indoors? As the Southern Pacific's favorite guidebook writer, Benjamin Truman, noted, "There is an even temperature [here] that can be found nowhere else. From January to December . . . there is really neither summer nor winter weather. Indeed, the weather at Monterey, from one year's end to the other, partakes of that delightful interlude known in the East and South as Indian Summer." Therefore, the Del Monte's real attraction was the 126 acres of gardens designed by famed landscape architect Rudolph Ulrich and the 7,000 acres of forest and beaches that surrounded

the hotel. To facilitate guest access to the outlying landscape, the Del Monte built and macadamized a ring road called Eighteen-Mile Drive.[6] "Invalids may prolong life at this delightful spot," Truman wrote. "The pure oxyde contained in every atom of air, and snuffed in at every breath, has a most efficacious effect upon the system."[7] From the beginning, the wealthiest Californians and easterners flocked to the Hotel Del Monte. It was the sort of place at which presidents such as Hayes and Benjamin Harrison vacationed. It was even a preferred destination of European royalty. Among the early visitors was Queen Victoria's daughter, the Duchess of Argyll. "[T]he Marquis and Princess Louise have been enjoying the surroundings without restraint, and with that absence of etiquette necessary to their movements while in [San Francisco]," reported the *San Francisco Call*, adding that the princess played a quadrille and a polka and even sang a bit. "The Princess is possessed of what might be termed a fair mezzo-soprano voice, but in the song it did not show to particularly good advantage," the paper added, with a certain absence of etiquette.[8]

Watkins had made pictures of other Southern Pacific–controlled hotels, such as the El Capitan at the Southern Pacific station in Merced, but the Del Monte demanded a broader treatment. Watkins made at least forty-six mammoth-plate pictures here, plus a hundred stereographs and an unknown number of medium-format pictures. He made his first Del Monte pictures in January 1882, which seems to have been the first availability on his schedule after the hotel opened, and perhaps on subsequent trips between 1883 and 1885.[9]

Watkins made two dozen stereographs of the Del Monte's main building but only one mammoth plate of it, a picture that carefully frames the hotel between trees and that situates it within Ulrich's gardens. The other forty-five mammoths focus on those gardens (Watkins had photographed Ulrich's work before, at Thurlow Lodge in Menlo Park) and Eighteen-Mile Drive. We don't know if Hotel Del Monte officials or whichever Southern Pacific or Pacific Improvement Corp. executive hired Watkins directed him toward the Monterey Peninsula's landscape, but it was a good decision. Watkins's pictures of the hotel grounds show a richly planted wonderland of old oaks, thoughtfully planted cactus gardens, dense shrubbery, and the paths that helped guests enjoy them. Watkins's pictures of Eighteen-Mile Drive show not just a series of coastal pastorals but the road that strings

together the scenes. Several pictures of cypress trees prove Watkins could still make a tree portrait like no one else.[10]

In February 1884, Carleton Watkins dashed off a telegram to Collis Huntington. Watkins had big news: William H. Lawrence wanted out of their business partnership. Lawrence had been the top executive of the Spring Valley Water Works, one of San Francisco's most important companies, for some time, and he was ready to make his next move: to enter electoral politics as a Republican San Mateo County supervisor. (Lawrence had previously been a GOP state committeeman.) Within a year of joining the board, Lawrence would be its chairman. San Mateo County was small but wealthy and positioned to benefit from San Francisco's growth. Lawrence doubtless planned the same dual businessman-politician career that many California Republicans, such as Leland Stanford, had enjoyed. At just forty-four years old and perfectly connected to San Francisco business, finance, and money, Lawrence was poised to go far.

Watkins wasn't angry—"I am indebted [to him] for what I have," he told Huntington—but he understood the gravity of the moment. Having lost half a career's worth of work in the 1870s, he didn't want it to happen again. He asked Huntington for a $1,500 loan so that he could buy out Lawrence, and proposed terms: two years to repay.

Was this the first time Watkins and Huntington had corresponded since the 1850s? Certainly it's the first communication between the two men that has survived. It's possible to read Watkins's sign-off—"Collis, fifteen months today, is a sturdy fellow"—as a hint or suggestion that Watkins and Huntington had been in correspondence at some point between the gold rush days and now, and that the correspondence has been lost. Then again, it could just be the necessary chumminess of someone asking for a $1,500 favor. As noted in chapter 18, Huntington seems to have been careful to save correspondence with Oneontans who traveled to California with him during the gold rush years, and this is the first Carleton-and-Collis exchange in Huntington's papers.

Huntington's response is lost, but he seems to have agreed to the loan.[11] The Watkins-Lawrence split seems to have left the photographer exposed. While Watkins had some staff, and while his wife, Frankie, ran the gallery in his stead, he was stretched thin. Certainly he took some work and made

some trips he shouldn't have. For example, the work Watkins made at Yellowstone National Park in 1884–85 is so poor it defies explanation, and pictures from an 1887 trip to make medium-format pictures in the Sonoma Valley for the Sonoma Valley Improvement Co. feel rushed. It's almost as if Watkins, who was fifty-eight when he made the Sonoma pictures, realized he was running out of time and energy. He seems to have saved most of it for his return trips to Kern County, where he would all but end his career with a flurry of great pictures.

26

THE NEW INDUSTRIAL AGRICULTURE NEAR BAKERSFIELD, CALIFORNIA

ALMOST AS SOON AS James Ben Ali Haggin settled *Lux v. Haggin* in about 1886, he hired Carleton Watkins to make a series of pictures detailing his transformation of the desert into the new California cornucopia. That both Miller & Lux and the Haggin consortium, the partnerships that transformed western land ownership and agriculture at the end of the nineteenth century, wanted Watkins to help them make their case, to acutely different publics, is a testament to what affiliation with Watkins could bring a business: each wanted their new Wests to be considered as the latest in the string of Wests that Watkins had helped create.

We don't know how Haggin and Watkins met, but as usual, there is a clear network of men connected to Watkins who may have helped. Haggin knew bankers and Watkins customers Billy Ralston and John Parrott, from whom he bought some of his Kern land. Watkins friend and commissioner George Davidson hired himself out as a surveyor of Haggin's Kern lands for twenty years; he could have introduced Haggin to Watkins.[1] Finally, Haggin was one of America's greatest and most successful horse breeders and racers, and in that capacity, he knew two of Watkins's clients and customers in the San Gabriel Valley: L.J. Rose and Lucky Baldwin.[2]

We also don't know how many trips Watkins made to Haggin's Kern from 1886 to 1889. His visits may have been annual, and they may have been even more frequent than that. Certainly Watkins's studio or gallery, probably diminished in these post-Lawrence years but still at the powerhouse intersection of Montgomery and California Streets, was kept busy printing Kern County work.[3] Among the mysteries of the Kern years—here our understanding is limited not just by the 1906 earthquake and fire but by the 1889 Bakersfield fire—is how Watkins could do so much for a major client, a client who would continue to use his work for at least fifteen years, and come out of it penurious. Either Watkins was content thinking of himself as an artist and a photographer and no more, or his failure to turn his relationships with some of the wealthiest men in America, this last one especially, into a more significant business opportunity or greater wealth for himself haunted him for the rest of his life.

Watkins's Kern work marks a significant shift in his practice. For thirty years, his best work, the work he spent the most time composing and making, had been wet-plate, mammoth-plate pictures. In the mid-1880s, two things changed. First, Watkins was aging. By the time he finished his work in Kern, he would be sixty years old. A mammoth-plate camera was big and heavy and required lots of stuff that all had to be hauled around and pulled out every time you wanted to use it. It still had its purposes—for example, it was important to attorneys in *Lux v. Haggin* that Watkins's prints were the same size as his negatives, that the final image allowed no manipulation of space—but the times were changing. Besides, mammoth-plate photography was challenging enough in 1861 for a thirty-two-year-old in the gentle Yosemite summer climate, but for a fifty-nine-year-old in brutally hot, dusty, immense Kern in 1889, wet-plate technology was a much tougher ask. Fortunately for Watkins, technology had advanced. The new thing was dry-plate photography, which was immensely simpler. The photographic plates were precoated, so Watkins no longer had to endure the slow, careful, steady-hands-required process of coating a four-pound glass plate with an emulsion in a dark tent before and after taking a picture. Now he could just unwrap a precoated eight-by-ten-inch plate and load it into the back of a camera smaller than his old standby. (A picture of the Kern Island Dairy shows Watkins, in shadow, making this very picture with a dry-plate camera. On a tripod, it's still almost six feet tall, but the camera housing itself is

obviously smaller than his mammoth-plate setup.) Watkins seems to have first used this new technology on his 1882–83 trip to the Pacific Northwest; now it became his primary medium. The many hundreds of pictures he would take in Kern would give him opportunity to master it. Most likely, Watkins's shift in medium—and the widespread availability of new point-and-shoot-style cameras that anyone could hold—both enabled his last major bodies of work and doomed his future prospects.

The Haggin job also marked a break with thirty years of Watkins's practice. This was an entirely commercial commission. For decades, even when Watkins had made pictures for clients, there had been something in it for him: a new way to show the landscape, pictures that worked both for the client and for a broader market through Watkins's gallery. In Haggin's Kern (and in a less accomplished series made in 1887 for an unknown client at El Verano in Sonoma County), it's hard to find any of Watkins's usual overlapping interests. Who would want a picture of forty-three cows in a Kern County alfalfa field? Still, Watkins approached the job with pictorial purpose. Historian and curator Jennifer Watts notes that many of these Kern medium-format works "are some of [Watkins's] most masterful works . . . [that] introduce spontaneous elements from everyday life that resisted treatment with the mammoth-plate camera and its tedious wet collodion negatives."[4]

Haggin's plan, which Watkins's hundreds of pictures would support, would revolutionize agriculture in the West and, in de facto partnership with the railroads, help create the modern agricultural system by which food grown in one part of America can be served two days later, more or less fresh, across the country. To succeed, Haggin would have to build or purchase irrigation infrastructure for his four hundred thousand acres and then attract new residents to farm that acreage. Crucially, he would have to wait to unlock his investment's potential until the California Supreme Court decided *Lux v. Haggin*. Fortunately for Haggin, he had bought his Kern land so cheaply—most or much of it from the federal government for the Desert Land Act price of $1 per acre and other plots from the Southern Pacific for just $3.50 per acre—that he could afford to wait.[5]

Even as *Lux v. Haggin* slogged its way through the California courts, Haggin—confident that any resolution of the case would leave him with at

least *some* water—began implementing his plan. He built out massive canals such as the Calloway, Pioneer, James, Stine, Kern Island, Farmers', and Buena Vista, canals that transported the Kern River across the entire county. Then he dug a system of ditches that carried water from the canals to individual farm plots, so many ditches that by the time Miller & Lux sued in 1881, Haggin could direct the entire flow of the Kern River to wherever he wanted. Finally, before Haggin could sell land in Kern, he had to prove that the irrigation system worked and that crops would grow in Kern's soil and climate. Throughout the 1880s, Haggin built and planted a couple of dozen test farms, what status-conscious Californians called *ranches,* in an effort to learn what would grow in Kern, what yields those crops would bring, and how expensive it would be to harvest those crops and deliver them to market. All of this information would help him price and market his land. Some of Haggin's test farms grew single crops—Hop Ranch was Haggin's hop farm—while others grew a range of crops including alfalfa, cotton, corn, sweet potatoes, pecans, apples, olives, beets, melons, peaches, and pears. All these newly planted crops would need to be supported by pollinators, so Haggin built an apiary. Other ranches raised cattle, pigs, poultry, and sheep (mostly for wool). Haggin also constructed cheese-making facilities called Kern Island Dairy and Mountain View Dairy. Even Billy Carr, whose skills were political rather than agrarian, contributed: he noticed that Kern sunflowers grew so tall that they blocked his office's view of the company's land. He cut down a few sunflowers and shipped them to San Francisco. Someone there told Carr that turpentine could be made from sunflower sap, so Carr and Haggin planted sunflowers at Lake Ranch and built a turpentine distillery.[6] It's when these test farms and their related production facilities had reached maturity that Watkins arrived in Haggin's Kern.

We don't know the order in which Watkins made his work for Haggin, or on what trip or trips he made it. However, it is easy to tell what Watkins's client deemed important. First and most importantly, Haggin hired Watkins to show that even though Kern was desert, there was water, lots of water, plenty of water, that there was *so much water.* Next, Watkins was to show Haggin's commitment to delivering that water to farms via his infrastructure and delivery systems. To motivate people from Ohio or Sacramento to move to Kern, Haggin needed prospective Californians to see that his system of canals and ditches would reliably deliver water for as far into the

future as a settler could imagine. Next, Watkins would have to prove that Kern agriculture wasn't merely a notion, a San Francisco capitalist's theory—that it could be done, that it had been done, that buying irrigated farmland in Kern was a better bet than buying farmland in Iowa or Alabama. Finally, Haggin needed Watkins to show that life in Kern, where it was very hot and very, very dry, could be comfortable, even pastoral, that you could make a good living farming here, and enjoy it.

It all started with water. Fundamental to Haggin's business and to Watkins's pictures was teaching prospective Kern Countians that they should not think of water as arriving in the usual way, descending vertically—Kern receives only about six inches of rain a year—but should instead think about it as arriving horizontally, from the Kern River. Haggin's hydrologists had measured the Kern's flow to about 3,000 cubic feet per second between May and August, but to only an erratic maximum of 500–1,200 cubic feet per second the rest of the year. In the peak years of the climatic phenomenon we now call El Niño, the Kern would deliver 9,000–12,000 cubic feet per second. That sounds great, but if that volume was unregulated and uncaptured (in, say, a dam), it would mean catastrophic flooding.[7] Haggin would not have needed to tell Watkins any of this. No American artist before or since has made as much work about how westerners captured and used water: Watkins had made pictures of the Spring Valley Water Works' accumulation of Peninsula water for distribution in San Francisco, hydraulic mining in the Sierra Nevada, a riverside timber mill and related facilities in Mendocino and along the Columbia River, water systems in the San Gabriel Valley, the Spanish missions' water systems, and plenty more.

The conceptual heart of the commission was the Calloway Canal, the backbone of Haggin's system.[8] The Calloway was (and still is) a thirty-two-mile-long, ninety-foot-wide man-made river that flowed from the Kern River north to a mostly dry creekbed optimistically known as Poso Creek. It delivered water to one of Haggin's two main tracts, the section north of Bakersfield. Via the Calloway and seventy subsidiary ditches that flowed from it, the canal would ultimately offer water to two hundred thousand acres of desert.[9] (Haggin's other tract was west of Bakersfield. Because that was the direction in which the Kern River flowed more or less naturally, Haggin's west-of-town tracts were fed by many canals.) Watkins made scores of pictures of the Calloway and scores more of the different Haggin

farms to which it supplied water, including the Rosedale, Collins, Jackson, Poso Creek, Evergreen, and Creasy Ranches. The canal was so important to Haggin's plans that Watkins made two two-part mammoth-plate panoramas of it, plus several other mammoths. The best panorama is a smartly composed diptych known as *View on the Calloway Canal, near Poso Creek*. It shows Calloway at its extreme northern end. At the left of the diptych, a tree, one of just two in a landscape that plainly extends for otherwise empty miles in every direction, dips down into the canal as if it is taking a sip. Across the broad canal, cattle are immune to the brown blah of the desert wasteland around them, content to munch on alfalfa. Water fills more than half of the view. A sharp-eyed viewer—and anyone considering buying farmland in Kern surely looked carefully—would have noticed that the only topographical feature anywhere in the picture is several mounds of alfalfa, each several stories high. We will return to Kern's gargantuan alfalfa mounds.

Kern presented many challenges to a photographer—or to any kind of artist, but what painter in his right mind would come *here?*—including hot, dusty conditions, relentlessly flat terrain, and, excepting some homes that Haggin built for his ranch superintendents, emptiness. Watkins made extensive use of the only compositional help available: standing atop his wagon so as to gain a wee vertical advantage over the surrounding plain.[10] This rise of six or, at most, eight feet may seem slight, but it allowed Watkins to fill his frame with a silvery swath of water and to push the surrounding desert to the edges of the picture. In (another) *View on the Calloway Canal*, Watkins magnifies an ever-so-slight turn in the canal to fill two-thirds of the picture with water, which seems to bend past us. On the opposite bank, three poplar trees are blurrily reflected in the flowing water, while a man sitting in a carriage behind a white horse attracts the eye to the opposite bank. He's tiny. But once we see his white horse, the only bit of brightness in the entire picture, we suddenly realize that there are hundreds of cattle grazing in the distance. (The only hills on Haggin's acreage were the beginnings of the Coast Range, to the west of Buena Vista Ranch. When he got there, Watkins would seize upon those hills like a thirsty man being offered a drink.)

Watkins's pictures are so insistently full of water that in aggregate, they can be almost comical. A picture of the headquarters for Bellevue Farm is built around a central fountain. There was so much water here in the desert, says Watkins's picture, that here's a burbling fountain. In another picture,

Carleton Watkins, *View on the Calloway Canal, near Poso Creek, Kern County, California*, ca. 1887–88. Collection of the Huntington Library, Art Collections and Gardens, San Marino, CA.

Watkins's path to the headquarters of the Alameda Farm and Dairy seems blocked by a giant puddle. How much water is there in Kern? So much that it will get in your way. (Fear not: Watkins made it to the Alameda headquarters, where he made a picture of a two-story building surrounded by thirsty trellised grapes, a weeping willow, and a dozen people.)

In each of these pictures, and in so many others, Kern seems impossibly remote. There was only so much Watkins could do to present the county as anything else—a picture of a parade in downtown Bakersfield is so startling that it feels staged—but he also understood that he had to find a way to show why Kern's distance from population centers wasn't total, that farmers had access to agricultural news and markets. Take a medium-format picture titled *The Calloway Canal*, a picture taken on the Southern Pacific tracks, looking along them as they cross the Calloway northwest of Bakersfield, a quarter mile from where a headgate redirects the Kern up the canal. The picture only barely updates what was by now a decades-old photographic trope: following railroad tracks to a vanishing point far in the distance. This is the kind of pictorial cliché Watkins had spent decades

avoiding—except when there was a reason to use it. Here the reason was the client's story: look at the water that will sustain your crops, look at the Southern Pacific tracks that will take them to market, and here, alongside the track, look at the telegraph line that would deliver to remote Kern County the information a prospective Kern farmer needed regarding crop prices and so forth. This kind of storytelling through composition, more common in painting, separated Watkins from anyone else Haggin could have hired.

Next, Watkins had to show how productive the newly watered desert could be. As every farmer and any prospective Kern land buyer knew, the most water-intensive crop in the West was alfalfa, which was grown for cattle feed. If there was enough water in Kern to grow alfalfa, there was enough water in Kern to grow anything. Watkins made dozens of pictures of alfalfa as it grew, as it was harvested, as it was stacked in mounds that looked like Paul Bunyan–sized loaves of bread, and as it was delivered to cattle.

Remarkably, weirdly, alfalfa motivated Watkins to some of his smartest compositions, pictures that tell a story, show a history, and boast of production. He photographed alfalfa fields being flooded with water, bits of plant poking up around what seems like a lake in the middle of the desert. He photographed alfalfa growing after it had absorbed all that water. Watkins made the best of these pictures at Buena Vista Ranch, where he conceptually mined his back catalogue to make a tree portrait of a beautifully beefy willow reflected in the perfectly still Buena Vista Slough. The thirsty willow is so magnificent that the surrounding thick field of alfalfa seems almost—but not quite!—incidental.[11] Behind the willow tree, several huge mounds of alfalfa testify to the production of previous seasons, a demonstration that Haggin didn't manipulate his canals to provide a single season of bounty for the camera.

The best-known, most-published work Watkins made in Haggin's Kern is of workers building an alfalfa mound, *Haying at Buena Vista Farm*. The picture exists in both a mammoth plate and in a smaller dry-plate version. The action starts in the lower-right foreground, where a vaquero, a Mexican cowboy, sits atop a bright-white horse. His crisp white sleeves and tall, round white cowboy hat testify to his supervisory role. No one dressed like this, in long, blindingly white sleeves and in clothes this crisp, is doing physical la-

Carleton Watkins, *Haying at Buena Vista Farm,* ca. 1886–89. Collection of the Huntington Library, Art Collections and Gardens, San Marino, CA.

bor. The vaquero's horse's nose points to the next place we are meant to see: a man in a suit and hat, also on horseback, whose white handkerchief is so fresh it stands out. We don't know who he is, but no one in their right mind would be wearing a suit out here in the dust and heat for any reason other than a photo op, so he's likely a Haggin executive reminding us he's the boss. Just above that horse in the picture's hierarchy is a man supervising the arrival of mule-drawn carriages piled high with alfalfa, a mule driver perched atop each carriage, holding the reins. They lead our eye to a giant ladder, which directs us to six men standing atop the alfalfa mound in progress. Their job is to evenly distribute alfalfa dropped onto the mound from a derrick fork, a pulleys-driven contraption that holds a huge bundle of alfalfa aloft directly above them. This progression through the picture is essentially a giant V through which Watkins shows us how he built the picture. In writing on *Haying,* historian Richard Steven Street drew an apt comparison with film, noting that Watkins loved to "direct" the making of his pictures.[12]

Watkins's alfalfa mounds are so refined that it's tempting to think he was riffing on an art historical standard. Watkins's *Haying* precedes the paint-

ings of the same subject that are the most famous today: Claude Monet would not begin his haystacks series until 1890. On the American East Coast, Martin Johnson Heade had begun painting haystacks in New England salt marshes in the 1860s, but Heade was virtually unknown until well into the twentieth century. However, Watkins may have known two other paintings: an 1849 Frederic Church known as either *Haying near New Haven* or *West Rock, New Haven,* and Jasper Francis Cropsey's 1851 *American Harvesting.* Both paintings show figures in the midst of a broad country in which an alfalfa field is dwarfed by a surrounding undomesticated landscape. Each painting includes towering trees and a mountain that looms over the rest of the scene. In 1880 Watkins's friend William Keith had painted his own haying pastoral, *Approaching Storm.*[13] Could Watkins have been updating those pictures intentionally? (Most likely, hay-harvest paintings were so common in American art that Watkins may have been doing the thing rather than engaging a specific painting.) There's a meaningful conceptual difference too. In the works by Church, Cropsey, and Keith, agriculture is nestled into nature. In Kern, capital had completely tamed the landscape, converting it for agricultural use. There may be a few clusters of oaks in the distance of Watkins's *Haying,* but they're dwarfed by the construction of the immense haystack. The faint rise of the Coast Range is visible in the far distance, behind and beyond the alfalfa mound. In the Watkins picture, western capital and labor dominate all.

There were other forms of Kern production to show off, including plenty of other crops and wool and dairy production. Watkins's pictures of the dairies at Mountain View and Kern Island are particularly good. Mountain View, on 5,280 acres at the southern edge of Haggin's properties, near the foothills of the Coast Range, was Haggin's largest dairy ranch, a demonstration to westerners that even though Kern was a long way from the primary markets in Sacramento and San Francisco, dairy products could be sourced from Kern and delivered 250 miles away without spoiling. (While in the eastern and midwestern states, the railroads had long ago helped make production of butter and cheese a largely industrial rather than a farm-based business, California dairies were still clustered around the big population centers. Haggin's Kern project—and former butter man Collis Huntington's Southern Pacific railroad—would change that.)[14] Sixteen staffers at Mountain View oversaw 500 cows, 42 Durham bulls, and 290 calves, and they

produced 17 cheese wheels weighing 26 pounds each, 442 pounds per day.[15] Kern Island was home to Haggin's largest dairy house, where the curing room prepared 1,200 wheels for market at a time, more than 15 tons' worth. Haggin's brand-new, built-from-scratch Kern dairies were almost impossibly massive: project Haggin's production numbers over a year, and Mountain View *alone* produced more cheese in a year than the entire states of Virginia or Texas.[16]

The last thing Watkins had to do in these medium-format Kern pictures was demonstrate that this was a place people might want to live. Accordingly, the final rough grouping of pictures Watkins made was of ranch life. These pictures would be light on laborers and heavy on the better-paid managerial staff that ran each of the test farms. Watkins's pictures show the houses Haggin provided for each ranch supervisor, typically a large, two-story home that was surrounded on all sides by liberal plantings of trees, gardens, and sometimes a gazebo and a lawn, often with a wraparound porch from which to enjoy it all. (One photo caption claimed that the porch lowered the ambient temperature by ten degrees.) Some of the lawns are lined with six-foot-high hedges, which allowed homeowners to define human-scaled spaces in the midst of the vast, flat country. Lawns feature ornamental cacti in urns, monumental oaks, and freshly planted ornamental trees such as magnolias. "The grounds, constantly green or bright with graceful foliage and lovely colors, are indeed a paradise of beauty," Haggin promised in a caption.[17] Watkins made the most striking of the dozens of these pictures at McClung Ranch, which mostly raised horses, stock, and alfalfa but was also home to Haggin's experiments with grain, with almonds, and with fruits such as orange, fig, pomegranate, peach, pear, apple, berries, and even watermelon. Watkins shows the large, handsome supervisor's house surrounded by poplars and shrubbery, with climbing roses almost covering the house. The supervisor at McClung, whose name is unknown, lived here with his wife and daughters, all of whom feature in Watkins's pictures of the ranch house.

It's always risky to read biography into an artist's work, but while there are many fine pictures of similar residences throughout the Kern body of work and even other pictures of children, often toddlers on rocking horses, the McClung Ranch pictures are different. The McClung supervisor's daughters were about seven and five years old, the same ages as Watkins's own

children, Julia and Collis. At McClung, Watkins made more pictures of the supervisor's children than anywhere else, posing them at the beginning of the long, cottonwood- and willow-lined, white-fenced drive that led to the ranch house. He posed them again at the end of the drive, one of them under an arching topiary, the other sitting just in front of her, on the wooden box that covered the artesian well in the front yard. One of the girls poses in a broad, round-brimmed straw hat in the ranch house's arbor, surrounded by Virginia creeper, jasmine, honeysuckle, verbenas, and marigolds. Watkins had spent thirty years traveling the West, usually with only one or two other men, making pictures of everything but leisurely domesticity. Maybe now, a year short of sixty years old, he was enjoying fatherhood and the opportunity to make some pictures of the country life he'd passed up.

The public relations campaign to promote the first sale of Haggin's Kern County lands started in 1888. The first indication that something was up in Kern came in San Francisco's *Daily Alta California*. In January 1888, it specu-estimated James Ben Ali Haggin's net worth at $10 million, a clear suggestion that his Kern venture was going spectacularly,[18] that his test farms were booming.

The next big hint came at the 1888 Mechanics' Institute Fair, San Francisco's annual social and mercantile exposition that spotlighted and promoted everything from imported German carp swimming in a tank to agricultural products to lumber to geodes. Watkins had exhibited regularly at the fair since at least 1864. This time he showed six hundred of his pictures of Kern County, a display no doubt approved by Haggin and designed to ramp up the buzz about California's newest growing region. It worked: the crucial *Pacific Rural Press* was awed. "The collection of characteristic photographs is extremely attractive," the paper reported.[19] It went back for more the next week: "Kern county's exhibit . . . would of itself afford a half-day's entertainment. There are many views of home-places, of irrigating canals, fields of alfalfa, cutting and stacking operations, herds of sheep and cattle, interiors of barns and dairy-rooms, orchards and hop-fields; besides reaches of the river, grand mountain scenery—which impress one with the varied character of the county and the industry and thrift of its inhabitants, and at the same time gratify the taste by the artistic manner in which they are

taken."[20] Haggin's Kern campaign, built almost entirely around Watkins's pictures, was now out in the open.

Finally, in early 1889, California's newspapers reported that Haggin was planning to sell ten thousand acres three weeks hence, in March. This was big news. To hear the *Pacific Rural Press* tell it, "for years the development of this splendid county has been checked because the parties holding the land would not sell."[21] (This was a tidy bit of hyperbolic boosterism. If the land was so splendid, why was it that "[a]bout 15 years ago, outside of Bakersfield, the county seat, there were not a dozen families and the valley was considered barren," which the *Rural Press* reported a few paragraphs later?)

Haggin announced the sale via advertisements in all of the state's major newspapers. The first sale of Haggin's Kern land, the ads said, would actually be of just seven thousand acres. This was less than 2 percent of Haggin's holdings of what the ads described as "fruit, vegetable, and alfalfa land within one to seven miles from Bakersfield."[22] Haggin saved his biggest PR blitz for the *Rural Press*. Haggin's team gave it one of Watkins's pictures from Kern of a thick, bushy, fruit-bulging hedge of Hamburg grapes. The paper used a relatively new technology called photoengraving to reproduce the Watkins not as an etching but as something pretty darn close to the actual photograph. As Haggin's PR people obviously knew, the *Rural Press* was the only West Coast paper that used this new technology. Starting here, Haggin's team would regularly provide Watkins's Kern pictures to the *Rural Press,* which would regularly publish them. Just as Watkins's pictures had introduced westerners and Americans to Yosemite and so many other western landscapes, so too would they introduce them to Kern County, industrial irrigation, and yet another western landscape.

The Watkins of Hamburg grapes was not his best Kern picture, not even close, but Haggin's team knew it fit the narrative on offer: "The showing of this profuse fruiting of the grape naturally calls attention to the locality of its growth, which is now rapidly coming to the front in products and development," gushed the *Rural Press* in an article explaining the picture. On the very next page, in the weekly roundup of agricultural news, the *Rural Press* reported on the farm of one Charlie Maul of Bakersfield—an independent farmer apparently unaffiliated with Haggin's operation (though surely he bought his water from Haggin)—who had twenty-three acres planted in fruit trees. "With his peach orchard and raisin vineyard, Mr. Maul is a rich

man," the *Rural Press* said. "The peach trees are mostly five years old this spring, and for the last two years have given their owner an income of about $400 an acre, with no other labor than was necessary in cultivating the trees and picking the fruit, as the latter was shipped East just as it came from the trees."[23]

With the picture of the grapes and with Maul's story, which Haggin's team almost certainly planted in the *Rural Press,* Haggin was nodding at an agricultural hierarchy well understood to nineteenth-century farmers. Lower-class agrarians sowed crops that grew close to the ground, required constant diligence, and required them to literally get their hands dirty, especially at harvest time. High-class planters raised fruit that grew off the ground, that required little day-to-day work, and that required capital investment at the beginning as it would take a couple of years before the trees or vines would bear fruit. Grapes suggested wine, which hinted at European sophistication. Watkins's pictures had nodded to all this: in one, a man in a business suit—capital!—poses with a peach tree, pulling down one of its fruit-laden branches so all could see. Only a tiny minority of Haggin's Kern land was given over to fruit. Most of it was given over to stock and alfalfa, which seem to have been immensely profitable, but which did not fit the story Haggin's team wanted to tell about the potential for class mobility in Kern.

On the page after noting Maul's success, the *Rural Press* ran a full-page ad for the sale. Haggin was about to find out if his transformation of the western desert into farmland—and Watkins's presentation of it—had worked well enough to attract buyers.

Haggin and his partners took nothing for granted. They arranged for special prices on special trains that delivered prospective buyers into Bakersfield from San Francisco and Los Angeles. The prospective buyers could stay at a new hotel, the Southern, four-star lodging in a one-stop town. The night before the auction, March 20, 1889, things looked good: the Southern was booked to capacity, and so was the Arlington House hotel and anywhere else in town that might have a bed.[24]

On the morning of the sale, the Tulare City Military Band welcomed prospective buyers, and Bakersfield's Committee on Salutes welcomed visitors by shooting off cannons. A local reception committee, identifiable by the huge silk badges they wore, roamed Bakersfield's two-block downtown, an-

swering visitors' questions. Finally, just before noon, everyone formed a procession to walk the few hundred yards from downtown to Cotton Ranch, where Haggin's team had set up a tent in a field of green alfalfa. The procession was welcomed to the ranch by the aroma of hundreds of pounds of roasting Kern meat: four cattle and four hogs. Kern-sourced milk, bread, and cheese were all freely available. It might have seemed like an awful lot of food, but it turned out to be necessary: nearly 1,500 people had turned out.[25]

Over the course of the first afternoon of the multiday sale, Haggin's auctioneers offered 250 lots. They sold for a combined $46,000. Kern residents were ecstatic. "Bakersfield takes her place among California cities. The Most Satisfactory Sale on Record," declared the *Kern County Californian* in a celebratory headline.[26]

The feast-cum-sale continued over the weekend. When it was over, Haggin had sold seven thousand acres for $258,390. Land that Haggin had bought for $1–$3.50 an acre had sold for an average of $37 an acre. Better farmland, such as at Hop Ranch, sold for $60 an acre. The best available land, on the Jewett Ranch test farm, adjacent to the town of Bakersfield and so close to the Kern River that buyers may not have needed to buy water from Haggin, sold for $300–$350 an acre. The town lots sold for even more. This first sale established the worth of Haggin's Kern lands at around $15 million, at least a 50 percent hike over the most recent assessment of the land's value. Haggin didn't just profit from the sale, he gleaned valuable information about what buyers would pay for what land and why. More importantly for the future development of the West, he had proved that vast tracts of desert could be irrigated into productivity, that people would buy that land, and that he could make massive profits on that land—all while still controlling the water farmers would need. It was a triumph that would, over the next several decades, transform western agriculture and that would create the industrial farmscapes we know today.

While he must have been exultant, and more than a little relieved, Haggin partner Billy Carr played it cool, real cool. "The prices hardly reached our expectations," Carr told the *Californian,* apparently with a straight face. "We decided to sell what was wanted, and how much it was wanted we did not know and had to find out."

Then he announced that Haggin's remaining 393,000 acres were now on the market.[27]

For both Carleton Watkins and his pictures of Haggin's Kern, the work was just beginning: he would return to make more pictures for Haggin later in 1889. For the next fifteen years, maybe more, Watkins's Kern suite would be central to everything Haggin and his adjunct, the Kern County Board of Trade, would do to market the remaining 98 percent of Kern land up and down California and across the country, and to lobby the federal government. By the early twentieth century, nearly every image anyone in America had seen about the new western industrial agriculture was made by Carleton Watkins.

First, and probably most importantly, Haggin bought albums of Watkins's medium-format pictures and distributed them, but information about how and where has been lost. While several of Watkins's Kern medium-format albums survive—as usual, the albums that have survived seem to have entered archival collections early on—today we know least (of all Watkins's albums) about how they were used by Watkins's client to tell the Kern story. It wasn't just Haggin who had access to them. Watkins's Kern albums were even on sale at A. C. Maude's news and stationery store in downtown Bakersfield for $30 per album of sixty pictures. (Maude published the *Kern County Californian*, so his business was as vertically integrated as Haggin's.) That kind of pricing might not have caused buyers to blink in wealthy San Francisco, but it was steep freight in Kern County. Still, after four months, they sold out.[28]

In addition to the bound Watkins material, Haggin and his allies published large pamphlets and small books with titles such as *The Era of California's Supreme Industrial Possibilities*, which included Watkinses of artesian wells and even hydraulic mining at North Bloomfield, and *The Bakersfield Californian: Homeseekers and Developers*. Watkins's work was included in much of it.[29]

In the late nineteenth century, large regional fairs, massive county-fair-style events that brought together a widely scattered population to gawk at everything from the latest drill bits to fashionable clothing, were a popular way to promote western land sales. Historian Richard Orsi describes these fairs as "turning points in the formation of a new image for [California] as an agricultural eden."[30] Watkins's pictures made up most of those land-sales displays. For example, Watkins's work was exhibited as a Kern promo-

tion at the 1893 Chicago World's Fair. The organizers of the Kern exhibition handed out a publication titled *The Greatest Irrigated Farm in the World*, which was loaded with Watkinses. Haggin's office especially made available a four-color lithograph titled *Bird's Eye View of Bakersfield and Kern Valley*, which showed the region's extensive canal infrastructure laid against a green bird's-eye map of Kern.[31] Surrounding the map were etchings or illustrations based on Watkins's Kern pictures. Sometimes Haggin and his Kern County Board of Trade and Southern Pacific allies constructed displays of Kern County agricultural products around Watkins pictures. This gave Watkins the opportunity to make pictures of how his pictures were used, such as the evocative mammoth-plate *Kern County Groups*, which offers umpteen Watkins pictures of water surrounded by the bounty of the Kern farms, including gourds, oranges, walnuts, pears, dates, peaches, corn, pomegranates, apples, peppers, bales of hay, and wheels of cheese.

There was also print media, many newspaper and magazine articles that were illustrated with Kern pictures that Haggin and Kern officials must have handed out as if they were, well, water. The *Pacific Rural Press* used the most Watkinses to spread Haggin's Kern story, but magazines used even more, and would keep on using them into the twentieth century. (That's a testament to their quality but also to Kern's remoteness.) It would be through magazines that Watkins's Kern pictures introduced the most Americans to the West's new, industrially irrigated landscape. As soon as the *Kern County Californian* had photo-publishing capability, in mid-1892, it published all the Watkinses of Kern that it could, and for months.[32] A magazine called *The Traveler* featured Watkins's pictures in 1893.[33] The Southern Pacific Railroad's popular magazine, *Sunset*, featured Watkins's Kern pictures in advertisements in 1904, fifteen years after they were made.[34] Even the august *Overland Monthly*, the West Coast's answer to the even more august Boston-based *Atlantic Monthly*, used them for years. Whereas the *Atlantic Monthly* had long leaned on Harvard intellectuals, the *Overland Monthly* leaned on the University of California orbit. Typical was the May 1897 issue, in which Carl E. Grunsky, a leading California hydrologist and civil engineer of the era, wrote the first in a series of articles titled "The Material Progress of California." Naturally, the first example was the newest example of progress, irrigation.[35]

Despite the immensity of Haggin's irrigation projects, the four hundred thousand acres (or more) that his company owned in Kern County were just a fraction of the Central Valley's fourteen million acres. Haggin, who, along with Miller & Lux, controlled the water rights to an entire river, had a business interest in reclaiming even more Central Valley land and in irrigating it. But how?

Precise statistics on how much of Kern County was irrigated by the time the 1889 land sales began are not available. By 1885, the latest relevant year for which data is available, Haggin had irrigated around sixty-five thousand acres of the county.[36] Certainly, by the end of the decade, he had irrigated more of his land but not all of it. Haggin was worth well into the eight figures; he either believed he lacked the capital to profitably irrigate more, or he believed that the job was so big that it was beyond private capital. And what of the rest of the potentially productive Central Valley? Certainly, by 1890, Haggin and his partners understood better than anyone else that private capital could not irrigate the whole valley, 97 percent of which remained unirrigated. When a global economic depression in the early 1890s caused a tightening of capital, irrigation became even harder. Given that Haggin effectively owned two-thirds of the entire flow of the Kern River, he knew that he could make more money selling more water to farmers than he had the capacity to build the infrastructure to realize. What to do about that?

Meanwhile, small farmers, men who owned twenty acres in Fresno or eighty acres in Tulare, had seen how well irrigation had worked at a small scale in their counties and at an industrial level in Kern. Like all western farmers, they were infatuated with irrigation's promise, but they were wary of how corporations such as Haggin's could make their lives difficult and how corporations could wring the profits out of farmers' work—they'd seen the Southern Pacific do just that. Farmers called for a new way, and in 1877 California legislators passed the Wright Act, which brought state government into the equation. The Wright Act allowed farmers to join together on a regional basis to form irrigation districts and then to tax themselves for the purpose of building out irrigation-related infrastructure. The act effectively gave local farmers a way forward that didn't require the capital of absentee Nob Hill capitalists such as Haggin and Miller & Lux.

Corporateers such as Haggin could have seen the Wright Act as a threat. Instead it showed them a new way: if private investors couldn't irrigate eve-

rything, maybe government could—and to the benefit of private capital. In the case of the Kern River, which was entirely controlled by two companies (and which remains the only Sierra Nevada–originating river not controlled by the State of California or the federal government), the Kern-interested Gilded Agers realized that government might be induced to pay the infrastructural costs related to irrigation and that private interests would still effectively own the water. The Southern Pacific, which had a long-term interest in the agricultural development of the lands through which it ran and of land it owned, realized this as well.[37] The Haggin operation and the railroad realized that small farmers had shown them the way.

In 1889 the U.S. Senate gave Haggin and the railroad the opportunity to push for federal involvement in western irrigation. Nevada Sen. William Morris "Big Bill" Stewart arranged to lead a special committee on the "irrigation and reclamation of arid lands," which meant the West. Stewart, who lived in California, was a longtime ally of San Francisco business. Through its report on irrigation, the Stewart committee would become a major advocate for a federal water policy that benefited big business such as Haggin, an advocacy that would essentially set the terms of the debate between the convening of Stewart's committee in 1889 and the eventual passage of the Reclamation Act in 1902. (The 1902 bill was written by San Francisco–based Nevada Rep. Francis G. Newlands. Remember the name.) Among the documents Stewart's committee accumulated and made available to Congress and federal agencies were Carleton Watkins's pictures of Kern County.[38]

At a time when knowledge about the efficacy and impact of irrigation was as much superstition as fact—the folkloric belief that irrigation directly caused more rain to fall on farmland was so widely held that Stewart asked committee witnesses about it[39]—Watkins's pictures offered indisputable proof of how irrigation worked and how it enabled production, even in a landscape as huge as Kern. Billy Carr testified before Stewart's committee and provided it with thirty-three loose-leaf Watkins dry-plate photographs of Kern, four framed mammoth-plate pictures, and, apparently, three albums.[40] "The photographs . . . indicate more clearly than words can tell the story what results have arisen from irrigation in the lower portion of the San Joaquin Valley," Carr told the committee. " . . . I believe that Congress can not be too liberal in the appropriation of money to be used in ascertaining and selecting the best sites for such reservoirs or other storage works, and

for the construction of the same."[41] The message was clear: irrigation works, you need big business such as us to do it, and the federal government should build out infrastructure such as reservoirs to help.

The thirteen-year history of how the western irrigation issue moved through Congress is infamously thorny. No single issue, factor, or point of influence made *the* difference or pushed federal policy in any one direction, but the Kern example made a strong impression on the committee. "Kern County embraces, as the evidence and reports given will show, not only the most extensive single system of irrigation works owned and constructed by one firm within the United States, but other and most essential features of arid land reclamation," reported the committee.[42] The clearest proof of the efficacy of that system of irrigation was Watkins's pictures.

Sure enough, the bill Congress passed and that President Teddy Roosevelt signed into law in 1902 enabled big business and furthered existing power, such as Haggin's. Watkins's pictures turned out to be the perfect argument for the big men—at the expense of the little guys such as himself.[43]

27

THE LAST GREAT PICTURE

BY THE FINAL DECADE OF THE NINETEENTH CENTURY, California clung to just a handful of people who had played roles in the West's emergence since the gold rush years. Most of them had returned to the East or died. Among the handful of exceptions were Carleton Watkins and his next Kern County client, Edward Fitzgerald Beale.[1] They had almost certainly met nearly thirty years earlier, at Jessie Benton Frémont's Unionist Black Point salon. As a young man, Beale had been involved in pretty much every bit of western intrigue imaginable. The Navy had sent Beale to England in 1845 to act as a spy and to learn the extent of British designs on Oregon Territory. A few years later, he aided the land forces in the Mexican-American War, helping an American regiment escape from certain defeat in the Battle of San Pasqual. Most famously, at least today, was Beale's role in the gold rush. In the summer of 1848, Beale traveled across Mexico, in disguise, with gold nuggets in tow. Upon reaching Washington, he showed them to President James K. Polk, who announced to America that the gold rush was on. Over a decade later, President Abraham Lincoln had named Beale surveyor general of California and Nevada, an appointment that led to Beale's surveying a portion of the route that would be used by the transcon-

tinental railroad. Beale may also have been the unknown presumed backer of Watkins's 1861 Yosemite trip.

Beale's home in California was a spectacular onetime Mexican land grant called the Tejon Ranch. The Tejon ran across the steep, dramatic Tehachapi Mountains that form the southern edge of the Central Valley and thus Kern County, and that, on the other side, separate the Central Valley and Kern from the San Fernando Valley and Los Angeles County.

Whereas Haggin and Miller & Lux were obsessed with wringing every last dollar out of Kern, Beale was substantially content to enjoy his country surroundings. (Just as well: little of Beale's water-poor and steep terrain had farming or ranching promise.) Back in the late 1850s and early 1860s, when Beale had worked as an Indian agent, he had helped settle Indian populations on this very land. Once he owned it, Beale encouraged them to remain (instead of driving out Native Americans as Californians had everywhere else), hired them as ranch employees, and built them homes and churches.

Once Beale retired to the Tejon, he took it upon himself to encourage the further development of distinctly western culture that Jessie had initiated. Among the writers he encouraged were Charles Nordhoff and Bayard Taylor, both of whom dedicated books to him. Beale was most important as a mentor to an overland traveler named Mary Austin, whom he met in 1888 when she settled on or near his land. Beale befriended her and helped guide her through a bout with depression by showing her the beautiful oak-strewn hills of the Tehachapis. He encouraged Austin to write about the land and her experiences in it, just as Jessie had Thomas Starr King. Austin would become one of the great thinkers on western nature, the third of a nineteenth-century triumvirate that included Starr and John Muir. Austin's 1903 *Land of Little Rain,* an appreciation of the California desert, and her autobiographical *Earth Horizon* are American classics.[2]

In 1888, when Beale was sixty-six, he invited Watkins, who was about to turn sixty, to the Tejon for a significant commission.[3] It is unclear if Beale summoned Watkins because he remembered him from the early days, or if he had been struck by Watkins's work for Haggin in Kern, or both. (Beale may have known Watkins's work in Kern because Beale had once owned some of the land Watkins photographed: back in 1878, Beale had sold off a sliver of the Tejon called San Emigdio Ranch, apparently to Haggin.[4]

A decade later, Watkins photographed San Emigdio, now a fruit farm and sheep ranch named after the Catholic saint invoked against earthquakes.)[5]

We don't know why Beale hired Watkins either. Maybe it was sentimentality combined with a desire to have a photographic record of his landscape. Maybe the success of the Haggin sale prompted Beale to consider breaking up the Tejon.[6] If Beale was thinking about selling the ranch, which would, at Beale's death in 1893, pass to his son Truxton, the pictures Watkins would make seem an odd way to have gone about it. Many of Watkins's best Tejon pictures showed the Indians and Californios who lived and worked at Tejon, people Beale considered friends and valued employees and that almost any other Californian of the era would have considered problems who would have to be removed.

Watkins made great landscape pictures of Tejon's oak-studded dried-grass canyons, the wild grapevines that covered everything they could reach, cactus hedges twice as tall as a man, springs that ran out of the mountains (which were also covered by grapevines), and even a bull being roped and then branded by Tejon ranch hands.[7] Most of this was the kind of thing Watkins had done well for thirty years. However, he made a grouping of work at the Tejon that exists nowhere else in his oeuvre: portraits of many of the Californios and the Indians who lived on the Tejon. (These are the pictures that most clearly suggest Beale wanted a photographic monument to his land.) Two of the Tejon portraits are the best Watkins ever made. One shows a family in front of an almost impossibly huge oak tree. A handsome man, smiling ever so slightly, stands slightly turned toward his wife, who is seated and who directly faces Watkins and his camera. A bright white kerchief both defies the ranch's dusty soil and offers a kind of frame for her sharp, distinguished features. A small girl, maybe three or four years old, attired in a dark dress with a white lace collar and cuffs, holds a cluster of big, shiny grapes. She leans into her mother, balancing her weight evenly between one booted foot and her mother's left leg. Everyone held perfectly still, ensuring a crisp portrait, except for the family dog. He mostly sits next to the little girl, a blur of fuzzy fur. The other is of famed Tejon majordomo Juan Jose Lopez, who provided a link to a network of Californios and farmers in the San Gabriel Valley that was no doubt useful to Beale and to the ranch. Lopez's ancestors probably came to Alta California with either Gaspar de Portola or Junipero Serra in 1769; one of them was the soldier-

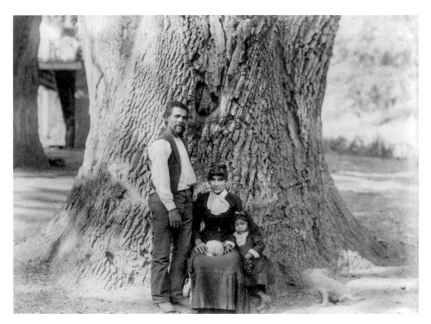

Carleton Watkins, *Family and Oak Tree, Tejon Ranch, Kern County, California*, ca. 1887–89. Collection of the Library of Congress.

escort and guard at the founding of Mission San Gabriel between Los Angeles and the San Gabriel Valley. By the time Watkins was at Tejon, Lopez had risen from herding sheep to become the No. 2 man. Watkins's portrait of Lopez is magnetic. In an effort to make sure Lopez held as still as possible, Watkins posed him leaning against a tree behind the Tejon store, maybe a big poplar or a willow. Lopez is raising his right leg slightly, anchoring himself against the tree, and uses his left hand to push back his vest and reveal a pale, freshly pressed button-up workshirt and a knife that he has tucked into his belt. A dark kerchief is neatly tied around his neck, its knot echoing the shape of Lopez's own rich mustache. A dark-and-white vertical band around his hat helps push his face forward from the tree trunk behind him. Lopez looks off to Watkins's right, the very model of a modern, handsome, confident ranch manager.

As good as those portraits are, as ever, Watkins was happiest when composing landscape into a picture. In *View of Paddocks*, apparently taken from

the northern, Central Valley side of the ranch, Watkins is up on a hillside, shooting across the narrow southern tip of the valley. In the golden-grass-filled foreground, he placed two baby oak trees, growing up side by side, with a copse of oaks and the valley unfolding down below them, either the Coast Range or the Tehachapis rising in the distance.

The mountains across most of the Tejon property are tightly folded, Appalachian style, and covered with contrasting dark oaks and golden grass, and Watkins made the most of them. He scampered his sixty-year-old bones up hillsides to build compositions that emphasized Tejon's beautiful valleys and thick oaks, including one that showed the old Fort Tejon, which the U.S. government built in 1854 to help secure the only overland pass between San Francisco and the Central Valley and Los Angeles. Down among the ruins of the fort, Watkins took a tree portrait of a preposterously enormous oak, with the adobe ruins of a fort wall, just to the right, included for scale. As he had at the missions, and maybe along the Columbia River Gorge, he was melding a landscape picture with a history picture.

Watkins's Tejon pictures are our most complete look at a traditional nineteenth-century California ranch. It is striking that Watkins fulfilled the Tejon Ranch commission as he was still shooting Haggin's land down below in Kern and producing those prints. Watkins was simultaneously making pictures of the West's future—of the birth of industrial agriculture—and of one of California's last traditional ranchos, a property with closer links to the eighteenth century than to the approaching twentieth.

The range and number of Watkins's Tejon work is unknown. Only one mammoth-plate picture, of a magnificently bushy fig tree, survives. Some Tejon pictures may have been made on the Central Valley side of Beale's land, making them difficult to separate from pictures Watkins made for Haggin's operation. Watkins seems to have included some Haggin pictures in the work he presented to Beale, and there are some Beale pictures in the collections of Haggin pictures in Kern County. Beale and his senior leadership were so fond of Watkins's pictures that they took great care of two of the albums Watkins made for them. The title page of the albums describes them as *Views of the Tejon Ranch* and "Property of Gen. Beale." In a way, they still are: today the albums are owned by the company that emerged out of Beale's holdings, the Tejon Ranch Co. Its namesake landholding is the largest single piece of private property in California.[8]

Carleton Watkins's last great Kern County picture, made in late 1889, was one of the greatest of his career. It is a masterpiece that distills decades in the West, a picture that summarizes the integration of the new industrial agriculture with the young statewide and transcontinental rail networks, as well as the West's pivot from extraction toward industrialization and modernity, and that reveals how, forty-one years after the gold rush, America's most remote outpost had finally become fully integrated into the nation's economy.

Late George Cling Peaches is a picture of twenty-four peaches packed into a shipping box. Watkins made it in or around September 1889, probably in his San Francisco studio. It was the culmination of not just his work in Kern County but a six-picture series of the maturation of a Kern peach orchard that Watkins began in 1888. Why had Watkins dedicated eighteen months to a single series of pictures? For Haggin and his allies, it was probably the most important picture of Watkins's whole Kern project. While his other Kern pictures had shown the water that would turn the desert into farmland, the canals and ditches that delivered that water to farmers and ranchers, the crops and herds that thrived in Kern's year-round growing conditions, the food-production facilities that turned raw materials such as milk into products, and the bucolic home plots of Kern's agricultural workers, before this picture, one thing was missing. However great it was that man had turned the desert into a producer of a cornucopia, none of it meant anything unless all that food could get to market.

Consider this problem within the context of what people knew about Kern in 1889. Anyone even remotely considering buying land there knew that it was a day's train ride from San Francisco, half a day's train ride from Los Angeles, and a heckuva lot farther from everywhere else. Prospective land buyers in New Orleans or Cleveland would have looked at a map, discovered the same thing, seen hard, visual proof of Kern's remoteness, and wondered if Kern was just too far away from market centers to be a good investment. The San Gabriel fruit planters had addressed this problem in the traditional way: instead of shipping fresh fruit to market, they had fermented or distilled it into alcohol, which shipped well. The San Gabriel Valley growers had so perfected their production that a prospective Kern farmer would have known that he couldn't turn new orchards into brandy, that he couldn't compete. (The other possible solution was canning, but it would not become widespread in California until the next century. The can-

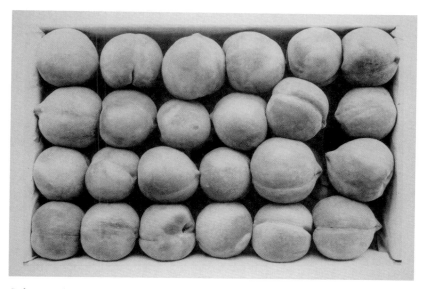

Carleton Watkins, *Late George Cling Peaches*, 1888–89. Collection of the Huntington Library, Art Collections and Gardens, San Marino, CA.

ning industry would not reach maturity until the 1920s.) Therefore, for a prospective Kern farmer and investor, distance equaled risk. If a farmer's crops arrived spoiled, they were worthless. *Late George Cling Peaches* is the answer to that concern. The caption the Kern County Board of Trade glued onto the mount explains:

> These Peaches were picked from my young orchard, four miles south of Bakersfield, planted in the months of February and March, 1888. The trees consequently have been but eighteen months planted, and as they were but one year old from the bud at the time of planting, the total age of the trees is but thirty months. A Photograph of the Orchard accompanying will show the size and thriftiness of the trees. S.W. WIBBLE [*sic*].
>
> We hereby certify that we are well acquainted with the Orchard from which the Peaches above referred to were picked, and we know the above statement of Mr. Wibble to be correct. C. BROWER, President; W.E. HOUGHTON, Secretary, Kern County Board of Trade.[9]

Simon W. Wible had come to California in the middle of the gold rush, in 1852. He had mined for gold in the Sierra and, in the process, learned how to move immense amounts of water efficiently. That experience motivated his 1874 move to Kern. Like Watkins, Wible started out working for Miller & Lux and moved on to work for Haggin.[10] While Kern was so isolated from the rest of the country that almost no one knew it (and because his work in Kern was for private concerns rather than for a city, county, or state), by 1889 Wible was surely one of America's most successful civil engineers. By 1889 Haggin was the most important person *to* Kern County, but Wible, who also cofounded the Bank of Bakersfield and made a fortune through an investment in an Alaska gold mine, was the most important man *in* it.[11] If the decision to make Wible's peaches the subject of the great, culminating picture of his Kern work was Watkins's, it was a shrewd choice.

The picture to which the caption refers is *Wible's Peach Orchard* (1888). It is a slightly elevated view of scores upon scores of young peach trees, planted in perfect rows. This orchard was one of several that Wible owned. In his *A Memorial and Biographical History of the Counties of Fresno, Tulare, and Kern, California,* author Myron Angel touted Wible's orchard as a regional model. (In an extraordinary coincidence, this is the same Myron Angel to whose father Watkins's dad, John, once apprenticed and who was a pal of a young Carleton back in Oneonta, New York. Like Watkins, Angel moved to California during the gold rush and stayed. He worked as a journalist for a series of newspapers in the foothills and in Oakland before moving to central California, where he wrote histories of the state of Nevada and of various parts of California. He was among the founders of the town of San Luis Obispo and helped found the California Polytechnic University there. While Watkins made pictures of Mission San Luis Obispo, the Eagle Hotel, and the surrounding landscape, all in 1877, there's no evidence that Watkins and Angel reconnected.)[12]

Wible initially planted twenty acres with peaches. As he expected Kern's long growing season and abundant water to produce unusually large, bushy trees, he planted his trees more widely spaced than was the custom. The trees Watkins pictured shortly after they were replanted grew to seventeen feet in height by the time they produced the peaches in Watkins's box. Wible's acreage produced five tons of peaches, enough to fill 7,731 boxes of the sort Watkins pictures. These boxes were all shipped east, where they sold

for between $1 and $2.40 per box, allowing a profit margin as high as 340 percent. In addition, Wible sold three thousand pounds of dried peaches, apparently within the California market, for another $450. Angel conservatively estimated Wible's profit from a single year's harvest on a single twenty-acre plot planted thirty months prior at an eye-popping $8,200, 40 percent more than California's governor earned in salary that year.[13] Charlie Maul's trees were a little older than Wible's, and he planted more acreage than Wible did. When Maul shipped his peaches east that same year, they filled sixteen railway cars and brought him $16,000. Wible and Maul, Angel did not need to point out, could have expected similar returns from their orchards for each year as far as the imagination could see.

So much about *Late George Cling Peaches* is unprecedented. First, consider Watkins's most important decision: to shoot the box head-on, directly and perfectly aligned with the picture plane. He could have ended his six-picture series of Kern fruit growing in so many other ways. He could have shot a single box of peaches at an angle rather than head-on. He could have made a picture of many boxes of Kern peaches, a picture that would have emphasized abundance. Instead, he presented Wible's peaches in a grid, as a metaphor for western modernity. This picture is one of the earliest grids in art, and it may be the earliest. It is so surprising that historians have routinely flat-out missed it. ("[T]he grid is an emblem of modernity by being just that: the form that is ubiquitous in the art of our century, while appearing nowhere, nowhere at all, in the art of the last one," art historian Rosalind Krauss wrote in 1978.)[14]

Late George Cling Peaches is neither an anticipation of modernity nor protomodern. It didn't have to be. The picture summarizes, both metaphorically and actually, modernity as it existed in California in 1889. Furthermore, there is every reason to believe that Watkins would have understood that a grid was the perfect visual metaphor for the new agriculture: western land, in Kern County especially, was apportioned on a grid system. The federal government gave land to the railroads based on a surveyed grid. Haggin sold land to farmers based on that same surveyed grid. Kern planters, including Maul and Wible, planted their orchards in a perfect grid, all the better to take advantage of irrigation. (These grids had been made possible by the geodetic mapping to which Watkins had contributed pictures.) Watkins's greatest strength was his visual intelligence. He surely realized that

his box of peaches was both reality and a metaphor for the newest, latest West. The first West was about mining, about working in, with, and often against the land and its contours. As California emerged from the mining era, it became a state of booming cities (all of which, even hilly, sandy San Francisco, were built on a grid) in which the newest opportunities and fortunes were in agriculture. The new industry didn't work within the landscape, it imposed itself *on* the landscape via a grid, and then grew things within it. *Late George Cling Peaches* suggests Watkins knew all this.

Watkins's next key decision was to make the edge of his picture the outer edge of the box in which the peaches sit. Today this seems elemental, even obvious: of course peaches can be boxed and shipped! But in 1889 it was such a new idea and such a sudden reality that the *Pacific Rural Press* published a nearly full-page article on how to prepare, box, and ship peaches. So unusual was the practice that the *Rural Press* even explained why the wood from some trees was good for peach-box building, and why other wood was not, and how the box should be papered and lined.[15] Watkins includes this newness in his picture: the outer edge of every surviving print is the outer edge of the papered peach box. A viewer in 1889 or 1899 or 1909 would have immediately understood what packing fruit this way meant: that the peaches would be loaded into a similarly rectangular boxcar for shipping to San Francisco and the East, where they would be distributed and sold through the new national agricultural economy. The picture is a thorough representation of a modern system, a new system of development, land ownership, irrigation, and transportation networks, of the new America made possible by the new West. The last great picture Watkins made was of the West that his work had done much to realize.

28

THE LONG, SLOW END

WHILE KERN COUNTY'S POWER BROKERS would continue to use his work well into the twentieth century, by the end of 1889, Carleton Watkins's work in Kern was complete. He appears to have made no provision to benefit financially from Haggin's long-term use of his work. In today's terms, that seems shortsighted, but in the nineteenth century, there was no understood framework under which artists or photographers or anyone else licensed images or editioned prints, methods photographers now routinely use to maintain control of their work and to derive continuing financial benefits from it. For example, Watkins's experience of producing extraordinary work only to lack long-term financial security was all too common for nineteenth-century American artists. Watkins's frenemy Albert Bierstadt, a painter so famous he sold pictures for five-figure sums and routinely supped at the White House, declared bankruptcy in 1895 and suffered a sale of his possessions so that his debts could be paid.[1]

Upon returning to San Francisco, Watkins might have built on the contacts he'd made in Kern, on the overwhelming success of the thirteen years over which he'd made pictures in San Francisco's most important, wealthiest, boomingest satellite economy. Instead, Watkins found himself involved in a legal action with Francis G. Newlands, one of the wealthiest, best-connected,

most powerful men in San Francisco.[2] It is unclear if Watkins sued Newlands or if Newlands sued Watkins.[3] It doesn't really matter. Men such as Watkins, who was reliant upon the extreme upper crust of San Francisco society for commissions and patronage, should not have ended up in court with leading figures of that class. The case marks the beginning of Watkins's professional and personal decline.

At the time, Newlands was a San Francisco attorney, which was something, and the husband of Clara Adelaide Sharon, which was far more. Clara was the only daughter of William Sharon, the former Billy Ralston associate, Comstock Lode profiteer, land baron, and a future congressman and U.S. senator for Nevada (even though he lived in San Francisco). Sharon, as we learned in chapter 17, ended up controlling all of Ralston's assets and debts at the time of his death. He parlayed the combination of Ralston's slack management and the good timing of his death into an enormous fortune, one of the West's if not one of America's largest. When William Sharon died in 1885, Clara Adelaide Sharon Newlands inherited his entire estate, which meant that her husband Francis did too. Newlands and his wife were spectacularly well connected across the San Francisco elite. James Ben Ali Haggin's Kern County business partner Lloyd Tevis's daughter would soon marry Clara Adelaide Sharon's brother. One of the men who sat on the Sharon Estate Co. board of directors was William F. Herrin, who was also the staff attorney for Spring Valley Water and who would later be the chief counsel for the Southern Pacific.[4] Watkins had ended up in a lawsuit with the San Francisco that had, for decades, enabled his career.

Watkins and Newlands faced each other in court in 1890. The records related to the case were destroyed in the events of 1906. The only surviving mention of the case is a single sentence in the December 6, 1890, *Daily Alta California*: "Judge Finn has given judgment for Francis G. Newlands and against C. E. Watkins for possession of the store, 26 New Montgomery Street, and rent due." All we know about the case is that Newlands won. (In a way, the specifics were irrelevant: no Gilded Age California court was ever going to side with a Watkins against a Newlands.) The address cited in the *Alta*, 26 New Montgomery Street, was the mailing address of the sprawling, blocks-filling Palace Hotel, the one that had been unfinished when Ralston died.

Did Watkins, in fact, have a "store" in the Palace Hotel? Maybe. Watkins never listed a Palace Hotel retail outlet in San Francisco city directories.

However, some of Watkins's Kern mammoth plates, such as *Late George Cling Peaches,* indicate that he had *two* business addresses: on 427 Montgomery, in the heart of San Francisco's downtown, and four blocks south, at what the captions list as "26 New Montgomery St., under Palace Hotel, S.F." The Palace was San Francisco's best hotel. Agricultural bigwigs such as L.J. Rose and Lucky Baldwin and aspiring L.J.s and Luckys stayed in the Palace when they visited San Francisco. If Watkins had a retail location at the Palace, why didn't he list it in the city directory? Perhaps that second address referred not to Watkins personally but to a Kern County Land Co. presentation of Watkins's Kern pictures. After all, these were the men Haggin wanted to reach. Then again, the court case was between Newlands and Watkins, not Newlands and Haggin.

If Watkins had a retail location at the Palace, we do not know when it opened or closed. Another possibility is that Watkins believed that Ralston had given him or provided for him a location at the Palace. It is possible that Sharon honored such an agreement, or that Sharon found it in the hotel's interest for Watkins to be on site, but when the property passed to Newlands, that new owner refused to honor a previous gentleman's agreement. (Contemporary accounts of the hotel suggest its retail-space leasing was a disappointment. Having a regular, nationally known tenant at low or no cost may have been a boon to the Palace.) Sharon died at the end of 1885. Would Newlands have really waited four years to sue Watkins for nonpayment of rent? Could Watkins have sued Newlands, believing that he had documentation that allowed him a space at the Palace at terms that, at some point, Newlands felt no longer bound him? Did the judgment for Newlands granting him "possession of the store" entitle Newlands to Watkins's prints and/or negatives? Could Watkins have lost his life's work, or at least a partial interest in it, a second time? Probably not, as he continued to make and sell prints from post-1876 negatives well into the 1890s, but who knows?

After completing his work in Kern County, Watkins accepted three commissions. He finished two of them. He was physically unable to finish the third.

First, either James Ben Ali Haggin or another of his business partners, California Sen. George Hearst, hired Watkins to go to Butte, Montana, to make pictures of a mine they co-owned. The mine was known as Anaconda. When

Haggin, Hearst, and Lloyd Tevis had started buying up shares in Anaconda, it was a silver mine. By the time Watkins got there, the consortium had discovered copper, and Anaconda was becoming one of the world's great copper mines. It was clear both that the mine needed further investment and that the American Anaconda team needed to cut a deal with European copper interests to find a way to stabilize volatile world copper prices so as to ensure maximum profitability for all. The Haggin team hired Watkins to go to Anaconda to make pictures of the mine that might convince European bankers to invest and convince European copper investors of their shared interest.

Starting in June 1890, Watkins spent five months in Montana.[5] Due to weather and, more importantly, mine-related pollution, it was some time before he could begin work. When he did, he made dry-plate negatives of the mine underground. Eighty of them are now at the University of Idaho Library. (If Watkins made mammoth-plate pictures or dry-plate outdoor pictures at Anaconda, they have not survived.) While Timothy O'Sullivan worked underground for the King Survey in 1867, these were the first and only pictures Watkins made underground. As a result of the confined spaces underground and Watkins's unfamiliarity with flash technology, they are far from his best work. Watkins knew it. I "went up to Butte last week and tried making views in the mine with a combination of electric and flash light," he wrote Frankie. "[I]t didn't work worth a damn, but I got it 'all the same.'"[6] The impact the Anaconda pictures had on European investors is unknown, but Haggin's mission to Europe was a success.

Next, over the late spring of 1890 and the summer of 1891, Watkins worked on his final outdoor commission, at the Golden Gate and Golden Feather mines in the Sierra Nevada foothills of Butte County, California. These mines were more industrially robust versions of the mining activity Charles Leander Weed had photographed in the late 1850s, by which miners had redirected rivers in order to get at the ore below. This updated alluvial mining required a much larger diversion of water and much, much more capital. As ever, the mine owners wanted Watkins to make pictures that would help make their case to investors. This would not be Watkins's best work either. Yes, Watkins's pictures showed the necessary industrial might with necessary competence, but they lack the pictorial inventiveness and clever, layered compositions of his finest pictures. When Watkins finished the commission, he was sixty-two years old.

The years after the Golden Gate/Golden Feather commission were tough on Watkins. As he advanced into his sixties, he complained to Frankie about a range of maladies. "I am in constant pain with my hip and have to limp in walking," Watkins wrote from Anaconda on July 5, 1890. "Sometimes it seems as if I could not stand it, but I have to."[7] A few months later, also from Anaconda: "Yesterday I was taken with one of my vertigo fits, and while I manage to get about, it has upset me completely. I was in hopes to get through with [this] infernal job before it got after me, but it was not to be." An 1891 letter Watkins wrote to Frankie references receiving several prescription medicines for his difficulties.

We can only guess what Watkins's precise challenges were. Certainly he seems to have suffered from acute arthritis. In 1890s lingo, "vertigo" could mean any of a range of ailments, from migraine headaches to acute dizziness to seizures.[8] He complained of feeling "D—— blue," which suggests he may have suffered from depression.[9]

With the Golden Gate/Golden Feather commission complete, Watkins returned to San Francisco for a while. He seems to have sold a number of mining-related pictures to George Hearst's widow, Phoebe, sales on which Watkins was increasingly reliant. "Things are very shaky with the old man and if his ship does not come in pretty soon—if it [is] nothing but a little canoe—well, it will get pretty bad," Watkins wrote to Frankie, who seems to have been visiting her family in Virginia City, Nevada. As Watkins's physical condition declined, so too did his capacity for earnings. "Mrs. H[earst] still stays away and, of course, my only hope lies with her. Let us hope."[10]

After the commission in Butte County, Watkins seems not to have worked for five years, the longest period of professional inactivity of his life. The tapering out of Watkins's career matches the rise of the Kodak camera, the moment at which photography became available to all. For several decades, in both Europe and the United States, artists who used cameras would struggle to find a response. Once anyone could take a picture of Yosemite, even a small one that wasn't as good, pictorially or otherwise, as a Watkins, they did.[11] If there was an upside to this, it was that Watkins finally spent extended time with his children. When Watkins finished the Golden Gate/ Golden Feather work, Julia was ten, and Collis was eight. Since Julia had been born, Watkins had traveled to British Columbia, Washington Territory, Montana, Wyoming Territory, Oregon twice, and all over California, includ-

ing to Sonoma County, to the Hotel Del Monte in Monterey, and to Kern County many, many times. Watkins probably had been away from home for about half of his kids' lives. (Perhaps as a result, Frankie's sister Helena seems to have moved in with the family.) His few surviving letters are full of warmth toward both children. "The fact is I am getting awful hungry for kisses and hugs and things," Watkins wrote from Montana in an 1890 letter addressed to "Wife and Babies & Sweetheart."[12]

Watkins's few surviving letters home rarely fail to address the children specifically and to include messages for them. Watkins came to fatherhood late, but he seems to have enjoyed it mightily. "Tell Juju that Papa has been too sick to write, but he hopes to be better in a few days and is very glad to hear that she and Collis are good children and are learning very fast," Watkins wrote in 1891.[13] And a month or two later: "Tell the children that Papa and I guess everybody in the building misses them. Tell Juju that the man that sells the rolls says the sun has not shone since she left, and he hopes Collis will come home with roses in his cheeks."[14]

On November 11, 1890, Frankie and the children celebrated Watkins's birthday even though he was busy in Montana. In the only letters surviving from their childhood, both children wrote to him of the affair. "My dear Papa, Grandpa made a mistake. He thought your birthday was Sunday, and so we got the ducks and chickens Saturday," Julia wrote. "Mama cooked the chickens Saturday . . . we had a very nice time and talked about you. I wish you could have been here."[15]

Decades later, Julia conducted two interviews with historians. They are highly unreliable documents, full of the shadows of decades-old memories and even impossibilities. Among Julia's few memories of childhood were her father's love of eating out and eating well, memories that probably date to the flush years of the 1880s, when Julia was a girl of seven or eight. When Watkins could, he doted on his family.

Watkins's next known opportunity to make new pictures would have to wait until 1896, when Phoebe Hearst asked Watkins to photograph her new East Bay estate. The details of this final commission are fragmentary and unclear. None of the work, if Watkins completed any, is known to have survived.

It is not clear how he came to be offered the commission, but it seems to have gone something like this: just after Watkins finished his work at Ana-

conda, George Hearst died. Phoebe didn't trust George's Anaconda partners Haggin and Tevis—who were perfectly reputable, it's just that Phoebe trusted no one—and she decided to sell her inherited interest in the mine. Concurrently, Phoebe was fed up with the way she believed her son, William Randolph, was carousing with what she believed to be the wrong crowd at her late husband's horse ranch in Pleasanton, east of San Francisco Bay. She kicked Will, as the family called him, off the Pleasanton property, gave him a small portion of the Anaconda proceeds, and left him alone as he began building what would become America's most notorious journalism empire.

With Pleasanton all to herself, Phoebe retained hotshot architect A.C. Schweinfurth to design an enormous mansion, which she would come to call Hacienda del Pozo de Verona. When the house was complete, in the summer of 1896, she moved in. It was probably around this point that she summoned Watkins, now sixty-five.[16]

That's all we know. Maybe the vertigo about which he had complained was flaring up. Maybe his vision had deteriorated so much that he could not work. In fact, he would never again make pictures. By 1903, Watkins's inability to see was so acute that he had to dictate his correspondence to his son, Collis, who both wrote and signed his father's letters. By 1906, Watkins's vision was limited to the ability to distinguish patches of light from patches of dark. The man who had done so much to bind the West to America was increasingly unable to see it.[17]

As Watkins's physical ailments increased and as his sight lessened, it became clear that Watkins needed assistance, and he had the good fortune to receive some. Collis Huntington stepped up first. Huntington purchased and gifted to Watkins eighty-one acres of prime farmland from a Southern Pacific–controlled land agency called the Capay Valley Land Co. The Capay Valley offered some of the best farmland in the northern third of California. A creek ran alongside the acreage, which meant that the land could be readily irrigated. According to Capay Valley Land Co. records, the plot of land cost Huntington $5,000, an exceptional sum given that the company's other nearby transactions were almost entirely in the $100 to $200 range, with a few plots selling for as much as $550. The sale of the land that Huntington purchased for Watkins (which he gave with the caveat that Watkins could not sell it) went through a few weeks before the end of 1895. Perhaps Hunt-

ington was balancing the company's books at the end of the calendar year and doing Watkins a favor all at once.[18]

Historian Eugene Compton believed that Watkins moved to the Capay Valley, at least for a time, in March 1896.[19] It is unknown how long Watkins lived there. Later documents indicate that the Watkinses either rented out the property or left it to be tended by Oliver MacDonald, whom Compton believed was an uncle of Watkins's. Despite all this uncertainty, this much is clear: a remote farm, no matter how productive the land might have been, would have been a difficult place for a blind, infirm man in his late sixties. Huntington also promised Watkins $1,000 in cash, which he paid in three installments.[20]

Six months after Collis Huntington purchased the Capay land, Watkins visited Huntington's nephew, Henry E. Huntington. Henry was the man who looked after Collis's West Coast interests. Henry learned that Watkins was maintaining a photographic office in the city but was trying to sell his stock. Henry advised Collis to urge Watkins to move to the Capay Valley for good. "He also says he expects to rent a place where he will be paying more rent ... get a better location, and he is talking of going out on the road again," Henry wrote. "I simply write you this to keep you informed."

"Carlton [sic] has not any sense, and never did have," Collis responded a few days later of the man who had done much valuable work for his companies. "I think you should tell him that he had better move up to Capay and stay there. . . . What is there that he can do to get a living otherwise than by making pictures?"[21] Given Watkins's degenerating sight, not much. Certainly he was not physically capable of improving his land with irrigation.

Before long Huntington regretted his churlishness. The prompt seems to have been a long letter that Watkins wrote Huntington, a letter that detailed Watkins's service to Huntington's enterprises over the previous twenty years. "I have no doubt all that he says is true," Huntington wrote from New York to another of his San Francisco capos, Alban Towne. "I wish you would renew his [complimentary railroad] passes and if you could let him have $2500, I would like to have you do so, charging it to expense account or any other that you like, as I think him fairly entitled to it."[22]

Between December 1895 and February 1897, Huntington gave Watkins the Capay farm and $3,500 in cash. Surely that would be enough to sustain a physically declining sixty-eight-year-old man in what must have seemed

like his final years, no? After receiving the final $2,500 from Huntington, Watkins vanished from the historical record for several years.

The next two people who helped Watkins the most, both professionally and in their friendship, were historians Charles Beebe Turrill and Harry C. Peterson. Turrill especially is responsible for almost all of what we know about the last twenty years of Watkins's life. He became Watkins's closest late-in-life friend, even his companion. He took a deep interest in the breadth of Watkins's work and in his well-being. At a time of blindness, injury, and endless frustration, he protected Watkins and, at the coming time of calamity, cared for him. By the late 1890s or early 1900s, when it seems that Frankie was spending her time in the Capay Valley while Watkins was in San Francisco, Turrill's friendship was probably the most important thing in Watkins's life. Up until the 1970s revival of scholarly interest in western photography, no one did more to ensure Watkins's place in American history than Charles Turrill.

Turrill was a pragmatic polymath whose jobs, interests, and hobbies benefited from a modernizing West and prepared him for his friendship with Watkins. As a young man, a native Californian, Turrill was a promoter, a kind of marketing-focused land agent for the Southern Pacific and its affiliated companies. Starting in 1883, he was involved with the California Immigration Commission, a Southern Pacific initiative that encouraged settlement in the West. Turrill promoted the state, mostly its agricultural potential, in books, magazines, and displays at fairs and expositions around both the United States and Europe in the 1880s and 1890s. Turrill was the office's exposition manager.[23] He seems to have worked for the railroad for almost twenty years, at which point he made one of his hobbies into a new career and co-opened a commercial photography studio with one Charles O. Miller. He and his partner focused their business on making pictures related to Bay Area history and industry. The Bay Area's Catholic community and its institutions seem to have been a pillar of the business: the largest troves of the firm's surviving pictures are of Jesuit-run Santa Clara University and of Bay Area Catholic churches. While Watkins was fiercely nonreligious and agnostic bordering on atheistic, his son, Collis, attended a Catholic school in the 1890s, perhaps at Turrill's instigation.[24] Near the end

of his career, Turrill morphed into a semiprofessional historian, writing short histories of San Francisco people and institutions.

That background in land sales, promotion, photography, and history gave Turrill the ideal perch from which to understand Watkins's accomplishments. Turrill seems to have known of Watkins by the mid-1880s, when he organized one of his first marketing displays, for the 1883 Illinois State Fair. He had certainly met Watkins by 1884, when he included Watkinses in his display for that year's World's Fair in New Orleans and in subsequent fairs around America. Among the Watkins pictures Turrill featured were views of Yosemite, the Tehachapi Loop, and the railroad's Hotel del Monte.[25] Turrill also bought Watkinses for his own personal collection, as many as he could afford. Then, late in Watkins's life, when Watkins could no longer write for himself, Turrill stood in, partly as Watkins's Boswell and partly as an advocate for Watkins to the handful of influential men who tried to aid an elderly man who had helped drive the state's growth.

Nothing is known of the Turrill-Watkins relationship between the 1880s and 1903, at which point Watkins somehow entered into a correspondence with George Pardee, an Oakland doctor and mayor who had just assumed office as California's first native-born governor. In a somewhat confusing letter addressed to Dr. Pardee rather than to Governor Pardee (could Watkins have been a patient of Pardee's?), Watkins sent Pardee two unknown pictures to thank him for "kindness to my daughter and myself [a] long time ago." In the letter, which a nearly blind Watkins dictated to his son, Collis, Watkins also asked if Pardee (and by extent the state) might purchase and present some of his pictures of Yosemite to President Teddy Roosevelt, who would be visiting Yosemite that summer.[26] The effort seems to have come to naught, but at some point, Turrill rallied to Watkins's side. Like Watkins, Turrill seemed to have a preexisting, even close, relationship with Pardee. Over the next few years, Turrill and Pardee would advocate for the inclusion of Watkins pictures at expositions such as the 1904 World's Fair in St. Louis and the 1905 Lewis and Clark Centennial Exposition in Portland, Oregon, an unofficial world's fair. Watkins "feels the state should have many of the views of historic interest that he has," Turrill wrote to Pardee in 1905, among the earliest arguments that Watkins's work was of such significance that it should be held by one of just a handful of entities that recorded the state's history.[27] Pardee, a photography collector himself, seems to have

suggested the state acquire pictures specifically for the California State Library's collection; he acquired Watkinses for his own collection as well. Pardee's correspondence with Turrill also establishes that Pardee's interest in Watkins wasn't merely official; he seems to have known Watkins well enough to be concerned about his well-being, an interest he would maintain throughout California's coming disaster.

Turrill's service to Watkins and his legacy would continue even after Watkins's death: in 1918 Turrill wrote the first minibiography on Watkins for *News Notes of California Libraries,* the official journal of the California State Library, the kind of publication created to help a young state value its past. When he wrote it, he hadn't talked with Watkins in at least two years, probably many more. The short essay is error strewn, probably in part because, especially after the events of 1906, Turrill had no way to check much of the information provided to him by Watkins and others. Still, until the mid-1970s, it was the single most valuable document about Carleton Watkins.[28]

Meanwhile, down the Peninsula, Harry C. Peterson was similarly well positioned to perpetuate Watkins's legacy. Between 1900 and 1917, Peterson was the director and curator of the Leland Stanford Jr. Museum, the repository of the fine art and artifacts collections of Leland and Jane Stanford. The museum was part of Stanford University, the school that the Stanfords built as a memorial to their son (who had died of typhoid fever at age fifteen). The university opened in 1885; the Stanford Museum followed in 1894. Over the next twelve years, the museum spread out to cover two large annexes. In 1902 the museum signed contracts to build two hundred thousand square feet of display space and ninety thousand square feet of storage space. It was to be the largest private museum in the world.

The Stanford Museum's collection, administered by Peterson but entirely chosen and purchased by the Stanfords and especially by Jane Stanford as she traveled the world after her husband's death in 1893, was farreaching. There were Egyptian bronzes, five thousand pieces of Greek and Roman pottery and glass, Sevres and Dresden wares, and copies of Old Master paintings, plus works by fashionable academic French painters such as Jean-Louis-Ernest Meissonier, Augustus Jules Bouvier, Léon Bonnat, and Carolus-Duran, and works by prominent Americans such as Albert Bierstadt, Charles Nahl, William Keith, and Thomas Hill. Jane Stanford had even

purchased Henry Chapman Ford's watercolors of California missions, quite a number of which were based not on the missions themselves but on Watkins's photographs. The museum's rambling collection even included Stanford family collectibles, such as the Central Pacific Railroad's transcontinental railroad–completing "last spike," Leland Stanford's horse-racing trophies, and Dutch lace and shawls Jane Stanford had purchased in India as souvenirs. It was a bit of a grab bag.

Among the more unusual collections at the Stanford Museum, at least by turn-of-the-twentieth-century standards, were photographs by Eadweard Muybridge. Today art museums routinely collect photographs; in the early 1900s, they did not. In 1910 the Buffalo Fine Arts Academy, which today is known as the Albright-Knox Art Gallery, was the first American art museum to present an exhibition of fine-art photography, while America's oldest art museum, New York's Metropolitan, would not collect photographs until 1928.[29] Included in the Stanford Museum's collections were Muybridge's pictures of animal locomotion, the pioneering images Muybridge began making on Stanford's farm that showed how horses and then other animals moved. Muybridge's animal-locomotion pictures would, in time, lead directly to the development of motion pictures and to California's movie industry, but for now they were simply pictures in a museum collection.

Usually Peterson's job was to say yes to anything Jane Stanford came up with, but these Muybridges gave Peterson ideas of his own: in late 1901 he decided that photographs should go on view near the paintings they often helped inform, paintings such as Jane Stanford's Albert Bierstadts and William Keiths. He typed up a memo to Jane Stanford detailing his thoughts on how to display photography and announced his plans to travel to San Francisco to try to find a suitable design for photography cases.[30]

When Jane Stanford died in 1905 (she was poisoned under circumstances that have never been fully explained), Peterson found himself with the opportunity to build and display Stanford Museum collections as he wished. Therefore, in April 1906, when someone, most likely Turrill, suggested to Peterson that Carleton Watkins's pictures merited his consideration, Peterson took a look.[31] Finally he had the opportunity to build some of the museum's collections himself, independent of Stanford's buy-and-dump approach.

Peterson was uniquely positioned to understand Watkins's importance and even the quality of his work: before joining the Stanford Museum, Pe-

terson had been the head of field research at the California State Library, a position that required him to travel up and down the Mother Lode gathering material, making photographs of mining sites, and taking oral histories. (In the years to come, Hollywood filmmakers would benefit from Peterson's knowledge, hiring him as a consultant on the production of films such as the John Wayne vehicle *The Big Trail* and *Fighting Caravans*, which starred Gary Cooper.) Peterson had also worked as the curator of the Sutter's Fort Historical Museum, which chronicled the early days of the gold rush, and had studied early San Francisco history, the history of California's roads, and the history of photography, even contributing several chapters to an early encyclopedia of the medium.[32]

Peterson visited Watkins in San Francisco on April 15, 1906. He immediately understood that the material in Watkins's possession, material that presumably included Watkins's decades-old mammoth-plate pictures and dry-plate work of the late 1880s, was significant. Peterson began the process of cataloguing Watkins's holdings. Later, Peterson told early photographic historian Robert Taft that Watkins's trove even included an oaken chest containing "dozens of rare daguerreotypes, including that of [Johann] Sutter of Sutter's Mill." It seemed as though Watkins's pictures—historians still debate whether that Watkins had dozens of daguerreotypes in his possession meant that he was himself a daguerreotypist or whether he, like so many Americans of his generation, simply owned old daguerreotypes—were on the cusp of being acquired by the Stanford Museum. This would have been significant, possibly the first American museum acquisition of photography as fine art. (Muybridge's animal-locomotion pictures had entered the Stanford Museum as Stanford family collectibles, not as art.) Peterson seemed to have a more historical view and seemed to have cut a quick deal to acquire the work from Watkins. When Taft published his landmark history of American photography in 1938, Peterson was no doubt pleased that Taft nodded to his assessment by including several of Watkins's pioneering Yosemite pictures.

"The chest was too heavy for me to handle alone," Peterson told Taft, "so I put it near the rear door and told [Watkins] I would bring one of the boys with me next Sunday [April 22] and in that way get it to the [train] station."[33]

Peterson never made it. Three days after his visit, at 5:12 A.M. on April 18, 1906, a section of the earth's crust south of San Francisco's Lake Merced

and a few miles off the San Mateo County coast snapped. The resulting series of concentric seismic waves reached Watkins's oaken chest about three seconds later. It was the biggest earthquake American San Francisco had ever experienced. Such was the intensity of the earthquake, believed to register around a 7.7 to 7.9 on the Richter scale, that it overwhelmed San Francisco–based seismographic equipment even as it registered on seismographs as far away as Japan and Washington, DC.[34]

The earthquake shattered buildings and severed gas lines throughout the city. This started several dozen fires. In an attempt to create firebreaks, city firefighters used dynamite to destroy neighborhoods, especially Chinese neighborhoods, and started even more fires. San Francisco crumbled, and burned for days. Places Watkins knew well, such as the Palace Hotel and the Mechanics' Institute, fell, burned, or both. Among the early casualties of the fire was everything Carleton Watkins owned, all of his work, his chest of daguerreotypes, his records, everything.

Charles Turrill happened to be not far from Watkins's apartment—the last known San Francisco address for Watkins is 1249 Market, between Eighth and Ninth Streets—when the quake hit. "The earthquake has wrecked his place very badly," Turrill wrote to Pardee three days after the calamity. "The subsequent fire consumed everything, his wife escaping in her night clothes." Frankie may have fled the fire and escaped to Golden Gate Park or to the Presidio, where many women, children, and injured were taken or directed. Turrill took care of Watkins, sleeping with him on an exposed hillside for two nights—aftershocks and the danger of continued collapses drove San Franciscans away from buildings and into the outdoors—and eventually took him to a hospital for what seems to have been leg injuries.[35] Watkins needed the help. By this time, he was nearly completely blind. "He is . . . able to distinguish very bright objects, as the sun or a gas jet," Turrill wrote to Pardee in the summer of 1906.

The earthquake and fire were an extraordinary calamity at a time when American communities lacked the infrastructure, bureaucratic and otherwise, to cope with an event that affected hundreds of thousands of people. Old, blind, and apparently significantly injured during the earthquake, Watkins was especially vulnerable. Frankie and her sister Helena left San Francisco after the quake. They "have gone to Virginia City and left him to the

care of Hospitals where he has not had any extraordinary care or food," Turrill wrote to Pardee.[36]

Watkins still had the ranch in the Capay Valley. For years he had resisted going there, believing its isolation would cut him off from perpetually hoped-for picture exhibition and sales. It is not unusual for the elderly to resist leaving the place where they have lived all their adult lives. Watkins had lived in San Francisco for fifty-six years. Leaving for the Capay Valley must have felt like giving up, like acknowledging that his life was over, that his prospects were at an end. When the earthquake hit and destroyed everything he owned, there was no longer any reason to hope. Watkins was willing to go to Capay, but finally understood that with his blindness and now his leg injury, he could not care for himself.

Turrill wrote to Pardee to plead for assistance, to ask that he might find a place for Watkins other than "the poor house."[37] (We do not know how Frankie, Julia, or Collis responded to the earthquake and fire or to Watkins's needs.) Turrill proposed to Pardee a way to create a fund for the support of his infirm friend, but at a time when San Francisco and California's economy was in crisis, a farsighted idea had no chance. Still, even with his state's most important city substantially in ruins, Pardee was sympathetic, responded quickly to Turrill's letter, and demonstrated an awareness of Watkins's importance to the state's history and of the imperative to care for him in his declining years. In 1906 California almost entirely lacked the kind of archival repositories, historical institutions, and art museums that might have sustained Watkins and his work. Pardee racked his brains to find an answer, but the need was ahead of the institutions available to him. Despite being overwhelmed by the needs of his state in the wake of disaster—historians give Pardee high marks for his response to the earthquake and fire[38]—he saw to it that the California State Library bought some prints, an extraordinary and materially (and financially) meaningful gesture at a time of statewide crisis.[39] As to Watkins's physical needs, both America and California mostly lacked a kind of social safety net. Evening approached.

It is not clear how Watkins took care of himself between the late summer of 1906 and 1909. Perhaps Frankie returned to San Francisco once the

aftershocks stopped and the fires were out. Perhaps not. The last mention of Frankie in any surviving material related to Watkins is in 1906.

By the summer of 1909, it appears that Watkins was in Capay and that only Julia, now twenty-eight, remained in his life. He was fully blind, and the leg injury suffered in the earthquake seems to have left him lame. Watkins's needs were greater than Julia could meet. On June 11, 1909, Julia (and Julia alone) formally petitioned the state for assistance. Her appeal is difficult to read: it declared that her father, now seventy-nine years old, "needs the care of some fit and proper person" and that he was "blind and an invalid and mentally incompetent, and incapable of properly taking care of himself or his property. That by reason of said physical and mental condition, he would be likely to be deceived or imposed upon by artful or designing persons."[40] A few days later, the court accepted Julia's petition and appointed her guardian of her father and his estate.[41] Six months later, a few weeks after Watkins turned eighty years old, the Yolo County magistrate and medical examiner ordered that Watkins be committed to the Napa State Hospital for the Insane.

Watkins would live for six more years. There are no records of what his life was like in the Napa asylum or, for that matter, what the lives of any similarly committed people were like. Late in her life, Julia gave two interviews to historians. They provide no information on her father's last years.

Watkins died at the Napa State Hospital on June 23, 1916. He is believed to have been buried in the hospital cemetery, but his grave has never been found. Carleton Watkins is lost to the land his art helped make.

ABBREVIATIONS

MANUSCRIPT COLLECTIONS

BANC	Bancroft Library, University of California, Berkeley
BRBLYU	Beinecke Rare Book & Manuscript Library, Yale University
CHS	California Historical Society, San Francisco
CSA	California State Archives, Sacramento
CSL	California State Library, Sacramento
CHS	California Historical Society, San Francisco
GTU	Graduate Theological Union, Berkeley, CA
HL	Huntington Library, San Marino, CA
LOC	Library of Congress
NARA	National Archives and Records Administration
SCP	Society of California Pioneers, San Francisco
SUL	Stanford University Libraries
YUL	Manuscripts and Archives, Yale University Library

INDIVIDUALS

AG	Asa Gray
CEW	Carleton E. Watkins
CPH	Collis P. Huntington
FB	Frederick Billings
FLO	Frederick Law Olmsted
FSW	Frances "Frankie" Snead Watkins
GD	George Davidson
JBF	Jessie Benton Frémont
JCF	John C. Frémont
JDW	Josiah D. Whitney
PEP	Peter E. Palmquist
RR	Randolph Ryer
RWE	Ralph Waldo Emerson
TSK	Thomas Starr King
WCR	William C. Ralston
WHB	William H. Brewer

NOTES

I HAVE TRIED TO cite the most broadly accessible versions of sources and have included extended citations in notes when this elucidation might provide clarity. For example, the Huntington Library's Clarence King material is almost entirely within the James D. Hague Papers but is catalogued as being within both the Hague Papers and the Clarence King Papers. In references to Carleton Watkins's mammoth plates, I have used the numbering system Weston Naef and Christine Hult-Lewis created for *Carleton Watkins: The Complete Mammoth Photographs.* In references to the stereographs, I have used Watkins's numbering system.

INTRODUCTION

1. While the museum at Stanford University would have been the first such institution to acquire CEW's work, in 1874 the California State Library acquired 113 CEW views.
2. T.J. Stiles, "Chernow's Portrait of Grant as a Work of Literary Craftsmanship, If Not Art," *Washington Post*, October 6, 2017.
3. White, *"It's Your Misfortune and None of My Own,"* 617.

CHAPTER 1. SUNRISE IN THE FOOTHILLS OF THE CATSKILL MOUNTAINS

1. Birth records from early Milfordville/Oneonta have never been located.
2. Howe, *What Hath God Wrought*, 39.
3. Campbell, *History of Oneonta*, 35–36.
4. Milener, *Oneonta*, 3.
5. Baker, *Oneonta in Olden Time*, 98.

6. Huntington, *Old Time Notes*. The original and apparently unpublished copy is at the Huntington Library, Oneonta, NY; the condensed, published version is Huntington, *Oneonta Memories*. *Otsego County (NY) Herald Democrat,* May 1, 1890.

7. Huntington, *Old Time Notes*, 1,796, 1,944, 2,048–49.

8. Huntington, *Old Time Notes*, 1,893; Campbell, *History of Oneonta*, 169–70.

9. Milener, *Oneonta*, 11; Baker, *Oneonta in Olden Time*, 33, 95.

10. Huntington, *Old Time Notes*, 1,987.

11. Ibid., 2,000–2,002.

12. Ibid., 1,918.

13. Ibid., 2,048–49.

14. Littman, *Heavens on Fire*, 2–3.

15. Lewis, *Physics and Chemistry of the Solar System* , 338.

16. Huntington, *Old Time Notes*, 1,847.

17. Ibid., 2,048–49.

18. Ibid., 2,074.

19. Ibid., 2,188.

20. Ibid., 2,014.

21. Howe, *What Hath God Wrought,* 118.

22. Howe, *What Hath God Wrought,* 31, 118–20; Billington and Ridge, *Westward Expansion,* 329–30.

23. Billington and Ridge, *Westward Expansion,* 331.

24. Huntington, *Old Time Notes,* 2,073.

25. Stiles, *First Tycoon,* 42.

26. Milener, *Oneonta,* 9.

27. Howe, *What Hath God Wrought,* 214–17; Milener, *Oneonta,* 147.

28. Milener, *Oneonta,* 12; Huntington, *Old Time Notes,* 2,143.

29. Billington and Ridge, *Westward Expansion,* 334.

30. Howe, *What Hath God Wrought,* 141.

31. Huntington, *Old Time Notes,* 2,014.

32. *Otsego County Herald Democrat,* May 1, 1890.

33. Hurd, *History of Otsego County, New York,* 55–63, 236; *Otsego County Herald Democrat,* May 1, 1890.

34. Campbell, *History of Oneonta,* 175.

35. Milener, *Oneonta,* 1.

36. Milener, *Oneonta,* 152.

37. U.S. Census, 1840.

38. CPH biographical material, MSS C-D 773, BANC.

39. Ibid.

40. Huntington, *Old Time Notes,* 2,221–22.

41. Howe, *What Hath God Wrought,* 45.

42. U.S. Census, 1840.

43. Milener, *Oneonta*, 140.
44. CPH biographical material, MSS C-D 773, BANC.
45. Campbell, *History of Oneonta*, 180–81.
46. Lavender, *Great Persuader*, 30.
47. Campbell, *History of Oneonta*, 177.

CHAPTER 2. ARRIVING IN CALIFORNIA

1. In *The Great Persuader* (8–9), Lavender offers an alternate route: that the Oneonta party boated down the Susquehanna River to Unadilla, NY, took a stagecoach to Deposit, NY, and rode the barely completed New York & Erie Railroad to Piermont, NY, where they would have boarded a steamboat for New York City. Lavender's source is 1851 correspondence between Collis Huntington and his brother Solon, which Lavender understands as accounting for the 1849 expenses of Egbert Sabin. Given that Collis Huntington was traveling with enough goods to establish a Huntington Bros. store in California, that the water flow of the Susquehanna River was typically so low in late winter as to allow little to no traffic, and that the Catskill route was both easier and more familiar to Collis, I believe that the 1851 letter details a different trip, likely the one on which Egbert assisted with Collis's wife's 1851 passage from Oneonta to San Francisco (on which it would have been routine for her to be accompanied by a companion such as Egbert, whom Collis had sent back to Oneonta in the spring of 1850). Furthermore, Collis is more likely to have accounted for 1851 expenses in an 1851 letter than to have detailed two-year-old expenses. Regarding Watkins's inclusion in the Oneonta group on the *Crescent City*, see Naef and Hult-Lewis, *Carleton Watkins*, xiii–xiv.
2. Milener, *Oneonta*, 12.
3. *New York Tribune*, March 10, 1849.
4. Unattributed addendum to Frémont, *Oregon and California*, 427.
5. Ibid., 434–35, 444–50, 453–54.
6. Herr, *Jessie Benton Frémont*, 185–87; Frémont, *Year of American Travel*, 10–12.
7. Chaffin, *Pathfinder*, 383.
8. Ayers, *Gold and Sunshine*, 27.
9. Naef and Hult-Lewis, *Carleton Watkins*, xiii.
10. Naef and Hult-Lewis speculate in *Carleton Watkins* (xiv) that Watkins was a daguerrean from 1850 to 1853, based on unknown (and unpublished) "stylistic consistencies." I am aware of no documentary evidence that supports this idea.
11. Marszalek, *Commander of All Lincoln's Armies*, 70.
12. Winks, *Frederick Billings*, 43.
13. Matthews, *Golden State in the Civil War*, 3.
14. The Chivs made much out of legislation that Frémont had sponsored that benefited the owners of land grants that dated back to the Mexican era. Frémont himself owned such a former grant, a gold-mining estate called Las Mariposas, but this was

less of a conflict of interest than it seemed; even the spokesperson for those opposed to Frémont's position on land grants supported his continuing in the Senate. See Chaffin, *Pathfinder*, 413–20, and Richards, *California Gold Rush*, 116–17.

15. Soulé, Gihon, and Nisbet, *Annals of San Francisco*, 486; *Financial History* (Summer 2012): 24, http://post.nyssa.org/files/early-corporate-america.pdf.

16. Palmquist and Kailbourn, *Pioneer Photographers of the Far West*, 496–99.

17. Palmquist, *Carleton E. Watkins, Photographer of the American West*, 7–8; Naef and Hult-Lewis, *Carleton Watkins*, 130–31.

18. *Daily Alta California*, May 2, 1855.

19. "Photographic Exhibition at the Society of Art," *Art Journal* 5 (1853): 54.

20. "Geology: Its Relation to the Picturesque," *Art Journal* 7 (1855): 275.

21. "Photographs from Sebastopol," *Art Journal* 7 (1855): 285.

22. Some of the same ideas that were put forth in *Art Journal* are in Ruskin's writing, particularly in *Modern Painters*. While we know that Watkins had access to *Art Journal*, we don't know that he had similar access to Ruskin.

23. Colville, *Colville's San Francisco Directory: Vol. 1 for the Year Commencing October, 1856* (San Francisco, 1856), 159.

24. Historians have speculated about CEW's professional origins for several decades. Examples include von Euw in Naef and Hult-Lewis, *Carleton Watkins*, 129–31; Palmquist and Kailbourn, *Pioneer Photographers*, 223–24, 242–43; and Turrill, "Early California Photographer: C.E. Watkins," 30–32. For example, while Turrill details a photograph taken out a window at Clay and Kearny Streets, known as *Over the Plaza*, as "quite likely" a picture by Watkins, later historians, such as von Euw, have taken that likelihood as fact. Turrill's account of Watkins's life is filled with numerous errors. It is important to remember that Turrill wrote his account of his friend's life in 1918, almost twenty years after CEW described to Turrill the events therein and sixty years after the beginning of CEW's career. Turrill also identifies Watkins's San Jose employer as Robert Vance. While the claim is repeated by von Euw in Naef and Hult-Lewis, *Carleton Watkins* (130), I know of no contemporary evidence that supports it. An 1856 advertisement places Watkins at Ford's. See *San Jose Tribune*, March 5, 1856, as reproduced in Palmquist, *Carleton E. Watkins, Photographer of the American West*, 6.

25. United States v. Charles Fossat, August 27, 1858, United States District Court, Northern District of California, San Francisco, Case No. 132ND, 798–801, California Land Case Collection, BANC.

26. Martin Cheek, "Mercury Uprising," *San Jose Magazine* 9, no. 1 (2006): 80–85; Johnston, *Mercury and the Making of California*, 1–2.

27. See Winks, *Frederick Billings*, 98–116; Hult-Lewis, "Mining Photographs of Carleton Watkins," 39–62; Fritz et al., *Judicial Odyssey*, 40–55. In Harris, *Paper Promises*, 137–47, Hult-Lewis offers a point of view on the effectiveness of Watkins's testimony that differs from my assessment.

28. Guadalupe Mine Receipt Book, HL.

29. Neal, *Vengeance Is Mine*, 62.

30. Palmquist and Kailbourn, *Pioneer Photographers*, 563; Mnookin, "Image of Truth," 10–11.

31. Winks, *Frederick Billings*, 116.

32. United States v. Fossat, 798–801.

33. Watkins would continue to make pictures for use in legal proceedings, including for *United States v. D. & V. Peralta* in 1861; at New Almaden, in a job related to *Fossat* in 1862 or 1863; and for *Lux v. Haggin* in 1881.

34. CEW to Henry Laurencel, July 20, 1859, New Almaden Collection, SUL.

35. Cross, *History of the Labor Movement*, 301.

36. The best account of the Broderick-Terry affair and the broader California political situation is Quinn, *The Rivals*.

37. Josephy, *Civil War in the American West*, 234.

38. Chaffin, *Pathfinder*, 383.

39. Herr and Spence, *Letters of Jessie Benton Frémont*, 189.

40. JDW in Billings, *Mariposas Estate*, 5–7.

41. Winks, *Frederick Billings*, 39–41.

42. Ibid., 48–49, 53, 59–65.

43. Ibid., 279.

44. No records detailing the precise commissioner of CEW's Las Mariposas work survive, but as Billings took the lead in the capital-raising scheme and would have a relationship with Watkins and his work in the future, I think he's the likeliest.

CHAPTER 3. CREATING WESTERN CULTURE AT BLACK POINT

1. According to Pauline Grenbeaux, Watkins was first at Las Mariposas in 1859. She believed that *Hutchings' California Magazine* had based etchings on Watkins pictures and published them in a July 1859 issue on the town of Bear Valley. The article is actually in the September 1859 issue, and none of the illustrations match Watkins pictures (nor is Watkins credited). The error has been much repeated in the Watkins literature. See Grenbeaux, "Carleton E. Watkins, Pioneer Photographer," 230.

2. Two attributions of Las Mariposas pictures to Watkins in Naef and Hult-Lewis, *Carleton Watkins*, are less clear-cut than other Las Mariposas attributions: NH-L 9, a picture of Bear Valley Mill, and NH-L 13, a picture of Oso Mill.

3. Billings, *Mariposas Estate*, 55.

4. JCF to J.J. Dixwell, May 18, 1859, Frémont Family Papers, BANC.

5. Chaffin, *Pathfinder*, 100, 424, 429.

6. While Watkins would print his Las Mariposas pictures on paper, Watkins and Frémont might also have discussed daguerreotypes. As late as 1861, Watkins was listed in the San Francisco directory as a "daguerrean operator." Watkins worked as a daguerreotypist in the years before and after *Fossat*, but the specific years of his daguerrean practice are unknown. Langley, *San Francisco Directory for the Year Commencing September, 1861* (San Francisco, 1861), 343.

7. Palmquist and Kailbourn, *Pioneer Photographers*, 584–89. Weed's American River mining pictures are at BANC. Additional American River pictures that Palmquist and Kailbourn attribute to Weed are at the George Eastman House, Rochester, NY, and were at Stanford University (but were stolen in the early 1970s).

8. Borthwick, *Three Years in California*, 111.

9. Ibid., 112–13.

10. Good examples include Taylor, *California Life Illustrated*; Helper, *Land of Gold*; Shaw, *Ramblings in California*; Field and Gorham, *Personal Reminiscences of Early Days*; Kip, *Early Days of My Episcopate*; and Borthwick, *Three Years in California*.

11. Delano and McKee, *Alonzo Delano's California Correspondence*, 57.

12. Nash, *Wilderness and the American Mind*, 8.

13. Ibid., 23–24.

14. Greeley, *Overland Journey*, 275.

15. Ibid.

16. Ibid., 287.

17. Ibid., 280.

18. Greeley, *Glances at Europe*, 39.

19. Greeley, *Overland Journey*, 293–94.

20. Richards, *Appletons' Illustrated Hand-Book*, 374–77.

21. Delano and McKee, *Alonzo Delano's California Correspondence*, 60.

22. Herr, *Jessie Benton Fremont: A Biography*, 314.

23. See Herr, *Jessie Benton Fremont*, 309–15; Herr and Spence, *Letters of Jessie Benton Frémont*, 189–90; Phillips, *Jessie Benton Frémont*, 228–35; Tarnoff, *Bohemians*, 28–31; Winks, *Frederick Billings*, 123–24.

24. Matthews, *Golden State in the Civil War*, 51–62; Monzingo, *Thomas Starr King*, 1–2.

25. Phillips, *Jessie Benton Frémont*, 230.

26. TSK to JBF, [early 1861], in Herr and Spence, *Letters of Jessie Benton Frémont*, 232–33.

27. JBF to TSK, December 29, 1861, in Herr and Spence, *Letters of Jessie Benton Frémont*, 302–4.

28. TSK to Horatio Alger Jr., April 20, 1863, Thomas Starr King Papers, BRBLYU.

29. JBF to TSK, [early 1861], in Herr and Spence, *The Letters of Jessie Benton Frémont*, 232.

30. Matthews, *Golden State in the Civil War*, 41–59. See also Monzingo, *Thomas Starr King*; Frothingham, *Tribute to Thomas Starr King*; Wendte, *Thomas Starr King*.

31. The best account and analysis of transcendentalist thought and history is Packer, *Transcendentalists*. See also Gura, *American Transcendentalism*.

32. See especially Richardson, *Emerson*, and Buell, *Emerson*.

33. Buell, *Emerson*, 31.

34. Carlyle and Emerson, *Correspondence of Thomas Carlyle and Ralph Waldo Emerson, 1834–1872*, vol. 2, 82.

35. JBF to TSK, January 16, 1861, in Herr and Spence, *Letters of Jessie Benton Frémont*, 232.

36. On Emerson's encouragement of artists and writers, see Buell, *Emerson*, 107–14.

37. Emerson, *Nature*, 15–16, 26–27.

38. In 2009 conservative lawmakers arranged for the removal of the statue of the progressive Starr in favor of a statue of Ronald Reagan.

39. TSK to RR, October 29, 1860, Thomas Starr King Papers, BANC.

CHAPTER 4. SECESSION OR UNION?

1. Kennedy, *Contest for California*, 142–43.

2. *Daily Alta California*, September 12, 1859.

3. *San Francisco Bulletin*, October 27, 1860.

4. *Daily Alta California*, October 27, 1860.

5. Ibid.

6. Baker's speech was published in San Francisco newspapers but is most accessible in Baker and Shuck, *Eloquence of the Far West*, 89–127. Audience reaction is included in accounts of the speech in the *Daily Alta California* and *San Francisco Bulletin*, October 27, 1860.

7. Scharnhorst, *Bret Harte*, 17–18; Blair and Tarshis, *Life of Colonel Edward D. Baker*, 112; *San Francisco Bulletin*, October 27, 1860.

8. Wendte, *Thomas Starr King*, 185.

9. Denton, *Passion and Principle*, 286.

10. Tarnoff, *Bohemians*, 58–62. TSK introduced Harte to *Atlantic Monthly* editor James T. Fields. Harte's first *Atlantic Monthly* story was "The Legend of Monte del Diablo." It ran in the magazine's October 1863 issue, immediately before Henry David Thoreau's essay "Life without Principle."

11. TSK, *White Hills*. Regarding the book's having been published in 1859, see Hosea Ballou II to TSK, December 22, 1859, TSK Correspondence, SCP.

12. Matthews, *Golden State in the Civil War*, 56.

13. Emerson, *Nature*, 26.

14. JBF to Francis Preston Blair, July 2, 1859, in Herr and Spence, *Letters of Jessie Benton Frémont*, 214–17.

15. Ballou to TSK, August 11, 1860, TSK Correspondence, SCP.

16. "[Yosemite National Park visitation statistics]," https://www.nps.gov/yose/planyourvisit/visitation.htm.

17. Huth, *Nature and the American*, 143–44; Huntley, *Making of Yosemite*, 65–81; Farquhar, *History of the Sierra Nevada*, 117–24.

18. Huntley, *Making of Yosemite*, 76–77.

19. Artist James Madison Alden also may have visited the valley around this time. See Stenzel, *James Madison Alden*.

20. Greeley, *Overland Journey*, 295–309.

21. *San Francisco Daily Times*, September 15, 1859, as quoted in Palmquist, *Carleton E. Watkins*, 15.

22. *Daily Alta California,* September 16, 1859.

23. Letters typically took four weeks to travel from San Francisco to Boston. For example, see TSK to William R. Alger, July 14, 1860, TSK Papers, BRBLYU.

24. TSK's *Transcript* essays have never been published in a single volume. The Yosemite and Mariposa Grove essays would not be compiled in book form until 1962, in TSK and Hussey, *Vacation among the Sierras.* They are most readily available at http://www.yosemite.ca.us/library/vacation_among_the_sierras/. While TSK seems to have mentioned planning a "California Book" to several of his correspondents, he died before it could be realized.

25. TSK, http://www.yosemite.ca.us/library/vacation_among_the_sierras/.

26. Ibid.

27. Ibid.

28. This metaphor was common in contemporary visual culture. For example, see Harbach & Bro., "The Destruction of the Snake of South Carolina," Patriotic Envelope Collection, New-York Historical Society.

29. TSK to James T. Fields, October 29, 1862, James Thomas Fields Papers, HL.

30. The poem is Bryant's "Not Yet." Wendte, *Thomas Starr King,* 183. For the entire poem, see Bryant, *Poetical Works of William Cullen Bryant,* 299–300.

31. Josephy, *Civil War in the American West,* 233–34.

32. TSK to RR, December 3, 1860, TSK Papers, BANC.

33. The best account is Winks, *Frederick Billings,* 133–41.

34. Historians are not in agreement on whether JCF and Corbett were conducting an affair. Billings was sure that they were.

35. TSK to RR, February 10, 1861, TSK Papers, BANC.

36. TSK to RR, February 20, 1861, TSK Papers, BANC.

37. *Daily Alta California,* February 24, 1861. Matthews puts the crowd closer to eight thousand in *Golden State in the Civil War,* 88–89.

38. *Daily Alta California,* February 24, 1861.

39. TSK to RR, February 24, 1861, TSK Collection, GTU.

40. *New York Times,* May 13, 1861.

41. None of the numerous prints of the photograph, including large-format prints at CHS or SUL, are signed or otherwise indicate that Watkins was the maker. Naef and Hult-Lewis attribute the picture to Watkins, apparently because there seem to have been few or no other photographers in San Francisco who could have made it. I see no reason to question their attribution. Naef and Hult-Lewis's suggested date of May 11, 1861, is incorrect. The photograph is erroneously dated May by other sources, including Matthews.

42. *Daily Alta California,* May 9, 1861.

43. Secessionist sentiment remained widespread in Southern California, especially in and around Los Angeles.

44. TSK to William R. Alger, May 9, 1861, TSK Papers, BRBLYU.

45. Hurd, *History of Otsego County,* 55; Smith, *History of the Seventy-Sixth Regiment,* 355–56; McDonald Family copied from Mrs. Lydia Fritts' Bible, Huntington Library, Oneonta, NY.

CHAPTER 5. TO YOSEMITE IN WARTIME

1. Hult-Lewis, "Mining Photographs," 73–87.
2. Turrill, "Early California Photographer," 29–37. While Turrill is unreliable, his account of Watkins having "had constructed in San Francisco" a new camera that could make eighteen- by twenty-two-inch glass-plate negatives is credible. Watkins may have had the camera built by a local cabinetmaker (Naef and Hult-Lewis, *Carleton Watkins,* 45) or have made it himself (Hult-Lewis, "Mining Photographs," 125). For more on Watkins and his relationship with 1860s technology, see Sexton, "Watkins' Style and Technique," 246.
3. Tarnoff, *Bohemians,* 36–40.
4. This is the size of the largest pictures CEW's contemporaries were making. For a summary of photographic technology and practice in Watkins's region, see Palmquist and Kailbourn, *Pioneer Photographers,* 46–71.
5. Weed's 1859 Yosemite pictures are at BANC.
6. A significant collection of Civil War–related photography is at the Library of Congress. See "Technical Information," https://www.loc.gov/collections/civil-war-glass-negatives/about-this-collection/technical-information.
7. See Davis and Aspinwall, *Timothy O'Sullivan.*
8. See Aspinwall, *Alexander Gardner.*
9. For example, see CEW stereograph no. 607.
10. Huntley, *Making of Yosemite,* 144; Palmquist, *Carleton E. Watkins,* 16.
11. WHB to JDW, August 14, 1865, in WHB Correspondence with JDW, BANC. WHB's estimate is double TSK's estimate of CEW's gear in TSK to RWE, September 9, 1862, in RWE Letters to William Emerson, Houghton Library, Harvard University.
12. See CEW stereograph no. 63.
13. Huntley, *Making of Yosemite,* 104; Margo, *Wages and Labor Markets,* 176n23.
14. In part because Park was in Yosemite Valley July 8–15, 1861, and because CEW took a stereographic picture of the Park party (CEW stereograph no. 85), Palmquist and Naef endorse Park as the backer of Watkins's 1861 Yosemite trip. No information, including in the Trenor W. Park Papers at the Bailey/Howe Library, University of Vermont, substantiates this theory. WCR, TSK, JBF, Billings, and even Beale are all more likely backers of Watkins's 1861 trip.
15. *Journal of the California State Legislature* (1859), 376; Huntley, *Making of Yosemite,* 104; Thomas A. Ayres, "Trip to the Yosemite Valley," *Daily Alta California,* August 6, 1856, http://www.yosemite.ca.us/library/a_trip_to_the_yohamite_valley/.
16. TSK, "A Vacation among the Sierras—No. 6, The Yo-Semite Valley," http://www.yosemite.ca.us/library/vacation_among_the_sierras/letter_6.html.

17. Ibid. TSK's estimates of distance, height, etc., were generally accurate. WHB, visiting Yosemite in late June 1863 (roughly the same time of year as CEW's visit, albeit two years later), also suggested that the Merced near Bridal Veil was wide and high: "The stream is so large that it cannot be forded here. I tried it two days ago, although in the best place, my horse was carried off his feet." WHB, *Up and Down California*, 403.

18. Holmes, *Ralph Waldo Emerson*, 93–94.

19. Emerson, *Nature*, 27.

20. Ibid., 8.

21. Ibid., 3.

22. Buell, *Emerson*, 110.

23. Emerson, *Nature*, 22.

24. TSK, "Lessons from the Sierra Nevada," probably 1863, in TSK, *Thomas Starr King Sermons*. It is unknown if the sermons were delivered as written. These appear to be final or near final drafts.

25. See CEW stereograph no. 42. A glass stereograph at the George Eastman House, Rochester, NY, features the verse written in CEW's own hand.

26. Naef and Hult-Lewis, *Carleton Watkins*, 63.

27. TSK, "A Vacation among the Sierras—No. 6, The Yo-Semite Valley," http://www .yosemite.ca.us/library/vacation_among_the_sierras/letter_6.html.

28. *Mariposa Gazette*, October 22, 1861.

CHAPTER 6. SHARING YOSEMITE

1. Goodheart, *1861*, 265.

2. TSK to RR, October 31, 1861, TSK Papers, BANC.

3. Goodwin, *Team of Rivals*, 381.

4. Langley, *San Francisco Directory for the Year Commencing September, 1861* (San Francisco, 1861), 573; *Daily Alta California*, December 12, 1861.

5. *Daily Alta California*, March 2, 1860.

6. *Daily Alta California*, September 25, 1862; *Daily Alta California*, February 27, 1863.

7. *California Farmer and Journal of Useful Sciences*, March 2, 1860.

8. See CEW stereograph no. 1886.

9. Nealy, "Horatio Stone, the Sculptor," 188.

10. *Daily Alta California*, September 19, 1862.

11. See CEW stereograph no. 799.

12. TSK to RR, January 10, 1862, in TSK Papers, BANC.

13. Lavender, *Nothing Seemed Impossible*, 118–20.

14. Starr, *Americans and the California Dream*, 178–80; Goetzmann, *Exploration and Empire*, 362–68. Within three weeks of landing in California, TSK had traveled to an enormous cavern in the Sierra foothills that had just been opened to the public. In the ensuing months and years, even as Starr traveled to mining districts and

inland towns to advocate for Lincoln and later for Union, he saw as much of California's wilderness as he could. He climbed the Bay Area's two most prominent mountains, Tamalpais and Diablo, trekked in the Napa Valley and through the geysers in neighboring Sonoma County, and went up the Sacramento River into the foothills, north to the volcanic peaks of Oregon and southern Washington Territory, up through the Columbia River Gorge to The Dalles, to Lake Tahoe, to the desert mountain ridges of Nevada Territory, and, of course, to Las Mariposas, the Mariposa Grove, and Yosemite. Starr loved sharing his trips with others; it's likely that CEW heard about all of them.

15. WHB, diary, January 31, 1862, WHB Papers, BANC. WHB notes that he saw the Watkinses in the afternoon and that he spent the "eve" at TSK's, a phrasing that is typical of WHB's brusque, time-melding diary entries. I understand WHB to mean that he saw the pictures and stayed at TSK's in the evening, which seems likeliest, as it was a Friday and WHB lived in Oakland, a transbay ferry ride away. Furthermore, CEW knew TSK and, so far as is documented, did not yet know WHB, rendering it unlikely that WHB would have seen the pictures before TSK. As ever, it is possible that WHB saw the Watkinses at an unknown place before arriving at TSK's, perhaps via an unknown person at the Montgomery Block, where he worked.

16. Goetzmann, *Exploration and Empire*, 355–89, is the best account of the California Geological Survey's work and import.

17. William Darlington to WHB, November 24, 1862, WHB Papers, YUL.

18. AG to WHB, March 7, 1862, WHB Papers, YUL.

19. AG to WHB, December 5, 1862, WHB Papers, YUL.

20. See WHB's diary of letters written and received, 1860–65, BANC.

21. TSK, "A Vacation among the Sierras—No. 4, The Big Trees," http://www.yosemite .ca.us/library/vacation_among_the_sierras/letter_4.html.

22. AG to WHB, April 30, 1863, WHB Papers, YUL.

23. See Dupree, *Asa Gray*, 185–307, for Gray's engagement with Darwin. AG, *Darwiniana*, 205–35.

24. WHB to AG, June 2, 1862, AG Correspondence Files of the Gray Herbarium, 1838– 1892 (inclusive), Correspondents General Br-Bz. Botany Libraries, Archives of the Gray Herbarium, Harvard University Herbaria. The Watkins picture is NH-L 559.

25. Benjamin Silliman Jr. to Susan Huldah Forbes Silliman, April 17, 1862; Benjamin Silliman Jr. to Susan Huldah Forbes Silliman, April 12, 1864; Benjamin Silliman Jr. to unknown family correspondent, November 3, 1864; in Silliman Family Papers, YUL. For a list of some of Silliman's purchases, see CEW's 1864 notebook in CEW Papers, BANC.

26. JDW to William D. Whitney, August 29, 1862, William Dwight Whitney Family Papers, YUL.

27. William D. Whitney to JDW, June 21, 1863, William Dwight Whitney Family Papers, YUL.

28. Phillips, *Jessie Benton Frémont*, 235.
29. Ballou to TSK, February 4, 1861, TSK Correspondence, SCP.
30. Holmes to TSK, April 13, 1862, TSK Correspondence, SCP.
31. Ibid.
32. Holmes, "Doings of the Sunbeam," 7–8.
33. TSK to RWE, September 9, 1862, RWE Letters to William Emerson, 1825–1868, Houghton Library, Harvard University.
34. Ibid.
35. TSK to Horatio Alger Jr., July 14, 1860, TSK Papers, BRBLYU.
36. TSK, "A Vacation among the Sierras—No. 4, The Big Trees," http://www.yosemite .ca.us/library/vacation_among_the_sierras/letter_4.html.
37. The only link between CEW and his circle and Concord, Massachusetts, at this time is RWE, through TSK. RWE had close ties to the Concord Free Library: he gave the keynote address at the library's opening in 1873, served on its Library Committee from 1873 until his death in 1882, and was chairman of the committee from 1875 until his death.
38. RWE, Bosco, and Myerson, *Later Lectures of Ralph Waldo Emerson*, 135–36.
39. Frederic Edwin Church was infatuated with pioneering German ecologist Alexander von Humboldt (as Watkins may have been too), and his paintings are richly informed by Humboldt's writings, but Church was not part of a network or coalition of broader interests.
40. Marsh, *Man and Nature*. For Billings and conservation, see Winks, *Frederick Billings*, 274–305.
41. *British Journal of Photography* 9, no. 173 (1862): 335. I'm grateful to Diane Waggoner for the reference. The journal's description of the pictures—"lakes, valleys, gigantic trees, and almost untrodden solitudes of the interior of California"—could apply nonspecifically and inaccurately to either the Las Mariposas or the Yosemite pictures. The best arguments for them being the slightly older Las Mariposas pictures are the journal's observation that the Watkinses were faded and the fact that the pictures were not specifically identified as photographs of Yosemite. San Francisco newspapers list no ships leaving San Francisco for London in the first eight months of 1862, so the pictures likely went through New York, raising the possibility that Watkins's Yosemite was known in New York even before the Goupil's exhibition opened.
42. *North Pacific Review* 2 (1863): 208.

CHAPTER 7. EXHIBITING YOSEMITE IN WARTIME

1. McPherson, *Battle Cry of Freedom*, 568–75; Eicher, *Longest Night*, 405.
2. CEW would begin to make albumen prints in 1861. Both the Las Mariposas work and a thirteen-picture commission he completed early in 1861 are salted-paper prints.
3. *New York Times*, October 20, 1862.

4. McPherson, *Battle Cry of Freedom*, 572–74.
5. Starr, *Americans and the California Dream*, 98.
6. *New York Times*, October 20, 1862; Harvey, *Civil War and American Art*, 82.
7. TSK, "Lessons from the Sierra Nevada," probably 1863, in TSK, *Thomas Starr King Sermons*. The line from the psalm is 145:16.
8. *New York Times*, December 12, 1862.
9. On Watkins and the appropriateness of using a new technology in new American land, see Knight, "Carleton Watkins on the Frontier."
10. *New York Times*, December 8, 1862; *New York Tribune*, December 16, 1862.
11. *New York Post*, December 11, 1862.
12. *New York Times*, December 8, 1862.
13. *New York Post*, December 11, 1862.
14. As a result, historians routinely fail to include *Under Niagara* in narratives of both Church's art and the American landscape tradition. An exception is Kelly, *Frederic Edwin Church*, 61.
15. Harvey, *Civil War and American Art*, 17–72.
16. See Church's *Banner in the Sky* (1861) and *The Icebergs* (1861), especially as considered in Harvey, *Civil War and American Art*, 31–38; *New York Post*, December 11, 1862.
17. *New York Times*, March 21, 1857.
18. Ibid.
19. "Sketchings," *Crayon* 4 (May 4, 1856): 157.
20. Kelly, *Frederic Edwin Church*, 52.
21. [Ruskin], *Modern Painters*, 329.
22. "Editor's Table," *Knickerbocker* 45 (1855): 532.
23. "Minor Topics of the Month," *Art Journal* 3 (1857): 262.
24. Raab, *Frederic Church*, 39.
25. *Sacramento Union*, June 18, 1857.
26. *Daily Alta California*, July 13, 1857.
27. *Daily Alta California*, July 21, 1860.

CHAPTER 8. EXPANDING THE WESTERN LANDSCAPE

1. Lavender, *Nothing Seemed Impossible*, 153–54.
2. San Francisco Home Guard Roster and Muster Rolls, 1861, BANC.
3. Lavender, *Nothing Seemed Impossible*, 155–56.
4. Ibid., 158.
5. See CEW stereograph nos. 606 and 696.
6. See CEW stereograph no. 947.
7. Chaffin, *Pathfinder*, 527n41.
8. Trobits, *Antebellum and Civil War San Francisco*.
9. *All the Year Round* 13 (1865): 424–28; Hult-Lewis, "The Mining Photographs," 128.

10. TSK, "Shasta and Mountain Scenery," probably 1862, in TSK, *Thomas Starr King Sermons;* Wendte, *Thomas Starr King,* 115–25; WHB, *Up and Down California,* 294–323. Ironically, *Up and Down California* is illustrated with an Appleton print of Shasta based on an uncredited CEW picture from 1867.

11. Brookman, *Helios: Eadweard Muybridge,* 53–55.

12. See Brechin, *Imperial San Francisco,* for exposition on how San Francisco's needs and appetites dominated the entire West.

13. California State Lands Commission, "California State Lands Commission Shipwreck Information."

14. Cox, *Mills and Markets,* 47; USDA Forest Service, *Timber Depletion,* 40.

15. Cox, *Mills and Markets,* 52.

16. Ibid., 47–67. See CEW stereograph nos. 216 and 226; Palmer, *History of Mendocino County,* 132–46.

17. Ryder, *Memories of the Mendocino Coast,* 5; Baumgardner, *Yanks in the Redwoods,* 63–78; *Sacramento Union,* April 23, 1863.

18. CEW's name is in an 1864 ledger book of Ford's Mendocino Lumber Co. as receiving a small payment, likely for a few pictures of Ford's operation that CEW had sent to Abram Everson, the proprietor of a local general store. Dozens of CEW pictures remained in Ford's family for nearly a century, until Ford's descendants gave them to BANC. Palmer, *History of Mendocino County,* 141, 536; Union Lumber Company Records, BANC.

19. See Winn, "Mendocino Indian Reservation."

20. Madley, *American Genocide,* 276–86.

21. Ibid., 259–60.

22. Avery and Kelly, *Hudson River School Visions,* 247.

23. Novak, *Nature and Culture,* 5.

24. Winks, *Frederick Billings,* 147, 274–75; Frederick Billings to Oel and Sophia Billings, [1861–62], Billings Family Archives, Woodstock, VT.

25. Winks, *Frederick Billings,* 146–47.

26. Ibid., 129–30.

27. TSK to Frederick Billings, October 22, 1863, Billings Family Archives, Woodstock, VT.

28. Matthews, *Golden State in the Civil War,* 3.

29. Louis Agassiz to Frederick Billings, August 1, 1864, Billings Family Archives, Woodstock, VT.

30. Winks, *Frederick Billings,* 152–60; FLO to Mary Olmsted, August 12, 1863, FLO Papers, LOC.

31. Rybczynski, *Clearing in the Distance,* 137, 142; Roper, *Biography of Frederick Law Olmsted,* 111.

32. Rybczynski, *Clearing in the Distance,* 256–59.

33. Langley, *San Francisco Directory for the Year Commencing September, 1861* (San Francisco, 1861), 343.

34. A photographer named William C. Lipp either shared 649 Clay with CEW or worked for him. No photographs made by Lipp are known. Langley, *San Francisco Directory for the Year Commencing October, 1863* (San Francisco, 1861), 228, 366; Palmquist and Kailbourn, *Pioneer Photographers*, 371.

35. Langley, *San Francisco Directory for the Year Commencing October, 1863*, 429; Langley, *San Francisco Directory for the Year Commencing December, 1865* (San Francisco, 1865), 274, 446, 519–20. Langley again lists a "photographer," William H. Lentz, as being "with" CEW in an unspecified manner. The only surviving photographs by Lentz were made in Petaluma, California (Palmquist and Kailbourn, *Pioneer Photographers*, 364).

36. CEW, untitled 1864 notebook, CEW Papers, BANC.

37. In addition to the pricing information in CEW's untitled 1864 notebook, see CEW to T.H. Boyd, May 28, 1864, George Davidson Papers, BANC. In selling fifteen pictures to JDW for $50, CEW seems to have given a friend and supporter a discount.

38. Ibid.; Lebergott, "Wage Trends, 1800–1900," in *Trends in the American Economy*, 457.

39. In my research for this book, I stumbled across numerous pictures not included in Naef and Hult-Lewis, including at the Huntington Library and Harvard University Herbaria.

40. CEW, untitled 1864 notebook, CEW Papers, BANC.

41. Lawrence & Houseworth Photography Albums: *California Views*, 1860–70, SCP. The specific picture referenced here is no. 1184, *Big River Lumber Mills, Mendocino County*.

42. Several decades ago, Peter Palmquist constructed a list of remaining CEW albums and found twenty-eight; see Peter E. Palmquist Papers, BRBLYU. A few other albums have been found since, including at least one album in the archives of agribusiness giant Tenneco West, Inc., that was broken up, and two fine late-career albums in the collection of the Tejon Ranch Co. in Lebec, California. I'm unaware of any historians who have updated Palmquist's list.

43. For Mark Twain's Buffalo career, see Reigstad, *Scribblin' for a Livin'*.

44. CEW, untitled 1864 notebook, CEW Papers, BANC.

45. Berglund, *Making San Francisco American*, 138.

46. Ibid., 155.

47. See CEW stereograph no. 607.

48. Reinhardt, *Four Books, 300 Dollars*, 19–21.

49. Twain and Branch, *Works of Mark Twain*, 68.

CHAPTER 9. THE BIRTH OF THE NATURE PARK IDEA

1. Farquhar, *History of the Sierra Nevada*, 120–24.

2. Starr, *Americans and the California Dream*, 174.

3. Emerson, *Young American: A Lecture*, 8.

4. Nash, *Wilderness and the American Mind*, 101–2.

5. TSK, "A Vacation among the Sierras—No. 7, The Yo-Semite Valley," http://www .yosemite.ca.us/library/vacation_among_the_sierras/letter_7.html.

6. Roper, *Biography of Frederick Law Olmsted*, 39–40, 264–65.

7. Ibid., 261.

8. According to Huth, JDW was opposed to the Yosemite idea, but others on the California Geological Survey team supported it. Huth, "Yosemite: Story of an Idea."

9. Emerson, *Essays: Second Series*, 185–86. While this essay shares the same title as the more famous 1836 work, it is a different essay.

10. Sachs, *Arcadian America*, 54.

11. Wills, *Lincoln at Gettysburg*, 73, 78; Sachs, *Arcadian America*, 37–38.

12. Rybczynski, *Clearing in the Distance*, 45, 163.

13. Wendte, *Thomas Starr King*, 181–83.

14. Sachs, *Arcadian America*, 35–36, 392n69.

15. Emerson, *Nature*, 16.

16. Sachs, *Arcadian America*, 37.

17. For the development of the former battlefield at Gettysburg, see Wills, *Lincoln at Gettysburg*.

18. David Wills to Gov. Andrew G. Curtin, July 24, 1863, Pennsylvania State Archives as quoted in Wills, *Lincoln in Gettysburg*, 21.

19. Wills, *Lincoln at Gettysburg*, 19–38.

20. Wendte, *Thomas Starr King*, 220; Roper, *Biography of Frederick Law Olmsted*, 79.

21. *Daily Alta California*, November 21, 1863.

22. Faust, *This Republic of Suffering*, 99–100.

23. For CEW's exhibition of Williston's portrait, see Halteman, *Publications in California Art No. 7*. For Williston, see Ellis and Guinn, eds., *Norwich University, 1819–1911*, vol. 2, 578–79. How CEW knew of Williston's distinguished record is a mystery. Williston's service was little noted in Northern California newspapers. Perhaps CEW and Williston were friends before the war and corresponded during it. Williston fought in many of the same battles in which CEW's brother Charles fought, so perhaps a connection was made through battlefield correspondence. Finally, perhaps FB knew Williston, who grew up in Norwich, Vermont, just ten miles northeast of Woodstock.

24. Roper, *Biography of Frederick Law Olmsted*, 228–31.

25. Wills, *Lincoln at Gettysburg*, 132.

26. As Runte notes, Yosemite is the first national park "in fact . . . if not in name." The *national* nomenclature would not be in widespread use until late in 1864 or 1865. Runte, *National Parks: The American Experience*, 30.

27. The letter was first published in Huth, "Yosemite: Story of an Idea." The idea was almost certainly not Raymond's alone: Conness refers to "gentlemen" as having put forward the idea.

28. See CEW stereograph no. 27.

29. Farquhar, *History of the Sierra Nevada*, 123; Browning, *Yosemite Place Names*, 30; J. McClatchy & Co., *Sacramento County and Its Resources*, 142–44.

30. Winks, *Frederick Billings,* 169.

31. FB to Julia Parmly Billings, March 5, 1864, Billings Family Archives, Woodstock, VT. FB's correspondence indicates that he was in Washington from at least February 8.

32. *San Francisco Bulletin,* March 4, 1864.

33. Ibid.

34. Henry Whitney Bellows, diaries, 1864–68, vol. 1, Henry W. Bellows Papers, Massachusetts Historical Society, Boston.

35. *Daily Alta California,* March 5, 1864.

36. Wendte, *Thomas Starr King,* 217; *Daily Alta California,* March 6, 1864.

37. Wendte, *Thomas Starr King,* 217.

38. Matthews, *Golden State and the Civil War,* 231.

39. *Boston Evening Transcript,* March 5, 1864.

40. Bartol, *The Unspotted Life: Discourse in Memory of Rev. Thomas Starr King,* not paginated. Accessed at the Massachusetts Historical Society in a bound set of pamphlets sold as a single volume for the benefit of the U.S. Sanitary Commission.

41. *Sacramento Union,* April 20, 1864.

42. See Bellows's diary for his account of the trip, Henry W. Bellows Papers, Massachusetts Historical Society, Boston.

43. Myerson, Petrulionis, and Walls, *Oxford Handbook of Transcendentalism,* 618; *Daily Alta California,* March 7, 1864.

44. *Congressional Globe,* 38th Congress, 1st Session (1864): 1,310.

45. Winks, *Frederick Billings,* 168–72.

46. *Congressional Globe,* 38th Congress, 1st Session (1864): 2,300–301.

47. FB letters to Solomon Foot, 1851–1862, HL; Dodge, *Encyclopedia, Vermont Biography,* 58.

48. S. 203, "A Bill Authorizing a Grant to the State of California of the Yo Semite Valley," passed March 28, 1864.

49. Duncan, *Seed of the Future,* 74.

50. An Act of June 30, 1864, 38th Congress, 1st Session, Public Law 159, 13 STAT 325. There is another fugitive, potential link between Lincoln and Yosemite: Ward Hill Lamon, Lincoln's friend, aide, and self-appointed bodyguard. Lamon was born in Winchester, Virginia, near the northern head of the Shenandoah Valley. Another Lamon born in the Shenandoah Valley, James C. Lamon, was among the earliest settlers in and caretakers of Yosemite. The men were not brothers but may have been related.

51. Farquhar, *History of the Sierra Nevada,* 123.

52. FLO to Virgil Williams, Thomas Hill, and CEW, July 26, 1865; FLO to Calvert Vaux, September 19, 1865; Vaux Papers, New York Public Library.

53. Johnson's heirs told National Park Service archivists that CEW gave the pictures to Johnson, which is impossible. Kendra Hinkle, Andrew Johnson National Historic Site, Greeneville, TN, interview by the author; National Park Service memorandum, November 15, 1977, in Archives of Andrew Johnson National Historic Site; Hugh A.

Lawing to Peter E. Palmquist, September 24, 1981, Archives of Andrew Johnson National Historic Site.

54. White, *Lincoln's Greatest Speech*, 38–39.

55. Martin, *Genius of Place*, 282–85; Roper, *Biography of Frederick Law Olmsted*, 267–69; Rybczynski, *Clearing in the Distance*, 256–59.

56. Martin, *Genius of Place*, 236.

57. Rybczynski, *Clearing in the Distance*, 180.

58. Roper, *Biography of Frederick Law Olmsted*, 73, 128; Rybczynski, *Clearing in the Distance*, 156.

59. The report was rediscovered by Laura Wood Roper, who published it in *Landscape Architecture* magazine in 1952. As the magazine's archives have not been digitized and are narrowly held, see instead FLO, "Yosemite and the Mariposa Grove: A Preliminary Report."

60. Rybczynski, *Clearing in the Distance*, 279–80.

61. Roper, *A Biography of Frederick Law Olmsted*, 178.

62. Hendricks, *Albert Bierstadt*, 154.

63. Ludlow, *Heart of the Continent*, 412.

64. Roper, *Biography of Frederick Law Olmsted*, 143–55; Rybczynski, *Clearing in the Distance*, 151–71.

65. Roper, *A Biography of Frederick Law Olmsted*, 345; Martin, *Genius of Place*, 313–14.

66. Goodheart, *1861*, 295–304.

67. CEW's engagement with the Colfax party is captured in CEW stereograph nos. 1034–36 and apparently in a mammoth-plate picture (NH-L 176) at the Crocker Art Museum, Sacramento.

68. Browning, *Yosemite Place Names*, 18, 81.

69. Later on, Gov. Leland Stanford led an effort to change the name of Mount Broderick to the Cap of Liberty, either because it resembled a cap on a coin or because it resembled the Phrygian cap of antiquity, a symbol of liberty and freedom (or both). Stanford's appellation didn't stick for several decades, and when it did, it was no accident that the mountain immediately adjacent to the 'new' Cap of Liberty was named for Broderick. Hartesveldt, "Yosemite Place Names"; Farquhar, *Place Names of the High Sierra*, http://www.yosemite.ca.us/library/place_names_of_the_high_sierra/.

70. Farquhar, *Place Names of the High Sierra*.

71. FLO to Calvert Vaux, September 19, 1865, Vaux Papers, New York Public Library.

72. RWE, *Nature*, 11–12.

73. RWE, *Nature*, 12.

CHAPTER 10. ASSISTING AMERICAN SCIENCE

1. State Geological Survey Records, F3747: 1–108, CSA.

2. FLO, *Yosemite and the Mariposa Grove: A Preliminary Report*, http://www.yosemite.ca.us/library/olmsted/report.html.

3. Geological Survey of California, *Yosemite Book*.

4. JDW to WHB, December 10, 1866, WHB Correspondence with JDW, BANC.

5. Jim Snyder, in JDW and CEW, *Yosemite Book* (Oakland: Octavo, 2003), 4. Electronic resource.

6. Ibid., 2.

7. Goetzmann, *Exploration and Empire*, 329.

8. Emerson, *Nature*, 36.

9. Goetzmann, *Exploration and Empire*, 321–22.

10. Number taken from Naef and Hult-Lewis, *Carleton Watkins*, by combining pictures at the Harvard University Herbaria, the Asa Gray Residence, and Harvard's Arnold Arboretum.

11. WHB to AG, March 21, 1863, AG Correspondence Files of the Gray Herbarium, 1838–1892 (inclusive), Correspondents General Br–Bz, Botany Libraries, Archives of the Gray Herbarium, Harvard University Herbaria; CEW untitled 1864 notebook, CEW Papers, BANC.

12. Photographs at Harvard University Herbaria Library & Archives.

13. AG's hanging of Yosemite pictures in his home is repeatedly mentioned in the correspondence between AG, WHB, and JDW (each of whom rented AG's house when AG was abroad). For example, see AG to WHB, May 14, 1865; Jane Gray to WHB, October 13, 1868; WHB Papers, YUL.

14. WHB Papers, BANC.

15. AG, *Darwiniana*, 205–35.

16. Worster, *Passion for Nature*, 203–8.

17. Tony Morse to Peter E. Palmquist, February 3, 1982, uncatalogued Peter E. Palmquist Papers, HL.

18. "Academy of Sciences," *Mining and Scientific Journal* 27, no. 1 (July 5, 1873): 24.

19. Novak, *Nature and Culture*, 59, 154.

20. WHB to JDW, August 14, 1865, WHB Correspondence with JDW, BANC.

21. JDW to WHB, July 5, 1866, WHB Correspondence with JDW, BANC.

22. NH-L nos. 120, 121.

23. JDW to WHB, June 9, 1867, as quoted in Sexton, "Carleton E. Watkins, Pioneer California Photographer," 316.

24. Harriet Errington to Mrs. Alfred Field, June 20, 1864, uncatalogued Peter E. Palmquist Papers, HL.

CHAPTER 11. TO OREGON (FOR INDUSTRY)

1. *Oregonian* (Portland, OR), July 15, 1867.

2. On CEW's stereographs, see Friedel and Toedtemeier, "Picturing Progress."

3. On the relationship between panorama painting and photography, see Sandweiss, *Print the Legend*.

4. Jack von Euw, in Naef and Hult-Lewis, *Carleton Watkins*, 130. The work von Euw references is a five-part panorama of San Francisco after daguerreotypes at the Art Institute of Chicago, Elizabeth Hammond Stickney Collection, 1909.290.

5. *Oregonian* (Portland, OR), July 20, 1867.
6. JDW to WHB, July 29, 1867, WHB Correspondence with JDW, BANC.
7. Abbott, *Portland in Three Centuries*, 18–20. CEW also made a nine-part stereograph panorama of Portland. Six of the nine parts feature foregrounded stumps.
8. Alinder, in *Carleton Watkins*, is unsure of whether CEW made his 1867 Oregon pictures in the order in which he numbered them (both stereographs and mammoth plates), but Friedel and Toedtemeier make a convincing argument that CEW did.
9. Goodall, *Oregon's Iron Dream*, 43–46; Corning, *Willamette Landings*, 174–80.
10. Bancroft, *Works of Hubert Howe Bancroft: History of Oregon*, 730; *Report of the [Oregon] Secretary of Agriculture*, 598.
11. TSK to RR, August 1, 1862, TSK Papers, BANC.
12. JDW to WHB, December 28–30, 1867, WHB Correspondence with JDW, BANC.
13. Becker, "Geometrical Form of Volcanic Cones and the Elastic Limit of Lava," *American Journal of Science* 30 (1885): 289.
14. JDW to WHB, December 28–30, 1867, WHB Correspondence with JDW, BANC.
15. George W. Murray to W. W. Baker & Co., September 18, 1863, Special Collections & University Archives, University of Oregon Libraries, Eugene, OR.
16. In Naef and Hult-Lewis, *Carleton Watkins*, 167, Naef speculates that Collis Huntington was engaged in commissioning CEW's Oregon pictures in this period because Huntington was an Oregon Steam Navigation Co. investor. Huntington did not engage the OSNC until 1879, when he paid $110,000 for an option on the company, which he chose not to exercise. Lavender, *Land of Giants*, 377.
17. On Ainsworth and his relationship with Ralston, see Lavender, *Nothing Seemed Impossible*, 21–23, 42, 175–79, 212–215.
18. This account is assembled from Gaston, *Portland, Its History and Builders*, vol. 1; Johansen, *Empire of the Columbia*; Johansen, "Capitalism on the Far-Western Frontier" (PhD diss., University of Oregon, Eugene, 1941); John Commigers Ainsworth dictation and related biographical material, BANC; John Commigers Ainsworth statement, October 1883, Hubert Howe Bancroft Collection, BANC; John C. Ainsworth Papers, Special Collections and University Archives, University of Oregon Libraries, Eugene, OR; Simeon and Amanda Reed Papers, 1823–1916, Special Collections, Eric V. Hauser Memorial Library, Reed College, Portland, OR.; Abbott, *Portland in Three Centuries*, 10–38; Lavender, *Nothing Seemed Impossible*, 175–78.
19. Gaston, *Portland, Its History and Builders*, 671.
20. John C. Ainsworth to Schuyler Colfax, September 2, 1871, and October 24, 1871, John C. Ainsworth Papers, Special Collections and University Archives, University of Oregon Libraries, Eugene, OR.
21. Bowles, *Across the Continent*, 185.
22. Richardson, *Beyond the Mississippi*, 400–401.

23. *Sacramento Union,* April 22, 1867; Bain, *Empire Express,* 315–41.

24. For a list of OSNC shareholders in 1860 and in 1862, see Gaston, *Portland, Its History and Builders,* 271–73.

25. Abbott, *Portland in Three Centuries,* 36–38; Lavender, *Nothing Seemed Impossible,* 175–78.

26. Johansen, "Capitalism on the Far-Western Frontier," 197–98; Abbott, *Portland in Three Centuries,* 36–38.

27. Johansen, "Capitalism on the Far-Western Frontier," 198–208.

28. *Congressional Globe,* 39th Congress, 1st Session 3252 (1866).

29. For Stevenson, see Gill, "Oregon's First Railway."

30. Timmen, *Blow for the Landing,* 27.

31. *Weekly Mountaineer* (Dalles City, OR), September 28, 1867.

32. Oregon Steam Navigation Company Records, OHS Research Library, Portland.

33. Winks, *Frederick Billings,* 240–51; CEW, *Photographs of the Columbia River Presented by the Oregon Steam Navigation Co. to Jay Cooke,* n.d., collection of the Oregon State Library, Salem, OR, on long-term loan to the Portland Art Museum.

CHAPTER 12. VOLCANIC LANDSCAPES

1. Historians have determined various numbers of travelers along the Oregon Trail and its offshoots into California, Oregon, and Utah. See Unruh, *Plains Across,* 408–10, 516. For a lower estimate, see Dary, *Oregon Trail: An American Saga,* xiii.

2. Erik Steiner, "Overlooking the Columbia," in *Carleton Watkins: The Stanford Albums,* ed. Cantor Arts Center, 222–24.

3. JDW to WHB, December 28–30, 1867, WHB Correspondence with JDW, BANC.

4. Ambrosini, Fowle, and van Dijk, *Daubigny, Monet, Van Gogh,* 72–73.

5. Lewis, *Journals of the Lewis & Clark Expedition,* April 9, 1806. (Spelling has been regularized.)

6. *Sacramento Union,* June 30, 1877.

7. Today we understand Shasta to be the twenty-second-highest peak in the contiguous United States. It is the most massive stratovolcano in the Cascade Range.

8. Brewer, *Up and Down California,* 316–17.

9. TSK to RR, August 1, 1862, TSK Papers, BANC.

10. TSK, "Shasta and [Mountain] Scenery," ca. 1862–63, in *Thomas Starr King Sermons.*

11. *Our Banner in the Sky* was made into a chromolithograph in the summer of 1861. Harvey, *Civil War and American Art,* 37–38.

12. Ibid.

13. Goetzmann, *Exploration and Empire,* 367.

14. Frederick A. Butman, a Maine-born painter living in San Francisco by 1859, seems to have been at Shasta sometime around this time. (Dates of the paintings he made there, such as *Mount Shasta and Shastina,* BANC, are unknown.)

15. This picture appears to exist only in a cut-down version. Naef and Hult-Lewis left it out of *Carleton Watkins.* De Young Museum, 2003.15.

16. Typically stereographs are useful in retracing CEW's path through a landscape, but not here. CEW would make a second trip to Shasta in 1870, and except where mammoth-plate pictures he made in 1867 line up with the stereographic record, it's impossible to be sure which pictures he made in 1867 and which he made in 1870. Naef's presentation of the Shasta pictures in *Carleton Watkins* reflects this complication: Naef assigns many of CEW's Shasta pictures to 1870 in one part of the book and to 1867 in another, and his notes on where in the region pictures were taken are in error. Historians generally date five mammoth plates to 1867.

17. One recent Shasta circumnavigator found that it took five days and four nights— and that was with contemporary ultralight hiking gear and absent CEW's heavy, bulky photographic equipment. See "Mt Shasta Circumnavigation," July 18, 2013, Backpackinglight.com, https://backpackinglight.com/forums/topic/79832/.

18. Japantown Task Force, *San Francisco's Japantown*, 7.

19. Ludlow, *Heart of the Continent*, 465.

20. Clarence King papers, 1859–1902, Clarence King Papers [in James D. Hague Papers, 1824–1936]; mssKing, Clarence King Papers, Box 2, [Notebook] 5, HL.

21. Blake, *Reports of the United States Commissioners to the Paris Universal Exposition, 1867, Vol. 1*, which includes within it *General Survey of the Exhibition; with a Report on the Character and Condition of the United States Section*, 47.

22. Ibid.

CHAPTER 13. BASKING IN ACHIEVEMENT, BUILDING A BUSINESS

1. *Daily Alta California*, June 28, 1867.

2. Greenwood, *New Life in New Lands*, 194.

3. Jostes and Parrott, *John Parrott, Consul*, quoted in Lavender, *Nothing Seemed Impossible*, 206.

4. *Daily Alta California*, June 28, 1867; Lavender, *Nothing Seemed Impossible*, 203–6; Bloomfield, "David Farquharson."

5. *Daily Alta California*, July 31, 1873.

6. Nordhoff, *Northern California, Oregon, and the Sandwich Islands*.

7. Lavender, *Nothing Seemed Impossible*, 321–36; James, *Roar and the Silence*, 77–142.

8. The story is told in several places, but the clearest is Palmquist, *Carleton E. Watkins*, 26.

9. James D. Smillie, diary, 1871, 1872, 1873, James D. Smillie and Smillie Family Papers, 1853–1957, Box 1, Folder 32–34, Archives of American Art, Smithsonian Institution; Bryant, *Picturesque America*, vol. 1, first of two unpaginated illustrations between pp. 424 and 426. Appleton included the image in *Picturesque America* and also sold it as a print. This print is in many collections, including at LOC, whose incorrect attribution of it has generated confusion. [E.P. Brandard, *Mount Shasta* [graphic]/S.S. Gifford, c. 1873, LOT 11505, LOC. "S.S. Gifford" is an error. No such painter is known.] Apparently without Appleton's knowledge, Smillie

made the drawing of CEW's photograph from which the engraving was made in early 1873.

10. Palmquist, *Carleton E. Watkins,* 52; von Euw, in Naef and Hult-Lewis, *Carleton Watkins,* 131.

11. De Witt Alexander to Abbie Alexander, July 22–27, 1867, as quoted in Sexton, "Carleton E. Watkins, Pioneer California Photographer," 284–86. Photocopy at CHS, MS 34; original unknown.

12. Palmquist and Kailbourn, *Pioneer Photographers,* 470.

13. Wilson, "Views in the Yosemite Valley," *Philadelphia Photographer* 3 (April 1866): 106–7.

14. "Geology: Its Relation to the Picturesque," *Art Journal* (October 1855): 275.

15. Wilson, "Views in the Yosemite Valley," *Philadelphia Photographer* 3 (April 1866): 106–7. Wilson also read CEW's picture of Bridal Veil as containing a sexual metaphor encompassing both the supernatural creation of Yosemite Valley and CEW's creation of his pictures: "It is called the 'Bridal Veil,' because of the light aerial sheet of water that leaps from the top of the rocks to the valley below, spreading a beautiful veil of spray over everything in its course, and looking as soft and charming as the veil of a new-made bride, and making one quite curious to know what beauties are hid beneath it. What is behind this rocky height that modest Dame Nature would not disclose, we will not inquire about. It may be a gorgeous sunset, or it may be some grand composition of nature, creeping closely up to some sensitized plate, and 'they twain become one,' for the purpose of giving us another grand view as the fruit of their union. Mayhaps the veil hides her blushes while the form of preparation goes on."

16. Sheirr, "Joseph Mozier and his Handiwork," *Potter's American Monthly* 6 (January 1876), 24–28.

17. *Sacramento Union,* July 31, 1869; Richardson, *Garnered Sheaves from the Writings of Albert D. Richardson,* 296–97.

18. Langley, *San Francisco Directory for the Year Commencing December, 1865* (San Francisco, 1865), 446, 520.

19. Richardson, *Garnered Sheaves,* 296–97.

20. *Oregonian* (Portland, OR), May 6 and 7, 1868; *Weekly Mountaineer* (The Dalles, OR), May 2 and 30, 1868.

21. For a record of CEW's participation in California fairs and similar exhibitions, see Halteman, *Publications in California Art No. 7.*

22. Clars Auction Gallery, *Clars May Fine Art & Antique Auction,* day 2, lot 6522, May 20, 2012. Auction catalogue.

CHAPTER 14. CELEBRATING GILDED AGE WEALTH

1. Palmquist and Kailbourn, *Pioneer Photographers,* 476–79.

2. Savage, "A Photographic Tour of Nearly 9000 Miles," *Philadelphia Photographer* 4 (September 1867): 287–89, 313–16.

3. Bennett, "John Thomas Gulick."

4. For Gardner's San Francisco pictures, see Aspinwall, *Alexander Gardner,* 159.

5. Halteman, *Publications in American Art,* 2000; Palmquist, *Carleton E. Watkins,* 44–45; "A Roster of Former Members of the Bohemian Club from the date of its founding in 1872 until 1945," Peter E. Palmquist Papers, BRBLYU (thanks to the Bohemian Club's Matt Buff for confirmation). The only support for Palmquist's assertion that CEW joined SFAA is in the *Elite Directory for San Francisco and Oakland* (San Francisco: Argonaut Publishing, 1879), an upscale business directory. It lists CEW as a "contributing member" of SFAA rather than as both an artist and a contributing member (which is how, say, William Keith and Virgil Williams are listed).

6. Naef and Hult-Lewis, *Carleton Watkins,* 238.

7. *Bancroft's Tourist Guide,* 224.

8. Naef and Hult-Lewis, *Carleton Watkins,* 240–81.

9. For Mills and Millbrae, see Cain and Graham, "Rudolph Ulrich"; Streatfield, "San Francisco Peninsula's Great Estates: Part II," 4; D.O. Mills and Company Collection, 1847–1927, CSL; Carr, "Rural Homes of California," 39–42, 69–72.

10. The *California Horticulturalist* 3 (1873): 21 dates these pictures to the end of 1872 or the first months of 1873.

11. See NH-L 580 and 581.

12. The title plate in the Latham album at SUL lists the project completion date as 1873.

13. *Daily Alta California,* December 13, 1871.

14. Bloomfield, "David Farquharson"; Howe, *Herter Brothers,* 158.

15. C.H. Shinn, "Early Books, Magazines, and Book-Making," *Overland Monthly* 12 (1888): 343.

16. John E. Mustain, in *Carleton Watkins: The Stanford Albums,* ed. Cantor Arts Center, 18–20; Schama, *Landscape and Memory,* 18–19.

17. For the Howards, see Streatfield, "San Francisco Peninsula's Great Estates: Part I," 10.

18. *Daily Alta California,* March 11, 1868.

19. *Daily Alta California,* March 12, 1868.

20. Palmquist and Kailbourn, *Pioneer Photographers,* 460–61, 608.

21. Thurston, *Reports of the Commissioners,* 203; Casanueva, *Report of the Consul General of Chile,* 23.

22. See Avery and Kelly, *Hudson River School Visions.*

23. Schama, *Embarrassment of Riches,* 130–45.

CHAPTER 15. TAKING SHASTA, DISCOVERING GLACIERS

1. Clarence King to WHB, December 18, 1863, WHB Papers, YUL.

2. Clarence King to A.A. Humphreys, December 18, 1871, Records of the U.S. Geological Survey, NARA.

3. Ibid.

4. For King's account of his 1870 Shasta expedition, see King, *Mountaineering in the Sierra Nevada*, 223–63.

5. Stephens, "LeConte Family."

6. For Muir and LeConte in Yosemite, see Farquhar, *History of the Sierra Nevada*, 155–61; Worster, *Passion for Nature*, 192–95.

7. Geological Survey of California [JDW], *Geology*, vol. 1, *Report of Progress and Synopsis of the Field-Work*, 421. JDW's quote is from Joseph Addison's *Cato, A Tragedy* (1713).

8. Ibid., 408.

9. Ibid., 416. There is no evidence that JDW or any other California Geological Survey member directed CEW to take any specific picture—indeed, the evidence indicates that CEW always worked independently—but from the start of what would become a fierce debate about the West's geologic origins, CEW's work was used to support JDW's ideas.

10. Ibid., 422.

11. Sandweiss, *Passing Strange*, 43.

12. JDW, *Yosemite Book*, 77.

13. Ibid., 75–76.

14. "Origin of the Yo-Semite Valley," *Mining and Scientific Press* 15, no. 10 (November 9, 1867): 1.

15. Samuel Franklin Emmons to Arthur Emmons, November 14, 1870, Samuel Franklin Emmons Papers, 1841–1911, LOC.

16. King, *Mountaineering in the Sierra Nevada*, 126.

17. Samuel Franklin Emmons to Arthur Emmons, November 14, 1870, Samuel Franklin Emmons Papers, 1841–1911, LOC.

18. King, *Mountaineering in the Sierra Nevada*, 235.

19. Ibid., 232–33.

20. Frenchman Auguste-Rosalie Bisson made pictures atop 15,774-foot Mont Blanc in 1861.

21. King, volcanoes notebook, ca. 1870, Clarence King Papers, Box 4, D-18, HL.

22. King, *Mountaineering in the Sierra Nevada*, 230–31.

23. Ibid.

24. Ibid.

25. King, volcanoes notebook, ca. 1870, Clarence King Papers, Box 4, D-18, HL

26. Avery, *Californian Pictures*, 175–76.

27. Clarence King, "Shasta."

28. Goetzmann, *Exploration and Empire*, 479.

29. John Muir, "Living Glaciers of California."

30. Ibid.

31. Ibid.

32. Ibid.

33. *New York Tribune,* December 5, 1871. The article may be more easily accessed at "Yosemite Glaciers," http://vault.sierraclub.org/john_muir_exhibit/writings /yosemite_glaciers.aspx.

34. King, *Systematic Geology,* 478.

35. Ibid., 477.

36. John Muir to Sarah Muir Galloway, September 7, 1874, John Muir Correspondence, Holt-Atherton Special Collections, University of the Pacific Library, Stockton, CA.

37. Worster, *Passion for Nature,* 223–24; *San Francisco Bulletin,* June 20, 1874.

38. *San Francisco Bulletin,* December 21, 1874; Worster, *Passion for Nature,* 184–85.

39. Thayer, *Western Journey with Mr. Emerson,* 76.

40. Worster, *Passion for Nature,* 209–12; Richardson, *Emerson,* 565.

41. Thayer, *Western Journey,* 108.

42. *Sacramento Union,* February 5, 1876.

43. For the identification of Mrs. George R. Russell, see RWE, Bosco, Johnson, and Myerson, *Collected Works of Ralph Waldo Emerson,* vol. 8, p. ci, n95. A note of Russell's gift to RWE is in uncatalogued documentation of wall hangings at the RWE House, Concord, MA.

44. Richardson, *Emerson,* 605n14.

45. Richardson, *Emerson,* ix, 58, 123, 428.

CHAPTER 16. THE BOOM YEARS

1. For the progression of mining practices in California and their effects, see Brechin, *Imperial San Francisco,* 30–38.

2. "Valley of the Grisly Bear," *Art Journal* 9 (1870): 252.

3. CEW's European career has been little studied. He routinely showed and won medals at world's fairs, and by now his pictures had been seen and known in London for a decade.

4. McPhee, *Assembling California,* 63–64.

5. Lavender, *Nothing Seemed Impossible,* 219–21.

6. "Capitol Dome," Architect of the Capitol, https://www.aoc.gov/capitol-buildings /capitol-dome.

7. Hult-Lewis, "Mining Photographs," 159–64; "Photographic Mining Views," *Mining and Scientific Press* 23, no. 18 (1871): 281.

8. "Photographic Mining Views," *Mining and Scientific Press* 23, no. 18 (1871): 281.

9. Brechin, *Imperial San Francisco,* 48–53.

10. Lavender, *Nothing Seemed Impossible,* 240–50; Bloomfield, "California Historical Society's New Mission Street Neighborhood." The picture is dated to 1865–68 in Naef and Hult-Lewis, *Carleton Watkins,* which is not possible as the hotel had not yet been built. CSL dates its print to 1874.

11. Lavender, *Nothing Seemed Impossible,* 240–50; *Bancroft's Tourist Guide,* 117–18; Player-Frowd, *Six Months in California,* 25; *Daily Alta California,* August 15, 1869, April 21, 1870, and July 25, 1870.

12. Price and Haley, *Buyers' Manual and Business Guide*, 153–54.

13. Ibid.

14. *Daily Alta California*, April 13, 1872.

15. "Julia Caroline Watkins," by William and Karen Current, February 12, 1975, unpublished typescript in uncatalogued Peter E. Palmquist Papers, HL.

16. "Text Page: Union and Central Pacific RR line," David Rumsey Historical Map Collection, http://www.davidrumsey.com/luna/servlet/detail/RUMSEY~8~1~24265~910055:Text-Page—Union-and-Central-Pacifi. This timetable, published by Rand McNally, was in effect January 1, 1872.

17. JDW to WHB, January 26, 1874, WHB Correspondence with JDW, BANC.

18. Strahorn, *Fifteen Thousand Miles by Stage*, 50.

19. *San Francisco Bulletin*, September 6, 1872. The paper reports that CEW took twenty pictures on the Farallones; today twelve mammoth-plate pictures are known.

20. Naef and Hult-Lewis, *Carleton Watkins*, 218–23; *Report of the Superintendent of the United States Coast Survey . . . 1869*, 48.

21. *Bancroft's Tourist Guide*, 145–46; Greenwood, *New Life in New Lands*, 198.

22. *Sydney Morning Herald*, April 9, 1875; "Australian Awards to California Exhibitors," *Mining and Scientific Press* 31, no. 4 (1875): 57.

CHAPTER 17. SAN FRANCISCO'S BORASCA

1. Dana, *Man Who Built San Francisco*, 332–33.

2. Ibid., 330–31.

3. On Ralston's collapse, see Lavender, *Nothing Seemed Impossible*, 352–79; Brechin, *Imperial San Francisco*, 84–89.

4. On the rise of the Bonanza Kings, see James, *Roar and the Silence*, 100–118.

5. Dana, *Man Who Built San Francisco*, 329–34.

6. *Daily Alta California*, October 4, 1875.

7. On the Palace Hotel, see Lavender, *Nothing Seemed Impossible*, 361–65.

8. *Daily Alta California*, June 20, 1874, and October 17, 1875.

9. *Daily Alta California*, October 25, 1874.

10. Mills resigned as president of the Bank of California in July 1873. Lavender, *Nothing Seemed Impossible*, 358–59. *Daily Alta California*, September 27, 1875.

11. "Talks by David Stoddard Atwood," Kern County Land Company Papers and Slides, 1886–1964, HL.

12. Dana, *Man Who Built San Francisco*, 347.

13. Lavender, *Nothing Seemed Impossible*, 371–79.

14. On Ralston's finances after the crash, see Lavender, *Nothing Seemed Impossible*, 377–85, and Brechin, *Imperial San Francisco*, 89–90.

15. *Daily Alta California*, October 3, 1875.

16. Ibid.

17. Carnegie, *Notes of a Trip*, 10.

18. Lloyd, *Lights and Shades*, 50–57.

19. Palmquist, in *Carleton E. Watkins,* 51, suggests that Cook himself made the original loan to CEW, and most CEW historians have cited Palmquist's conclusion. Even though CEW made many trips to Mariposa County, nothing ties him to Cook before December 1875. It's unlikely that the two men knew each other until after Ralston's assets were dispersed.

20. Lavender, *Nothing Seemed Impossible,* 383.

CHAPTER 18. THE COMEBACK

1. This picture is attributed to CEW by virtue of a corresponding stereograph, CEW stereograph no. 3581. That clouds are printed into the sky behind the bank building, something CEW almost never did, is a puzzlement and suggests that the picture may have been printed by an outside agent or that Taber and Cook hadn't taken full possession of CEW's negatives until after July 4, 1876.

2. *Daily Alta California,* October 4, 1875.

3. For Farquharson, see Bloomfield, "David Farquharson."

4. CEW apparently sent his pictures of Yosemite, San Francisco, and Oregon to the fair before losing his gallery or purchased his own pictures from Taber and Cook so as to send them to Philadelphia. The fair opened on May 10, 1876.

5. Huntington, *Collis P. Huntington Papers.*

6. CPH and Isaac E. Gates (CPH's brother-in-law and the confidant who handled his personal affairs) to John M. Watkins, November 10, 1870; CPH to A.G. Shaw (a business associate who handled CPH's Oneonta-based affairs), March 14, 1876; in Huntington, *Collis P. Huntington Papers.*

7. See *Collis Huntington Papers,* Series I, Reels 7–10.

8. CEW to Policarpo Bagnasco, March 30, 1880, Carleton Watkins Letters, BANC. "Superintendent" was the nineteenth-century term for a company's top staff executive, roughly analogous to today's title of chief executive officer. CEW to CPH, February 8, 1884, in Huntington, *Collis P. Huntington Papers,* reveals CEW's familiarity with Towne.

9. I.E. Gates to Clarence King, February 11, 1871, in Huntington, *Collis P. Huntington Papers.*

10. Historian Christine Hult-Lewis argues for the logic of this approach in Hult-Lewis, "Mining Photographs," 181–203. Contradictory contemporary reports in the *Nevada Tribune* seem to argue for a slightly different itinerary—but they also refer to CEW as "Col. Palmer" and make other obvious errors. See *Nevada Tribune,* September 22 and 29, 1876.

11. TSK, "Living Water from Lake Tahoe," probably 1863, in TSK, *Thomas Starr King Sermons.*

12. Lebergott, *Trends in the American Economy,* 452. Hult-Lewis, in "Mining Photographs," 188, suggests that this $970 would have paid for more of CEW's work than just the Carson and Tahoe Lumber and Fluming Co. portion of the trip. She com-

pares CEW's price for studio pictures, such as Yosemite views at his San Francisco gallery, to commission work. She may be correct. Conversely, there's no reason to assume CEW would have charged a client the same rate for a time-consuming commission as he would have charged gallery customers for existing pictures. Nor is it clear why a client such as the Carson and Tahoe Lumber and Fluming Co. would have paid for pictures of mines owned by the Bonanza Kings or for pictures of Central Pacific Railroad facilities. More likely, the company was just one of half a dozen clients on this trip.

13. Lavender, *Nothing Seemed Impossible*, 360; James, *Roar and the Thunder*, 55.

14. For more on artists' approach to Lake Tahoe and the surrounding region, see Wolfe, *Tahoe: A Visual History*.

15. Ibid., 216–17.

16. Lekisch, *Tahoe Place Names*, 29–30.

17. Naef and Hult-Lewis, *Carleton Watkins*, 404.

18. Muir, *September–October, 1878, Notes of Travel on the East Side of the Sierra*, John Muir Journals, John Muir Papers, Holt-Atherton Special Collections, University of the Pacific Library, Stockton, CA. Westerners would be on the vanguard of much of America's conservationism and environmentalism, but on deforestation they were late.

19. James, *Roar and the Silence*, 111–17.

20. Browne, *Peep at Washoe and Washoe Revisited*, 57.

21. Ibid., xix–xxi.

22. James, *Roar and the Silence*, 106–8; Couch and Carpenter, "Nevada's Metal and Mineral Production," 138.

23. "Mining Interests of 1876," *Mining and Scientific Press* 34, no. 3 (January 20, 1877): 40. Quoted in Hult-Lewis, *Mining Photographs*, 185.

24. Greenwood, *New Life in New Lands*, 177.

25. Ultimately the most likely client is the Virginia & Truckee Railroad. All of the mills along the Carson in Lyon County were enabled by the railroad's arrival, which caused a sudden geographic shift of Comstock stamp-milling from the old area west of Virginia City to the Carson Valley in the east. James, *Roar and the Silence*, 84.

26. James, *Roar and the Silence*, 100–101; Drabelle, *Mile-High Fever*, 131.

27. *Monographs of the United States Geological Survey*, vol. 4, 309.

28. Shearer, *Pacific Tourist: Adams & Bishop's Illustrated Trans-Continental Guide of Travel*, 252, 254, 259, 270–71.

CHAPTER 19. CREATING SEMI-TROPICAL CALIFORNIA

1. White, *Railroaded*, 127. For more on graft and what White cleverly names "friendship" in the railroad business during the Gilded Age, see 93–133.

2. The first transcontinental railroad was built in the middle of the country, extending out of the North, because it was legislatively born after the South had seceded from the Union.

3. Sources for the battle between the Texas & Pacific and the Southern Pacific include Orsi, *Sunset Limited*, 21–23; Churella, *Pennsylvania Railroad*, vol. 1, *Building an Empire*, 419–26; Mullaly and Petty, *Southern Pacific in Los Angeles*, 11–22; White, *Railroaded*, 93–133.

4. Orsi, *Sunset Limited*, 19–20.

5. Contemporary documents refer to the Tehachapis as part of the Sierra Nevada. We now know that they are not.

6. For the challenges the Tehachapi Mountains provided the Southern Pacific, see Signor, *Tehachapi*, 13–17; Middleton, *Landmarks on the Iron Road*, 89–92; Orsi, *Sunset Limited*, 19.

7. Signor, *Tehachapi*, 15.

8. CPH to David D. Coulton, February 14, 1876, in Huntington, *Collis P. Huntington Papers*.

9. Deverell, *Railroad Crossing*, 96–99; Mullaly and Petty, *The Southern Pacific in Los Angeles*, 12–13.

10. *Daily Alta California*, May 28, 1884; Signor, *Tehachapi*, 17. The *Alta* cites only costs for the construction of the Loop and the San Fernando Tunnel. Its figures are exclusive of significant surveying costs and costs of construction of the other sixteen tunnels.

11. Crocker also sent dispatches back to the *Daily Alta California*. See *Daily Alta California*, September 6, 1876.

12. White, *Railroaded*, 123.

13. Mullaly and Petty, *Southern Pacific in Los Angeles*, 19.

14. Ibid.; Signor, *Tehachapi*, 15.

15. The trip is datable via a notice in the *Los Angeles Star*, March 31, 1877.

16. For the importance of development to the Southern Pacific, especially agriculture, see Orsi, *Sunset Limited*, 51–62.

17. CEW's numbering suggests that one and possibly two Loop-area mammoth plates have been lost.

18. *Daily Alta California*, September 6, 1876.

19. One of the pictures is plainly datable to 1877. The other appears to fall into CEW's numerical sequencing as an 1877 picture, but it may have been made in 1880.

20. Shearer, *Pacific Tourist*, 320.

21. For example, see *Crofutt's New Overland Tourist and Pacific Coast Guide*, vol. 2.

22. Ibid., 322.

23. The name of the architect is lost. See Kane, "Arriving in Los Angeles."

24. White, *Railroaded*, 128–33.

CHAPTER 20. SHOWING CALIFORNIA ITS HISTORY

1. Stevenson, "San Carlos Day: An Article in a California Newspaper," *Scribner's Magazine* 68 (August 1920): 209–11.

2. Stevenson, *Across the Plains*; Jackson, *Ramona*.
3. For mission history, see Kimbro and Costello, *California Missions*.
4. Hackel, *Junipero Serra*, 166–70.
5. Starr, *Americans and the California Dream*, 369; Chaffin, *Pathfinder*, 325–64.
6. Harte, *Complete Works of Bret Harte*, vol. 2, 197. Harte also addressed mission culture in his debut *Atlantic Monthly* short story, "The Legend of Monte del Diablo" (1863).
7. Stevenson, "San Carlos Day," 210.
8. The chronology of CEW's missions-related trip up the coast and through coastal valleys in 1877 is determined from his picture-numbering system.
9. Kimbro and Costello, *California Missions*, 170.
10. Miller, *Account of a Tour*.
11. Vischer, *Missions of Upper California*, 1872.
12. Kimbro and Costello, *California Missions*, 194.
13. The record of pictures Watkins made at San Juan Capistrano is confusing and possibly incomplete. Naef and Hult-Lewis list five mammoth plates from San Juan Capistrano, which includes one mammoth made by photographing a stereograph and another that Naef and Hult-Lewis say was made in a similar manner. That second picture, NH-L 781, appears to be a broader view than the corresponding stereograph rather than a detail, raising the possibility that CEW may have made one more as yet unknown mammoth here. (CEW's own numbering system, of unknown origin, does not leave room for such a picture.)
14. *Sacramento Union*, July 24, 1880.
15. Allen and Felton, *Water System at Mission Santa Barbara*. Like so many books about California, this one includes an uncredited CEW picture. It is on p. 14.
16. Stevenson and Gosse, *Works of Robert Louis Stevenson*, vol. 2, 164–65.
17. Hult-Lewis, "Mining Photographs," 228–32.
18. *Tucson and Tombstone General and Business Directory for 1883 and 1884* (Tucson, 1883), 9; Hamilton, *Resources of Arizona*, 116.
19. On April 22, 1880, the *Arizona Weekly Star*, a Tucson newspaper, reported that CEW made seven views of San Xavier del Bac, so it's possible that several were lost, damaged, or later rejected.
20. Watts, "The California Missions Project," in Naef and Hult-Lewis, *Carleton Watkins*, 315.
21. Ford, *Etchings of the Franciscan Missions of California*.
22. See Tyler, *Old California Missions*; Walkley, S. L., Walkley photograph albums, approximately 1888, photCL 57, HL; Jarvis, *Mission San Gabriel*, photPF 20113, HL; Jarvis, *Old Mission San Luis Rey*, photPF 20121, HL.

CHAPTER 21. ENTER WILLIAM H. LAWRENCE

1. The company was called Spring Valley Water Works until 1903, when it became Spring Valley Water Co. Babal, "History of the Spring Valley Water Company."

2. Ibid.

3. *Daily Alta California*, October 22, 1888; *San Mateo Times and Gazette*, October 27, 1888, November 17, 1888. The Lawrence-Green family tree is from an unpublished family history in the author's possession.

4. Dupree, *Asa Gray*, 9; Bancroft, *Works of Hubert Howe Bancroft*, vol. 24, *History of California*, vol. 7, 736.

5. *Appendix to Journals of the Senate, of the Eleventh Session of the Legislature of the State of California*, 376.

6. *Engineering and Mining Journal* 46, no. 17 (October 27, 1888): 354.

7. Unpublished Lawrence-Green family history.

8. For Lawrence's history with Spring Valley, see *San Francisco Water* 5, no. 2 (April 1926): 1–4.

9. Babal, "History of the Spring Valley Water Company," 14.

10. William H. Lawrence, professional diary, photocopy, San Mateo County Historical Association, Redwood City, CA. *San Francisco Water* 3, no. 1 (January 1923): 8 establishes the damming of San Andreas as beginning in 1866, which is when Lawrence's diary begins.

11. CEW's presence at Pilarcitos is established by CEW stereograph no. 911. CEW made mammoth-plate pictures for Spring Valley, now lost. Naef and Hult-Lewis, *Carleton Watkins*, 537. They date those mammoths to 1864. If that date is correct, CEW worked for Spring Valley over the course of at least three years.

12. Naef and Hult-Lewis, *Carleton Watkins*, 540. It appears that one of CEW's Pilarcitos mammoths was published by Spring Valley in its monthly magazine, *San Francisco Water*. See *San Francisco Water* 1, no. 3 (July 1922): 9. This picture was taken at the same time as and just a few feet from CEW stereograph no. 912. The picture is not credited. Another uncredited picture from the era that may be by CEW is in *San Francisco Water* 2, no. 1 (January 1923): 8 and shows San Andres Dam (now known as San Andreas Dam).

13. *San Francisco Water* 5, no. 2 (April 1926): 1–4.

14. Lawrence's professional diary indicates that he's in charge of each of these projects.

15. Marcellino and Jebens, "History of Human Use at Lake Merced."

16. Author's collection.

17. Langley, *San Francisco Directory for the Year Commencing April, 1879* (San Francisco, 1879), 888. The 1879 city directory, published at the start of the year, lists CEW's new gallery address for the first time, which suggests the gallery was up and running in 1878, a suggestion confirmed by the 1878 directory's listing of several San Franciscans as CEW employees. Langley, *San Francisco Directory for the Year Commencing February, 1878* (San Francisco, 1878), 561, 604.

18. Lavender, *Nothing Seemed Impossible*, 370–72; Brechin, *Imperial San Francisco*, 84–89.

19. Postel, *San Mateo*, 73.

20. *Daily Alta California*, March 18, 1875.

21. The existence of a Mountain Queen Mining Co. near the Southern Pacific Railroad in Arizona is notable. Could the *Daily Alta California* have misidentified Lawrence's 1875 investment as being in a Nevada company when it was in an Arizona company? If so, it might be a reason CEW went to Arizona in 1880.

22. *Daily Alta California,* August 27, 1888.

23. Advertisement in the *Daily Alta California,* November 4, 8, 10, 11, 12, 14, 16, 23, and 25, 1879.

24. Jostes and Parrott, *John Parrott, Consul,* 151–52.

25. Private collection, Menlo Park, CA.

26. *Daily Alta California,* June 15, 1884.

27. Knight, *Hand-book Almanac for the Pacific States,* 222.

28. *Sacramento Union,* December 3, 1870.

29. Carr, "Rural Homes of California," 69–72.

30. *Daily Alta California,* September 27, 1875.

31. *Sacramento Union,* July 28, 1871

32. *San Francisco Call,* January 1, 1910.

33. *San Mateo County Gazette,* July 17, 1880; *Daily Alta California,* October 10, 1884, December 15, 1885.

34. *San Mateo County Gazette,* August 28, 1880.

35. Alexander and Hamm, *History of San Mateo County,* 184.

CHAPTER 22. REBUILDING A BUSINESS

1. Palmquist, in *Carleton E. Watkins, Photographer of the American West,* 57–59, asserts that CEW made three trips to Yosemite after losing his gallery and negatives: in 1878, 1879, and 1881. In Palmquist's subsequent chronology in Nickel, *Carleton Watkins,* 218–19, he no longer includes an 1879 Yosemite trip. (However, CEW's correspondence with George Davidson reveals that he was in Yosemite that year.) Some historians, such as Naef in Naef and Hult-Lewis, *Carleton Watkins,* continue to cite Palmquist, *Carleton E. Watkins, Photographer of the American West,* in asserting 1879 and 1881 trips. I could not find evidence of an 1881 trip. The confusion may come from CEW's gallery, which seems to have offered pictures for sale in a rented space in Yosemite in 1881: on May 7, 1881, the *Pacific Rural Press* listed CEW's gallery as among several that would be taking up a salesroom in the valley. The gallery seems to have been staffed by CEW salesperson Sallie Dutcher.

2. *Crofutt's New Overland Tourist and Pacific Coast Guide,* 236; *Sacramento Union,* April 20, 1877.

3. Gordon-Cumming, *Granite Crags in the Valley,* 129, 262–63.

4. Ibid., 129.

5. Ibid., 283–84.

6. *California Farmer and Journal of Useful Services,* October 24, 1878.

7. Gordon-Cumming, *Granite Crags in the Valley,* 129.

8. The dating of the Calaveras pictures is uncertain. Naef attributes them to 1878 because he believes they are "stylistically related" to pictures CEW made after 1875, and he offers no further elucidation. (Naef, in Naef and Hult-Lewis, *Carleton Watkins*, 122.) While CEW's own numbering of the Calaveras pictures makes it likely that they were made after 1875, anything more specific than that would seem to be speculative.

9. Gordon-Cumming, *Granite Crags in the Valley*, 110.

10. Ibid., 111–12.

11. While Adams often claimed to be unimpressed by CEW's work, he certainly knew it. In 1942 he included several CEW pictures in an exhibition he curated at the Museum of Modern Art, New York, *Photographs of the Civil War and the American Frontier,* on view from March 3 to April 5, 1942, https://www.moma.org/calendar/exhibitions/3031. CEW was also featured in Robert Taft's 1917 *Photography and the American Scene,* the most important photography-history text of the era. Historian William Deverell recounts routinely delivering the Watkins albums at SUL to Adams and his friend Wallace Stegner, who often visited the library together to view them (interview by the author, January 16, 2018).

12. *Appendix to the Journals of the Senate and Assembly of the Twenty-Seventh Session of the Legislature of the State of California,* vol. 1, 11; Bingaman, *Pathways.*

13. Marzio, *Democratic Art*, 60.

14. Kate Nearpass Ogden, "California as Kingdom Come," in *Yosemite: Art of an American Icon,* ed. Scott, 30–31.

15. Ball, *Inventor and the Tycoon*, 155–99.

16. For Muybridge's extraordinary life, see two excellent books: Brookman, *Helios: Eadweard Muybridge in a Time of Change,* and Solnit, *River of Shadows: Eadweard Muybridge and the Technological Wild West.*

17. Solnit, *River of Shadows*, 83.

18. The picture is at CSL. It is not clear if the title CSL uses was Muybridge's.

19. Farquhar, *Place Names of the High Sierra.*

20. *New York Tribune,* December 5, 1871.

21. Ibid.

22. Ibid.

23. Hutchings, *In the Heart of the Sierras*, 468.

24. Bingaman, *Pathways,* chap. 5.

25. This picture has confused historians. The only prints of it are on Taber mounts, which suggests that CEW made it before roughly December 1875. However, CEW's numbering of his photographs indicates that he made no such picture in 1861, 1865, or 1866, the only three years in which he is known to have been in the valley. A news item in the *Los Angeles Herald,* July 24, 1875, says that CEW photographed the opening of the new Mariposa Road into Yosemite on July 22, 1875, suggesting that he could have been in the valley that summer. However, no other CEW pictures of

Yosemite are datable to 1875. It's also possible but unlikely that CEW, at a later date, could have sold to Taber a negative he did not plan to print from himself. CEW included a similar overshaded picture of Agassiz Rock in his post-1875 series of stereographs.

26. *New York Tribune,* December 5, 1871.
27. Ibid.
28. Ibid.
29. Ibid.

CHAPTER 23. MAPPING FROM THE MOUNTAINTOPS

1. [T.H. Boyd] to GD, May 28, 1864, George Davidson Papers, MSS C-B 490, BANC. For GD, see Oscar Lewis, *George Davidson,* and "Professor George Davidson, A Sketch of Our Most Prominent Pacific Coast Scientist," *Mining and Scientific Press* 51, no. 7 (August 15, 1885): 1.

2. See Mammoth Plate Landscape Photographs from the George Davidson Collection, BANC PIC 1905.17143-ffALB, BANC (not all CEW pictures in this collection are mammoth-plate pictures); and Portraits from the George Davidson Papers, BANC PIC 1946.010, BANC. GD pictures may be in other BANC collections too.

3. "Davidson, George," *Appletons' Cyclopædia of American Biography,* January 4, 2011, Wikisource, https://en.wikisource.org/.

4. Fremont et al., *Report of the Exploring Expedition to the Rocky Mountains,* 34.

5. For GD's geodetic survey work along the 38th parallel, see John Cloud, *Science on the Edge,* chaps. 3–6; Theberge, *Frontier Coast*; *Report of the Superintendent of the U.S. Coast and Geodetic Survey . . . June, 1879,* 54–56; *Report of the Superintendent of the U.S. Coast and Geodetic Survey . . . June, 1880,* 40–41; George Davidson, "Occupation of Mount Conness," *Overland Monthly* 19 (2nd series), no. 110 (February 1892): 115–29; Charles Howard Shinn, "California Lakes," *Overland Monthly* 18 (2nd series), no. 103 (July 1891): 1–19. I'm grateful to Skip Theberge and John Cloud for their guidance.

6. Foner, *Fiery Trail,* 5.

7. *Mining and Scientific Press* 39, no. 17 (October 25, 1879).

8. Wendte, *Thomas Starr King,* 132–33.

9. GD, Notebook 64, [diary of May 19, 1879, to July 31, 1879], George Davidson Papers, BANC MSS C-B 490, BANC.

10. The order of CEW's pictures on his 1879 U.S. Coast and Geodetic Survey trip is broadly determined by his own numbering of his mammoth plates from the trip. CEW didn't necessarily number pictures in the exact order in which he made them, but when considered with other evidence, it is certain that the Lola pictures are numbered "before" the Round Top pictures.

11. Charles Howard Shinn, "California Lakes," *Overland Monthly* 18 (2nd series), no. 103 (July 1891): 1–19. *Overland Monthly* had published CEW pictures of Kern County earlier that same year.

12. Louis Sengteller to GD correspondence, George Davidson Papers, BANC MSS C-B 490, BANC.

13. Louis Sengteller, [field sketches of a 360-degree view of prominent peaks visible from Round Top in July 1879], Records of the Coast and Geodetic Survey, RG 23, National Archives, College Park, MD.

14. GD, notebook no. 64, George Davidson Papers, BANC, has him leaving Lola on July 31, 1879, and notes his departure from Round Top on August 22, 1879.

15. See dates on E. F. Dickens, *Topography of Round Top, Alpine County, California,* map T-1466A, NOAA, in Cloud, *Science on the Edge.*

16. My source for the dating is GD's notebook no. 64 and the notations on Dickens's map. Also, it was June 7 before weather and accumulated snow and ice allowed GD's party to ascend Lola. When they were there, they still had to contend with frozen earth. Round Top is 1,500 feet higher than Lola, and the footing on the summit ridge is significantly more precarious. It's unlikely that the USCGS structures on Round Top could have been built before, say, late June, and there is no known record of USCGS personnel being on the mountain before Sengteller, who was there in July.

17. Naef and Hult-Lewis, in *Carleton Watkins,* 367, assign a picture to CEW that he himself did not include within his numerical narrative, NH-L 869.

18. See NH-L 874. NH-L 871 is in the direction of Mount Saint Helena.

19. See NH-L 866.

20. Naef and Hult-Lewis, *Carleton Watkins,* 366.

21. Shinn, "California Lakes," *Overland Monthly* 18 (2nd series), no. 103 (July 1891): 2.

CHAPTER 24. BECOMING AGRICULTURAL

1. Brechin, *Imperial San Francisco,* 44–65.

2. Ibid., 44–53; Barnard et al., "Sediment Transport in the San Francisco Bay Coastal System."

3. Alan L. Olmstead and Paul W. Rhode, "Evolution of California Agriculture, 1850–2000," in *California Agriculture,* ed. Siebert, 4–6.

4. Starr, *Inventing the Dream,* 130–32. For examples of the imperative of agricultural development after mining-related ecological devastation, see Wilder, *History of Fresno County,* 165.

5. For the development of industrial agriculture in California, see Pisani, *From the Family Farm to Agribusiness,* 54–153; Igler, *Industrial Cowboys: Miller & Lux*; Worster, *Rivers of Empire*; Orsi, *Sunset Limited,* 193–237.

6. McWilliams, *Southern California,* 3, 5, 114.

7. Ibid., 117.

8. Sadler, *Crescenta Valley Pioneers,* 7–8.

9. *Pacific Rural Press,* April 3, 1880. Carr mentions that CEW took "imperial" pictures at the fair, by which she no doubt means mammoth plates. (The technical differ-

entiations between the two sizes would have been of little import to Carr.) Those pictures are lost.

10. For Wilson, see Read, *Don Benito Wilson*. For the development of agriculture in Southern California, see Starr, *Inventing the Dream*, 13–52.

11. After Shorb's death, CPH's nephew Henry would buy this house and the surrounding land. Today the Huntington Library, Art Collections, and Botanical Gardens is on what was Lake Vineyard.

12. Truman, *Tourists' Illustrated Guide*, 89–90; Croffutt, *Croffut's New Overland Tourist*, 251; Pomeroy, *In Search of the Golden West*, 7–8.

13. From the late 1870s forward, every issue of the magazine *Semi-Tropic California*, the promotional organ of the Southland landowners, offered these terms in both advertising and editorial copy.

14. Patterson, *From Acorns to Warehouses*, 143.

15. McWilliams, *Southern California*, 77.

16. Truman, *Semi-Tropical California*, 126–28; "Reminiscences of Early San Gabriel, a transcription of a 1965 interview between Mrs. Ronald Ross and Maude Rose Easton, daughter of L.J. Rose of Sunny Slope, at her apartment in Santa Monica," HL; *Illustrated History of Southern California*, 765; Wilson, *History of Los Angeles County*, 131–32.

17. CEW, *Sunny Slope, San Gabriel, Cal.*, PhotCL 522, HL.

18. Patterson, *From Acorns to Warehouses*, 107.

19. Palmquist, *Carleton E. Watkins*, 53. (While I think much information on CEW and the commercial market has been found since Palmquist wrote on CEW in 1983, he's excellent on the history of the photography market in the West here and in other books.) For the rise and fall of the stereograph market, see Marien, *Photography: A Cultural History*, 81–85. As western markets for many consumer goods, including stereographs, could be somewhat out of sync with national markets, see Palmquist and Kailbourn, *Pioneer Photographers of the Far West*, 306, for the impact CEW rival Lawrence & Houseworth had on the San Francisco market.

20. *Launceston (Tasmania) Examiner*, December 17, 1880; *Melbourne International Exhibition, 1880–81*, 531.

21. CEW and FSW may have met years earlier: Palmquist identified a portrait made at CEW's Yosemite Art Gallery in around 1875 as FSW. Palmquist, *Carleton E. Watkins*, 54.

22. Palmquist, *Carleton E. Watkins*, 54–62. Palmquist's account of how CEW and FSW met and married is incorrect, but his account of CEW-as-father seems reliable. *Bishop's Directory of Virginia City, Gold Hill, Silver City, Carson City and Reno*, 450.

23. Julia Watkins, interview by William and Karen Currant, February 12, 1975, Collection of Yosemite National Park Research Library, photocopy accessed in Peter E. Palmquist Papers, BRBLYU. In this interview and in Donald McHenry, interview by Ralph Anderson, October 26, 1949 (interviews relating to Yosemite National Park, BANC), Julia proves to be an unreliable witness who routinely makes assertions that are plainly in error. She was ninety-four at the time of her interview with the Currants.

24. U.S. Census. Year: 1880; Census Place: San Francisco, San Francisco, California; Roll: 74; Family History Film: 1254074; Page: 740B; Enumeration District: 059; Image: 0402.

25. Average annual precipitation in Bakersfield, California, is 6.47 inches. National Centers for Environmental Information, National Climate Data Center, 1981–2010 Climate Normals database, https://www.ncdc.noaa.gov/cdo-web/datatools /normals; Mares, *Encyclopedia of Deserts*, 52.

26. USDA Economic Research Service, Cash receipts by commodity state ranking, https://data.ers.usda.gov/reports.aspx?ID = 53580.

27. Street, "Kern County Diary." Street puts the number of CEW Kern dry-plate pictures at 726.

28. Berg, *History of the Kern County Land Company*), 1–19; Angel, *Memorial and Biographical History*, 178, 279–80.

29. Igler, *Industrial Cowboys*, 4, 5, 9, 16, 35–48, 72–83.

30. Ibid., 101–2; Berg, *History of the Kern County Land Company*, 7–12; Angel, *Memorial and Biographical History*, 263.

31. Igler, *Industrial Cowboys*, 94–101.

32. Berg, *History of the Kern County Land Company*, 11–15.

33. Accounts of the case include Igler, *Industrial Cowboys*, 92–121; Berg, *History of the Kern County Land Company*, 11–15; Worster, *Rivers of Empire*, 104–7; and Bremer, "Trial of the Century."

34. *Charles Lux et al. v. James B. Haggin et al.* (nos. 8587 and 8588 in the Supreme Court of the State of California), vol. 1–10, 1882–85, California Land Case Collection, BANC. CEW's testimony is on pp. 577–81. CEW was called as a witness for the plaintiffs. Igler, in *Industrial Cowboys*, 3, argues that CEW worked for both plaintiff and defendant. Watts, in Naef and Hult-Lewis, *Carleton Watkins*, 397, points to Haggin as CEW's commissioner.

35. Morgan, *History of Kern County*, 112.

36. Unknown author, *Map of a Portion of Kern County, California. Showing ranches, lakes, rivers, canals, sloughs, and artesian wells* (San Francisco: Britton & Rey, 1888), call no. 336672, HL.

37. Worster, *Rivers of Empire*, 107.

CHAPTER 25. TRAVELING THE WEST (AGAIN)

1. CEW to FSW, September 19, 1882, CEW Letters, BANC; [Federal Writers Project, OR], *Oregon: End of the Trail*, 217.

2. Naef and Hult-Lewis, in *Carleton Watkins*, 199, speculate that CEW named the feature, but I could find no evidence to support this. It's more likely that Oregon Steam Navigation Co. founder and later Northern Pacific Railroad director John C. Ainsworth, whose family had roots in Oneonta, NY, informed its naming.

3. *Seattle Post-Intelligencer*, September 22, 1882.

4. Truman, *Tourists' Illustrated Guide*, 133.

5. Hittell, *Bancroft's Pacific Coast Guide Book*, 116–17.
6. Today the road is known as Seventeen-Mile Drive.
7. Truman, *Tourists' Illustrated Guide*, 134–61.
8. *San Francisco Call*, December 17, 1882, as quoted in the *New York Times*, December 25, 1882.
9. "Winter at the Seaside in California," *Mining and Scientific Press* 46, no. 1 (January 6, 1883): 9. Engravings made from CEW's pictures in Truman, *Tourists' Illustrated Guide* (1883), a production of the Associates' own publishing house, assign some of his pictures to January 1882 and leave others undated. For reasons that are not explained, Naef and Hult-Lewis, in *Carleton Watkins*, assign all of the Hotel Del Monte–area pictures to 1883–85, with the exception of one dated to 1885.
10. My exposure to these pictures has come from Naef and Hult-Lewis, *Carleton Watkins*, 289–308. The Hispanic Society of America, which has the only known prints of almost all of them, has closed the collection to researchers and, accordingly, denied me access. The HSA offered me access to small, not-for-publication digital images for a fee. I declined.
11. CEW to CPH, February 8, 1884, Huntington, *Collis P. Huntington Papers*.

CHAPTER 26. THE NEW INDUSTRIAL AGRICULTURE NEAR BAKERSFIELD, CALIFORNIA

1. Worster, *Rivers of Empire*, 360n8.
2. Ardery, "Fabulous James Ben Ali Haggin."
3. *Kern County Californian*, July 7, 1888, details both an 1887 and an 1888 visit. Naef and Hult-Lewis, in *Carleton Watkins*, list many of CEW's Kern mammoths as "1886–1888." Historians have long debated whether CEW was in Kern in 1889, as the printed label on *Late George Cling Peaches* suggests. I think this picture was most likely made in CEW's studio, in San Francisco. A CEW mammoth plate of Bakersfield's Southern Hotel, N-HL 968, is the best argument for an 1889 trip: the hotel opened in March 1889 (*Daily Alta California*, February 10, 1889).
4. Watts, in Naef and Hult-Lewis, *Carleton Watkins*, 397.
5. Morgan, *History of Kern County*, 18–19.
6. Latta, *Historic Lakeside Ranch*.
7. Haggin, "Kern County Irrigation (prepared testimony)," in *Miscellaneous Documents of the Senate of the United States for the Second Session of the Forty-Ninth Congress* (1886–87), vol. 1, 76–77.
8. For the Calloway Canal, see Berg, *History of the Kern County Land Company*, 8–11; Worster, *Rivers of Empire*, 104; and Boyd, *California Middle Border*, 101–2. For an accounting of Kern's new canal infrastructure, see Angel, *Memorial and Biographical History of the Counties of Fresno, Tulare and Kern*, 251–58; B.F. Mull, "List of Artesian Wells (prepared testimony)," *Miscellaneous Documents of the Senate of the United States for the Second Session of the Forty-Ninth Congress* (1886–87), vol. 1, 78–81.

9. Angel, *Memorial and Biographical History*, 248. Pisani, in *From the Family Farm to Agribusiness*, 200, says that in 1879, not long before CEW's visit for *Lux v. Haggin*, Calloway served water to seventy thousand acres.

10. Street discusses this viewpoint at length in "A Kern County Diary."

11. The tree might be an oak, but the caption on the picture, CEW Kern County no. 651, says it's a willow. (CEW's numbering system for his Kern County medium-format pictures is not related to his numbering systems for mammoth plates or stereographs. I refer to them as "Kern County no.")

12. Street, "Kern County Diary," 247.

13. The Church is at the New Britain Museum of American Art in Connecticut; the Cropsey is at the Indiana University Art Museum in Bloomington; and the Keith is at the Metropolitan Museum of Art, New York.

14. U.S. Industrial Commission, *Reports of the Industrial Commission on the Distribution of Farm Products*, vol. 6, 291–92.

15. Captions on CEW Kern County nos. 158 and 181. Haggin also operated dairies at Cotton Ranch and Anderson Ranch.

16. *Report of the Statistics of Agriculture in the United States at the Eleventh Census: 1890*, 44, 76.

17. CEW Kern County no. 460.

18. *Daily Alta California*, January 24, 1888.

19. *Pacific Rural Press*, August 18, 1888.

20. *Pacific Rural Press*, August 25, 1888.

21. *Pacific Rural Press*, March 16, 1889.

22. *Los Angeles Herald*, March 4, 1889.

23. *Pacific Rural Press*, March 16, 1889; Angel, *Memorial and Biographical History*, 241.

24. *Kern County Californian*, March 22, 1889.

25. *Kern County Californian*, Friday, March 22, 1889; *Los Angeles Herald*, March 22–24, 1889. Nota bene: The *Californian* erroneously dated both its Friday, March 22, paper and its Saturday, March 23, paper as "March 22." For clarity, I've included the day of the week in all references.

26. *Kern County Californian*, Saturday, March 22, 1889.

27. Ibid.

28. Street, "Kern County Diary," 255; *Kern County Californian*, October 6 and November 10, 1888.

29. Street, "Kern County Diary," 255.

30. Orsi, *Sunset Limited*, 138.

31. Collection of the Kern County Museum, Bakersfield, CA.

32. *Kern County Californian*, June 4, 11, and 18; July 2; August 20 and 27; September 3, 10, 17, and 24, 1892.

33. The *Traveler* 1, no. 7 (July 1893). The *Traveler* also ran a CEW Shasta picture on the second page of its first issue, vol. 1, no. 1 (January 1893), and like many Californa-

based magazines of the period, it was routinely stuffed with CEW pictures. Did CEW benefit financially from the new ability of magazines and newspapers to publish photographs? We don't know.

34. *Sunset* 13, no. 1 (May 1904), unpaginated advertisement.

35. C.E. Grunsky, "Material Progress of California I—Irrigation," *Overland Monthly* 29 (2nd series), no. 173 (May 1897): 516–19.

36. Haggin, "Kern County Irrigation (prepared testimony)," *Miscellaneous Documents of the Senate of the United States for the Second Session of the Forty-Ninth Congress* (1886–87), vol. 1, 76–77.

37. Worster, *Rivers of Empire*, 107–11; Orsi, *Sunset Limited*, 213–20.

38. *Report of the Special Committee of the United States Senate on the Irrigation and Reclamation of Arid Lands*, vol. 2—*The Great Basin Region and California*, 314–16.

39. Ibid., 218.

40. Ibid., 316–18.

41. Ibid., 296–97.

42. *Report of the Special Committee of the United States Senate on the Irrigation and Reclamation of Arid Lands: Report of Committee and Views of the Minority*, 22–23.

43. Worster, *Rivers of Empire*, 131–69.

CHAPTER 27. THE LAST GREAT PICTURE

1. For Beale, see Starr, *Inventing the Dream*, 22–30.

2. Austin, *Land of Little Rain*; Austin, *Earth Horizon*.

3. An album owned by the Tejon Ranch Co. includes this inscription: "R[obert]. M. Pogson, Sept. 4th, 1888." The inscription is in a different hand and in a different color ink from other markings in the album and should not be read as necessarily being contemporary to the receipt of the album.

4. Gates, *Land and Law in California*, 343.

5. Mornin and Mornin, *Saints of California*, 63.

6. The *Kern County Californian*, Saturday, March 22, 1889, reported that Beale was planning to put three hundred thousand acres on the market "as soon as [the land was] supplied with railroad transportation."

7. For details about the sites and people CEW photographed at Tejon Ranch, see Latta, *Saga of Rancho El Tejon*.

8. See the Tejon Ranch Co. website, http://tejonranch.com/the-company/.

9. Caption taken from the print at HL.

10. For Wible, see Boyd, *California Middle Border*, 93–94; Burmeister, *Golden Empire*, 80–81; Morgan, *History of Kern County*, 323–24; Angel, *Memorial and Biographical History of the Counties of Fresno, Tulare, and Kern*, 241, 419–20, 504–6.

11. Angel, *Memorial and Biographical History*, 505–6; "Simon William Wible," Alaska Mining Hall of Fame Foundation, http://alaskamininghalloffame.org/inductees/wible.php.

12. Myron Angel Papers, 1827–1911, SCP.

13. *Governmental Roster 1889,* 3.

14. Krauss, "Grids," 52.

15. J. Oliver, "Drying and Packing Peaches," *Pacific Rural Press* (March 9, 1889): 218.

CHAPTER 28. THE LONG, SLOW END

1. Hendricks, *Albert Bierstadt,* 315.

2. *Daily Alta California,* December 6, 1890.

3. Case records were destroyed in 1906.

4. Brechin, *Imperial San Francisco,* 98.

5. The best account of CEW's Montana trip is Hult-Lewis, "Mining Pictures," 240–73.

6. CEW to FSW, July 5, 1890, CEW Letters, BANC.

7. Ibid.

8. Hewett and Bartolomei, "Epilepsy and the Cortical Vestibular System."

9. CEW to FSW, July 5, 1890, CEW Letters, BANC.

10. CEW to FSW, June 16, 1894, CEW Letters, BANC.

11. Sandweiss, *Print the Legend,* 11.

12. CEW to FSW, August 5, 1890, CEW Letters, BANC. Based on information from Julia Watkins, Eugene Compton believed "sweetheart" to be a CEW gallery salesperson named Myra. It's as likely that it was CEW's way of referring to any of the other women in the home, such as FSW's sister, Helena, or her niece, also named Helena. Eugene Compton Papers, BANC.

13. CEW to FSW, January–February 1891, CEW Letters, BANC.

14. CEW to FSW, February–March 1891, CEW Letters, BANC.

15. Julia Caroline Watkins to CEW, November 11, 1890, CEW Letters, BANC.

16. Nasaw, *Chief: Life of William Randolph Hearst,* 94–98; Nickliss, "Phoebe Apperson Hearst," 157–68; Hult-Lewis, "Mining Photographs," 246, 305. Julia believed that her father lived at the Hacienda in Pleasanton for a year. No other information supports this.

17. Charles B. Turrill to Gov. George C. Pardee, February 11, 1905, Pardee Correspondence and Papers, BANC; Turrill, "Early California Photographer," 35.

18. Capay Valley Land Co. Records, vol. 293, SUL. The transaction is dated December 14, 1895.

19. Compton, "Notes regarding CEW and his family," Eugene Compton Papers, BANC. Compton also believed that the CEW family lived in a railroad car at Seventh and Grove Streets in Oakland for eighteen months prior to moving to the Capay Valley. San Francisco city directories continue to offer business listings for CEW through 1898. Compton's own notes indicate that Julia told him that she was first raised at 427 Montgomery and that she lived there through 1895.

20. Henry E. Huntington to CPH, June 22, 1896, photocopy, in uncatalogued Peter E. Palmquist Papers, HL.

21. Henry E. Huntington to CPH, June 13, 1896, photocopy, in uncatalogued Peter E. Palmquist Papers, HL.

22. CPH to Alban N. Towne, February 11, 1897, in Huntington, *Collis P. Huntington Papers, 1856–1901.*

23. Orsi, *Sunset Limited,* 51, 136–43, 148–51.

24. Eugene Compton, "Notes regarding Carleton E. Watkins and his family," Eugene Compton Papers, BANC.

25. Peter E, Palmquist Papers, BRBLYU; Turrill, *Catalogue of the Products of California.*

26. CEW to George Pardee, May 13, 1903, George Pardee Papers, BANC.

27. Charles B. Turrill to George Pardee, February 11, 1905, George Pardee Papers, BANC.

28. Some CEW historians have taken Turrill mostly at face value, resulting in numerous inaccuracies and confusions.

29. *International Exhibition of Pictorial Photography,* November 3–December 1, 1910, Buffalo Fine Arts Academy.

30. Harry C. Peterson Papers, SUL.

31. Palmquist, *Carleton E. Watkins,* 82.

32. Harry C. Peterson Papers, SUL.

33. H.C. Peterson to Robert Taft, June 1, 1933, as quoted in Taft, *Photography and the American Scene,* 255–56.

34. Fradkin, *Great Earthquake and Firestorms of 1906,* 96.

35. Charles Turrill to George Pardee, April 21, 1906, George Pardee Papers, BANC. The injury to the leg, referred to as "ulcerated," is enumerated in Turrill to Pardee, June 4, 1906, George Pardee Papers, BANC.

36. Turrill to Pardee, June 4, 1906, George Pardee Papers, BANC.

37. Ibid.

38. Fradkin, *Great Earthquake and Firestorms of 1906,* 82–84.

39. Charles Turrill to George Pardee, June 14, 1906, George Pardee Papers, BANC.

40. *On the Matter of the Guardianship of Carlton* [sic] *E. Watkins, an Incompetent;* Case no. 1493, filed in the Superior Court of the State of California in and for the County of Yolo, filed June 12, 1909.

41. *On the Matter of the Guardianship of Carlton* [sic] *E. Watkins, an Incompetent;* Case no. 1493, filed in the Superior Court of the State of California, in and for the County of Yolo, filed June 28, 1909.

BIBLIOGRAPHY

I HAVE ACCESSED WATKINS'S pictures at almost all of the institutions with major holdings. The significant exception is the Hispanic Society of America, which said that its Watkins collection was closed for conservation reasons related to album condition (as opposed to the condition of prints). The society refused to share with me, even for study purposes, high-quality digital images. (See chapter 25, n. 10.)

For nineteenth- and early twentieth-century texts on Yosemite, some of which are immensely difficult to find in their original form (especially outside the West), I've provided links to Dan Anderson's superb Yosemite Online library, where virtually every key early text regarding Yosemite is available.

UNPUBLISHED PRIMARY SOURCES

ARCHIVES OF AMERICAN ART, SMITHSONIAN INSTITUTION, WASHINGTON, DC
James D. Smillie and Smillie Family Papers

ARCHIVES OF THE ANDREW JOHNSON NATIONAL HISTORIC SITE, GREENEVILLE, TN

BAILEY/HOWE LIBRARY, UNIVERSITY OF VERMONT
Trenor W. Park Papers

BANCROFT LIBRARY, UNIVERSITY OF CALIFORNIA, BERKELEY
John Commigers Ainsworth dictation and related biographical material; John Commigers
 Ainsworth statement in the Hubert Howe Bancroft Collection
William H. Brewer Correspondence with Josiah D. Whitney, 1860–84

William H. Brewer Fieldbooks
William H. Brewer Papers
California Land Case Collection
Eugene Compton Papers
George Davidson Papers
Frémont Family Papers
James B.A. Haggin Papers
William Hammond Hall Papers
C.F. Hoffmann Letters to Josiah Whitney and William H. Brewer
Collis Potter Huntington biographical material for H.H. Bancroft's *Chronicles of the Builders of the Commonwealth, 1880–90* (bulk 1887–90)
Interviews relating to Yosemite National Park, ca. 1948–1976, conducted under the auspices of the National Park Service and the Regional Oral History Office, Bancroft Library
Thomas Starr King Papers
Pacific Mill & Mining Co. Papers
[George] Pardee Correspondence and Papers
Keith McHenry Pond Collection
San Francisco Home Guard Roster and Muster Rolls, 1861
Spring Valley Water Company Records, 1856–1952
Union Lumber Company Records, 1854–1960
Virginia & Truckee Railroad Co. Papers
Carleton E. Watkins Papers
Carleton Emmons Watkins Letters
Henry M. Yerington Papers

BEINECKE RARE BOOK & MANUSCRIPT LIBRARY, YALE UNIVERSITY
Thomas Starr King Papers
Peter E. Palmquist Papers

BILLINGS FARM & MUSEUM/WOODSTOCK FOUNDATION, WOODSTOCK, VT
Billings Family Archives

CALIFORNIA HISTORICAL SOCIETY, SAN FRANCISCO
Nanette Sexton photocopy in MS 34

CALIFORNIA STATE ARCHIVES, SACRAMENTO
California State Parks Archive
Malakoff Diggins SHP Collection; North Bloomfield Gravel Mining Co.
State Geological Survey Records
State Land Office Records [Yosemite files]

CALIFORNIA STATE LIBRARY, SACRAMENTO
Harriet Errington Papers
D.O. Mills and Company Collection

GRADUATE THEOLOGICAL UNION ARCHIVES, BERKELEY, CA
Thomas Starr King Collection

GRAY HERBARIUM, HARVARD UNIVERSITY
Asa Gray Correspondence Files
Photographic Files

HARVARD UNIVERSITY HERBARIA LIBRARY & ARCHIVES

HAUSER MEMORIAL LIBRARY, REED COLLEGE, PORTLAND, OR
Simeon and Amanda Reed Papers

HOLT-ATHERTON SPECIAL COLLECTIONS, UNIVERSITY OF
THE PACIFIC LIBRARY
John Muir Correspondence
John Muir Papers

HOUGHTON LIBRARY, HARVARD UNIVERSITY
Ralph Waldo Emerson Letters to William Emerson, 1825–68

HUNTINGTON LIBRARY, SAN MARINO, CA
Frederick Billings Letters to Solomon Foot, 1851–62
Maud Rose Easton Typescript
James Thomas Field Papers and Addenda
Guadalupe Mine Receipt Book, 1858–60
James D. Hague Papers
Halleck, Peachy & Billings Collection
Letters from Collis P. Huntington to Mark Hopkins, Leland Stanford, Charles Crocker,
 E.B. Crocker, Charles F. Crocker and D.D. Cotton [sic]
Kern County Land Company Papers and Slides, 1886–1964
Clarence King Papers
Thomas Starr King Correspondence
Nevada Railroads Records
New Almaden Mine Collection
Leonard John Rose Papers, 1813–1953
Peter E. Palmquist Papers [uncatalogued]
S.L. Walkley Photograph Albums
Benjamin Davis Wilson Collection

HUNTINGTON MEMORIAL LIBRARY, ONEONTA, NY
"The McDonald Family copied from Mrs. Lydia Fritts' Bible," memoranda in possession
 of Alfred G. Shaw, 1949

LIBRARY OF CONGRESS
Samuel Franklin Emmons Papers
Frederick Law Olmsted Papers

MASSACHUSETTS HISTORICAL SOCIETY, BOSTON
Henry Whitney Bellows Papers

NATIONAL ARCHIVES, COLLEGE PARK, MD
Records of the Coast and Geodetic Survey (Record Group 23)

NATIONAL ARCHIVES AND RECORDS ADMINISTRATION,
WASHINGTON, DC
Records of the U.S. Geological Survey (Record Group 57)

NEW-YORK HISTORICAL SOCIETY
Patriotic Envelope Collection. Series I: Civil War envelopes, 1861–65

NEW YORK PUBLIC LIBRARY
Miriam and Ira D. Wallach Division of Art, Prints and Photographs
[Calvert] Vaux Papers

OREGON HISTORICAL SOCIETY RESEARCH LIBRARY, PORTLAND
Ainsworth Family Papers
Oregon Steam Navigation Co. Records

DAVID RUMSEY HISTORICAL MAP COLLECTION

SAN MATEO COUNTY HISTORICAL ASSOCIATION,
REDWOOD CITY, CA
William H. Lawrence Professional Diary (photocopy)
Spring Valley Water Works Co. Papers, Photographs

SOCIETY OF CALIFORNIA PIONEERS, SAN FRANCISCO
Thomas Starr King Correspondence
Lawrence & Houseworth Photography Albums
Myron Angel Papers

STANFORD UNIVERSITY LIBRARIES
New Almaden Collection
Capay Valley Land Co. Records
Harry C. Peterson Papers

UNIVERSITY OF OREGON LIBRARIES, EUGENE, OR
John C. Ainsworth Papers
George W. Murray Letter to W.W. Baker and Co.

YALE UNIVERSITY LIBRARY
William Henry Brewer Papers
Silliman Family Papers
William Dwight Whitney Family Papers

PERIODICALS

All the Year Round
American Journal of Science
Arizona Weekly Star
Art Journal
Atlantic Monthly
Beadle's Monthly
Boston Evening Transcript
British Journal of Photography
California Farmer and Journal of Useful Sciences
The California Horticulturalist
Congressional Globe
The Crayon
Daily Alta California (San Francisco)
Financial History
Harper's New Monthly Magazine
The Knickerbocker
Launceston (Tasmania) *Examiner*
Mariposa Gazette
Mendocino Historical Review
Mining and Scientific Journal
Mining and Scientific Press
Nevada Tribune
New York Post
New York Times
New York Tribune
The North Pacific Review
Oregonian (Portland, OR)
Otsego County (NY) *Herald Democrat*
The Overland Monthly
Pacific Rural Press
Park and Cemetery Landscape Gardening

Philadelphia Photographer
Potter's American Monthly
Sacramento Union
San Francisco Bulletin
San Francisco Call
San Francisco Water
San Jose Magazine
San Jose Tribune
San Mateo Gazette
San Mateo Times and Gazette
Scribner's Magazine
Seattle Post-Intelligencer
Semi-Tropic California
Sunset
Sydney Morning Herald
The Traveler
The Weekly Mountaineer (Dalles City, OR)

PUBLISHED SOURCES

Abbott, Carl. *Portland in Three Centuries: The Place and the People.* Corvallis: Oregon State University Press, 2011.

Album of the Yo-Semite Valley, California. New York: D. Appleton, 1866.

Alexander, Philip W., and Charles P. Hamm. *History of San Mateo County from the Earliest Times.* Burlingame, CA: Press of Burlingame, 1916.

Alinder, James. *Carleton Watkins: Photographs of the Columbia River and Oregon.* Carmel, CA: Friends of Photography, 1979.

Allen, Rebecca, and David L. Felton. *The Water System at Mission Santa Barbara.* N.p.: California Mission Studies Association, 1998.

Ambrosini, Lynne, Frances Fowle, and Maite van Dijk. *Daubigny, Monet, Van Gogh: Impressions of Landscape.* Edinburgh: National Galleries of Scotland, 2016.

Amend, Anthony. "The Yosemite Book by Josiah Dwight Whitney." *Economic Botany* 58 (2004): 742–43.

An Illustrated History of Southern California. Chicago: Lewis Publishing, 1890.

Anderson, Ralph. "Carleton E. Watkins, Pioneer Photographer of the Pacific Coast." *Yosemite Nature Notes* 32 (April 1953): 32–37.

Angel, Myron. *A Memorial and Biographical History of the Counties of Fresno, Tulare, and Kern, California.* Chicago: Lewis Publishing, [1892?].

Angel, Myron, ed. *History of Nevada.* Oakland: Thompson & West, 1881.

A "Pile," A Glance at the Wealth of the Monied Men of San Francisco and Sacramento City. San Francisco: Cooke & Lecount, 1851.

Appendix to Journals of the Senate, of the Eleventh Session of the Legislature of the State of California. Sacramento: C. T. Botts, State Printer, 1860.

Appendix to the Journals of the Senate and Assembly of the Twenty-Seventh Session of the Legislature of the State of California, vol. 1. Sacramento: State Office, 1887.

Appletons' Illustrated Hand-Book of American Travel. New York: D. Appleton, 1857.

Ardery, Philip. "The Fabulous James Ben Ali Haggin." *Louisville Courier-Journal Magazine*, May 8, 1983.

Aspinwall, Jane L. *Alexander Gardner: The Western Photographs, 1867–68*. Kansas City, MO: Hall Family Foundation and Nelson-Atkins Museum, 2014.

Atherton, Gertrude. *California: An Intimate History*. New York and London: Harper & Brothers, 1914.

Austin, Mary. *The Land of Little Rain*. Boston, New York: Houghton Mifflin, 1903.

———. *Earth Horizon: An Autobiography*. Boston, New York: Houghton Mifflin, 1932.

Avery, Benjamin Parke. *Californian Pictures in Prose and Verse*. New York: Hurd and Houghton, 1878.

———. *Californian Pictures in Prose and Verse*. San Francisco: Samuel Carson, 1885.

Avery, Kevin J., and Franklin Kelly. *Hudson River School Visions: The Landscapes of Sanford R. Gifford*. New York: Metropolitan Museum of Art, 2003.

Ayers, James J. *Gold and Sunshine: Reminiscences of Early California*. Boston: Richard G. Badger, 1922.

Babal, Marianne. "A History of the Spring Valley Water Company." Master's thesis, University of California, Santa Barbara, 1993.

Bain, David Haward. *Empire Express: Building the First Transcontinental Railroad*. New York: Viking, 1999.

Baker, Edward D., and Oscar T. Shuck. *Eloquence of the Far West, No. 1, Masterpieces of E. D. Baker*. San Francisco: Murdock Press, 1899.

Baker, Harvey. *Oneonta in Olden Time & Bits of Oneonta History: An Interesting Series of Articles by Harvey Baker, Published in the Oneonta Herald During the Years 1892–93*. Voorheesville, NY: Square Circle Press, 2010.

Ball, Edward. *The Inventor and the Tycoon*. New York: Doubleday, 2013.

Bancroft, Hubert Howe. *The Works of Hubert Howe Bancroft, Vol. 30, History of Oregon, Vol. 2, 1848–1888*. San Francisco: History Co., 1888.

———. *The Works of Hubert Howe Bancroft, Vol. 24, History of California, Vol. 7, 1860–90*. San Francisco: History Co., 1890.

Bancroft's Tourist Guide: Yosemite, San Francisco and around the Bay (South). San Francisco: A.L. Bancroft, 1871.

Barnard, Patrick L., David H. Schoellhamer, Bruce E. Jaffe, and Lester J. McKee. "Sediment Transport in the San Francisco Bay Coastal System: An Overview." *Marine Geology* 345 (2013): 3–17.

Bartol, C[yrus] A[ugustus]. *The Unspotted Life: Discourse in Memory of Rev. Thomas Starr King*. Boston: Walker, Wise, 1864.

Baumgardner, Frank H. *Yanks in the Redwoods*. New York: Algora, 2010.

Becker, George F. "The Geometrical Form of Volcanic Cones and the Elastic Limit of Lava." *American Journal of Science* 30 (1885): 283–93.

Bell, Virginia. "Trenor Park: A New Englander in California." *California History* 60 (1981): 158–71.

Bennett, Terry. "John Thomas Gulick (1832–1923)—Pioneer Photographer in Japan." *Trans Asia Photography Review* 1 (2011). http://hdl.handle.net/2027/spo.7977573.0001 .203.

Bentley, Wm. R. *Bentley's Hand-Book of the Pacific Coast.* Oakland: Pacific Press, 1884.

———. *Bentley's Hand-Book of the Pacific Coast.* Oakland: Pacific Press, 1885.

Berg, Norman. *A History of the Kern County Land Company.* Bakersfield, CA: Kern County Historical Society, 1971.

Berger, Martin A. "Whiteness and the Landscape Photography of Carleton Watkins." *Oxford Art Journal* 26 (2003): 3–23.

Berglund, Barbara. *Making San Francisco American: Cultural Frontiers in the Urban West, 1846–1906.* Lawrence: University Press of Kansas, 2010.

Billings, Frederick. *The Mariposas Estate.* London: Whittingham and Wilkins, 1861.

Billington, Ray Allen, and Martin Ridge. *Westward Expansion: A History of the American Frontier.* 5th ed. New York: Macmillan, 1982.

Bingaman, John W. *Pathways: A Story of Trails and Men.* Lodi, CA: End-Kian Pub., 1968. www.yosemite.ca.us/library/pathways/.

Bishop's Directory of Virginia City, Gold Hill, Silver City, Carson City and Reno. San Francisco: Vandall, 1878/79.

Blair, Harry C., and Rebecca Tarshis. *The Life of Colonel Edward D. Baker, Lincoln's Constant Ally, Together with Four of his Great Orations.* [Portland, OR]: [Oregon Historical Society], 1960.

Blake, William P., ed. *General Survey of the Exhibition; with a Report on the Character and Condition of the United States Section.* Washington, DC: Government Printing Office, 1868.

———. *Reports of the United States Commissioners to the Paris Universal Exposition, 1867,* vol. 1. Washington, DC: Government Printing Office, 1870.

Bloomfield, Anne. "David Farquharson: Pioneer California Architect." *California History* 59 (1980): 16–33.

———. "A History of the California Historical Society's New Mission Street Neighborhood." *California History* 74 (Winter 1995/96): 372–93, 446–48.

Bonsal, Stephen. *Edward Fitzgerald Beale: A Pioneer in the Path of Empire, 1822–1903.* New York: G. P. Putnam's Sons, 1912.

Borthwick, J. D. *Three Years in California.* Edinburgh: Blackwood and Sons, 1857.

Bowles, Samuel. *Across the Continent: A Summer's Journey to the Rocky Mountains, the Mormons, and the Pacific States with Speaker Colfax.* Springfield, MA: Samuel Bowles, and New York: Hurd & Houghton, 1865.

Boyd, William Harland. *A California Middle Border: The Kern River Country, 1772–1880.* Richardson, TX: Havilah Press, 1972.

Brechin, Gary. *Imperial San Francisco: Urban Power, Earthly Ruin.* Berkeley: University of California Press, 2007.

Bremer, Jeff R. "The Trial of the Century: 'Lux v. Haggin' and the Conflict over Water Rights in Late Nineteenth Century California." *Southern California Quarterly* 81 (1999): 197–220.

Brewer, William H. *Up and Down California in 1860–1864*. Edited by Francis P. Farquhar. New Haven, CT: Yale University Press, 1930.

Brewster, Edwin Tenney. *Life and Letters of Josiah Dwight Whitney*. Boston: Houghton Mifflin, 1909.

Brookman, Philip. *Helios: Eadweard Muybridge in a Time of Change*. Göttingen: Steidl, 2010.

Brother Cornelius. *Keith: Old Master of California*. New York: G. P. Putnam's Sons, 1942.

Browne, J. Ross. *A Peep at Washoe and Washoe Revisited*. 1860 and 1863. Reprint, Balboa Island, CA: Paisano Press, 1959.

Browne, Janet. "Asa Gray and Charles Darwin: Corresponding Naturalists." *Harvard Papers in Botany* (2010): 209–20.

Browning, Peter. *Yosemite Place Names: The Historic Background of Geographic Names in Yosemite National Park*. Lafayette, CA: Great West Books, 2005.

Brucken, Carolyn, and Virginia Scharff. *Empire and Liberty: The Civil War and the West*. Oakland: University of California Press, 2015.

Bryant, William Cullen. *Picturesque America*, vol. 1. New York: D. Appleton, 1872.

———. *Picturesque America*, vol. 2. New York: D. Appleton, 1874.

———. *Poetical Works of William Cullen Bryant*. New York: D. Appleton, 1880.

Buell, Lawrence. *Emerson*. Cambridge, MA: Belknap Press of Harvard University Press, 2004.

Burmeister, Eugene. *The Golden Empire: Kern County, California*. Beverly Hills, CA: Autograph, 1977.

Burnett, Julia M. "Galen Clark." *Sunset* (May 1904): 91. Printed by author, 1907.

Cain, Julie, and Marlea Graham. "Rudolph Ulrich on the San Francisco Peninsula." *Eden* 6, no. 3 (Fall 2003): 1–8.

California State Lands Commission. "California State Lands Commission Shipwreck Information." www.slc.ca.gov/Info/Shipwrecks/ShipwreckInfo.pdf.

Campbell, Dudley M. *A History of Oneonta: From Its Earliest Settlement to the Present Time*. Oneonta, NY: G. W. Fairchild, 1906.

Cantor Arts Center. *Carleton Watkins: The Stanford Albums*. Stanford, CA: Stanford University Press, 2014.

Carlyle, Thomas, and Ralph W. Emerson. *The Correspondence of Thomas Carlyle and Ralph Waldo Emerson, 1834–1872*, vol. 2. Boston: Ticknor, 1888.

Carnegie, Andrew. *Notes of a Trip round the World*. New York: Carnegie, 1879.

Carr, Mrs. E. S. [Jeanne]. "The Rural Homes of California." *California Horticulturalist*, no. 2 (February 1873): 39–42.

———. "The Rural Homes of California." *California Horticulturalist*, no. 3 (March 1873): 69–72.

Casanueva, Francisco. *Report of the Consul General of Chile at San Francisco, As Manager of the Second International Exposition of Chile for the States of California, Nevada & Oregon*. San Francisco: Bonnard & Daly, 1875.

Chaffin, Tom. *Pathfinder: John Charles Fremont and the Course of American Empire*. New York: Hill and Wang, 2002.

Cherny, Robert W. "City Commercial, City Beautiful, City Practical: The San Francisco Visions of William C. Ralston, James D. Phelan, and Michael M. O'Shaughnessy." *California History* 73 (Winter 1994/95): 296–307.

Churella, Albert J. *The Pennsylvania Railroad, Volume 1: Building an Empire, 1846–1917*. Philadelphia: University of Pennsylvania Press, 2013.

Clark, Galen. *Early Days in Yosemite Valley*. Los Angeles: Docter Press, 1964.

Cloud, John. *Science on the Edge: The Story of the Coast and Geodetic Survey from 1867–1970*. https://www.lib.noaa.gov/noaainfo/heritage/coastandgeodeticsurvey/index.html.

Coates, Peter A. "Garden and Mine, Paradise and Purgatory: Landscapes of Leisure and Labor in California." *California History* 83 (2005): 8–27.

Conference on Research in Income and Wealth. *Trends in the American Economy in the Nineteenth Century*. Princeton, NJ: Princeton University Press, 1960.

Conway, John. *Tourists' Guide from the Yosemite Valley to Eagle Peak*. San Francisco: Spaulding, Barto, 1878.

Corning, Howard McKinley. *Willamette Landings*. Hillsboro, OR: Binfords & Mort for the Oregon Historical Society, 1947.

Couch, Bertrand F., and Jay A. Carpenter. "Nevada's Metal and Mineral Production (1859–1940, inclusive)." *Geology and Mining Series* 37 (1943): 132–38.

Cox, Thomas R. *Mills and Markets: A History of the Pacific Coast Lumber Industry to 1900*. Seattle: University of Washington Press, 1944.

Crofutt's New Overland Tourist and Pacific Coast Guide. Vol. 2, 1879–80. Chicago: Overland Publishing, 1880.

Cross, Ira Brown. *A History of the Labor Movement in California*. Berkeley: University of California Press, 1935.

Dana, Julian. *The Man Who Built San Francisco*. New York: Macmillan, 1937.

Darling, Curtis. *Kern County Place Names*. Fresno, CA: Pioneer, 1988.

Dary, David. *The Oregon Trail: An American Saga*. New York: Knopf, 2004.

Davis, Keith F., and Jane L. Aspinwall. *Timothy O'Sullivan: The King Survey Photographs*. Kansas City, MO: Hall Family Foundation and the Nelson-Atkins Museum of Art, 2012.

Delano, Alonzo, and Irving McKee. *Alonzo Delano's California Correspondence*. Sacramento, CA: Sacramento Book Collectors Club, 1952.

DeLuca, Kevin Michael, and Anne Teresa Demo. "Imaging Nature: Watkins, Yosemite, and the Birth of Environmentalism." *Critical Studies in Media Communication* 17 (2000): 241–60.

Denton, Sally. *Passion and Principle: John and Jessie Frémont, the Couple Whose Power, Politics and Love Shaped Nineteenth-Century America*. Lincoln: University of Nebraska Press, 2009.

De Quille, Dan. *History of the Big Bonanza*. Hartford, CT: American Publishing, 1877.

Deverell, William. "Convalescence and California: The Civil War Comes West." *Southern California Quarterly* 90 (2008): 1–26.

———. "Fighting Words: The Significance of the American West in the History of the United States." *Western Historical Quarterly* 25 (1994): 185–206.

———. *Railroad Crossing: Californians and the Railroad, 1850–1910.* Berkeley: University of California Press, 1994.

Didion, Joan. *We Tell Ourselves Stories in Order to Live: Collected Nonfiction.* New York: Knopf, 2006.

Dimock, George. *Exploiting the View: Photographs of Yosemite & Mariposa by Carleton Watkins.* North Bennington, VT: Park-McCullough House, [1984].

Dodge, Prentiss C. *Encyclopedia, Vermont Biography: A Series of Authentic Biographical Sketches of the Representative Men of Vermont and Sons of Vermont in Other States, 1912.* Burlington, VT: Ullery Publishing, 1912.

Drabelle, Dennis. *Mile-High Fever: Silver Mines, Boom Towns, and High Living on the Comstock Lode.* New York: St. Martin's Press, 2009.

Duncan, Dayton. *Seed of the Future: Yosemite and the Evolution of the National Park Idea.* Yosemite National Park, CA: Yosemite Conservancy, 2013.

Dupree, A. Hunter. *Asa Gray: American Botanist, Friend of Darwin.* Cambridge, MA: Belknap Press of Harvard University Press, 1959.

Eicher, David J. *The Longest Night: A Military History of the Civil War.* New York: Simon & Schuster, 2001.

Eliot, William G., Jr. "Thomas Starr King in Oregon, 1862." *Oregon Historical Quarterly* 32 (1931): 105–13.

The Elite Directory for San Francisco and Oakland. San Francisco: Argonaut Publishing, 1879.

Ellis, William Arba, and Robert Darius Guinn, eds. *Norwich University, 1819–1911, Her History, Her Graduates, Her Roll of Honor,* vol. 2. Montpelier, VT: Grenville M. Dodge, 1911.

Emerson, Ralph Waldo. *Essays: Second Series.* Boston: James Munroe, 1844.

———. *Nature.* Boston: James Munroe, 1849.

———. *The Young American: A Lecture.* London: John Chapman, 1844.

———, Ronald A. Bosco, Glen M. Johnson, and Joel Myerson. *The Collected Works of Ralph Waldo Emerson,* vol. 8. Cambridge, MA: Belknap Press of Harvard University Press, 2010.

———, Ronald A. Bosco, and Joel Myerson. *The Later Lectures of Ralph Waldo Emerson, 1843–71.* Athens: University of Georgia Press, 2010.

Evans, Albert S. *A La California.* San Francisco: A.L. Bancroft, 1873.

Falconer, Paul A. "Muybridge's Window to the Past: A Wet-Plate View of San Francisco in 1877." *California History* 57 (1978): 130–57.

Farquhar, Francis P. *History of the Sierra Nevada.* Berkeley: University of California Press, 1965.

———. *Place Names of the High Sierra,* 1926. www.yosemite.ca.us/library/place_names_of_the_high_sierra/.

Faust, Drew Gilpin. *This Republic of Suffering: Death and the American Civil War.* New York: Knopf, 2012.

Fick, Ronald G. "The Antoine Borel Family." *La Peninsula, The Journal of the San Mateo County Historical Association* 20 (Spring 1980).

Field, Stephen J., and George C. Gorham. *Personal Reminiscences of Early Days in California*. Privately printed, [after 1877]. Available through Internet Archive, archive.org.

Figueiredo, Yves. "Inventing Yosemite Valley: National Parks and the Language of Preservation." *Historical Geography* 35 (2007): 12–37.

Foner, Eric. *The Fiery Trial*. New York: W. W. Norton, 2012.

Ford, Henry Chapman. *Etchings of the Franciscan Missions of California. With the Outlines of History, Description, etc.* New York: Studio Press, 1883.

Fradkin, Philip L. *The Great Earthquake and Firestorms of 1906: How San Francisco Nearly Destroyed Itself*. Berkeley: University of California Press, 2006.

Frémont, Jessie Benton. *A Year of American Travel*. New York: Harper & Brothers, 1878.

Frémont, John C. *Oregon and California: The Exploring Expedition to the Rocky Mountains, Oregon and California*. Buffalo: G. H. Derby, 1849.

———. *Report of the Exploring Expedition to the Rocky Mountains in the Year 1842, and to Oregon and North California in the years 1843–'44*. Washington: Gates and Seaton, 1849.

Friedel, Megan K., and Terry Toedtemeier. "Picturing Progress: Carleton Watkins's 1867 Stereoviews of the Columbia River Gorge." *Oregon Historical Quarterly* 109 (Fall 2008): 388–411.

Fritz, Christian G., Michael Griffith, and Janet M. Hunter. *A Judicial Odyssey: Federal Court in Santa Clara, San Benito, Santa Cruz, and Monterey Counties*. San Jose, CA: Advisory Committee—San Jose Federal Court, n.d.

Frothingham, Richard. *A Tribute to Thomas Starr King*. Boston: Ticknor and Fields, 1865.

Gaston, Joseph. *Portland, Its History and Builders*. Vol. 1. Chicago and Portland, OR: S. J. Clarke, 1911.

Gates, Paul W. *Land and Law in California: Essays on Land Policies*. West Lafayette, IN: Purdue University Press, 2002.

Geological Survey of California [Josiah D. Whitney]. *Geology*. Vol. 1, *Report of Progress and Synopsis of the Field-Work, From 1860 to 1864*. Philadelphia: Caxton Press of Sherman & Co., published by the Authority of the Legislature of California, 1865.

Geological Survey of California. *The Yosemite Book*. New York: J. Bien, 1868.

Gill, Frank B. "Oregon's First Railway: The Oregon Portage Railroad at the Cascades of the Columbia River." *Quarterly of the Oregon Historical Society* 25 (1924), 171–235.

Goetzmann, William H. *Exploration and Empire: The Explorer and the Scientist in the Winning of the American West*. Austin: Texas State Historical Association, 2000.

Goodall, Mary. *Oregon's Iron Dream: A Story of Old Oswego and the Proposed Iron Empire of the West*. Portland, OR: Binfords & Mort, 1958.

Goodheart, Adam. *1861: The Civil War Awakening*. New York: Knopf, 2011.

Goodwin, Doris Kearns. *Team of Rivals: The Political Genius of Abraham Lincoln*. New York: Simon and Schuster, 2006.

Gordon-Cumming, C. F. *Granite Crags in the Valley*. Edinburgh and London: William Blackwood and Sons, 1886.

Governmental Roster 1889, State and County Governments of California. Sacramento: State Printing Office, 1889.

Gray, Asa. *Darwiniana: Essays and Reviews Pertaining to Darwinism.* New York: D. Appleton, 1889.

———. *Field, Forest, and Garden Botany: A Simple Introduction to the Common Plants of the United States East of the Mississippi, Both Wild and Cultivated.* New York: Ivison, Phinney, Blakeman, 1868.

———, and Charles Wright. "Diagnostic Characters of New Species of Phaenogamous Plants Collected in Japan by Charles Wright." *Memoirs of the American Academy of Arts and Sciences* 6 (1859): 377–452.

Greeley, Horace. *An Overland Journey from New York to San Francisco in the Summer of 1859.* New York: C.M. Saxton, Baker, 1860.

———. *Glances at Europe.* New York: Dewitt & Davenport, 1851.

Green, Tyler. "New Carleton Watkins Book Is Mammoth." *Modern Art Notes,* December 6, 2011. http://blogs.artinfo.com/modernartnotes/2011/12/new-carleton-watkins-book-is-mammoth/.

Grenbeaux, Pauline. "Carleton E. Watkins, Pioneer Photographer." *California History* 57 (1978): 220–41.

Greenwood, Grace. *New Life in New Lands: Notes of Travel.* New York: J.B. Ford, 1873.

Guinn, James Miller. *A History of California and an Extended History of Its Southern Coast Counties: Also Containing Biographies of Well-known Citizens of the Past and Present.* Vol. 1. Los Angeles: Historic Record, 1907.

Gura, Philip F. *American Transcendentalism: A History.* New York: Hill and Wang, 2007.

Hackel, Steven W. *Junipero Serra: California's Founding Father.* New York: Hill and Wang, 2014.

Hackett, Fred M. *The Industries of San Francisco.* San Francisco: Payot, Upham, 1884.

Haggerty, Timothy J. "The San Francisco Gentleman." *California History* 65 (1986): 96–103.

Haggin, James Ben Ali. *The Desert Lands of Kern County, Cal.* San Francisco: C.H. Street, 1877.

Halteman, Ellen. *Exhibition Record of the San Francisco Art Association, 1872–1915, Mechanics' Institute, 1857–1899, California State Agricultural Society, 1856–1902.* Los Angeles: Dustin Publications, 2000.

Hamilton, Patrick. *The Resources of Arizona.* Prescott, AZ, 1881.

Harris, Mazie M. *Paper Promises: Early American Photography.* Los Angeles: J. Paul Getty Museum, 2017.

Harrison, Alfred C., Jr. *The Art of William Keith.* Moraga, CA: St. Mary's College, 1988.

Harte, Bret. *The Complete Works of Bret Harte.* Vol. 2. London: Chatto and Windus, 1880.

Hartesveldt, Richard J. "Yosemite Valley Place Names." *Yosemite Nature Notes* 34 (1955): 1–22. www.yosemite.ca.us/library/yosemite_valley_place_names/.

Harvey, Eleanor Jones. *The Civil War and American Art.* New Haven, CT: Yale University Press, 2012.

Helper, Hinton R. *The Land of Gold, Reality versus Fiction.* Baltimore: Henry Taylor, 1855.

Hendricks, Gordon. *Albert Bierstadt: Painter of the American West.* New York: H.N. Abrams, 1975.

———. "The First Three Western Journeys of Albert Bierstadt." *Art Bulletin* 46 (1964): 333–65.

Herr, Pamela. *Jessie Benton Fremont: A Biography.* Norman: University of Oklahoma Press, 1988.

Herr, Pamela, and Mary L. Spence. *The Letters of Jessie Benton Frémont.* Urbana: University of Illinois Press, 1993.

Hewett, Russell, and Fabrice Bartolomei. "Epilepsy and the Cortical Vestibular System: Tales of Dizziness and Recent Concepts." *Frontiers in Integrative Neuroscience* 7 (November 2013): 47.

Holmes, Oliver Wendell. "Doings of the Sunbeam." *Atlantic Monthly* 12 (1863): 1–15.

———. *Ralph Waldo Emerson.* Boston: Houghton Mifflin, 1886.

Hoover, Mildred Brooke, Hero Eugene Rensch, and Ethel Grace Rensch. Revised by William N. Abeloe. 3rd ed. *Historic Spots in California.* Stanford, CA: Stanford University Press, 1966.

Howe, Daniel Walker. *What Hath God Wrought.* Oxford: Oxford University Press, 2007.

Howe, Katherine S. *Herter Brothers: Furniture and Interiors for a Gilded Age.* New York: Harry N. Abrams in association with the Museum of Fine Arts Houston, 1997.

Hult-Lewis, Christine. "The Mining Photographs of Carleton Watkins, 1859–1891 and the Origins of Corporate Photography." PhD. diss., Boston University, 2011.

Huntington, Collis Potter. *The Collis P. Huntington Papers, 1856–1901.* Sanford, NC: Microfilming Corp. of America, 1979.

Huntington, Willard V. *Old Time Notes.* Oneonta, NY: Upper Susquehanna Historical Society, n.d.

———. *Oneonta Memories.* San Francisco: Bancroft, 1891.

Huntley, Jen. *Making of Yosemite: James Mason Hutchings and the Origin of America's Most Popular National Park.* Lawrence: University of Kansas Press, 2011.

Hurd, D. Hamilton. *History of Otsego County, New York, 1740–1878 with illustrations and Biographical Sketches of Some of Its Prominent Men and Pioneers.* Philadelphia: Everts & Fariss at the Press of J.B. Lippincott, 1878.

Hutchings, James Mason. *In the Heart of the Sierras: The Yo Semite Valley.* Oakland: Pacific Press, 1888.

———. *Scenes of Wonder and Curiosity in California.* San Francisco: J.M. Hutchings, 1862.

Hutchinson, Elizabeth. "They Might Be Giants: Carleton Watkins, Galen Clark and the Big Tree." *October* 109 (Summer 2004): 46–63.

Huth, Hans. *Nature and the American.* Berkeley: University of California Press, 1957.

———. "Yosemite: The Story of an Idea." *Sierra Club Bulletin* 33, no. 3 (March 1948): 47–78. www.yosemite.ca.us/library/yosemite_story_of_an_idea.html.

Igler, David. *Industrial Cowboys: Miller & Lux and the Transformation of the Far West, 1850–1920.* Berkeley: University of California Press, 2001.

———. "The Industrial Far West: Region and Nation in the Late Nineteenth Century." *Pacific Historical Review* 69 (2000): 159–92.

"Index to Original Photographs in *The Philadelphia Photographer*." Princeton, NJ: Firestone Library, Princeton University. https://graphicarts.princeton.edu/wp-content/uploads/sites/158/2016/06/philadelphia-photographer-by-name-1.pdf.

Issel, William, and Robert W. Cherny. *San Francisco, 1865–1932: Politics, Power, and Urban Development*. Berkeley: University of California Press, 1986.

J. McClatchy & Co. *Sacramento County and its Resources: Our Capital City, Past and Present: A Souvenir of the Bee*. Sacramento, CA: J. McClatchy, 1895.

Jackson, Helen Hunt. *Ramona: A Story*. London: Macmillan, 1884.

James, Ronald M. *The Roar and the Silence: A History of Virginia City and the Comstock Lode*. Reno: University of Nevada Press, 1998.

Japantown Task Force, Inc. *San Francisco's Japantown*. San Francisco: Arcadia Publishing, 2005.

Johansen, Dorothy O. "Capitalism on the Far-Western Frontier: The Oregon Steam Navigation Company." PhD. diss., University of Oregon, Eugene, 1941.

———. *Empire of the Columbia: A History of the Pacific Northwest*. 2nd ed. New York: Harper & Row, 1957.

Johnson, David Alan. *Founding the Far West: California, Oregon, and Nevada, 1840–1890*. Berkeley: University of California Press, 1992.

Johnson, Kenneth M. *The New Almaden Quicksilver Mine*. Georgetown, CA: Talisman Press, 1963.

Johnston, Andrew Scott. *Mercury and the Making of California: Mining, Landscape, and Race, 1840–1890*. Boulder: University Press of Colorado, 2015.

Josephy, Alvin M. *The Civil War in the American West*. New York: Vintage Books, 1993.

Jostes, Barbara Donohoe, and John Parrott. *John Parrott, Consul, 1811–1884, Selected Papers of a Western Pioneer*. San Francisco: Lawton and Alfred Kennedy, 1972.

Journal of the California State Legislature. Vol. 1859. Sacramento, CA: State Printing Office, 1859.

Jung, Maureen A. "Capitalism Comes to the Diggings: From Gold Rush Adventure to Corporate Enterprise." *California History* 77 (Winter 1998/99): 52–77.

Kane, Holly Charmain. "Arriving in Los Angeles: Railroad Depots as Gateways of the California Dream." Master's thesis, University of Southern California, 2007. http://libraryarchives.metro.net/DPGTL/dissertationstheses/2007-kane-arriving-los-angeles-railroad-depots-gateways-california-dream.pdf.

Kelley, Robert L. "Forgotten Giant: The Hydraulic Gold Mining Industry in California." *Pacific Historical Review* 23 (1954): 343–56.

Kelly, Franklin. *Frederic Edwin Church*. Washington: National Gallery of Art, 1989.

Kennedy, Elijah R. *The Contest for California in 1861: How Col. E.D. Baker Saved the Pacific States to the Union*. Boston: Houghton Mifflin, 1912.

Kimbro, Edna E., and Julia G. Costello. *The California Missions: History, Art and Preservation*. Los Angeles: Getty Conservation Institute, 2009.

Kimmelman, Michael. "Gazing across Time and Space into Vistas of the West." *New York Times*, October 14, 1999.

King, Clarence. *Mountaineering in the Sierra Nevada*. London: Sampson Low, Marston, Low, & Searle, 1872.

——. "Shasta." *Atlantic Monthly* 28 (December 1871): 710–20.

——. *Systematic Geology*. Washington, DC: Government Printing Office, 1878.

King, Thomas Starr. *Thomas Starr King Sermons*. Andover, MA: Northeast Document Conservation Center, 2000. Microfilm.

——, and John A. Hussey. *A Vacation among the Sierras: Yosemite in 1860*. San Francisco: Book Club of California, 1962.

——, and Edwin Percy Whipple. *Christianity and Humanity: A Series of Sermons*. Boston and Cambridge, 1877.

——. *The White Hills: Their Legends, Landscape, and Poetry*. Boston: Crosby, Nichols, [1859].

Kip, William Ingraham, *The Early Days of My Episcopate*. New York: Thomas Whittaker, 1892.

Kneeland, Samuel. *The Wonders of the Yosemite Valley, and of California*. Boston: Alexander Moore; Lee & Shepard; New York: Lee, Shepard & Dillingham, 1872.

Knight, Christopher. "Carleton Watkins on the Frontier of U.S. Photography." *Los Angeles Times*, October 17, 2008. www.latimes.com/entertainment/arts/la-et-watkins17–2008oct17-story.html.

Knight, William Henry. *Hand-book Almanac for the Pacific States: An Official Register and Business Directory*. San Francisco: Bancroft, 1864.

Krauss, Rosalind. "Grids." *October* 9 (Summer 1979): 51–64.

Lapp, Rudolph M., and Robert J. Chandler. "The Antiracism of Thomas Starr King." *Southern California Quarterly* 82 (2004): 323–42.

Latta, Frank. *Historic Lakeside Ranch*. Bakersfield: Kern County Museum, 1951.

——. *Saga of Rancho El Tejon*. Santa Cruz, CA: Bear State, 1976.

Lavender, David. *The Great Persuader*. Boulder: University Press of Colorado, 1998.

——. *Land of Giants: The Drive to the Pacific Northwest, 1750–1950*. Lincoln: University of Nebraska Press, 1979.

——. *Nothing Seemed Impossible*. Palo Alto, CA: America West, 1975.

Lebergott, Stanley. *Trends in the American Economy in the Nineteenth Century*. Princeton, NJ: Princeton University Press, 1960.

LeConte, Joseph. *A Journal of Ramblings through the High Sierras of California*. Yosemite National Park, CA: Yosemite Association, 1994.

Lekisch, Barbara. *Tahoe Place Names: The Origin and History of Names in the Lake Tahoe Basin*. Lafayette, CA: Great West Books, 2007.

Lesley, Lewis B. "A Southern Transcontinental Railroad into California: Texas and Pacific versus Southern Pacific, 1865–1885." *Pacific Historical Review* 5 (1936): 52–60.

Lewis, John S. *Physics and Chemistry of the Solar System*. Waltham, MA: Academic Press, 2004.

Lewis, Meriwether. *Journals of the Lewis & Clark Expedition*. https://lewisandclarkjournals.unl.edu/item/lc.jrn.1806-04-09.

Lewis, Oscar. *George Davidson: Pioneer West Coast Scientist.* Berkeley: University of California Press, 1954.

Littman, Mark. *The Heavens on Fire: The Great Leonid Meteor Storms.* New York: Cambridge University Press, 1998.

Lloyd, B. E. *Lights and Shades of San Francisco.* San Francisco, 1876.

Loeffler, Jane C. "Landscape as Legend: Carleton E. Watkins in Kern County, California." *Landscape Journal* 11 (1992): 1–21.

Ludlow, Fitz Hugh. *The Heart of the Continent: A Record of Travel across the Plains and in Oregon.* New York: Hurd and Houghton, 1870.

Lux v. Haggin, 69 Cal. 255; 10 P. 674; (1886).

Mackenzie, George G. *Yosemite, Where to Go and What to Do.* San Francisco: C. A. Murdock, 1888.

Madison, James H. "Taking the Country Barefooted: The Indiana Colony in Southern California." *California History* 69 (1990): 236–49.

Madley, Benjamin. *An American Genocide: The United States and the California Indian Catastrophe, 1846–1873.* New Haven, Conn.: Yale University Press, 2016.

Makley, Michael J. *The Infamous King of the Comstock: William Sharon and the Gilded Age in the West.* Reno: University of Nevada Press, 2006.

Mansfield, George C. *History of Butte County, California.* Los Angeles: Historic Record, 1918.

Marcellino, Sara, and Brandon Jebens. "The History of Human Use at Lake Merced." May 24, 2001. http://online.sfsu.edu/bholzman/LakeMerced/landuse.htm

Mares, Michael A. *Encyclopedia of Deserts.* Norman: University of Oklahoma Press, 2017.

Margo, Robert A. *Wages and Labor Markets in the United States, 1820–1860.* Chicago: University of Chicago Press, 2009.

Marien, Mary Warner. *Photography: A Cultural History.* London: Laurence King, 2006.

Marsh, George Perkins. *Man and Nature.* New York: Charles Scribner, 1865.

Marszalek, John F. *Commander of All Lincoln's Armies.* Cambridge, MA: Harvard University Press, 2009.

Martin, Justin. *Genius of Place: The Life of Frederick Law Olmsted.* Cambridge, MA: Da Capo Press, 2012.

Marx, Leo. *The Machine in the Garden.* New York: Oxford University Press, 2000.

Marzio, Peter C. *The Democratic Art: An Exhibition on the History of Chromolithography in America, 1840–1900.* Fort Worth, TX: Amon Carter Museum of Western Art, 1979.

Matthews, Glenna. *The Golden State in the Civil War: Thomas Starr King, the Republican Party, and the Birth of Modern California.* Cambridge: Cambridge University Press, 2012.

Mazzi, Frank. "Harbingers of the City: Men and Their Monuments in Nineteenth Century San Francisco." *Southern California Quarterly* 55 (1973): 141–62.

McPhee, John. *Assembling California.* New York: Farrar, Straus and Giroux, 1994.

McPherson, James M. *Battle Cry of Freedom, The Civil War Era.* Vol. 6 of *The Oxford History of the United States.* New York: Oxford University Press, 1988.

McWilliams, Carey. *Southern California: An Island on the Land.* Layton, UT: Gibbs Smith, 1946.

Melbourne International Exhibition, 1880–81: Official Record, Containing Introduction, History of Exhibition, Description of Exhibition and Exhibits, Official Awards of the Commissioners, and Catalogue of Exhibits. Melbourne: Mason, Firth & McCutcheon, 1882.

Mendell, G.H. *Report on the Various Projects for the Water Supply of San Francisco, Cal.* San Francisco: Spaulding & Barto, 1877.

———. *Report upon the Blasting Operations at Lime Point, California in 1868 and 1869.* Washington: Government Printing Office, 1880.

Middleton, William D. *Landmarks on the Iron Road: Two Centuries of North American Railroad Engineering.* Bloomington: Indiana University Press, 1999.

Milener, Eugene D. *Oneonta: The Development of a Railroad Town.* Deposit, NY: Courier Printing, 1983.

Miller, Angela. "Albert Bierstadt, Landscape Aesthetics, and the Meanings of the West in the Civil War Era." *Art Institute of Chicago Museum Studies* 27, Terrain of Freedom: American Art and the Civil War (2001): 40–59, 101–2.

Miller, Henry. *Account of a Tour of the California Missions: The Journal & Drawings of Henry Miller.* San Francisco: Book Club of California, 1952.

The Miscellaneous Documents of the Senate of the United States for the Second Session of the Forty-Ninth Congress (1886–87). Vol. 1. Washington, DC: Government Printing Office, n.d.

Mnookin, Jennifer L. "The Image of Truth: Photographic Evidence and the Power of Analogy." *Yale Journal of Law & the Humanities* 10 (1998). http://digitalcommons.law .yale.edu/yjlh/vol10/iss1/1.

Monographs of the United States Geological Survey. Vol. 4. Washington: Government Printing Office, 1883.

Monzingo, Robert A. *Thomas Starr King: Eminent Californian, Civil War Statesman, Unitarian Minister.* Pacific Grove, CA: Boxwood Press, 1991.

Moore, James Gregory. *Exploring the Highest Sierra.* Stanford, CA: Stanford University Press, 2000.

———. *King of the 40th Parallel: Discovery in the American West.* Stanford, CA: Stanford General Books, 2006.

Morgan, Wallace M. *History of Kern County, California.* Los Angeles: Historic Record, 1914.

Mornin, Edward, and Lorna Mornin. *Saints of California: A Guide to Places and Their Patrons.* Los Angeles: Getty Publications, 2009.

Muir, John. "Living Glaciers of California." *Harper's New Monthly Magazine* 51 (1875): 769–76.

———. "Reminiscences of Joseph Le Conte." *University of California Magazine* 7 (1901): 209–13.

———, and Jeanne C. Smith Carr. *Afoot to Yosemite: A Sketch.* San Francisco: Book Club of California, 1936.

Mullaly, Larry, and Bruce Petty. *The Southern Pacific in Los Angeles, 1873–1996.* San Marino, CA: Golden West Books and the Los Angeles Railroad Heritage Foundation, 2002.

Munro-Fraser, J.P. *History of Santa Clara County, California.* San Francisco: Alley, Bowen, 1881.

Myerson, Joel, Sandra H. Petrulionis, and Laura D. Walls. *The Oxford Handbook of Transcendentalism*. New York: Oxford University Press, 2000.

Naef, Weston. *Carleton Watkins in Yosemite*. Los Angeles: J. Paul Getty Museum, 2009.

Naef, Weston, and Christine Hult-Lewis. *Carleton Watkins: The Complete Mammoth Photographs*. Los Angeles: J. Paul Getty Museum, 2011.

Naef, Weston, and James N. Wood. *Era of Exploration: The Rise of Landscape Photography in the American West, 1860–1885*. Boston and New York: New York Graphic Society, 1975.

Nasaw, David. *The Chief: The Life of William Randolph Hearst*. Boston: Houghton Mifflin, 2001.

Nash, Roderick Frazier. "The American Invention of National Parks." *American Quarterly* 22 (1970): 726–35.

———. *Wilderness and the American Mind*. 5th ed. New Haven, CT: Yale University Press, 2014.

National Centers for Environmental Information, National Climate Data Center. 1981–2010 Climate Normals database. https://www.ncdc.noaa.gov/data-access/land-based-station-data/land-based-datasets/climate-normals.

Neal, Bill. *Vengeance Is Mine: The Scandalous Love Triangle that Triggered the Boyce-Sneed Feud*. Denton: University of North Texas Press, 2000.

Nealy, Mary E. "Horatio Stone, the Sculptor." *Aldine* 8 (1876): 188.

Newmark, Marco R. "Phineas Banning: Intrepid Pioneer." *Historical Society of Southern California Quarterly* 35 (1953): 265–74.

Nickel, Douglas R. *Carleton Watkins: The Art of Perception*. New York: Harry N. Abrams, 1999.

Nickliss, Alexandra Marie. "Phoebe Apperson Hearst: The Most Powerful Woman in California." PhD diss., University of California, Davis, 1994.

Nordhoff, Charles. *Northern California, Oregon, and the Sandwich Islands*. New York: Harper and Brothers, 1874.

Norman, David K., and Jaretta M. Roloff. *A Self-Guided Tour of the Geology of the Columbia River Gorge—Portland Airport to Skamania Lodge, Stevenson, Washington*. Olympia: Washington State Department of Natural Resources, 2004.

Novak, Barbara. *Nature and Culture: American Landscape and Painting, 1825–75*. 3rd ed. New York: Oxford University Press, 2007.

O'Connor, Jim E. "The Evolving Landscape of the Columbia River Gorge." *Oregon Historical Quarterly* 105 (2004): 390–421.

Olmsted, Frederick Law. *Yosemite and the Mariposa Grove: A Preliminary Report, 1865*. www.yosemite.ca.us/library/olmsted/report.html.

Orsi, Richard J. *Sunset Limited: The Southern Pacific Railroad and the Development of the American West, 1850–1930*. Berkeley: University of California Press, 2007.

Packer, Barbara L. *The Transcendentalists*. Athens: University of Georgia Press, 2007.

Palmer, Lyman L. *History of Mendocino County, California*. San Francisco: Alley, Bowen, 1880.

Palmquist, Peter E. "The California Indian in Three-Dimensional Photography." *Journal of California and Great Basin Anthropology* 1 (1979): 89–116.

———. "Carleton E. Watkins, A Biography." *Photographic Historian* 8 (1987–88): 1–9.

———. *Carleton E. Watkins, Photographer of the American West.* Albuquerque: Published for the Amon Carter Museum by the University of New Mexico Press, 1983.

———. *Carleton E. Watkins: Photographs 1861–1874.* San Francisco: Fraenkel Gallery, 1989.

———, and Thomas R. Kailbourn. *Pioneer Photographers of the Far West: A Biographical Dictionary, 1840–1865.* Stanford, CA: Stanford University Press, 2001.

———. "Watkins: The Photographer as Publisher." *California History* 57 (1978): 252–57.

Patterson, Thomas C. *From Acorns to Warehouses: Historical Political Economy of Southern California's Inland Empire.* Walnut Creek, CA: Left Coast Press, 2015.

Perl, Jed. "The Discoverer." *New Republic,* December 1, 2011. https://newrepublic.com/article/97960/carleton-watkins-complete-mammoth-photographs.

Peterson, Richard H. "The Spirit of Giving: The Educational Philanthropy of Western Mining Leaders, 1870–1900." *Pacific Historical Review* 53 (1984): 309–36.

———. "Thomas Starr King in California, 1860–64. Forgotten Naturalist of the Civil War Years." *California History* 69 (1990): 12–21.

———. "The United States Sanitary Commission and Thomas Starr King in California, 1861–1864." *California History* 72 (Winter 1993/94): 324–37.

Phillips, Catherine Coffin. *Jessie Benton Frémont: A Woman Who Made History.* Lincoln: University of Nebraska Press, 1955.

Pisani, Donald J. *From the Family Farm to Agribusiness: The Irrigation Crusade in California and the West, 1850–1931.* Berkeley: University of California Press, 1984.

Player-Frowd, J.G. *Six Months in California.* London: Longmans, Green, 1872.

Pomeroy, Earl. *In Search of the Golden West: The Tourist in Western America.* New York: Knopf, 1957.

Posner, Russell M. "Thomas Starr King and the Mercy Million." *California Historical Society Quarterly* 43 (1964): 291–307.

Postel, Mitchell. *San Mateo: A Centennial History.* San Francisco: Scottwall Associates, 1994.

———. *San Mateo County: A Sesquicentennial History.* Belmont, CA: Star Publishing, 2007.

Potter, David Morris. *The Impending Crisis, 1848–1861.* New York: Harper & Row, 1976.

Price, J., and C.S. Haley. *The Buyers' Manual and Business Guide.* San Francisco: Francis & Valentine, 1872.

Proceedings of the Great Mass Meeting in Favor of the Union Held in the City of San Francisco on Washington's Birthday, February 22d, 1861. San Francisco: Alta California Job Office, 1861.

Quinn, Arthur. *The Rivals: William Gwin, David Broderick, and the Birth of California.* New York: Crown Publishing, 1994.

Raab, Jennifer. *Frederic Church: The Art and Science of Detail.* New Haven, CT: Yale University Press, 2015.

Rather, Lois. *Jessie Frémont at Black Point.* Oakland, CA: Rather Press, 1974.

Read, Nat B. *Don Benito Wilson, From Mountain Man to Mayor, Los Angeles, 1841–1878*. Santa Monica, CA: Angel City Press, 2008.

Reed, Walter G., and William Ladd Willis. *History of Sacramento County, California*. Los Angeles: Historic Record, 1923.

Reigstad, Thomas J. *Scribblin' for a Livin': Mark Twain's Pivotal Period in Buffalo*. Amherst, NY: Prometheus, 2013.

Reinhardt, Richard. *Four Books, 300 Dollars and a Dream*. San Francisco: Mechanics' Institute, 2005.

Report of the Fourth Industrial Exhibition of the Mechanics' Institute of the City of San Francisco. San Francisco: Mining and Scientific Press, 1864.

Report of the Secretary of Agriculture. Salem, OR: Department of Agriculture, 1870.

Report of the Special Committee of the United States Senate on the Irrigation and Reclamation of Arid Lands. Vol. 2, *The Great Basin Region and California*. Washington, DC: Government Printing Office, 1890.

Report of the Special Committee of the United States Senate on the Irrigation and Reclamation of Arid Lands: Report of Committee and Views of the Minority. Washington, DC: Government Printing Office, 1890.

Report of the Statistics of Agriculture in the United States at the Eleventh Census: 1890. Washington, DC: Government Printing Office, 1895.

Report of the Superintendent of the United States Coast Survey Showing the Progress of the Survey during the Year 1869. Washington, DC: Government Printing Office, 1872.

Report of the Superintendent of the U.S. Coast and Geodetic Survey Showing the Progress of the Work during the Fiscal Year Ending with June, 1879. Washington, DC: Government Printing Office, 1881.

Report of the Superintendent of the U.S. Coast and Geodetic Survey Showing the Progress of the Work during the Fiscal Year Ending with June, 1880. Washington, DC: Government Printing Office, 1882.

Richards, Leonard L. *The California Gold Rush and the Coming of the Civil War*. New York: Knopf Doubleday, 2007.

Richards, T. Addison. *Appletons' Illustrated Hand-Book of American Travel*. New York: D. Appleton, 1857.

Richardson, Abby Sage, ed. *Garnered Sheaves from the Writings of Albert D. Richardson, Collected and Arranged by His Wife*. Hartford, CT: Columbia Book Co., 1871.

Richardson, Albert. *Beyond the Mississippi: From the Great River to the Great Ocean*. Hartford, CT: American Publishing, 1867.

Richardson, Robert D. *Emerson: The Mind on Fire, a Biography*. Berkeley: University of California Press, 1997.

Robinson, John W. "Colonel Edward J.C. Kewen: Los Angeles' Fire-Eating Orator of the Civil War Era." *Southern California Quarterly* 61 (1979): 159–81.

Rojas, A.R. *California Vaquero*. Fresno: Academy Library Guild, 1953.

Roper, Laura Wood. *A Biography of Frederick Law Olmsted*. Baltimore: Johns Hopkins University Press, 1973.

Rosenheim, Jeff L. *Photography and the American Civil War.* New Haven, CT: Yale University Press, 2013.

Rudisill, Richard. "Watkins and the Historical Record." *California History* 57 (1978): 216–19.

Rule, Amy, ed. *Carleton Watkins: Selected Texts and Bibliography.* Boston: G.K. Hall, 1993.

Runte, Alfred. "The National Park Idea: Origins and Paradox of American Experience." *Journal of Forest History* 21 (1977): 64–75.

———. *National Parks: The American Experience.* 3rd ed. Lincoln: University of Nebraska Press, 1997.

[Ruskin, John]. *Modern Painters,* Part 1–2; vol. 1. New York: John Wiley and Sons, 1890.

Rybczynski, Witold. *A Clearing in the Distance: Frederick Law Olmsted and America in the 19th Century.* New York: Scribner, 1999.

Ryder, David Warren. *Memories of the Mendocino Coast: Being a Brief Account of Discovery[,] Settlement and Development of the Mendocino Coast.* San Francisco: Privately printed, 1948.

Sachs, Aaron. *Arcadian America: The Death and Life of an Environmental Tradition.* New Haven, CT: Yale University Press, 2013.

———. *The Humboldt Current: Nineteenth-Century Exploration and the Roots of American Environmentalism.* New York: Viking, 2006.

Sadler, Jo Anne. *Crescenta Valley Pioneers and Their Legacies.* Stroud, Gloucestershire: History Press, 2012.

Sandweiss, Martha. *Passing Strange: A Gilded Age Tale of Love and Deception across the Color Line.* New York: Penguin, 2014.

———. *Print the Legend: Photography and the American West.* New Haven, CT: Yale University Press, 2004.

Schama, Simon. *The Embarrassment of Riches: An Interpretation of Dutch Culture in the Golden Age.* New York: Vintage, 1997.

———. *Landscape and Memory.* London: Harper Perennial, 2004.

Scharnhorst, Gary. *Bret Harte: Opening the American Literary West.* Norman: University of Oklahoma Press, 2000.

Schroeder, Michael D., and J. Gray Sweeney. "Gilbert Munger's Quest for Distinction." *The Magazine Antiques* 164 (2003): 78–87.

Scott, Amy. "Art and Adventure in Nineteenth-Century California." *California History* 86 (2009): 14–23, 81–82.

———, ed. *Yosemite: Art of an American Icon.* Berkeley: University of California Press, 2006.

Scott, W.E., C.A. Gardner, D.R. Sherrod, R.I. Tilling, M.A. Lanphere, and R.M. Conrey. *Geologic History of Mount Hood Volcano, Oregon: A Field-Trip Guidebook.* [Menlo Park, CA]: U.S. Geological Survey, 1997.

Sexton, Nanette Margaret. "Carleton E. Watkins, Pioneer California Photographer, 1829–1916: A Study in the Evolution of Photographic Style during the First Decade of Wet Plate Photography." PhD diss., Harvard University, 1983.

Sexton, Nanette. "Watkins' Style and Technique in the Early Photographs." *California History* 57 (1978): 242–51.

Shearer, Frederick E. *The Pacific Tourist: Adams & Bishop's Illustrated Trans-Continental Guide of Travel.* New York: Adams & Bishop, 1881.

Shaw, Pringle. *Ramblings in California.* Toronto: James Bain, [1860?].

Shuck, Oscar T., ed. *Eloquence of the Far West, No. 1: Masterpieces of E. D. Baker.* San Francisco: Published by the editor, 1899.

Siebert, Jerome B. *California Agriculture: Dimensions and Issues.* Berkeley: University of California Press, 2004.

Sierra Madre Villa: Open all the year . . . [Los Angeles?]: Sierra Madre Villa Hotel, 1888.

Signor, John R. *Tehachapi.* San Marino, CA: Golden West Books, 1983.

Sikes, Patricia G. "George Roe and California's Centennial of Light." *California History* 58 (1979): 234–47.

Silva, Richard. *Chronology of Early Historical Travel through Siskiyou County California.* Privately printed, 2012. (Available at College of the Siskiyous Library, Weed, CA.)

Simonds, William Day. *Starr King in California.* San Francisco: Paul Elder and Company, 1917.

Sixth Census or Enumeration of the Inhabitants of the United States, As Corrected at the Department of State, in 1840. Washington: Thomas Allen, 1841.

Smith, A[bram] P. *History of the Seventy-Sixth Regiment New York Volunteers.* Cortland, NY, 1867. Reprinted, Gaithersburg, MD: Ron R. Van Sickle Military Books, 1998.

Smith, Duane A. "Mother Lode for the West: California Mining Men and Methods." *California History* 77 (Winter 1998/99): 149–73.

Smith, Henry Nash. *Virgin Land: The American West as Symbol and Myth.* Cambridge, MA: Harvard University Press, 2009.

Solnit, Rebecca. *River of Shadows: Eadweard Muybridge and the Technological Wild West.* New York: Penguin, 2010.

Soulé, Frank, John H. Gihon, and James Nisbet. *The Annals of San Francisco.* New York: D. Appleton, 1855.

Spirn, Anne Whiston. "Constructing Nature." In *Uncommon Ground: Rethinking the Human Place in Nature,* edited by William Cronon, 91–113. New York: W. W. Norton, 1996.

Stanger, Frank M. *South from San Francisco: San Mateo County, California, Its History and Heritage.* San Mateo, CA.: San Mateo County Historical Association, 1963.

Starr, Kevin. *Americans and the California Dream, 1850–1915.* Oxford: Oxford University Press, 1973.

———. *Inventing the Dream: California through the Progressive Era.* New York: Oxford University Press, 1995.

Stenzel, Franz. *James Madison Alden, Yankee Artist of the Pacific Coast, 1854–1860.* Fort Worth, TX: Amon Carter Museum, 1975.

Stephens, Lester D. "LeConte Family." In *New Georgia Encyclopedia* (2014). www.georgiaencyclopedia.org/articles/history-archaeology/leconte-family.

Stevenson, Robert Louis. *Across the Plains, with Other Memories and Essays.* London: Chatto & Windus, 1892.

———. *The Works of Robert Louis Stevenson.* Vol. 2. With bibliographic notes by Edmund Gosse. London: Cassell, in association with Chatto and Windus, William Heinemann, and Longmans Green, 1906.

Stiles, T.J. *The First Tycoon: The Epic Life of Cornelius Vanderbilt.* New York: Knopf, 2009.

Strahorn, Carrie Adell. *Fifteen Thousand Miles by Stage.* New York: Putnam's Sons, 1911.

Streatfield, David C. "The San Francisco Peninsula's Great Estates: Part 1." *Eden* 15 (Winter 2012): 1–12.

———. " The San Francisco Peninsula's Great Estates: Part 2: Mansions, Landscapes, and Gardens in the Late 19th and Early 20th Centuries." *Eden* 15, no. 2 (Spring 2012): 1–17.

Street, Richard Steven. "A Kern County Diary: The Forgotten Photographs of Carleton E. Watkins, 1881–1888." *California History* 61 (1983): 242–63.

———. *Photographing Farm Workers in California.* Stanford, CA: Stanford University Press, 2004.

———. "Rural California: A Bibliographic Essay." *Southern California Quarterly* 70 (1988): 299–328.

Suchanek, Ron. "The Columbia River Gorge: The Story of the River and the Rocks." *Ore Bin* 36 (1974): 197–212.

Taft, Robert. *Photography and the American Scene: A Social History, 1839–1889.* New York: Dover Publications, 1917.

Tarnoff, Ben. *The Bohemians: Mark Twain and the San Francisco Writers Who Reinvented American Literature.* New York: Penguin, 2014.

Taylor, Bayard. *Eldorado, or, Adventures in the Path of Empire.* London: Richard Bentley, 1850.

Taylor, William. *California Life Illustrated.* New York: Carlton & Porter, 1858.

Tays, George. *The Montgomery Block, Registered Landmark #80.* Berkeley: State of California, Department of Natural Resources, Division of Parks, 1936. Written under the auspices of Works Progress Administration District #8, Project #65-3-3218, Symbol #1873.

Terfousse, Hans L. *Andrew Johnson: A Biography.* New York: W.W. Norton, 1999.

Thayer, J.B. *A Western Journey with Mr. Emerson.* Boston: Little, Brown, 1884.

Theberge, Skip. *The Frontier Coast, NOAA Central Library.* https://www.lib.noaa.gov/noaainfo/heritage/coastsurveyvol1/BACHE6.html.

Theran, Susan. *Leonard's Price Index of Latin American Art at Auction.* London: Palgrave Macmillan UK, 1999.

Thurston, Robert H., ed. *Reports of the Commissioners of the United States to the International Exhibition Held at Vienna, 1873.* Washington, DC: Government Printing Office, 1876.

Timmen, Franz. *Blow for the Landing: A Hundred Years of Steam Navigation on the Waters of the West.* Caldwell, ID: Caxton Printers, 1973.

Trachtenberg, Alan. *The Incorporation of America: Culture and Society in the Gilded Age.* New York: Hill and Wang, 2007.

Trobits, Monika. *Antebellum and Civil War San Francisco: A Western Theater for Northern & Southern Politics.* Charleston, SC: History Press, 2014.

Troyen, Carol. "Innocents Abroad: American Painters at the 1867 Exposition Universelle, Paris." *American Art Journal* 16 (Autumn 1984): 2–29.

Truman, Benjamin C. *Homes and Happiness in the Golden State of California*. San Francisco: H.S. Crocker, 1885.

———. *Semi-Tropical California*. San Francisco: A.L. Bancroft, 1874.

———. *Tourists' Illustrated Guide to the Celebrated Summer and Winter Resorts of California*. San Francisco: H.S. Crocker, 1883.

Tuckerman, Henry T. *Book of the Artists, American Artist Life*. New York: G.P. Putnam & Son, 1867.

Turrill, Charles Beebe. *Catalogue of the Products of California: Exhibited by the Southern Pacific Company at the North, Central and South American Exposition, New Orleans, Nov. 10th 1885 to April 1st, 1886*. New Orleans: Press of W.B. Stanbury, 1886.

———. "An Early California Photographer: C.E. Watkins." *News Notes of California Libraries* 13 (1918): 29–37. Sacramento: California State Printing Office, 1918.

Twain, Mark, and Edgar M. Branch. *The Works of Mark Twain: Early Tales & Sketches. Vol. 2, 1864–65*. Berkeley: University of California Press, 1981.

Tyler, W.B. *Old California Missions*. San Francisco: H.S. Crocker, 1889.

U.S. Census, 1840–1910. Available online from several sources.

U.S. Department of Agriculture Economic Research Service. Cash receipts by commodity state ranking. https://data.ers.usda.gov/reports.aspx?ID=17844.

[U.S. Department of Agriculture Forest Service]. *Timber Depletion, Lumber Prices, Lumber Exports, and Concentration of Timber Ownership, Report on Senate Resolution 311*. Washington, DC: Government Printing Office, 1920.

U.S. Industrial Commission. *Reports of the Industrial Commission on the Distribution of Farm Products*. Vol. 6. Washington, DC: Government Printing Office, 1901.

Unruh, John David. *The Plains Across: The Overland Emigrants and the Trans-Mississippi West, 1840–1860*. Urbana: University of Illinois Press, 1993.

Vischer, Edward. *Missions of Upper California, 1872*. San Francisco: Winterburn, 1872.

———. *Vischer's Pictorial of California*. San Francisco: J. Winterburn, 1870.

Waggoner, Diane. *East of the Mississippi*. New Haven, CT: Yale University Press, 2017.

Weinstein, Robert A. "North from Panama, West to the Orient: The Pacific Mail Steamship Company, as Photographed by Carleton E. Watkins." *California History* 57 (1978): 46–57.

Wendte, Charles W. *Thomas Starr King, Patriot and Preacher*. Boston: Beacon Press, [1921?].

White, Richard. *"It's Your Misfortune and None of My Own": A New History of the American West*. Norman: University of Oklahoma Press, 1991.

———. *Railroaded: The Transcontinentals and the Making of Modern America*. New York: W.W. Norton, 2012.

White, Ronald. *Lincoln's Greatest Speech*. New York: Simon & Schuster, 2002.

Whitney, Josiah Dwight, and Carleton E. Watkins. *The Yosemite Book*. Oakland, CA: Octavo, 2003.

Wilder, Paul E. *History of Fresno County, California*. Fresno: Historical Record, 1919.

Wills, Garry. *Lincoln at Gettysburg: The Words that Remade America*. New York: Simon & Schuster, 1992.

Wilson, Albert J. *History of Los Angeles County, California*. Oakland, CA: Thompson & West, 1880.

Wilson, James Grant, and John Fiske. *Appletons' Cyclopædia of American Biography*. New York: D. Appleton, 1900.

Wilson, Raymond L. "Painters of California's Silver Era." *American Art Journal* 16 (Autumn 1984): 71–92.

Winks, Robin W. *Frederick Billings: A Life*. New York: Oxford University Press, 1991.

Winn, Robert. "The Mendocino Indian Reservation." *Mendocino Historical Review* 12 (Fall/Winter 1986): 1–38.

Wolfe, Ann M. *Tahoe: A Visual History*. New York: Skira Rizzoli, 2015.

Worster, Donald. *Nature's Economy: The Roots of Ecology*. Garden City, NY: Anchor Press, Doubleday, 1977.

———. *A Passion for Nature: The Life of John Muir*. Oxford: Oxford University Press, 2008.

———. *Rivers of Empire: Water, Aridity, and the Growth of the American West*. New York: Oxford University Press, 1985.

INDEX

Page references followed by *fig.* indicate illustrations or material contained in their captions.

American art, 122; Civil War and, 173–76; Claudean composition in, 342; East Coast oceanscapes, 136–37; haying pastorals, 430; Lake Tahoe in, 315–16; landscapes of, 367; luminist painting style, 317; museum holdings of, 461; pre–Civil War, 121; science and, 194–95; Watkins Yosemite photos and, 186, 198. *See also specific artist*

American Association for the Advancement of Science, 109, 193, 265

American Harvesting (painting; Cropsey), 430, 508n13

American River, 49–50, 323, 474n7

American science, 188–89

American Theater (San Francisco, CA), 64–67, 174

Amon Carter Museum (Fort Worth, TX), 296

Anaconda Mine (MT), 453–54, 455

Ancient Glacier Channel, Lake Tenaya (photograph; Muybridge), 375, 375*fig.*

Anderson, Ralph, 505n23

Anderson Ranch (Kern County, CA), 508n15

Andrew Johnson National Historic Site (Greeneville, TN), 169, 171, 485–86n53

Angel, Myron, 14, 15, 448, 449

Angel, William, 14, 15, 16

Angel Island (San Francisco, CA), 241

Antietam, Battle of (1862), 80, 116–18, 119–20, 158, 252

antislavery, 56–57, 121, 143, 163, 166

Apache Indians, 349

Appleton & Company, 243–44, 482n10, 490–91n9

Approaching Storm (painting; Keith), 430

"April Day, An" (poem; Longfellow), 96

Aquila (ship), 131

Arbutus, 109

architectural photography, 311*fig.*, 312

Arizona Territory, 312, 327, 335, 346, 348–49, 352, 410, 501n21

Arizona Weekly Star, 499n19

Arkell Museum (Canajoharie, NY), 98

Arlington Hotel (Santa Barbara, CA), 399

Arlington House Hotel (Bakersfield, CA), 434

Army of Northern Virginia (CSA), 158

Army of the Potomac (USA), 158

Arnold Arboretum (Harvard University), 192

"Art" (Emerson), 61

artesian wells, 397, 436

artificial enhancement, 296

Art Institute of Chicago, 487n4 (Ch. 11)

Art Journal, 31–33, 84, 126, 246–47, 283–84, 472n22

Ashburner, William, 168

Asian trade, 203

Associates, the, 326–29, 330

As You Like It (Shakespeare), 252

Atherton, Faxon, 254, 257, 360

Atlanta (GA), 307

Atlantic Monthly, 57, 73, 110, 111–12, 274, 437, 475n10

At Lassen's Butte, Siskiyou County, California (photograph; Watkins), 269*fig.,* 270

At the Residence of Leonard J. Rose, Sunny Slope, Los Angeles County, California (photograph; Watkins), 401*fig.*

Austin, Mary, 442

Australia, 133, 299–300, 404

Ayres, Thomas, 70, 86, 235

Babcock, William, 354

Bacon, H.D., 242–43

Bagnasco, Policarpo, 314

Baja California (Mexico), 146

Baker, Edward: American Theater speech of, 64–67, 74, 174, 475n6; as antislavery politician, 39; Broderick eulogy given by, 39–40, 67; Civil War military service of, 81, 100; death of, 100–101, 163, 166, 174, 175–76; Lincoln and, 78; oratorical skills of, 64, 100, 165; as Oregon senator, 63; return to California, 63–64; western cultural Unionism promoted by, 71, 82, 115, 157, 265

Baker, Thomas, 407–8

Baker Beach (San Francisco, CA), 259–60

Bakersfield (CA), 326–27, 422, 425, 427, 433, 434–35, 448, 506n25, 507n3

Bakersfield Californian, The (promotional pamphlet), 436

Bullion Mine, Storey County, Nevada
(photograph; Watkins), 320–21, 321*fig.*
Bullock, Wynn, 133
Bull Run, Battle of (1861), 81
Bunsen, Robert, 102
Buri Buri (Mexican-era rancho; modern-day
San Mateo County, CA), 254–55, 359,
360, 361
Burnham & Lord (New York, NY), 256
Burnside, Ambrose, 116, 118
Butman, Frederick A., 131, 489n14
Butte (MT), 453–54
Butte County (CA), 27, 454–55
butter economy, 19–20, 21, 23
*Buyers' Manual and Business Guide,
The* (guidebook), 291

cable cars, 292
Calame, Alexandre, 176
Calaveras County (CA), 107
Calaveras Grove (Stanislaus County, CA),
152, 161, 166, 234, 365, 502n8
Calhoun, John C., 77
Caliente (CA), 327
California: Baker cultural Unionism speech
and, 65–67; Bank of California collapse
and, 306; during Civil War, 80; eastern
ignorance of, 274; elections (1859), 39, 66;
elections (1860), 74, 79, 130; Emerson
visit to, 279–81; first-person narratives of,
50–53, 474n10; founding period of, 166;
geodetical survey difficulties, 385–86;
during Gilded Age, 253–54; gold
discovered in, 21, 42 (*see also* California
Gold Rush (1849)); gold mining in,
28–30, 49–50; horsemen in, 358–59, 404,
421; industrial transition in, 332, 335, 395,
406, 450; Lawrence arrival in, 353;
Mexican-era land claims in, 385, 445;
military rule of, 42; movie industry in,
462, 463; northern coast of, 132–33;
Oneontans moving to, 21–22, 23–26, 448,
471n1; Oregon Trail offshoots to, 489n1;
Pacific Republic threat in, 74–75, 79, 130,
141; paper currency shortages in, 312;
photographic portrayals of, 48–50, 51*fig.*;

racism in, 138; secessionist sentiment in,
258, 476n43; slavery dispute in, 27–29,
39–40, 56–57; Spanish colonial history in,
337, 338–40, 343; Starr King arrival in,
478–79n14; statehood (1850), 6, 28, 42;
Stevenson tour in, 336–37; tourism in,
416–17; transportation connections to,
63, 80, 105–6; travel guide portrayals of,
53–54
California Academy of Sciences, 194
California Coastal National Monument, 133
California Democratic Party, 28–29, 39–40,
56, 79
*California Farmer and Journal of Useful
Sciences,* 101
California Geological Survey (CGS): Brewer
as field director of, 103, 104, 147; dialogue
with eastern peers, 110, 114; King as
volunteer with, 139, 263; Mount Diablo
visit of, 386; Muir and, 278; Oregon
interest of, 208; science and, 185–86;
Shasta visit of, 234; underfunding of, 173,
186, 200; Watkins Yosemite trips
instigated by, 186–88, 234, 493n9;
Whitney as head of, 41, 103, 266; *Yosemite
Book* project of, 187–89; Yosemite
Commission members from, 168;
Yosemite glacier missed by, 278;
Yosemite idea and, 155, 484n8
California Gold Rush (1849): Beale and, 441;
beginning of, 21, 42, 441; Billings and, 42;
Oneontans participating in, 21–22;
printed information about, 23–24; timber
prices and, 133; tools used during, 282
California Historical Society, 255–56
California Horticulturist, 256
California Immigration Commission, 459
California Indians, 137–38
California Life Illustrated (Taylor), 474n10
Californian, The (literary newspaper), 150, 151
California painters, 293
California pitcher plant, 106
California Polytechnic University (San Luis
Obispo, CA), 448
California Regiment, 81
California Republican Party, 63–64, 163

Colorado River, 328, 329

Colton, David D., 301

Columbia Hills, 221

Columbia River, 203; flooding on, 216, 217, 219–20; geology of, 219; impassability of, 415; Oneonta Creek junction with, 414; Watkins trip up, 214–32

Columbia River Gorge, 210, 212; geological past of, 415; Starr King visit to, 207–8, 479n14; Watkins trip to (1882), 413

Columbia River Gorge photographs (Watkins; 1867)—scenic: bound volumes of, 222; Cape Horn photos, 226–28, 227*fig.*; Castle Rock photos, 232, 233*fig.*; commercial popularity of, 248–49; exhibitions of, 496n4; Multnomah Falls photos, 228–32, 229*fig.*, 231*fig.*; numbers of, 214; photographic quality of, 232; printing of, 261; private holdings of, 258; remaking of, 414; sales of, 223, 226; Watkins fame as result of, 332, 350; Watkins's motivations for, 225

Columbia River photographs (Watkins; 1867)—OSNC-specific: bound volumes of, 222; Cape Horn/Celilo photos, 220–22, 220*fig.*, 221*fig.*; The Dalles photos, 217–20, 218*fig.*; Eagle Creek Lumber Mill photos, 215–17, 216*fig.*; exhibitions of, 496n4; multiple uses of, 223–24; numbers of, 214; OSNC fee for, 249; printing of, 261; private holdings of, 258; sales of, 223, 226; Watkins fame as result of, 332, 350

Columbia University, 104, 189, 266

Comanche (ironclad), 131

Compromise of 1850, 28

Compton, Eugene, 458, 510n12, 510n19

Comstock Lode (Virginia City, NV): Bank of California and, 243; Bonanza Kings and, 292, 302, 310; gold/silver production at, 38–39; Hayward profits from, 357; Mills and, 287; Ralston and, 243, 287, 302, 303, 304, 310; satirical writing about, 56; second boom, 322; stamp-milling relocation, 497n25; timber supplier for, 315; Virginia & Truckee RR and, 242, 254;

Watkins commission from officer at, 312; Watkins photographs of, 317–22

Concord (MA), 93, 281, 480n37

Concord Free Library (Concord, MA), 480n37

Conness, John, 154, 161, 162, 166, 175, 484n27

conservationism: Billings as convert to, 36, 114, 141, 157, 167; Californians' beginning interest in, 288; deforestation and, 497n18; Marsh tract on, 284; Muir and, 173, 280; photography and, 114–15; Watkins interest in, 140–41; Watkins photos and public interest in, 201; western-motivated, 173, 497n18

Consolidated Virginia and California Mining Company, 321–22

consumerism, 144

Cook, John Jay, 308, 363, 496n1, 496n19

Cooke, Jay, 222

Coolbrith, Ina, 73

Cooper, Gary, 463

Cooper, James Fenimore, 11

Cooperstown (NY), 11, 14

copper mining, 454

copyright law, 243, 244

Corbett, Margaret, 75, 476n34

Cordell, Edward, 298

Corot, Camille, 227

Cosmopolitan Hotel (San Francisco, CA), 289

Costello, Julia G., 338

Cotton Ranch (Kern County, CA), 435, 508n15

Coulter, George, 162

Coulterville (CA), 86

Courbet, Gustave, 227

Crawford, Thomas, 174

Crayon, The (magazine), 126

Creasy Ranch (Kern County, CA), 426

Crescent City (steamer), 24–25

Crimean War, 32–33

Crittenden, A.P., 34, 35, 36, 37

Crocker, Charles, 7, 307, 330, 498n10

Crocker, Edward B., 292, 301

Crocker, Margaret, 292

Crocker Art Museum (Sacramento, CA), 486n67

Inness, George, 139, 256

Innocents Abroad, The (Twain), 150

Inspiration Point (Yosemite Valley, CA), 86–87, 88, 195–99

Intercolonial Exhibition (Sydney, Australia; 1875), 299–300

International Exposition (Santiago, Chile; 1875–1876), 261

Inverted in the Tide Stand the Gray Rocks (photograph; Watkins), 96

Irish Americans, 302–3

Irish immigrants, 138, 140

ironclads, 131

iron piping, 398, 400

irrigation, 8, 15, 288, 398, 404, 423, 424–28, 427*fig.*, 438–40

Ithaca (NY), 102

Jackson, Helen Hunt, 337, 349

Jackson, William Henry, 296, 342, 391

Jackson Ranch (Kern County, CA), 426

James Canal (Kern County, CA), 424

James D. Hague Papers (Huntington Library), 469n

Japan, 252, 464

Japanese immigrants, 237

Jarvis firm (Pasadena, CA), 350

Jefferson, Thomas, 228

Jessie Benton Frémont at Black Point (stereograph; Watkins), 55*fig.*

Jewett Ranch (Kern County, CA), 435

Johnson, Andrew, 169–71

Johnson, Eastman, 256

Jones, John P., 334

J. Paul Getty Museum (Los Angeles, CA), 296, 378

Jurassic period, 264

Kailbourn, Thomas R., 474n7

Kamm, Jacob, 130

Kansas Pacific Railroad, 252

Keene (CA), 332

Keith, Elizabeth Emerson, 293

Keith, Mary McHenry, 293

Keith, William: artistic knowledge of, 261; as California painter, 293; career back-

ground of, 292–93; haying pastoral of, 430; honeymoon of, 345; mission paintings of, 345, 349; Mount Diablo paintings of, 386; Mount Hood paintings of, 232; Muir and, 279; museum holdings of, 461, 462; patrons/enablers, 293, 358; Scots-Irish heritage of, 130; Shasta paintings of, 235; Utah trip of, 292, 294, 313; Watkins and, 130, 239, 279, 293

Kelly, Franklin, 481n14

Kemper Art Museum (Washington University, St. Louis, MO), 68

Kensett, John Frederick, 139

Kentucky, 385

Kern, Edward, 235

Kern County (CA): agricultural economy in, 406–7; agricultural investment in, 396–98, 406; boundaries of, 442; fire in (1889), 410, 422; flooding in (1863), 407–8; investment groups in, 408–9; irrigation systems in, 406; land interests in, 7; land sales in, 432–35, 509n6; Oneontans in, 15; railroad links to, 509n6; rainfall in, 406, 425, 506n25; Ralston land sales in, 305; Tehachapi Loop in, 329–30, 331*fig.*, 332–33, 397, 460, 498n10; Tejon Ranch in, 442–45; Watkins trips to, 422, 456, 507n3

Kern County Board of Trade, 436, 447

Kern County Californian, 435, 437, 509n6

Kern County Groups (photograph; Watkins), 437

Kern County Land Company, 453

Kern County photographs (Watkins): agricultural abundance photos, 428–31, 429*fig.*, 433–34; agricultural significance of, 8; continued use of, 7; dry-plate technology used in, 422–23; exhibitions of, 432; Haggin's use of, in land sales campaign, 432–34, 436–37; irrigation-related photos, 424–28, 427*fig.*, 439–40; *Late George Cling Peaches*, 446–50, 447*fig.*, 453; legislative use of, 439–40; long-term financial benefits from lacking, 451; *Lux v. Haggin* photos, 410–12, 410*fig.*, 422; magazine publishing of,

Merced (CA), 418

Merced Peak, 275

Merced Range, 275

Merced River, 47–48, 86, 88–89, 94, 171, 176, 275, 365, 478n17

mercury, 34, 109, 132, 302. *See also* quicksilver

Merrimac Mill (Lyon County, NV), 319

metaphor, 94–96, 177–78, 449–50

Metropolitan Museum of Art (New York, NY), 462, 508n13

Mexican-American War (1846–1848), 6, 28, 34, 42, 339, 441

Mexico, 6, 340, 343

Michigan Territory, 52

Milfordville (NY), 10–11, 12

Millbrae (Mills mansion; San Mateo County, CA), 255–56, 255*fig.*, 304, 360

Miller, Charles O., 459

Miller, George, 360

Miller, Henry, 342–43, 408

Miller & Lux (San Francisco, CA), 360, 408, 409, 410–12, 421, 438, 442, 448

Millet, Jean-François, 227

Mills, Darius Ogden, 130, 242, 254–57, 292, 304, 307, 313, 359–61, 369, 408, 495n10

Milton City (OR), 208

Milwaukee (WI), 143

Milwaukie (OR), 208

mining: environmental degradation from, 8, 288; Gilded Age wealth from, 253, 302; Greeley view of, 53; Starr King and, 478n14; transition to agriculture economy, 332, 335, 395, 406, 450; Western economy and, 8. *See also* copper mining; gold mining; silver mining

Mining & Scientific Press, 287

"Mining Photographs" (Hult-Lewis), 496n10, 496–97n12

Mirror Lake (Yosemite Valley, CA), 87, 96, 183*fig.*, 184, 373

mission photograph series (Watkins): artistic influence of, 349–50, 462; artistic influences on, 343; competing photographers' imitations of, 341–42, 350; continuation of (1880), 346–48; cultural ideas embedded in, 339, 343; numbers of, 337; sales of, 349–50; San Carlos Borromeo, 346–47; San Diego de Alcalá, 340, 341*fig.*, 350; San Juan Capistrano, 343, 499n13; San Luis Obispo, 345–46, 448; San Luis Rey de Francia, 341–42, 346; San Miguel Arcangel, 345–46; Santa Barbara, 343–45, 345*fig.*; Santa Clara de Asís, 337; Santa Inés mission, 345; San Xavier del Bac, 337, 348–49, 348*fig.*, 499n19; as transitional moment, 350; travel conditions for, 347; trip route, 499n8; unphotographed missions, 347–48; water systems shown in, 425; western cultural awareness through, 337–38

Mission San Carlos Borroméo de Carmelo, Monterey County, California (photograph; Watkins), 346–47, 347*fig.*

Mission Santa Barbara, Santa Barbara County, CA (photograph; Watkins), 345, 345*fig.*

Mission San Xavier del Bac, near Tucson, Arizona Territory (photograph; Watkins), 348, 348*fig.*, 349

Mission Woolen Mills (San Francisco, CA), 241–42

Mississippi River, 130

Missouri, 75, 99, 106

Modern Painters (Ruskin), 472n22

Modoc Indians, 371

Mojave Desert, 332, 333–34

Monet, Claude, 228, 430

Mono Trail (Yosemite Valley, CA), 374–75

Montana, 211, 413, 453–54, 455

Monterey (CA), 28, 336, 337, 338, 417–19, 456, 507n9

Monterey Californian, 336, 337

Monterey County (CA), 346–47

Montgomery Block (San Francisco, CA), 30–31, 33, 36, 42–43, 145, 154, 209, 479n15

moraines, 271, 275–76

Morse, John F., 162

Morse, Tony, 194

motion pictures, 371, 462

Mound Springs (CA), 86

Mountaineering in the Sierra Nevada (King), 274

Mountain Queen Mining Company, 357–58, 501n21

Mountain View Dairy (Kern County, CA), 424, 430

Mount Auburn cemetery (Cambridge, MA), 156, 158, 160

Mount Broderick and Nevada Fall (photograph; Watkins), 181*fig.*

Mount Hood and The Dalles, Columbia River, Oregon (photograph; Watkins), 218*fig.*, 219, 224–25

Mount Hood from Sandy River (painting; Keith), 293

Mount of the Holy Cross (CO), 391

Mount Shasta, Siskiyou County, California (photograph; attr. Watkins), 236–38, 236*fig.*, 243, 490–91n9

Mount Shasta and Shastina (painting; Butman), 489n14

Mount Vernon (VA), 156

Mount Watkins, Fully Reflected in Mirror Lake, Yosemite (photograph; Watkins), 183*fig.*, 184, 373

Mouth of the Kern Canyon, Kern County, California (photograph; Watkins), 410*fig.*, 411

Mozier, Joseph, 247–48

Muir, John, 256, 398; Agassiz Column naming and, 377; California arrival of, 265–66; as conservationist leader, 7; as Darwinist, 193; Davidson and, 383; education of, 269; Emerson and, 279–80; as glaciologist, 278, 280, 374–76, 382; Glenbrook visit of, 317; journal of, 317; King vs., 277–78, 376; Scots-Irish heritage of, 130; Shasta visit of, 279; as Sierra Club founder, 114–15, 280; Starr King and, 62; as USCS guide, 383; Watkins and, 2, 7, 130, 278–79, 381, 383; writings of, 276, 277, 278, 279, 280, 374–75, 381; Yosemite Commission report and, 173; Yosemite formation debate and, 269; Yosemite glacier located by, 275–77

Muir, Sarah, 278

Multnomah Falls, 228–32, 229*fig.*, 231*fig.*, 414

Multnomah Falls, Front View, Oregon (photograph; Watkins), 229*fig.*

Multnomah Falls, Side View, Oregon (photograph; Watkins), 230–32, 231*fig.*

Munger, Gilbert, 253, 293, 377

Murray, George W., 21, 29, 30–31, 33, 34, 36, 42, 145, 209, 246, 314

Museum of Fine Arts (Boston, MA), 175

Museum of Modern Art (New York, NY), 502n11

Muybridge, Eadweard: animal-locomotion photos of, 462, 463; artistic knowledge of, 261; career background of, 371; Devil's Slide photos of, 296; Mendocino (CA) photographs of, 133; Muir glacier theory and, 374, 375–76, 375*fig.*; museum holdings of, 462, 463; panoramas of, 204; photographic style of, 392; Ralston and, 254; San Francisco photography studio of, 199; SFAA exhibitions of, 252; Watkins and, 38, 371; Watkins Yosemite photos (1861) and, 367, 372–74, 372*fig.*; Watkins Yosemite photos (1865–1866) and, 199; Watkins Yosemite photos (1878–1881) and, 374; Yosemite photos of, 392; Yosemite visits of, 371–72, 374, 375–76

Myra (Yosemite Gallery salesperson), 510n12

Naef, Weston, 298, 469n, 471n10, 472n24, 476n41, 477n14, 483n39, 488n16, 489n15, 490n16, 494n10, 499n13, 501n1, 506n2, 507n9

Nahl, Charles, 461

Napa State Hospital for the Insane, 466

Napa Valley (CA), 479n14

Napoleon III (emperor of France), 75, 176

Nash, Roderick Frazier, 52

national parks, 2, 62, 153, 155. *See also* Yosemite idea

National Park Service, 169, 485n53

Native Americans, 6, 137–38, 153, 263, 338–39, 349, 371, 407, 442

Nature (Emerson), 61, 91–93, 144, 156, 157

"Nature" (essay; Emerson), 156

Nature and Culture (Novak), 194

nature park idea, 153. *See also* Yosemite idea

Nebraska Territory, 175

Neilson, Adelaide, 301–2

Nevada Bank (San Francisco, CA), 305, 310–12

Nevada Bank Building, San Francisco (photograph; Watkins), 310–12, 311*fig.*

Nevada County (CA), 358

Nevada Fall (Yosemite Valley, CA), 72–73, 181*fig.*

Nevada photographs (Watkins): business interests behind, 496–97n12; Comstock mining photographs, 317–22, 320*fig.*, 321*fig.*; Huntington and, 313–15; Lake Tahoe photographs, 315, 316–17, 316*fig.*; trip route, 315, 496n10

Nevada State Legislature, 395

Nevada Territory, 74, 163, 213, 224, 313, 479n14

Nevada Tribune, 496n10

New Almaden Mining Company, 34, 109, 132, 473n33

New Britain Museum of American Art, 508n13

New Haven (CT), 146

Newlands, Clara Adelaide Sharon, 452

Newlands, Francis G., 439, 451–53

New Mexico Territory, 327, 335

New Orleans (LA), 460

News Notes of California Libraries, 461

New York (NY), 2, 15, 19–20, 100, 133, 143, 146, 247–48, 417, 471n1, 502n11; hotels in, 303; Sanitary Commission fair in (1864), 175

New York & Erie Railroad, 471n1

New York Botanical Garden, 256

New York College of Physicians and Surgeons, 266

New York Evening Post, 57

New York Post, 122, 123, 157

New York Times, 77–78, 117–18, 121, 122, 125, 143

New York Tribune, 53, 58, 70, 118, 126, 153, 171, 277, 278, 374–75

Niagara (painting; Church), 122, 123, 124–28, 127*fig.*, 169, 198

Niagara Falls, 72–73, 121, 143–44, 149, 156, 365, 367

Nine Sisters, 346

nitroglycerin, 211

Nordhoff, Charles, 242, 442

North Beach (San Francisco, CA), 306

North Bloomfield Gravel Mining Company (Nevada County, CA), 242, 283, 284–88, 287*fig.*, 289, 299–300, 436

North Dome (Yosemite Valley, CA), 382

Northern Pacific Railroad, 213, 222, 415, 416, 506n2

North Rim (Yosemite Valley, CA), 367

Norway, 133

Norwich (VT), 484n23

Novak, Barbara, 140, 194

Nova Scotia (Canada), 10

Noyo River, 133

Oakland (CA), 165, 243, 479n15

Oakland Museum of California, 256

O'Brien, William S., 292, 302–3, 321–22. *See also* Bonanza Kings

Occidental Hotel (San Francisco, CA), 154, 289

"Of Truth of Water" (Ruskin), 126

Ogden, Captain, 150

Ohio, 209

Ohio River, 129–30, 209

O'Keeffe, Georgia, 366

Olive and Palm Orchard, Mission San Diego de Alcalá, San Diego County, California (photograph; Watkins), 341–42, 341*fig.*

Olmsted, Frederick Law, 114; Billings and, 143; Bryant and, 157; career background of, 143–44; as Central Park (NYC) designer, 143, 157, 174, 182; correspondence of, 182; Emersonianism and foundational ideas of, 144–45, 280; fiancée of, 159; as Las Mariposas supervisor, 143, 145; Mills and, 254–55, 257; nanny hired by, 200; as Sanitary Commission secretary, 143, 154, 157, 174; Starr King and, 143; Watkins and, 2, 143, 172, 241; as Yosemite Commission head, 168, 171; Yosemite idea and, 154–55, 156,

Olmsted, Frederick Law *(continued)* 159–60, 382. *See also Preliminary Report upon the Yosemite and Big Tree Grove* (Yosemite Commission)

Olmsted, Mary, 178–79

Oneonta (NY): Ainsworth family roots in, 506n2; butter economy in, 19–20, 21, 23; gold rushers from, 21–22, 448, 471n1; Huntington family in, 18–19; Leonid meteor shower as seen in (1833), 12–13, 21; name change of, 11; population growth in, 20–21; transportation connections to, 14–16; U.S. western migration and, 17; Watkins childhood in, 12–14, 16–18; Watkins residence in, 314

Oneonta (steamship), 210

Oneonta Creek, 414, 506n2

Oneonta Gorge, 414

orange orchards, 400, 402–3, 404

Oregon, 200–201; British designs on, 441; Colfax party trip to, 210; Starr King visit to, 207, 479n14; Watkins mammoth-plate photos taken in, 214; Watkins photographs in *(see* Columbia River Gorge photographs (Watkins; 1867)—scenic; Columbia River photographs (Watkins; 1867)—OSNC-specific); Watkins trip to (1882), 455

Oregon and California (Frémont expedition report), 23–24

Oregon City (OR), 206–7, 208

Oregon Democratic Party, 63

Oregon Historical Society, 194, 222, 414

Oregonian (steamer), 214

Oregon Iron Company, 206, 354

Oregon Portage Railroad, 215

Oregon Steam Navigation Company (OSNC): archives of, 222; Big Four leadership of, 211, 222; economic significance of, 202, 203, 211–12; founding of, 208, 209–10, 416, 506n2; Huntington as investor in, 488n16; Keith as painter for, 292–93; Ralston and, 241; transcontinental railroad threat and, 210–14; Watkins connections with, 209, 241; Watkins guide/assistant appointed by, 214–15, 225–26; Watkins work for, 202,

249. *See also* Columbia River pictures (Watkins; 1867)—OSNC-specific

Oregon Trail, 224–25, 489n1

Orsi, Richard, 436

Oso Mill (Las Mariposas estate), 473n2

O'Sullivan, Timothy, 83–84, 117, 129, 264–65, 273, 295*fig.*, 296, 454

Oswego (OR), 206

Otego (NY), 14

Otsego County (NY), 22

Our Banner in the Sky (painting; Church), 234

Outline View of Half Dome (photograph; Watkins), 169

Overland Journey, An (Greeley), 53, 70

Overland Monthly, 388, 394, 437, 503n11

Over the Plaza (photograph; attr. Watkins), 472n24

Pacific Improvement Corporation, 418

Pacific Northwest: boosterism efforts, 210; geography of, 212; Keith paintings in, 292–93; OSNC in, 202, 210

Pacific Northwest photograph series (Watkins; 1882–1883): British Columbia photos, 413, 415–16; business interests behind, 416; dry-plate technology used in, 423; inventory rebuilding as need for, 413; Montana photos, 413; Oregon photos, 414–15, 414*fig.*; photographic quality of, 416, 420; Washington Territory photos, 413, 415–16; Yellowstone photos, 413, 420

Pacific Railroad Act (1862), 134, 152, 210

Pacific Railroad Survey, 233

Pacific Republic threat, 74–75, 79, 141

Pacific Rural Press, 432–34, 437, 450, 501n1

Pacific Tourist, The (CPRR guidebook), 323, 333

Palace Hotel (San Francisco, CA), 242, 303–4, 305, 306, 307, 361, 452–53, 464

Palmer House Hotel (Chicago, IL), 303

Palmquist, Peter, 31, 474n7, 477n14, 483n42, 496n19, 501n1, 505n19, 505n22

palm trees, 340

Panama, 24, 25, 133

Panama Canal, 265

Panic of 1873, 303

Poso Creek, 425
Poso Creek Ranch (Kern County, CA), 426
Potter's American Monthly, 247
Potthast, Edward, 345
Poverty Bar, Middle Fork, American River
(photograph; Weed), 50, 51*fig.*
*Preliminary Report upon the Yosemite and Big
Tree Grove* (Yosemite Commission): Civil
War and American art linked in, 173–75;
as cultural Unionist document, 175–80;
Emerson and, 280; European landscapes
alluded to in, 176, 177; historical
significance of, 173; metaphor as used in,
177–78; Olmsted reading of draft report
(1865), 171–73, 173*fig.*; rediscovery of,
486n59; science in, 185–86
Prescott, William H., 66
presidios, 338
Princeton University, 104, 189
Puget Sound, 211, 415, 416

quartz mining, 41, 45, 283
quicksilver, 34. *See also* mercury

racism, 138
Railroad Bridge, Looking Down the Mountain
(photograph; Watkins), 46, 47*fig.*
railroads, 7, 15, 16, 471n1; cliché photography
of, 427–28; construction quality of, 330;
land grants of, 408; surveyed grids and,
449. *See also* Northern Pacific Railroad;
Southern Pacific Railroad; transconti-
nental railroad, final (Northern Pacific);
transcontinental railroad, first (Central
Pacific/Union Pacific); Union Pacific
Railroad; Virginia & Truckee Railroad;
specific railroad
Ralston, Bertha, 242, 292
Ralston, Lizzie, 301
Ralston, William C. ("Billy"): banquets given
by, 301–2; Belmont estate of, 253–54, 257,
301, 307; business colleagues of, 292;
career background of, 129–30; competi-
tion of, 302–3, 310–11; death of, 306, 352;
as equestrian, 358; estate settlement,

307–9, 452, 496n19; financial downfall of,
302–6, 313, 357; industrial intelligence
system of, 304; investments of, 130, 304,
311, 313, 361, 408 (*see also* Grand Hotel
(San Francisco, CA); North Bloomfield
Gravel Mining Company (Nevada
County, CA); Palace Hotel (San
Francisco, CA)); memorial service for,
309; OSNC and, 209–10; as San Francisco
art patron, 86, 209, 301–2; as San
Francisco banker, 209, 240–41; Spring
Valley scheme of, 304–6, 357; as Unionist,
129, 130–31; Watkins and, 2, 86, 119, 130,
209, 252, 360; Watkins art gallery move
and, 288–89, 308, 417; Watkins/Haggin
meeting and, 421; Watkins San Francisco
work for, 241–43, 253–54, 284–88; western
career of, 7; Yosemite honeymoon of,
102
Ralston's Ring, 241, 242, 243, 289, 307, 312,
315, 318–19, 358, 359, 374
Ramblings in California (Shaw), 474n10
Ramona (Jackson), 337, 349
Rancherie Indian reservation (CA), 137–38
Raymond, Israel W., 154, 155, 161–62, 166, 175,
182, 484n27
Raymond, Mount (Yosemite Valley, CA), 182
Reagan, Ronald, 475n38
Reclamation Act (1902), 439–40
Red Cross, 62
Redding, Benjamin Bernard, 292
Red Peak, 275
redwoods, 133, 134, 358
Reed, Amanda, 222
Reed, Simeon, 211, 213, 222
Reed College (Portland, OR), 222
Reign of the Stoics, The (Holland), 281
Reno (NV), 323
Report of the Fortieth Parallel Survey (King),
277–78
Republicanism, 62, 100
Republican Party, 40, 52, 56–57, 65, 358, 359,
361–62
Republican Unionism, 129, 172
Rescue (tugboat), 259

Scappoose, 202, 205

Scenes in the Indian Country (photographs; Gardner), 83

Schama, Simon, 258, 262

Schweinfurth, A.C., 457

science, 201; American, 188–89; artists interested in, 194–95; Humboldtian, 188, 194; Watkins Shasta photos and, 270–71, 274, 275; Watkins tree portraits and, 189–95; Watkins Yosemite photos (1878–1881) and, 374; *Yosemite Book* project and, 187–89; Yosemite idea and, 382

Scots-Irish, 130, 215, 279, 383

Scott, Tom, 327, 335

Scott, William A., 70

Scupham, J.R., 292

Seal Rocks (San Francisco, CA), 252, 298–99, 299*fig.*

secession movement, 71–72, 75–76, 79, 131, 177–78, 179, 258

Secret Town Trestle, Central Pacific Railroad, Placer County, California (photograph; Watkins), 322*fig.*, 323

Selby, Thomas, 254, 301, 306

self-reliance, 60–61, 180, 280

Selover, Albia A., 54, 75

Semi-Tropic California (magazine), 401, 505n13

Sengteller, Louis, 390, 504n16

Sentinel Rock (Echo Canyon, UT), 294

Sentinel Rock (Yosemite Valley, CA), 89–90, 196, 377

Sentinel Rock and Merced River (painting; Keith), 293

Sequoia gigantea, 193

sequoias, 365

Serra, Junipero, 338, 340, 443

Seventy-Sixth Regiment, 80

Seward, William H., 76

Shakespeare, William, 180, 252, 301

Shanahan's (Portland, OR), 203

Shanghai (China), 307

Shannon, Julia, 39

Sharon, William, 302, 303, 305–6, 307–8, 313, 318–19, 452, 453

Shasta, Mount, 107, 132, 208; Appleton appropriation of Watkins photo of, 243; artist visits to, 235, 237, 489n14; circumnavigation of, 238, 490n17; cultural Unionism and, 234; geology of, 270, 271; glacier on, 271, 272–73, 273*fig.*, 291, 350, 374; height of, 489n7; Muir visits to, 279; Munger visit to, 377; photo-publishing technology and, 508–9n33; road access to, 232–33; San Franciscan visitors to, 233–34; Shastina, 238, 271–72; Watkins photographs of (1867), 236–38, 236*fig.*, 258, 281, 332, 482n10, 489n15, 490–91n9, 490n16; Watkins photographs of (1870), 269–71, 272–73, 273*fig.*, 274–75, 291, 490n16; Watkins visit to, 232–33, 235–38, 377

Shasta Valley, 235

Shastina, 238, 271–72

Shaw, Pringle, 474n10

Sheraton Taipei, 307

Shew, William, 31

Shorb, J. de Barth, 399, 400, 403, 505n11

Sierra Club, 62, 114–15, 280

Sierra del Encino, 192

Sierra del Encino (photograph; Watkins), 35*fig.*

Sierra Madre Villa (San Gabriel Valley, CA), 399–400, 401

Sierra Nevada Mountains, 29–30, 120, 167, 211; foothills of, 395, 454–55, 478n14; hydraulic mining in, 425; Kern River origins in, 411; snowmelt from, 407; Tehachapi Mountains and, 498n5; transcontinental railroad built through, 325

Silliman, Benjamin, Jr., 109, 146–47, 154

Silliman, Benjamin, Sr., 104, 268

silver mining, 38–39, 302, 358, 454

Siskiyou Mountains, 211, 232

Sisson, John, 235

Sisson, Justin, 265, 269, 270, 279

Sisson, Lydia, 235

Sisson's ranch (Strawberry Valley, CA), 235–36, 237, 270

Slot, the (San Francisco, CA), 3

269–70; geographical vagaries and, 385; geological knowledge of, 346; as landscape photographer, 84–85; Lone Mountain photographs, 101; metaphor as used by, 449–50; Mills and, 359–60; Muir and, 278–79, 381; Muybridge and, 371; Newlands legal action and, 451–53; notebooks of, 483n37; numbering system of, 225, 253, 284–85, 469n, 488n8, 498n17, 498n19, 499n8, 502n8, 508n11; panoramas of, 204–7, 206–7 figs. 27–29; patrons/enablers, 129, 166, 241, 284, 293; *Peralta* lawsuit, 81–82, 473n33; portraits, 291–92, 355–57, 505n21; pricing information, 483n37; professional decline of, 451–54, 455–57, 510n19; professional origins of, 472n24; public institutions holding albums of, 149–50; Ralston and, 241–43, 252, 284, 304, 308; Ralston's Ring and, 307; San Francisco business addresses of, 452–53; science and, 270–71; SFAA and, 492n5; staff hired by, 54, 419, 483n34, 483n35; Stanford Museum interest in work of, 462–63; Starr King and, 60, 69, 73–74, 82, 119, 163–64, 166, 198, 262; still lifes, 282; surviving albums, 483n42; technique-sharing by, 251–52; Utah photographs, 294–97, 297 fig.; Utah trip of, 292, 294–97; visual intelligence of, 449–50; wagon of, 33, 294, 352, 364, 389; Washington's Birthday rally photo attributed to, 77 fig., 78; western cultural Unionism supported by, 115; works of destroyed (1906), 1, 3–6, 5, 364; *Yosemite Book* project and, 187–89; Yosemite Commission report and, 176; Yosemite idea and, 156. *See also* Columbia River Gorge photographs (Watkins; 1867)—scenic; Columbia River photographs (Watkins; 1867)—OSNC-specific; Kern County photographs (Watkins); Las Mariposas photographs (Watkins); Mendocino (CA) photographs (Watkins); Pacific Northwest photograph series (Watkins; 1882–1883); Yosemite

photographs (Watkins; 1861); Yosemite photographs (Watkins; 1865–1866); Yosemite photographs (Watkins; 1878–1881)

Watkins, Carleton E.—comeback year (1876): CPRR photographs, 322–24, 322 fig., 323 fig.; Huntington and, 313–15; Nevada Bank building photographs, 310–12, 311 fig. *See also* Nevada photographs (Watkins)

Watkins, Charles (brother), 80, 117, 484n23

Watkins, Collis (son), 405, 419, 431–32, 455–56, 457, 459, 460, 465

Watkins, Frances Snead ("Frankie"; wife), 405–6, 419, 455, 464–66, 505nn21–22

Watkins, George (brother), 18, 80

Watkins, James (brother), 18

Watkins, Jane (sister), 18

Watkins, John Maurice (father): children of, 10, 18; correspondence of, 314; marriage of, 11–12; Ohio move of, 16–18; as Oneonta hotel owner, 13–14, 16; return to Oneonta, 18, 51; trades learned by, 20, 448; Watkins Christmas gift to, 250

Watkins, Julia Anne (mother), 10, 11–12, 16, 18

Watkins, Julia (daughter), 5, 405, 431–32, 455–56, 465, 466, 505n23, 510n12, 510n19

Watkins, Lydia Burgett (grandmother), 11

Watkins, Mount (Yosemite Valley, CA), 182–84, 183 fig., 373–74

Watts, Jennifer, 423

Wayne, John, 463

W. C. White Company, 378

Weapons of the Argonauts (photograph; Watkins), 282

Weber Canyon, 294–97

Weber River, 296

Webster, Daniel, 76

Webster's American Dictionary, 110

Weed, Charles Leander: American River mining photos of, 49–50, 51 fig., 454, 474n7; camera used by, 85, 91; career background of, 48–49; critical reviews of, 71; Exposition Universelle (Paris; 1867)

Weed, Charles Leander *(continued)*
 mistake involving, 239; San Francisco
 gallery of, 48, 102; as Watkins competi-
 tor, 83; Yosemite photos of (1859), 70–71,
 83, 84, 89–90, 90*fig.*, 162, 196–98, 477n5;
 Yosemite trip of, 86, 195
Weekly Mountaineer, The (newspaper), 217–18
West, the: as artificial construct, 6–7; as
 beautiful, 48; during Civil War, 81;
 conservationism/environmentalism in,
 497n18; cultural Unionism called for,
 65–67; cultural visions of, 7–8, 59;
 geological past of, 493n9; industrial
 transition in, 332; metaphors for, 449–50;
 migration to, 17, 25, 123; overland routes
 to, 224; photographic challenges of, 251;
 photography market history in, 505n19;
 pre-American history in, 337–38;
 settlement of, 459; tourism in, 279;
 transcontinental railroad connected to,
 279; USCS/USCGS mapping project, 383,
 385–86; volcanic activity in, 271; Watkins
 and, 7–9
West Church (Boston, MA), 165
West Coast Furniture Company (San
 Francisco, CA), 304
western fiction, 56
western humor writing, 52
western nature, 442
Western Shore with Norman's Woe (painting;
 Lane), 137
Weston, Edward, 133
West Rock, New Haven (painting; Church),
 430, 508n13
wet-plate photographs, 46, 48, 49, 85, 176,
 272, 422
Whale Stranded at Berckhey (print; Matham),
 262
White, Minor, 133
White, Richard, 7–8, 497n1
White Hills, The (Emerson), 68
White Hills, The (Starr King), 187, 188
White Mountains, 9, 60, 72, 82, 120, 121, 167
White Rock Lake, 388
Whitney, Josiah D., 374; artistic knowledge
 of, 195; Blake vs., 268, 269, 277; as CGS

head, 41, 103, 104, 173, 266, 268;
 correspondence of, 193, 195, 200, 205,
 487n13; glacier named after, 272–73; Gray
 and, 190; Harvard appointment of, 241,
 266–67; King vs., 272; in Oregon, 205;
 pirated Watkins edition and, 244; Shasta
 visit of, 234, 274; Watkins engagement
 with, 186; Watkins Yosemite photos
 shared by, 107, 110; western career of, 7;
 western sociocultural alliances and, 114;
 Yosemite Book project and, 187; as
 Yosemite Commission member, 168;
 Yosemite formation theory of, 267–68,
 274, 276–77, 493n9; Yosemite idea and,
 155, 484n8
Whitney, Mount, 263
Whitney, William, 110
Whitney Glacier, 272–73, 273*fig.*, 274, 291,
 374
Whittier, John Greenleaf, 73
Wible, Simon W., 447–49
Wible's Peach Orchard (photograph;
 Watkins), 448
Wildcat Creek, 373
Wild Cat Fall (photograph; Muybridge),
 372*fig.*, 373
Wilderness, Battle of the (1864), 154, 174
Willamette River, 202, 203, 206, 226
Willamette Valley, 203, 206, 211, 248, 354
Willard's Hotel (Washington, DC), 162–63
Williams, George Henry, 213, 214
Williams, Stevens, Williams & Co. (New
 York, NY), 126–27
Williams, Virgil, 168, 261, 293
Williamsport (MD), 160
Williston, Edward B., 160, 484n23
Wills, David, 158–59, 160
Wills, Gary, 160–61
Wilmington (CA), 334
Wilson, Benjamin Davis ("Don Benito"),
 398–99
Wilson, Edward L., 245–47, 491n15
Windom, William, 325
wine, 397, 403, 403*fig.*, 434
Winnemucca Lake, 389
Wisconsin Territory, 48